RENAISSANCE OF ISLAM: ART OF THE MAMLUKS

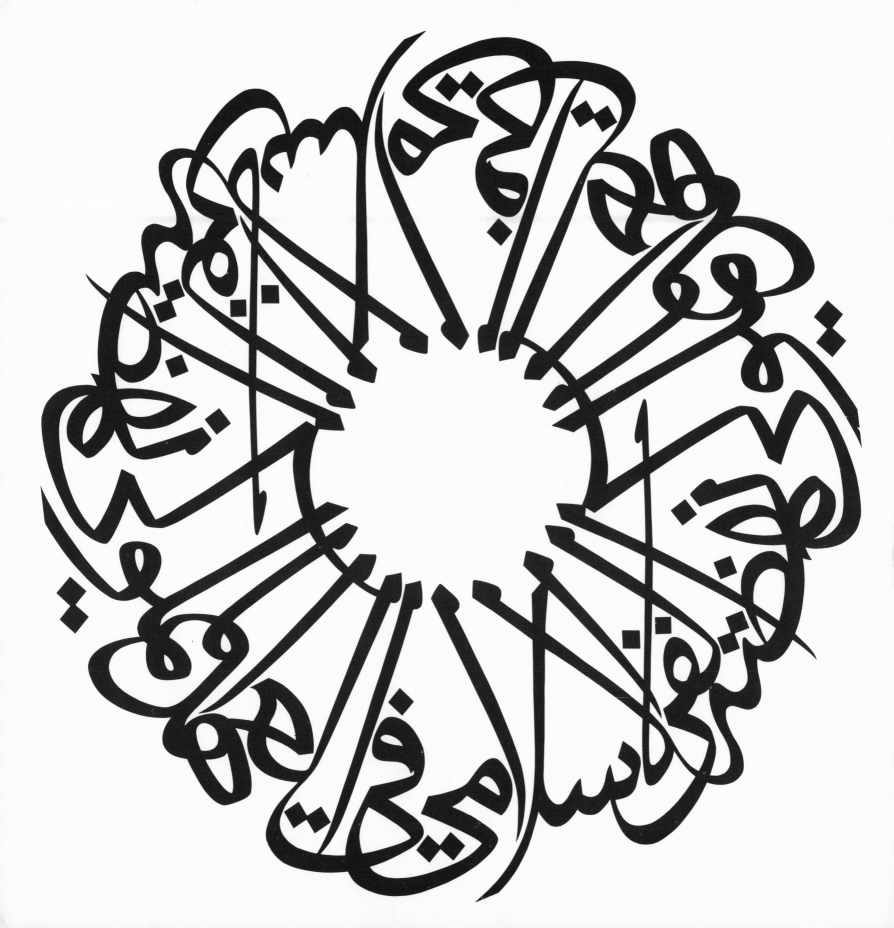

Publication made possible by a grant from United Technologies Corporation

RENAISSANCE OF ISLAM
ART OF THE MAMLUKS

Esin Atıl

SMITHSONIAN INSTITUTION PRESS, WASHINGTON, D.C., 1981

Published on the occasion of an exhibition circulated by the
Smithsonian Institution Traveling Exhibition Service and shown at:
 Washington D.C., National Museum of Natural History,
 Smithsonian Institution
 Minneapolis, The Minneapolis Institute of Arts
 New York, The Metropolitan Museum of Art
 Cincinnati, Cincinnati Art Museum
 Detroit, The Detroit Institute of Arts
 Sacramento, Crocker Art Museum
 San Diego, San Diego Museum of Art
 Phoenix, Phoenix Art Museum
 Hartford, Wadsworth Atheneum

Library of Congress Cataloging in Publication Data

Atıl. Esin.
 Renaissance of Islam.

 Published on the occasion of an exhibition shown at the National
Museum of Natural History, and other museums.
 Bibliography: p.
 1. Art, Mameluke—Egypt. 2. Art, Islamic—Egypt. 3. Art,
Mameluke—Near East. 4. Art, Islamic—Near East. I. National
Museum of Natural History. II. Title.
N7385.3.M35A84 709'.17'671074013 80-607866
ISBN 0-87474-214-5
ISBN 0-87474-213-7 (pbk.)

Cover: detail of no. 21

Designed and produced by Birdsall & Co.
Typeset in Monophoto Modern no. 7 by Balding & Mansell
Color reproduction by Medway Reprographic
Printed on Glastonbury Antique Book Laid and Chromosatin by Penshurst Press
Binding by Croft Bookbinders

Reprinted 1982

Printed and bound in Great Britain

CONTENTS

Why is it that a society blossoms out in a bouquet of artistry at a given moment in time? Such a moment occurred when the Mamluk sultans, based in Cairo, ruled the East from the mountains of Turkey to the sands of Nubia, from the eastern shores of the Mediterranean to the Arabian Sea.

By Western reckoning, the period was that of the Middle Ages. For the world of Islam, the two hundred and fifty years of Mamluk rule marked a rebirth, a renaissance. Yet there were parallels between West and East in terms of human goals and achievements. As the workers, peasants, and merchants of medieval Europe thrust their Gothic spires toward heaven, the craftsmen of the Arab East gave expression to their faith and their societal concepts with achievements of architecture, religious manuscripts, metalwork, and glass, which form a legacy of opulence and beauty.

In a sense, the title of this book and the traveling exhibition that it recaptures is not entirely accurate. The Mamluks were not artists, far from it. They were professional soldiers, merchants if you will, the sultan's bodyguards, who themselves in time rose to be sultans and establish the Mamluk dynasty. Their origins were not in the great cities of the East—Cairo, Damascus, Baghdad—but in the far-off plains of central and western Asia.

Nor did they provide a perfect stability for the lands over which they reigned. Violence and turmoil were endemic in the East as in the West in the thirteenth, fourteenth, and fifteenth centuries. And the Mamluks in the main did not sit easily on their thrones.

And yet they were men of vision and practicality. They drove the Crusaders from the Levant and turned back the Mongols. They then proceeded to trade with both Europe and Asia. This trade together with the natural gifts of the region and skills of its people brought a fabled wealth.

Mamluk society found it natural to divert vast portions of its wealth to the support of artists and craftsmen. It was equally natural for those artisans to reflect this generosity by devoting their creative efforts to the glorification of their benefactors. This interaction of patron and artist is hardly unique to the Mamluks; it has sustained art through the ages.

One must remember, though, that this exhibition and book deal not simply with a renaissance, but with a renaissance of Islam. From the time of the Prophet Muhammad until today, Islam has represented a way of life, an all-encompassing approach to life itself. The era's dedication to the philosophy and message of Islam is mirrored in its art, predominantly ordered, symmetrical, and geometric in conception and execution. It is possible to speculate that this overriding sense of order was in part a reaction to disorder—to the period's wars, palace rivalries, and cruelties.

Despite the disorder, the world of the Mamluks was a world of commerce. A rich dividend offered by this volume and exhibition is the evidence they provide of the extent to which the flow of trade across the world inspired an intermingling of images and artistic concepts.

Today, as five centuries ago, the world yearns for peace and unity. It is heartening then, to note that this treasure of Mamluk art was gathered together with the unstinting cooperation of the governments of Egypt and Syria and museums, national and private, on four continents, with the generous support of an American enterprise, the United Technologies Corporation, and with the dedicated help of the Smithsonian Institution Traveling Exhibition Service and a variety of other Smithsonian staff members and offices. It is through such joint efforts that the cultural accomplishments of the past can be harnessed to enrich the present.

S. Dillon Ripley
Secretary, Smithsonian Institution

ACKNOWLEDGMENTS

This project was initially conceived as a survey of Mamluk art. As my research progressed, I became enchanted with the richness of the artistic traditions and wanted to share with a wider audience an appreciation of the technical excellence and aesthetic refinement of these remarkable objects, and thus the handbook became an exhibition catalogue. The enthusiasm and support of friends and colleagues encouraged me to undertake the organization of a traveling exhibition that would present the splendid art of the Mamluks to the American people. This project is the result of a joint effort by many individuals who have enabled me to bring the exhibit to realization by providing reference material and assisting in the selection of objects. I am grateful to the collections in Canada, Egypt, England, France, Ireland, Syria, and the United States for the loan of their precious objects as well as to the American museums for hosting the exhibition.

For the assistance given by the Egyptian authorities I wish to acknowledge His Excellency Dr. Ashraf A. Ghorbal, the Ambassador of the Arab Republic of Egypt to the United States; Dr. Mansur Hassan, Minister of Culture and Information; Dr. Fouad el-Orabi, Executive Assistant to the Head of the Higher Council for Cultural Affairs; Dr. Shehada Adam, President of the Egyptian Antiquities Organization; Dr. Salah Abd el-Sabor, Director of the General Book Organization in Cairo and Director of the National Library; and Abd el-Rauf Ali Yusuf, General Director of the Museum of Islamic Art, and members of his curatorial staff. For the assistance given by the Syrian authorities, I am grateful to His Excellency Dr. Sabah Kabbani, formerly the Ambassador of the Syrian Arab Republic; Madame Nagar Attar, Minister of Culture and National Guidance; Dr. Afif Bahnassi, Director General of Antiquities and Museums; and Muhammed al-Kholi, Curator of Islamic art, National Museum in Damascus. I am especially grateful to His Excellency Alfred L. Atherton, Jr., Mrs. Atherton, and Alan Gilbert of the American Embassy in Cairo; His Excellency Talcott W. Seelye and Kenneth R. Audroué of the American Embassy in Damascus; Paul E. Walker and James Allen of the American Research Center in Egypt who gave all possible help in arranging loan negotiations.

Friends and colleagues who provided assistance include David Alexander, Research Assistant in the Arms and Armor Department, Metropolitan Museum of Art; Leopoldine H. Arz, Registrar, Walters Art Gallery; Marthe Bernus-Taylor, Curator of the Islamic Section. Musée du Louvre; Susan Boyd, Curator of the Byzantine Collection, Dumbarton Oaks; Filiz Çağman and Zeren Tanındı, Curator and Assistant Curator of Manuscripts, Topkapı Palace Museum; John Carswell, Director, Oriental Institute Museum; Patricia Fiske, Assistant Curator, Textile Museum; Sidney M. Goldstein, Curator of Ancient Glass, Corning Museum of Glass; Laila Ibrahim, Professor, American University in Cairo; David James, Assistant Director, Chester Beatty Library; Arielle P. Kozloff, Curator of Ancient Art, and Dorothy Shepherd, Curator of Islamic Art, Cleveland Museum of Art; Kurt T. Luckner, Curator of Ancient Art, Toledo Museum of Art; Louise W. Mackie, formerly Curator, Textile Museum, now at the Royal Ontario Museum; Maan Madina, Professor of Middle East Languages and Cultures, Columbia University; Elsie Holmes Peck; Associate Curator of Near Eastern Art, Detroit Institute of Arts; John Rodenbeck, Director, University Press of the American University in Cairo; John E. Vollmer, Associate Curator, Royal Ontario Museum; and Oliver Watson, Assistant Keeper for Islamic Art, Victoria and Albert Museum.

Special thanks go to Marilyn Jenkins, Associate Curator of Islamic Art, Metropolitan Museum of Art, and J. Michael Rogers, Assistant Keeper of the Department of Oriental Antiquities, British Museum, for their willingness to share their research; Amal Abul-hajj (Hull), formerly Curator, Islamic Museum of Haram al-Sharif in Jerusalem, for her advice on inscriptions; Amal el-Emary, Professor of Islamic

ACKNOWLEDGMENTS

Art, University of Cairo, for verifying inscriptions on objects from Cairo; Ludvik Kalus, Professor of Arabic Epigraphy, École du Louvre, Paris, for reading the passages on the Louvre pen box and helmet; Yousif Ghulam for deciphering the kufic inscriptions on the Walters Art Gallery candlestick; and Yasser al-Tabba of the Institute of Fine Arts for his assistance in translating the inscriptions on late-fifteenth-century metalwork.

Among the staff of the Freer Gallery of Art I would like to thank William T. Chase, Head Conservator, who photographed the remarkable peripheral views of the beakers from the Walters Art Gallery and who repaired the copper tray from the Embassy of the Arab Republic of Egypt; Lynda Zycherman, Conservator, who prepared the technical report on objects from Cairo as well as on other loans; Stanley E. Turek and James T. Hayden, who photographed several objects, including those from the Madina Collection and the Textile Museum; Harriet McWilliams, Assistant Registrar, who assisted in the typing of the final manuscript; and Darcy Curtiss, my invaluable secretary, who typed numerous drafts, made corrections, and spent hours on the Arabic transcriptions.

I would like to acknowledge Kathleen Preciado of the Smithsonian Institution Press, who edited the catalogue; Anne R. Gossett, Emily Dyer, and the staff of the Smithsonian Institution Traveling Exhibition Service, which organized the exhibition and arranged the national tour; Richard S. Fiske, Director of the National Museum of Natural History, for hosting the Washington, D.C., showing, and Eugene Behlen, Chief of the Office of Exhibits at the same museum, for giving full support during the installation; M. U. Zakariya, who created the epigraphic blazon of the Arabic title of the exhibition; Manuel Keene, who prepared the panel with ivory plaques on display from the Metropolitan Museum of Art; and Derek Birdsall for his superb and sensitive design of the book.

Justin Andrew Schaffer spent many weeks photographing objects in Cairo and Damascus. His photographs of the Mamluk monuments in Cairo are included in the exhibition and most of the color illustrations in the catalogue are the result of his work.

References to the objects and the bibliography were compiled by Marianna S. Simpson, whose assistance was inestimable during the planning stages of the exhibition and catalogue, Carol Bier helped finalize the project, and Holly Edwards worked on various aspects of the exhibition.

This project would not have been possible without grants from the Smithsonian Foreign Currency Program, the Commission for Educational and Cultural Exchange between the United States of America and the Arab Republic of Egypt, the Smithsonian Institution Scholarly Studies Program, and Trans World Airlines. I am particularly indebted to Mrs. George McGhee for her financial assistance.

Above all I am grateful to Harry Gray, Chairman of United Technologies Corporation. His company's generous and imaginative support made possible both this catalogue and the exhibition itself.

Esin Atıl
Curator of Near Eastern Art
Freer Gallery of Art

LENDERS TO THE EXHIBITION

Baltimore, The Walters Art Gallery
Boston, Museum of Fine Arts
Cairo, Museum of Islamic Art
Cairo, National Library
Cleveland, The Cleveland Museum of Art
Corning, New York, The Corning Museum of Glass
Damascus, National Museum
Detroit, The Detroit Institute of Arts
Dublin, The Chester Beatty Library
London, The British Museum
London, Victoria and Albert Museum
New York, Madina Collection
New York, The Metropolitan Musem of Art
Paris, Musée du Louvre
Toledo, The Toledo Museum of Art
Toronto, Royal Ontario Museum
Washington, D.C., Dumbarton Oaks
Washington, D.C., Embassy of the Arab Republic of Egypt
Washington, D.C., The Textile Museum

THE MAMLUK EMPIRE: HISTORY AND ADMINISTRATION

Diacritical marks are not used in the transliteration of Arabic words and names.

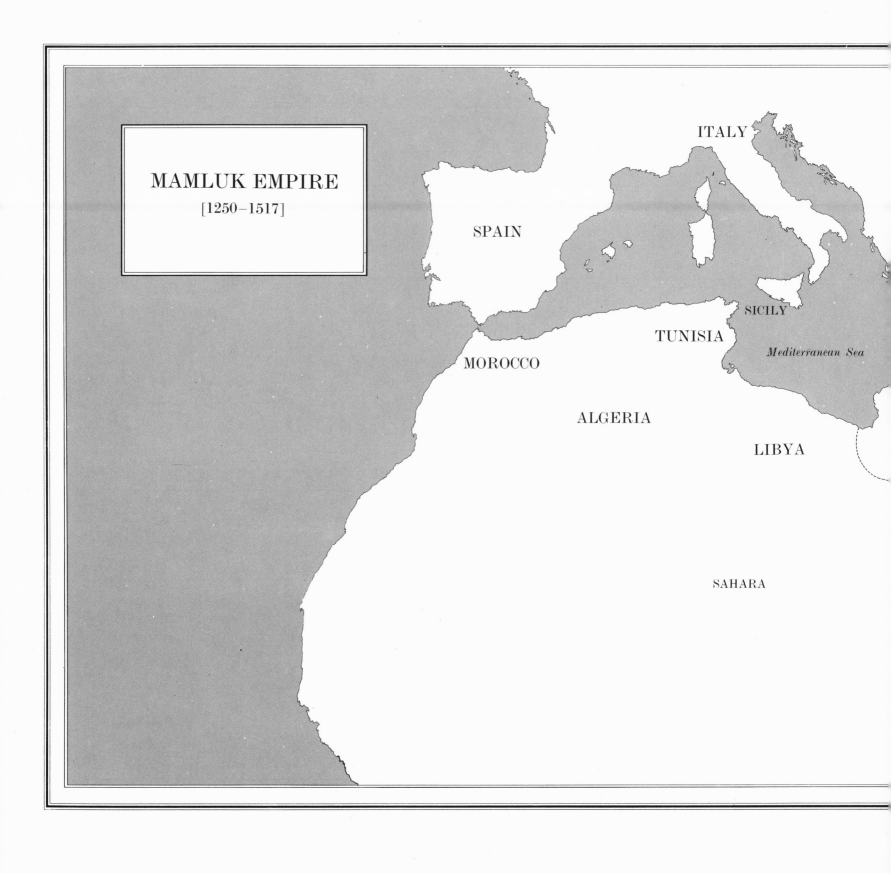

MAMLUK EMPIRE
[1250–1517]

ITALY

SPAIN

SICILY

TUNISIA

MOROCCO

Mediterranean Sea

ALGERIA

LIBYA

SAHARA

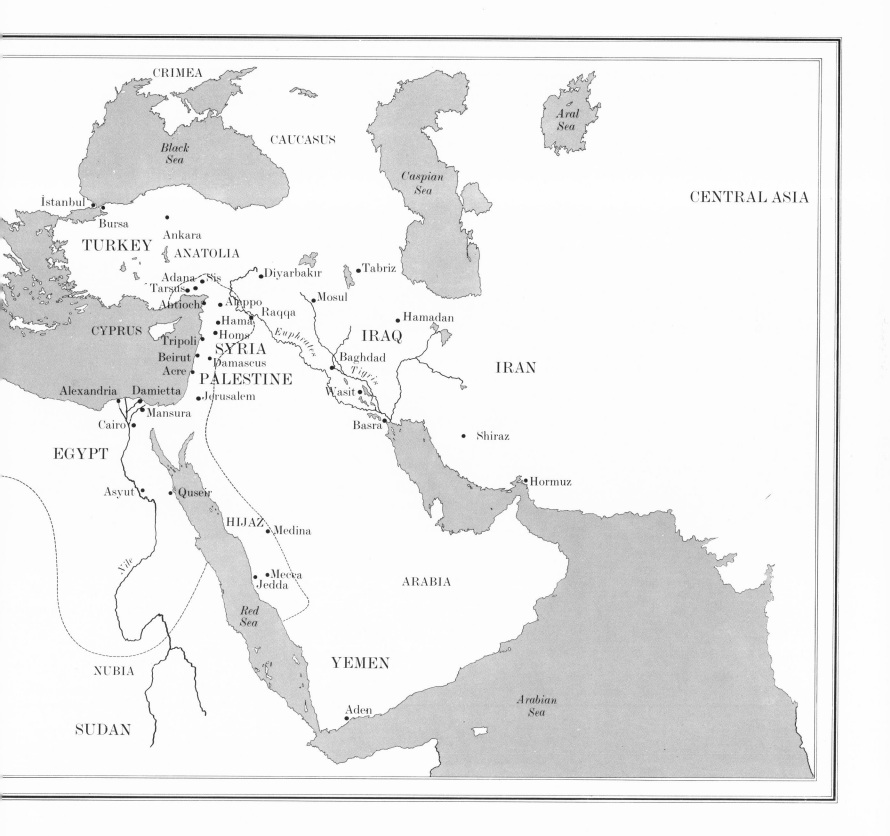

CRIMEA

CAUCASUS

Black Sea

Aral Sea

Caspian Sea

CENTRAL ASIA

İstanbul

Bursa

Ankara

TURKEY

ANATOLIA

Diyarbakır

Tabriz

Adana Sis

Tarsus

Antioch

Aleppo

Mosul

Raqqa

Hamadan

CYPRUS

Hama

Homs

Euphrates

IRAQ

IRAN

Tripoli

SYRIA

Beirut

Damascus

Acre

PALESTINE

Baghdad

Tigris

Alexandria

Damietta

Jerusalem

Wasit

Mansura

Basra

Cairo

Shiraz

EGYPT

Hormuz

Asyut

Quseir

HIJAZ

Medina

Nile

ARABIA

Mecca

Jedda

Red Sea

NUBIA

YEMEN

SUDAN

Aden

Arabian Sea

Following the collapse of the Ayyubid state in 1250, the Mamluk sultans established a formidable empire, ruling Egypt, Syria, and Palestine for more than two hundred and fifty years, their frontiers extending from southeastern Anatolia to the Hijaz and incorporating parts of Sudan and Libya.[1] Soon after coming to power, they defeated the Mongols and expelled the last of the Crusaders from the Near East. Trade and agriculture flourished under Mamluk rule, and Cairo, their capital, became one of the wealthiest cities in the Near East and the center of artistic and intellectual activity. It also became the seat of the caliphate and, thus, the most prestigious capital in the Islamic world.

The word mamluk derives its meaning from the root of the verb "to own" in Arabic and refers to persons who were purchased, captured, or acquired as gifts or tribute. The mamluks were at first drawn exclusively from the Turkish tribes of Central Asia but later included other peoples from Western Asia. Carefully trained in all forms of warfare and horsemanship, they were employed as bodyguards of the sultans. Later, they were freed and assigned to specific offices that entitled them to have their own mamluks. Amirs or freed mamluks rose rapidly within the administration; they often usurped the throne, attempting to establish their own dynasties. In spite of the risks involved, the chivalry of the mamluks made them indispensable to the rulers, who could not rely upon the loyalty of their subjects and who feared the rivalry of their relatives.

The tradition of owning an elite corps of bodyguards can be traced to early Islamic history when the caliphs of Baghdad began to acquire mamluks. It continued under the Ayyubids; Sultan al-Salih Najm al-Din Ayyub (1240–49) stationed his mamluks in Cairo on the Island of Roda overlooking the Nile. This corps was known as al-Bahriyya al-Salihiyya, identified by the location of their barracks of their origin (*bahri* meaning the sea or those who came from across the sea) and the honorific title of their owner.

It was the leaders of this group who established in Egypt and Syria the first Mamluk empire, called the Bahri Mamluk or more correctly the Dawlat al-Turk, the Turkish State. The sultanate of the Bahri Mamluks was overthrown by the mamluks of Sultan Qalawun (1279–90), who had created a regiment of his own bodyguards and quartered them in towers in the Citadel of Cairo. This second period, called the Burji Mamluk (*burj* meaning tower), is referred to by Arab historians as the Dawlat al-Jarkas, the Circassian State, since most of the Burji sultans were originally from the Caucasus. The historical distinction between the two Mamluk empires, however, is arbitrary and there is no real, social, political, or administrative difference between the Bahri and Burji periods.

HISTORY

Bahri Period (1250–1390)

The formation of the Mamluk state reads like a medieval romance, full of violence and female intrigue. When Najm al-Din Ayyub died in November 1249, his wife Shajar al-Durr (Tree of Pearls) concealed the news of his death and ruled by herself for several months until his son and heir, Turan Shah, could arrive from Mosul where he had been serving as governor. Shajar al-Durr, a woman of intelligence and ambition, had formerly been in the harem of al-Mustasim, the Abbasid caliph of Baghdad, who sent her as a gift to Najm al-Din Ayyub.

The Ayyubid army, unaware of the sultan's death, won a remarkable victory over the Crusaders in February 1250, at the Battle of al-Mansura. Turan Shah, who finally arrived in Cairo and ascended the throne, was greatly disliked and was murdered within two months. His death ended Ayyubid rule in Egypt; the Bahri mamluks elected Shajar al-Durr as their new sultana and appointed an amir named Aybak as her commander-in-chief. Thus, the Mamluk state was born in May 1250, with a woman on the throne.

Al-Mustasim, however, was reluctant to bestow the diploma of investiture to a woman who had once belonged to him, and it was finally decided that Shajar al-Durr should marry the commander-in-chief, Aybak. She abdicated the throne in his favor after having reigned only eighty days. The Bahri mamluks, vehemently opposed to Aybak, supported a rival named Aktay who was murdered by the new sultan. Aktay's death forced many of his mamluk allies to escape to the courts of the last Ayyubid princes who still ruled in Syria. Although Aybak was able to withstand the mamluks' antagonism, he made the fatal mistake of offering to marry the daughter of the ruler of Mosul in 1257 and, thereby, incurred the wrath of Shajar al-Durr. The queen subsequently lured him to her chambers and murdered him in his bath. Shajar al-Durr herself met an equally treacherous end three days later at the hands of Aybak's vengeful concubines, who beat the queen to death with their clogs and threw her body from the walls of the palace.

The throne of the newly founded Mamluk state passed to Aybak's son, a fifteen-year-old youth named Ali who ruled until 1259, at which date he was deposed by an amir named Qutuz. Qutuz welcomed the exiled Bahri mamluks to Cairo and invited them to join forces against the Mongols who, having captured Baghdad and killed the caliph a year earlier, were now rapidly moving into Syria. Among those who returned to Cairo to take up their old positions were Baybars and Qalawun, both Kipchak Turks and former mamluks of Najm al-Din Ayyub.

The Bahri chapter of Mamluk history actually begins with Baybars (1260–77), who fought valiantly with Qutuz in September 1260 and helped devastate the Mongol forces at Ain Jalut near Nazareth. This glorious victory, which was the Mongols' first defeat, was sung by poets and celebrated throughout the Islamic world. A month later Qutuz was stabbed to death, and the Mamluk throne passed to Baybars, who was called al-Bunduqdari, the bowman, after his first official post. He took the additional titles al-Malik al-Zahir Rukn al-Din al-Salihi (officer of Salih, that is, Najm al-Din Ayyub). During his seventeen-year reign, Baybars consolidated the empire, unified the army, and formed the basis of a powerful state that endured until the second decade of the sixteenth century.

Baybars was the epitome of the chivalrous, energetic, and enlightened sultan. He moved back and forth throughout his empire with the speed of lightning, reconstructing fortresses, roads, bridges, and canals; inspecting the army and the navy; and checking the fiefs. He established a regular postal service between Egypt and Syria that had twice-weekly pickups and four-day delivery; even so, Baybars found this method of communication too slow and often relied on carrier pigeons.

In the area of foreign affairs the sultan established good relations with the Byzantine emperor Michael VIII Palaeologus and with Manfred of Sicily. These contacts placed him in a position to be well informed of any new developments on the part of the Crusaders. He also formed an alliance with Berke Khan, the head of the Golden Horde (the Kipchak Mongols of the Volga) and grandson of Genghis Khan, who had converted to Islam, becoming a sworn enemy of the still-pagan Ilkhanid Mongols of Iran. Baybars also developed a friendly rapport with the Seljuks of Anatolia whose lands were strategically placed next to the Mongol realm and the Christian kingdom of Cilicia.

The sultan's military activities are also noteworthy. He fought simultaneously in Anatolia and Nubia, conducting thirty-eight campaigns in Syria alone and personally leading half of them. Baybars disposed of the last of the Ayyubids in Syria, put an end to the feared sect of the Assasins, and continued to inflict severe defeats upon the Mongols. As amir, he had taken part in the Battle of al-Mansura against the Crusaders, and as sultan he continued to weaken their strength by taking almost all Crusader strongholds and ports from Caesarea to Antioch, sacking Sis, Adana, and Tarsus.

In addition to vanquishing the pagan Mongols and the infidel Crusaders, Baybars had the

foresight, and the political savvy, to welcome the last member of the Abbasid house of Baghdad, which had been destroyed by the Mongols in 1258. The reinstatement of the Abbasid caliph in Cairo not only enhanced the importance of Egypt, but also led to the Mamluks' suzerainty over the holy cities of Mecca and Medina in the Hijaz. Now the Mamluk empire was not only one of the strongest political entities in the Near East, but also the protector of Islam.

Although Baybars was primarily preoccupied with battles against foreign invaders and local insurgents, as well as the problem of consolidating his state, he found time to restore the major buildings in the empire and to construct new edifices. His most important structures are a mosque and madrasa in Cairo and a mausoleum in Damascus. His amirs also supported the arts and commissioned metal and glass objects (see nos. 10–12 and 46). The energetic patronage provided by the court enabled artists to formulate a "Mamluk" style of art and architecture that became fully established by the beginning of the fourteenth century.

A legend in his own time, Baybars died at the height of his career in June 1277 after drinking a cup of poisoned fermented mare's milk. He was succeeded by two of his sons, Baraka Khan (1277–79) and Salamish, a seven-year-old child whose reign lasted only four months.

The next sultan was Qalawun, who established a dynasty that ruled the Mamluk empire until 1390. Fourteen of his descendants, from sons to great-great-grandson, ruled consecutively with only three relatively brief interruptions. Qalawun had been a trusted friend of Baybars and was made Commander of One Thousand or *amir-i alf*, which was included in his titles, al-Malik al-Mansur Sayf al-Din Qalawun al-Alfi, together with al-Salihi, in homage to his first master, Sultan al-Salih Najm al-Din Ayyub. Qalawun followed the policies of Baybars, to whom he was related by his daughter's marriage to Baybars's son Baraka Khan; he had also served as the *atabek* or regent for Baybars's other son, Salamish.

Qalawun succeeded in protecting the empire against the continual attacks of the Mongols and defeated them in 1281 at Homs, forcing their withdraw from Syria. In 1285 his armies took the fortress of the Hospitalers at al-Marqab, compelling the Christian knights to retreat to Tripoli, which Qalawun also took four years later. The sultan died at the age of seventy in November 1290 as he was preparing for the seige of Acre, the last of the Crusader strongholds.

The Mamluk empire was now firmly established as the major power in the Near East, and the threat of the Mongols and Crusaders was permanently thwarted. Qalawun followed Baybars's foreign policy and established amiable diplomatic and trade relations with neighboring states. Trade flourished with merchants from China, India, and Yemen bringing valuable goods through Mamluk ports and leaving rich revenues to the state. Like Baybars, Qalawun renovated the fortifications of the Mamluk frontier towns and provided security for both residents and merchants. His complex in Cairo, comprising a mausoleum, madrasa, and hospital, was lavishly adorned with stucco, marble, and glass mosaics, symbolizing the wealth of the empire.

After Qalawun's death, his eldest son, Khalil, was appointed sultan and reigned for three years. Khalil's most important political activity was the seige of Acre begun by his father. This Christian stronghold fell in 1291 together with Tyre and Beirut. The sultan continued commercial and diplomatic relations with neighboring states and built a fleet to protect his Mediterranean coasts and monopolize the East–West trade route, which went either inland through Syria or across southern Arabia, the Red Sea, Alexandria, and Damietta before reaching Europe. Heir to the political stability, administrative efficiency, and flourishing commercial activity established under the first Mamluk sultans was Nasir al-Din Muhammad, Qalawun's younger son, who reigned for almost half a century.

Al-Malik al-Nasir Nasir al-Din Muhammad was eight years old when the mamluks chose him as their sultan after his stepbrother Khalil was assassinated in December 1293. He was deposed the following year by Amir Kitbugha, one of his father's former mamluks. In 1296 Kitbugha was

killed and replaced by another amir, Lajin, who met the same fate three years later. In February 1299 Nasir al-Din Muhammad, now fourteen years old, was reinstated on the Mamluk throne. The young sultan was able to rule for ten years before again being deposed. The new sultan, Baybars II, al-Jashnigir, was formerly the imperial taster. In 1303 he and Amir Salar won a victory against the Mongols in Syria. When Baybars II usurped the throne in 1309, he took the title al-Muzaffar Rukn al-Din and made Salar his viceroy. This arrangement lasted about a year and in 1310 Nasir al-Din Muhammad returned to the throne for the third time, had Baybars II and Salar killed, and ruled without interruption until his death in June 1341.

Although Nasir al-Din Muhammad's first two reigns were characterized by unrest and political turmoil, his third reign was renowned not only for its duration but also for its peace and prosperity. He became adept at settling affairs of state through diplomacy and friendly alliances with neighboring powers. In 1323 the sultan concluded a peace treaty with Abu Said, the first ruler of the Ilkhanids to be born a Muslim, thus ending the long feud with the Mongols that had been going on since the birth of the Mamluk empire. His court was frequented by embassies from the Khans of the Golden Horde, Rasulids of Yemen, Ilkhanids of Iran, and sultans of Delhi, as well as the Pope and the kings of Aragon, France, Byzantium, Bulgaria, Tunisia, and Abyssinia. Trade was supported by both the Mamluks and the Mongols to mutual benefit, and luxury goods from the Orient passed through Syria and Egypt.

The golden age of Mamluk art occurred during Nasir al-Din Muhammad's reign. With his treasury overflowing with revenues from trade and improved methods of agriculture, he could well afford to be the greatest Mamluk patron of the arts, commissioning magnificent palaces and mosques and ordering spectacular objects for both secular and religious use. The amirs competed with the sultan, building and furnishing mosques, madrasas, mausoleums, *khanqas* (Sufi monasteries), *wakalas* (inns), *sabils* (fountains), baths, and palaces. The wealth of the Mamluk empire and the luxury of the sultan's court stimulated artists and architects to achieve the highest technical and aesthetic perfection during the first half of the fourteenth century. The competitive and demanding patronage of the court enabled artists to excel in the creation of manuscripts, metalwork, glass, ceramics, textiles, and all forms of architectural decoration (see nos. 1–3, 18–28, 50–51, 53, 66–73, 77–84, 92–96, 99–100, 102–3, 106, and 113–17; I and II).

The fierce competition among powerful amirs of the court who held the posts of imperial cup-bearer, taster, and secretary (such as Qusun, Almas, Altunbugha, Beshtak, Salar, Toquztimur, and Kitbugha and Baybars—the latter two later usurped the throne) extended into the patronage of art and architecture and led to an unprecedented explosion in artistic production (see nos. 15–16, 27–28, and 93–96). The arts were also supported by the *arbab al-qalam* or men of the pen, including the renowned scholar Abu'l-Fida, who was a descendant of the Ayyubids and a trusted friend of the sultan (see nos. 23–24 and 53). The work of Mamluk artists was in demand by the Rasulid sultans of Yemen, who ordered a number of inlaid brasses and enameled and gilded glass (nos. 14, 22, and 50).

The wealth of goods arriving from the East introduced new decorative features readily adapted by Mamluk artists. Far Eastern and Central Asian floral motifs (such as lotus and peony scrolls) and fantastic animals (including the *ch'i-lin* and phoenix) enriched the decorative vocabulary and were absorbed by the indigenous traditions, which showed a predominance of arabesques and inscriptions. Figural compositions employed on metalwork, glass, ceramics, and textiles had a last great flourish (see nos. 10–23, 44–48, 82–84, 102, 113, and 117) but were gradually replaced by epigraphy and blazons (see nos. 24–32, 50, 52, and 93–96), which along with the arabesque became characteristic themes of Mamluk art until the end of the empire.

The descendants of Nasir al-Din Muhammad continued to support the arts and lived in luxurious surroundings, even though the actual rule of the empire was in the hands of their amirs.

Twelve sultans were enthroned (some of them twice) in a span of forty-nine years following the death of Nasir al-Din Muhammad, with the longest reigns belonging to Hasan and Shaban II. During the reign of Sultan Hasan (1347–51 and 1354–61), one of Nasir al-Din Muhammad's eight sons to ascend the throne, the real ruler was Amir Sarghithmish. Shaban II (1363–76), grandson of Nasir al-Din Muhammad, was placed on the throne at the age of ten by the powerful Amir Yelbugha and was under his control for most of his sultanate.

Despite the lack of political independence, both Hasan and Shaban II were active patrons of art and architecture (see nos. 4–6, 30–33, 52; III and IV). One of the most celebrated structures in Cairo is the madrasa and mausoleum of Sultan Hasan, built between 1356 and 1362 and decorated with superb stonework, metalwork, and woodwork. The glass mosque lamps (no. 52) produced for this complex are among the masterpieces of Mamluk art. Amir Sarghithmish, the sultan's master-of-the-robes, and Amir Shaykhu, his cup-bearer, also commissioned mosques, *khanqas*, and *sabils*, which were adorned with impressive lamps and other architectural decoration. In his turn, Shaban II dedicated spectacular Korans (nos. 5–6) for his complex built in 1376 as well as for the madrasa of his mother, Khwand Baraka, founded in 1368/69.

In the second half of the fourteenth century, the political and economic fortunes of the Mamluk state were undermined by several natural calamities and man-made disasters. Pestilence and disease attacked livestock and agricultural produce; the dreaded Black Death seriously reduced the population of Egypt and the Near East between 1348 and 1350. A fleet from Rhodes, Venice, and Genoa, led by the king of Cyprus, invaded Alexandria in 1365, plundered the city, and captured thousands of residents. Peace was finally secured in 1370, enabling the Mamluks to move against the kingdom of Cilicia, a troublesome Christian state from the Mamluk view for its continual support of the Crusaders. Mamluks captured Adana and Tarsus. The fall of Sis, the capital, put an end to the kingdom. A different type of disaster was brewing to the east with the Central Asian armies of Timur advancing into the heart of the Islamic world.

But this time a Burji amir named Barquq had overthrown the Bahri ruler and claimed the sultanate in 1382, taking the titles al-Malik al-Zahir Sayf al-Din. The last Bahri sultan, Hajji II, was reinstated and ruled until 1390, at which date he was once again deposed by Barquq, thereby ending the Bahri Mamluk period.

Burji Period (1382–1517)

Barquq had been purchased in the Crimea and, unlike other mamluks, he knew his father, Anas. He overthrew the eleven-year-old Hajji II but was himself ousted in an uprising among the mamluks, who imprisoned him and reinstalled Sultan Hajji in 1389. Barquq escaped from prison, gathered his forces, and made a triumphant reentry into Cairo the following year. He reclaimed the Mamluk throne, establishing the Burji rule in Egypt and Syria.

Timur's advance into Iran and Iraq forced Barquq to form an alliance with the sultan of the Ottomans and the Khan of the Golden Horde; he also offered refuge to the ruler of Iraq, Sultan Ahmad Jalair, whose capital of Baghdad, had been sacked by the Timurids. Barquq died in 1399, before he could confront Timur himself. It was left to Faraj, his thirteen-year-old son and successor, to face the fearsome enemy. After Timur's army sacked Aleppo and Damascus, Faraj was forced to sign a humiliating treaty.

Barquq's ambition had been not only to terminate the rule of the Bahri sultans but also to recreate their glorious age and to outdo their magnificent endowments. In 1384–86 he erected a mosque next to the complex of Qalawun and the mosque of Nasir al-Din Muhammad and embellished it with enameled and gilded mosque lamps, marble pavements, and silver inlaid metal doors. Faraj, following in his footsteps, built a great *khanqa* and mausoleum for his father in the northern cemetery of Cairo.

During the early decades of the fifteenth century, the Mamluk economy was weakened by inadequate collection of taxes, loss of trade revenue, increasing military expenditures, devaluation of the currency, and inflation. Famine and food shortages added to the high cost of living and began to undermine the wealth of the empire. In the Burji period, the sultanate was generally achieved through violence and intrigue, and it became customary for rulers to reward their supporters quite handsomely in order to remain in power. The sultans purchased new slaves and created a personal corps for self-protection, further draining the treasury. Unlike the mamluks of the Bahri period, these slaves were often adults and difficult to control; they became unruly, harassed the population, and incited riots. Offices were now sold to pay bribes and buy new slaves. In the next ten years the Mamluk throne was occupied by several amirs, each of whom came to a violent end. The most powerful among them was al-Muayyad Sayf al-Din Shaykh (1412–21), who was able to reestablish internal security and partially restore the economy.

In spite of internal unrest and corruption, the empire was still strong enough to extend its frontiers and continue trade activities. During the sultanate of Barsbay (1422–38), who took the title al-Ashraf Sayf al-Din, Cyprus was conquered in 1426 and the territory of the Akkoyunlu Turkmans in southeastern Anatolia was raided. Barsbay resorted to devious and unorthodox measures to increase the revenues of his state: he diverted the Indian trade from Aden to Jedda, which was under Mamluk rule, and thus collected a substantial amount of additional taxes; he placed a state monopoly on commercial items, such as spices and sugar; he even banned non-Muslims from entering government service, knowing well that they would try to get in by paying large sums, which would eventually find their way into the state treasury.

Following the practice of Mamluk rulers, Barsbay built impressive structures in Cairo, including a mosque-madrasa and a *khanqa* with his mausoleum (see no. 107), and supplied them with illuminated Korans (nos. 7–8). The sultan also commissioned metalwork for both personal and ceremonial use (no. 41).

Barsbay was succeeded by his fourteen-year-old son, Yusuf, who was overthrown after ninety-four days by his regent, Jaqmaq (1438–53). During the next fifteen years, the throne was occupied by six rulers, the longest sultanates belonging to Inal (1453–61) and Khushqadam (1461–67).

The reign of the next sultan, Qaitbay (1468–96), was phenomenal in that it lasted almost three decades and witnessed the renaissance of Mamluk art. Qaitbay was second only to Sultan Nasir al-Din Muhammad in his patronage of the arts. He was obsessed with endowing buildings and erected numerous mosques, fountains, gates, palaces, and inns throughout the capital as well as in Alexandria, Mecca, Syria, and Palestine (see nos. 105 and 112). His mausoleum, built between 1472 and 1474 in the northern cemetery of Cairo, is a jewel of Mamluk architecture, richly decorated with carved and inlaid stone, stained glass, and metalwork. Under his patronage, all forms of artistic production were revitalized, with the court commissioning manuscripts, metalwork, glass, ceramics, textiles, and rugs (see nos. 9, 34–35, 39, and 121–28).

Qaitbay, whose reign titles were al-Malik al-Ashraf Abu'l-Nasir Sayf al-Din al-Mahmudi al-Zahiri, was originally purchased by Barsbay. He ruled with compassion, wisdom, and strength. He treated deposed rulers and their descendants with respect and earned the true devotion of his mamluks. The sultan increased state revenues by encouraging commercial activities; he granted new privileges to Europeans and protected local merchants by abolishing certain taxes. The income from improved commercial activities, however, was all but spent on supporting the army and constructing new buildings.

Qaitbay antagonized the Ottoman sultan Beyazıd II by supporting his brother and pretender to the throne. Beyazıd retaliated by invading Cilicia, capturing Tarsus and Adana. Although the Mamluk army was successful in halting the enemy advance, Qaitbay recognized the immense power of the Ottomans and sued for peace in 1491.

The final years of Qaitbay's reign were troubled by the plague, which killed a substantial portion of the population, including his wife and daughter. This calamity was followed by a devastating famine. Despite these disasters, the age of Qaitbay was the highest point in the Burji period. The sultan, who died in July 1496, left a proud and glorious legacy; he had recaptured the splendor of the past, however briefly.

Qaitbay was succeeded by his son Muhammad, who was replaced in 1498 by his uncle Qansuh. In the following three years, two amirs ascended the throne, each to be overthrown by the mamluks of his rival. In April 1501 the council chose an amir named Qansuh al-Ghuri, a man of sixty who soon demonstrated that he was still vigorous and energetic in spite of his advanced age.

The new sultan's first move was to replenish the empty treasury. He achieved this goal by resorting to extortion and heavy taxation, which brought in substantial revenues. With these funds he strengthened many Mamluk fortresses, reconstructed the pilgrimage road to Mecca, and built a series of impressive structures, including mosques, madrasas, palaces, inns, and a mausoleum (see nos. 101 and 110). Sultan Qansuh al-Ghuri was an intellectual and one of the rare Mamluk rulers who showed an interest in literature and painting. He sponsored the Turkish translation of the *Shahnama*, the epic history of Iran written in Persian by Firdausi, and employed painters to illustrate the text (no. v). He also wrote poetry and had several works copied by his court artists.

Commercial activity, which constituted a major portion of Mamluk state income by way of tariffs, had begun to decline ever since the landing of the Portuguese in India in 1498. Trade, now controlled by the Portuguese, was routed around the Cape of Good Hope, resulting in vast losses to the Mamluk treasury. In an effort to divert the trade back to the Red Sea, the sultan sent a fleet to fight the Portuguese in the Indian harbor of Chaul. The first encounter in 1508 was successful, but in the following year the Mamluk navy was destroyed in the battle of Diu, near Bombay, and the Mamluk world was cut off from its most essential source of income, a loss that proved to be fatal on the eve of Ottoman advances in the Near East.

The Ottomans, led by Selim I, defeated the Safavids of Iran in 1514 and then moved against the Zulkadirs, a tributary state of the Mamluks in southeastern Anatolia. Qansuh al-Ghuri met the Ottomans at Marj Dabik, north of Aleppo, in August 1516. His forces were outnumbered by the Ottomans, who had superior artillery and military discipline, which were sadly lacking among the Mamluks. When the left wing of the Mamluk army joined the enemy, defeat was inevitable and Qansuh al-Ghuri lost his life in the ensuing battle. Selim I moved easily through Syria and arrived in Egypt. Meanwhile, Tumanbay II who had just been elected sultan, led the remaining Mamluk forces; he was first defeated near Gaza, then at Raidaniyya, outside Cairo. The final battle was fought in January 1517, and the Ottoman sultan was recognized as the master of Egypt and Syria. Tumanbay was caught and executed in April 1517, thus ending the Mamluk rule. Egypt was now an Ottoman province; the Hijaz with the holy cities of Mecca and Medina passed to the Ottomans; and İstanbul became the seat of the new sultanate as well as the caliphate.

The Ottoman conquest did not bring a radical change in administration since Egypt and Syria were still ruled by a powerful and elite foreign group. The Ottomans relied on mamluks to run a number of bureaus; in fact, the first Ottoman governor of Egypt was Khairbay, a Burji amir. The governors sent from İstanbul and the local mamluk aristocracy continued to build charitable foundations and to maintain existing endowments. The art and architecture produced during the Ottoman period (1517–1848) depended on the Mamluk decorative vocabulary and reveal a continuation of older traditions.

ADMINISTRATION

At first glance the Mamluk state appears to have been full of paradoxes: it was strong and stable enough to survive for more than two and a half centuries despite continuous exposure to internal rivalries and intrigue. Needless to say, the greatest asset of the empire was its wealth, acquired through various sources of taxation, such as duties on all goods passing through Egypt and Syria and taxes on land, monopolies, and agricultural produce.

The strength and weakness of the state lay in the institution of the mamluks, which enabled an individual to rise from slave ranks to supreme rule, and yet the sultan had to be elected or confirmed by the council. The mamluk system forced the ruling military elite to be splendidly trained in warfare and in the art of self-preservation. Its administrative machinery enabled the bureaus to continue working independently in spite of internal turmoil, corruption, and bribery. The amirs kept their quarrels to themselves and did not allow interference by natives or foreigners, thus retaining a solidarity in the face of internal or external attacks.

At the head of the military oligarchy was the sultan, a mamluk by origin. He was surrounded by a group of high amirs, also former mamluks. This ruling elite constituted the *arbab al-suyuf* or men of the sword. The sultan had a group of mamluks, entitled the *mamalik al-sultaniyya*, who served as his personal bodyguards and held specific offices in the palace. When these imperial mamluks were freed and became amirs, they were given prestigious appointments in the provinces and held military commands and court offices. The amirs had their own corps of mamluks, the *mamalik al-umara*, who could be freed or passed on to imperial service. The members of the *arbab al-suyuf* were of foreign descent, predominantly Kipchak Turks and Circassians; they were all Muslims but retained their Turkish names.

The social structure of the military class was rigidly defined. The amirs were allotted fiefs (*iqta*), which were landed estates, towns, villages, or even annual revenues from taxes and custom duties. Each amir was obliged to divide two-thirds of his fief among his mamluks, giving them either a portion of the estate or an allowance. The fiefs, the backbone of the administration, were controlled by a special office that determined their allocation and checked their administration and maintenance.

The *arbab al-suyuf* also constituted the army, which consisted of three basic units: the mamluks of the sultan, the amirs, and the mamluks of the amirs. Although there were auxiliary troops made up of natives—such as Bedouins, Egyptians, Palestinians, and Syrians—the bulk of the military forces were amirs and mamluks.

Technically, the sultan was chosen by the consent of the leading amirs of the state, and upon his accession he was given the diploma of investiture by the caliph. Even when the sultanate was inherited from father to son, this protocol was duly observed.

The next class constituted the *arbab al-qalam* or men of the pen, who were native, free-born Muslims, with a few local Christians and Jews. They held civil appointments and served as judges, teachers, learned men, clerks, and administrators. The amirs' sons, who had Muslim names, also belonged to this class and were called *awlad al-nas*, sons of the people.

Although the rule of the sultan was absolute, he was assisted by high officials of the two classes. When he held council, these officials took their place on either side of him according to rank. The senior amirs, called Amirs of the Council, included the sultan's representative (*naib*), commander-in-chief (*amir kabir*), president of the council (*amir majlis*), commander of the guards, minister of war, minister of interior or secretary (*dawadar*), minister of the palace or majordomo (*ustadar*), chief military judge, and other important personages.

Below Amirs of the Council were Amirs of One Thousand, from which the governors of the Syrian provinces (Aleppo, Damascus, Hama, and Tripoli) were chosen. The next group was

composed of Amirs of Forty, who had the right to be accompanied by their own *tablakhana*, military band. The succeeding ranks consisted of Amirs of Ten and the lowest military officers.

The mamluks were purchased by a special officer, the *tajir al-mamalik*. The newly acquired slaves were educated in the mamluk school in Cairo, then distributed to various corps as pages. They served such diverse posts as cup-bearer, sword-bearer, polo master, and master-of-the robe. When the youths acquired the necessary training, they were placed in the service of the amirs and, as vacancies occurred, they were sent to the sultan's palace. Those fortunate enough to be included among the sultan's bodyguards were called *khassaki* and later became powerful amirs.

The offices held by the mamluks and the amirs were identified by blazons, which are unique to the Mamluk world.[2] Although heraldic emblems had been employed by other Turkish rulers—such as the Artukids of Anatolia, Seljuks of Rum, and Khwarazm Shahs of Turkestan—they were generally symbols of royalty and did not represent a hierarchic system. In the Mamluk world, the blazon identified a specific office and was used by the amir who held that post. Everyone in his household, including his mamluks and women, could use the emblem. The blazon was placed on his houses and religious foundations; it was applied to his boats, tents, baggage, banners, blankets, and train; and it was used on his garments, arms and armor, and on objects he commissioned for personal and ceremonial use. When an amir was disgraced or executed, his blazons were erased; when his possessions were taken over by another amir, the new master placed his own blazon on the holdings of the former owner.

Blazons embellished all types of Mamluk art and architecture. They are found on religious buildings, carved in stone or stucco, painted on wood ceilings and doors, as well as on furnishings, such as minbars (pulpits), *kursis* (lecterns), and *rahles* (bookstands). Heraldic emblems were woven into textiles and carpets, inlaid into brass objects, and painted on glass, ceramics, and tiles.

In the Mamluk world, the word for blazon was *rank*, which means "color," indicating that color played an important role in the identification of the signs. The emblem was always enclosed by a round, pointed, pear-shaped, or oval shield. At times the shield was divided into either two or three fields, each of which contained a different sign, constituting a hybrid or composite blazon.

The chronological and typological development of the Mamluk blazon makes a fascinating study and assists in the dating of many objects. The first sultan to use a blazon was Aybak, who was formerly the *jashnigir* or imperial taster of Najm al-Din Ayyub; he used the symbol of a round table to identify his former office. Some of the early Mamluk sultans (such as Kitbugha and Baybars II) used as their blazons the signs of their previous offices. After the second quarter of the fourteenth century the rulers adopted an epigraphic format in which their official reign titles were given in a round shield divided into three fields.

Mamluk blazons fall into five groups: they either contain animals, specific motifs, epigraphy, or signs of office or they are composites. The first sultan to use an animal was Baybars, who chose the lion as his emblem. The lion, symbol of power and strength, was used on all the sultan's buildings and objects (see no. 108) and was employed by his officials who combined it with their own blazons (see no. 46). The lion also figured in the blazon of Baybars's son Baraka Khan. The single- or double-headed eagle, another imperial symbol, is thought to identify Nasir al-Din Muhammad. It often appears in combination with other elements (such as a cup, napkin, or sword) on objects made for his amirs holding the offices identified by these signs (see nos. 27 and 96). Some animals, such as the fish, duck, and horse, might have had specific meanings, but they do not appear to constitute true blazons and were used only for decorative purposes.[3]

Certain motifs, including the fleur-de-lis, rosette, crescent, bends, and bars, are difficult to identify and were most likely used to indicate imperial power. The fleur-de-lis (an abstracted lotus blossom), six-petaled rosette, and crescent are thought to represent the house of Qalawun (see nos. 17, 27–28, 93, 96, and 114–15). The five-petaled rosette was chosen as the blazon of

the Rasulid dynasty of Yemen and was employed on all objects made for the Rasulid sultans in the thirteenth and fourteenth centuries (see nos. 14, 22, and 50). The bends or diagonal lines in the lower half of a shield identified the Hama branch of the Ayyubids and were used in the blazon of its most famous member, Abu'l-Fida (see nos. 24 and 46). The bars or horizontal lines do not appear on imperial wares and may have been used by a lower class of freed mamluks. Other devices, such as the checkerboard and cross, were probably decorative motifs with no heraldic connotations. The *tamgha*, the stamp or mark used by Turkish tribes, however, identified a particular group of dignitaries who never served as mamluks (see no. 83).

The epigraphic blazon, which began to be used by Nasir al-Din Muhammad around the 1320s, became the heraldic emblem of all subsequent Mamluk sultans. On objects made for the Bahri sultans (nos. 26, 29–31, and 52), the round shield was divided into three horizontal units, with the name and titles of the ruler inscribed in the center. In the Burji period, inscriptions were placed in all three fields and read in the sequence of second, first, and third bars (see nos. 34–35, 101, and 110). This form was used by the Mamluk sultans until the Ottoman conquest.[4]

As mentioned earlier, Aybak was the first amir to use the symbol of an office, a table identifying the *jashnigir*. Other signs of office included the cup used by the *saqi* or cup-bearer (see nos. 15–16, 28, 109, and 125); the pen box of the *dawadar* or secretary (nos. 20–21) the napkin (*buqja*) of the *jamdar* or master-of-the-robes (no. 93); the sword of the *silahdar* or sword-bearer (no. 94); the bow of the *bunduqdar* or bowman; the ewer of the *tishtdar* or superintendent of stores (no. 88); the polo-stick of the *jukandar* or polo master; the banner of the *alamdar* or flag-bearer; the mace of the *jumaqdar* or mace-bearer; and the drum of the *tabldar* or drummer in the *tablakhana*, military band. In some cases, amirs incorporated the sign of office with the blazon of their masters; for instance, Amir Toquztimur, who was the *saqi* of Nasir al-Din Muhammad, employed as his blazon an eagle standing above a cup, which identifies both his master and his rank (see nos. 27 and 96).

The composite blazon of the Burji period is a shield divided into three fields representing several symbols, such as a cup, napkin, pen box, and sword and a peculiar motif identified as a powder horn (see nos. 39 and 124). This type of blazon was used collectively by all the mamluks of a particular sultan, that is, by the *mamalik al-sultaniyya* as well as by the amirs and their *mamalik al-umara*. Although the sultan retained the exclusive right to the epigraphic blazon, the collective blazon of his mamluks and amirs was also represented on some of his objects.

Although more than one hundred Mamluk blazons have been identified, their study is far from complete. A number of motifs functioned both as decorative elements and as heraldic emblems; some, like the lion of Baybars, are very specific, while others, such as the rosette and crescent, have a more general application.[5]

The Mamluks established a formidable state with a strong administrative and military system that withstood foreign invasion, internal strife, and economic crisis. They were the true defenders of Islam: they preserved the caliphate, were victorious in their jihads or holy wars, and protected the holy cities. Their piety, often overshadowed by political ambition, benefited artists, for each sultan and amir attempted to outdo his predecessor by endowing more magnificent buildings and commissioning more impressive objects. Their zeal for establishing religious foundations, reconstructing existing endowments, and supplying them with beautiful furnishings places the Mamluks among the greatest patrons of art and architecture in the history of Islam.

It could be argued that Mamluk art was not innovative and did not create new styles and themes but merely elaborated upon traditions established in the past. And yet Mamluk artists, stimulated by the demands of their patrons, produced the most spectacular examples of Islamic manuscripts, metalwork, and glass; but their aesthetic achievements were often overshadowed by a display of technical virtuosity.

Notes

An abbreviated format is used for references; the Key to Shortened References begins on page 266.

1. For additional historical data see entries on the Mamluks and individual rulers in *Encyclopedia of Islam*; Lapidus 1967; Ziada 1969 and 1975.

2. The most extensive study on blazons appears in Mayer 1933 and 1937; Meinecke 1972 and 1974.

3. The duck was believed to be the blazon of Sultan Qalawun whose name was thought to mean "duck" in Turkish. This word does not appear in Turkish dictionaries; moreover, there is no record in Mamluk blazons of a canting coat,

. that is, an emblem symbolizing the name of the holder. Professor Şinasi Tekin of Harvard University, however, has informed me that there exists a word in Uygur Buddhist texts, *kalavink*, which means "cuckoo" or a type of wild pheasant. This word appears to have the same sound as the name Qalawun and its meaning is related to the word for wild duck, which appears on Mamluk objects.

 The same association with name and canting coat was thought to exist with the lion of Baybars, whose name means "Lord Panther" in Turkish. This attribution is highly doubtful, since the lion, the king of the animal kingdom, was employed as an emblem of royalty in ancient times and symbolized ultimate power.

4. It appears to have continued even under Ottoman rule. For instance, the Citadel of Jerusalem, restored by Sultan Süleyman in 1531–32, has a shield divided into three fields with the dedicatory inscription following the traditional Mamluk format: "Glory to our master, the sultan al-Malik al-Muzaffar Abu'l-Nasir Süleyman Shah ibn Uthman, may his victory be glorious" (Mayer 1933, p. 39).

5. Numismatic evidence offers little help, since a definite correlation between blazons and devices used on coins cannot be established. See Allan 1970.

ILLUMINATED MANUSCRIPTS

ILLUMINATED MANUSCRIPTS

The exquisite illuminations, calligraphy, and bindings of Mamluk Korans are unequaled in any other Islamic tradition of bookmaking. The technical and artistic virtuosity found in these manuscripts is representative of the Mamluks, who, embracing Islam with the fervor of converts, endowed elaborate religious complexes and supplied each major foundation with its set of Korans. Patronage of the court stimulated artists to develop a rich repertoire of decorative elements and to excel in the execution of different styles of script.

The manuscripts illustrated in this section represent the most significant periods in the development of Mamluk Korans and religious texts; they reveal the evolution of illumination and calligraphy as well as the importance of patronage.

The majority of Korans were specifically commissioned by the sultans and amirs for their mosques and madrasas. The manuscripts were registered in the waqf or endowment records and kept in the buildings for which they were commissioned until the end of the nineteenth century, at which time many were moved by the Comité de Conservation des Monuments de l'Art Arabe to the National Library in Cairo, which now houses the largest collection of Mamluk Korans. Another important group of manuscripts is in the Topkapı Palace Museum in İstanbul, but this collection comprises non-waqf books taken after the Ottoman conquest. Ottoman sultans and their governors respected the Mamluk foundations and their endowments. They protected the religious buildings and the objects registered as waqf to these establishments, including Korans, metalwork, glass, and furnishings. Select manuscripts that left Cairo at the end of the nineteenth and beginning of the twentieth century are today owned by a number of European museums, including the Chester Beatty Library in Dublin and the British Library in London. The production of Korans under the Mamluks was so prolific that today every public and private collection devoted to Islamic art owns several folios from an imperial manuscript.

Bahri Period (1250–1390)
The Mamluks must have donated Korans to their establishments during the second half of the thirteenth century, but no dated or datable example from before the turn of the fourteenth century has been identified. Most of the earliest datable manuscripts were conceived as thirty-volume sets, the characteristic format of Mamluk Korans.

Although multivolume Korans were produced in Iran during the Seljuk period as early as the eleventh century, this format achieved an unprecedented popularity in the Mamluk period. One of the earliest thirty-volume Mamluk Korans is in the National Library and contains the waqf of Muhammad ibn Ishaqi, dated 1303/4; another set, seven volumes of which are now in the British Library, was produced in 1304 for Baybars, al-Jashnigir, who later became sultan.[1] The next extant work is the famous and controversial thirty-volume Koran copied in 1313 for al-Malik al-Nasir Muhammad. This Koran, housed in the

National Library, contains the waqf of Sayf al-Din Baktimur, who donated the entire set in 1326 to his foundation in Cairo.[2] A fourth set, belonging to this group of early Korans, in undated: two of its surviving volumes are owned by the Chester Beatty Library (nos. 1–2); the remaining part, in the British Library, contains the waqf of Sultan Faraj, which was added in the early 1400s.

The dates of these thirty-volume Korans coincide with the reign of Nasir al-Din Muhammad (1293–1341, with interruption). Muhammad ibn Ishaqi, the donor of the earliest work, has not been identified in historical sources, but he must have been one of the court officials. The second work was commissioned by Baybars while he served the sultan. This ambitious amir forced the sultan to abdicate in 1309 and reigned for almost a year before Nasir al-Din Muhammad was able to regain his throne and have Baybars eliminated.

The thirty-volume Koran dated 1313 and dedicated to al-Malik al-Nasir Muhammad is thought to have been written for Oljaitu (1304–17), the Ilkhanid ruler of Iran. The titles given in the manuscript were used both by Nasir al-Din Muhammad and Oljaitu, who converted to Islam and took the name Muhammad together with the honorific al-Malik al-Nasir, meaning "the Victorious King." The dedication, however, also includes the titles Nasir al-Dunya wa'l-Din Ghiyath al-Dunya wa'l-Din, which were never used by Mamluk sultans. In addition, the Koran praises at length the twelve Shiite imams, precluding its patronage by the protector of the Sunni caliphate, the Mamluk sultan. The colophon states that the manuscript was copied and illuminated by Abdallah ibn Muhammad ibn Hamdani in September 1313 in Hamadan (western Iran), further supporting the argument that it was produced for the Ilkhanid ruler.

The manuscript must have arrived in Cairo by 1326 and fallen into the possession of Amir Sayf al-Din Baktimur, the *saqi* or cup-bearer of Sultan Nasir al-Din Muhammad. It is possible that the Koran came as a diplomatic gift from the Ilkhanid sultan Abu Said who succeeded Oljaitu and concluded a peace treaty with the Mamluks in 1323. Abu Said is recorded as having sent camel-loads of gifts to the Mamluk court following the armistice, and this work may have been included in the shipment. Ilkhanid and Mamluk Korans, however, reveal a number of similar stylistic features,[3] and the decorations of the 1313 Koran are very close to those found in other early Mamluk manuscripts (see nos. 1–3).

Many of these early manuscripts were commissioned by Sultan Nasir al-Din Muhammad who donated them to his foundations. One of his most celebrated single-volume Korans is written in gold and bears a waqf notation dated 1330. This remarkable work does not possess a colophon, but it must have been completed shortly before the date of the waqf.[4] That same year the sultan commissioned another single-volume Koran, which is now in the Keir Collection in London.[5] A third Koran, copied in 1334 (no. 3), does not have a dedication or a waqf, but its date of execution falls within the sultanate of Nasir al-Din Muhammad. The same date is found on a thirty-volume Koran, five parts of which are now in the Chester Beatty Library.[6] Several other Korans lack dedications, yet their dates indicate that they were also produced in the court of Nasir al-Din Muhammad.[7]

These manuscripts demonstrate that the tradition of the thirty-volume Koran was firmly established in the Mamluk world by the first quarter of the fourteenth century. The volumes in each set have uniform bindings, illuminations, and script; and each part contains one *juzz*, prayers for each day of the Muslim month. The entire set would have been stored in a large Koran box, generally given to the establishment by the same patron who donated the Koran. Several such boxes (see no. 25), made of wood and covered with plates of brass inlaid with silver and gold, were produced during the reign of Sultan Nasir al-Din Muhammad.[8]

The format established by these early Korans was standardized in the second half of the fourteenth century and applied to single-volume, two-volume, and thirty-volume Korans (nos. 4–6). The manuscripts open with a double frontispiece, which is followed by an illuminated double folio containing the first verses; the text is adorned with illuminated chapter headings, marginal ornaments, and verse-stops, some of which contain the word *aya* (verse). The concluding double folios are also illuminated and followed by a double finispiece. A symmetry governs the organization of the book with the layout of the opening folios mirrored in the concluding pages. Insistence on symmetry is also evident in the design of the double folios and in the decoration of individual pages. The double frontispiece, that is, the first pair of illuminated pages, is conceived as a unit with a wide arabesque border enclosing the composition across the two pages. The border thus surrounds three sides of each page but does not extend down the spine (see nos. 4–5). The rectangular area created by the border is divided into three fields with two narrow panels placed above and below a central square. The upper and lower panels are subdivided to form two small squares flanking an oblong unit. Koranic verses, rendered in white or gold kufic (angular script) appear within cartouches in the oblong units, and an intricate geometric composition fills the central square. Koranic passages, spread across two facing pages of the frontispiece, often quote well-known verses from Surat al-Waqia (The Event; LVI:77–80):

Certainly this is an honored Koran, in a book that is protected, none shall touch it save the purified, [it is] a revelation from the Lord of the Worlds.

In some cases this is replaced by a quotation from Surat al-Shuara (The Poets; XXVI:192–97), which also stresses the divine revelation of the Holy Book.

It is in the decoration of the central square that Mamluk artists truly excelled, combining impeccable technique and fine aesthetic sense to create extraordinarily sophisticated geometric compositions. The geometric designs are often radial and composed of units evolving from

twelve-pointed or sixteen-pointed stars that form concentric rings subdivided into polygons of diverse shapes. Each unit is filled with symmetrically arranged and superimposed geometric and floral motifs. The illuminations symbolize the universe; the motifs are inspired by solar and astral bodies bursting with energy and radiating from the core with a phenomenal centrifugal force accelerated by variations in color and form. The composition is harnessed by continuous thin bands that define and outline the units, inducing order and harmony from otherwise turbulent movement. No other Islamic artistic tradition approaches the refinement of design and the depth of spirituality found in these illuminations.

The basic tripartite division of the frontispiece persists in the illuminated double folios with verses of the opening chapter placed in the central square. The text is outlined by contour bands and a delicate arabesque appears in the background. These opening folios are as carefully decorated as the frontispiece (no. 6) and reveal a harmonious balance between illumination and calligraphy.

Cooperation between illuminator and calligrapher is evident throughout the manuscript. The illuminator was responsible for decorating the chapter headings, marginal ornaments, and verse-stops, all of which show an infinite variety of geometric and floral motifs in each volume. The calligrapher was responsible for perfect copying of the text and the chapter headings. The chapter headings were rendered in kufic, at times substituted by thuluth, a hierarchic script used for inscriptions on architectural decorations and metal and glass objects. The body of the manuscript was written in the cursive *muhaqqaq* script. *Muhaqqaq*, meaning "meticulously produced," was the characteristic script of Mamluk Korans, its sweeping horizontals contrasting harmoniously with its tall straight verticals. Some manuscripts employed *rihani*, another variation of the cursive style closely related to *muhaqqaq*. The letters in *rihani* script are generally smaller, and the contrast between horizontals and verticals is not as pronounced as in *muhaqqaq*; the diacritical marks and orthographic signs are often written with a finer pen.

Although a wealth of Korans was produced during the Bahri Mamluk period, very few manuscripts contain the names of calligraphers and illuminators. Only a handful of calligraphers are known from the colophons: Muhammad ibn al-Walid copied the thirty-volume Koran for Baybars in 1304; Ibrahim ibn Muhammad al-Khabbaz copied the Koran dated 1315; Muhammad ibn Bilbek al-Muhsini al-Nasri worked on one dedicated to Nasir al-Din Muhammad in 1330; Amir Hajj ibn Ahmad al-Saini copied the thirty-volume set finished in 1334; Ahmad ibn Muhammad ibn Kamal ibn Yahya al-Ansari al-Mutatabbib was the calligrapher of the 1334 Koran (no. 3); Yakub ibn Khalil al-Hanafi worked on a two-volume manuscript completed in 1356 and dedicated twelve years later by Sultan Shaban to his mother's madrasa;[9] and Ali ibn Muhammad al-Mukattib al-Ashrafi executed in 1372 the Koran (no. 6) dedicated four years later by Sultan Shaban to his complex. The

names of illuminators are even scarcer: Muhammad ibn Mubadir and Aydughdir ibn Abdallah al-Badri worked on the thirty-volume Koran dated 1304, and Ibrahim al-Amidi's name is given in the colophon of the manuscript completed in 1372 (no. 6).

Among Mamluk Korans of the second half of the fourteenth century are oversized single volumes that required special *kursis* or lecterns for the reciter. These magnificent *kursis*, made of carved wood and inlaid in ivory, can still be seen in many religious foundations dating from this period. The production of gigantic Korans, some of which are over one meter high (more than three feet), appears to coincide with the construction of large mosque-madrasa-mausoleums.

Two-volume medium-size Korans (about fifty centimeters or twenty inches high) also make their appearance in this period, particularly during the sultanate of Shaban II (1363–76), grandson of Nasir al-Din Muhammad. Both Sultan Shaban and his mother, Khwand Baraka, donated Korans (nos. 5–6) for their foundations.

Amirs of the sultans also endowed pious foundations and commissioned Korans for their establishments. Among the patron amirs were Arghun Shah, thought to be in the service of Sultan Shaban. Arghun Shah's Koran (no. 4) was produced about the same time as those made for the sultan. Sarghithmish, another amir, in the service of Sultan Hasan (1347–61, with interruption), commissioned two sets of thirty-volume Korans for his madrasa completed in 1356.[10] His master, Sultan Hasan, gave to his famous foundation in Cairo several Korans, both single-volume manuscripts and thirty-volume sets.[11]

Burji Period (1382–1517)

The production of large single-volume Korans, midsized two-volume manuscripts, and smaller thirty-volume sets continued in the Burji period. These manuscripts follow the traditional format established in the fourteenth century and reveal the same high technical and aesthetic standards. Barquq (1382–99, with interruption), founder of the new regime and patron of the large mosque-madrasa bearing his name, is known to have donated a number of Korans to his foundation.[12] His son and successor, Faraj, commissioned a thirty-volume Koran in 1410, four parts of which are now in the Keir Collection.[13]

The majority of fifteenth-century Korans are either oversize single-volume manuscripts or smaller thirty-volume sets. One of the largest Korans was copied in 1417 by Musa ibn Ismail al-Kinani al-Hanafi, known as al-Hijjini. It was donated in 1419 by Sultan Shaykh (1412–21) to his mosque called al-Muayyad.[14] Another single-volume Koran was executed in 1444 for Sultan Jaqmaq (1438–53) by Muhammad Abu'l-Fath al-Ansari.[15] The name of this calligrapher also appears in the colophon of a manuscript completed in 1454 for Sultan Khushqadam (1461–67), whose waqf appears on several thirty-volume Korans.[16]

The most energetic patron among fifteenth-century sultans was Barsbay (1422–38), who donated several single-volume, two-volume, and thirty-volume Korans to his madrasa built in 1425. One of the most beautiful two-volume sets bearing his waqf (nos. 7–8) reveals the change in style and taste that occurred in the fifteenth century: the books are smaller and squatter than those made in the second half of the fourteenth century, the centrifugal designs characteristic of earlier frontispieces are subdued and the astral motifs appear more decorative than symbolic, and although kufic appears in the headings, the text has been copied in naskhi and not in the usual *muhaqqaq*.

The last of the great Mamluk patrons was Sultan Qaitbay (1468–96), who not only donated Korans to his foundations but also commissioned books on history, literature, and theology for his personal library.[17] One of the outstanding works made for Qaitbay (no. 9) displays the extraordinary virtuosity of the calligrapher, Qanem al-Sharifi, who executed four different cursive scripts (thuluth, naskhi, *naskh fada*, and *riqa*) in varying sizes and different colored inks.

The bindings of Mamluk books reveal versatile techniques and designs. Similar to all Islamic bookcovers, they are made on a pasteboard core covered with leather.[18] The decoration was stamped as well as blind-tooled and gilded; in a few cases, parts of the design were painted with touches of blue or green. The traditional design of bookbindings consists of a central medallion filled with geometric motifs repeated in four corner quadrants, while a series of braids and bands frames the edges. Some bookbindings are decorated with an overall geometric design recalling the composition of the frontispiece. The doublures (inner covers) are also made of leather and block-stamped with delicate floral and geometric patterns.

Mamluk bindings with filigree designs are among the most exquisite of all Islamic bookcovers. The design, cut into leather, was placed against a colored ground, generally of finely woven silk. The motifs on the raised areas were blind-tooled, gilded, and painted. Filigree designs, which appear on the interior of fifteenth-century examples from Iran, are placed on the exterior of many Mamluk Korans. The most beautiful filigree bindings are found on manuscripts produced for Khushqadam and Qaitbay, suggesting that this technique was fully developed in the Mamluk world by the middle of the fifteenth century.

Although in the fifteenth century imperial patronage appears to have dwindled in certain arts, particularly in metalwork and glass, it is very evident in the production of Korans and other religious texts. The same support is observed in the construction of buildings with more than half of the existing Mamluk structures in Cairo dating from the Burji period. The interest in building is paralleled by the enthusiasm in supplying these foundations with suitable Korans. Competition among amirs led to the endowment of elaborate architectural complexes and to the creation of the most sumptuous Korans in the history of Islam.

Notes

1. Cairo, National Library, 70, complete thirty-volume set (Cairo 1969, no. 280); London, British Library, Add. 22406–12 (Lings 1976, pl. 62; Lings and Safadi 1976, nos. 66–69).

2. Cairo, National Library, 72, complete thirty-volume set (Cairo 1969, no. 281; Lings 1976, pls. 54–59). Inscriptions from six volumes (parts twenty-five to thirty) are given in Wiet 1932a, no. XIV, pls. XXXII–XXXIII.

3. Ilkhanid Korans are exceptionally rare. There exist, however, two thirty-volume Korans, one of which was produced in Mosul in 1310 and dedicated to Sultan Oljaitu and his two ministers, Rashid al-Din and Sad al-Din (part twenty-five in London, British Library, Or. 4945; other parts in Istanbul [Lings 1976, pls. 52–53; Lings and Safadi 1976, no. 99]). Another thirty-volume Koran, dated 1304, is thought to have been copied in Baghdad (Tehran, Iran Bastan Museum, 3548 [Lings and Safadi 1976, no. 97]). The Ilkhanid court also commissioned a sixty-volume Koran, a part of which is now in London, British Library, Or. 1339. Korans with sixty parts, although rare, are not unusual and were produced in Maghrib during the thirteenth century. Two such sets are in London, British Library, Or. 12523 and 12808 (Lings and Safadi 1976, nos. 45–47).

4. Cairo, National Library, 4 (Cairo 1969, no. 282; Lings and Safadi 1976, no. 71).

5. London, Keir Collection (Lings and Safadi 1976, no. 72; B. W. Robinson 1976a, no. VII.9).

6. Dublin, Chester Beatty Library, MS 1469 (Arberry 1967, nos. 69–73).

7. London, Keir Collection, dated 1315 (Lings and Safadi 1976, no. 70; B. W. Robinson 1976a, no. VII.8); Dublin, Chester Beatty Library, MS 1481, dated 1320 (Arberry 1967, no. 56).

8. Berlin, Museum für Islamische Kunst, I 886 (Berlin 1971, no. 19 and fig. 69; London 1976, no. 214); Cairo, al-Azhar Library (Wiet 1929, no. 571; Wiet 1932, app. no. 180; Cairo 1969, no. 60 and pl. 9).

9. Cairo, National Library 8 (Lings 1976, pls. 73–74; London 1976, no. 536).

10. Cairo, National Library, 61 (Cairo 1969, no. 287) and 60 (Lings and Safadi 1976, no. 74).

11. Single-volume Korans are in Cairo, National Library, 5, and Dublin, Chester Beatty Library, MS 1455 (Arberry 1967, no. 57). Thirty-volume Korans are in Cairo, National Library, 59 and 62.

12. Single-volume Koran is in Cairo, National Library, 13. The same collection owns several thirty-volume sets (76 and 153) and one *juzz* manuscripts (74 and 77–79).

13. B. W. Robinson 1976a, no. VII.19–32, pl. 151.

14. Cairo, National Library, 17 (Cairo 1969, no. 292; London 1976, no. 540).

15. Dublin, Chester Beatty Library, MS 1507 (Arberry 1967, no. 101). There is also a Koran copied in 1448 by Khayr al-Din, called Ibn al-Khatib al-Marashi, in London, Keir Collection (B. W. Robinson 1976a, no. VII.39). Although this Koran does not have a dedication, its date of completion coincides with Sultan Jaqmaq's reign.

16. Single-volume Koran is in Cairo, National Library, 90 (Lings and Safadi 1976, no. 94); thirty-volume Korans are also in the same collection, 9, 104, and 401. An undated manuscript in Dublin, Chester Beatty Library, MS 1483, was copied for Sultan Khushqadam by Janam ibn Abdallah al-Saifi (died 1483).

17. Several Korans bearing Qaitbay's name are housed in Cairo, National Library, 19 and 86 (both single-volume works); and 88 and 101 (parts of thirty-volume manuscripts). Other Korans dedicated to him are in Dublin, Chester Beatty Library, MS 1508 (Arberry 1967, no. 104); London, Keir Collection, copied by Muhammad ibn Ali al-Suheyli (B. W. Robinson 1976a, no. VII.43); and Manchester, John Rylands University Library, 39, copied by Shahin al-Nasiri in 1469 (Lings and Safadi 1976, no. 88). Among the manuscripts in Istanbul, Topkapı Palace Museum, commissioned by Qaitbay are texts on archery (A2425), theology (A2956), genealogy and biography of the Prophet (A6032), and literature (A8549).

18. One of the most extensive collections of Mamluk bookbindings is in Chicago, Oriental Institute, which is planning a special exhibition in May 1981 of Islamic bookmaking and a catalogue of its holdings. Most of these bindings were studied in Bosch 1952; several examples were published in Baltimore 1957, nos. 61–71. See also Ettinghausen 1959.

Opposite: detail of no. 4

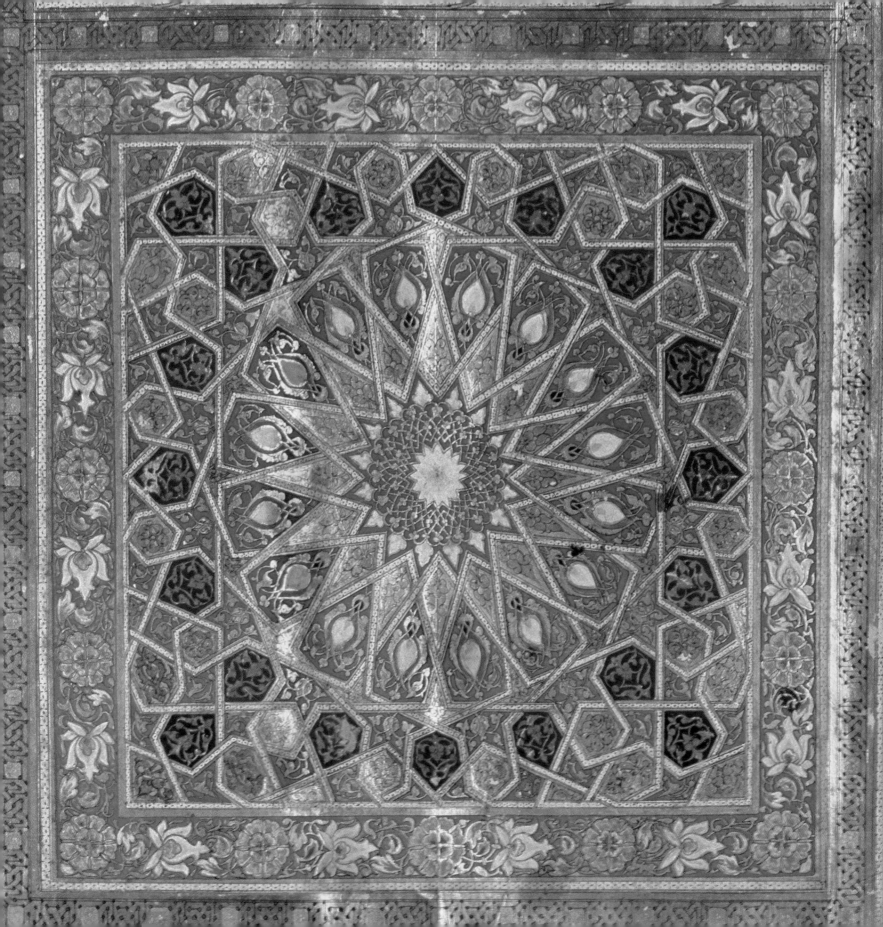

1

Illuminated heading with Surat al-Waqia
 (The Event; LVI:77–78)
Part 4 of 30-volume Koran
First quarter 14th century

Height: 26.3 cm. (10⅜ in.)
Width: 19.3 cm. (7⅝ in.)
Written in *muhaqqaq* script with kufic
 headings: 5 lines, 37 folios

Dublin, The Chester Beatty Library,
 MS 1464 (fols. 2b–3a)
Purchased 1930

This small manuscript belongs to a thirty-
volume Koran of which only three parts
have survived: part nine is in the British
Library,[1] parts four and twelve are owned
by the Chester Beatty Library (see also no.
2). The volume in the British Library
contains a waqf notation giving the name of
Sultan Faraj (1399–1405 and 1406–12), who
must have taken possession of the entire set
sometime after the work was completed.
Although the original patron of the work is
unknown, the style of its decoration
suggests that it was executed in the first
quarter of the fourteenth century.
The Koran, of imperial quality, may have
been commissioned during the second or
third reign of Sultan Nasir al-Din
Muhammad (1299–1309 or 1310–41) or by
an official in his court.
 Each of the existing parts comprises
thirty-seven folios written in *muhaqqaq*
script with kufic employed in the
illuminated chapter headings. The
manuscripts have a double frontispiece,
followed by another set of illuminated folios
that present the opening verses. The text is
embellished with large gold verse-stops
containing the word *aya* and with
exquisitely illuminated marginal rosettes
and chapter headings. The anonymous
artist who executed this Koran has used a
rich repertoire of decorative motifs: the
illuminations of the double frontispiece,
double folios with opening verses, chapter
headings, and marginal decorations of each
volume are adorned with designs based on
infinite variations of geometric patterns and
floral arabesques.
 The illuminated double frontispiece of
part four has a wide floral arabesque
framing a central panel of geometric units
filled with floral motifs. The following folios,
which are illustrated, contain two verses
from the Surat al-Al-i Imran (The Family of
Imran; III:92–93). Each folio has a series of
gold marginal lines extending along the
spine together with an inner band filled with
a white beaded motif. The three outer edges
have a frame composed of polychrome
trefoils that alternate with a single lobed

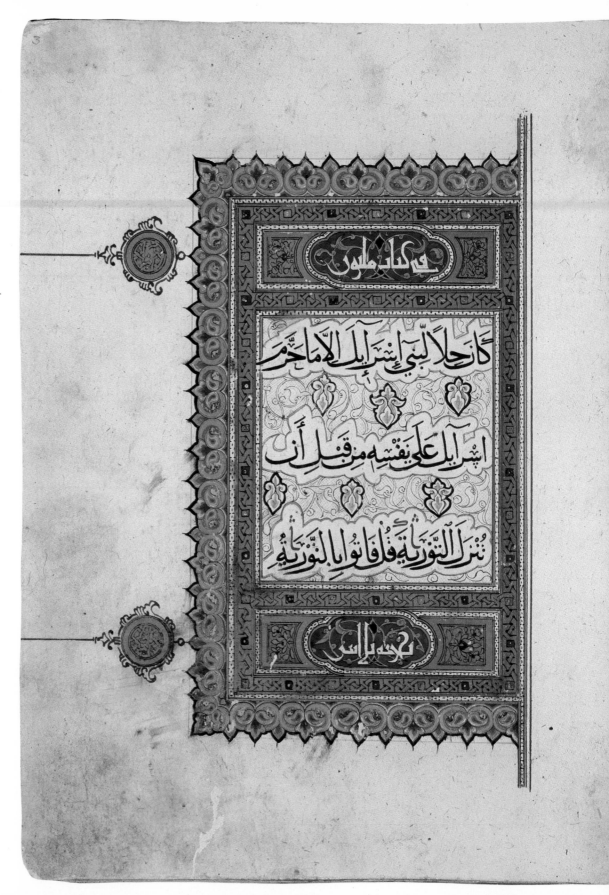

30

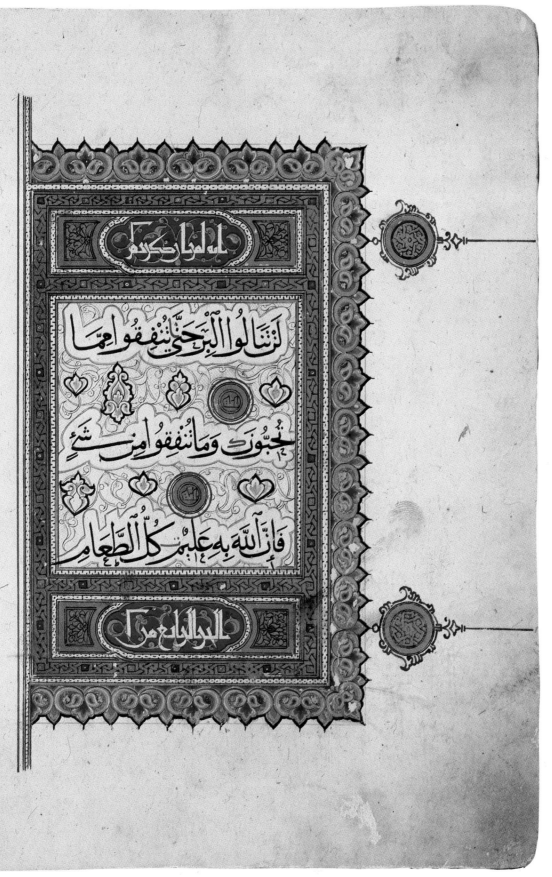

floral unit. A thick gold braid, accented by gemlike polychrome squares and enclosed by white beaded bands, frames the central rectangle and divides it into three fields. The narrow panels above and below contain an oval unit with kufic inscriptions written in white on a blue ground enhanced with a gold floral scroll. The two upper panels contain the famous verses from Surat al-Waqia: "Certainly this is an honored Koran, in a book that is protected"; the two lower panels state that "this is the fourth *juzz* of thirty."

The central, almost square, section has three lines of beautifully rendered *muhaqqaq* script enclosed by contour bands; an arabesque with split leaves, accentuated by large cartouches, appears behind the contour bands. The *muhaqqaq*, a cursive script with harmonious balance between straight verticals and sweeping horizontals, was used in many Mamluk Korans (see nos. 3–6). Two large gold roundels with the word *aya* are used as verse-stops on the right half (fol. 2b). Two pairs of larger gold roundels with finials are placed in the margins next to the kufic inscriptions.

These two folios reveal a highly sophisticated sense of design and a superb technical virtuosity in the use of color and form. The understated elegance of the central panel with black used in the text, contour bands, and arabesques and cartouches of the background is contrasted by the sumptuous richness of gold employed in the braid, marginal roundels, and verse-stops. The massiveness of the gold braid is counteracted by the delicacy of the white kufic inscriptions and the white beaded bands that enclose the braid and outline the oval units in the narrow panels. The composition is further enriched by the addition of color. Blue is used in the ground of the kufic inscriptions and varying intensities of pink, red, blue, and green, with touches of white, appear in the outer frame. Finally, the two pairs of finials placed in the margins extend the illuminated panels almost beyond the physical boundaries of the folios. Throughout the work the artist has provided many striking contrasts: between the rigid white kufic and flowing black *muhaqqaq*; between the loose drawing of the floral arabesque and thick gold braid; and between these last two elements and the painterly handling of the polychrome motifs in the outer frame.

Published
Arberry 1967, no. 75.

Notes
1. London, British Library, Or. 848 (Lings and Safadi 1976, no. 75, pl. IX and fig. 75).

2
Double frontispiece
Part 12 of 30-volume Koran
First quarter 14th century

Height: 27.0 cm. (10⅝ in.)
Width: 19.3 cm. (7⅝ in.)
Written in *muhaqqaq* script with kufic
 headings: 5 lines, 37 folios

Dublin, The Chester Beatty Library,
 MS 1465 (fols. 1b–2a)
Purchased 1934

Part twelve of the thirty-volume Koran
described earlier (no. 1) has an identical
binding and boasts the same high
aesthetic and technical standards found
in part four. It has a matching binding in
dark reddish brown leather, stamped and
tooled in gold. In the center of each cover
is an eight-lobed medallion with
radiating finials, enclosing a geometric
unit composed of pentagons; the corner
spandrels are lobed and filled with
strapwork. The central medallion on the
flap is almost identical to the medallions
on the covers, except that it is adorned
with strapwork instead of pentagons.
The stamped doublure of the binding
uses the same leather as the exterior; an
overall pattern is created by geometric
units that radiate from a series of twelve-
pointed stars and form diverse polygons
filled with floral motifs and lotus
blossoms.

 The double frontispiece has thin gold
lines extending along the spine and a
wide floral arabesque framing the three
outer edges with a series of minute blue
finials projecting into the margins.
The deep blue ground of this frame is
overlaid with a fine mesh of scrolling
branches and split leaves rendered in
gold and enhanced by red and pink buds
that alternate with white and black
cartouches. The overall effect resembles
gold filigree inlaid with niello and
precious gems.

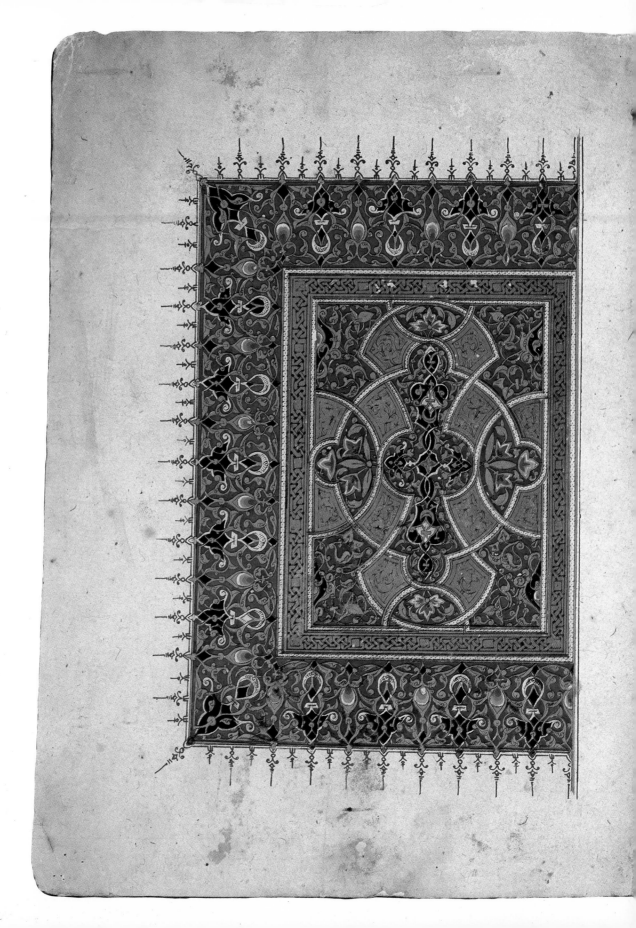

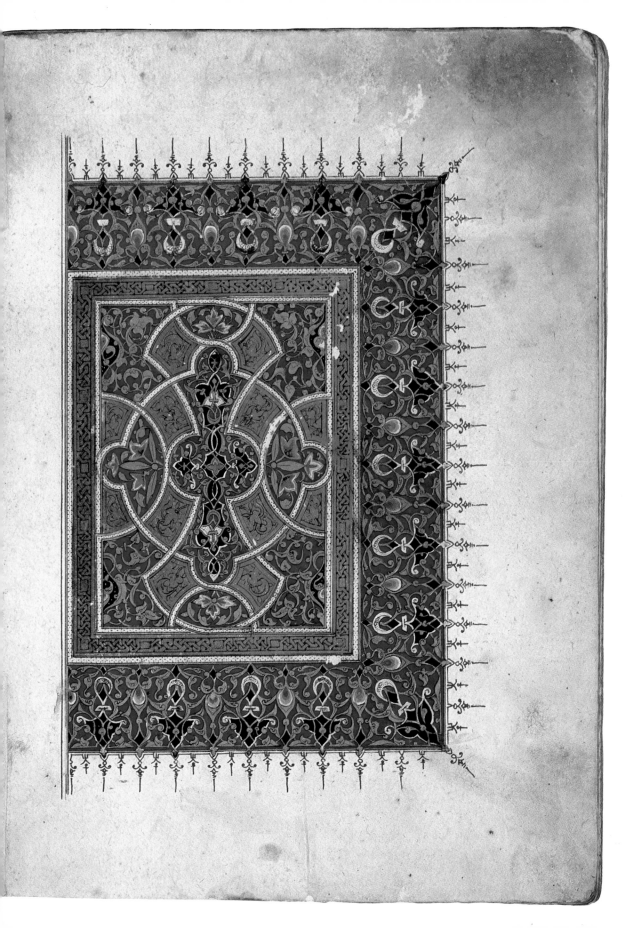

A thick gold braid enclosed by white beaded bands frames the central portion, which consists of geometric units formed by overlapping circles and lobed polygons. The inner white beaded band also outlines the geometric units; it is conceived as a continuous line that loops around the units and creates an intricate maze. The four corner units have a blue ground with gold leaves and buds that are cut off by the frame. The same blue ground with gold florals appears in the central cartouche and four axial units. The central cartouche has a self-contained arabesque, accented by white and black, similar to the decoration of the outer frame. The four axial units are filled with sprays of blossoms rendered either in red and pink or in two shades of green. The remaining units, variously shaped polygons created by intersecting bands, are painted in two tones of gold; a reddish gold forms the background and a brighter, greenish gold is used in the floral elements.

Although a sense of superimposed planes is created by the blue and gold grounds, the four axial units with polychrome blossoms and the central cartouche with black and white accents appear more prominent, suggesting a third plane. And yet the entire composition reverts to a two-dimensional design when the eye follows the intersecting white beaded band. This hypnotic interplay of background and foreground, principal and secondary elements, is typical of Islamic decoration and finds ultimate expression in the composition of these two beautiful folios.

Published
Arberry 1967, no. 76 and pl. 37 (fol. 35a).

3

Double finispiece with Surat al-Ha-Mim
 al-Sajda (Abbreviated Letters or Fusilat;
 XLI:41–42)
Copied by Ahmad ibn Muhammad ibn Kamal
 ibn Yahya al-Ansari al-Mutatabbib in
 Cairo, April–May 1334

Height: 51.0 cm. (20 in.)
Width: 36.0 cm. (14⅛ in.)
Written in *muhaqqaq* script with kufic
 headings: 11 lines, 380 folios.

Cairo, National Library, 81 (fols. 377b–378a)
From Mosque of Shaykhun al-Amari, 1881

This single-volume Koran, produced during
the third reign of Sultan Nasir al-Din
Muhammad (1310–41), is one of the rare
Mamluk manuscripts bearing a colophon that
not only gives the place and date of execution
(al-Qahira, Shaban 734) but also the name of
the calligrapher (fol. 378b). The artist,
justifiably proud of his achievements, has
inserted at the end of the manuscript after
the colophon a fairly long notation describing
his work (fols. 379a–380b). The same name
appears in the colophon of another Koran
dated 1331 in Cairo.[1]
 The binding and several flyleaves at the
front and back were added later. The first
flyleaf (fol. 1a) bears a note stating that the
manuscript came from the mosque of
Shaykhun al-Amari in 1881, which suggests
that the restoration took place sometime
before that date.
 The original manuscript opens with a
double frontispiece (fols. 1b–2a): a wide
arabesque frames three sides of the
rectangular unit, which is divided into three
fields by a braided band; the narrow upper
and lower panels contain oval cartouches
with kufic inscriptions; the square central
unit has a geometric design composed of
polygons radiating from a twelve-pointed
star, in the center of which is another kufic
inscription.
 The next pair of illuminated double folios
(fols. 2b–3a) contains the beginning of the
text. These pages are also divided into three
fields: kufic headings are placed in the narrow
panels at the top and bottom and five lines of
muhaqqaq script, enclosed by contour bands,
appear in the central unit. The body of the
manuscript is virtually unadorned, with
eleven lines of script placed on folios devoid
of marginal lines. The last double folio with
text is illuminated in the same manner as the
first double folio with text that follows
the frontispiece (fols. 376b–377a).[2]

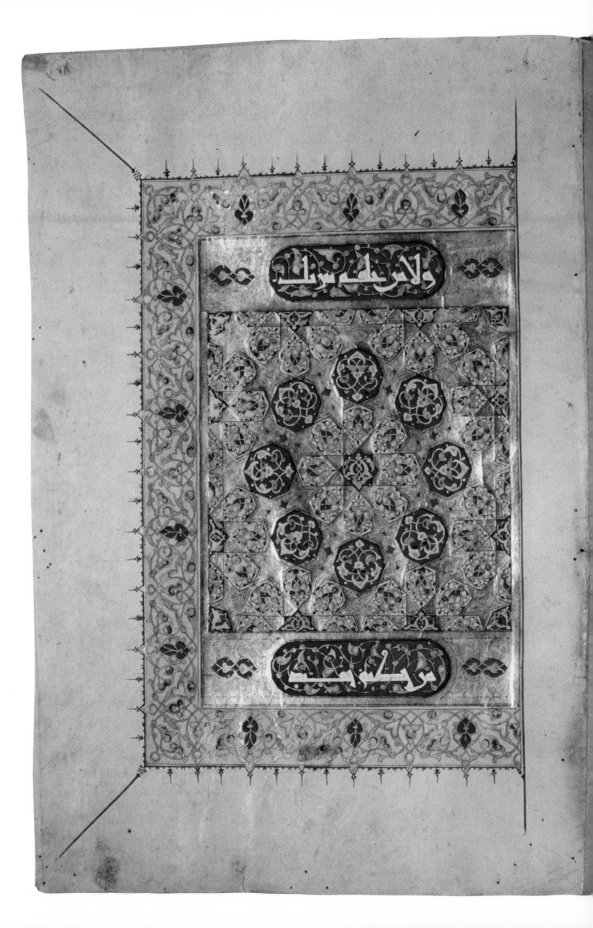

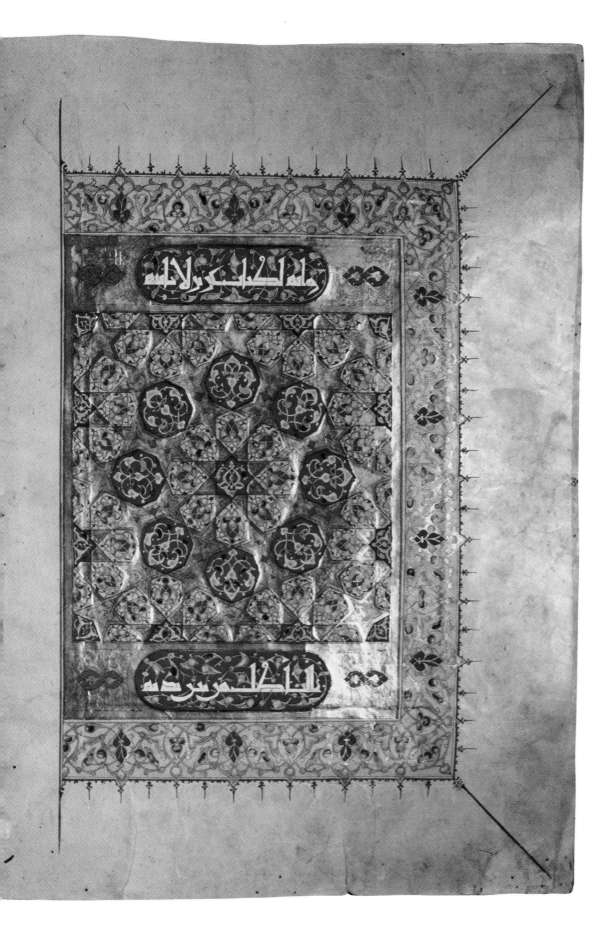

This double finispiece (fols. 377b–378a) is perhaps the best preserved set of illuminated folios in the manuscript. Almost identical to the double frontispiece, these folios are framed on three outer edges by a floral arabesque, outlined by a thin blue line with minute roundels and finials projecting into the margins. The exaggerated corner finials extend almost to the edges of the folios. The floral arabesque of the frame is composed of scrolling branches with split leaves, blossoms, and cartouches. The muted tones of blue, green, and red accentuating the blossoms and leaves are better preserved on these folios than in the frontispiece. Gold bands enclose a rectangular unit divided into three fields: two narrow panels at the top and bottom have oval cartouches with white kufic inscriptions placed against a blue ground covered with a gold floral arabesque.

In contrast to the frontispiece, the central square unit of the finispiece has a series of polygons that radiate from an eight-pointed star and form several rings around the core. The concentric zones are defined by various color combinations: white on blue, gold on gold, and blue on white, each with touches of polychrome.

The intensity of color and the size of the units create a bursting effect comparable to astral formations. Even the arabesques filling the polygons are charged with a force that propels them away from the core. Because the composition extends beyond the restrictive gold frame (which cuts off the elements at the edges), one has the feeling that what is captured and translated into visual form is only a microcosm of a powerfully radiant celestial phenomenon.

The implication of celestial light, stressed by the use of gold and blue—the colors of the heavens—is perhaps the most sophisticated symbol of the omnipotence of the Creator, a befitting finispiece to the Holy Book of Islam. The text included is also an appropriate ending to the manuscript and refers to the Koran: "No falsehood can approach it from before or after; it is sent down by one full of wisdom, worthy of all praise."

Equally emphatic expressions of this energetic centrifugal design can be found in the other contemporary arts, particularly in architectural decoration and in carpets (see nos. 99, 104, and 125–28).

Published
Cairo 1969, no. 284 and pl. 52 (fol. 377b).
Lings 1976, p. 119 and pl. 63 (fols 376b–377a).
Lings and Safadi 1976, no. 73 (fol. 375b).

Notes
1. Cairo, National Library, 184.
2. Lings 1976, pl. 63; Lings and Safadi 1976, no. 73.

4

Double frontispiece with Surat al-Shuara (The Poets; XXVI:192–97)

Circa 1370

Donated by Arghun Shah al-Maliki al-Ashrafi

Height: 70.5 cm. (27¾ in.)
Width: 49.5 cm. (19½ in.)
Written in *muhaqqaq* script with kufic and thuluth headings: 11 lines, 388 folios

Cairo, National Library, 54 (fols. 1b–2a)
From Mosque of Mustafa Chorbaji Mirza (built 1698), 1877

The large size of this manuscript is typical of the single-volume Korans executed in the second half of the fourteenth century. Its contemporary binding is made of dark reddish brown leather, stamped and gilded both on the exterior and on the interior. The exterior of the covers contains a central medallion with a series of polygons radiating from a sixteen-pointed star. A simple oval cartouche adorns the interior.

The manuscript, particularly the opening and closing folios, shows damage caused by time and abuse. It has undergone some restoration, with the edges of the pages consolidated by strips of paper.

The work opens with a double frontispiece, followed by another set of illuminated double pages containing the first verses (fols. 2b–3a). In the ensuing folios, the text is enclosed by blue and gold marginal lines and decorated with gold verse-stops and illuminated marginal ornaments and chapter headings; the work terminates with another set of illuminated double folios containing the concluding verses (fols. 387b–388a). The composition of the two sets of illuminated folios with text at the beginning and at the end is identical.

A further development of the powerful centrifugal design discussed previously (see no. 3) can be seen in this double frontispiece. The radiating geometric unit in the center is encircled by multiple frames. The wide three-sided frame enclosing the composition and the two large medallions placed in the center of the margins have white and gold floral arabesques, enlivened by touches of black and placed on a blue ground. Alternating lotus blossoms and buds, highlighted with white and pale green, accentuate the arabesque in the frame, while a large solitary blossom appears in the marginal medallions. Both the frame and the medallions radiate with blue finials, a feature typical of Mamluk illumination.

The middle frame is composed of a gold scroll with blue, green, and white lotus blossoms intermingled with buds and alternately shown frontally and in profile. The ground of this frame is painted in a lighter tone of gold and trailed on both sides with additional gold bands and white beaded strips. The adjacent border has a dense gold braid that forms occasional knots and almost camouflages its blue ground; it divides the rectangular field into its traditional components, two oblong panels above and below a central square.

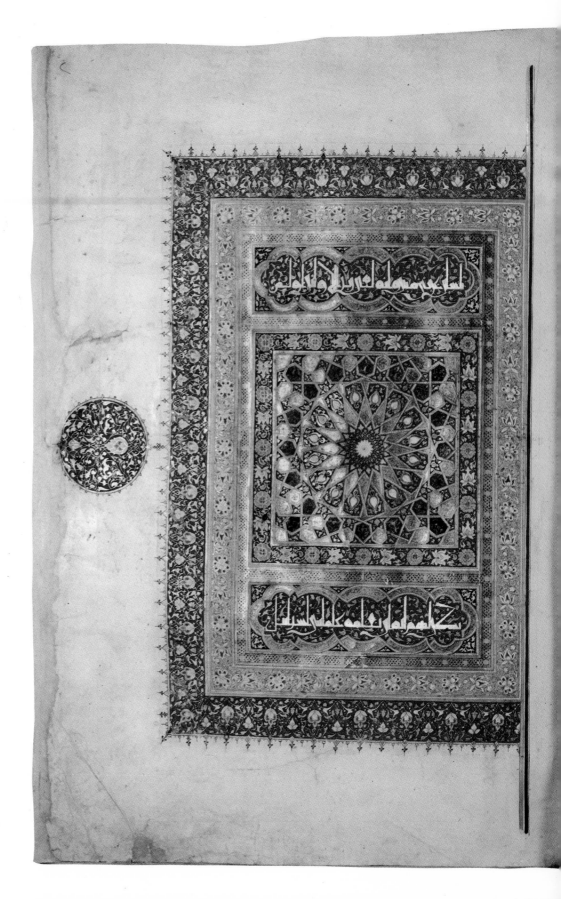

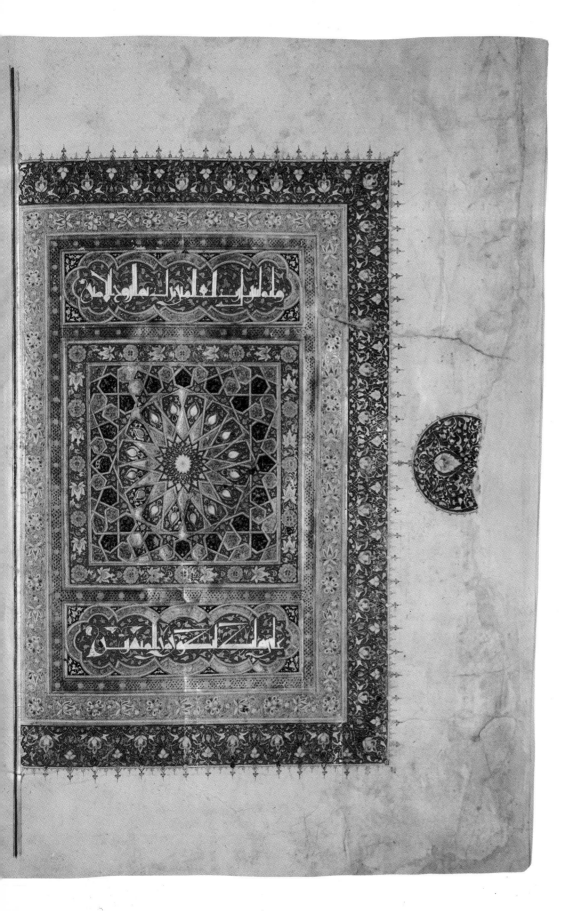

The oblong panels contain a cartouche of five superimposed circles with additional lobes at the sides. A gold floral band and two white beaded ribbons frame the cartouche. White floral sprays on a black ground appear in the interstices. The cartouche bears kufic inscriptions rendered in white and placed on a gold floral scroll with a blue ground.

A blue band adorned with a gold scroll bearing alternating lotus blossoms and peonies encircles the central square. A white beaded ribbon enclosed by gold strips frames this band and outlines the intricate design in the central square. This design evolves from a white sixteen-pointed star radiating from a diffused gold core, the ultimate visual expression of dazzling and blinding celestial light. As the design bursts forth, the color becomes more intense, accentuating the "white" radiation generated by the core.

Three rings of increasingly widening circumference radiate from the sixteen-pointed star, the last one cut off by the frame. The innermost ring, composed of a gold arabesque on a blue ground, terminates with white trefoils. The next zone, a large astral formation, has sixteen elongated diamonds with gold lotus blossoms on a gold ground; enclosing this is a series of pentagons that have gold cartouches on a blue ground with touches of green, white, and black. The third zone is composed of polygons in varying shapes, which through repetition of color and design form two internal rings. The sixteen pentagons of the first ring are painted in reddish brown with green cartouches; they alternate with units decorated with gold on gold and gold on blue. The pentagons of the next and last ring are visible only in the corners; they are identical in design to those in the first ring but have a dark brown ground under the green cartouches.

The artist has displayed remarkable virtuosity in developing throughout the manuscript his compositional theme, first introduced in the stamped decoration on the binding.

The waqf notation gives the name of Arghun Shah, who refers to himself as being in the service of al-Malik al-Ashraf (fol. 1a). Although the title al-Malik was used by all Mamluk sultans, al-Ashraf was employed by only two fourteenth-century rulers: Kujuk (1341–42) and Shaban II (1363–76). The name Arghun Shah was also used by several amirs, one of whom served Sultan Kujuk as Amir of Forty.[1] Although it is tempting to assign the Koran to this Arghun Shah who died in 1349, the style of the frontispiece and the overall conception of the manuscript reveal a closer association with a group of later works commissioned by Shaban II (see no. 5). It seems more likely that the patron of this Koran was an unknown Arghun Shah who served Sultan Shaban and that the work was produced around 1370.

Published
Ettinghausen 1962, pp. 173–75.
Cairo 1969, no. 286.
Lings 1976, p. 119 and pls. 64–65 (fols. 1b–2a).
Lings and Safadi 1976, no. 80 and pl. XIII (fol. 2a).

Notes
1. Mayer 1933, p. 77, and Mayer 1937, p. 34.

5
Double frontispiece with Surat al-Waqia
 (The Event; LVI:77–80)
Part 1 of 2-volume Koran
Donated by Sultan Shaban II to the madrasa of his
 mother in al-Tabana district of Cairo, March 25, 1369

Height: 75.2 cm. (29⅝ in.)
Width: 49.5 cm. (19½ in.)
Written in *muhaqqaq* script with kufic headings: 7 lines,
 380 folios

Cairo, National Library, 9 (vol. 1, fols. 1b–2a)
From Umm al-Sultan Shaban Madrasa (built 1368/69)

Both Shaban II (1363–76) and his mother, Khwand
Baraka, were enthusiastic patrons of the arts and
commissioned a number of Korans for their religious
foundations. The earliest of these volumes were for
Khwand Baraka's madrasa, called Umm al-Sultan
Shaban, completed in 1368/69. The sultan donated three
Korans to his mother's endowment: two are almost
identical in size and were produced as a two-volume set
and one is a slightly larger single volume.[1] Khwand
Baraka herself commissioned other Korans for her
madrasa: in 1368 she donated a thirty-volume set and in
the following year she bestowed a single-volume work.[2]
Sultan Shaban gave only one Koran to his own
foundation (no. 6).

 The double frontispiece illustrated here is from the first
volume of one of the Korans donated by Sultan Shaban to
his mother's madrasa. It displays an unusual composition,
using an extensive range of colors and employing a
subdued overall pattern in contrast to the explosive and
radiant ones seen in the illuminations of other con-
temporary Korans (see no. 4). It seems almost as though
the bursting celestial light has here given way to astral
formations that float across the folios, changing ever so
slightly in perpetual slow motion. This design represents a
different conception of the heavens, less turbulent but
equally potent.

 Following the established format of the double
frontispiece, a wide blue frame encloses the folios on three
outer edges, with tiny finials extending into the margins.
This frame is adorned with an arabesque scroll, its
intersecting branches, rendered alternately in gold and
white, forming cartouches filled with floral motifs. Lighter
and darker shades of the same color are applied to the
leaves, blossoms, and cartouches, producing a three-
dimensional effect. The execution reveals the artist's
understanding of the principles of modeling and their
application. The motifs are painted in jewellike tones of
greens, blues, and reds (from cool mauve to hot orange
red) with touches of black enhancing the vivid palette.
Colors are most intense in the center and become paler
and more subdued toward the edges, which are often
outlined in white.

 A gold braid divides the illumination into its three
components; the upper and lower oblong panels have
kufic inscriptions, while the square in the center contains
the astral design. Thin white beaded bands outline the
three fields and internal subdivisions. The oblong panels
have a central cartouche with gold kufic inscriptions on a

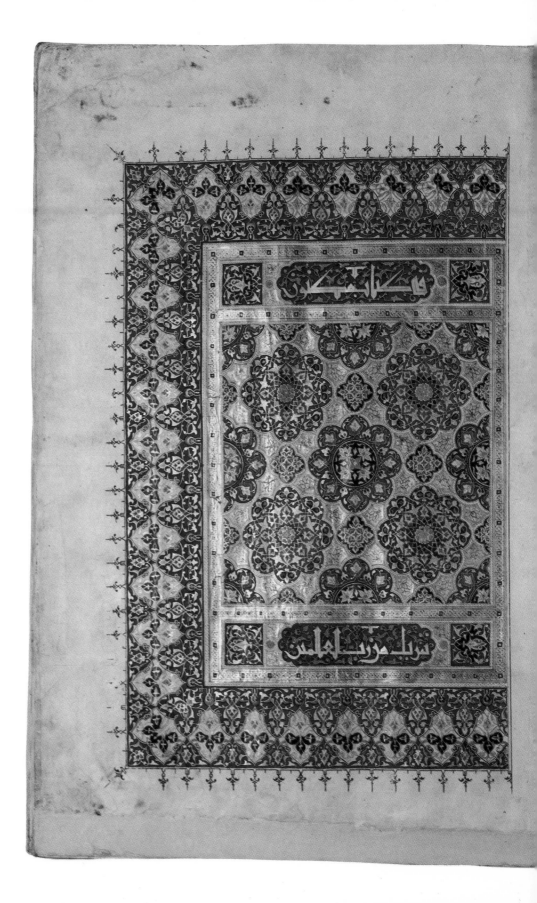

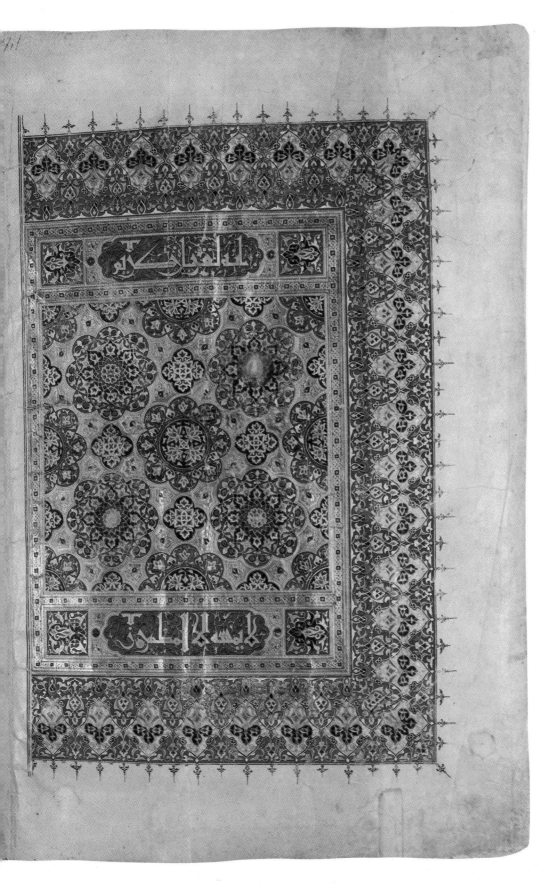

blue ground covered with a green floral arabesque; the square units flanking the cartouche also have a blue ground but are highlighted by a white scroll enclosing a single polychrome blossom.

The composition of the central square is based on the repetition of eight-lobed medallions: one of these appears in the core, surrounded by four similar units; eight others are cut by the frame into halves at the edges or into quarters at the corners. The zones between the medallions are filled with polygons embellished with gold lotus blossoms on a gold ground or quatrefoils decorated with blue florals on a black ground. A white beaded band links the components, underpassing and overpassing while looping around them to create an intricate maze.

The eight-lobed medallions are decorated with slightly different motifs. Each half of the double frontispiece shows a variation in design and color. The central medallion, the four half-medallions on the sides, and the four quarter-medallions in the corners are identical, while the remaining ones have another design. The first group bears four lotus blossoms surrounding a central quatrefoil on a black ground; the outer zone has a blue ground with a gold scroll on top of which are cartouches with lotus buds. Placed around the central medallion are four medallions, which have in the center a peony framed by an elaborate star formation whose golden points evolve into a complex arabesque. The ground alternates between blue, black, and brown.

As in other imperial Mamluk Korans, the frontispiece is followed by an illuminated double folio with the opening verses (fols. 2b–3a). The physical layout of these pages is identical to that of the frontispiece, except that three lines of script appear in the central square. The following folios have illuminated headings, marginal ornaments, and verse-stops with the word *aya*. Minutely written commentaries are placed diagonally in the margins. The last page (fol. 380b) is also illuminated. The binding dates from the Ottoman period.

The waqf notation, which fills the entire page (fol. 1a), contains a lengthy praise of the sultan and gives his titles and names, al-Malik al-Ashraf Abu'l-Muzaffar Shaban. It also mentions his ancestors: Husein (his father), Sultan Nasir al-Din Muhammad (his grandfather), Sultan al-Mansur Muhammad (his cousin and immediate predecessor), and Sultan Salih (his uncle and predecessor of his cousin). The waqf states that the sultan stipulated that the Koran be placed in his mother's madrasa on the fifteenth day of Shaban 770.

Published
Cairo 1969, no. 289 and pl. 53 (vol. 1, fol. 3b).
Lings 1976, p. 120 and pls. 69–70 (vol. 1, fols. 1b–2a, 2b–3a).
Lings and Safadi 1976, nos. 82–83 (vols. 1–2) and pl. xv (vol. 1, fol. 2a).

Notes
1. Single-volume Koran is in Cairo, National Library, 7, dated 1369 (Lings 1976, pls. 66–68; Lings and Safadi 1976, no. 81 and pl. xiv). Two-volume Koran is in the same collection, 8, waqf dated 1368, copied by Yakub ibn Khalil in 1356 during the second reign of Sultan Hasan (Lings 1976, pls. 73–74; London 1976, no. 536). The other two-volume Koran also in the same collection, 9 (for part one see published references listed above; part two in Lings and Safadi 1976, no. 83 and fig. 83).
2. Only thirteen parts of the thirty-volume Koran have survived; they are in Cairo, National Library, 80. The single-volume Koran is in the same collection, 6 (Lings 1976, pls. 75–77; Lings and Safadi 1976, no. 79 and pl. xii).

6

Illuminated heading with Surat al-Fatiha
 (The Opening; I:1–7) and Surat al-Waqia
 (The Event; LVI:77–80)
Donated by Sultan Shaban II to his complex, with
 khanqa, madrasa, and mosque, near the Citadel in
 Cairo, May–June 1376
Copied by Ali ibn Muhammad al-Mukattib al-Ashrafi,
 July 17, 1372
Illuminated by Ibrahim al-Amidi

Height: 73.6 cm. (29 in.)
Width: 50.8 cm. (20 in.)
Written in *muhaqqaq* script with kufic headings:
 13 lines, 217 folios

Cairo, National Library, 10 (fols. 2b–3a)
From Complex of Sultan Qalawun (built 1284–85)

This Koran was donated by Shaban II (1363–76) to his
foundation in 1376, four years after it was copied on
the fifteenth day of Muharram 774.¹ This single-
volume work is almost the same size as the two-volume
set commissioned for his mother's madrasa (no. 5).
Like the previous example, it was restored at a later
date, and its binding dates from the Ottoman period.
The endowment notation, set in an illuminated
polylobed medallion on the first page (fol. 1a), praises
the sultan, lists his titles and name as al-Malik
al-Ashraf Abu'l-Muzaffar Shaban ibn Husein, and
refers to his famous ancestors. It also states that the
work was endowed for his establishment in Muharram
778 and that the sultan himself was responsible for the
Koran during his lifetime, after which the task would
fall upon the overseer of the foundation.

 The overall composition of the double frontispiece
recalls the decoration of the previous Koran with a
central unit enclosed by four others and surrounded by
four half-units at the sides and four quarter-units at
the corners. The total effect, however, is remarkably
different since these units are decagons radiating from
pentagons, and the excessive use of gold is only
somewhat relieved by the polychrome elements.²

 The next set of illuminated double folios with text
is here illustrated. It is subdued and not as dazzling
as the frontispiece but reveals an equally refined
composition. A wide blue frame overlaid with gold and
white scrolls bearing leaves and blossoms surrounds
the text on three sides. The scrolls form cartouches
alternately filled with black and brown; the black
cartouches contain a composite blossom, its petals
painted in two tones of blue, green, orange red, and
mauve; while the brown cartouches have three golden
dots in the center and are embellished with a bright
green pendant.

 The text is framed by a gold braid with touches of
color applied to the knots and enclosed on both sides
by a white braid. The white beaded band seen earlier
(nos. 1–2 and 4–5) has been replaced by a new motif:
a braid composed of triple ribbons that knot at regular
intervals.

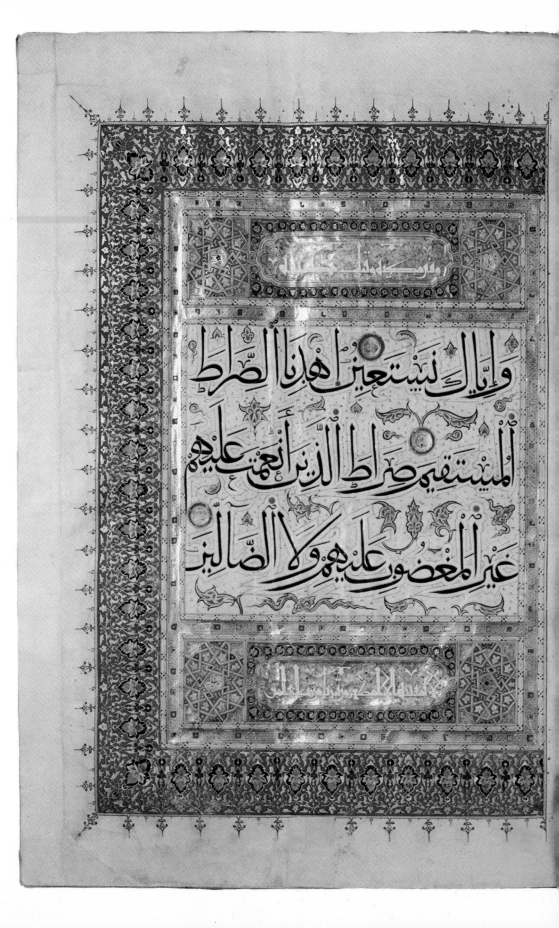

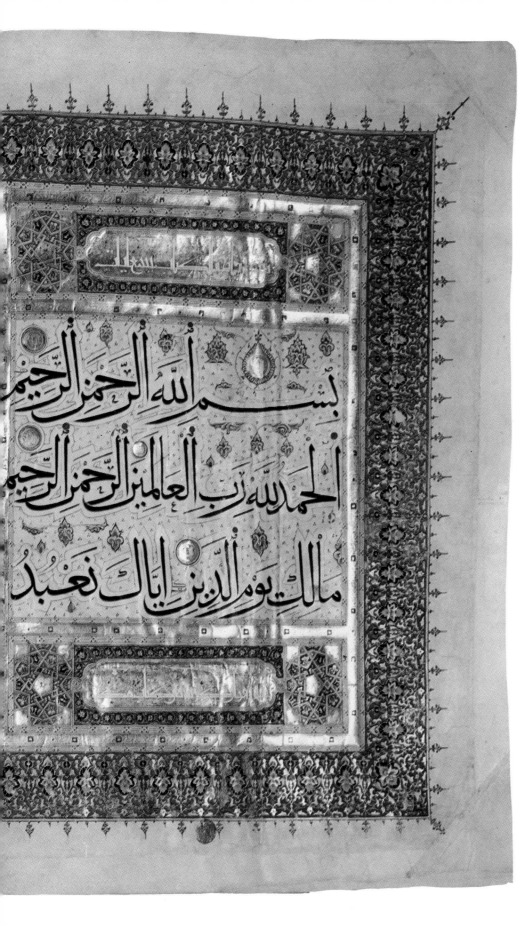

The two oblong panels at the top and bottom have an oval cartouche with kufic inscriptions rendered in white against a reddish gold ground overlaid with gold flowers. This cartouche is enclosed by a polychrome floral scroll composed of gold, black, turquoise—a new color in Mamluk Korans—and two tones of red on a blue ground. The inscription in the top right cartouche states: "Surat al-Fatiha, the beginning of the book, [containing] seven verses"; the cartouche on the upper left indicates that this chapter was "revealed at Mecca and Medina." Below, on the lower two panels, are the famous verses from the Surat al-Waqia that frequently appear on Mamluk frontispieces and illuminated headings (see nos. 1, 5, and 7). The square units at either side employ the same colors as the central cartouche, their design echoing the theme seen in the frontispiece: a decagon radiating from a pentagon.

It is in the central square that the illuminator, Ibrahim, reveals his true talent. As if challenging the fact that he is an accompanyist to the calligrapher, Ibrahim has filled the voids between the exquisite *muhaqqaq* script in such a way that there is harmonious equality between text and illumination. He has drawn a tight contour band around the letters, disallowing the more generous space allowed by other illuminators (compare with nos. 1 and 8), and covered the space around the script with an overall pattern of concentric semicircles (the so-called wave-pattern), in the center of which are three blue dots. Large composite blossoms and tiny buds, simple and complex split leaves with one leaf folding over another, and clouds with trails and puffy formations rendered in two tones of blue and highlighted by white fill the areas between the tall vertical letters and echo the sweeping movement of the calligraphy. Illuminated verse-stops with the word *aya*, placed against a reddish gold ground and encircled with a contrasting green line, accent the text. The use of the word *aya* in the verse-stops was also seen in other Mamluk Korans (see nos. 1–2 and 5). The three lines of text on each folio contain the seven verses of Surat al-Fatiha, preceded by the *basmala*.

The body of the manuscript has exquisitely illuminated chapter headings, each of which differs in design and contains the numbers of words within that section. The work terminates with a superbly rendered double finispiece with the concluding verses and colophon giving the calligrapher's name (fols. 216b–217a), repeating the format seen in the beginning. The background of these folios is painted a delicate pink and adorned with crosshatching instead of the concentric scrolls seen in other folios. The last page (fol. 217b) contains a statement on the contents of the verses and the name of the illuminator, Ibrahim al-Amidi (from Amid, that is, Diyarbakır in southern Anatolia), set within an illuminated polylobed medallion, identical to the one with the waqf in the beginning of the manuscript.

Published
Cairo 1969, no. 290.
Lings 1976, p. 120 and pls. 71–72 (fols. 1b–2a).
London 1976, no. 537 (fols. 2b–3a)

Notes
1. Sultan Shaban's name appears on three glass lamps and one glass bowl (Wiet 1929, nos. 265–67 and 4055; app. nos. 122–25 and pls. LIX–LXI). His name is also found on five metal objects: a key (see no. 33), a ewer and two chandeliers (Wiet 1932, pp. 5, 25, 113, and 275, app. nos. 271 and 278–79, and pl. XXIV), and a tray in London, British Museum, 66 12–29 60.
2. The frontispiece is illustrated in Lings 1976, pls. 71–72.

7
Double frontispiece with Surat al-Waqia
(The Event; LVI:77–80)
Part 1 of 2-volume Koran
Donated by Sultan Barsbay to his madrasa in
the Ambarin district of Cairo, March 16, 1425

Height: 53.6 cm. (21⅛ in.)
Width: 40.0 cm. (15¾ in.)
Written in naskhi script with kufic headings:
11 lines, 178 folios

Cairo, National Library, 98 (vol. 1, fols. 1b–2a)
From Madrasa of Sultan Barsbay
(built 1425), 1882

Sultan Barsbay (1422–38) commissioned
several magnificent Korans for his mosque-
madrasa completed in 1425. The earliest of
these is an almost identical pair of two-
volume Korans, both donated in the year the
complex was built. Although the first set (nos.
7–8) is of considerably higher quality than the
second set, the size of the volumes and style
of the illuminations and script are so similar
that they must have been executed by the
same illuminator and calligrapher or
produced in the same studio. Perhaps the
only obvious difference is that the second set
includes large marginal roundels in the
frontispiece and illuminated double folios
with text.[1]

The two-volume Koran was beautifully
restored in the beginning of the eighteenth
century (see restorer's notation discussed in
no. 8). The stamped dark red leather bindings
of both parts date from this period as do the
additional blank sheets added to the front
and back of the volumes.[2]

The first page of volume one contains the
waqf (fol. 1a), which gives the date, Friday,
the twenty-fifth day of Rabii II, 828, and the
name of the donor, al-Malik al-Ashraf Abu'l-
Nasir Barsbay, and states that this two-
volume Koran was designated by the sultan
for the madrasa he established in the
Ambarin (Amber-workers) district in Cairo.
It also states that any one who tries to alter
the Koran would be committing the greatest
sin and would be severely punished by God.

The double frontispiece is slightly squatter
in format than those discussed earlier.
Its predominant colors are blue and gold, and
its basic design is a floral arabesque. The wide
blue frame on the three outer edges enclosing
the composition is overlaid with a gold floral
scroll containing split leaves, buds, and lotus
blossoms; the blossoms are highlighted with
orange red and golden yellow and outlined in
white, creating a three-dimensional effect.
A series of minute blue finials and triple dots
extend into the margins; the corner finials
are considerably elongated, reaching to the
edges of the folios.

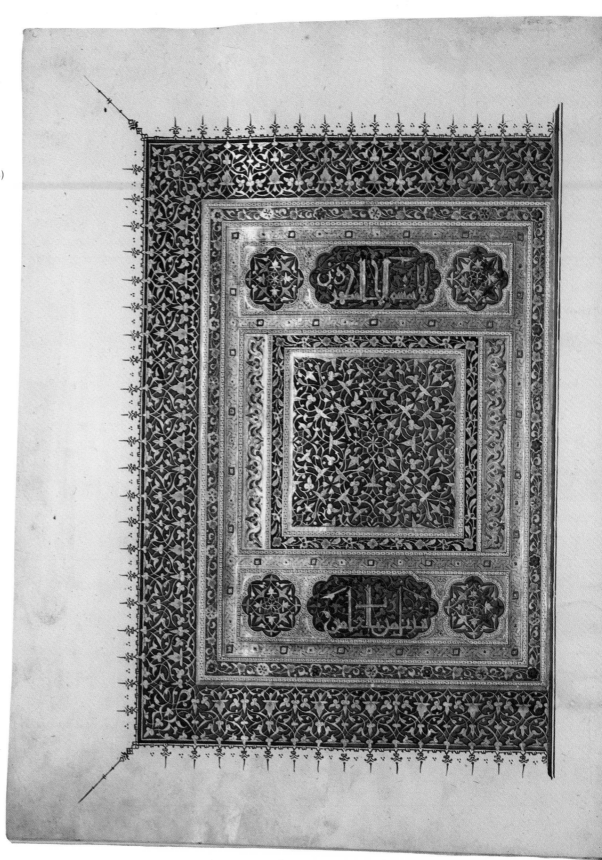

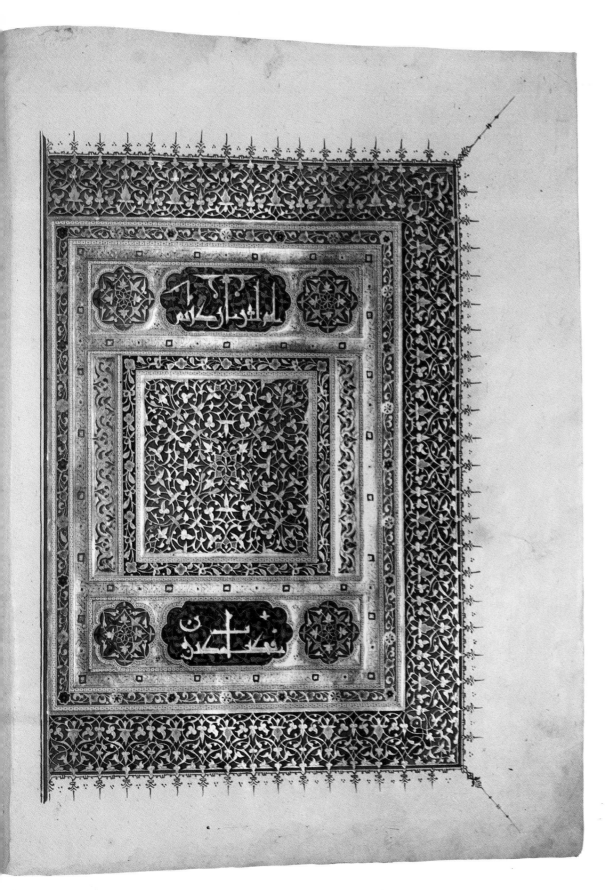

A red band, adorned with a gold scroll bearing lotus and peony blossoms painted in gold and varying tones of blue and green, encloses the inner section; ribbons filled with gold and white beaded motifs appear on either side of this band. The inner section is broken into the standard three fields by a bold gold braid, its knots accentuated with gemlike polychrome squares. A beaded white ribbon is used to trace this braid and outline the three panels and their subdivisions.

The two oblong panels above and below have a rich blue ground. The eight-lobed medallions on the two ends are filled with gold and light blue quatrefoils, accentuated by a central eight-petaled blossom painted in red; the central oval cartouche has a jade green scroll, on top of which is a kufic inscription rendered in gold.

The central square is densely filled with gold and white floral scrolls, similar to the decoration used in the eight-lobed medallions. Although there seems to be an overall arabesque filling the square, the basic design principle is not unlike that of earlier frontispieces (nos. 3–5), which contained a radiating central motif encircled by similar elements.

In the core of the square is an eight-petaled blue and red blossom, its white outlines extending to create a large quatrefoil. The frame cuts off eight other blue and red blossoms encircling the central motif, making them appear as halves at the sides of the square and as quarters at the corners. The blossoms in the corners are also enclosed by a white quatrefoil, of which only one-quarter is visible.

A black band filled with a floral scroll identical to the outer red scroll frames the central square. Two vertical gold strips with light and dark blue floral scrolls appear on either side of the square. They compensate for the squat proportions of the frontispiece and transform the central unit into a proper square.

Published
Lings 1976, p. 120 and pl. 78 (fol. 178a).
Lings and Safadi 1976, no. 92 (fol. 178a).

Notes
1. Cairo, National Library, 96 (Lings and Safadi 1976, nos. 90–91). Sultan Barsbay's waqf appears on seven other Korans, four of which were conceived as thirty-volume sets. These thirty-volume Korans are in Dublin, Chester Beatty Library, MS 1451, dated 1413/14 (one *juzz*, Arberry 1976, no. 99); London, Keir Collection, dated 1423 (one *juzz*, B. W. Robinson 1976a, no. VII. 34 and pl. 152); Cairo, National Library, 105, dated 1424, and 99, dated 1427. The single-volume Korans are in Dublin, Chester Beatty Library, MS 1496, dated 1429 (Arberry 1967, no. 100); Cairo, National Library, 93, dated 1432, and 94, dated 1437.
2. These sheets, one in the beginning and two at the end of volume one, bear a European watermark containing a shield with an eagle holding an olive branch and sword and the words "R Gentile Vittorio."

8

Double finispiece with Surat al-Falaq
 (The Daybreak; CXIII:1–5) and Surat
 al-Nas (Mankind; CXIV:1–6)
Part 2 of 2-volume Koran
Donated by Sultan Barsbay to his
 madrasa in the Ambarin district of
 Cairo, March 16, 1425

Height: 54.0 cm. (21¼ in.)
Width: 41.3 cm. (16¼ in.)
Written in naskhi script with kufic
 headings: 11 lines, 184 folios

Cairo, National Library, 98 (vol. 2,
 fols. 183b–184a)
From Madrasa of Sultan Barsbay
 (built 1425), 1882.

The first folio of volume two of Sultan
Barsbay's Koran contains the name of
the restorer, Yusuf Mawardy, and the
date of restoration, Jumada II, 1113
(November 1701). The restorer was
justifiably proud of his conservation
efforts, which have enabled this
magnificent Koran to remain in an
excellent state of preservation.
The waqf notation (fol. 2a) has the
same wording as the one included in
the first volume (no. 7).
 Volume two opens with a double
frontispiece nearly identical to that in
the first volume, the only difference
occurring in the central square: here,
the blossoms cut off by the sides are
enclosed by a white scroll as are those
in the center and in the corners. The
illuminated double folios with text and
the body of the manuscript with gold
chapter headings, illuminated marginal
roundels, and verse-stops repeat the
format employed in the first part.
 The second volume of Sultan
Barsbay's Koran terminates with a
double finispiece followed by an
illuminated medallion containing
the colophon (fol. 184b), which states
that the work was ordered by Sultan
al-Malik al-Ashraf Abu'l-Nasir Barsbay.
 This double finispiece employs the
same proportions and design layout as
the frontispiece (no. 7). A wide blue
band with a gold floral arabesque
frames the composition on three sides
of each page. A superimposed white
scroll weaves in and out of the gold
arabesque and forms cartouches
alternately painted red and black;
the black cartouches are further
embellished with lotus blossoms
painted in light and dark blue and
outlined with white. Tiny blue finials
extend into the margins.

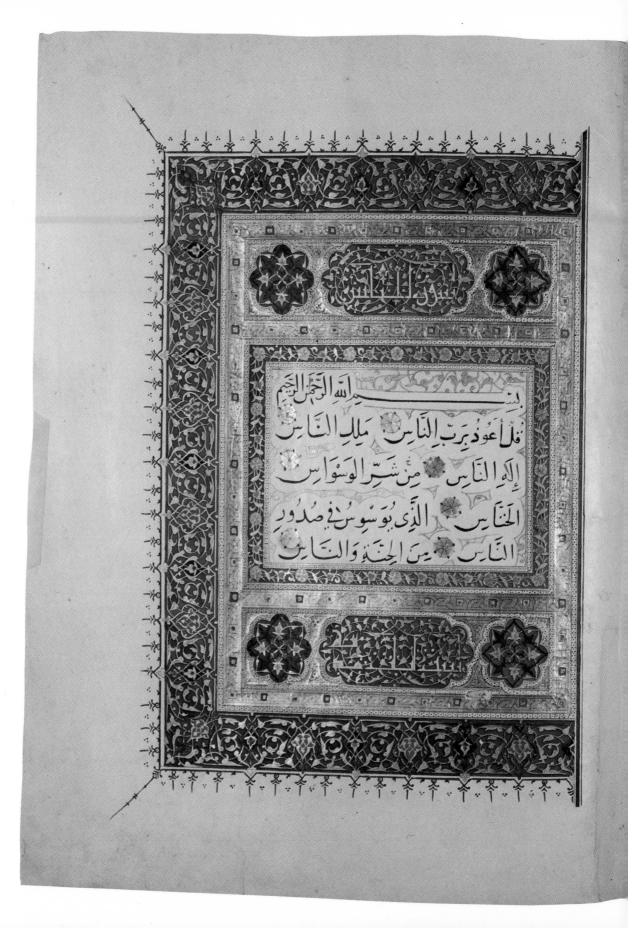

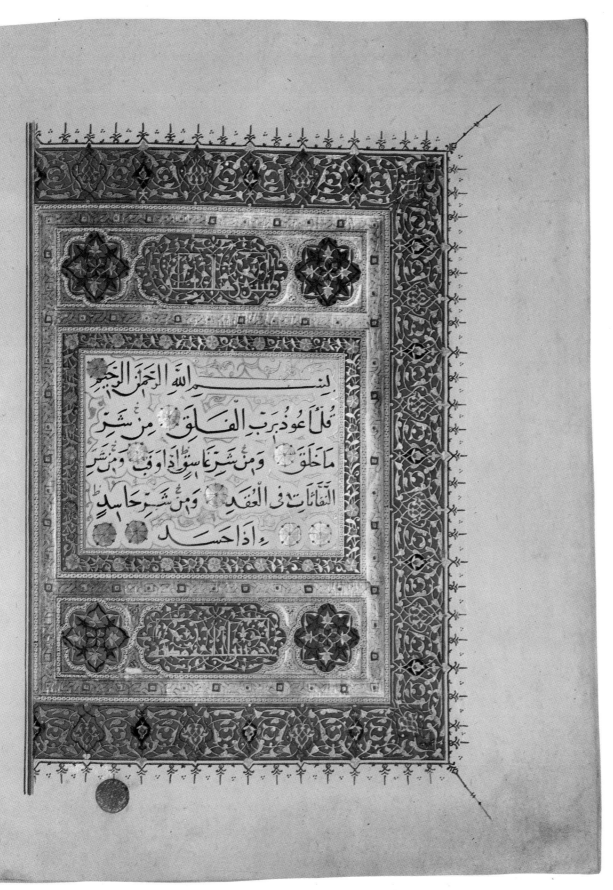

A thick gold braid, encrusted with gemlike polychrome units, divides the central section into three components. White beaded ribbons frame either side of the braid and define the subdivisions within the three panels. The upper and lower oblongs have a central oval cartouche flanked by eight-lobed medallions. The central cartouches bear foliated kufic inscriptions written in white on a blue ground with a gold floral scroll. The lobed medallions are adorned with gold and green quatrefoils accentuated by a central eight-petaled red blossom. The background of these panels is painted in the same tone of blue that appears in the wide frame and in the thin band enclosing the text. This band is embellished with a gold scroll laden with polychrome lotus and peony blossoms.

The central panel is horizontal and contains five lines of fine naskhi script enclosed by spacious contour bands; the gold floral scroll in the background is barely visible. Illuminated eight-petaled rosettes with colored dots around the lobes serve as verse-stops.

Published
Lings and Safadi 1976, no. 93.

9

Double frontispiece with dedication to Sultan
 Qaitbay
From *al-Kawakib al-Durriyya* of al-Busiri
Circa 1470
Copied by Qanem al-Sharifi

Height: 40.5 cm. (15 15/16 in.)
Width: 30.0 cm. (11 13/16 in.)
Written in thuluth, naskhi, *naskh fada*, and
 riqa scripts: 15 lines, 30 folios

Dublin, The Chester Beatty Library, MS 4168
 (fols. 1b–2a)
Purchased in Cairo, 1920s

This slim volume consists of a laudatory
poem to the Prophet composed by al-Busiri
(died 1296). It also includes a *takhmis*,
metrical amplification of the verses, written
in a smaller script. With the exception of the
double frontispiece and the ensuing pair of
folios (each page with five lines of thuluth
alternately rendered in gold, red, and blue),
the body of the manuscript has fifteen lines
on each page. These folios contain a block of
three lines of small naskhi script, followed by
one line of large *naskh fada*; written on an
angle next to the naskhi is a line of *riqa*.
This combination of large and small scripts is
repeated three times on each page. The large
naskh fada was used for al-Busiri's poem,
entitled *al-Kawakib al-Durriyya fi Madh
Khair al-Bariyya*, also called the *Qasidat
al-Burda (Ode to the Mantle)*. This celebrated
work is a eulogy commemorating the Prophet
for placing his own mantle on the shoulders of
a poet when the latter recited a *qasida* (ode)
he had composed in praise of Muhammad.
In the Mamluk period it became traditional
to increase al-Busiri's work with a *takhmis*,
which literally means "the making of five."
This poetic form was constructed by
composing four additional verses to rhyme
with each line of the *qasida*, thus making five.
The verses of *al-Kawakib al-Durriyya* are
always copied in a larger script and the four
takhmis lines are rendered in smaller scripts,
often in different styles with varying colored
inks. In the Dublin manuscript the *takhmis* is
written in blue, green, red, or gold, while
al-Busiri's ode is transcribed in black ink.

This double frontispiece has a striking
design, employing gold floral arabesques on
bright blue and red grounds, accentuated by
white outlines. Tiny blue finials, elongated at
the corners, appear around the illumination.
In the center of the outer margins is a large
blue roundel adorned with gold lotus
blossoms and buds and enclosed by a gold
band and blue border with finials extending
on the vertical axis.

In contrast to other illuminated folios
framed on the three outer edges of each page,

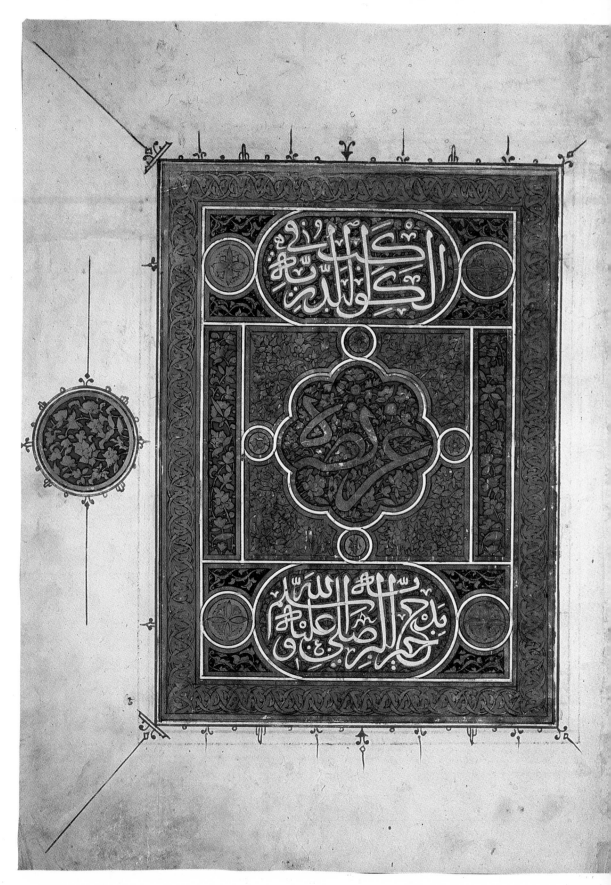

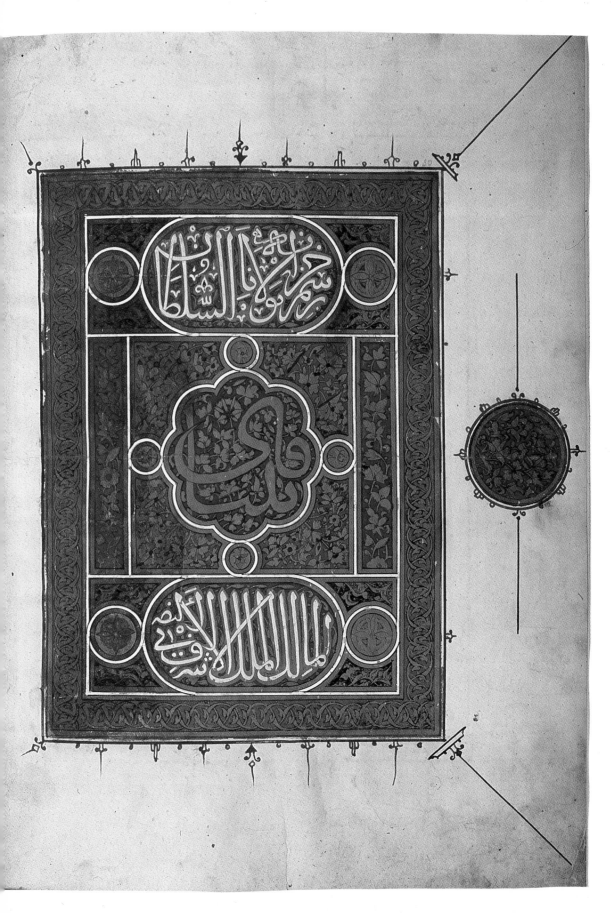

this illumination is self-contained: it is enclosed on all four sides. A red frame, overlaid with a gold braid composed of scrolling split leaves, encircles the rectangular panel and is outlined by several thin gold bands. Gold and white bands divide the composition into a central unit with oblong panels at the top and bottom; the central unit is transformed into a square by vertical strips added to the sides.

The rigid rectangles of the composition are relieved by the circular subdivisions in each unit, boldly outlined in white and gold. An oval cartouche flanked by two roundels appears in the oblong panels; in the center is an eight-lobed medallion surrounded by four small roundels. A blue ground appears in the oblong panels, vertical strips, and eight-lobed medallion; red is used as the ground for the central square. The gold floral scrolls placed on the red and blue fields repeat the themes seen in the marginal ornaments with touches of color accenting the lotus blossoms and buds.

A further contrast is provided by the inscriptions: majestic white thuluth appears in the oval cartouches, while large gold thuluth fills the central medallions. The medallions contain the name of the patron and the benediction "Qaitbay, may his victory be glorious."

The text on the upper right panel states that the manuscript was ordered for the treasury of "our master, the sultan," the lower panel contains Qaitbay's titles, "the royal al-Malik al-Ashraf Abu'l-Nasir." The corresponding panels on the left give the title of the work and conclude with the phrase "God bless him and grant him salvation."

Although this copy is undated, an identical manuscript made for Amir Yashbak, the secretary (*dawadar*) of Qaitbay, bears the date 1472/73.[1] Both works are so similar in style that they must have been produced at the same time by the same calligrapher and illuminator. Three other known manuscripts with similar *takhmis* executed during the reign of Qaitbay are also undated.[2]

Published
Arberry 1955–56, vol. 5, no. 4168 and pl. 140 (fol. 1b).
James 1974, fig. 23 (fol. 1b).

Notes
1. Dublin, Chester Beatty Library, MS 4169. This volume contains the *takhmis* of Nasir al-Din Muhammad ibn Abd al-Samad al-Makki al-Fayyumi (Arberry 1955–66, no. 4169).
2. One of these, dedicated to Qaitbay, has the *takhmis* composed by Sharaf al-Din Abu Said Shaban ibn Muhammad al-Kurashi al-Asari (died 1452). The work is in Istanbul, Topkapı Palace Museum, A2303 (Karatay 1962–69, vol. 4, no. 8549). The other was recently auctioned in London (Sotheby 1980, no. 170). The third, in Berlin, Staatsbibliothek, or. fol. 1623, was donated in 1476 to Qaitbay's madrasa (London 1976, no. 576).

Overleaf: detail of no. 5

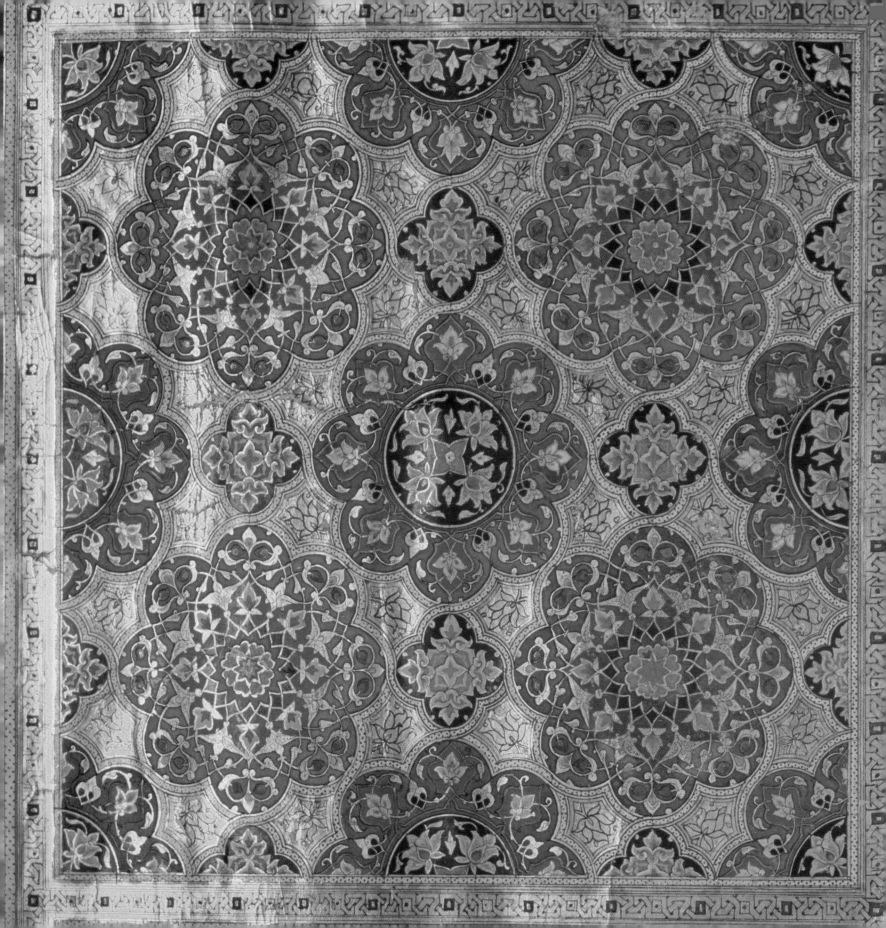

METALWORK

The art of the Mamluks is possibly best known for the creation of spectacular metalwork, examples of which are among the most cherished possessions of many public and private collections around the world. The Bahri sultans and amirs commissioned an unprecedented number of metal objects, and artists vied with one another to produce larger and more impressive pieces for their patrons. Some examples are so detailed and executed with such finesse that they surpass even the work of illuminators and painters.

The most famous examples of Mamluk metalwork were executed in the fourteenth century, when the art of the metalworker reached its epitome. Artists created delicate pieces for personal use and ostentatious objects for ceremonial functions, decorating them with silver and gold inlay.

In the Burji period, the production of metalwork declined noticeably. Inlaying with precious metals was discontinued, and brass objects were simply engraved with bitumen applied to the background. In the late fifteenth century, copper was also used and often covered with a thin coat of tin.

Bahri Period (1250–1390)
Early Mamluk metalwork shows a continuation of Ayyubid styles and themes (see nos. 10–24). Figural compositions, inscriptions, floral and geometric motifs developed by the Ayyubids flourished under the Mamluks and persisted until the second quarter of the fourteenth century.

Figural compositions include the traditional courtly repertoire of warriors and hunters, musicians and dancers, drinkers and revelers (see nos. 10, 12–14, 18, and 20–23). Figures are also employed to personify planets and constellations of the zodiac (nos. 13–14 and 16).

An assortment of real and fantastic animals is frequently depicted in pairs, with predators chasing their prey (see nos. 10, 14, 16, 18–19, and 21–22), or intermingled with arabesques in which the tendrils of the scrolls terminate with heads or bodies of various creatures (nos. 10–11, 13, 18, 21–22, 24, and 26). One of the most popular animals is the wild duck, shown in flocks encircling medallions or as confronted and addorsed pairs in geometric units (see nos. 16–19, 22–24, and 31). This theme appears to have flourished between the 1290s and the 1320s, lingering on until the middle of the fourteenth century.

The third and most common ingredient of Mamluk art is writing, which is used on almost all metal objects here discussed, the only exception being a candlestand (no. 17). Inscriptions are rendered in a variety of scripts: angular kufic (see nos. 12, 23, 25, and 32), which was at times used as a decorative feature, with letters plaited or foliated (nos. 10 and 16); simple naskhi (nos. 10–13, 18, 20–22, and 32), sometimes animated with letters composed of human and animal figures (nos. 15 and 18); and thuluth, the most characteristic Mamluk script (nos. 14–16, 18–19, and 22–43). Kufic and naskhi, employed in

earlier pieces, were abandoned in favor of the more majestic and hierarchic thuluth, which soon became the favored style of writing.

The evolution of thuluth as the dominant script on Mamluk metalwork coincides with a change in the style of decoration. After the 1320s, bold inscriptions became the main decorative theme (see nos. 25–32). Inscriptions appear in panels interrupted by medallions and in circular formations with the vertical shafts of the letters radiating from the center. Epigraphic blazons containing the sultan's name and title were also inserted into prominent areas of the design.

Geometric motifs and floral arabesques, either used in the background of the figural and epigraphic units or as main themes, are the next most common decorative elements. Various geometric patterns appear in the center of medallions, serve as borders, and cover large areas. Floral motifs, consisting of stylized arabesques and naturalistic lotus and peony blossoms, evolved at the same time as the epigraphic style and survived until the end of the Mamluk period.

Geometry was the basis for the decorative layout of Mamluk metalwork, with surfaces divided into tripartite or quadripartite segments, which in turn were subdivided into multiples of threes and fours. Tripartite divisions soon became predominant, particularly after the development of the epigraphic style (see no. 26). Each segment of the design is interrelated, displaying a syncopated rhythm of geometric units, inscriptions, and decorative motifs. Continuous strips encircle the units and loop around them, creating an intricate maze that defines and unifies the components, similar to compositions in manuscript illumination.

Between 1275 and 1350 the art of Mamluk metalwork reached its apogee. During these years the figural style flourished and the epigraphic style was established. At this time artists responded to an extremely energetic and supportive patronage by creating unique and spectacular pieces. The majority of Mamluk objects bearing signatures of metalworkers dates from this period. The names of seventeen artists from the Bahri period are known; in contrast, there are only five or six signatures from the subsequent Burji period.[1]

Among the outstanding artists was Mahmud ibn Sunqur, who produced an exquisite pen box in 1281 (no. 13); the renowned *muallim* (teacher or master) Muhammad ibn al-Zayn, who created a magnificent bowl and basin between 1290 and 1310 (nos. 20–21); and Ahmad ibn Husein al-Mawsili, who made a tray (no. 22) circa 1300–1320 for the Rasulid sultan Dawud.

Other great artists known by their works include Ahmad ibn Ali al-Baghdadi, whose name appears on a late-thirteenth-century bowl;[2] Muhammad ibn Sunqur al-Baghdadi, called *ibn al-muallim* (son of the master), who made for Sultan Nasir al-Din Muhammad an oversize hexagonal table in 1327 and a Koran box around the same date, working on the latter with Hajj Yusuf ibn al-Ghawabi;[3] Ahmad ibn Bara al-Mawsili, who in 1322 made another Koran box for the sultan;[4] and Muhammad al-Waziri, the artist of a mirror dedicated around

1340 to Amir Altunbugha.[5] One should add to this list of metalworkers: Ali ibn Umar ibn Ibrahim al-Sunquri al-Mawsili, who in 1317 made a candlestick;[6] Badr ibn Ali Yala, who made a lantern in 1329 for Amir Qusun, cup-bearer of Sultan Nasir al-Din Muhammad;[7] and Ahmad al-Hakam, the artist of a mid-fourteenth-century bowl.[8]

One of the more prolific metalworkers was Ali ibn Husein al-Mawsili, whose name is inscribed on three pieces of imperial quality: a ewer made in 1275 for the Rasulid sultan Yusuf, a candlestick dated 1282, and a basin dated 1285.[9] The name Ali ibn Hamud al-Mawsili also appears on three pieces: a vase made for Qustah ibn Tudhrah in 1259 and a ewer dated 1274 and matching undated basin dedicated to Amir Atmish al-Sadi.[10] The last two objects, most likely made in Syria, were found with other contemporary pieces of metalwork in 1908 in Hamadan, western Iran. The patrons of the pieces have not been identified, but their Turkish names indicate that they were former mamluks in the service of the last Ayyubid sultan and early Mamluk rulers. Another matching ewer and basin was made by Ali ibn Abdallah al-Alawi al-Mawsili.[11] This set, which is not dated, reveals the same stylistic features of early Mamluk metalwork seen in works of al-Mawsili metalworkers. A significant group of artists working in the early Mamluk period used the *nisba* (word designating place of origin) of al-Mawsili, meaning from Mosul in Iraq. In addition to the six individuals mentioned earlier, two other metalworkers employed this term: Muhammad ibn Hasan, who made a candlestick dated 1269 (no. 10); and Muhammad ibn Hilal, who in 1275 made a celestial globe.[12] It is difficult to sort out the family relationships between the Muhammads, Ahmads, and Alis who use the same *nisba*. Only one family appears to be more or less distinguishable: a metalworker named Husein ibn Muhammad al-Mawsili executed a ewer in Damascus in 1258 for the last Ayyubid sultan, Yusuf;[13] the artist's two sons, Ali ibn Husein ibn Muhammad and Ahmad ibn Husein (who omits his grandfather's name), worked in Cairo, as stated in the inscriptions of their objects dated between 1275 and 1320 (see no. 22). Incidentally, these artists, together with Muhammad ibn Hasan are the only ones to include the names of cities on their objects (see no. 10).

These al-Mawsili artists should be considered as a group of men who worked in a specific style, perhaps associated at one time with the metalwork tradition of Mosul. They display an expert handling of figural compositions and a refined technique. The consistent use of the *nisba* al-Mawsili long after Mosul and its artistic production fell into oblivion suggests that these men regarded themselves as members of an elite group, perhaps a guild or society. It is quite possible that al-Mawsili was used in the same spirit as the *nisba* al-Tawrizi (from Tabriz) and al-Shami (from Sham, that is, Damascus) were used by potters. The *nisba* and the figural style of Mamluk metalwork disappear after the second quarter of the fourteenth century.

The production of metalwork during the Bahri period was extremely prolific, including imperial and ceremonial wares as well as

objects for personal use. Among the extant imperial wares is a group of large basins with matching ewers, some of which were used in Muslim ablution rites, while others were obviously show pieces. The basins (nos. 18, 21, and 26–28) have beautifully decorated exterior and interior surfaces and are often inscribed with the names and titles of patrons. Similar decorations are found on ewers (no. 19), trays (nos. 14 and 22), bowls (nos. 20 and 29), candlesticks (nos. 10, 15–16 and 30), and pen boxes (nos. 13 and 23–24). Mamluk metalworkers also produced candlestands (no. 17), incense burners constructed as globes (no. 11) or domed cylinders resting on three feet (no. 12), rosewater or perfume sprinklers (no. 31), and an assortment of stands for trays, cylindrical boxes, rectangular caskets, vases, mirrors, silver and gold jewelry, and even inlaid butcher hooks.[14]

The endowment of furnishings and decorations for religious establishments was a Mamluk practice, and many patrons supplied their foundations with appropriate candlesticks, Koran boxes (no. 25), and lanterns (no. 32). Gifts were also donated to the holy shrines in Mecca, Medina, and Jerusalem (see no. 34). It was the duty and privilege of the sultan to present exquisitely embellished keys to the Kaaba in Mecca (no. 33) and to oversee the maintenance of the sacred buildings. Many religious structures in the capital and in the provinces were enhanced with metal chandeliers, doors, and windows.

The most zealous patrons of art were the descendants of Qalawun and their amirs. Sultan Nasir al-Din Muhammad, who reigned with brief interruptions for almost half a century until 1341, was the most enthusiastic of all. His glorious age is represented by more than ten objects, produced either for him or for his officers (see nos. 18–27).

The court of Sultan Nasir al-Din Muhammad, who established peaceful relations with neighboring states, was frequented by embassies from Western and Eastern powers. These emissaries obviously admired the luxury items in the Mamluk court and reported back to their rulers who requested similar objects. Commissions came from the Rasulid sultans of Yemen who ordered a number of metal and glass pieces (nos. 14, 22, and 50). Another noteworthy client was Hugh IV of Lusignan, king of Cyprus (1324–59). His unique basin, decorated with thuluth inscriptions, was executed in the epigraphic style, which flourished after the second quarter of the fourteenth century.[15]

It was also during the age of Nasir al-Din Muhammad that blazons were incorporated into the decorative vocabulary of metalwork. The first true blazon containing the sign of an office is found on Kitbugha's candlestick (nos. 15–16) and displays the cup of the *saqi* or cup-bearer. A tray (no. 14) made during the same period reveals the five-petaled rosette adopted as the blazon of the Rasulid dynasty.

Subsequent pieces, dating between 1300 and 1340, show a full range of both heraldic and epigraphic blazons. Nasir al-Din Muhammad's own epigraphic blazon appears in his large basin (no. 26) and that of his renowned official, Abu'l-Fida, is found on a pen box (no. 24). Hybrid or composite charges employed by the amirs are represented on the basin

(no. 27) commissioned by Qushtimur who used the blazon of his master, Toquztimur.

The epigraphic blazon, which evolved around 1320–30 and became identified with royalty, appears on the rosewater sprinkler made for Sultan Hasan (1347–61, with interruption) as well as on a bowl and candlestick (nos. 29–31). The amirs generally used the signs of their office, as seen on the basin (no. 28) commissioned by Tabtaq, the *saqi*.

Inscriptions on these objects are indicative of the structure of the Mamluk state and the importance given to the military oligarchy. Dedications include such terms as "the great amir, the defender of the faith, the warrior of the frontiers, the champion of Islam, the victorious, the triumphant" in addition to the usual benediction "the wise, the learned, the just." It is also significant that the imperial epigraphic blazons begin with the words "glory to our master, the sultan," and terminate with the phrase "may his victory be glorious."

Similar wording appears on objects made for ladies of the court. A large candlestick produced around 1345 bears a notation stating that it was made for Fatima, daughter of Shaban I.[16] A brass bowl, dated around the turn of the fourteenth century, was made for another Fatima, daughter of an amir, and is decorated with the crescent blazon of her father.[17] A steel mirror, made for the wife of a *dawadar*, includes the pen box blazon identifying the official as secretary.[18]

The production of metalwork, which exploded during the reign of Nasir al-Din Muhammad, continued to flourish under the patronage of his sons and heirs. Among the most renowned pieces produced in the middle of the fourteenth century are a basin and jug adorned with naturalistic trees. They are dedicated to Sultan Ahmad, one of the sons of Nasir al-Din Muhammad, who succeeded him in 1342 and reigned briefly for several months.[19] A second son, Ismail (1342–45), commissioned a rosewater sprinkler and cylindrical box.[20] Another cylindrical box was made around 1370 for Amir Timur al-Ashrafi, the cup-bearer of Shaban II. This box represents a landscape with animals and the blazon of the owner.[21]

Although Nasir al-Din Muhammad's heirs continued to commission inlaid metalwork, the objects became more intimate in scale. They were made for private rather than ceremonial use, as exemplified by the rosewater sprinkler of Sultan Hasan (no. 31) and an exceptionally beautiful pen box made for Sultan Muhammad (1361–63), his successor.[22] Shaban II (1363–76), the last of the great Bahri patrons, commissioned a key to the Kaaba (no. 33) and several inlaid brass objects, including a magnificent tray.[23]

Burji Period (1382–1517)

Production of metalwork began to decline in the last quarter of the fourteenth century and steadily deteriorated in ensuing years due to a lack of imperial patronage. In contrast to the flamboyant pieces of the early fourteenth century, objects were now conservative in size and decoration.

The small number of signed and dated pieces testifies to the lack of imperial support during the Burji period. Between the middle of the fourteenth and the middle of the fifteenth century, there are no significant objects bearing artists' names. One of the rare late-fifteenth-century signed objects is a small jar with lid made in 1467 by Shir Ali ibn Muhammad Dimishqi,[24] who was working in Syria (see also no. 36). Other Burji metalworkers known by their inscribed pieces include Muhammad ibn al-Kamal and his brother Yusuf, who in 1488 made an iron grille for the mausoleum near Aleppo of Amir Uztimur al-Ashrafi, and Hasan Ahmad, who made a padlock dated 1492.[25]

A brief renaissance occurred in the last quarter of the fifteenth century under the patronage of Sultan Qaitbay (1468–96). Brasses inlaid with silver and gold began to be produced for the court, but they were limited in number and were soon replaced by more humble pieces employing less expensive materials. Displaying a remarkable ingenuity, artists made the most of limited resources, producing an interesting series of engraved brass and tinned-copper objects.

Sultan Qaitbay's name appears on a number of basins, bowls, candlesticks, and trays. One of his most beautiful pieces is a bowl inlaid with silver and gold.[26] Other objects made for the sultan are either inlaid with silver or simply engraved, with bitumen applied to the background. Among the silver inlaid pieces is a large bowl (no. 35) with articulated base, a feature characteristic of the period. Engraved designs appear on a large candlestick (no. 34) donated by the sultan in 1482/83 to the Mosque of Medina. Similar metal pieces were commissioned by the amirs of Qaitbay's court and his wife Fatima, who is known to have ordered several objects, including a silver inlaid ewer made in 1496 by Ahmad.[27] This famous piece, recalling four-teenth-century themes, is decorated with inscriptions, bands of real and fantastic animals, and panels with cypresses and flowering trees and quadrupeds and flying ducks.

Copper and tinned-copper objects, mostly trays, lunch boxes, and bowls, became popular at the turn of the sixteenth century. These pieces (nos. 38–39) are not without artistic merit and display a certain technical finesse. Two metalworkers are associated with these wares: Ahmad al-Sab, who made a tray, and Rustam ibn Abu Tahir, who made a bowl.[28]

Objects made for the Burji court are generally inscribed with the usual repertoire of honorific and benedictory phrases, such as "the royal, the just, the defender of the faith . . . may his glory be victorious." A different type of inscription appears on bowls and basins (nos. 37–38) made for anonymous and most likely nonroyal patrons. They contain lofty phrases praising the vessel or the owner. The inscriptions are poorly written, often rendered in two registers. The pieces are devoid of heraldic emblems and were probably mass-produced for the middle classes without specific patrons in mind.

Blazons of the Burji Mamluks, found on objects made for the court, consist of a circular shield divided into three fields filled with an

assortment of cups, napkins, pen boxes, and powder horns (no. 39). In many cases emblems are superimposed, such as a cup charged with a pen box. Identifying the entire class of ruling elite, the same blazon was used by the sultan and his amirs.[29] Ladies of the court also used the composite blazons of their fathers and husbands, similar to the practice observed in the Bahri period.[30]

In contrast, the sultans had exclusive use of the epigraphic blazon, which also had a circular shield divided into three fields, each filled with inscriptions (see nos. 34–35). This tradition was established during the reign of Qaitbay and continued until the end of the Mamluk empire. Some of Qaitbay's metalwork bear both collective and epigraphic blazons.

One of the most important duties of Mamluk metalworkers was to supply the army with arms and armor. A suit of Mamluk armor consisted of helmet, mail shirt, stockings, leggings, and boots with spurs.[31] The warriors carried swords, daggers, and knives as well as bows and arrows, spears, maces, axes, and shields. Although the majority of Mamluk arms and armor date from the Burji period, representations of amirs on metalwork produced in the early Bahri period provide useful information regarding the types of weapons used in the thirteenth and fourteenth centuries (see nos. 18 and 20–23). The best collection of late Mamluk arms and armor, consisting of both ceremonial and utilitarian weapons dates from the reign of Qaitbay to the end of the Mamluk period and is housed in the Topkapı Palace Museum in İstanbul. The National Museum in Florence is also rich in Mamluk arms, particularly helmets.

Among the earliest datable helmets is one made for Sultan Barsbay (no. 41). Burji helmets were tall and conical with a plume socket at the apex; they were supplied with nasals and peaks as well as ear and neck guards. Helmets were made of iron or steel, adorned with incised or gilt inscriptions and arabesques. The plates on the coat of mail contained similar decorations, and at times even the links were embellished with inscriptions. The only surviving brigandine (coat worn over armor) is a long-sleeved jacket made of a very strong fibrous material covered with red velvet and encrusted with brass nails.[32] The inscription on the collar states that it was made for Sultan Jaqmaq (1438–53).

The most formidable Mamluk weapon was the sword, called *sayf* in Arabic, which was used in battles, hunting expeditions, tournaments, and other court functions.[33] The blade of the sword was made of steel, often decorated with gilt inscriptions praising the owner as the "father of the poor and the miserable, killer of the unbelievers and the polytheists, reviver of justice among all" and concluding with the standard phrase "may his victory be glorious" (see no. 42).

The importance given to arms is further confirmed by the offices assigned to various weapon-bearers and the use of weapons on blazons. The *silahdar* (sword-bearer), one of the most important officials in the Mamluk court, used the representation of the sword in his blazon. The bow identified the *bunduqdar* (bowman); the ax was used by the

tabardar (ax-bearer or halberdier); and the mace was assigned to the *jumaqdar* (mace-bearer). Mamluk weapons have not been properly studied and only one of the late-fifteenth-century axes containing a composite blazon has been thoroughly published.[34]

The insignia of the sultans and officers were used on their banners, standards, and shields as well as on arms and armor, blankets, baggage, and tents (see no. 124). Although no banners have survived, the existing standards (see no. 43) show that victorious benedictions, Koranic phrases, and blazons were frequently employed. One of the earliest standards bears the name of Barquq,[35] while a great many date from the end of the fifteenth century. Also dating from the end of the fifteenth century is a shield with composite blazons; it is one of the extremely few surviving examples.[36]

The life of the Mamluks was preoccupied with horsemanship and chivalry in both battles and tournaments. It is, therefore, not surprising that they developed such a high technology in the production of arms and armor and an elaborate system of *furusiyya* or military games and tactics (see no. IV).[37]

During military campaigns and ceremonies the sultans and Amirs of Forty had the privilege of being accompanied by their own *tablakhana* (military band), composed of various drums, trumpets, cymbals, and other percussion instruments. The drum with sticks and the trumpet were used as the blazon for members of the *tablakhana*.

Among the surviving drums is a silver inlaid bronze example dedicated to al-Malik al-Nasir, its decorative style suggesting the period of Sultan Hasan.[38] Another drum, also inlaid with silver, bears an inscription with the name al-Malik al-Ashraf, which may refer to Sultan Qaitbay.[39] Inscriptions on Mamluk drums (see no. 40) contain phrases similar to those on swords, indicating that they were a part of military equipment.

The tradition of Mamluk metalwork had a strong impact on the arts of neighboring states. Early Ottoman metalwork shows many shapes and decorative features developed by the Mamluks. Their influence is observed on sixteenth-century Venetian art in a series of buckets, bowls, trays, and handwarmers executed either by Muslim artists who emigrated to Venice or by local metalworkers trained by them.[40] Derived directly from late-fifteenth-century Mamluk art, "Veneto-Islamic" metalwork employs the same techniques and decorative vocabulary found on pieces made during the reign of Sultan Qaitbay.

Mamluk metalwork was also imitated in Ming dynasty ceramics made for export to the Near East. One of the most curious copies is a fifteenth-century blue-and-white porcelain stand found in Damascus.[41] Other blue-and-white Chinese wares imitating Mamluk metalwork include basins, ewers, stemmed cups, jugs, flasks, pen boxes, and lunch boxes.[42]

The tradition of metalwork established during the sultanate of Nasir al-Din Muhammad was revived in the nineteenth century. Two of the most ostentatious pieces frequently reproduced are a large hexagonal table and a box for a thirty-volume Koran, both originally made in the 1320s by Muhammad ibn Sunqur.[43] A pair of these tables, now in the Topkapı Palace Museum, is recorded as having come from the complex built in Gebze around 1520–30 for Çoban Mustafa Paşa. This official served as the governor of Egypt in 1522 and his foundation in Gebze reveals a strong Mamluk influence. The Palace records do not, however, indicate when the tables were installed in the complex. It is possible that some of these late copies, such as the İstanbul pieces, were made in Egypt in the sixteenth century, while others were produced in Egypt or Syria in the nineteenth century.

Although the box was definitely functional (it was originally intended to protect a thirty-volume Koran and was later made into a chest), the purpose of the hexagonal table remains ambiguous. Called a *kursi* (lectern) and thought also to be a Koran case, it is around 80 centimeters ($31\frac{1}{2}$ inches) high and has a diameter of 40 centimeters ($15\frac{3}{4}$ inches); the body is pierced and the interior has a shelf, accessible through a small double door. If it ever served as a Koran box, the manuscript placed on the shelf would have been much smaller than the Korans produced during the fourteenth century. The inscriptions on both the original table and its copies are secular, containing lengthy praises of the sultan. It is more likely that the piece was used as a decorative furnishing and served as a floor lamp, an incense burner, or even as a food warmer.

Notes

1. For metalworkers see Mayer 1959; al-Mawsili artists are discussed in D. S. Rice 1957.
2. London, British Museum 78 12–30 691.
3. The hexagonal table is in Cairo, Museum of Islamic Art, 139 (Cairo 1969, no. 61 with full bibliography); the Koran box is in Berlin, Museum für Islamische Kunst, I 886 (published in several places, including Berlin 1971, no. 19 and fig. 69; London 1976, no. 214).
4. Cairo, Library of al-Azhar Mosque (Cairo 1969, no. 60 and pl. 9).
5. İstanbul, Topkapı Palace Museum, 2/1786 (Mayer 1959, p. 74; Aslanapa 1977, p. 75 and fig. 6).
6. Athens, Benaki Museum (Mayer 1959, p. 38).
7. Cairo, Museum of Islamic Art, 509 (Mayer 1933, p. 186; Mayer 1959, p. 39).
8. East Berlin, Staatliche Museen (Mayer 1959, p. 28). The following should be added to the list of metalworkers: Sad al-Din al-Isirdi, designer of coins under Sultan Aybak; Ali ibn Abu Bakr, who made a candlestick in 1288; Muhammad ibn Yusuf, who made another candlestick in 1340; and Hamid, who made a tray in 1345 (Mayer 1959, pp. 81, 32, 74, and 43, respectively).
9. The ewer is in Paris, Musée des Arts Décoratifs; the candlestick is in Cairo, Museum of Islamic Art, 15127; and the basin is in Paris, Louvre (Mayer 1959, pp. 34–35).
10. The vase is in Florence, National Museum; the ewer and basin are in Tehran, Gulistan Palace Museum (Mayer 1959, pp. 33–34; Pope and Ackerman 1964–67, pp. 2496–98 and pls. 1341–42; see also pls. 1332 and 1334).
11. East Berlin, Staatliche Museen (Kühnel 1939).
12. London, British Museum (D. S. Rice 1957, pp. 325–26).
13. Paris, Louvre, 7428 (Mayer 1959, p. 46; Paris 1971, no. 152; Paris 1977, no. 273).
14. The few published examples of Mamluk jewelry include two gold bracelets, one of which has a sword blazon, and a silver ring with the sign of the *jamdar* (master-of-the-robes). These are in Cairo, Museum of Islamic Art, 14802, 15471, and 16355 (Cairo 1969, nos. 20 and 22, pl. 2b). A number of bracelets are also in Damascus, National Museum (Damascus 1976, p. 210). The butcher hook, in Paris, Louvre, 7082, was made for Umar in the second half of the fourteenth century (Paris 1977, no. 317).
15. Paris, Louvre, MAO 101 (D. S. Rice 1956; Paris 1971, no. 165; Paris 1977, no. 491; Welch 1979, no. 23).
16. Paris, Louvre, 5005 (Paris 1971, no. 166; Paris 1977, no. 101).
17. Athens, Benaki Museum (D. S. Rice 1952).
18. London, British Museum 1960 2-15 1 (London 1976, no. 228).
19. Basin is in Cairo, Museum of Islamic Art, 15921 (Cairo 1969, no. 76); the jug is in the same collection, 15126 (D. S. Rice 1953a; Cairo 1969, no. 68; London 1976, no. 221).
20. Cairo, Museum of Islamic Art, 15115 and 15169 (Izzi 1974, figs. 2–6).
21. Paris, Louvre, 7438 (D. S. Rice 1953a; Paris 1971, no. 169).
22. Cairo, Museum of Islamic Art, 4461 (Cairo 1969, no. 80 and pls. 16a–b; London 1976, no. 224).
23. For a ewer and two chandeliers see Wiet 1932, pp. 5, 25, 113, and 275; app. nos. 271 and 278–79, and pl. XXIV. The tray is in London, British Museum, 66 12–29 60.
24. İstanbul, Topkapı Palace Museum, 2/2160 (Mayer 1959, p. 83 and pl. XIV).
25. Mayer 1959, pp. 43 and 70.
26. İstanbul, Museum of Turkish and Islamic Arts (Güvemli and Kerametli 1974, p. 48). For other objects bearing Qaitbay's name see Wiet 1932, app. nos. 355–77; Melekian-Chirvani 1969.
27. London, Victoria and Albert Museum, 762–1900 (Mayer 1959, p. 27; D. S. Rice 1953a, pl. VI).
28. Mayer 1959, pp. 30 and 80, pl. XII. See also Allan 1969 and 1971 for trays and lunch boxes made in the same style.
29. Meinecke 1972 and 1974.
30. D. S. Rice 1952.
31. Several Mamluk helmets and other arms and armor are published in H. R. Robinson 1967, pls. IX-XII.
32. Florence, National Museum (Mayer 1952, pl. X).
33. A. Zaki 1966.
34. Nickel 1972.
35. İstanbul, Topkapı Palace Museum (Mayer 1952, p. 103).
36. Kalus 1975.
37. Ayalon 1961; see also Ayalon 1977 and 1978.
38. Berlin, Museum für Islamische Kunst, I 10162 (Berlin 1965, no. 46). Another silver inlaid drum is in London, British Museum, 1966 10–19 1.
39. Paris, Louvre, 3780 (Paris 1977, no. 422).
40. Among the artists working in Venice were Ala al-Din al-Birjandi, Muhammad Badr, Mahmud al-Kurdi, Muhammad, Qasim, Umar, and Zayn al-Din (Mayer 1959, pp. 31–32, 56–58, 63–64, 67, 78, 87, and 91, pl. XV; Atıl 1975, no. 79).
41. London, British Museum, 1966 12–15 1 (Carswell 1966).
42. See Gray 1940 and Carswell 1972b. One of the Ming dynasty ceramics imitated an Ayyubid canteen. Both pieces are in Washington, D.C., Freer gallery of Art, 58.2 and 41.10 (Pope 1959; Atıl 1975, no. 28).
43. A Koran box and a pair of hexagonal tables are in İstanbul, Topkapı Palace Museum, 21/729 (Çığ 1978). Another table is in Damascus, Azem Palace Museum, and a fourth example is in Philadelphia, University Museum (Dam 1928). The Semitic Museum, Cambridge, Mass., also owns a Koran box and a hexagonal table. A number of these tables are currently on the market.

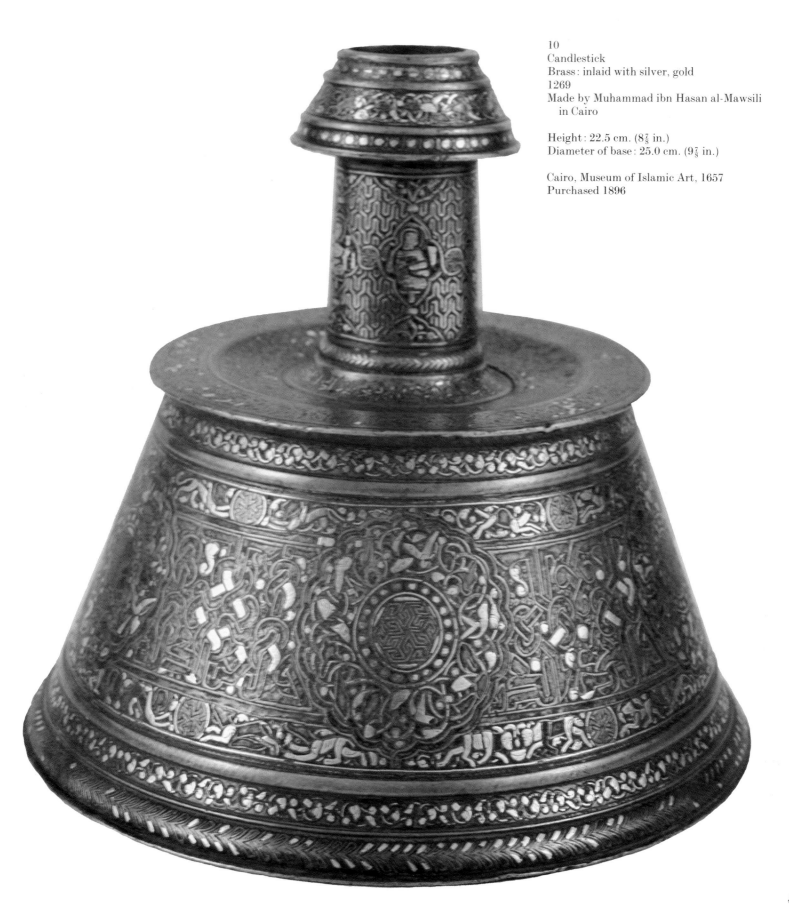

10
Candlestick
Brass: inlaid with silver, gold
1269
Made by Muhammad ibn Hasan al-Mawsili
 in Cairo

Height: 22.5 cm. (8⅞ in.)
Diameter of base: 25.0 cm. (9⅝ in.)

Cairo, Museum of Islamic Art, 1657
Purchased 1896

Inscriptions
Band on shoulder:

نقش محمد بن حسن الموصلى رحمه الله تعالى عمل بمصر
المحروسه فى سنة ثمان وستين وسبعائه هجريه له العز والبقاء

Engraved by Muhammad ibn Hasan al-Mawsili,
may God have mercy upon him. Made in Misr,
the protected, in the year six hundred and sixty
and eight Hijra [A.D. 1269]. To [the owner] glory
and long life.

This squat candlestick is the earliest dated
example of metalwork made under Mamluk rule in
Cairo. It is adorned with bands and medallions
filled with animal and human figures, inscriptions,
geometric motifs, and floral arabesques
reminiscent of Ayyubid metalwork. The socket
has a floral scroll framed above and below by a
beaded band. The neck is covered with
latticework filled with geometric motifs,
arabesques, and seated figures. The figures in the
five central quatrefoils hold tambourines, lutes,
and cymbals. Between the quatrefoils are small
roundels decorated with strapwork.

A chevron ring joins the neck and shoulders.
The shoulder has three concentric bands: the
inner band bears the inscription giving the date,
name of the maker, and place of execution; the
central one is filled with plaited kufic; and the
outer one has a frieze of running animals
interrupted by six strapwork roundels. Each unit
of this band has three quadrupeds running to the
left, in the same direction of the script.

The main portion of the body contains a plaited
kufic band interrupted by five polylobed
medallions. The core of these medallions has a
beaded band enclosing a geometric design
radiating from a six-pointed star; framing this
band is a floral arabesque with heads of real and
fantastic creatures. Animals appear in the two
narrow horizontal bands encircling the central
portion: at the top, separated by strapwork
roundels, pairs of quadrupeds face each other; at
the bottom, placed between the roundels, are two
pairs of confronted animals. A plain ring, followed
by a floral scroll, encircles the top and bottom
bands. The foot has a chevron ring identical to the
one seen at the base of the neck.

A significant portion of the silver inlay has
disappeared; the gold inlay, used only in the
strapwork roundels and in the core of the large
medallions, is mostly intact.

The most remarkable feature of the candlestick
are the extremely well-rendered figural
compositions: the musicians on the neck,
quadrupeds on the shoulder and body, and animal
heads. Even though the proportions of the piece
are rather awkward, the style of execution
forms a link between late Ayyubid and early
Mamluk art.[1]

The artist, who calls himself *naqqash* (decorator,
designer, or engraver), has added the *nisba*
al-Mawsili (from Mosul) after his name. This *nisba*
was used in the Ayyubid period to designate a
group of metalworkers who associated themselves
with the famous workshops of Mosul, which
flourished in the first half of the thirteenth
century. It is difficult to determine whether the
maker of this candlestick (or his family) actually
came from Mosul or whether the artist was using
the name of that city to identify the style of his
work. Metalwork signed by al-Mawsili artists is
distinguished by impeccable technique with
elaborate compositions employing a rich
repertoire of inscriptions, geometric and floral
arabesques, and, most significantly, figural
compositions. Muhammad appears to have been
quite proud of his work, as is evident from the use
of the word *naqqash*, which frequently occurs on
metalwork made by al-Mawsili artists, although it
is more appropriately used on manuscript
illumination and illustration. He may have used
al-Mawsili in the same spirit, attempting to
associate his work with the renowned figural style
of Mosul.

In addition to the illustrated candlestick,
several other early Mamluk pieces signed by
al-Mawsili artists were produced in Cairo,
including a ewer made in 1275 by Ali ibn Husein
ibn Muhammad for Yusuf (1250–95), Rasulid
sultan of Yemen (see also no. 14);[2] an exquisite
candlestick made in 1282 by the same artist;[3] a
basin made in 1282 by Ali ibn Husein;[4] and a large
tray (no. 22) made for the Rasulid sultan Dawud
(1296–1322) by Ahmad ibn Husein al-Mawsili.

Incised inside the body is the name of al-Sayyid
Ismail ibn Muhammad, who must have owned this
candlestick at a later date.

Published
Répertoire, vol. 12, no. 4609.
Migeon 1900, p. 26.
Berchem 1904, p. 22.
Herz 1906, pp. 182–83, no. 9 and fig. 34.
Herz 1907, pp. 170–71, no. 9 and fig. 33.
Wiet 1932, no. 1657, app. no. 81 and pl. XXVII.
Wiet 1932a, p. 79.
Kratchkovskaya 1935, p. 197.
Kühnel 1939, p. 11, no. 16.
Taymur 1942, pp. 111, 211, note 388.
Lamm 1952–54, p. 89 and fig. 9.
Hasan Abd al-Wahhab 1955, p. 556.
D. S. Rice 1955, p. 206, no. 5.
D. S. Rice 1957, p. 325, note 19, p. 326, no. 18.
Mayer 1959, pp. 68–69.

Notes
1. A candlestick with an identical shape but slightly different
 decoration is in Naples, Duca di Martina (Naples 1967, no. 11
 and fig. 7).
2. Paris, Musée des Arts Décoratifs (Wiet 1932, p. 48, no. 9).
3. Cairo, Museum of Islamic Art, 15127 (Wiet 1932, p. 48, no. 10
 and p. 185, no. 94; Wiet 1932a, p. 79 and pl. XIII).
4. Paris, Louvre (Mayer 1959, pp. 34–35).

11
Pierced globe
Brass; inlaid with silver
Circa 1270
Made for Badr al-Din Baysari

Diameter: 18.4 cm. (7¼ in.)

London, The British Museum, 78 12-30 682
Henderson Bequest, 1878

Inscriptions
Band at apex:

بدر الدين بيسرى الظاهرى السعيدى الشمسى المنصورى البدرى

Badr al-Din Baysari, [officer] of al-Zahir
al-Said, al-Shamsi al-Mansuri al-Badri.

Band on rim of upper hemisphere:

مما عمل برسم المقر الكريم العالى المولوى الاميرى الكبيرى
المحترمى المخدومى اسفهسلارى المجاهدى المرابطى المثاغرى
المؤيدى المظفرى

One of the things made for the honorable
excellency, the sublime master, the great amir,
the revered, the masterful, the chief of the armies,
the defender [of the faith], the warrior [of the
frontiers], the protector [of the frontiers],
the supporter [of Islam], the victorious.

Band on rim of lower hemisphere: Identical to
that at rim of upper hemisphere, except that
the seventh word المولوى (the master) is
omitted.

Band at base: Identical to that at apex, except
that the phrase عز نصره (may his victory be
glorious) is inserted between the names
al-Shamsi and al-Mansuri.

This pierced globe, constructed of two identical
hemispheres joined by a bayonet fitting, is empty
and lacks the coal pot and gimbals commonly
found in globular handwarmers and incense
burners. The size is unusually large for a
handwarmer, and the loop at the apex suggests
that it was suspended. The piece—most likely
used as a hanging ornament—was possibly filled
with incense, the fumes of which escaped through
the holes.

Each hemisphere is divided into four concentric
zones: the rim or widest ring in the middle has an
inscription band on a floral arabesque; the next
zone has five large pierced medallions representing
a double-headed eagle; the units between the
medallions are filled with floral scrolls and have a
central roundel decorated with geometric motifs
radiating from a six-pointed star (see also no. 10).
Another inscription band on a floral arabesque
appears at the top, while medallions at the apex
and base are pierced and adorned with an
arabesque formed by five double-headed eagles
and lion-headed masks. Continuous strips of silver

encircle the inscription bands and loop around the pierced medallions, unifying the diverse segments of the piece.

The silver inlay applied to the globe is completely intact. The only units not inlaid are the geometric roundels between the five large pierced medallions, the designs of which are engraved on brass. Roundels filled with geometric motifs were often inlaid with gold to accentuate the composition (see, for example, nos. 10, 13–16, 18–19, and 23–24). A similar effect is created on this globe by leaving these roundels in brass, which appear "golden" when polished.

The piece was made for Badr al-Din Baysari, one of the important Syrian amirs in the early Mamluk period. Originally employed by the last Ayyubid sultan, Baysari entered the service of the Mamluks after the Ayyubids were overthrown. The inscription on the globe refers to two of his Mamluk masters: al-Zahir (Baybars I, 1260–77) and al-Said (Baraka Khan, 1277–79). This powerful amir was twice offered the Mamluk

throne, which he refused, preferring to remain an officer. He was imprisoned by Qalawun but reinstated by the next sultan, Khalil, under whom he served as Amir of One Hundred. Badr al-Din Baysari died in 1298 and was buried in Cairo.

The double-headed eagle, a popular motif adopted as a blazon by several Mamluk sultans, was used in Syria and Anatolia during the twelfth century as an imperial symbol and ornamental motif (see also no. 12). Its use on the globe is purely decorative and does not constitute a heraldic emblem.

Published
Lane-Poole 1886, pp. 209–13 and fig. 81 (small format);
 pp. 174–77 and fig. 81 (large format).
Migeon 1907, vol. 2. p. 204 and fig. 160.
Migeon 1927, vol. 2. p. 70 and fig. 249.
Wiet 1932, app. no. 87.
Mayer 1933, p. 112.
Barrett 1949, pp. xiv–xv and xxiii and pl. 22.
London 1976, no. 210.

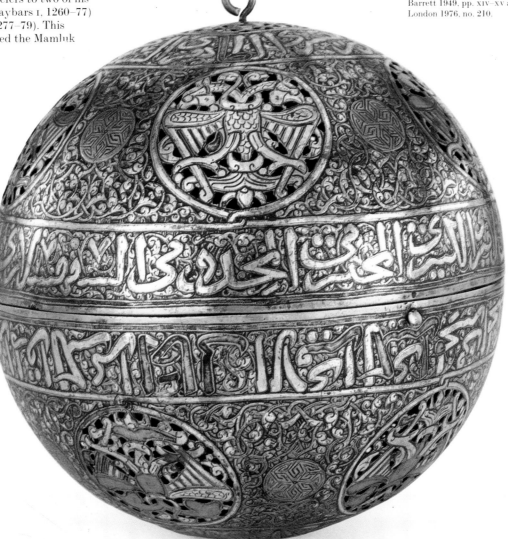

12
Incense burner
Brass: inlaid with silver
Second half 13th century

Height: 17.0 cm. (6¹¹⁄₁₆ in.)
Diameter of base: 8.6 cm. (3⅜ in.)

Cairo, Museum of Islamic Art, 15107
Purchased 1945
Ex-Harari Collection, 168

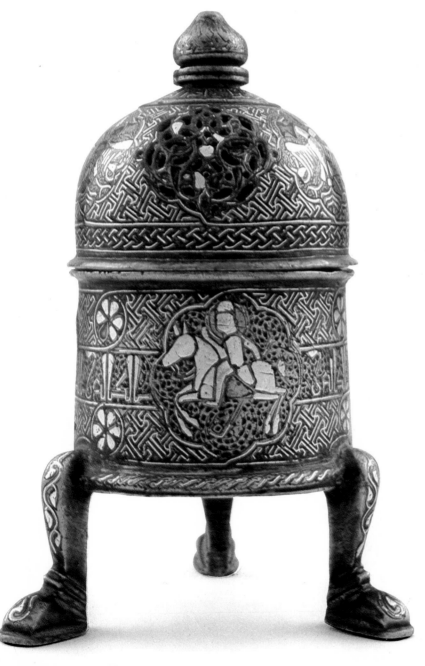

Inscriptions
Band at apex of lid:

العز الدائم والعمر السالم والاقبال الزائد لصاحبه

Eternal glory and safe life and increasing prosperity to the owner.

Three panels on body (repeated 3½ times):
العز الدائم *Eternal glory.*

The most popular shape and possibly the most functional luxury object in Islamic metalwork is the incense burner with domical lid surmounted by a knob attached by hinges to a cylindrical body resting on three legs with rounded feet.[1] The shape, which can be traced to the Coptic period, also appears in Byzantine art; similar examples were made in Iran as early as the eleventh century.

This incense burner, which lacks its original handle, has a domical lid divided into three concentric zones. An inscription band appears at the apex and a braid encircles the lower edge. The wide panel in the center is decorated with six large medallions placed on a geometric ground composed of T-fret patterns. Three medallions have pierced arabesques and alternate with those representing a double-headed eagle, the tips of its outstretched wings terminating in animal heads.

The body also reveals a tripartite composition and T-fret pattern. It contains three large medallions connected with kufic bands. Six-petaled rosettes appear in the center of the units above and below the inscriptions. One of the large medallions is bare, indicating where the original handle was attached. The remaining two medallions represent riders galloping to the left, placed against a floral scroll ground. The chevron ring at the base is interrupted by three bold legs firmly planted on large pawlike feet; scrolls with leaves adorn the legs and feet. The lid and body are outlined by continuous strips of silver that loop around the medallions and rosettes, linking them with the horizontal bands.

The double-headed eagle on this piece was most likely used as a decorative element and not as a heraldic emblem, similar to its representation on the previous example (no. 11). The six-petaled rosette, thought to be a symbol of royalty employed by the Ayyubids and the house of Qalawun, should also be considered as a decorative motif since the inscriptions lack any reference to an imperial patron.

This piece belongs to a group of early Mamluk metalwork that relies on themes—such as medallions with riders, overall T-fret patterns, chevrons, and braided bands—developed in the Ayyubid period. One of the comparative examples was produced in 1243/44 and is attributed to Mosul;[2] another, dated late thirteenth or early fourteenth century, is assigned to Syria.[3] The Cairo incense burner is stylistically between the two and should be dated second half of the thirteenth century.

This type of incense burner found its ultimate expression several generations later. One of the renowned examples, representing lively riders, was found in 1966 at Qus in upper Egypt.[4] The most spectacular incense burners were made for Sultan Nasir al-Din Muhammad (1293–1341, with interruption) and were lavishly inlaid with silver and gold.[5]

Published
Aga-Oglu 1945, pp. 32–33 and fig. 7.
Pope and Ackerman 1964–67, vol. 12, pl. 1338c.

Notes
1. For a detailed discussion of this type see Aga-Oglu 1945.
2. London, British Museum, 678–1878 (Aga-Oglu 1945, p. 32, fig. 6; Barrett 1949, fig. 15c).
3. New York, Metropolitan Museum of Art, 17.190.1716 (Aga-Oglu 1945, p. 37, fig. 13).
4. Cairo, Museum of Islamic Art, 24078 (El-Emary 1966, pp. 123–27 and pls. XIX–XX).
5. There seem to be three of these incense burners. The first, formerly on loan to the Victoria and Albert Museum, London, is now in a private collection (published in a number of places, including Ross 1931, pl. 317; Wiet 1932, app. no. 185; Aga-Oglu 1945, p. 37, fig. 14). Aga-Oglu mentions two other examples, one of which was in the Rothschild Collection (Aga-Oglu 1945, pp. 204 and 206, nos. 195 and 202).

13
Pen box
Brass: inlaid with silver, gold, niello
1281
Made by Mahmud ibn Sunqur

Height: 3.2 cm. (1¼ in.)
Length: 19.7 cm. (7¾ in.)
Width: 4.3 cm. (1¹¹⁄₁₆ in.)

London, The British Museum, 91 6-23 5
Purchased 1891
Ex-Rhode-Hawkins Collection

Inscriptions
Under hasp:

عمل محمود بن سنقر فى سنة ثمانين وستمائه

Work of Mahmud ibn Sunqur in the year six-hundred and eighty [A.D. 1281].

This small and exquisitely detailed pen box is constructed in two parts: the lid is attached to the body by two hinges at the back and fastened by a frontal hasp; the hinges and hasp have filigree designs and silver studs. With the exception of the missing inkpot, the piece is intact and in an excellent state of preservation.

The upper surface of the lid has three large medallions, each encompassing four roundels bearing symbols of the zodiac together with the signs of the planets in whose domiciles they fall. The medallions contain (beginning with the roundel on the far right and moving counterclock-wise): 1 Aries with Mars (ram with warrior holding a severed head), Taurus with Venus (bull with lute-player), Gemini with Mercury (only one of the twins is shown; the man on the left holds a scroll),

and Cancer with the moon (crab and figure with a crescent); 2 Leo with the sun (lion and radiating disc), Virgo and Mercury (one figure holding an ear of corn and another reaping grain), Libra with Venus (balance and figure with a lyre), and Scorpio with Mars (figure holding scorpions); 3 Sagittarius and Jupiter (fused together as an archer), Capricorn with Saturn (goat with figure carrying a sickle), Aquarius and Saturn (fused as an old man holding a pickax at a well), and Pisces and Jupiter (figure with a fish and a ewer [?]).

The zones between the medallions are filled with a fantastic arabesque scroll containing the heads, torsos, and bodies of diverse animals. In the center of each zone is a lobed floral cartouche; on its four corners are roundels filled with geometric motifs radiating from a tiny bead.

The underside of the lid contains seven medallions within an oval cartouche. With the exception of the one in the center, each medallion depicts a seated figure symbolizing a planet and holding its attributes. Beginning on the right, they represent: Saturn (sickle and fruit), Jupiter (ewer or bottle), Mars (helmeted figure with sword and severed head), the sun (face enclosed by radiating disc), Venus (lute-player), Mercury (scribe with pen and scroll), and the moon (figure holding crescent).

The outer sides of the body have a floral scroll containing heads and torsos of long-eared animals, similar to that on the sides of the lid. The scroll is interrupted by five cartouches representing dancers, drinkers, and musicians; arabesques fill the cartouches placed around the hinges and the hasp. The name of the artist and the date are written in the square panel in the front, which is hidden under the hasp when the lid is closed.

Inserted at the bottom of the pen unit is a filigree plate decorated with a floral arabesque with animal heads. The inner sides of this unit bear a similar design, broken by four small medallions, each representing a musician holding a lute, tambourine, lyre, or flute. The inkpot was obviously detachable and has been removed.

A most beautiful decoration appears at the bottom of the case, which has three large medallions adorned with geometric motifs. The two units between the medallions represent four riders: one of them portrays a pair of warriors bearing lances, while the other depicts a couple of hunters confronted by a rabbit, lion, goose (?), and two intertwined dragons. The ground of these units is filled with an arabesque scroll bearing fantastic creatures. A floral border including flying cranes appears around the edge, accentuated by six geometric roundels.

The pen box with its rich composition is impeccably executed, lavishly inlaid with silver and gold, enhanced with niello. Gold accents the turbans and boots of the figures, appears in the geometric roundels, and highlights the arabesques.

Published
Répertoire, vol. 13, no. 4803.
Berchem 1904, p. 38.
Pedersen 1928, p. 107.
Christie 1931, p. 119 and fig. 20.
Wiet 1932, app. no. 93.
Hartner 1938, p. 136 and figs. 13–15.
Briggs 1940, p. 35.
Aga-Oglu 1945, p. 37, note 83, p. 43, note 135.
Barrett 1949, pp. xviii and xxiv and pls. 32–33.
M. H. Zaki 1956, no. 494 and fig. 494.
Mayer 1959, p. 60.
Pope and Ackerman 1964–67, vol. 6, p. 2521, no. 13; vol. 13, pls. 1336A-B.
Baer 1973–74, fig. 31 and p. 45.
Hartner 1973–74, pp. 109–12 and figs. 4–5.
London 1976, no. 202.

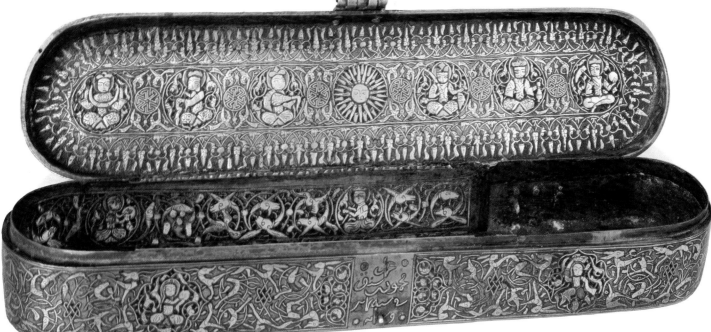

14
Tray
Brass: inlaid with silver
Circa 1290
Made for Yusuf, Rasulid sultan of Yemen

Height: 8.0 cm. (3⅛ in.)
Diameter: 55.5 cm. (21⅞ in.)

Cairo, Museum of Islamic Art, 15153
Purchased 1945
Ex-Harari Collection, 12

Inscriptions
Band on rim:

العز الدائم العمر السالم والاقبال الزائد والدولة الباقية السلامة
الكاملة الامر النافذ والدولة الباقية السلامة الكاملة الامر النافذ
والخير القادم الكرامة الكاملة الراحة العالية والدولة والامر النافذ
والغالب الكاملة الكرامة والاجر الزائد والغالب والاقبال الزائد
والدولة السائدة والسلامة والكاملة والعمر السالم والامر النافذ
والجد الصاعد والعالى والكرامة السعد الغالب والامر النافذ والجد
الصاعد والدين المساعد والكرامة له والعافية الامر النافذ والدوام
العالية والدوام لصاحبه

*Eternal glory, safe life and increasing prosperity
and enduring state, perfect safety, long-lasting
command and enduring state, perfect safety, long-
lasting command and advancing riches, perfect
honor, tranquility, exaltation and wealth and long-
lasting command and victory and perfection and
honor and increasing rewards and victory and
increasing prosperity and happy state and perfect
safety and safe life and long-lasting command and
growing fortune and sublimity and happy honor,
victory, and long-lasting command and growing
fortune and happiest rewards and honor to him and
health, long-lasting command and sublime
honor and perpetuity to the owner.*

Twelve panels on walls:

عز لمولانا السلطان الملك * المظفر العالم العامل *
العادل.الغازى المجاهد ا * لمرابط المؤيد المظفر المنصور *
سلطان الاسلام * قاهر الخوارج وا *
لمتمردين قاتل الكفره والمشركين * محى العدل فى العالمين حامى *
حوزه الدين يد الملوك وال * سلاطين حامل السيف *
والعلم المؤيد العالم وا * لعلم الملك المظفر يوسف بن عمر

*Glory to our master, the sultan al-Malik
al-Muzaffar, the learned; the efficient, the just, the
champion [of Islam], the defender [of the faith],
the warrior [of the frontiers], the supporter [of
Islam], the victorious, the triumphant, sultan of
Islam, conqueror of the heretics and the rebellious,
killer of the infidels and the polytheists, reviver of
justice among all, protector [and] preserver of
religion, [right] hand of the kings and the sultans,
bearer of the sword and the knowledge, the
supporter of the learned and the knowledge,
al-Malik al-Muzaffar Yusuf ibn Umar.*

Six panels on inside:

المقر العالى المولوى * الاميرى الكبيرى * السيدى السندى المالكى *
الذخرى الغياثى * الحمامى العونى * المشيرى دام عزه

*The sublime excellency, the master, the great amir,
the wise, the royal supporter, the upholder of the
needy, the heroic defender, the counselor, may his
glory be eternal.*

Sultan Yusuf (1250–95), second Rasulid ruler of
Yemen, must have been a devotee of Mamluk art
as there exist several other pieces of metalwork
that bear his name.[1] The only dated and signed
example is a ewer made in 1275 in Cairo by Ali ibn
Husein ibn Muhammad al-Mawsili.[2] This sultan
also ordered a candlestick, a brazier, and five
trays, one of which is illustrated here.[3]

Four concentric rings of varying width divide
the tray. The innermost zone has a central
medallion representing a radiating disc with a
lion, symbolizing the sun with Leo (see also nos.
13 and 16). Surrounding medallions enclose six
figures holding symbols of the planets: the moon
(crescent), Mercury (scroll and pen), Saturn (sickle
and fruit [?]), Venus (lute), Mars (sword and
severed head), and Jupiter (bucket or well).

The next ring consists of a band adorned with
fifteen quadrupeds running clockwise and divided
into three equal units by roundels filled with
geometric motifs.

The third ring is the widest and contains six
large medallions representing hunters or couples
participating in courtly entertainment. The
hunters are mounted, their horses facing right
while the figures themselves turn back; they spear
a lion attacking the rump of the horse, shoot at a
gazelle with a bow and arrow, or carry a hawk.
The alternating medallions depict couples placed
on benches; they play a flute and a tambourine,
dance to the accompaniment of a lyre, or hold
beakers. The interstices are subdivided into three
units: in the middle is an inscription panel; the
upper and lower sections contain roundels
depicting a hawk attacking a bird.

The fourth ring repeats the second but depicts
twice as many animals; geometric roundels break
this panel into six parts, each with five
quadrupeds running clockwise. The animals in
both rings include lions, foxes, hares, gazelles,
bears, bulls, sphinxes, and a solitary elephant.

The shallow cavetto or inner walls of the tray
bears a lengthy inscription divided into twelve
parts by five-petaled rosettes, the heraldic emblem
of the Rasulid dynasty.

The everted rim is decorated with two bands:
the inner band contains a continuous inscription,
and the outer one has a beaded band.

Continuous thin ribbons encircle the concentric
zones and loop around the medallions and
roundels, unifying the diverse segments of the
piece. The background is filled with two types of
floral designs: a dense overall arabesque and a
spiral scroll.

The piece has suffered considerably through
time and abuse, and almost all of the silver inlay
has disappeared.

The decorative and figural themes follow the
style developed during the first half of the
thirteenth century under Ayyubid rule. Models of
astrological symbols and princely themes must
have been readily available to the Mamluk artists.

Published
Wiet 1932, p. 71, no. 9.

Notes
1. Rasulid pieces are published in Berchem 1904; Dimand 1928,
 p. 107, fig. 8; Dimand 1931. For objects bearing Sultan
 Yusuf's name see also Wiet 1932, p. 76.
2. Paris, Musée des Arts Décoratifs (Wiet 1932, p. 48, no. 9;
 Dimand 1944, p. 151).
3. The candlestick is in Lyons, Musée des Beaux-Arts, D. 569
 (Melekian-Chirvani 1970, fig. 1). The brazier is in New York,
 Metropolitan Museum of Art, 91.1.540 (Dimand 1931,
 pp. 229–30, 236, fig. 1; Dimand 1944, p. 151, fig. 90). Trays,
 not illustrated in the text, are owned by Cairo, Museum of
 Islamic Art, 3155 (Wiet 1932, pp. 69–76, pl. XLVIII) and 4022
 (Wiet 1932, pp. 103–4 with earlier references, and pl. XLVII;
 Cairo 1969, no. 54). Two other trays are in Paris, Louvre and
 Vasselot Collection (Wiet 1932, p. 76).

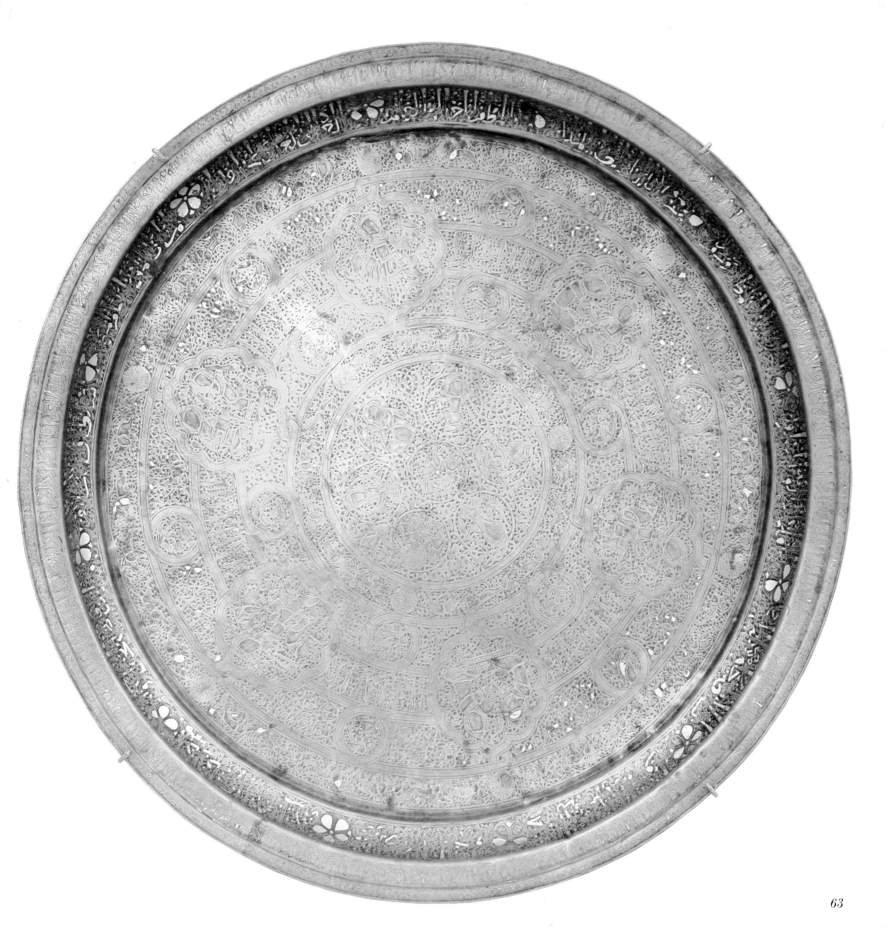

15
Socket and neck of candlestick
Brass: inlaid with silver, gold
Circa 1290
Made for Zayn al-Din Kitbugha

Height: 14.5 cm. (5$\frac{11}{16}$ in.)
Diameter of lip: 8.5 cm. (3$\frac{5}{16}$ in.)

Cairo, Museum of Islamic Art, 4463
Purchased 1917

Inscriptions
Three panels on socket:

مما عمل برسم طشتخاناه المقر ١ * لعالى المولوى الزينى زين ١ *
لدين كتبغا المنصورى الاشرفى

*One of the things made for [the] storeroom
[or pantry] of the sublime excellency, the master,
al-Zayni Zayn al-Din Kitbugha, [officer] of
al-Mansur al-Ashraf.*

Band on neck:

العز والبقا والظفر بالاعداء
Glory and long life and triumph over enemies.

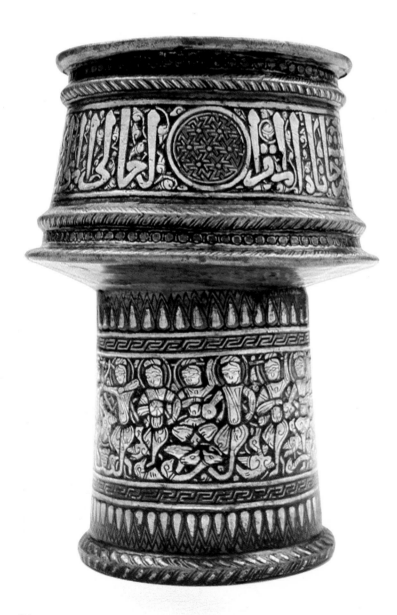

This socket and neck unit belong to the famous
candlestick made for Zayn al-Din Kitbugha while
he was an officer in the service of Sultan al-Mansur
al-Ashraf Khalil (1290–93). Although Kitbugha,
who ascended the throne in 1294, was deposed in
1296 by an amir named Lajin, he continued to
hold important posts until his death in 1303.
His name appears in three other inscriptions, all
of which predate his sultanate, as indicated by
the honorific titles used in the text.[1]

Since candlesticks were generally made in two
sections soldered together, the upper portion with
the neck and socket frequently broke off from the
base. The socket and neck unit of this candlestick
must have become detached before 1917, at which
date it was acquired by the Museum of Islamic
Art in Cairo. The base (no. 16) is now in the
Walters Art Gallery in Baltimore.

The socket is adorned with two pairs of rings
placed at the rim and base: the ring at the lip is
decorated with an arabesque scroll, while the
others are embellished with chevron patterns.
The recessed bands between the rings have beaded
designs. The wide central portion of the socket
contains an inscription broken into three parts by
roundels filled with geometric motifs radiating
from a series of minute dots. A loose floral scroll
forms the background of the inscription.

The neck, which terminates in a chevron ring,
has two identical bands placed above and below
the center. The outer band is decorated with
lancet leaves and the inner contains a meander
pattern. The wide central portion has an
exquisitely rendered animated inscription with
sixteen human figures intermingled with ducks
and birds. Their torsos and arms form the shafts
of the letters, their legs are transformed into
scrolls terminating with the heads of lions,
gazelles, and humans. The figures hold an
assortment of objects, including arrows, spears,
shields, ewers, and possibly, a tray. A halo
surrounds each turbaned head. This unit, cast as a
single piece, is lavishly inlaid with silver. Gold is
applied to the geometric roundels of the socket
and to the meander pattern bands of the neck.

Animated inscriptions were highly developed in
the late Ayyubid period, the most outstanding
example found on a canteen, dated around 1250 in
the Freer Gallery of Art in Washington, D.C.[2]
This particular style of writing continued to be
practiced in the Mamluk period (see also no. 18).

Published
Comité 1922, p. 509.
Wiet 1930, pl. 44.
Wiet 1932, no. 4463 and pls. XXIV and cover.
M. H. Zaki 1948, p. 556 and fig. 453.
Mostafa 1961, p. 29 and fig. 43.
Melekian-Chirvani 1970, pp. 48–49.

Notes
1. Wiet 1932, p. 126.
2. Atıl 1975, no. 28.

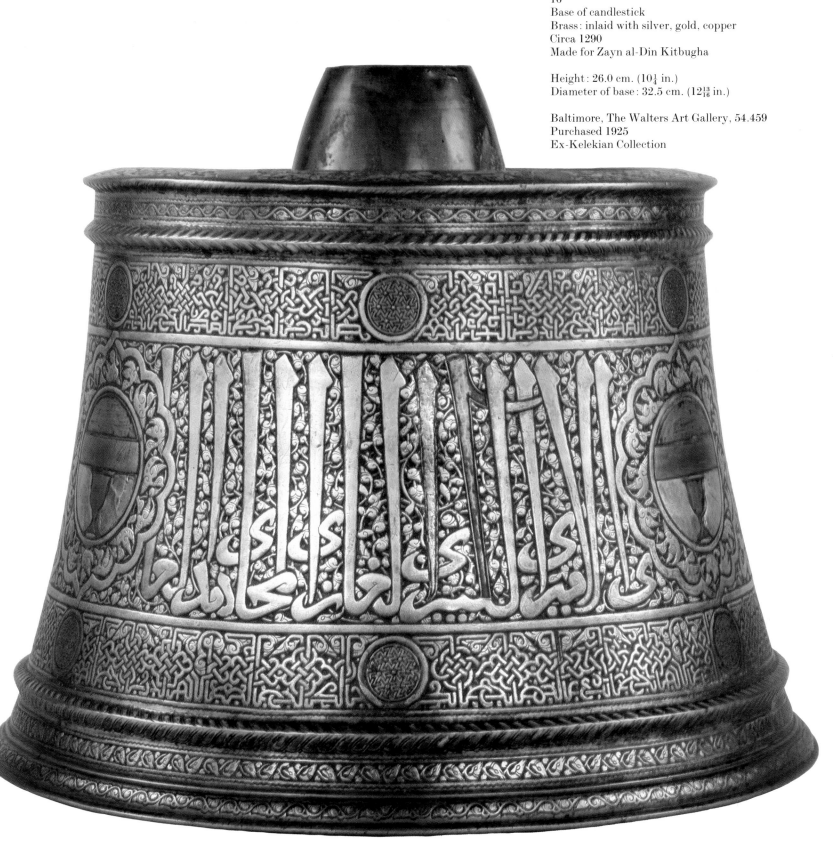

16
Base of candlestick
Brass: inlaid with silver, gold, copper
Circa 1290
Made for Zayn al-Din Kitbugha

Height: 26.0 cm. (10¼ in.)
Diameter of base: 32.5 cm. (12¹³⁄₁₆ in.)

Baltimore, The Walters Art Gallery, 54.459
Purchased 1925
Ex-Kelekian Collection

Inscriptions
Three panels on body:

مما عمل برسم طشتخاناه المقر العالى المولو *

ى الاميرى الكبيرى الغازى المجاهدى العا *

دلى الزينى زين الدين كتبغا المنصورى الاشرفى

One of the things made for [the] storeroom [or pantry] of the sublime excellency, the master, the great amir, the champion [of Islam], the defender [of the faith], the just, al-Zayni Zayn al-Din Kitbugha, [officer] of al-Mansur al-Ashraf.

The base of Amir Kitbugha's candlestick is just as exquisitely decorated as the socket and neck. It employs a richer decorative repertoire, including astrological symbols, bands of running animals, and heraldic emblems.

The inclusion of blazons on the piece helps to confirm the date proposed for the top section (no. 15). The rounded shields enclose a bar placed over a stemmed cup, indicating that the owner was the *saqi* of the sultan. Kitbugha was known to

have held that office before ascending the throne. Although the *saqi* blazon was used by Kitbugha after he began his sultanate, the inscriptions on the candlestick do not refer to the owner as a sultan. The choice of honorifics reinforces the fact that the piece was commissioned while Kitbugha was serving Sultan Khalil (1290–93).

The shoulder of the candlestick has an outer band with a frieze of eighteen quadrupeds divided into six panels by roundels with geometric motifs

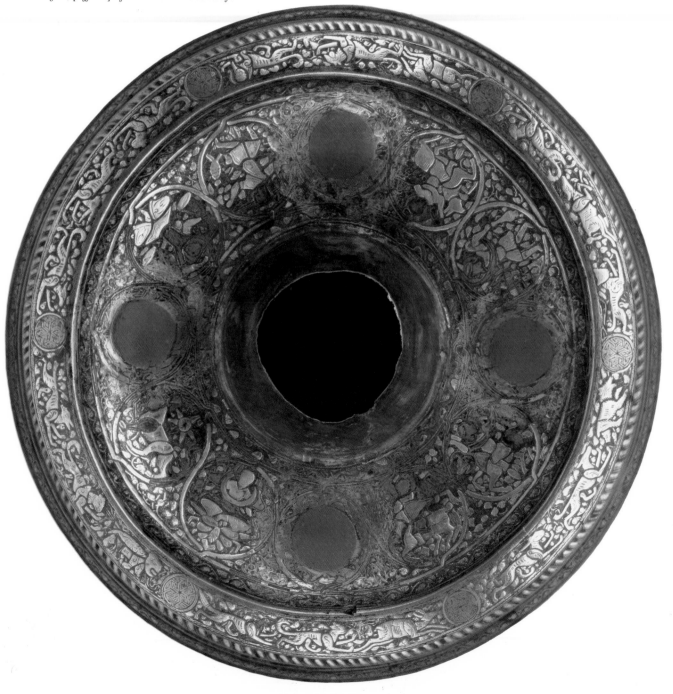

radiating from six-pointed stars (see no. 11). The animals—including cheetahs, bulls, lions, bears, foxes, hares, gazelles, and a solitary elephant—are depicted running counterclockwise. The inner band contains twelve roundels, each of which originally represented one of the constellations of the zodiac together with the associated planets (see nos. 13–14). Four of the medallions have been damaged and are now covered with copper plugs, which obliterate the compositions. Surviving medallions show Aries with Mars (ram with warrior holding sword and severed head), Taurus with Venus (bull and lute-player), Gemini (?), Cancer with the moon (crab with figure holding crescent), Leo with the sun (lion with radiating disc), Virgo (?), Libra (figure holding balance), Scorpio (figure holding scorpions), Sagittarius (?), Capricorn with Saturn (goat with figure holding sickle and fruit), Aquarius (figure at well holding jar), and Pisces (?). Floral arabesques appear behind the figures and fill the zones between the medallions.

The body has a pair of chevron rings at the top and bottom, which enclose a recessed scroll composed of the heads of gazellelike animals. The foot contains two additional rings, one of which bears a floral scroll. The wide portion between the rings is divided into three horizontal bands. The narrow upper and lower bands contain foliated and plaited kufic inscriptions, each intersected by six roundels adorned with geometric motifs radiating from a series of dots (see no. 18). The central and main band has a hierarchic thuluth inscription placed on a floral arabesque ground, broken by three large medallions. The medallions are enclosed by scalloped frames with sixteen plump ducks flying in alternating directions. In two of the medallions, the ducks at the top are replaced by a harpy or a griffin. The circular shields in the center of the medallions contain the blazon of the cup-bearer, inlaid in copper and placed on a silver field. This is the only area that employs copper inlay; silver is lavishly used all over the piece; gold is reserved for the roundels with geometric designs, identical to those decorating the socket and neck.

One of the outstanding features of this candlestick is the variety of script styles: ordinary thuluth and animated naskhi appear on the socket and neck; plaited kufic and majestic thuluth are seen on the body.

The kufic inscriptions on the upper and lower bands of the base have been only partially deciphered. The phrases that could be read bestow the traditional benedictions found on Ayyubid and Mamluk metalwork: "the great, the learned, the conqueror, the defender (of the faith), the triumphant, the just."

Published
Mayer 1937, p. 61 and pl. VIIa.
Melekian-Chirvani 1970, pp. 48–49.
London 1976, no. 211.

17

Base of candlestand
Brass: inlaid with silver, gold
Late 13th century

Height: 6.0 cm. (2⅜ in.)
Length: 13.4 cm. (5¼ in.)

New York, Madina Collection, M12

Diminutive candlestands were most likely produced for private dwellings in contrast to the large candlesticks that served ceremonial functions and were often used in religious structures. It is in the decoration of these small and unassuming pieces that the artists really excelled, both technically and aesthetically.

The little base originally had a tall shaft inserted into the hole at the top. A comparable example in the Louvre bears the titles of an amir in the service of Sultan Nasir al-Din Muhammad.[1] The shaft of the Louvre piece is accentuated with three rings and surmounted by a shallow tray, which had a tapered central pin used to affix the candle. The diameter of the tray equals the length of the pyramidal base, and the total height is 4½ times that of the base. If the Madina candlestand were complete, it would have been about twenty-eight centimeters (eleven inches) high. The shapes of these candlestands go back to Seljuk and Ayyubid times and were often of varying size.

The pyramidal base of the Madina candlestand rests on three heavy legs with pawlike feet, reminiscent of those seen on contemporary incense burners (see no. 12). The top has a hole in the center with triangles filling the three corners. Each of the three sides is decorated with a central roundel enclosing a six-petaled rosette inlaid in gold. The remaining areas are filled with a floral scroll, its tendrils terminating in four plump ducks

that fly toward the rosette. The execution of the ducks recalls those represented in the polylobed medallions on the base of Amir Kitbugha's candlestick and on a ewer (nos. 15–16 and 19).

A cartouche filled with arabesques hangs down from the center of the lower edge of each side, balancing the legs and the heavy proportions of the feet. The legs are faceted and decorated with scrolls and anklets; the feet are also adorned and have slightly upturned toes.

The delicacy of the decoration of the base is contrasted with the bold and splayed feet that firmly grasp the ground, providing support for the tall shaft and wide tray.

The ducks are portrayed with charm and whimsy; the same facile approach is seen in the execution of the feet, with anklets and upturned toes injecting a touch of humor and diminishing the clumsy effect. During the last decade of the thirteenth century an interest in the representation of ducks appears and continues until the middle of the fourteenth century (see nos. 18–19, 22–24, and 31).

The six-petaled rosette is thought to be a royal symbol associated with the house of Qalawun. Its parallel can be seen in the five-petaled rosette adapted as the family blazon by the Rasulids of Yemen (see nos. 14, 22, and 50). Although the placement of the six-petaled rosette on the candlestand suggests a heraldic emblem, swirling petals were not used in blazons. The rosette on this piece appears to have been employed as a decorative element.

Unpublished

Notes
1. Paris, Louvre, 7440; height 30.8 cm. (12⅛ in.), diameter 13.2 cm. (5³⁄₁₆ in.) (Wiet 1932, p. 10, no. 20, app. no. 168; Paris 1971, no. 162; Paris 1977, no. 319).

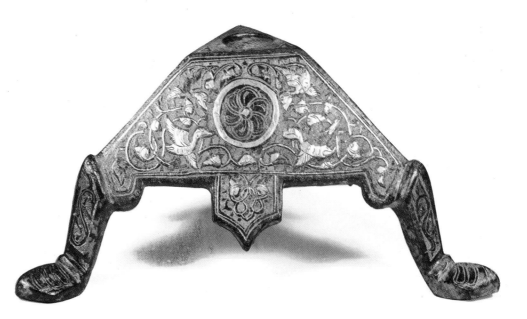

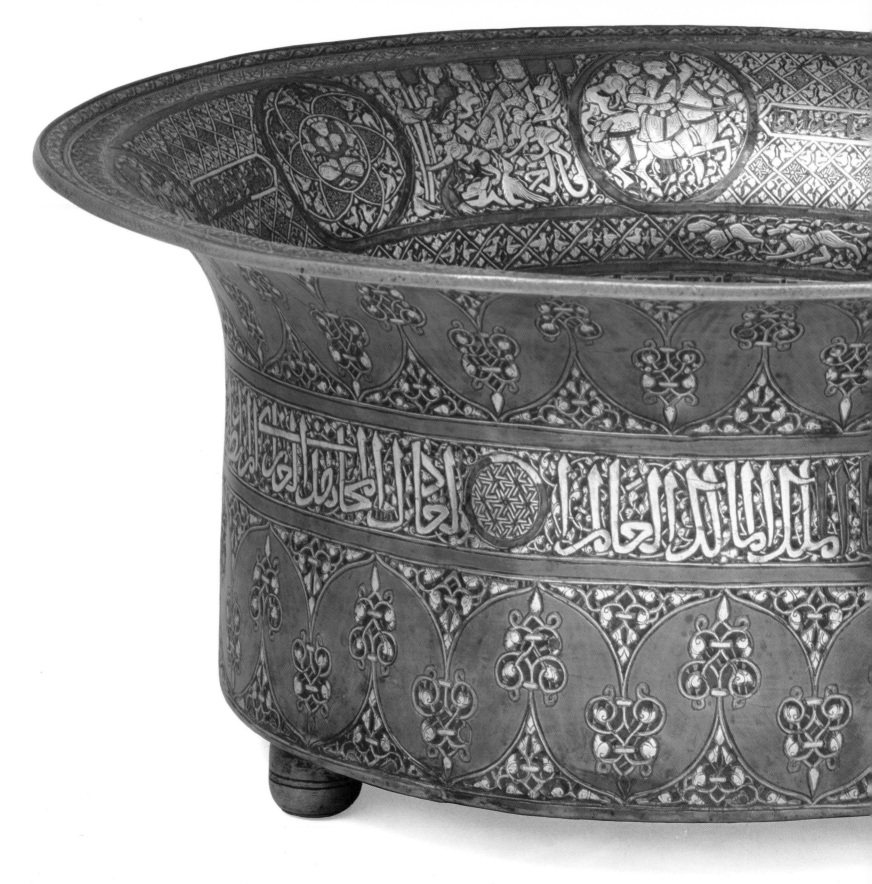

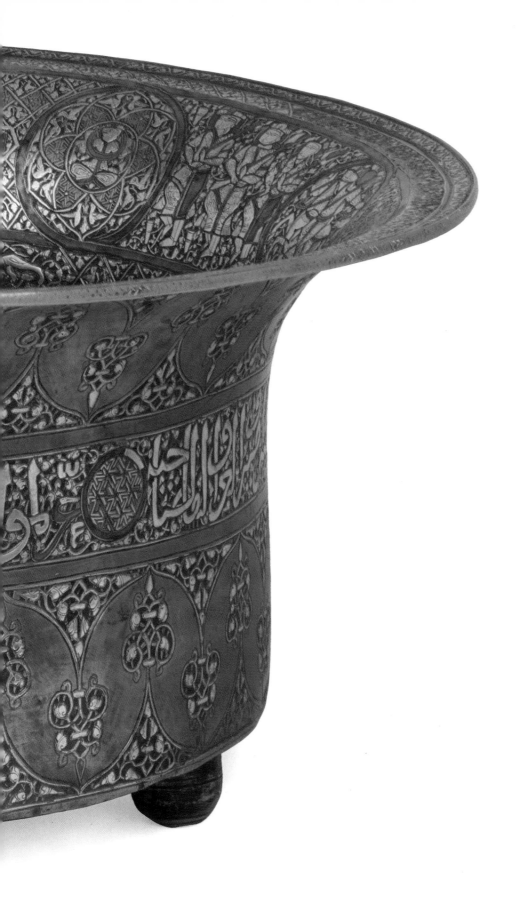

18
Basin
Brass: inlaid with silver, gold
Circa 1300
Made for an anonymous patron

Height: 18.5 cm (7¼ in.)
Diameter of rim: 42.5 cm. (16¾ in.)

London, Victoria and Albert Museum, 740-1898
Purchased 1898

Inscriptions
Six panels on exterior:

عز لمولانا الملك المالك العالم ا * لعادل المجاهد الغازي المرابط *
المثاغر ركن الاسلام والمسلمين كهف * الظعفا [sic]
والمسكين تاج الملوك وا * لسلاطين محي العدل في العالمين *
ناصر الحق بالبرامين والعز الاقبال لصاحبه

*Glory to our master, the king, the royal, the
learned, the just, the defender [of the faith], the
champion [of Islam], the warrior [of the
frontiers], the protector [of the frontiers], pillar of
Islam and of Muslims, protector of the weak and
the paupers, crown of kings and sultans, reviver of
justice among all, defender of truth and proof, and
glory and prosperity to the owner.*

Four bands on rim:

العز والاقبال داما والبقا لك ايها المولى الكبير الشان *
السعد والجد المجدد ... ماد الفضل والاجاد *
انت الذى طاع الملوك لامره وتباشرت لقدومه الثكلان * ...

*Perpetual glory and prosperity and long life to
you, the master [of] great fame. Happiness and
good fortune and glory ... prolonging and
superabundance and goodness. You are he whose
orders kings obey and at whose approach the
bereaved rejoice. ...*

Four bands on inner walls:

العز والاقبال داما * لك ايها المولى الكبير الشان *
الصاده الدامه * البقا لصاحبه ادا [sic]

*Perpetual glory and prosperity to you, the master
[of] great fame, eternal happiness, long life
to the owner.*

Two panels on inner walls:

عز داما * الاقبال العلي

Perpetual glory, sublime prosperity.

Among the largest and most impressive objects
produced by the Ayyubid and Mamluk
metalworkers is a group of basins that are almost
identical with slightly flaring sides and wide
everted rims (see nos. 21 and 26–28). The
proportions are consistent, averaging twenty
centimeters (almost eight inches) in height and
forty-five centimeters (about eighteen inches) in
diameter, giving a ratio of 1:2¼. This basin, whose
shape is typical, has an unusual decorative
repertoire and, in contrast to other examples, rests
on three rounded feet. Varied decorative themes

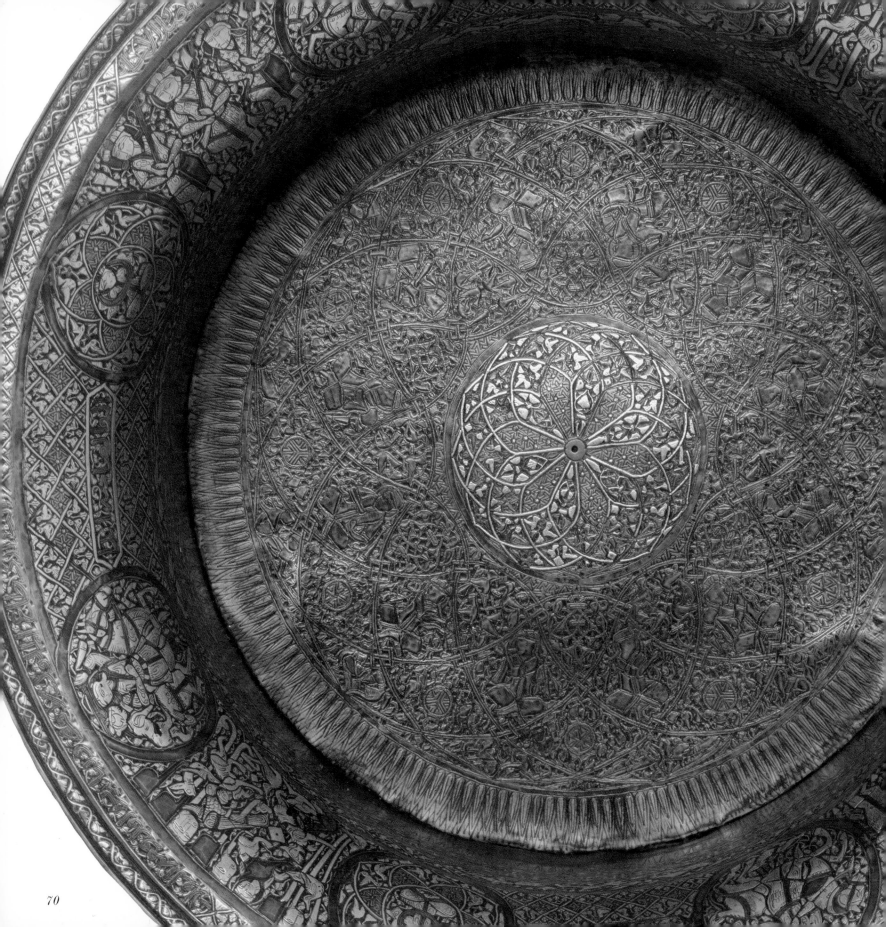

70

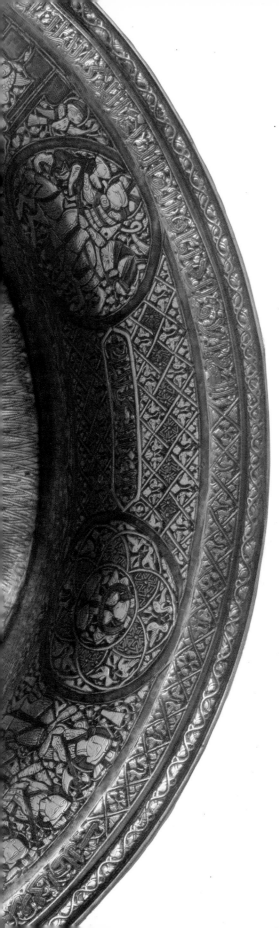

appear inside the rim. while a subdued design with bold inscriptions adorns the exterior.

The thuluth inscription on the exterior is placed against a floral arabesque and divided by six strapwork roundels. The surrounding area is sparsely decorated with triangular cartouches and knotted pendants.

The decoration of the rim is quite remarkable. It is almost a sampler of diverse styles of script, decorative motifs, and figural compositions. Two bands frame the rim: the outer band contains a floral scroll, the inner one is divided into eight units alternately filled with inscriptions and latticework. The lozenge units of the latticework enclose a pair of ducks. The wide panel below has eight large medallions, alternately depicting a rider and a lunar figure. The four riders are placed against a floral ground and turn toward the lunar figures. They wear turbans, knee-length robes, and boots and ride galloping horses. One rider holds a hawk while a dog runs below; another turns back and swings his sword to defend himself against a leopard (or tiger) that has leaped onto the rump of his horse; the third turns back to shoot with his bow and arrow at a bird, which is crammed into the medallion; the last figure repeats the defensive act of the second rider against an attacking lion. The lunar figures in the four alternate medallions are identical: a figure sits crosslegged and holds up with both hands a crescent in front of his torso. Six superimposed semicircles form a net around the figures; the triangles adjacent to the figures are filled with strapwork, while pairs of confronted ducks appear in the outer units.

The eight panels between the medallions also have alternating themes. Four of them are filled with a lattice design, its lozenge units adorned with strapwork or confronted ducks; in the center is an oblong cartouche bearing an inscription.

The remaining four panels employ two compositions: two panels have standing figures bearing arms, while the other pair is decorated with animated inscriptions. The warriors are dressed in the same fashion as the riders and lift up one leg as if marching to the left; three of them hold axes, two bear swords, and a single figure carries a spear. The two panels with animated inscriptions have real and fantastic animals chasing one another in and out of the script; hawks, ducks, and lions intermingle with harpies, sphinxes, and griffins. The script is not fully animated since the letters, which begin or terminate with animal and human heads, are intact. In fully animated inscriptions, the figures themselves form letters, each part of the body designating a stroke (see no. 15). Nevertheless, it is a particularly difficult script to read.

Below this zone are three narrow bands. The first has four units with three animals running to the left, interrupted by four panels containing pairs of confronted ducks. The second shows a plaited kufic inscription. The last is embellished with loose arabesques, similar to those on the exterior. A series of lancet leaves extends to the base.

The interior of the base is exquisitely decorated. The design consists of overlapping semicircular bands radiating from a six-petaled central rosette. The units in the first register are filled with strapwork, arabesques, or pairs of ducks. In the outer and wider zone, the units are larger; some contain geometric roundels in the center of arabesques, others have two pairs of ducks, and twelve of them depict seated figures holding beakers or playing lutes, flutes, and tambourines. This is the only portion of the basin that has lost most of its inlay.

Gold inlay appears in the strapwork units on the exterior, interior, and base. The remarkable preservation of the silver inlay, with very few large pieces lost on the body, suggests that the basin was cherished and carefully handled to preserve its decoration.

The basin was thought to have been made for either Baybars I (1260–77) or Baybars II (1309–10), both of whom took the title Rukn al-Din. This attribution is highly doubtful since the phrase used on the basin is *rukn al-islam* (pillar of Islam), and the reign titles of these two sultans, al-Zahir (Baybars I) and al-Muzaffar (Baybars II), are noticeably absent. The wording of the inscription is ambiguous: it omits *al-sultan*, which is standard on imperial dedications, but includes several other royal benedictions, and concludes with the phrase "to the owner," suggesting that the piece was made for an anonymous patron.

Unpublished

19
Ewer
Brass: inlaid with silver, gold
Circa 1300
Made for an anonymous amir

Height: 46.0 cm. (18⅛ in.)
Max. diameter: 24.5 cm. (9⅝ in.)

Cairo, Museum of Islamic Art, 15089
Purchased 1945
Ex-Harari Collection, 8

Inscriptions
Upper band on neck:

المقر الكريم العالى المولوى المالكى الاميرى الكبيرى
الغازى المجاهدى

*The honorable excellency, the sublime master, the
royal, the great amir, the champion [of Islam],
the defender [of the faith].*

Ring on neck (repeated 3 times):
العزه *Glory.*

Lower band on neck:

المولوى المالكى الاميرى الكبيرى الغازى المجاهدى المرابطى

*The master, the royal, the great amir, the
champion [of Islam], the defender [of the faith],
the warrior [of the frontiers].*

Band on shoulder:

برسم المقر الكريم العالى المولوى الاميرى الكبيرى المجاهدى

*Made for the honorable excellency, the sublime
master, the great amir, the defender [of the faith].*

Upper band on spout:

المقر المولوى العالى

The excellency, the sublime master.

Lower band on spout:

المقر الكريم العالى المولوى

The honorable excellency, the sublime master.

Although this ewer has undergone a considerable
amount of abuse, even after it was repaired in the
Ottoman period, the beauty of the original design
is still preserved. In its pristine condition, the
piece must have been extremely impressive,
harmoniously blending inscriptions, floral
decorations, and bands with running animals.
 The ewer was constructed in several pieces,
including a socketlike mouth, neck, handle, spout,
and body. The neck, handle, and spout consist of
two parts joined by rings; these joints have been
broken and the rings date from a later restoration.

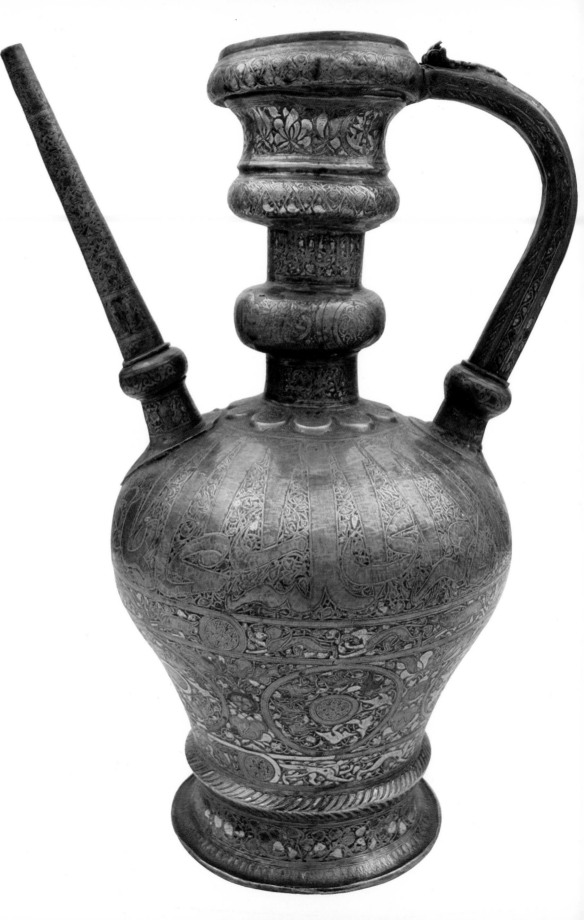

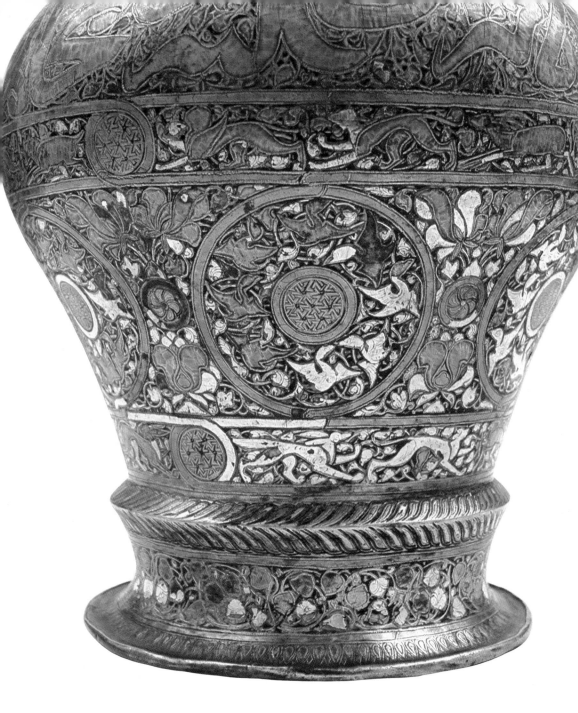

rosettes and lotus blossoms fill the interstices. At the base is another band of running animals with three geometric roundels; the nine quadrupeds represented here repeat the same species depicted above, but they run in the reverse direction. A chevron ring joins the body to the foot, which has a band of floral arabesques similar to that on the lip; lancet leaves appear at the edge of the splayed foot, which is turned up to form a sturdy base.

The underside of the footring is beautifully decorated with floral scrolls on the edge and in the central boss. The boss is enclosed by a sunken floral scroll enhanced by three roundels with lotus blossoms. This is the best preserved portion of the piece and must have delighted guests, who could see this "hidden" design only when the ewer was being used.

The faceted handle, adorned with floral scrolls and braids, is attached to the shoulder with a heart-shaped plaque. An identical plaque joins the spout, which is divided into four units containing inscriptions and floral arabesques.

Although the overall shape of the ewer follows Ayyubid examples, the heavy socketlike mouth and the bold rings on the neck, handle, and socket appear to be Mamluk innovations.[1]

This piece belongs to a group of transitional objects combining figural compositions with lotus blossoms and inscription bands, which became fashionable after the second quarter of the fourteenth century. One of the floral motifs on the foot shows trefoil petals with strokes designating veins, a characteristic decorative motif of metalwork produced during the reign of Sultan Nasir al-Din Muhammad (see nos. 25–26).

Unpublished

Notes
1. The same features appear in another Mamluk ewer in Cairo, Museum of Islamic Art, 24084 (El-Emary 1966, pp. 128–29, pls. XXI–XXIV).

The mouth contains two rings with floral designs; the upper one is damaged and slightly askew. Between them is a recessed panel decorated with lotus blossoms and buds, divided by three roundels containing two pairs of confronted and addorsed ducks.

The neck is divided into three units: the upper and lower portions contain an inscription on a floral ground; the ring in the middle, dating from the Ottoman period, bears another inscription divided by three arabesque medallions.

The neck joins the shoulder with a series of ten scallops filled with floral motifs. The shoulder has a zone of oversize inscriptions on a floral ground. Below this is a band with fifteen running animals, interrupted by three geometric roundels. The animals move toward the left and represent winged sphinxes and such quadrupeds as bears, wolves, gazelles, hares, lions, foxes, and bulls. The tapering lower portion of the ewer has six medallions, each containing a geometric roundel encircled by a flock of eight ducks. Six-petaled

73

20
Bowl
Brass: inlaid with silver, gold
Circa 1290–1310
Made by Ibn al-Zayn

Height: 10.3 cm. (4 1/16 in.)
Diameter of rim: 17.2 cm. (6 3/4 in.)

Paris, Musée du Louvre, MAO 331
Bequest of Marquet de Vasselot, 1956

Inscriptions
On bowl held by figure:

عمل ابن الزين

Work of Ibn al-Zayn.

The exterior of Ibn al-Zayn's small bowl portrays eighteen figures participating in ceremonial and courtly activities. The piece has the characteristic shape of Mamluk bowls with its rounded base, inverted sides, and slightly everted heavy rim (see nos. 29 and 37). A continuous thin strip of silver encloses the band and loops around the three medallions. A floral arabesque with lancet leaves adorns the lower edge of the band. Floral motifs also appear behind the figures.

The three medallions represent enthroned figures wearing crowns. Each sits crosslegged on the throne, with one hand resting on the hip, the other hand holding a beaker. The remaining three units each have five figures representing court officials, entertainers, and hunters.

The first panel shows a group of officials seated crosslegged on the ground. In the center is an enthroned figure holding a bow and sword, symbols of high office; he wears a soft furry hat of the Central Asian steppe, in contrast to the other figures, who wear turbans. The figure on the far right holds a large footed bowl with the name of the artist engraved on the upper portion; on the ground rests a beaker. Nearby a man displays a sword. The two figures on the other side of the enthroned personage hold a large rectangular pen box and an ax (this type of pen box also appears in no. 21, see also nos. 23–24). The scene symbolizes the administration with the enthroned figure representing a high Turkish amir, surrounded by his cup-bearer, sword-bearer, secretary, and mace-bearer.

The next panel is devoted to less serious activities of the court. A pair of musicians playing flutes and tambourines flanks a dancer who holds clappers. Cups and wine bottles scattered between the figures provide further indication of the joyous atmosphere created by the court entertainers.

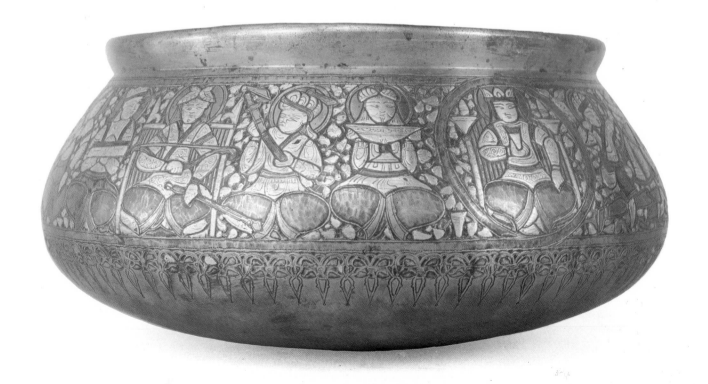

The third panel depicts an imperial hunt, which in this case concentrates on wild geese, found in abundance in the marshes outside the capital. Once again there is a central figure, who holds a dead goose; two pairs of figures on either side are actively pursuing the game, shooting with bows and arrows and slaying quarry.

The interior of the bowl contains two rings, each composed of six fish; the fish in the inner ring swim counterclockwise, while those in the outer are reversed and interspersed with small roundels. The exterior of the base is undecorated.

The artist has attempted to differentiate facial features of the figures and to identify them racially. Some are of Central Asian or Turkish origin, while others are more Mediterranean or a blend of both types. He is obviously "portraying" members of the ruling class as accurately as his medium allows (see also no. 21).

There are several examples of Mamluk metalwork displaying a similar virtuosity in representing figural compositions, and it is highly possible that they were made in the same workshop. One of the celebrated examples is an exquisite incense burner found at Qus in upper Egypt.[1] The six medallions on the lid and base of this piece represent mounted hunters in very realistic and lively poses. A spectacular mirror in Istanbul, representing a profusion of animals and personifications of signs of the zodiac, is signed by Muhammad al-Waziri and dedicated to Amir Altunbugha, the cup-bearer of Sultan Nasir al-Din Muhammad.[2] Another bowl, in the Louvre, its exterior and base decorated with medallions depicting animals in combat, seated figures, and symbols of the planets, also belongs to this short-lived renaissance of a figural style epitomized by the art of Ibn al-Zayn.[3]

Published
Répertoire, vol. 11, no. 4366.
Wiet 1932, p. 20, no. 25, p. 66, no. 9, and app. no. 64.
Dimand 1941, p. 210.
Mayer 1952, p. 9.
Mayer 1959, p. 74.
Pope and Ackerman 1964–67, vol. 6, p. 2499, note 1, p. 2528, no. 18 and fig. 808; vol. 12, pl. 1340.
Paris 1967, no. 56.
Cairo 1969a, no. IX.
Chambéry 1970, no. 74.
Paris 1971, no. 163 and cover.
Rogers 1974, pp. 390–94 and fig. 1.
Paris 1977, no. 263.

Notes
1. El-Emary 1966, pp. 123–27, pls. XIX–XX.
2. Istanbul, Topkapı Palace Museum, 2/1786. The mirror is dedicated to Ala al-Din, thought to be Ala al-Din Altunbugha who died in 1342. He was the governor of Aleppo in 1314 and the viceroy of Syria in 1340 under Sultan Nasir al-Din Muhammad (Mayer 1933, pp. 62–63; Mayer 1959, p. 74 with full bibliography; Aslanapa 1977, p. 75, fig. 6).
3. Paris, Louvre, 6032 (Paris 1971, no. 161; London 1976, no. 215; Paris 1977, no. 451).

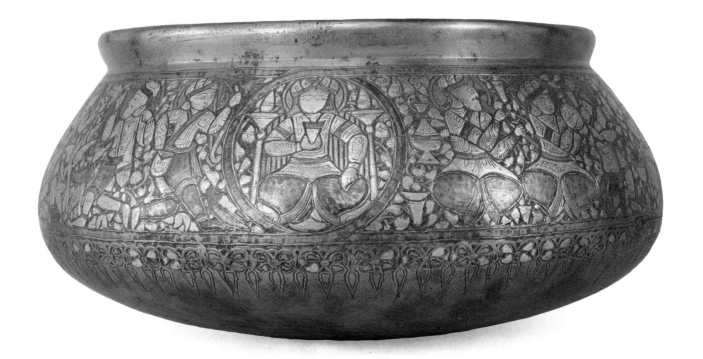

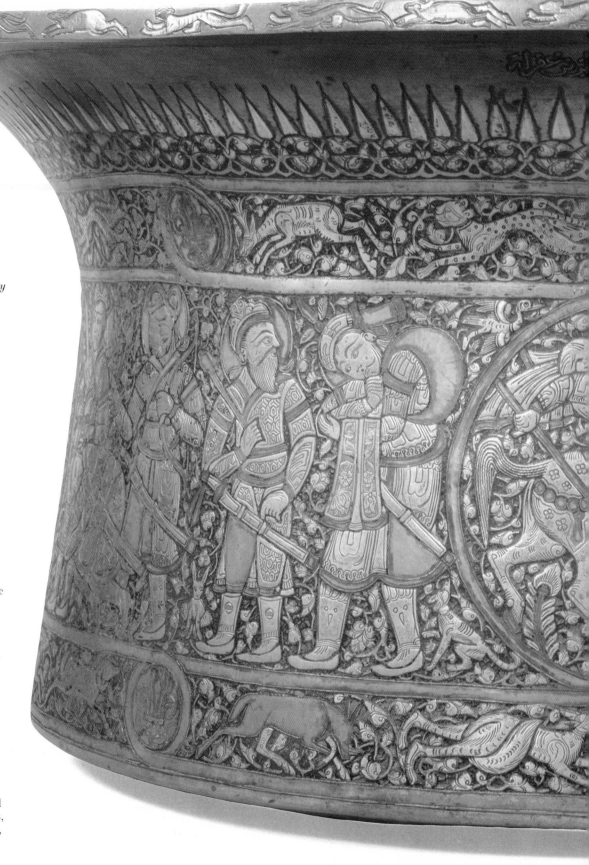

21
Basin
Brass: inlaid with silver, gold
Circa 1290–1310
Made by Muhammad ibn al-Zayn

Height: 22.2 cm. (8¾ in.)
Diameter of rim: 50.2 cm. (19¾ in.)

Paris, Musée du Louvre, LP 16
Bequest of Marquet de Vasselot, 1956

Inscriptions
Exterior under rim:

عمل المعلم محمد ابن الزين غفر له

*Work of the master Muhammad ibn al-Zayn, may
he be forgiven [by God].*

Exterior on stemmed cup held by figure in one
 panel; interior on throne backs and on beakers
 held by kings in two medallions:

عمل ابن الزين

Work of Ibn al-Zayn.

Exterior on bowl held by figure in one panel:

انا مخفيى لحمل الطعام

I am a vessel to carry food.

Interior on pen boxes held by figure in two
 medallions:

دوه and [sic] دواه

Pen box.

This spectacular basin, lavishly inlaid with silver
and gold, is the most celebrated piece of Mamluk
metalwork and among the masterpieces of Islamic
art. The compositions are carefully structured,
representing both the general and the specific.
The scenes in the medallions are repetitive,
depicting generalized themes, such as enthroned
figures and riders. In contrast, those in the panels
portray specific activities and figures, possibly
even individuals, attired in the costumes of their
rank.
 The flaring rim of the basin contains an
arabesque scroll terminating with lancet leaves,
while a row of forty-four quadrupeds appears on
the edge of the widened lip. The exterior has a
wide central unit divided into four panels by
medallions and enclosed by two narrow bands
with animals, each broken by four roundels.
The bands depict real and fantastic predators and
prey, such as unicorns, leopards, foxes, wild boars,
griffins, and lions, which chase elephants, gazelles,

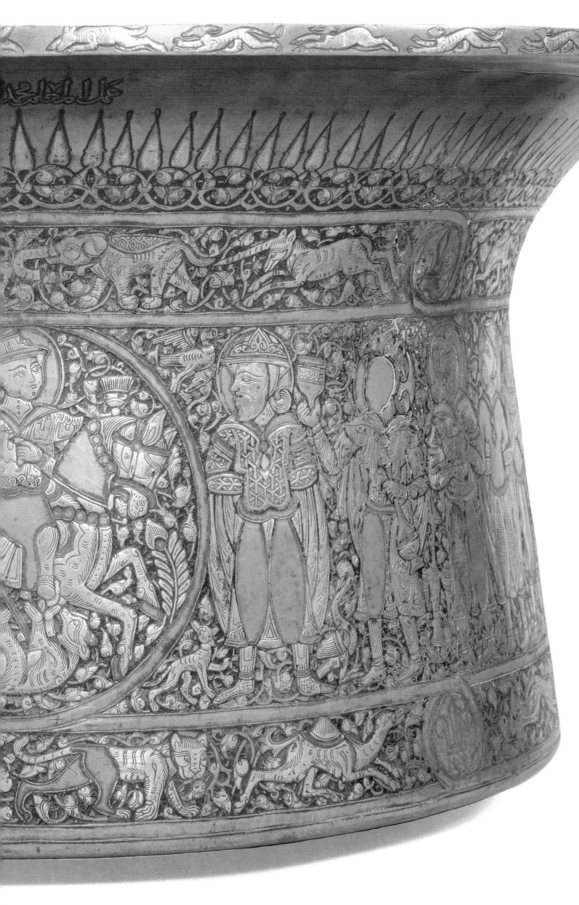

deer, hares, sphinxes, and camels. The four
roundels on each band have been covered at a
later date by the French fleur-de-lis.

The four medallions represent different types of
riders. Two of them wear hats and cloaks and
spear a dragon or a bear. Those in the alternating
medallions are attired in turbans, long robes, and
boots; one rider attacks a lion with his sword
while the other holds a polo-stick.

The four panels also represent two figural types
identified as amirs and royal servants. The amirs
bear swords and other weapons; they are attired
in turbans, long robes, and leggings with blazons.
The royal servants, who are not armed, wear hats
and cloaks.

The first panel with amirs shows five figures
bearing such weapons as a sword, mace, bow; the
first amir bends low as if approaching a sultan and
the last carries a bundle on his back with a cloth
draped over his arm. The second panel of amirs is
also represented by five armed figures, with the
first bending low and preceded by a child who
holds a polo-stick; one of the other figures carries
a gazellelike animal across his shoulders. These
two scenes most likely portray high court officials,
including the sword-bearer (*silahdar*), mace-bearer
(*jumaqdar*), bowman (*bunduqdar*), master-of-the-
robes (*jamdar*), and polo master (*jukandar*), who
bear gifts to the sultan.

The remaining two panels depict servants of the
hunt and the royal household, each preceded by
the overseer, who stands erect with hands folded
behind his back. The panel with the hunters has
three additional figures who hold either a cheetah
on a leash, a falcon, or a crane. The officials in
the second panel carry a long-necked bottle, a
stemmed cup, a kid, and a large bowl. These
figures portray the falconer (*bazdar*), cup-bearer
(*saqi*), and possibly the imperial taster (*jashnigir*),
who are also presenting gifts to the ruler.

The interior of the basin has the same layout as
the exterior. Two strips frame the edge of the rim;
the outer strip is braided and the inner one shows
a series of overlapping fish. Below is a band of
animals representing the predators and prey seen
on the exterior, divided by four roundels covered
with fleur-de-lis. Another animal band broken by
roundels appears below the wide central unit and
is followed by an arabesque scroll terminating
with lancet leaves similar to that on the upper
portion of the exterior.

The interior medallions reveal two alternating themes: a shield placed on a floral scroll, covered by the coat of arms of France; and an enthroned figure flanked by his sword-bearer and secretary. The enthroned personages wear crowns and hold beakers, while sword-bearers carry the imperial sword and secretaries carry pen boxes.

The four panels between the medallions have three riders and depict the two most representative activities of the Mamluks: an imperial hunt, shown in two consecutive panels, and a battle, enacted in the remaining pair. These riders belong to the ruling class and wear armor and helmets or long robes and turbans; each figure is fully equipped with weapons and has boots with blazons.

The first panel of warriors portrays a distinguished figure in full armor who has just shot the fleeing enemy with an arrow. The warrior is accompanied by his aide who holds an ax and keeps respectful distance. The central figure in the second panel uses a bow and arrow against the enemy and on either side of him are warriors who join the attack with lance and sword.

One of the hunting scenes shows two riders, accompanied by a falconer, killing a lion and a bear. The second panel represents a pair of hunters attacking a leopard and a lion, a third figure tries to defend himself against a lion that has jumped onto the rump of his horse.

The interior of the base of the basin is as elaborately decorated as the exterior and interior walls. An arabesque scroll with lancet leaves encircles a fantastic design composed of concentric rings of fish, interspersed with a variety of other marine creatures—including eels, crabs, turtles, frogs, lizards, and crocodiles—intermingled with ducks, pelicans, and harpies, with roundels in the interstices. The center of the composition is formed by a group of six fish with their heads pointing inward; the fish in each of the five encircling rings swim in alternate directions, creating a whirlpool effect. Although concentric rings of fish are commonly seen in contemporary basins, the diversity of sea animals represented here is without equal (see nos. 26–28).

Each unit of the basin is enhanced by a rich floral arabesque flowing in the background with occasional animals—including cranes and wild ducks, foxes and hares—intermingled with flora. Thin ribbons define the units and loop around the roundels and medallions in a continuous strip.

The maker of this basin must have been extremely proud of his accomplishment since his name appears in five different areas in addition to the formal inscription placed under the rim.[1]

As mentioned earlier, the coat of arms of France in the four medallions of the interior and the fleur-de-lis in the sixteen roundels in the exterior and interior are later additions, placed over the blazons in the nineteenth century. D. S. Rice, who has studied this basin in detail, was able to identify the original blazons: a rampant lion

appears on four roundels of the exterior, and a particular mark of the Turkish tribes of Central Asia, called *tamgha*, is seen in the remaining ones.

Based on the interpretation of the blazons, Rice has suggested that the basin was made for Amir Salar who was one of the wealthiest amirs of the time and became the viceroy of Egypt in 1299. He conspired with Baybars, who overthrew Sultan Nasir al-Din Muhammad in 1309. The following year the sultan regained his throne and had Baybars killed. Salar was imprisoned and died of starvation within months.

If one can accept the theory that Salar was the patron of the work, then the basin was made between 1290, the year Salar was elevated to high office, and 1310, the year of his death. This time span is also confirmed by stylistic evidence. During the long reign of Nasir al-Din Muhammad, figural compositions reached an ultimate level of perfection and scrolls with trefoil leaves (seen around the medallions of the interior) were coming into fashion. The lack of imperial inscriptions or references to a sultan also strengthens the assumption that the piece was made for a wealthy but nonroyal patron.

The history of the Louvre basin is as fascinating as the identification of its patron. The earliest record of its existence appears in a travel book written in 1742, which states that the basin was used for the baptism of the children of the ruling house of France and was thought to have been brought back from the Near East by Louis IX during one of his crusades (which predates the basin by almost half a century).[2] The basin was kept in the Treasury of Sainte-Chapelle on the grounds of the Chateau de Vincennes until 1852 when it was moved to the newly established museum at the Louvre Palace. It was used for the baptism of Prince Napoleon-Eugène in 1856—the last time it served as a baptismal font.

Published (selected)
Répertoire, vol. 11, no. 4365.
Lane-Poole 1886, pp. 217–20 and figs. 73, 82 (small format); pp. 181–83 and figs. 73, 82 (large format).
Migeon 1907, vol. 2, pp. 198–200 and fig. 153.
Migeon 1922, vol. 1, no. 71 and pl. 22.
Migeon 1927, vol. 2, pp. 61–64 and fig. 243.
Wiet 1932, p. 20, no. 24, p. 66, no. 8, and app. no. 63.
Paris 1938, no. 200.
Dimand 1941, p. 210.
Aga-Oglu 1945, p. 36.
M. H. Zaki, 1948, p. 548 and fig. 449.
D. S. Rice 1950, pp. 367–80.
Mayer 1952, pp. 9, 45 and pl. II.
D. S. Rice 1953.
Ettinghausen 1954, pp. 245–49.
Mayer 1959, p. 75.
Pope and Ackerman 1964–67, vol. 6, pp. 2477, 2499, 2528, no. 17; vol. 12, pl. 1339.
D. T. Rice 1965, pp. 137–38 and fig. 138.
Paris 1970, no. 193.
Paris 1971, no. 164.
Sourdel-Thomine and Spuler 1973, pp. 334–35 and pl. 304.
Aslanapa 1977, p. 74 and fig. 5.
Paris 1977, no. 274.
Papadopoulo 1979, color pl. 81.

Notes
1. An identical basin, which has lost all its inlay, is mentioned as being in New York, Kevorkian Collection (Mayer 1952, pls. IV–V).
2. D. S. Rice 1953, p. 9.

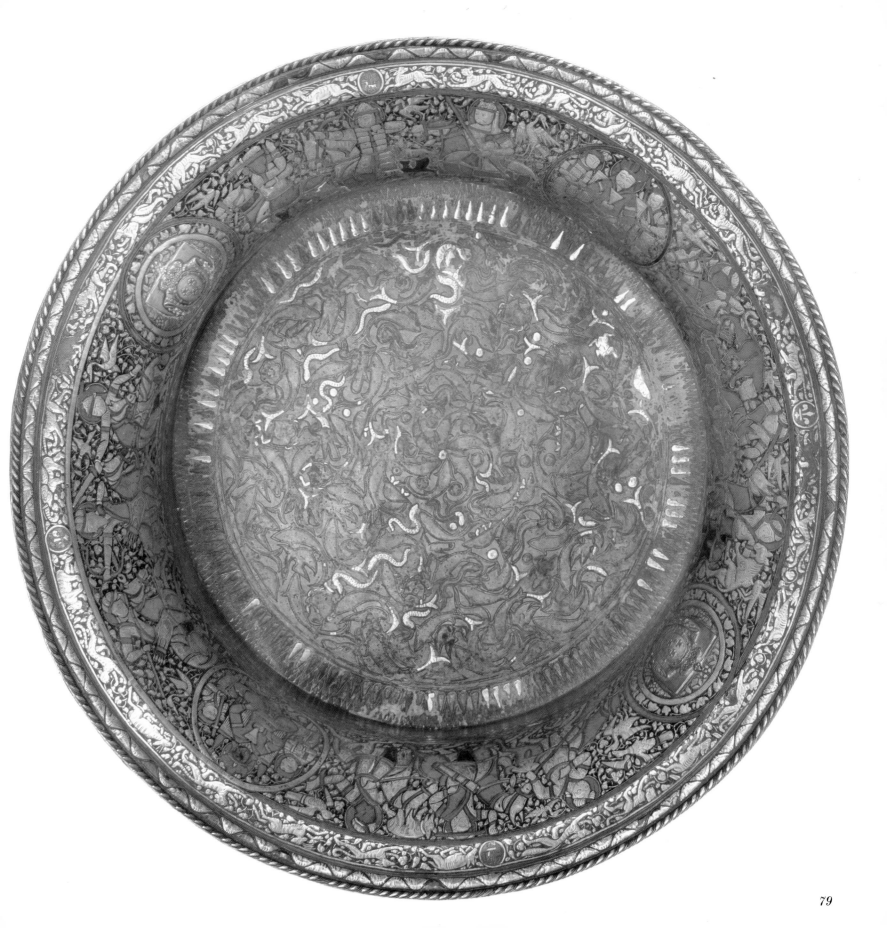

22
Tray
Brass: inlaid with silver
Circa 1300–1320
Made by Ahmad ibn Husein al-Mawsili
 in Cairo
Made for Dawud, Rasulid sultan of Yemen

Height: 2.5 cm. (1 in.)
Diameter: 77.8 cm. (30⅝ in.)

New York, The Metropolitan Museum of Art,
 The Edward C. Moore Collection, 91.1.602
Bequest of Edward C. Moore, 1891

Inscriptions
Three panels on rim:

عز لمولانا السلطان الملك المؤيد العالم العادل المجاهد المرابط
المثاغر هزبر الدنيا والدين * داوود سلطان الاسلام والمسلمين
مظهر العدل فى العالمين ابن مولانا السلطان الملك ا *
لمظفر السعيد الشهيد شمسى الدنيا والدين يوسف ...
احمد بن حسين الموصلي بالقاهره

*Glory to our master, the sultan al-Malik
al-Muayyad, the learned, the just, the defender
[of the faith], the warrior [of the frontiers], the
protector [of the frontiers], the lion of the world
and religion, Dawud, sultan of Islam and the
Muslims, the manifestation of justice among all,
son of the master, the sultan al-Malik
al-Muzaffar, the fortunate, the martyr, Shams
al-Dunya wa'l-Din Yusuf . . . Ahmad ibn
Husein al-Mawsili in Cairo.*

Three panels on base:

عز لمولانا السلطان الملك ا * لمؤيد عالم العادل المجاهد المرا *
بط المثاغر هزبر الدنيا والدين داوود عز نصره

*Glory to our master, the sultan al-Malik
al-Muayyad, the learned, the just, the defender
[of the faith], the warrior [of the frontiers], the
protector [of the frontiers], the lion of the world
and religion, Dawud, may his victory be glorious.*

The figural style discussed earlier (nos. 20–21)
continued well into the fourteenth century, as
observed in this tray made for the Rasulid sultan
Dawud (1296–1322). Dawud commissioned from
Mamluk artists several pieces of inlaid metalwork
and enameled glass, including a pen box, in the
Victoria and Albert Museum in London, dated
1302/3; another tray, in the Metropolitan Museum
of Art in New York; and a glass bottle (no. 50) in
the Detroit Institute of Arts.[1]

His predecessor, Yusuf, had also commissioned
a number of metal objects from the Mamluk
workshops in Cairo (see no. 14). The name of
Dawud's son, Ali, is inscribed on several objects
including a tray in the Louvre, a basin and bowl
at the Metropolitan, an enameled glass bowl in
Toledo, and a glass bottle at the Freer.[2]

The tray on display forms a transition between

the earlier group of Mamluk metalwork decorated
with figural compositions and the later examples
in which the predominant themes are hierarchic
thuluth inscriptions and lotus blossoms.
The tripartite division of design is also a
characteristic of later pieces.

The piece is divided into two main sections: a
large central medallion and a wide inscription
band broken into three parts by lobed medallions.
In the core of the central medallion is a five-
petaled rosette, the blazon of the Rasulid dynasty.
The geometric design radiating from the rosette
first creates a fine interlace and then opens out to
form seven units composed of real and fantastic
animals, some of which are engaged in combat.
In the center of each unit is a crowned sphinx,
shown frontally in a squatting position with
extended wings. On either side of the sphinxes are
winged lions swooping down to attack winged
bulls separated by small harpies. The composition
is further enhanced by flying ducks and the heads
of lions and bulls, which appear as parts of the
intertwined scrolls. This remarkable zoomorphic
arabesque is a masterpiece of design and execution.

The three lobed medallions in the outer zone
represent figures riding counterclockwise and
against the direction of the inscription. One of the
riders, who shoots an arrow at a lion (?), wears a
turban with a fluttering band, a belted robe, and
high boots; a sword encased in a scabbard hangs
from his waist. The second warrior is in full armor
with ribbons or plumes attached to the top of his
helmet; he is shooting at a small human figure
with a bow and arrow; the quiver hanging from
his waist is full of arrows. The last rider is also in
full armor and bears a bow and quiver and a
sword; he is spearing a diminutive human figure
who carries a sword. The riders and their mounts
are rendered in detail against a fine floral
arabesque. Unfortunately, the inlay and a great
amount of fine detailing has disappeared.

A floral arabesque with flying ducks fills the
ground of the inscription panel. The vertical
shafts of the letters radiate toward the rim, and
the script uses the same ground line as the riders,
a feature also observed in the tray made for
Dawud's father (see no. 14). In trays produced
later—including one made for Dawud's son, Ali—
the inscription is reversed, the shafts of the letters
are oriented toward the center to create a
radiating and revolving effect (see also the panel
on the lid in no. 25 and medallions in nos. 30–31).

A chevron design appears on the walls and the
rim has two bands. The inner band is broken into
six panels by five-petaled rosettes: an inscription
panel alternates with a unit containing eight
quadrupeds moving counterclockwise in the same
direction as the script. The animals include lions,
bears, foxes, cheetahs, gazelles, wolves, hares,
bulls, and a camel. The ground of both units is
filled with a floral arabesque. The outer band
is adorned with a scroll of flying ducks.

Since the inlay has completely disappeared, it is
difficult to determine whether the five-petaled
rosettes, the blazons of the Rasulid house, were
originally inlaid with copper. It was common
practice among metalworkers to use copper to
suggest the color red, traditionally employed in
this heraldic symbol.

The inscription on the rim states that the tray
was made by an al-Mawsili artist working in
Cairo. Although it is feasible that the maker of
Sultan Dawud's tray could trace his ancestry for
at least four generations to Mosul, it is more likely
that he was trained in the style of that city as
suggested by the superb figural compositions
employed on the tray (see also no. 10).

The tray appears to have been owned at one
time by al-Husein ibn al-Hasan, who inserted his
name after the silver inlay on one of the letters fell
out. He has added after his name the words *amir
al-muminin*, amir or commander of the faithful, a
title traditionally employed by caliphs. This
practice is also observed on inscriptions added to
several examples of Mamluk metalwork that in
the seventeenth century passed into the collection
of a particular family thought to be among the
aristocracy in Yemen.[3]

Published
Répertoire, vol. 14, no. 5454.
Dimand 1931, pp. 231–34 and 236, no. 3 and fig. 3.
Wiet 1932, p. 21, no. 39, p. 48, no. 11, p. 71, no. 15, and app.
 no. 141.
Wiet 1932a, p. 79.
Kühnel 1939, p. 11, no. 17.
Dimand 1944, pp. 151–52.
M. H. Zaki 1948, p. 562.
D. S. Rice 1957, pp. 291 and 326, no. 26 and fig. 9.
Mayer 1959, p. 29.

Notes
1. London, Victoria and Albert Museum, 370–1897 (Dimand
 1931, pp. 230–34 and 236). The second tray in New York,
 Metropolitan Museum of Art, 91.1.605 (Dimand 1931, fig. 2).
 Dimand also mentions a brass candlestick in the Kraft
 Collection and an enameled glass basin in Paris, Marquis de
 Vogüé Collection (Dimand 1931, p. 231). See also Wiet 1929,
 app. nos. 19–20; Wiet 1932, app. nos. 122 and 140–43.
2. The tray is in Paris, Louvre, 6008 (Wiet 1932, p. 72, no. 32
 and p. 218, no. 263; Paris 1971, no. 170; Paris 1977, no. 95;
 and Welch 1979, no. 24). The basin is in New York,
 Metropolitan Museum of Art, 91.1.589; the bowl is also in the
 same collection, 91.1.590 (Dimand 1931, pp. 234–36, figs. 4–5).
 The glass bowl is in Toledo, Toledo Museum of Art, 44.33
 (Wiet 1929, app. no. 120; Sotheby 1944, no. 147). The glass
 beaker is in Washington, D.C., Freer Gallery of Art, 34.20
 (Atıl 1975, no. 74). See also Wiet 1932, app. no. 260–68 and
 270. The dome of a brass chandelier in Cairo, Museum of
 Islamic Art, 15122, also bears this sultan's name (Mostafa
 1958, no. 40, fig. 30).
3. The name Muhammad ibn Ahmad ibn *amir al-muminin*
 appears on a basin and candlestick in Cairo, Museum of
 Islamic Art, 3937 and 3982, the candlestick dated 1662.
 The name of his son, al-Husein, is found on a candlestick
 in Lyons and a basin in Paris, the latter dated 1678.
 See Melekian-Chirvani 1970.

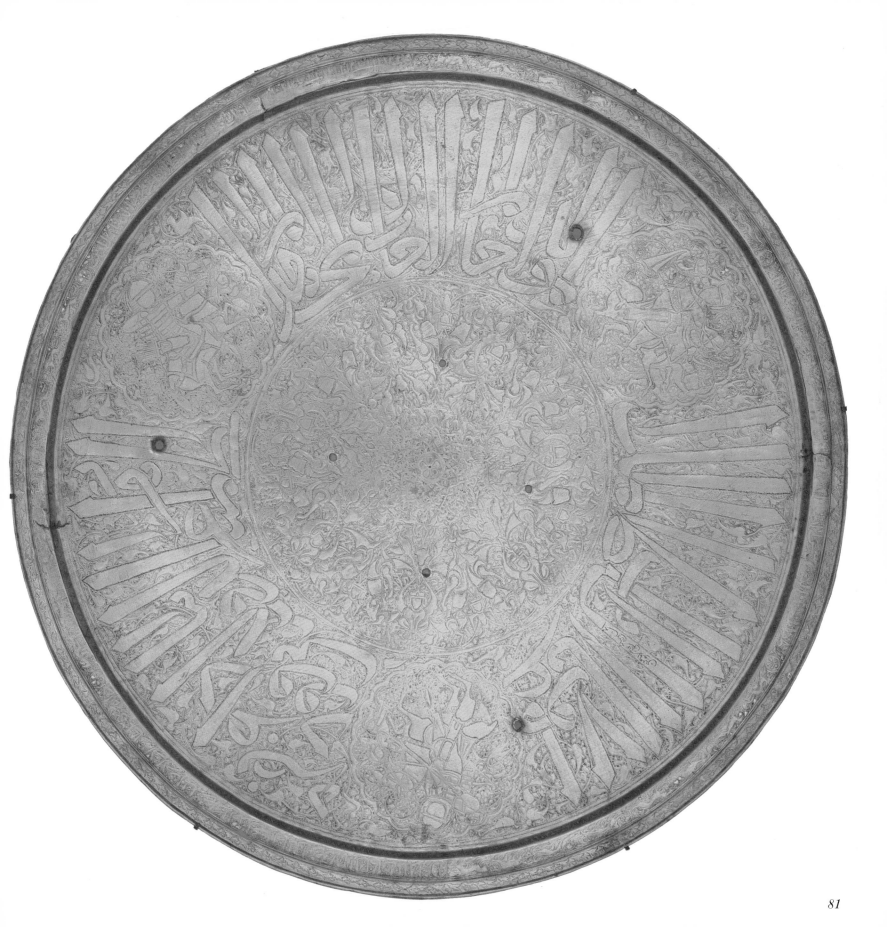

23
Pen box
Brass: inlaid with silver, gold
1304/5

Height: 7.0 cm. (2¾ in.)
Length: 32.4 cm. (12¾ in.)
Width: 8.5 cm. (3⁵⁄₁₆ in.)

Paris, Musée du Louvre, 3621
Purchased 1895

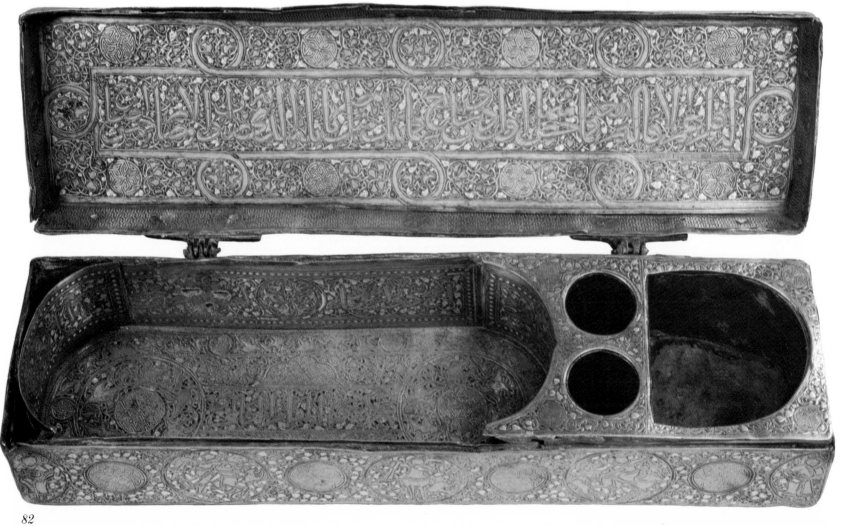

Inscriptions

Four panels on top of lid:

دواة مولانا عدت او * صافها مكملة شهدت نسخّنا قد *
اقلامها المعدلة ا * م الكتاب قد عدت لايها

The pen box of our master; its qualities have been judged to be perfect; its prototype bears witness to the stature of its pens adjusted; the substance of writing had been counted among its signs.

Panel at base of pen unit:

يدوم به المقام العالى وغر

[This is] a source from which his learned majesty draws.

Panel inside lid:

له قلم عم الاقاليم نفعه فا خص منها اول حون سابع فما نبل
مثل مصر نابله الذى زان به والامصار خمس اصابع

He has a pen that benefits all provinces, without differentiating the first of them from the seventh, and without striking, like a metropolis, his shooter who ornaments with it [the pen], and the metropolises are the five fingers.

Four panels around walls of pen unit:

افتح دواة سعادة * اقلامها (؟) ... يجزى بسعد (؟) من عطا
وقرا * عملت لعبد الله راجى رحمة ربه ومستجير به * ليوم الاخر
عملت فى سنة اربع وسبعما * ثة من الهجرة

Open the pen box of happiness; its pens . . . who receive and read. Made for the servant of God [Abdallah?] who hopes for the mercy of God and His protection for the Last Day. Made in the year four and seven hundred of Hijra [A.D. 1304/5].

This pen box, considerably larger than the one made by Mahmud ibn Sunqur in 1281 (no. 13), has the rectangular format commonly found in the fourteenth century (see no. 24; also represented in nos. 20–21). The object is made of several pieces: both the lid and the body are double shelled and held together by a series of studs; the sections for the reed pens and the inkwell are separate units; the inkwell contains a semicircular depression for the inkpot and two small rounded holes for the containers for sand, starch paste, or red ink. The inkpot and the other two containers are missing. When the piece was repaired at a later date, the upper panel on the lid was reversed; the inscriptions now face the back instead of the front. The two hinges attaching the lid to the body at the back also date from this period. The frontal hasp is missing.

The decoration consists of an extensive repertoire of inscriptions, floral and geometric arabesques, and figural compositions. The inner and outer surfaces of the lid and body are completely covered with meticulously executed designs, which produce a stunning overall effect.

The upper surface of the lid has been abraded and has lost its inlay. A band of kufic inscription, intersected by eight six-petaled rosettes, frames the central panel, which contains three medallions representing riders. The field, divided by the medallions into four units, is filled with a floral arabesque; each unit contains a thin strip of thuluth inscription in the center with two roundels with geometric motifs placed on the vertical axis. The central medallion depicts a hunter with a hawk, presented in arrested movement. The riders in the two lateral medallions gallop toward the center, bearing a bow and arrow, and are accompanied by a dog, which attacks an onager or a leopard (?).

The outer sides of the lid contain oval units with plaited kufic inscriptions alternating with six-pointed stars enclosed by roundels. The central roundel in the front is blank, possibly reserved for the hasp.

The inner surface of the lid has a large central panel with a thuluth inscription on a floral ground. The encircling frame is also adorned with floral motifs and decorated with sixteen small medallions containing pairs of ducks that alternate with roundels filled with geometric designs. The inner surface of the sides has an overall geometric pattern, accentuated by eight six-petaled roundels.

The outer sides of the body have ten large medallions alternating with geometric roundels against a floral ground. The medallions at the edge of the sides turn around the corners and are thus broken into two halves. These four split medallions contain a standing figure in each half, while the six complete ones represent riders. Following the format seen on the upper surface of the lid, each long side has a central figure depicted in arrested movement, while the lateral figures ride toward him. The rider in the center of the front of the pen box is shown frontally; he bears a sword and attacks a lion. His counterpart at the back turns into the picture frame; he wears full armor and pursues an enemy with a sword. The riders in the remaining four medallions use bows and arrows to hunt leopards, foxes, and lions. The hinges obliterate two scenes. The short sides of the pen box contain only two split medallions. The worn underside of the body has an overall geometric pattern.

The most elaborately decorated and best preserved portion of the piece is the interior, which is divided into two unequal parts: an oval unit for pens and a section with three compartments for ink, sand, and paste. The base of the pen unit has a border of flying ducks interrupted by six geometric roundels. In the center is an inscription panel flanked by two large medallions. The inscription, placed on a floral arabesque, is accentuated by two axial pendants with geometric motifs. Each of the large medallions is composed of a geometric roundel surrounded by a border in

which six ducks fly amidst a floral scroll. The walls of the pen unit are constructed in four panels; the two at the sides curve in to form an oval. One of these panels was placed upside down during the restoration. A beaded border frames each of the panels, which reveal inscriptions broken by a central roundel with six flying ducks. Floral arabesques enhanced with geometric roundels appear in the compartments reserved for the containers, which were likely made of brass.

As in other examples of Mamluk metalwork, gold is employed exclusively in the geometric roundels, while silver appears in the inscriptions, floral arabesques, and figural compositions. The precious materials used in the inlays not only form a contrast but also accentuate the different decorative motifs.

This magnificent pen box, which dates from the reign of Sultan Nasir al-Din Muhammad, must have been made for a highly sophisticated and learned man who could appreciate the metaphors and mystical implications included in the inscriptions. He was obviously one of the scholars of the age and belonged to the men of the pen.

Published
Répertoire, vol. 13, no. 5181.
Migeon 1907, vol. 2, p. 208.
Migeon 1922, vol. 1, no. 97 and pl. 28.
Migeon 1927, vol. 2, pp. 82 and 86.
Wiet 1932, p. 25, no. 41, p. 81, no. 10, and app. no. 126.
D. S. Rice 1957, p. 304.
Chambéry 1970, no. 76.
Paris 1971, no. 160.
Angoulême 1974–75, no. 66.
Paris 1977, no. 449.

24

Pen box
Brass: inlaid with silver, gold, copper
Circa 1320
Made for Imad al-Din Abu'l-Fida Ismail

Height: 7.5 cm. (2$\frac{15}{16}$ in.)
Length: 31.0 cm. (12$\frac{3}{16}$ in.)
Width: 9.5 cm. (3$\frac{3}{4}$ in.)

Cairo, Museum of Islamic Art, 15132
Purchased 1945
Ex-Harari Collection, 179

Inscriptions
Panel on top of lid:

عز لمولانا السلطان الملك المؤيد عماد الدنيا والدين ابى
الفداء اسماعيل عز نصره

*Glory to our master, the sultan, al-Malik
al-Muayyad Imad al-Dunya wa'l-Din Abu'l-
Fida Ismail, may his victory be glorious.*

The shape and dimensions of Abu'l-Fida's pen box
are almost identical to the previous example
(no. 23), but the decoration consists of repetitive
minute patterns that contrast and accentuate the
bold inscription on the lid. The work is in two
sections; the hinges and hasp are missing.

The upper surface of the lid contains a large
inscription panel bearing the dedication. This is
the only inscribed portion of the pen box. It is
exceptionally striking, with majestic thuluth
placed against an intricate floral arabesque
accentuated with gold and filled with birds,
harpies, and animal heads. The border reveals a
lattice pattern in which diamond-shaped units are
alternately filled with gold geometric motifs and
silver trefoils resembling fleur-de-lis or stylized
lotus blossoms.

The outer sides of the lid contain a series of
roundels bearing three different motifs: floral
arabesques, quatrefoil blossoms, and heraldic
shields with a plain field above ten bends
(diagonal lines). Although an attempt is made to
alternate these motifs, the sequence of arabesques,
blossoms, and shields is not always consistent.
The number of roundels at the sides totals forty-
eight, including five that were defaced by later
restoration attempts to attach the hinges and
hasp. The decoration is further enhanced by two
additional series of smaller geometric units placed
above and below the roundels; the field is filled
with a floral arabesque. A continuous ribbon
encircles the units and links them with each other.

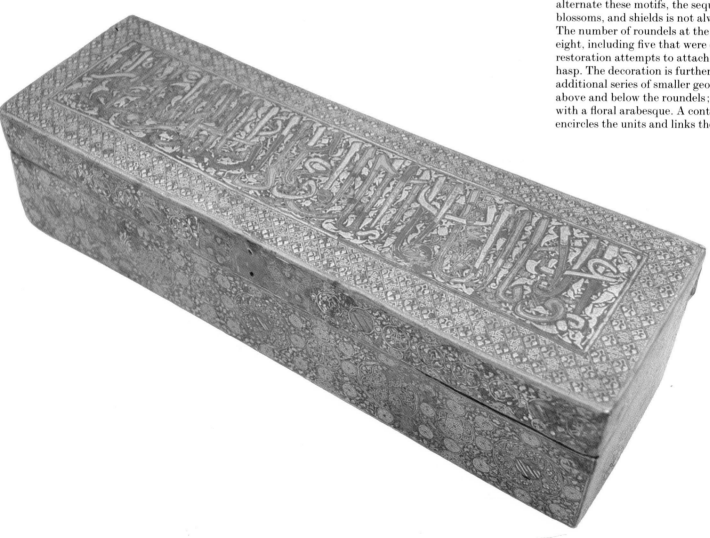

Adorning the outer sides of the body is a similar profusion of minuscule elements, accentuated by twelve medallions employing two alternating themes framed by floral scrolls: the heraldic shield enclosed by strapwork and six-petaled blossoms decorated with geometric motifs. Between the medallions are six-petaled roundels, each petal bearing a trefoil. The surrounding field is filled with dense floral arabesques and tiny geometric roundels. Each unit is interconnected by a thin silver ribbon.

The underside of the body is also beautifully decorated. A band broken into ten strips by geometric roundels surrounds the base; the strips are filled with scrolls alternately bearing flowers or five flying ducks. In the center are three medallions linked by quatrefoil cartouches placed on a field of floral arabesques accentuated by geometric roundels. The central medallion has floral arabesques, the lateral medallions contain six-petaled rosettes.

The inside of the pen box is perhaps the most carefully executed section and reveals the same floral and geometric motifs that decorate the exterior. The section for the inkwell is missing (see also no. 13); the oval pen unit has a central medallion with a geometric roundel in the core enclosed by two rings with trefoils and geometric motifs. Additional geometric roundels and units link the medallion with the two lateral quatrefoil cartouches that are filled with floral decorations. The interstices are densely covered with a floral arabesque; an identical decoration interrupted by four roundels forms the border.

Silver is used lavishly on the piece; gold is reserved for the geometric motifs and outlines the quatrefoils and six-petaled blossoms; the heraldic shields make exclusive use of copper, which alternates with gold and bitumen in the bends.

The contrast between the main inscription band and the dense overall pattern creates an impact that is at once bold and intricate. The circular motifs create a slow perpetual movement that revolves around the piece, harmoniously blending the diverse elements. The effect produced is not unlike the astral symbolism seen in illuminations of the Koran (see no. 5). This sophisticated design concept and microscopically detailed composition would have been much to the liking of the owner, Abu'l-Fida (1273–1331), descendant of the Hama branch of the Ayyubids.

The patron of the work, whose full name—Imad al-Din Abu'l-Fida Ismail—is given in the inscriptions, was a celebrated soldier, statesman, and scholar. He served as Amir of Ten (1291), Amir of Forty (1293), and governor of Hama (1310). He received a number of honors during his illustrious life, including the title al-Malik al-Muayyad and the rank of sultan, which were bestowed upon him in 1320 by Nasir al-Din Muhammad. Since both honorifics appear on the pen box, the piece must have been made shortly after this date.

Abu'l Fida's blazon is repeated seventeen times on his pen box: eleven times on the lid and six times on the body. His heraldic symbol consisted of a two-fielded shield: the upper plain and the lower divided into ten to twelve bends, alternately colored yellow (gold), red (copper), and black (bitumen). The same blazon appears on the mosque of Abu'l-Fida at Hama. It has been suggested that this blazon was the heraldic symbol of the Hama branch of the Ayyubids who served the Mamluks (see also no. 46).

Abu'l-Fida is renowned for his literary works, the most important of which are a history of the world and a geography. The former, entitled *Mukhtasar Tarikh al-Bashar*, printed in İstanbul in 1869/70, begins with the pre-Islamic period and concludes with the events of the year 1329; the geography, *Takwin al-Buldan*, completed in 1321, became the standard text for later scholars.[1]

Published
Mayer 1933, pp. 46–47 and pl. XLIX.
Mostafa 1958, no. 36.
Cairo 1969, no. 64 and fig. 11.

Notes
1. H. A. R. Gibb, "Abu'l-Fida," *Encyclopedia of Islam*, 2d ed. (Leiden: E. J. Brill; London: Luzac & Co., 1960), 1: 118–19.

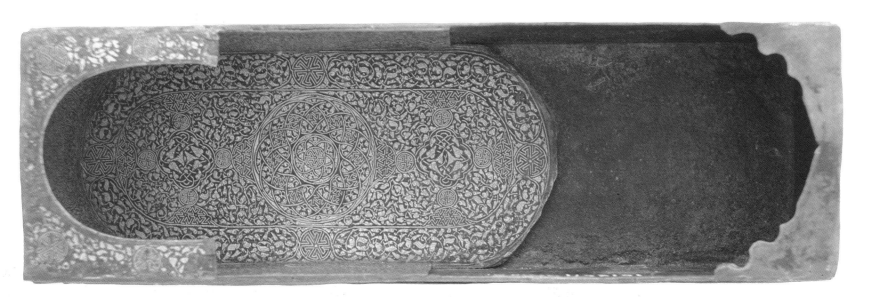

25
Koran box
Wood: plated with brass, inlaid with silver, gold;
 interior faced with paper
Circa 1330

Height: 28.0 cm. (11 in.)
Length and width: 44.5 cm. (17½ in.)

Cairo, Museum of Islamic Art, 183
From Mosque of Sultan Qansuh al-Ghuri (built in
 1504), 1882–99

Inscriptions
Central medallion on top of lid: Surat al-Hashr
 (The Gathering; LIX:23).
Band framing top of lid: Surat al-Al-i Imran
 (The Family of Imran; III:18–19 and 26–27).
Band encircling sides of lid: Surat al-Waqia
 (The Event; LVI:76–80).
Band encircling sides of base: Ayat al-Kursi
 (Verse of the Throne; II:255).

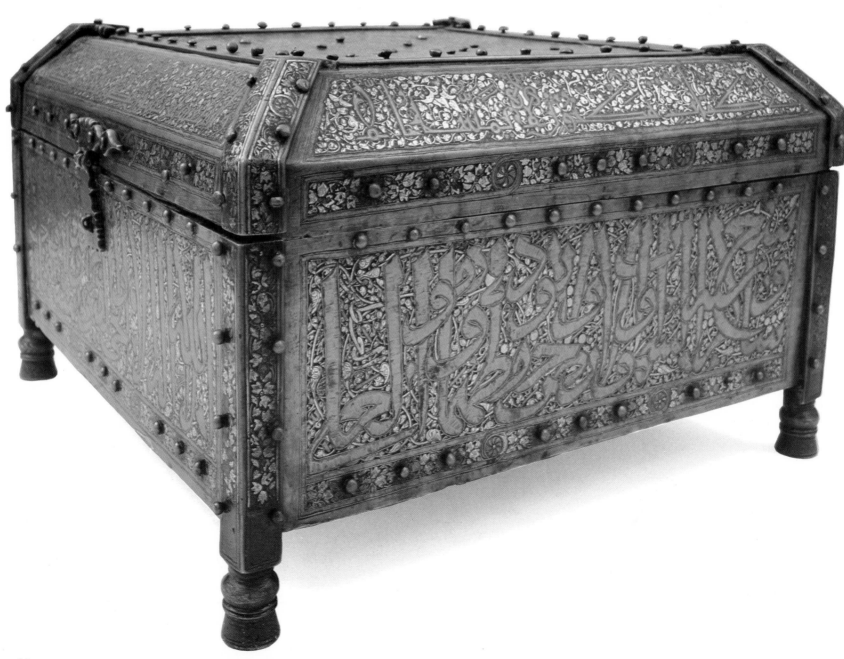

This magnificent Koran box was made to protect a thirty-volume Koran donated by the sultan to his religious foundation. Although the date and the name of the patron are not given, its style suggests that it was made during the reign of Nasir al-Din Muhammad, who was renowned for his charitable establishments and spectacular objects (see no. 26). A similar box, signed by an artist named Muhammad ibn Sunqur, is now in Berlin.[1] The same artist produced in 1327 a hexagonal table, popularly called a *kursi* (lectern), for Sultan Nasir al-Din Muhammad.[2] Another Koran box, made in 1322 by Ahmad ibn Bara al-Mawsili, is in the Library of al-Azhar Mosque in Cairo and bears a dedication to Nasir al-Din Muhammad.[3] The signatures of the artists in the Berlin and al-Azhar boxes appear on the hasp. Unfortunately, the hasp of the illustrated example has been replaced and whatever inscription it may have contained is now lost.

The box was made in two sections: an angular lid and a square body resting on four feet. The lid is attached to the body by two hinges and fastens with a frontal hasp. The box is constructed of wood and covered with plates of inlaid brass, which are bound with bands and attached to the wood core by studs. The interior has two compartments, each partitioned to hold fifteen slender volumes. The underside is plain and the interior of the lid and the body were lined with paper, which has since deteriorated. The piece has been repaired, and the hasp and three of the feet were replaced at a later date.

The lid has a flat top with a lobed central medallion bearing a radiating inscription. In the middle of each side is a lobed triangular cartouche filled with trefoils and bunches of grapes; these units are joined to the medallion by roundels with swirling rosettes. Large lotus blossoms, five-petaled florets, and flowers resembling peonies with oversized serrated petals appear in the corners. A frieze of inscriptions encloses the top, with four swirling rosettes in the corners. The reinforcing band, which attaches the top panel of the lid to the wood core, is decorated with a scroll bearing trefoils, interrupted by swirling rosettes. The same design is used on the vertical bands on the four corners.

The tapering sides of the lid have a beautifully rendered kufic inscription placed on a refined floral scroll with large lotus blossoms intermingled with smaller buds. The last word in each of the four panels has been omitted. It is possible that the artists were working from cartoons and did not take into account the necessity of cutting the sides of the panels in order to accommodate the reinforcing bands. The strips at the lower edges of the lid are adorned with the same trefoil blossoms and swirling rosettes seen on the reinforcing bands.

The sides of the body have a majestic thuluth inscription on a floral ground. While working on the right side, the artist obviously discovered that the text could not fit into the allotted space and wrote the last verse perpendicularly to the rest. The terminating band on the body repeats the decoration seen on the lower portion of the lid and reinforcing bands.

The inscriptions and decorative repertoire of the box are consistent with the style associated with the reign of Sultan Nasir al-Din Muhammad. Bunches of grapes decorating the top of the lid are rather unusual, but they also appear in a stone panel (no. 111).

The side panels of the lid, with kufic inscriptions placed on a floral scroll ground, resemble the units employed in the illuminations of contemporary Korans (nos. 1–3).

Published
Herz 1906, p. 187, no. 15 and fig. 35.
Herz 1907, p. 174, no. 15 and fig. 34.
Migeon 1907, vol. 2, p. 208 and fig. 167.
Migeon 1927, vol. 2, p. 82 and fig. 257.
Ross 1931, p. 325 (bottom).
Abd el-Rauf 1962, pp. 104–5 and fig. 7.
Cairo 1969, no. 62.
Aslanapa 1977, p. 77, fig. 10.

Notes
1. Berlin, Museum für Islamische Kunst, I 886 (published in several places, including Berlin 1971, no. 19, fig. 69; London 1976, no. 214).
2. Cairo, Museum of Islamic Art, 139 (Cairo 1969, no. 61 with bibliography).
3. Published in Wiet 1929a, no. 571; Wiet 1932, app. no. 180; Cairo 1969, no. 60 and pl. 9.

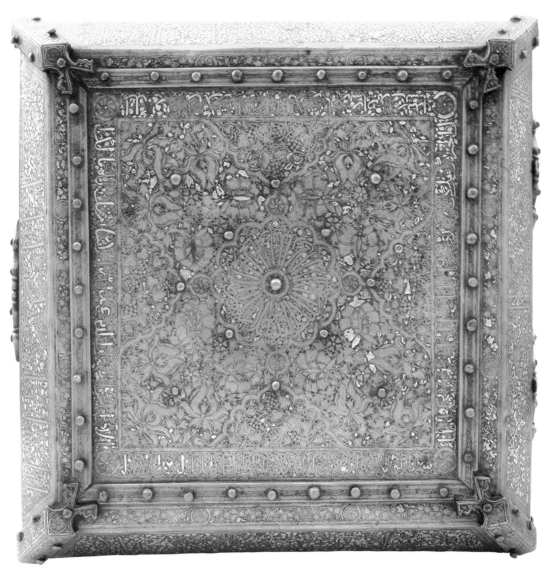

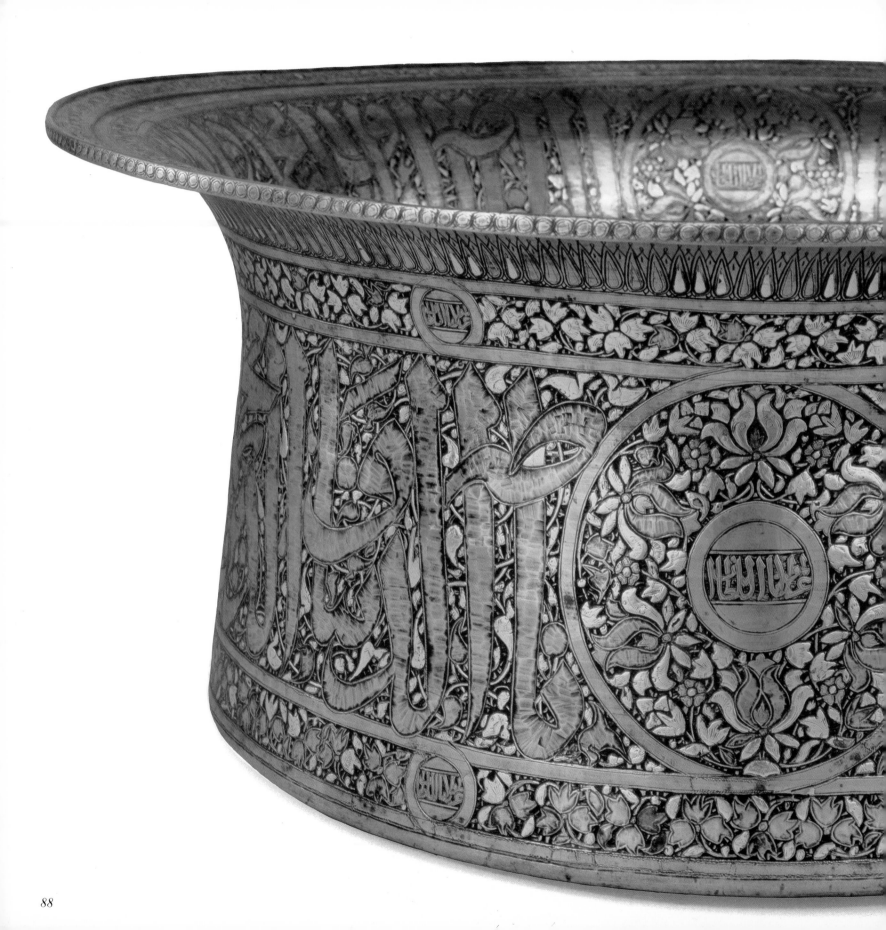

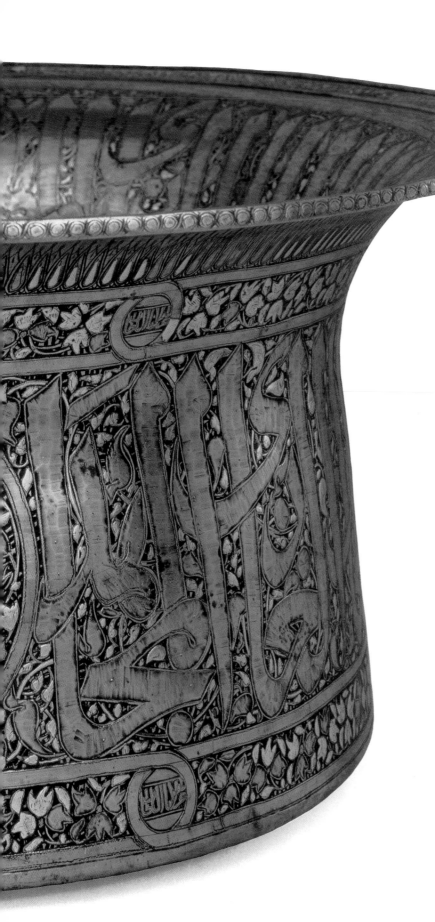

26
Basin with epigraphic blazon
Brass: inlaid with silver, gold
Circa 1330
Made for Sultan Nasir al-Din Muhammad

Height: 22.7 cm. (8⅝ in.)
Diameter of rim: 54.0 cm. (21¼ in.)

London, The British Museum, 51 1-4 1
Purchased 1851

Inscriptions
Exterior on three panels of body:

عز مولانا السلطان [sic] الملك لناصر العابد الغازى المجاهد *

ناصر الدنيا والدين محمد بن قلاون

Glory to our master, the sultan al-Malik al-Nasir, the devout, the champion [of Islam], the defender [of the faith], Nasir al-Dunya wa'l-Din Muhammad ibn Qalawun.

Exterior on six roundels in upper and lower bands and in center of three medallions (an extra alif is added to those in the medallions):

عز مولانا السلطان

Glory to our master, the sultan.

Under rim:

الصبر عبادة

Patience is worship.

Interior on three panels on rim:

عز مولانا السلطان الملك الناصر * العالم العابد الغازى المجاهد ا*

لمرابط ناصر الدنيا والدين محمد بن قلاون عز نصره

Glory to our master, the sultan al-Malik al-Nasir, the learned, the devout, the champion [of Islam], the defender [of the faith], the warrior [of the frontiers], Nasir al-Dunya wa'l-Din Muhammad ibn Qalawun, may his victory be glorious.

Interior on roundels in center of three medallions:

عز مولانا السلطان

Glory to our master, the sultan.

Sultan Nasir al-Din Muhammad, who ruled for almost half a century until 1341 with an interruption of only four years, was indeed the most outstanding patron of the arts. He was a fervent builder who commissioned dozens of magnificent objects for his establishments and personal use.[1] The art of inlaid metalwork—employing a variety of decorative themes—reached the ultimate technical and aesthetic perfection under his patronage. During his reign the figural compositions associated with the school of Mosul flourished (see nos. 18–23) and the epigraphic Mamluk style became fully established.

The most striking element in this style is the bold script rendered in majestic thuluth. Inscriptions are not only used to transmit messages, but they now become the main decorative feature. Inscriptions are also employed in royal blazons with circular shields containing the name and titles of the sultans (see nos. 30–31, 34–35, 52, 101, and 110). The boldness of the script is accentuated by a ground of intricate floral scrolls, their tendrils often transformed into flying ducks or birds. The impact of the script is also contrasted by medallions enclosing lotus blossoms, peonies, and five-petaled florets and by bands filled with a peculiar flora composed of trefoils with gold cores and delicately marked veins (see no. 25).

The traditional Mamluk decorative layout is based on multiples of threes. Each component is at once an independent unit and an integral part of the whole, harmoniously united by various design features, such as continuing inscriptions, repetitive motifs, and thin ribbons that encircle and link the diverse segments. The same tripartite design with detached and combined components is a feature characteristic of manuscript illumination and was perhaps first perfected by painters (see nos. 1–3).

This basin is an outstanding example of the Mamluk epigraphic style established during the reign of Sultan Nasir al-Din Muhammad, its vestiges still to be found in the modern arts and crafts produced in Egypt and Syria. Although a number of silver inlays have been lost, particularly large pieces of the inscriptions, the basin is of imperial quality, befitting the fame of its patron.

The wide thuluth band on the exterior is divided into three panels by large medallions and framed above and below by a floral scroll interrupted by six roundels. The inscription is placed against a floral scroll with some of the leaves transformed into ducks, geese, or other fowl. The medallions have a wide frame with six lotus blossoms alternately facing in and out, intermixed with five-petaled blossoms and trefoils. The epigraphic blazons in the core have a central field with a phrase praising the sultan. The roundels in the floral bands above and below are identical to those in the medallions. A series of lancet leaves encircles the neck and a beaded band adorns the thickened lip.

The everted rim has a double border: the outer edge has a scroll bearing trefoil blossoms and five-petaled flowers; the inner border shows a row of flying ducks intersected by six-petaled rosettes. The decoration of the inner walls repeats that of the exterior, with a thuluth inscription broken into three parts by large medallions. Below the inscription panel is a floral arabesque terminating in a series of lancet leaves.

The interior of the base is framed by a band identical to the one encircling the lower portion of the inner walls. Inside this band are three double rows of fish, which swim in opposing directions and encircle a central unit of six fish with their heads forming the core. Irregularly placed roundels fill the interstices. The position of each fish is counteracted by another, creating the effect of rippling movement. The depiction of fish swimming in slow motion in the bottom of basins and bowls is a traditional Islamic feature dating from the twelfth century. The image of a fish pond recurs on later Mamluk examples and survives through the sixteenth century (see no. 21 for its most elaborate representation; see also nos. 20 and 27–29).

In Nasir al-Din Muhammad's basin there is no trace of silver inlay on the bottom. The fish have been incised and grooves for fixing the silver have been placed outside the original outlines. This suggests the possibility that the designer and the inlayer were two different people. The epigraphic mistakes in the inscriptions also indicate that the person who wrote the messages was not a professional scribe but an artisan attached to the workshop. Similar discrepancies occur in the inscriptions on other fourteenth-century metalwork, confirming group efforts by members of a workshop.

The wording of the inscriptions and the phrases on the blazon are characteristic of this period. They appear on all the objects bearing Nasir al-Din Muhammad's name, including the magnificent tray in the Victoria and Albert.[2] The inscriptions on this tray contain another version of the epigraphic design employed on metalwork: the letters revolve around a medallion, their shafts radiating from the center (see nos. 25 and 30–31).

Published
Lane-Poole 1886, pp. 227–28 (small format); p. 190 (large format).
Migeon 1907, vol. 2, p. 206 and fig. 164.
Migeon 1927, vol. 2, pp. 76–77 and fig. 253.
Ross 1931, p. 318.
Wiet 1932, app. no. 183.
Barrett 1949, pp. xvii and xxiii and pl. 28.
M. H. Zaki 1956, nos. 508–9 and figs. 508–9.
Aslanapa 1977, p. 76, fig. 9.

Notes
1. Wiet 1932, p. 27 and app. nos. 175–202 lists twenty-eight pieces bearing his name. See also Izzi 1974. One of Sultan Nasir al-Din Muhammad's candlesticks decorated with figural compositions is now in Vienna, Österreichisches Museum für angewandte Kunst, Go 1033 (Vienna 1977, no. 122). His name also appears on a basin identical to the one in the British Museum; this piece, in Naples, Capodimonte, omits the inscriptions in the roundels (Naples 1967, no. 12 and pl. 1).
2. London, Victoria and Albert Museum, 420-1854 (Lane-Poole 1886, small format, p. 229).

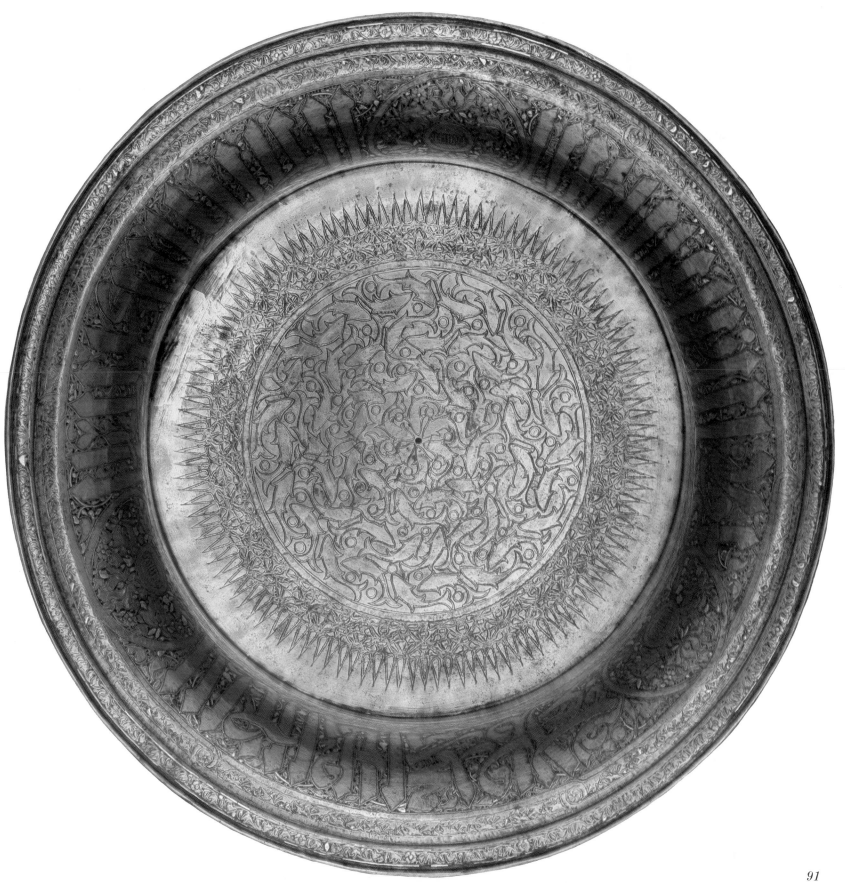

27
Basin
Brass: inlaid with silver, copper
Circa 1340
Made for Qushtimur, majordomo of Toquztimur

Height: 19.5 cm. (7$\frac{11}{16}$ in.)
Diameter of rim: 44.0 cm. (17$\frac{5}{16}$ in.)

Cairo, Museum of Islamic Art, 15038
Purchased 1945
Ex-Harari Collection, 166

Inscriptions
Three panels on exterior:

الجناب العالى المولوى الاميرى الكبيرى المالكى * العالمى العاملى
العدلى الغازى المجاهدى المرا * بطى المخدومى السيفى قشتمر
استاذ الدار الكريمة طقزتمر امير مجلس عز نصره

*The sublime highness, the master, the great amir,
the royal, the learned, the efficient, the just, the
champion [of Islam], the defender [of the faith],
the warrior [of the frontiers], the masterful,
al-Sayfi Qushtimur, the majordomo of the noble
house of Toquztimur, the Amir of the Council,
may his victory be glorious.*

Six panels on interior: Same as exterior except
that the ninth word العدل (the just) is replaced
by المخدومى (the masterful), which itself is
omitted further on.

Mamluk officers frequently commissioned metal
objects for their establishments and personal use.
They were proud of being associated with the
powerful amirs and often used the blazons of their
masters on their objects. The blazon used on this
basin is a composite and contains an almond-
shaped shield containing an eagle with
outstretched wings. The eagle stands between a
stemmed cup and a bar. The inscription states
that this basin was made for Qushtimur, who was
the majordomo of Toquztimur, the *amir majlis*
(president of the council). Although Qushtimur's
own blazon was a circular shield with five bars,[1] he
preferred to use his master's heraldic emblem on
this basin. Toquztimur, who died in 1345, was
once the mamluk of Abu'l-Fida (see no. 24) and
the *saqi* of Sultan Nasir al-Din Muhammad.
He became *amir majlis* in 1330/31 and later served
as viceroy of Egypt and Syria. Toquztimur's
blazon appears on a number of objects, including a
brass base in Cairo, two glass lamps in the British
Museum,[2] and a ceramic flask (no. 96). Qushtimur,
the majordomo of Toquztimur, used his master's
blazon on at least three other objects.[3]
 The basin has a typical Mamluk shape with flat
bottom, slightly tapering sides, and wide everted
rim. Encircling the exterior is a solitary band of
thuluth inscriptions broken into three panels by
medallions enclosing the blazons. The medallions
have floral scroll borders and foliate pendants.

Above and below the middle of each panel are
triangular cartouches with floral motifs. Floral
scrolls adorn the ground of the inscriptions,
thickened lip, and two borders of the rim.
 The decoration of the rim is more elaborate
than that of the exterior. A similar inscription
band encircles this area, but it is broken into six
panels by medallions with alternating designs.
Three panels enclose blazons identical to those on
the exterior, while the other three have a central
six-petaled rosette surrounded by a scroll with
four pairs of ducks. These rosettes, associated
with the house of Qalawun, also appear on
Toquztimur's flask (no. 96). A loose foliate design
with finials appears below.
 The interior of the base has a border similar to
the one on the lower portion of the interior.
The central design is composed of three concentric
rows of fish with roundels filling the interstices.
Six fish swimming in opposite directions form the
inner row; the same countermovement appears in
the next group of ten fish and concluding row of
twelve. The direction of the fish creates a rippling
effect frequently seen in Mamluk basins and bowls
(see nos. 20–21 and 28–29).
 Almost all of the silver inlay has disappeared;
the copper, used for the ground of the shield, is
still intact.

Published
Wiet 1932, app. no. 212.
Cairo 1969, no. 69 and fig. 14.
London 1976, no. 222.

Notes
1. Qushtimur's blazon appears on a tray (Mayer 1933, no. 192,
pl. XLII-6).
2. For Toquztimur's blazon see Mayer 1933, pp. 235–37, pl. XVI;
D. S. Rice 1950, pp. 372–73 and 373, note 1. The vase is in
Cairo, Museum of Islamic Art, 15125 (Mayer 1933, pl. XVI;
London 1976, no. 223). The lamps are in London, British
Museum, 69 6–24 1 (Harden 1968, no. 158, pl. IV); and
69 6–24 2.
3. Mayer 1933, pp. 236–37, nos. 4–6.

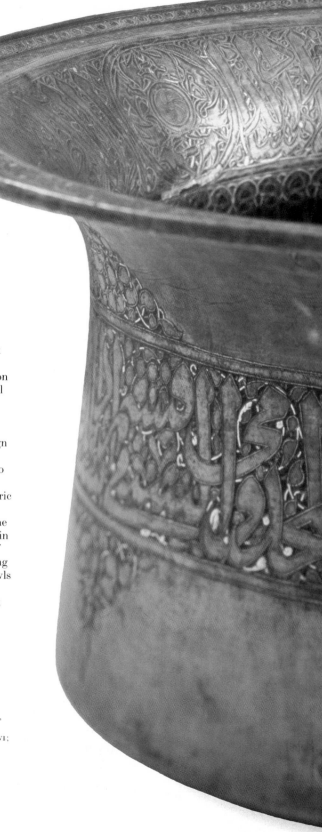

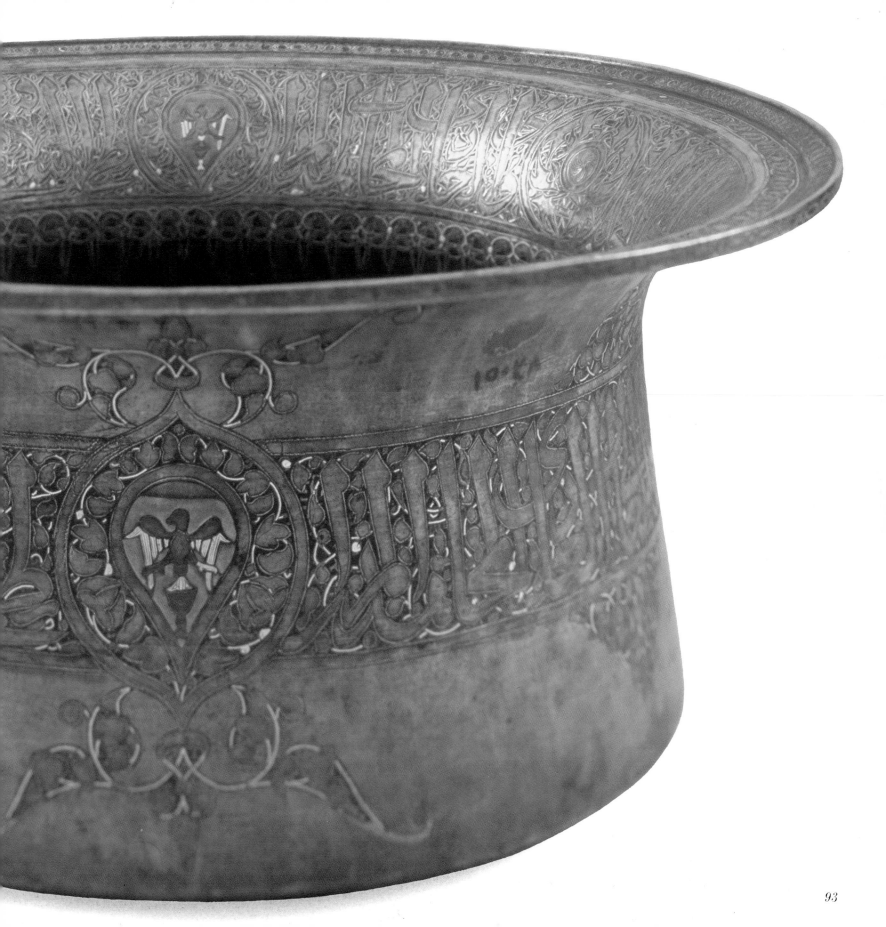

28
Basin
Brass: inlaid with silver, copper
Mid 14th century
Made for Tabtaq, an officer of Sultan al-Malik al-Ashraf

Height: 18.2 cm. (7⅛ in.)
Diameter of rim: 44.0 cm. (17⁵⁄₁₆ in.)

Cairo, Museum of Islamic Art, 24085
Found at Qus, 1966

Inscriptions
Six panels on exterior:

مما عمل برسم المقر الاشرف * العالى المولوى * العالمى العاملى *

العادلى الغازى * المجاهدى المخدومى السيفى * ططو (طبطق) الملكى الاشرفى

*One of the things made for the noble excellency, the sublime master, the learned,
the efficient, the just, the champion [of Islam], the defender [of the faith], the
masterful, al-Sayfi Tabtaq [?], [officer] of al-Malik al-Ashraf.*

Six panels on interior:

مما عمل برسم المقر الاشرف * العالى المولوى المشيرى * العالمى العاملى العـ *

ادلى الغازى المجاهدى المرابطى المالكى المخدومى السيفى * ططو (طبطق) الملكى الاشرفى

*One of the things made for the noble excellency, the sublime master, the
counselor, the learned, the efficient, the just, the champion [of Islam], the
defender [of the faith], the warrior [of the frontiers], the royal, the masterful,
al-Sayfi Tabtaq [?], [officer] of al-Malik al-Ashraf.*

The basin was made for a Mamluk amir named Tabtaq (or Toqto), who—as
indicated by the blazon representing a stemmed cup placed between two
bars—appears to have been a *saqi* in the service of a certain al-Malik
al-Ashraf. These titles were used by Khalil (1290–93), Kujuk (1341–42), and
Shaban II (1363–76). The bold epigraphic design of the basin suggests a date
after the reign of Nasir al-Din Muhammad, for whom Tabtaq served as the
governor of Qus (between 1312 and 1320),[1] where this piece and a matching
ewer were found.[2] Since this sultan's titles are not given in the inscriptions,
it seems likely that Tabtaq ordered the basin and ewer while he was employed
by Sultan Kujuk.

The shape of this piece differs from that of traditional basins and has a
rounded bottom with curving sides, resembling a large bowl. The high and
wide everted rim is disproportionate to the body and overburdens the piece.
Nevertheless, the simple but elegant decoration, impeccably executed, more
than compensates for any misgivings in regard to its rather awkward shape.

The bold thuluth inscription on the exterior, placed on a sparse floral
ground, is interrupted by six medallions bearing circular blazons.
The blazons contain three bars with a stemmed cup placed in the center:
the upper bar is inlaid in copper, the lower is filled with a black bituminous
material and minutely hatched, the field of the central bar is plain brass, the
cup is covered with bitumen. Obviously, an effort was made to reproduce
the colors—black (bitumen), red (copper), and yellow (polished brass)—
traditionally used to depict this blazon.

An identical inscription band, broken by six blazons, adorns the rim.
A pearl band frames the outer edge, followed by a narrow floral scroll
interrupted by six six-petaled rosettes. The scroll contains trefoil leaves with
accentuated veins associated with the style of the period (see nos. 19, 21,
25–26, and 29). The rosettes are plain and devoid of silver inlay.

The interior of the base has the traditional group of fish swimming in
opposite directions. Here a simplified version is used, with six fish arranged
in a single row, their heads pointed toward the core.

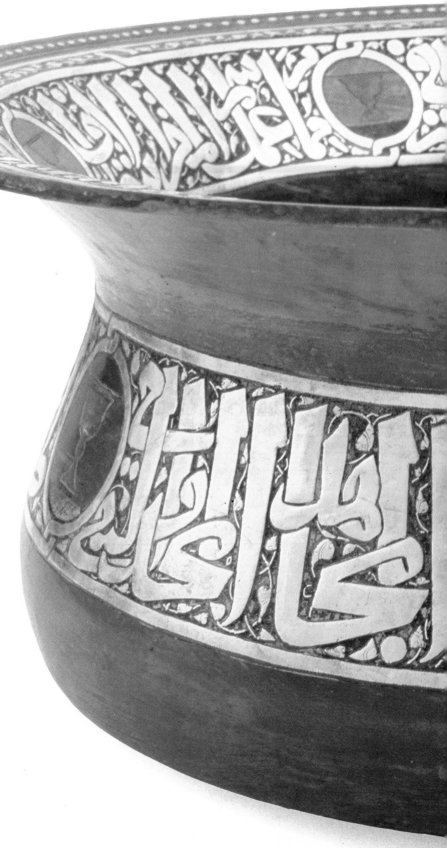

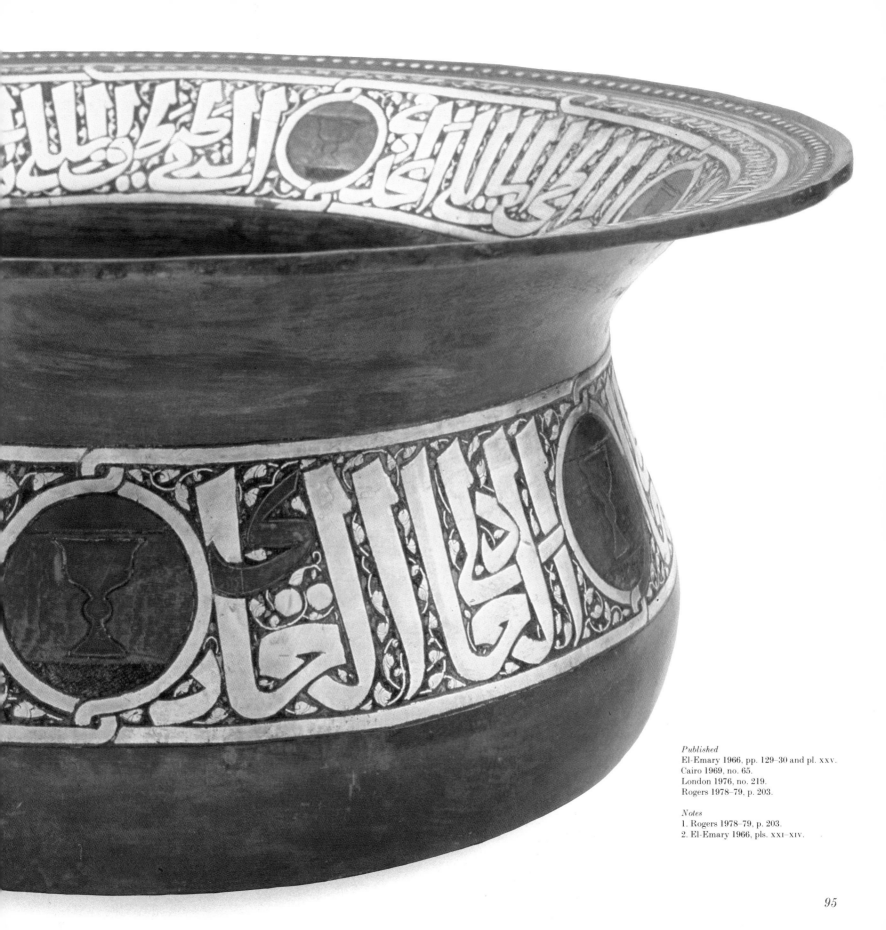

Published
El-Emary 1966, pp. 129–30 and pl. xxv.
Cairo 1969, no. 65.
London 1976, no. 219.
Rogers 1978–79, p. 203.

Notes
1. Rogers 1978–79, p. 203.
2. El-Emary 1966, pls. xxi–xiv.

29
Bowl
Brass: inlaid with silver, gold
Mid 14th century
Made for an officer of Sultan al-Malik al-Muzaffar

Height: 9.5 cm. (3¾ in.)
Diameter of rim: 17.0 cm. (6¹¹⁄₁₆ in.)

Cairo, Museum of Islamic Art, 15131
Purchased 1945
Ex-Harari Collection, 126

Inscriptions
Three panels on exterior:

المقر العالى المولوى الاميرى * الكبيرى السيدى السندى المالكى الذ *
خرى الغياثى الهمامى العونى المشيرى دام عزه

*The sublime excellency, the master, the great
[and] wise amir, the wise, the royal, the upholder
of the needy, the heroic defender, the counselor,
may his glory be eternal.*

Roundels in center of three medallions on exterior
(and possibly on base):

الملك المظفر
al-Malik al-Muzaffar.

Medallion on base:

المقر العالى المولوى الاميرى الكبيرى العالمى العامل السيدى
الملكى دام عزه

*The sublime excellency, the master, the great amir,
the learned, the efficient, the wise, the royal, may
his glory be eternal.*

Bowls with rounded bases, curving sides, and
thickened straight rims were produced in large
quantities by Mamluk metalworkers. The
majority are adorned with wide inscription panels
interrupted by three or six medallions.

Inlaid decoration completely covers the exterior
of this piece. The walls have three identical
medallions interrupting the wide inscription panel
placed against a floral arabesque. The medallions
contain epigraphic blazons enclosed by trefoil
leaves. Below the inscription panel is a scroll with
the same trefoils, broken into three by roundels
filled with geometric patterns.

The base of the bowl has a central roundel, the
design of which is too abraded to decipher.
Surrounding it is a circular inscription with the
vertical shafts of the letters radiating outward.
The enclosing zone is composed of six semicircular
bands that overlap, forming a series of units filled
with floral arabesques and roundels. The larger
units of the outer zones contain three epigraphic
blazons that alternate with six-pointed stars; the
six smaller units in the middle have two pairs of
ducks. Floral scrolls fill the interstices, joining the
decoration of the base with that of the walls.

The interior is relatively plain and has a central
twelve-petaled rosette around which six fish swim.
The petals of the rosette swirl in a counterclock-
wise direction, while the fish move in the
opposite direction, creating the whirlpool effect
so commonly seen in bowls (no. 20) and basins
(nos. 21 and 26–28).

The honorific titles given in the blazon, al-Malik
al-Muzaffar, were used by several Mamluk sultans.
The only sultan whose titles correspond with the
style of decoration is Hajji I (1346–47); the
anonymous amir who commissioned this bowl
must have been one of the officials in his court.

Unpublished

30
Candlestick
Brass: inlaid with silver
Mid 14th century
Made for an officer of Sultan al-Malik al-Nasir

Height: 40.0 cm. (15¾ in.)
Diameter of base: 36.5 cm. (14⅜ in.)

Cairo, Museum of Islamic Art, 15080
Purchased 1945
Ex-Harari Collection

Inscriptions
Four panels on socket:

المقر العالى المولوى الاميرى الغازى المرابطى *
المثاغرى الهمامى النظامى * العالمى العامل المالكى الملكى الناصرى

*The sublime excellency, the master, the great amir,
the champion [of Islam], the defender [of the
faith], the warrior [of the frontiers], the protector
[of the frontiers], the generous administrator,
the learned, the efficient, the royal, [officer] of
al-Malik al-Nasir.*

Four roundels on socket:

الملك الناصر
al-Malik al-Nasir.

Three panels on shoulder:

المقر العالى المولوى المالكى العامل الهمامى * النظامى الافضلى الاكاملى
الغازى المجاهدى المرابطى ا * لمثاغرى المؤيدى العضدى الذخرى
المشيرى الكفيلى

*The sublime excellency, the master, the royal, the
learned, the efficient, the generous administrator,
the ultimate in perfection, the champion [of
Islam], the defender [of the faith], the warrior
[of the frontiers], the protector [of the frontiers],
the supporter [of Islam], the generous helper,
the equal counselor.*

Three panels on body:

المقر العالى المولوى المالكى المخد [sic] * المخدومى الهمامى
المجاهدى المرابطى العالمى * الكاملى المالكى الملكى الناصرى

*The sublime excellency, the master, the royal . . .
the masterful, the generous, the defender [of the
faith], the warrior [of the frontiers], the learned,
the perfect, the royal, [officer] of al-Malik
al-Nasir.*

Three medallions on body:

المقر العالى المولوى المحترمى المالكى العالمى العامل المرابطى المجاهدى
الملكى الناصرى

*The sublime excellency, the master, the revered, the
royal, the learned, the efficient, the warrior [of the
frontiers], the defender [of the faith], [officer] of
al-Malik al-Nasir.*

Roundels in center of three medallions on body:

عز لمولانا السلطان
Glory to our master, the sultan.

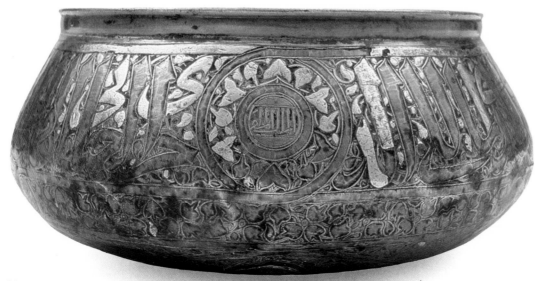

This candlestick is representative of the epigraphic style that became predominant in Mamluk metalwork after the middle of the fourteenth century. It was made for an amir who called himself the officer of "al-Malik al-Nasir," which suggests that his master was Sultan Hasan (1347–61, with interruption; see also no. 31).

The decoration of the piece relies on inscriptions used in roundels, medallions, and horizontal panels, as well as a latticework field with diamond-shaped units filled with clusters of trefoils or stylized lotus blossoms, resembling those used in the pen box of Abu'l-Fida (no. 24). The socket, the lip of which is chipped, has an inscription band broken by four epigraphic blazons bearing Hasan's titles. Braided rings encircle the top and bottom of the socket.

The neck is adorned with an overall latticework, each diamond-shaped unit containing a cluster of three leaves springing from a central core. A braided ring appears at the base of the neck.

The shoulder has eight roundels alternately filled with lotus blossoms and swirling rosettes. The sloping edge of the shoulder contains a band divided into six panels by eight-petaled rosettes; the panels have inscriptions or floral scrolls.

The upper portion of the body has two braided rings enclosing a recessed area decorated with a loose floral scroll. The body is decorated with three large polylobed medallions, in the center of each is an epigraphic roundel; surrounding the roundels are circular inscriptions with the vertical shafts of the letters radiating from the core. The zones between the medallions have the same lattice pattern seen on the neck but are divided by a central inscription panel. Roundels with lotus blossoms appear in the middle of each half. A braided ring projects from the lower part of the base, followed by two bands; the first repeats the floral scroll on the top and the second shows a simple beaded motif.

The epigraphic roundels on the socket bear the titles of the sultan, those in the center of the large medallions contain benedictory phrases. The longer inscriptions on the socket and base state that the owner was an officer in the service of the sultan. This combination of inscriptions was frequently used in the fourteenth century, and amirs often employed the epigraphic blazons of their rulers.

Incised inside the base is the name of a later owner, Imad al-Din, who was in the household of Murshid al-Mansuri.

Unpublished

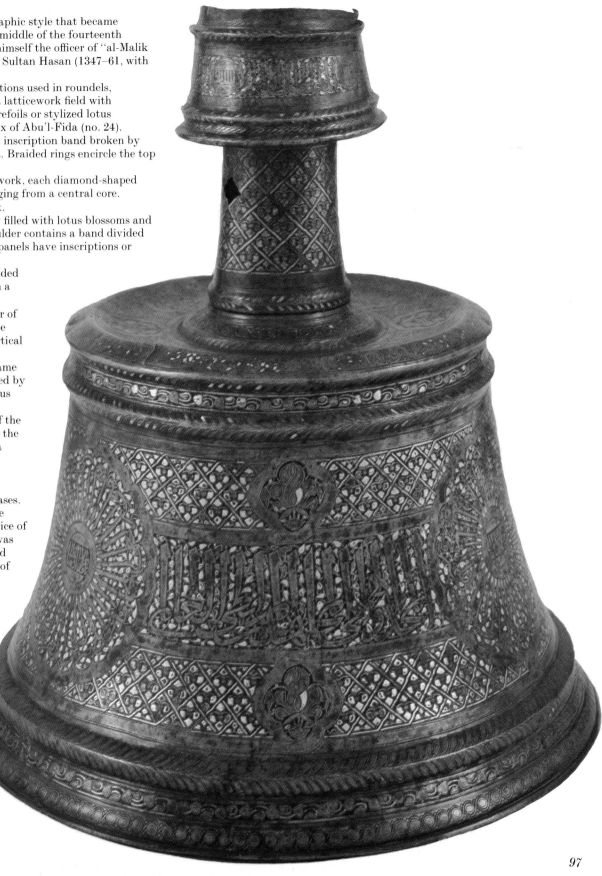

Rosewater sprinkler
Brass: inlaid with silver, gold
Mid 14th century
Made for Sultan Hasan

Height: 23.5 cm. (9¼ in.)
Max. diameter: 11.0 cm. (4⁵⁄₁₆ in.)

Cairo, Museum of Islamic Art, 15111
Purchased 1945
Ex-Harari Collection, 171

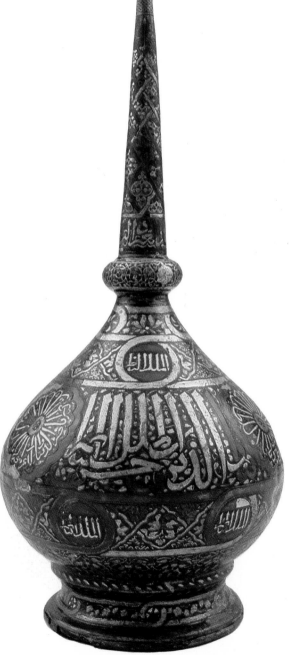

Inscriptions
Band on neck:

دام لك العز والهنا والحياه فى الصبح والمسا

*Eternal glory and tranquility and long life in the
morning and evening to you.*

Roundels on body: three in upper band and six in
lower band:

الملك الناصر

al-Malik al-Nasir.

Three panels on body:

عز لمولانا السلطان الملك الناصر ناصر الدنيا والدين الملك
الناصر حسن

*Glory to our master, the sultan al-Malik al-Nasir
Nasir al-Dunya wa'l-Din al-Malik al-Nasir
Hasan.*

Three medallions on body:

عز لمولانا السلطان الملك الناصر ناصر الدنيا والدين

*Glory to our master, the sultan al-Malik al-Nasir
Nasir al-Dunya wa'l-Din.*

Sultan Hasan is renowned for having built the
most impressive complex in Cairo and for
donating hundreds of lamps to light his madrasa
and mausoleum (see no. 52). A substantial amount
of metalwork was commissioned by the sultan and
his amirs. The majority of those that bear Sultan
Hasan's name was designated for his complex.[1]
This rosewater sprinkler is among the rare objects
made for his personal use.

The neck of Sultan Hasan's bottle has been
broken and repaired: the upper portion and ring
date from the Ottoman period.[2] The lip was
broken after restoration. The arabesque
cartouches on the neck and the good wishes
expressed in the lower portion follow the style of
the Ottoman period.

The body is divided into five unequal horizontal
panels, each adorned with a tripartite composition
containing roundels or medallions placed on
alternating vertical axes. The shift in vertical axis
is further stressed by the use of gold in the circular
areas. Each segment is framed by a continuous
band that not only defines the units but links
them with one another.

The uppermost band of nine lotus blossoms is
broken by three swirling rosettes. The next band
is composed of diamond-shaped units with pairs of
confronted and addorsed ducks. The triangular
interstices are filled with geometric motifs; three
epigraphic blazons interrupt this zone.

The central panel is the widest and has a large
inscription broken by three polylobed medallions
with inscriptions radiating from a rosette; both
units are placed on a floral ground.

The fourth band repeats the second but, due to
the wider proportions of the lower body, has twice
as many units. A floral scroll with lancet leaves
appears below the braided ring at the base.

The splayed foot is decorated with a floral
scroll, interrupted by six roundels with rosettes.
The underside of the foot has a scroll around the
rim, a floral arabesque in the circular recessed
unit, and a large eight-petaled boss in the center
(see also no. 19).

Gold appears in the rosettes, cores of the lotus
blossoms, inscriptions in the roundels and
medallions, and geometric motifs in the
latticework.

Published
Wiet 1932, app. no. 255.
Mostafa 1958, no. 70 and fig. 29.
Mostafa 1961, pp. 48–49 and fig. 42.
Cairo 1969, no. 79 and fig. 15.
London 1976, no. 225.

Notes
1. Wiet lists five other pieces with Sultan Hasan's name: a
lantern, two candlesticks, a vase shaped as a lamp, and a ewer
(Wiet 1932, p. 6, pls. XIII and XXVI).
2. An identical sprinkler, made for Sultan Ismail, Hasan's
brother and predecessor, is in Cairo, Museum of Islamic Art,
15115 (Izzi 1974, fig. 6).

32
Lamp
Brass: inlaid with silver, gold
Second half 14th century

Height: 29.9 cm. (11¾ in.)
Diameter of rim: 14.6 cm. (5¾ in.)

Cairo, Museum of Islamic Art, 15123
Purchased 1945
Ex-Harari Collection, 170

Inscriptions
Panel and four narrow bands on neck, the latter
interrupted by six roundels containing the word
Allah: Surat al-Fath (The Victory:
XLVIII:1–15).
Panel on body: Ayat al-Kursi (Verse of the
Throne; II:255).
Two bands on body and one band on foot, each
interrupted by six roundels containing the word
Muhammad:

لا اله الا الله * رسول الله

*There is no God but Allah; [Muhammad is] the
messenger of God.*

Panel on foot:

محمد رسول الله صلى الله عليه وسلم وابى بكر ثم عمر
ثم عثمان ثم على رضى الله عنهم اجمعين

*Muhammad is the messenger of God. God's
blessing and peace be upon him, and Abu Bakr
and Umar and Uthman and Ali, may God be
pleased with them all.*

Although the shape of this vessel imitates that of a glass lamp (see nos. 52–53 and 58), it could not have been used to emit light. The inscriptions deviate from the Ayat al-Nur (Verse of Light; XXIV:35) traditionally employed on mosque lamps (see nos. 52–53) and contain other Koranic passages, including the Ayat al-Kursi (Verse of the Throne; II:255), which is commonly seen on mosque furnishings, such as Koran boxes (see no. 25). This piece was probably used as an ornament in a religious building and suspended from the ceiling by chains or ropes attached to the three loops on the body.

The lamp is exquisitely decorated with inscription bands of varying sizes and styles of script. The neck has a wide thuluth panel with a group of three narrow bands encircling the rim and the base. The upper and lower bands in each group are identical and contain naskhi inscriptions broken into six panels by roundels enclosing the word Allah. A scroll with split leaves appears in the narrow band between these inscriptions.

The wide thuluth band on the body is divided into three by medallions adorned with six-petaled blossoms and leaves; in the center of each medallion is a boss with a loop used for suspension. The band encircling the shoulder is composed of interlaced scalloped ribbons that divide this zone into a series of triangular units with floral motifs, six-petaled blossoms, and leaves. The band below has six roundels enclosing the word Muhammad, alternating with triangular cartouches filled with floral motifs; a strip with kufic inscriptions appears between the medallions and the cartouches. The same band is repeated below the wide thuluth panel, another band with intersecting scalloped ribbons appears above the footring, which is decorated with floral motifs.

The splayed foot is divided into three horizontal zones: the upper is filled with floral motifs, the second contains a thuluth inscription, and the last repeats the band with roundels containing the word Muhammad.

The vessel is lavishly inlaid with silver and gold, the latter used in the word Allah, the six-petaled blossoms, and in the floral scrolls on the neck. The contrast between the bold thuluth inscriptions placed on a floral ground and the minuscule naskhi and kufic scripts is most effective. The high quality of execution suggests an imperial patron whose name, unfortunately, is not provided.

During the reign of Sultan Hasan there was an unprecedented flourish in the production of glass mosque lamps. The sultan and his amirs commissioned hundreds of lamps, which must have stimulated the execution of similar shapes in other materials, such as inlaid metalwork.

Ornamental lamps made from materials other than glass are not uncommon in Islamic art. A similar piece made of brass was produced for Sultan Hasan, possibly for his complex,[1] while examples executed in ceramics were frequently ordered in the Ottoman world in the sixteenth century.[2]

Published
Ross 1931, p. 322.

Notes
1. Cairo, Museum of Islamic Art, 130 (Wiet 1932, p. 6, pl. XXVI).
2. The most celebrated are blue-and-white lamps made for the mausoleum of Sultan Beyazid II around 1510 and the famous polychrome example donated to the Dome of the Rock in Jerusalem by Sultan Süleyman the Magnificent in 1549 (Denny 1980, figs. 145–46 and 153).

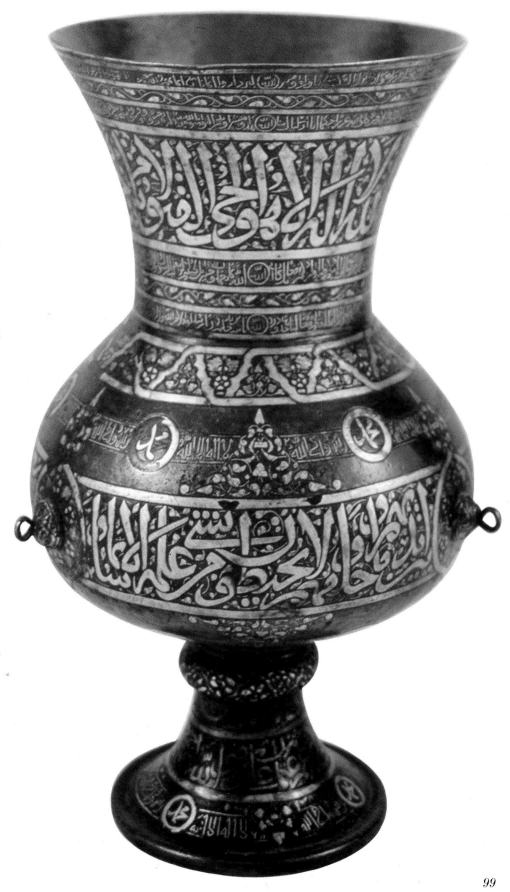

33
Key
Bronze: inlaid with silver
1363/64
Donated by Sultan Shaban II to the Kaaba in
Mecca

Length, including ring: 34.0 cm. (13⅜ in.)

Cairo, Museum of Islamic Art, 15133
Purchased 1945
Ex-Harari Collection, 180

Inscriptions
First cube on top, below knob: Surat al-Fath
(The Victory; XLVIII:28)[1]
Second cube in center:

الله لا اله الا الله * شعبان بن حسين *
فى سنة خمسى وستين * وسبع ماية العزه

*There is no God but Allah, Shaban ibn Husein,
in the year seven hundred and sixty and five
[A.D. 1363/64], glory [may his victory be glorious].*

Third cube at bottom:

مما عمل لبيت الله * الحرام فى ايام مو*
لانا السلطان * الملك الاشرف

*One of the things made for the sacred house of God
[the Kaaba] during the reign of [our] master,
the sultan al-Malik al-Ashraf.*

Key: Surat al-Fath (The Victory; XLVIII:1–4) and
Surat al-Al-i Imran (The Family of Imran;
III:96–97).

Among the sacred objects commissioned by
Mamluk sultans were keys for the Kaaba in
Mecca, the most revered shrine in Islam. Mecca
and Medina were under the jurisdiction of the
Mamluks, and the sultans were responsible for the
maintenance of mosques in these cities and the
protection of the pilgrimage routes. Many rulers
spent a substantial portion of state revenues on
the reconstruction of buildings and donated
valuable Korans and metalwork to the mosques.

Shaban II (1363–76), who restored the
pavement of the court of the mosque enclosing the
Kaaba, donated this silver inlaid key to the shrine.

The key is constructed of several movable units:
a large ring is attached to a faceted knob; below
the knob are three cubes separated by spheres;
finally, there is an oblong silver inlaid shaft, which
contains passages from the Koran and gives the
date and name of the donor. The knob, the
spheres between the cubes, and the teeth of the
key are incised with simple floral motifs.

The keys to the Kaaba were carefully preserved,
and a great number of them are presently in the
Topkapı Palace Museum in İstanbul.[2] These
sacred objects were taken to the İstanbul court by
the Ottomans in 1517, following the defeat of the
Mamluks and the annexation of the Hijaz.
The collection of Kaaba keys in İstanbul is
extensive, dating from the early years of Islam
through the Ottoman period. Among the Kaaba
keys owned in Western collections is one
commissioned by Sultan Faraj, who restored the
Mosque of Mecca in 1405.[3] Although these keys
differ in shape, they all bear the same Koranic
inscriptions and include the names of the donors.

The Koranic verses inscribed on the key are
symbolic of its function. The first group (from the
Surat al-Fath) refers to the Treaty of Hudaibiyya,
in which the Meccans recognized the Prophet
Muhammad and his followers and allowed the
Muslims to perform their first pilgrimage. This
event, which took place in 628, was a great moral,
social, and political victory for Islam. The second
excerpt (from the Surat al-Al-i Imran) describes
the founding of the holy shrine at Mecca and
explains the significance of the pilgrimage.

Published
Berchem 1904, pp. 93–96.
Sarre and Martin 1912, vol. 4, no. 3154.
Devonshire 1927, pp. 124–25 and fig. v.
Wiet 1932, app. no. 271.
Sourdel-Thomine 1971, pp. 71–72, no. 11 bis.

Notes
1. The same passage is found in IX:33 and LXI:9.
2. Sourdel-Thomine 1971.
3. Paris, Louvre, 6738 (Paris 1971, no. 175; Paris 1977, no. 237).

34
Candlestick
Brass: engraved
1482/83
Donated by Sultan Qaitbay to Mosque of Medina

Height: 48.0 cm. (18⅞ in.)
Diameter of base: 40.0 cm. (15¾ in.)

Cairo, Museum of Islamic Art, 4297
Purchased 1916

Inscriptions
Band on socket:

هذا ما اوقف على الحجرة النبوية مولانا السلطان الملك
الاشرف ابو النصر قايتباى بتاريخ سنة سبع وثمانين وثمانمائة

*This was endowed to the Shrine of the Prophet
[at Medina] by our master, the sultan al-Malik
al-Ashraf Abu'l-Nasir Qaitbay, dated in the
year eight hundred and eighty and seven
[A.D. 1482/83].*

Band on neck:

عز لمولانا السلطان الملك العادل المجاهد المالك الملك
الاشرف ابو النصر قايتباى

*Glory to our master, the sultan, the king, the just,
the defender [of the faith], the royal, al-Malik
al-Ashraf Abu'l-Nasir Qaitbay.*

Two panels on shoulder: Repeats inscription on
socket; adds after the name Qaitbay عز نصره
(may his victory be glorious); and the following
phrase after the date: فى شهر رمضان المعظم قدره
(in the exalted month of Ramadan).

Two roundels on shoulder:

السلطان ابو النصر * قايتباى * عز نصره
*The sultan, Abu'l-Nasir Qaitbay, may his victory
be glorious.*

Two panels on body:

عز لمولانا السلطان الملك العادل المجاهد سلطان *
الاسلام والمسلمين الملك الاشرف ابو النصر قايتباى

*Glory to our master, the sultan, the king, the just,
the defender [of the faith], sultan of Islam and
Muslims, al-Malik al-Ashraf Abu'l-Nasir
Qaitbay.*

Two medallions on body:

عز لمولانا السلطان الملك الاشرف * ابو النصر قايتباى *
عز نصره

*Glory to our master, the sultan al-Malik al-Ashraf
Abu'l-Nasir Qaitbay, may his victory be glorious.*

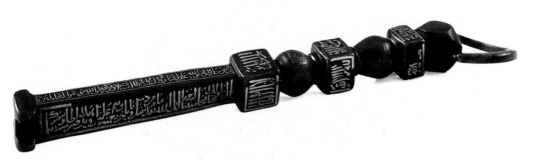

The donation of objects to the Mosque of Medina was also considered a pious act on the part of the Mamluk sultans. Qaitbay (1468–96), an outstanding patron of the arts, commissioned a number of new buildings in the capital and restored many existing structures in the provinces. The restoration of the Mosque of Medina was of particular interest to him, and he donated at least five candlesticks to that structure in 1482, including this example.[1]

The candlestick of Qaitbay is decorated with bold inscriptions and naturalistic floral scrolls that characterize the stylistic features of his age. The socket contains an uninterrupted inscription panel enclosed by braided rings. The neck has another continuous inscription band framed by two floral scrolls with abstracted lotus buds and peony blossoms. Another floral scroll followed by a braided ring joins the neck to the shoulder. The shoulder has an inscription band broken by two epigraphic roundels and is enclosed by a floral border.

The body is divided into three unequal horizontal zones by braided rings. The two narrow strips at top and bottom have floral scrolls, the lower one is adorned with large lotus and peony blossoms. The wide central portion contains an inscription broken into two panels by large epigraphic medallions with scalloped borders. Floral decorations appear behind the panels and medallions.

The large inscriptions on the neck and body are written in an unusual manner: the vertical shafts of the letters cross at the top to form a series of pincers enclosing lotus buds. This convention also appears in inscriptions on other pieces of contemporary metalwork (see no. 35).

The epigraphic blazons on the shoulder and body are divided into three fields containing phrases that are commonly found on Qaitbay's objects (see also nos. 9 and 35).

Although silver inlaid brasses continued to be produced in this period, a new style of decoration employing a simpler technique (as exemplified by this candlestick) was becoming increasingly popular. Objects were incised with a sharp tool and a black bituminous material was applied to the sunken areas of the background. This black substance was always used in metalwork and provided a dark ground to the silver and gold inlays. During Qaitbay's reign, however, this black material begins to be used alone in contrast with the polished brass surfaces, thereby creating a feeling of depth.[2] This practice became predominant in the ensuing years, replacing the technique of inlaid metalwork.

Published
Wiet 1932, no. 4297 and pl. xxxiv.
Melekian-Chirvani 1969, p. 115.
London 1976, no. 226.

Notes
1. Wiet 1932, app. nos. 338–42.
2. For some two dozen objects bearing Qaitbay's name see Wiet 1932, app. nos. 355–77. See also Melekian-Chirvani 1969 (with additional references). Among the pieces made for his court is a silver-inlaid ewer made by Ahmad for his wife, now in London, Victoria and Albert Museum, 762–1900 (D. S. Rice 1953a, pl. vi).

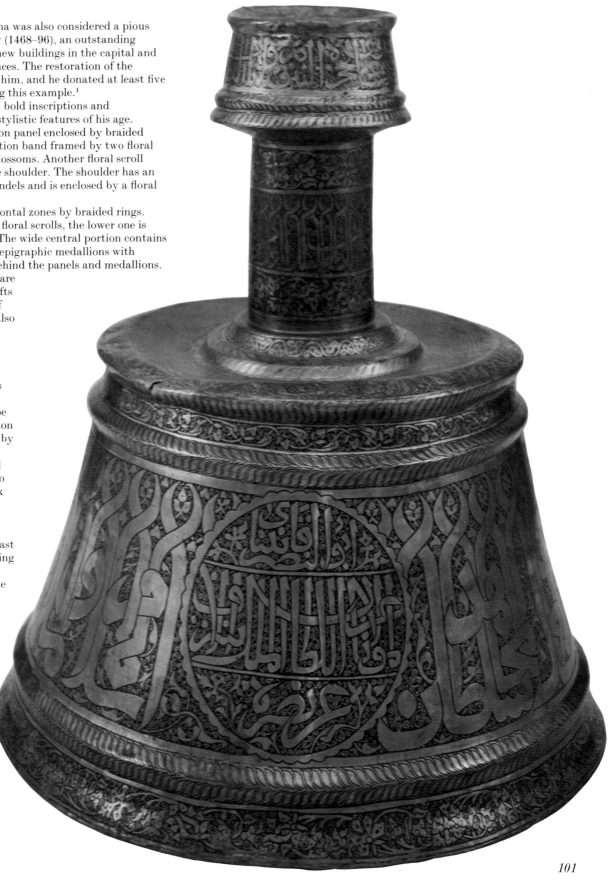

35
Bowl with articulated base
Brass: inlaid with silver
Circa 1470–90
Made for Sultan Qaitbay

Height: 13.0 cm. (5⅛ in.)
Diameter of rim: 32.0 cm. (12⅝ in.)

New York, The Metropolitan Museum of Art,
 The Edward C. Moore Collection, 91.1.565
Bequest of Edward C. Moore, 1891

Inscriptions
Four panels on body:

عز لمولانا السلطان الملك * الاشرف ابو النصر قايتباى اعظم سلطان *
سلطان الاسلام والمسلمين * الملك الاشرف ابو النصر قايتباى السلطان

*Glory to our master, the sultan, al-Malik
al-Ashraf Abu'l-Nasir Qaitbay, the great sultan,
sultan of Islam and Muslims, al-Malik al-Ashraf
Abu'l-Nasir Qaitbay, the sultan.*

Four medallions on body:

الملك الاشرف * قايتباى * عز نصره

*al-Malik al-Ashraf Qaitbay, may his victory be
glorious.*

The production of metalwork, which had declined
during the first half of the fifteenth century, was
revitalized under the patronage of Qaitbay, who
brought relative peace and prosperity to the
Mamluk empire. Even though the splendid
examples of fourteenth-century inlaid brasses
could not be recreated, the artists of Qaitbay's
period revived traditions and created new forms
and designs. One of the innovations of the age is
the production of bowls with articulated bases
composed of a series of scallops or triangles
executed in relief. New developments appear in
epigraphy, in which vertical letters form pincers
at the apex, and in naturalistic floral scrolls
containing lotuses, peonies, and blossoms with a
spiked petal and two curling lobes (see no. 34).
 This bowl characterizes the style of metalwork
produced at the end of the fifteenth century.
The thin edge of the lip is adorned with a floral
scroll, now abraded. The straight rim has a floral
scroll with lotus blossoms, peonies, buds, and
spiked leaves on a tightly wound scroll ground.
 The main panel of the body is decorated with
inscriptions on a tightly wound scroll, enclosed in
four oval units alternating with lobed medallions.
A continuous thin strip encloses each unit, looping
around the ovals and medallions. The medallions
bear epigraphic blazons of the sultan in three
registers on an extremely fine scroll. Between the
ovals and medallions is an elaborate knot with
four lotus blossoms in the corners. The lower
portion of the bowl has a series of twenty-four
scallops, decorated with lotus blossoms, peonies,
or arabesques.

The bottom of the bowl, heavily abraded,
reveals an elaborate design in two concentric
zones. The core of the inner zone is too worn to be
identified; it is encircled by six medallions with
geometric designs enclosing a central rosette.
Six twelve-pointed stars surround the medallions.
The units are linked to one another by a
continuous thin strip and placed on a fine floral
ground. The outer zone is filled with a floral
arabesque containing knots, buds, split leaves,
and blossoms; it is enclosed by a thin strip, which
also loops around the scallops on the lower portion
of the walls. The execution of the bottom is
extremely refined, and the overall effect recalls
manuscript illumination (see nos. 7–8).

The interior of the base repeats the layout of
the two concentric zones: the inner ring is plain,
the outer one has a floral ground with twelve lotus
blossoms, peonies, and other flowers.
 Even though the piece, particularly the
articulated base, is worn and has been repaired, it
must have been quite spectacular in its pristine
condition. Silver inlay, which appears as small
dots in the floral scroll on the rim and in the main
panel on the body, is carelessly and haphazardly
rendered, indicating a later attempt to improve
the appearance of the piece.
 There exists a number of similar bowls
dedicated to Qaitbay, the most magnificent of
which, in the Turkish and Islamic Arts Museum in
Istanbul, is inlaid with silver and gold.[1]

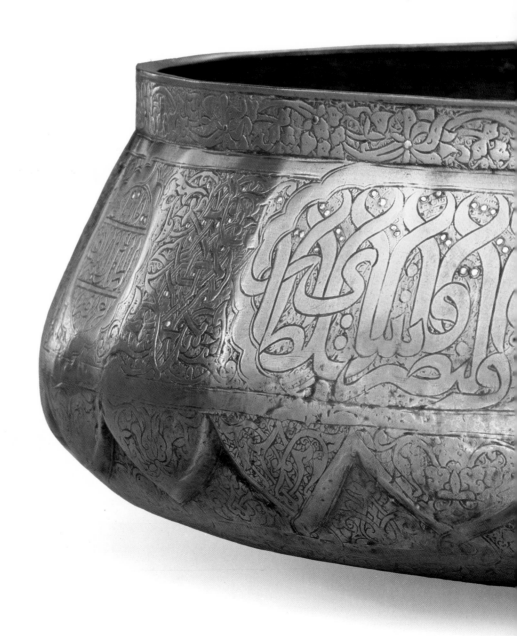

Published
Dimand 1944, p. 151.
Melekian-Chirvani 1969, p. 133 and fig. 34.

Notes
1. Güvemli and Kerametli 1974, p. 48.

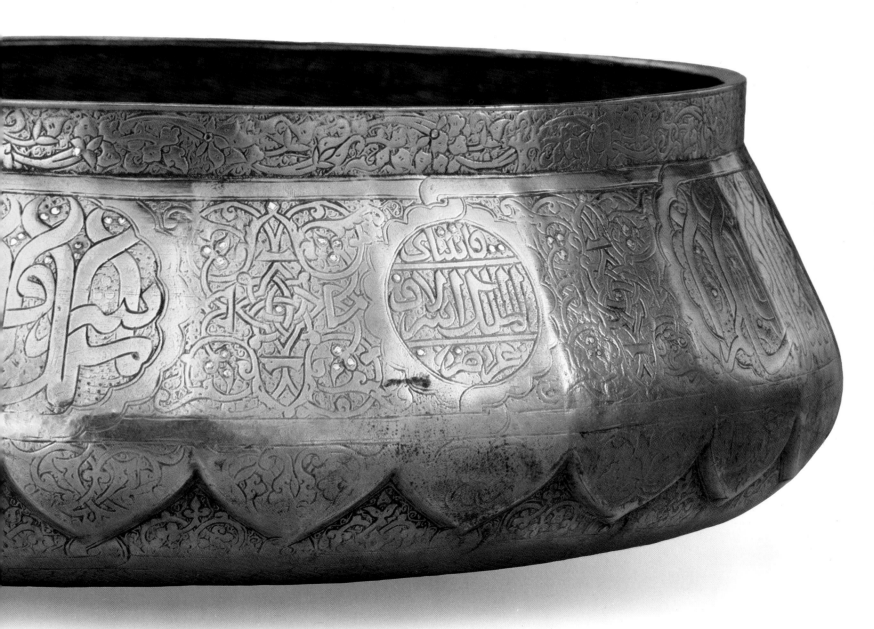

36
Box
Brass: inlaid with silver
15th century
Made for al-Wathiq bi'l-Mulk al-Wali ibn
 Muhammad
Made by Muhammad ibn Ali al-Hamawi

Height: 10.2 cm. (4 in.)
Length: 17.0 cm. (6¹¹⁄₁₆ in.)
Width: 8.0 cm. (3⅛ in.)

New York, The Metropolitan Museum of Art,
 The Edward C. Moore Collection, 91.1.538
Bequest of Edward C. Moore, 1891

Inscriptions
Cartouche on top of lid:

مما عمل برسم الواثق بالملك الولى بن محمد
محمد بن على الحموى الموقت بالجامع الاموى

*One of the things made for al-Wathiq bi'l-Mulk
al-Wali ibn Muhammad. Muhammad Ali
al-Hamawi, the timekeeper in the Umayyad
mosque.*

Cartouche in front of body: Not deciphered.
Cartouche on right side of body:

ولصاحبه السعاده والسلامه وطول العمر وعز لا
يدانيه هوان واقبال الى يوم القيامه

*And to its owner happiness, security, longevity,
glory unmarred and prosperity to the Day of
Judgment.*

Cartouche on left side of body:

يارب انت رجائي وفيك حسبت ظني فاغفر لى
ذنوبى وعافنى واعف عنى

*O God! You are my hope and in you I assured my
doubts, forgive me for my sins.*

Cartouche at back of body: Not deciphered.

The inscriptions on several pieces of fifteenth-
century metalwork are poorly written and require
interpretative reading. This small oval box with
flat top appears to have been made for an
unknown patron by an artist named Muhammad
ibn Ali al-Hamawi (from Hama), who was the
timekeeper at the Great Mosque of Damascus.
The work represents a provincial type of
metalwork available to the middle classes and
differs in quality from those produced in the
capital for the court.

In spite of the fact that the maker had problems
copying the inscriptions, the box is well designed
and executed. The top of the lid has an oval panel
filled with floral motifs; in the center written in
two lines is a lobed unit containing the names of
the patron and the artist; on either side is a
cartouche joined to the central unit by knotted
motifs. A scroll composed of trefoils and split
leaves encircles the scooped shoulder of the lid.
The front and back sides of the lid are adorned
with a pair of cartouches linked by knotted
elements and large scrolls. Loose floral scrolls fill
the cartouches and the interstices.

The body is divided into three horizontal zones:
the upper and lower bands are filled with loose
floral scrolls interrupted by trefoil finials of the
lobed units in the central panel. The wide central
panel has four cartouches with inscriptions in the
center of each side. Lobed medallions with trefoil
finials on the vertical axis appear between the
cartouches to which they are joined by knotted
motifs. The inscriptions, written in two registers,
bestow good wishes and contain pious phrases.
The frontal hasp appears to be a later addition
and is decorated with a combination of four letters
thought to have a symbolic meaning.

The specific function of this box is not clear,
although the oval shape resembles fourteenth- and
fifteenth-century food containers. Some of these
containers have handles on the lid, others have
knobs; they are either single or stacked to form up
to three units.[1] Such boxes were used to carry
food, each unit containing a different preparation.
This box, the shape of which seems to have been
inspired by food containers, must have been used
to protect small and precious items.

Unpublished

Notes
1. Wiet 1932, pls. LXV–LXVI and LXIX. See also Allan 1971.

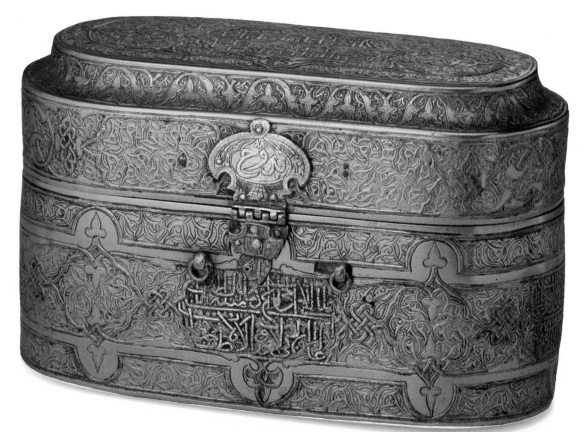

37
Bowl
Brass: engraved
Late 15th century

Height: 9.3 cm. (3$\frac{11}{16}$ in.)
Diameter of rim: 16.5 cm. (6$\frac{1}{2}$ in.)

New York, The Metropolitan Museum of Art,
 1978.551.
Gift of Charles and Irma Wilkinson, 1978

Inscriptions
Five panels on body:

انا طاسى حوكل المعانى * نصيرى ... المنا والامانى *
لونى والصنع لون جعال وطرا * والبريع فى بنيانى عز من برا * ...

I am a bowl which contains all meaning.
My helper . . . wishes and aspirations. My color
and workmanship are beautiful and flattering and
the excellence of my construction. . . .

The production of metalwork rapidly declined
after the reign of Qaitbay. The empire was faced
with a great financial crisis, and wars with the
Ottomans and Turkmans had drained the
treasury. No longer able to afford silver and gold,
metalworkers relied on incised and engraved
designs and made smaller pieces. The reduction in
size of the objects clearly indicates that the
objects were being produced for a conservative
and frugal society.

This small bowl reveals a highly refined
execution even though it is not inlaid with
expensive materials. Its only decoration is a band
composed of three registers adorning the upper
walls. The upper register has delicate strapwork
intersected by ten roundels, each filled with a
tightly wound spiral scroll. The next zone has ten
medallions decorated with a similar scroll that
forms four internal volutes. The panels between
the medallions contain alternating designs:
inscriptions on a tightly wound scroll and an
overall arabesque with split leaves. The lower
register repeats the layout and design of the first.
A continuous band encircles the registers and
loops around the roundels and medallions.

A series of ten triangular cartouches filled with
spiral scrolls appears below the medallions. Split
palmettes extend from each cartouche, and a finial
composed of a spiked leaf with two curling lobes
hangs toward the base.

Although the design has been abraded through
centuries of use, the delicacy of workmanship is
still apparent. The artist was very proud of his
work, as indicated by the inscriptions that prase
the bowl.

Unpublished

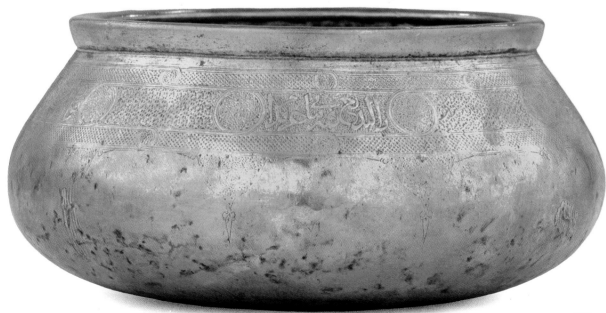

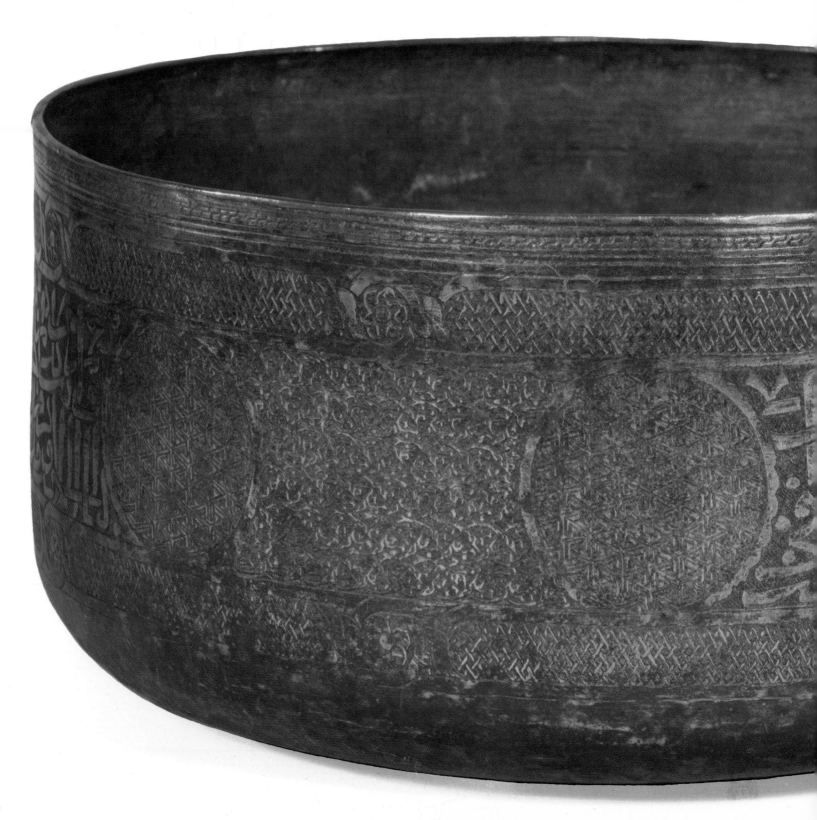

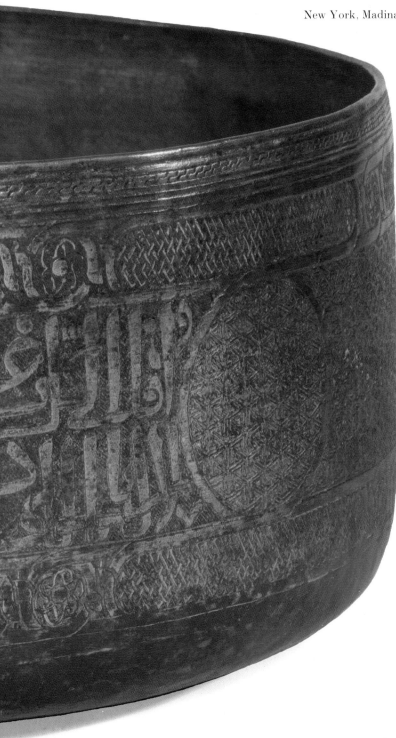

38
Basin
Copper: tinned, engraved
Late 15th–early 16th century

Height: 15.2 cm. (6 in.)
Diameter of rim: 33.7 cm. (13¼ in.)

New York, Madina Collection, M10

Inscriptions
Four panels on body: Not deciphered

This basin, one of the last examples of Mamluk metalwork produced before the Ottoman conquest in 1517, reveals the persistence of traditional designs and motifs as well as the use of new materials. The economic depression of the age caused expensive metals such as silver and gold to virtually disappear from the market, and even brass became prohibitive. Artists resorted to the less expensive copper and applied a thin wash of tin to improve its appearance and produce a more pleasant contrast with the bituminous material applied to the background.[1]

The piece has a rounded base with straight sides. Adorning the rim is a series of thin bands, one of which is braided. The walls are divided into three unequal horizontal zones; the upper and lower bands are identical in design and contain eight oblong panels filled with strapwork, alternating with roundels composed of six overlapping petals.

The central zone has eight scalloped medallions filled with a type of fretwork found on early Mamluk inlaid brasses (see nos. 10–11, 13–16, 18–19, and 23–24). The panels between the medallions have either a dense and minutely executed floral scroll with split leaves or thuluth inscriptions written in two registers on a crosshatched ground. A continuous ribbon, which encircles the panels and loops around the circular units, defines and joins each segment. The bottom is plain and the interior is undecorated.

The inscriptions are not clear and could not be read. Although several words can be deciphered, it is difficult to make sense out of the entire passage, which appears to express lofty sentiments and good wishes.

The composition and decorative themes on this basin appear frequently in late-fifteenth- and early-sixteenth-century metalwork. They are found on several bowls and food boxes, some of which bear dedications to Mamluk amirs.[2] The inscription on one of these bowls states that it was made by Rustam ibn Abu Tahir.[3]

The particular themes employed on this example were also used on printed cloth dating from the same period (no. 122), suggesting that this style was highly favored at the end of the Mamluk empire.

Unpublished

Notes
1. Similar trays and lunch boxes are published in Allan 1969 and 1971. See also Naples 1967, nos. 16–25 and figs. 17–18.
2. A bowl in Cairo, Museum of Islamic Art, 8124, was made for Amir Qasrawah circa 1500 (Wiet 1932, pp. 135–36, pl. XLV). The same collection has two boxes, 3368 and 3959, the latter made for Amir Taimur (Wiet 1932, pls. LXVI and LXIX).
3. Mayer 1959, p. 80 and pl. XII.

39
Tray
Copper: tinned, engraved
Late 15th–early 16th century
Made for an anonymous amir

Height: 5.0 cm. (2 in.)
Diameter: 38.1 cm. (15 in.)

Washington, D.C., Embassy of the Arab Republic
of Egypt, 15944

Inscriptions
Medallion in center:

مما عمل برسم الكريمى العالى المولوى الاميرى الكبيرى

*One of the things made for the honorable, the
sublime, the master, the great amir.*

This tray belongs to a series of tinned-copper
pieces produced during the last decades of the
fifteenth and the early years of the sixteenth
century. The shape of the tray deviates from the
larger and flatter fourteenth-century examples
(see nos. 14 and 22); it is smaller and deeper,
recalling plates executed in ceramics.

The foliated rim has a simple scroll. The cavetto
contains six oval cartouches placed between six
medallions: these units are framed by a scroll and
joined by two thick bands that intersect and loop
around them. The cartouches are filled with a
dense floral arabesque composed of split leaves or
strapwork, identical to those motifs seen on two
contemporary pieces (nos. 37–38). The six
medallions also have alternating designs: three
contain a composite blazon and three have a
Y-fret pattern.

The base of the tray is divided into three
concentric zones, in the core of which is a
medallion with the same composite blazon seen
on the cavetto; enclosing it is a ring of inscriptions
placed on a floral ground. The next zone has four
superimposed trefoils, which overlap and create a
series of triangles and lozenges alternately filled
with Y-fret patterns and strapwork. Another scroll
frames the central composition.

The composite blazons consist of a circular
shield divided into three fields: the upper bar
contains a napkin, the central bar has a cup
charged with a pen box and flanked by two
powder horns, and the lower bar displays another
cup. This emblem with six heraldic signs was used
by Sultan Qaitbay and his amirs, two of whom
later ascended the throne and continued to use
this blazon until the Ottoman conquest of Egypt.[1]
It appears on rugs and textiles (see no. 124) and
on trays, bowls, and lunch boxes dating from this
period.[2] This blazon was also used by ladies of the
court and is found on a brass basin made for
Fatima, the wife of Sultan Qaitbay.[3]

Published
Embassy 1954, pp. 24–25, no. D

Notes
1. A thorough study of late Mamluk composite blazons appears
 in Meinecke 1972, pp. 273–78; Meinecke 1974, pp. 231–40.
2. A number of late-fifteenth-century trays and lunch boxes are
 published in Allan 1969 and 1971. See also Mayer 1933,
 pl. LXII; Mayer 1937, pl. 1b. Belonging to this group is a tray,
 found in 1966 at Jabal Adda, which is now in Cairo, Museum
 of Islamic Art, 23967 (Cairo 1969, no. 90).
3. D. S. Rice 1952, p. 577, fig. 7 and pl. 11.

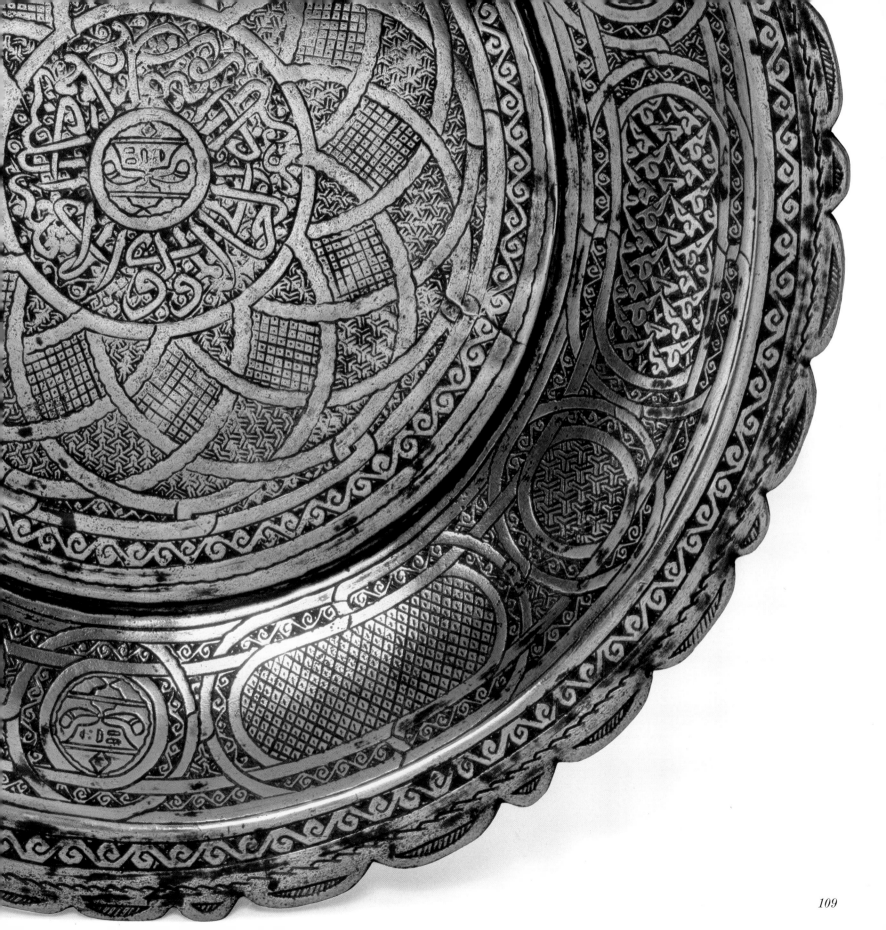

40
Drum
Brass: inlaid with silver
15th century

Height: 14.7 cm. (5¾ in.)
Diameter of rim: 27.4 cm. (10¾ in.)

New York, Madina Collection, M11

Inscriptions
Three panels on walls:

<div dir="rtl">المقر العالي ا * لمالكي المر * ا (بطي) ...</div>

The sublime excellency, the royal, the warrior [of the frontiers]. . . .

An essential, and obligatory, function of Mamluk metalworkers was to supply
the army with arms and armor. They produced both practical weapons and
richly adorned arms and armor for ceremonial use. Mamluk society was based
on a rigid military hierarchy, each rank provided with its specific weapons
and outfits. The Amirs of Forty were among the privileged officers who were
granted their own *tablakhana*, that is, military band. Members of these bands
accompanied the amirs in battles and ceremonial activities, playing an
assortment of drums, horns, and cymbals (see no. 1, fig. 1). During battles
they not only encouraged the soldiers but also demoralized the enemy.
The drum was most effective, its thundering beat accelerating the attack or
announcing the arrival of the amirs.
 This example has lost its inlay and a portion of the side is missing. Its shape
with flat bottom, flaring sides, and straight rim is characteristic of Mamluk
drums. The rim is pierced with sixteen equally spaced holes used to attach the
skin to the top; several other holes have been drilled when the drum was
repaired at a later date. The swelling sides are decorated with a large
inscription panel placed on a spiral ground interrupted by three medallions,
each containing a large lotus blossom enclosed by a floral scroll. The tapering
lower portion has a band filled with intersecting chevrons, its background
textured with circular punches.
 An identical band encircles the bottom, in the center of which is a six-
petaled rosette surrounded by a twelve-pointed star. Braided bands frame
each of the zones and loop around the large medallions.
 Although Mamluk drums are not found in abundance, several examples are
owned by European museums.[1] Since their decorations and dedications are
fairly standardized, they can only be roughly dated between the fourteenth
and fifteenth centuries.
 Certain decorative motifs—such as the spiral scroll ground of the
inscriptions, large lotus blossoms in the medallions, and twelve-pointed
stars—indicate that the Madina drum may have been made in the fifteenth
century (see also no. 35).

Unpublished

Notes
1. London, British Museum, 1966 10–19 1; Berlin, Museum für Islamische Kunst, ɪ 10163 (Berlin
 1965, no. 46); Paris, Louvre, 1895 (Paris 1977, no. 422).

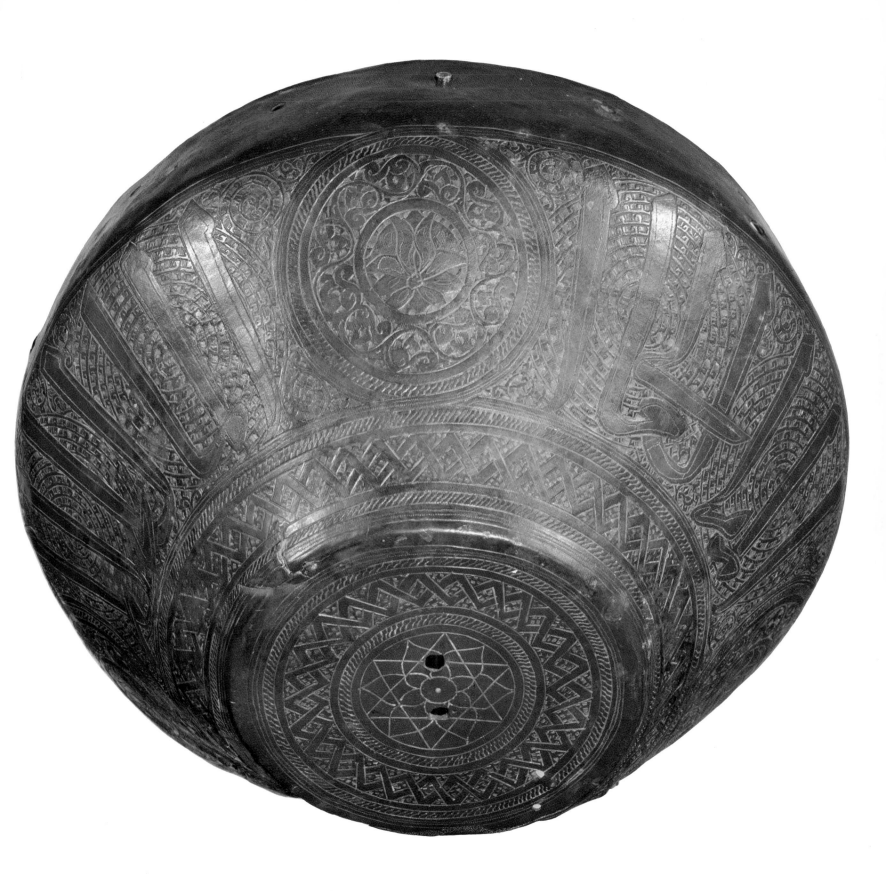

41
Helmet
Iron : gilded
Circa 1430
Made for Sultan Barsbay

Height, excluding neck guard : 32.5 cm. (12¾ in.)
Diameter of base : 22.3 cm. (8¹³⁄₁₆ in.)

Paris, Musée du Louvre, 6130
Gift of The Friends of the Louvre, 1908

Inscriptions
Central medallion on peak :

عز لمولانا السلطان ا |sic|

Glory to our master, the sultan.

Two oval cartouches on peak.

عز لمولانا السلطان الملك الاشرف ناصر |sic| *
الدنيا والدين ابو النصر برسباى ... عز نصره (؟) العز والاقبال

*Glory to our master, the sultan al-Malik al-Ashraf
Nasir al-Dunya wa'l-Din Abu'l-Nasir Barsbay
. . . may his victory be glorious, glory and
prosperity.*

Central medallion on neck guard :

عز لمولانا السلطان

Glory to our master, the sultan.

Two oval cartouches on neck guard :

عز لمولانا السلطان المالك الملك * الا (شرف) ... ابو النصر
برسباى عز نصره

*Glory to our master, the sultan, the royal, al-Malik
al-Ashraf . . . Abu'l Nasir Barsbay, may his
victory be glorious.*

The inscriptions on the Louvre helmet state that
it was made for Sultan Barsbay (1422–38), whose
reign titles were al-Malik al-Ashraf. This sultan's
name also appears on two gilt iron mirrors, one in
Cairo, the other in İzmir.[1] He also built a large
madrasa in Cairo, to which he donated several
magnificent Korans (see nos. 7–8 ; also no. 107).

Barsbay's helmet has an elegant ovoid shape
with only a suggestion of fluting. A knobbed
plume socket appears at the apex, and a gilt band
with oval cartouches and medallions containing
inscriptions and floral scrolls adorns the lower
edge. Although the gilt inscriptions on this band
have worn off, those on the peak (or visor) and
neck guard are well preserved.

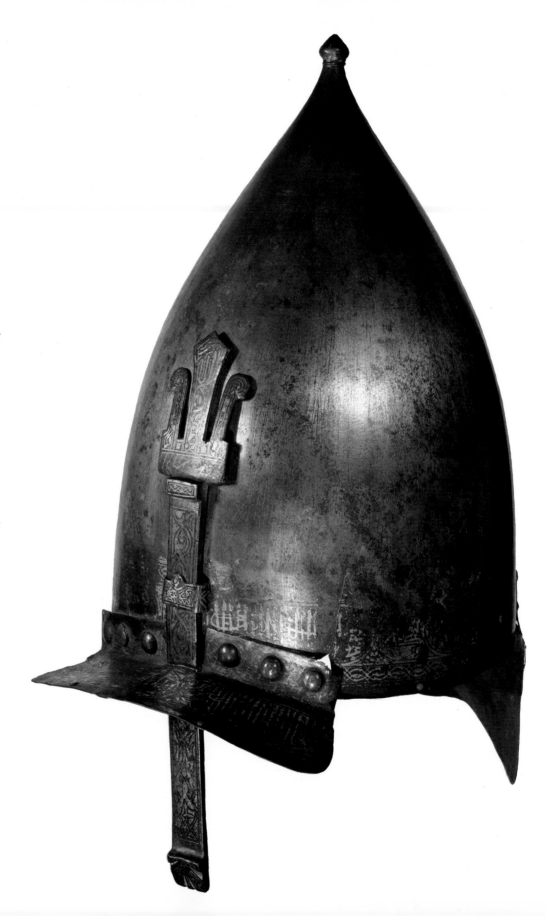

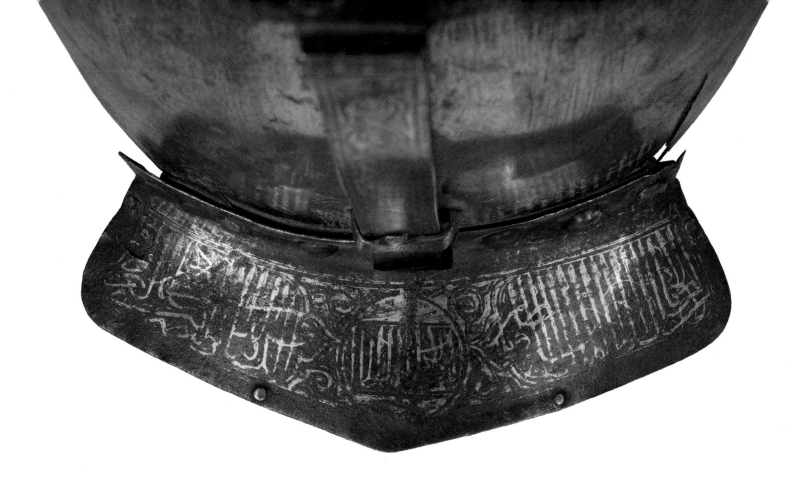

The peak is attached to the front with six studs and has two oval cartouches flanking a medallion. The movable nasal in the center terminates with a triple-plume-shaped motif; it slides through the groove in the middle of the peak and the carrier attached to the helmet. The nasal, decorated with floral motifs, contains the mark of the İstanbul arsenal and may have been added to the helmet during the Ottoman period. Also dating from the Ottoman period is a patch applied to the damaged portion at the side.

The neck guard, attached to the helmet with three flexible double-jointed links, also has oval cartouches flanking a medallion. This portion, by far the best preserved, is decorated with additional bands of floral scrolls that encircle the medallion and enclose the cartouches. Three of the original leather straps used to attach the chain mail are preserved inside the helmet. When the helmet was used, plumes and ribbons were affixed to the finial at the apex.

The richest collection of Mamluk arms and armor is housed in the Topkapı Palace Museum in İstanbul. The Ottoman sultans admired the military equipment of the Mamluks and confiscated a substantial number of weapons after the conquest of Cairo. These items were kept in the Imperial Arsenal on the Topkapı Palace grounds and the mark of the arsenal was stamped on each piece. This mark appears on Barsbay's helmet, indicating that it was once in the imperial Ottoman collection. Since most Mamluk arms and armor in İstanbul date from the reign of Qaitbay and ensuing Mamluk sultans, this helmet would have been one of the earliest in the collection.

It is at times difficult to differentiate between Mamluk and Ottoman helmets, which employ similar shapes and decorative motifs. The oldest extant Mamluk helmet, now in Brussels, is thought to be from the first half of the fourteenth century.[2] Another, dating from the second half of the fifteenth century is worn by the equestrian figure on display in the Islamic galleries of the Metropolitan Museum of Art in New York.[3]

Published
Migeon 1922, vol. I, no. 53 and pl. 18.
Mayer 1943, p. 7 and fig. 8.
Mayer 1952, p. 43 and pl. VII.
Kühnel 1963, p. 203 and fig. 162.
H. R. Robinson, 1967, p. 80 and fig. 44.
Kühnel 1970, p. 195 and fig. 162.
Angoulême 1974–75, no. 69.
Paris 1977, no. 411.
Rogers 1978–79, p. 204.
Marcq-en-Barœul 1979, no. 131.

Notes
1. Cairo, Museum of Islamic Art, 15246 (Wiet 1932, app. no. 309; Cairo 1969, no. 81). The İzmir mirror is published in Riefstahl 1931, p. 116 and fig. 228.
2. Mayer 1952, pp. 41–42.
3. This piece, 36.25.116, appears to date from the last quarter of the fifteenth century.

42
Sword
Gilt steel blade; gilt silver crosspiece; horn hilt
Circa 1501
Made for Sultan Tumanbay I

Length: 93.0 cm. (36⅝ in.)

Cairo, Museum of Islamic Art, 5267
Purchased 1919

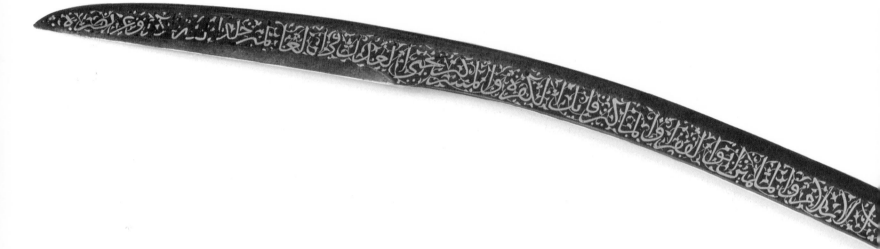

Inscriptions
On blade:

السلطان المالك الملك العادل ابو النصر طومانباى سلطان الاسلام
والمسلمين ابو الفقرا والمساكين قاتل الكفره والمشركين محى العدل
فى العالمين خلد الله ملكه وعز نصره

The sultan, the royal, al-Malik al-Adil Abu'l-Nasir Tumanbay, sultan of Islam and all Muslims, father of the poor and the miserable, killer of the unbelievers and the polytheists, reviver of justice among all, may God prolong his kingdom and may his victory be glorious.

The double-edged sword, whose elegant shape matched its performance, was the most revered weapon of the Mamluks and an indispensable part of an amir's outfit. Imperial swords were elaborately decorated with gold inscriptions that gave the names and titles of the sultans and at times included Koranic verses related to victorious battles. According to the inscriptions, the owner of this sword was al-Adil Sayf al-Din Tumanbay, one of the last Mamluk sultans, who reigned for three months in 1501.

Tumanbay's sword has a curved hilt and a crosspiece divided into quarters, with lateral projections terminating in ovoid units. One of the tips extending over the blade has been broken. The delicately curved blade is decorated on one side with a remarkably well-preserved gilt inscription. The scabbard (not illustrated) is stamped leather reinforced with metal; it appears to date from the Ottoman period.

Metalworkers, painters, and other artists often depicted hunters and warriors slaying their prey or enemies with swords; they also portrayed officials participating in court ceremonies with their weapons neatly encased in scabbards (see nos. 20–21). The office of the *silahdar*, sword-bearer or more literally weapon-bearer, was among the highest in the state, and amirs who held the post used its representation on their blazons (see no. 94).

The Arabic word for sword, *sayf*, appears in some inscriptions, identifying the owner as being a sword-bearer (see nos. 27 and 43). It was also used as a honorific title, Sayf al-Din, meaning Sword of the Religion, by several sultans, including Barsbay, Qaitbay, and Tumanbay.

Published
Mostafa 1958, no. 64.
A. Zaki 1966, pp. 148 and 154 and fig. 2.
Cairo 1969, no. 91.
London 1976, no. 230.

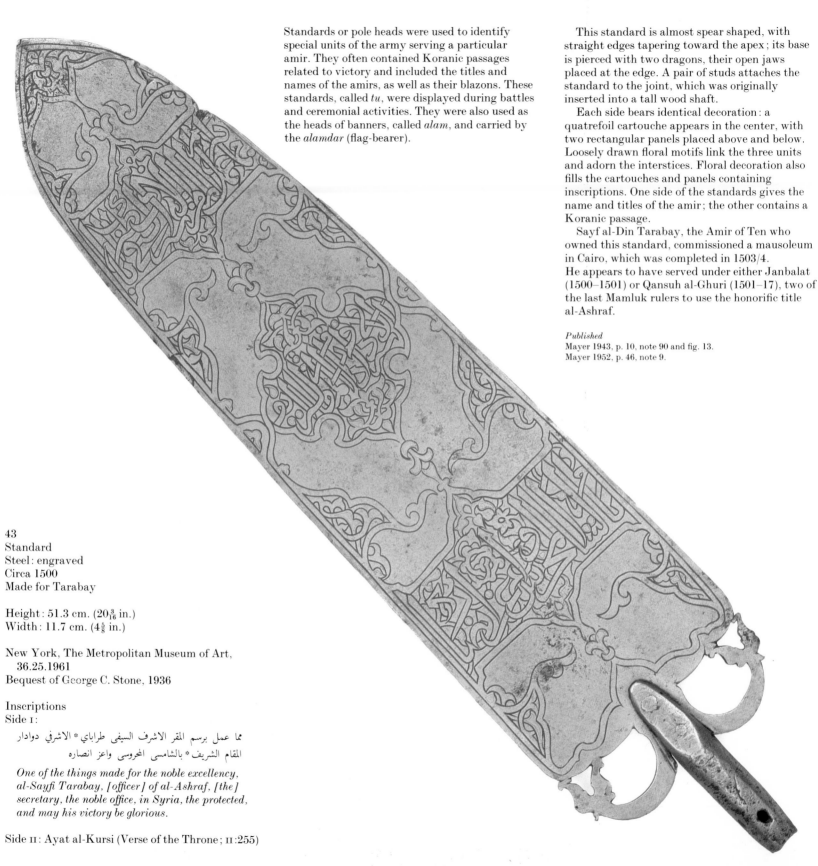

Standards or pole heads were used to identify special units of the army serving a particular amir. They often contained Koranic passages related to victory and included the titles and names of the amirs, as well as their blazons. These standards, called *tu*, were displayed during battles and ceremonial activities. They were also used as the heads of banners, called *alam*, and carried by the *alamdar* (flag-bearer).

This standard is almost spear shaped, with straight edges tapering toward the apex; its base is pierced with two dragons, their open jaws placed at the edge. A pair of studs attaches the standard to the joint, which was originally inserted into a tall wood shaft.

Each side bears identical decoration: a quatrefoil cartouche appears in the center, with two rectangular panels placed above and below. Loosely drawn floral motifs link the three units and adorn the interstices. Floral decoration also fills the cartouches and panels containing inscriptions. One side of the standards gives the name and titles of the amir; the other contains a Koranic passage.

Sayf al-Din Tarabay, the Amir of Ten who owned this standard, commissioned a mausoleum in Cairo, which was completed in 1503/4. He appears to have served under either Janbalat (1500–1501) or Qansuh al-Ghuri (1501–17), two of the last Mamluk rulers to use the honorific title al-Ashraf.

Published
Mayer 1943, p. 10, note 90 and fig. 13.
Mayer 1952, p. 46, note 9.

43
Standard
Steel: engraved
Circa 1500
Made for Tarabay

Height: 51.3 cm. (20 3/16 in.)
Width: 11.7 cm. (4 5/8 in.)

New York, The Metropolitan Museum of Art,
 36.25.1961
Bequest of George C. Stone, 1936

Inscriptions
Side I:

مما عمل برسم المقر الاشرف السيفى طراباي * الاشرفي دوادار
المقام الشريف * بالشامسى المحروسى واعز انصاره

One of the things made for the noble excellency, al-Sayfi Tarabay, [officer] of al-Ashraf, [the] secretary, the noble office, in Syria, the protected, and may his victory be glorious.

Side II: Ayat al-Kursi (Verse of the Throne; II:255)

GLASS

The Mamluks inherited a rich tradition of glassmaking, which they exploited to the fullest. Artists excelled in the execution of enameled and gilded glass, producing at first small vessels with delicate compositions, then creating dazzling oversize objects, which reveal a tour de force unequaled in any glass tradition. This burst of creativity occurred around 1300, continued until the middle of the fourteenth century—at which time production of enameled and gilded glass began to decline—and disappeared after 1400.

The disappearance of enameled and gilded glass is one of the mysteries of the Mamluks, and so far no logical explanation has been proposed. The sack of Damascus by Timur in 1401 is most frequently cited as the reason for the termination of the tradition; it is thought that Timur not only destroyed the Syrian glass industry but took Mamluk glassmakers back with him to Samarkand. And yet no great glass tradition is known to have existed in Turkestan in the fifteenth century, and the status of Egyptian glassmakers, who were undisturbed by the Timurid invasion, has not been fully discussed in scholarly literature.

Although Syria was the main center for glass production in the Mamluk period, artists in Egypt were also actively involved, particularly in the manufacture of lamps commissioned by the court throughout the fourteenth century. The destruction of Damascus was detrimental to the glass industry and proved to be fatal when combined with the economic recession and growing inflation that curtailed the demand for luxury items. A similar decline in production and lack of imperial patronage was observed in the tradition of metalwork. It is also possible that a change in taste occurred at the same time, with patrons preferring to purchase porcelain imported from China.

While enameled and gilded glass was made for the court, the general public was provided with a variety of simpler transparent and opaque glass pieces, some of which rivaled the quality of imperial wares. Transparent glass was colorless or tinted blue, green, brown, or purple—the same range of colors employed in opaque glass. Glass objects were often decorated with tooling, applied thread, and colored inlay.

Mamluk artists produced every conceivable shape applicable to the medium of glass, including beakers, cups, goblets, flasks, bottles, bowls, basins, vases, stands, and lamps. The enameled and gilded pieces were varied in shape and were often executed in ostentatious sizes, obviously as show pieces intended for ceremonial use.

Enameled and Gilded Glass

The glass tradition of the Ayyubids has not been thoroughly studied. Existing pieces indicate highly developed techniques and an extensive decorative vocabulary employing figural compositions, arabesques, floral motifs, and inscriptions. Among surviving intact pieces are a number of beakers with an inscription band encircling the rim. Some are decorated with rows of swimming fish, others have animals and trees or revelers and musicians. A beaker with flat base, straight sides, and flaring rim was the model for Mamluk glassmakers, who also reproduced a bottle with a tall slender neck adorned with a ring. The earliest example of a bottle with this shape was produced in the middle of the thirteenth century for Salah al-Din Yusuf, the last Ayyubid sultan of Syria.[1] The designs of the late Ayyubid examples make abundant use of gilding and are outlined in red and filled with black, white, red, blue, green, and yellow enamels.

Early Mamluk glassmakers continued to employ Ayyubid shapes, techniques, and decoration. Figural compositions were produced until the turn of the fourteenth century, at which time they began to be replaced by the epigraphic style characterized by bold inscriptions and floral motifs. A parallel development was observed in the tradition of metalwork.

The most interesting figural compositions on early Mamluk glass produced between 1250 and 1300 occur on small beakers, flasks, and bottles. An exquisite beaker in the Louvre is decorated with three lively riders,[2] and a unique flask in the British Museum shows two cloaked riders placed above medallions representing a drinker and lyre-player.[3] This flask also has floral scrolls composed of animal heads, resembling the fantastic arabesque scrolls of early Mamluk metalwork (for instance, nos. 10, 13, and 22). At times figures are placed within an architectural setting, as in the pair of beakers in the Walters Art Gallery in Baltimore (nos. 44–45).

Figural compositions were combined with heraldic symbols, some of which were not established as true blazons in the experimental stage of the development of Mamluk heraldry. A perfume sprinkler in the Louvre, made in the middle of the thirteenth century, has architectural compositions on the sides, with central medallions representing an eagle.[4] The eagle most likely constitutes a symbol of royalty and not the blazon of an individual ruler, similar to its representation on early Mamluk metalwork (see nos. 11–12).

Another flask has a shield with a lion above a series of bends or diagonal lines (no. 46). A curious vessel, thought to be a lamp, with rounded base and broken neck, displays a blazon with a lion on a napkin; its inscription gives the name Altunbugha (died 1293), an amir in the service of Sultan Baybars.[5] The lion was the heraldic emblem of Baybars and was also used by his officers, who added their own signs of office. The bends of the perfume flask identify a Syrian official, while the napkin on the "lamp" symbolizes the *jamdar* or master-of-the-robes, a position held by Altunbugha.

A similar "lamp" in the Louvre, also with a broken neck, depicts eagles or harpies alternating with shields enclosing triangles; this example was made around 1295 for Umar II, Rasulid sultan of Yemen.[6] A bottle in Berlin with a tall slender neck and rounded body, dated to the last quarter of the thirteenth century, depicts a series of riders and five-petaled rosettes, the blazon of the Rasulid dynasty.[7]

The Louvre "lamp" made for Umar II obviously predates the establishment of the proper Rasulid blazon that appears on the Berlin bottle, although the rosette was used a few years earlier on a metal tray (no. 14), made around 1290 for Umar's father, Yusuf. Decorative motifs resembling blazons also appear on a perfume sprinkler dating from the same period (no. 47).

The execution of human figures on early Mamluk glass is extremely refined and detailed, revealing the hand of master painters. Among the pieces produced in this style is a bowl with the signs of the zodiac (no. 48), an oversize beaker decorated with riders,[8] and one of the earliest Mamluk lamps, sparsely adorned with mounted figures.[9] Figural compositions are often combined with delicately drawn floral scrolls, braided bands, and inscriptions. Many pieces have fluting (nos. 48–49), a decorative feature that falls out of fashion in the fourteenth century.

The first half of the fourteenth century was the most brilliant period of gilded and enameled Mamluk glass. A chronological sequence for Mamluk glass is provided by the mosque lamps that bear the names and blazons of sultans and amirs. Although none of the lamps have dates, they were made for specific religious foundations that are dated. Objects made for secular use—such as large bottles, goblets, and basins—generally contain dedications to anonymous patrons, with the exception of those commissioned by the Rasulids, which almost always bear the names of the sultans. The inscriptions reveal information about the glass industry and the demands made upon the artists. Secular pieces were mass-produced, expensively and exquisitely decorated for purchase by wealthy clients. Others were made according to specification for the sultans of Yemen, and mosque lamps were commissioned by the court for religious establishments. It is conceivable that the lamps were also mass-produced since their designs follow a predetermined format: after a piece was made the names of the patron could be inserted into the inscription panels and his blazons painted in the medallions reserved for this purpose.

Among the secular pieces are a series of bottles or vases in three slightly different shapes: the first has a tall slender neck with a bulbous body and low foot (no. 49), the second has an applied ring on the neck and a body that swells toward a high flaring foot (no. 50), and the third resembles a lamp with a pair of trailed handles applied between the neck and shoulders. Judging from the surviving examples, the most popular shape was the first, which made its appearance in the third quarter of the thirteenth century as represented by the Berlin bottle decorated with riders and Rasulid blazons. Such bottles are usually adorned with fabulous phoenixes, winged creatures, quadrupeds, roosters, and lions; figural compositions depicting riders, dancers, and revelers; and arabesque and inscription bands interrupted by medallions enclosing lotus blossoms. One of the more unusual bottles bears a pen box, the blazon of the *dawadar* or secretary and includes the name of Sayf al-Din Jurji, who was in the service of Sultan Hasan.[10]

Similar decorations appear on the second type of bottle with a ring on the neck, which follows a mid-thirteenth-century example made for the last Ayyubid sultan of Syria.[11] One of these bottles (no. 50) was commissioned by Dawud, Rasulid sultan of Yemen, and another was ordered by his son, Ali.[12] A third example was made for Toquztimur, an amir of Sultan Nasir al-Din Muhammad appointed governor of Damascus in the 1340s.[13] Toquztimur's blazon, which consisted of an eagle standing above a cup, appears in three medallions on his bottle. The five-petaled rosette is found on those ringed-neck bottles made for the Rasulid sultans Dawud and Ali.

The third bottle type, with trailed handles, was not as popular as the others. One of these bottles bears a six-petaled rosette, thought to be an imperial symbol associated with the house of Qalawun; it was possibly made for him or for one of his immediate followers.[14] A similar piece with five-petaled rosettes was ordered by an anonymous Rasulid sultan.[15]

Goblets or stemmed cups, which represented the office of the *saqi* (cup-bearer), were also executed in enameled and gilded glass. Many goblets are very large and spectacularly decorated. Among the earliest is an example in the Metropolitan Museum of Art in New York, which has figural decorations and a shield with an eagle.[16] Several goblets have a thick glass scroll applied to the middle of the stem and are made of three joined sections (bowl, stem, and foot).[17]

Another Mamluk shape is a footed bowl with domical lid. Its body is similar to the shape of a goblet but is squatter. Only two lidded examples have survived intact, one in the Freer Gallery of Art in Washington, D.C., and the other in the Toledo Museum of Art.[18] The body of the Freer example is exquisitely adorned with a frieze of real and fantastic predators and prey, interrupted by three medallions with a phoenix painted in reserve on a turquoise ground. The Toledo piece has an inscription panel broken into four sections by lotuses. Surmounted by small domes with globular knobs at the apex, the domical lids of both pieces are identical.[19]

By the middle of the fourteenth century, Mamluk glassmakers were able to produce any given shape. In addition to bottles, goblets, and footed bowls, they shaped and decorated basins based on metalwork models.[20] A basin bearing the Rasulid blazon was made between 1300 and 1320 for Sultan Dawud.[21] The Rasulid sultans also commissioned large bowls: one of these has a sturdy foot and is dedicated to Ali;[22] another, with an ovoid base represents unicorns, sphinxes, and griffins.[23] This example must have rested on a cylindrical stand made of glass or metal.[24] A similar shape, that is, a cylinder with a ring around the midriff, also served as a lamp and is unique among hundreds of hanging lamps. An example in Lisbon, dedicated to Sultan Nasir al-Din Muhammad, has a conical support for inserting a candle in the base.[25] Among other unusual objects are a basinlike vase (no. 51), a flat-bottomed plate with shallow walls,[26] a candlestick imitating brass examples,[27] and the "Toledo flagon," inspired by unglazed and molded pottery canteens.[28] A unique jar decorated with riders and a

tiny kidney-shaped perfume bottle adorned with eight musicians made in the second half of the fourteenth century reveal the last vestiges of the figural style.[29] The Treasury of the Cathedral of Saint Stephen in Vienna owns several rare Mamluk glass vessels, including a double-handled bottle and a large pilgrim flask representing riders and musicians.[30]

Several pieces of enameled and gilded fourteenth-century glass are recorded as having been acquired in China, suggesting that Mamluk pieces were cherished not only in the West but in the East as well. Among the pieces found in China is a large bottle or vase with four strap handles, its neck bearing shields containing the Rasulid blazon.[31] This robust piece may have been sent as a gift to the Chinese court by one of the sultans of Yemen who had commercial and diplomatic links with the Eastern empires.

It is for lamps that Mamluk glassmakers are best known. The sultans and amirs commissioned hundreds of oversize lamps to adorn their religious establishments in Cairo, most of which were removed in 1881 by the Comité de Conservation des Monuments de l'Art Arabe and deposited in the Museum of Islamic Art.[32]

The Mamluk lamp has a characteristic shape with wide rim, high flaring neck, sloping shoulders with six applied handles, bulbous body, and prominent footring (nos. 52–53). The necks of lamps made for religious buildings always contain the celebrated Ayat al-Nur (Verse of Light, XXIV:35), which pertains to the manifestation of divine light:

> *God is the light of the heavens and the earth; a likeness of His light is like a niche in which there is a lamp; the lamp is in glass; the glass is as if it were a shining star.*

Thus, the lamp became the symbol of divine light and often appears in representations of the mihrab in prayer rugs and in architectural decoration (see no. 111). These lamps not only symbolize celestial radiance but also provide soft and shimmering light for lofty interiors. Although the generic term in Western literature for these lamps is "mosque lamp," only those bearing the Ayat al-Nur can definitely be assigned to religious monuments. Those lacking this Koranic passage were likely made for use in residential palaces and mansions.

The names of Khalil (1290–93), Baybars II (1309–10), and Nasir al-Din Muhammad (1293–1341, with interruption) appear in the earliest lamps commissioned by sultans. Only one lamp dedicated to Sultan Khalil has survived;[33] two are known to have been made for Baybars II;[34] and at least a dozen bear Nasir al-Din Muhammad's name.[35] The sultan who appears to have been the most preoccupied with lamps was Hasan (1347–61, with interruption). He literally covered the ceilings of his famous madrasa and mausoleum with lamps (no. 52), some of which were attached to glass globes or "eggs."[36] The decorations on Sultan Hasan's lamps reveal the full artistic repertoire developed by Mamluk artists: some pieces have the Ayat al-Nur on the neck and a dedication to the sultan on the upper portion of the body; others are decorated with lozenge-shaped panels with floral motifs or

overall designs with lotus blossoms amidst leaves. Imperial epigraphic blazons often appear in medallions on the neck and lower part of the body.

The production of enameled and gilded glass, particularly lamps, declined in the second half of the fourteenth century after the reign of Sultan Hasan. The few lamps commissioned around 1370 by Shaban II are sparsely adorned with cartouches and bands that reveal a marked deterioration in quality from mid-fourteenth-century examples. Sultan Shaban's mother, an otherwise important patron of the arts, provided her favorite madrasa with plain glass lamps.[37]

There was a brief revival of the technique during the reign of Barquq (1382–99), who put an end to the house of Qalawun and established the Burji Mamluk rule. Nearly forty lamps are known to have been made in the 1390s for Barquq's mosque.[38] This decade witnessed the last great effort on the part of Mamluk glassmakers, who were capable of recreating the rich designs employed by the early masters but were unable to equal their technique. Although Barquq's lamps were made in abundance, there is a noticeable lack of care in the painting. Presumably, the lamps had to be produced rapidly, and masters worked alongside less experienced apprentices.

In the fifteenth century only a few lamps were made. Two were commissioned by Sultan Shaykhu around 1420; an amir by the name of Qanibay ordered one two decades later; Amir Inal, who later became sultan, commissioned another around 1450; and only one made for Qaitbay at the end of the Burji period has come to light.[39] It is only fitting that the last imperial mosque lamp was made for the celebrated Qaitbay, who tried valiantly to revive both the arts and the economy of the state.

Because they bear a variety of blazons, lamps made for amirs are far more interesting than those produced for sultans. The bow appears on the lamp of Aydakin, the *bunduqdar* (bowman), commissioned for his foundation in Cairo built in 1284/85 and known as the Khanqa al-Bunduqdariyya.[40] Amir al-Malik, the *juqandar* (polo master) ordered two lamps depicting a pair of polo sticks for his mosque completed in 1319 in Cairo.[41] Ahmad al-Mihmandar ordered for his mosque dated 1324/25 a lamp bearing his pointed shield.[42] Among the most unusual blazons is a shield in which a horse stands beneath a parasol or dome. It is thought to represent a ceremonial saddle, symbolizing the office of the *jawish* (royal usher or messenger), and appears on a lamp in Lisbon.[43]

The amirs of sultans Nasir al-Din Muhammad and Hasan competed with one another and rivaled the rulers in the number of enameled glass lamps they commissioned. The most prominent patron was Toquztimur, who ordered the spectacular vase now in the Louvre. His blazon, a circular shield enclosing an eagle over a cup, appears on two refined lamps owned by the British Museum.[44]

One lamp bearing the blazon of the *silahdar* (sword-bearer) was commissioned by Sayf al-Din Qijlis, who was in the service of Sultan Nasir al-Din Muhammad.[45] Two other lamps with the sword blazon of the *silahdar* are not inscribed, but the lotus blossoms adorning these pieces are so similar to those found on Sultan Hasan's lamps that they were probably made for his sword-bearer.[46]

One of the most important lamps was ordered by a cup-bearer of Sultan Nasir al-Din Muhammad, Amir Qusun, for his mosque completed in 1329/30. It bears the signature of the maker, Ali ibn Muhammad al-Rammaki (from Rammaka in Syria), on the foot between medallions with lotus blossoms.[47] The same artist signed another lamp made for Almas, whose mosque was also completed in 1329/30. Almas was the *jashnigir* (imperial taster) and used a round table as his blazon.[48] The artist misspelled his *nisba* in the inscription on Almas's lamp, writing "al-Ammaki" instead of "al-Rammaki." Ali ibn Muhammad is the only glassmaker whose name has been preserved.

The blazon of the cup-bearer appears on a lamp made for Altunbugha, who held the office in the 1340s; his contemporary Tugaytimur, a *dawadar* (secretary), employed a pen box, the sign of his office, in the bar above the cup on his lamp.[49] One of Sultan Hasan's cup-bearers, Shaykhu, commissioned almost a dozen lamps, which were most likely designated for his famous *khanqa* built in 1355 in Cairo.[50] Sarghithmish, the *jamdar* (master-of-the-robes) of Sultan Hasan, commissioned for his madrasa dedicated in 1356 lamps as well as decorative balls, which were suspended above the lamps.[51]

Some lamps made for amirs do not represent blazons. For instance, a famous example commissioned by Salar, presumably for his mausoleum dated 1303/4, is adorned only with inscriptions and elegant floral decorations.[52] Blazons are also absent on lamps made for nonmilitary patrons. An example made around 1320 for a most remarkable man, Karim al-Din, is decorated only with inscriptions (no. 53), as is a contemporary piece dedicated to a governor named Taqi al-Din.[53] Another person named Nasir al-Din Muhammad, son of the famous Amir Arghun, the *dawadar* of Sultan Nasir al-Din Muhammad, commissioned three lamps around 1330. Since he was the son of an amir and did not hold a military post, his lamps are devoid of blazons.[54] All three lamps have lengthy inscriptions with the titles of the owner and those of his renowned father. It is possible that these were made for secular use since the traditional Ayat al-Nur is not included on the pieces.

The provenance of enameled and gilded glass is far more problematic than the dating of the pieces. Syria was the main center for the production of early Mamluk pieces. A number of Syrian artists, such as Ali ibn Muhammad al-Rammaki, must have moved to Cairo, where their work was in great demand. It is logical to assume that most of the mosque lamps were made in Egypt, since it was certainly easier—and safer—to transport artists rather than fragile glass objects.

Excavations at Hama have yielded all types of glass from the Ayyubid and Mamluk periods, indicating that Syrian artists were

quite prolific. Mamluk glass finds from Fustat have not yet been published, and limited material has been unearthed at Quseir.[55]

Among important finds in Egypt is a bottle discovered at Qus (no. 49) together with a number of important pieces of metalwork and a small glass perfume flask.[56] The flask bears an inscription giving the name of Badr al-Din Muhammad, who was the governor of Qus under Sultan Nasir al-Din Muhammad. It is adorned with a band of musicians interrupted by two shields representing a circular motif often identified as the table of the *jashnigir*. It is difficult to attribute this little flask and bottle to a specific region, since they could have been made in Egypt or Syria.

The fabric of Mamluk enameled and gilded glass is bubbly and colorless, honey colored, or slightly grayish. The enamels are pure and brilliant white, red, blue, green, and yellow, with black used sparingly and only in the earlier pieces. Since the same technique and materials were used by artists working in both Egypt and Syria, it is difficult to differentiate between the two regions.

The decorative layout of glass objects is remarkably similar to that of metalwork, particularly after the first quarter of the fourteenth century. The surfaces are divided into horizontal bands, each broken by three or four medallions, while a continuous strip often encircles the compartments and links them with one another. The bands are filled with inscriptions, floral scrolls, flying birds, and running animals; the medallions bear large lotus blossoms, arabesques, heraldic symbols, and birds.

Mosque lamps are predominantly decorated with inscription bands and medallions bearing floral motifs or blazons. The inscription on the neck is often written in blue enamel on a gilded ground with a scroll of polychrome leaves and buds. The inscription on the body is generally rendered in gold on a blue ground enhanced with gold floral motifs. The decorations on some of the lamps with overall floral designs, such as those made for Sultan Hasan, are painted in reserve on a blue ground, with blossoms executed in gold.

After the vessels were blown, with the lip and foot often folded under or over, the handles and rings were applied. Some objects, such as large goblets, were made in separate sections and then reheated and fused together.

The decoration was first sketched with a thin red line and then filled in with thickly applied polychrome enamels and gilding. The entire surface of the piece was often completely covered with decoration. The artists frequently painted both the inside and outside of vessels with large openings, such as bowls, basins, and lamps. In several large bowls the inscription is written on the inner walls and can only be read by looking into the vessel.[57]

The technique of Mamluk glassmaking has a strong impact on the glass industry of Venice, which started producing enameled and gilded glass at the end of the fifteenth century. The Venetian industry replaced the already exhausted Mamluk tradition, monopolizing the

world market with luxury glass for years to come.

During the late nineteenth century, interest in "Moorish" interior decoration and the fad for Turquerie designs in Europe led to imitations of enameled and gilded Mamluk glass. Many wealthy homes had "Turkish corners," with divans, large cushions, low tables, and "oriental" accessories. European and American world fairs in the 1880s and 1890s often included pavilions and objets d'art reflecting this new taste, and artists were quick to follow the trend. Among the French glassmakers who copied Mamluk objects was Emile Gallé, who made pastiches of Islamic and pseudo-Islamic themes.[58] Joseph Brocard, a far more conscientious artist, obviously studied all the Mamluk glass available to him and even learned to accurately copy Arabic inscriptions.[59] He imitated mosque lamps in the Cluny Museum and those shown in Union Centrale's 1865 and 1867 exhibitions in Paris; he also copied specific pieces such as vases, goblets, bottles, and bowls found in various French museums and private collections. Mamluk glass also served as models for other glassmakers, including Antonio Salviati of Venice and Ludwig Lobmeyer of Vienna, as well as for Théodore Deck, the French ceramicist who translated Mamluk glass shapes and decorations into pottery.[60]

Other Techniques

Little attention has been paid to the simpler and more functional types of Mamluk glass, which were produced in abundance. There are a number of transparent purple glass vessels decorated with opaque white glass threads, which were combed into various swirling, festoon, or herringbone designs and marvered (see nos. 56–57). In some piece the applied threads were not combed, but the pieces were fluted, creating a rippling effect (nos. 54–55). Most of these vessels are small bowls, cups, beakers, and perfume or cosmetic flasks, as well as larger bottles and minuscule chess pieces and inkpots. One of the rarer pieces—similar to those found at Hama—is a fairly large bowl with domical lid owned by the Metropolitan.[61] The technique of decorating with applied glass thread was invented by the ancient Egyptians and was revived in the Islamic period. It continued to be practiced up to the turn of the fourteenth century.

Opaque white thread was also applied to transparent colorless glass as well as to green, blue, and brown glass. Purple glass embedded with white thread was the most popular combination. A sprinkler with doughnut-shaped body and tiny handles and feet from the Corning Museum is perhaps one of the finest examples of this type (no. 57).

The same delicacy of execution may be seen on transparent colorless glass vessels (nos. 58–60). Many of the smaller vessels are bottle shaped, with or without tall, slender necks, and are often adorned with applied decoration and tooling. A few pieces, exemplified by the mold-blown flask (no. 61), were made for the tourist trade. This flask, decorated with a cross, must have been produced for Christian pilgrims visiting the Holy Land. Stamped designs were also used, particularly on glass weights, which were frequently made from a green matrix and shaped as discs.

Small vessels were also made in transparent blue, green, brown, and purple glass. Deep blue glass, at times enhanced with enameled and gilded decoration, was most attractive (nos. 62–63). One blue vessel, a tiny perfume sprinkler, has a herringbone pattern painted in light blue enamel with gilt arabesques in the interstices.[62] The decoration of the piece was inspired by examples with opaque white thread.

Among the most popular vessels are beakers with tooled decorations or inlaid with threads of contrasting colors (nos. 64–65). An interesting beaker, made of greenish glass and trailed with blue thread, has around the rim tiny rings attached to loops, which were used to draw the attention of the wine steward when the drinker required a refill (no. 64). Similar rings are found on stemmed cups, some of which have curious traylike projections at the center of the stems. Several beakers with applied thread are also ribbed and twisted at the top, creating a pleasing swirl of transparent and opaque glass (no. 65).

Glassmakers also contributed to architectural decoration, making stained-glass windows and gilded or colored tesserae for mosaic panels in the mihrabs of early Mamluk buildings.

Vestiges of the art of the Mamluk glassmaker can still be seen in Egypt and Syria. Modern pieces are generally made of transparent purple, green, blue, and brown glass and are shaped into bottles, ewers, and beakers.

Notes

1. Cairo, Museum of Islamic Art, 4261 (Wiet 1929, pl. I; Cairo 1969, no. 166; London 1976, no. 135).
2. Paris, Louvre, 6131 (Paris 1977, no. 421).
3. London, British Museum 69 1–20 3 (Harden 1968, no. 153).
4. Paris, Louvre, 7244 (Paris 1977, no. 265).
5. Cairo, Museum of Islamic Art, 18038 (Mayer 1933, pp. 62–63; Cairo 1969, no. 167).
6. Paris, Louvre, 7448 (Paris 1977, no. 264).
7. Berlin, Museum für Islamische Kunst, I 2573 (Berlin 1971, fig. 68 and pl. 10).
8. Washington, D.C., Freer Gallery of Art, 48.14 (Atıl 1975, no. 71).
9. London, Victoria and Albert Museum, 330-1900.
10. The most beautifully decorated bottles are in London, Victoria and Albert Museum, 328-1900; New York, Metropolitan Museum of Art, 41.150, formerly in the imperial Hapsburg Collection (Dimand 1944, fig. 159; Metropolitan 1975); Cairo, Museum of Islamic Art, 24249 (London 1976, no. 141); London, British Museum, s 334 (Harden 1968, no. 155); and Lisbon, Gulbenkian Collection (Lisbon 1963, no. 2). Sayf al-Din Jurji's bottle is in London, Victoria and Albert Museum, 223-1879 (Schmoranz 1899, pl. XXV; Mayer 1933, pp. 134–35).
11. Bottles with this shape include examples in the following collections: New York, Metropolitan Museum of Art, 3633 (Dimand 1944, fig. 160); Cairo, Museum of Islamic Art, 4262 (Wiet 1930, no. 92); London, Victoria and Albert Museum, 328-1900; Cleveland, Cleveland Museum of Art, 44.488 (Hollis 1945).
12. Washington, D.C., Freer Gallery of Art, 34.20 (Atıl 1975, no. 74).
13. Paris, Louvre, 3365 (Mayer 1933, pp. 235–39; Paris 1977, no. 344). Another example, formerly in Paris, Vapereau Collection, is published in Schmoranz 1899, pl. XXIX.
14. Corning, New York, Corning Museum of Glass, 55.1.36 (Schmoranz 1899, pl. V; Lamm 1929–30, pl. 178:8; Vavra 1954, pl. 35).
15. Cairo, Museum of Islamic Art, 24250, formerly Gezira Museum, 172 (Cairo 1969, no. 174, pl. 30). There is another example in New York, Metropolitan Museum of Art, 91.1.1531.
16. New York, Metropolitan Museum of Art, 91.1.1538 (Dimand 1944, fig. 155; Nickel 1972, fig. 3).
17. New York, Metropolitan Museum of Art, 23.189; London, British Museum, 1924 1-25 1 (Harden 1968, no. 154); Toledo, Toledo Museum of Art, 54.27 (Toledo 1969, p. 40). See also Lamm 1929–30, pl. 189:1–3.
18. Washington, D.C., Freer Gallery of Art, 58.16 (Atıl 1975, no. 72); Toledo, Toledo Museum of Art, 70.56 (*JGS* 1971, no. 34).
19. Detached lids also exist, for instance, in London, British Museum, OA 529.
20. The Hague, Gemeentemuseum, OG 13-1932 (London 1976, no. 137); New York, Metropolitan Museum of Art, 91.1.1532.
21. Cairo, Museum of Islamic Art, 24252, formerly Gezira Museum, 150 (Cairo 1969, no. 168).
22. Toledo, Toledo Museum of Art, 44.33 (Sotheby 1944, no. 147). A similar example dedicated to an anonymous sultan is in Paris, Louvre, 7880-65 (Paris 1977, no. 345).

23. Washington, D.C., Freer Gallery of Art, 33.13 (Atıl 1975, no. 73).
24. One of these glass stands is in Cairo, Museum of Islamic Art, 24251; another is published in Schmoranz 1899, pl. XXXII.
25. Lisbon 1963, no. 31.
26. New York, Metropolitan Museum of Art, 91.1.1533 (Aanavi 1968, p. 201).
27. Formerly in the Rothschild Collection, now in a private collection (Lamm 1929–30, pl. 126:17; Schmoranz 1899, fig. 34).
28. Toledo, Toledo Museum of Art, 27.217 (Toledo 1969, p. 40).
29. The jug, formerly in the Rothschild Collection, is published in Schmoranz 1899, pl. XXX. The bottle is in Washington, D.C., Freer Gallery of Art, 29.8 (Atıl 1975, no. 77).
30. Schmoranz 1899, pls. IV–IVA and XIII.
31. Washington, D.C., Freer Gallery of Art, 34.19 (Atıl 1975, no. 75).
32. The lamps in Cairo are published in Wiet 1929.
33. Wiet 1929, pl. IV.
34. Wiet 1929, app. nos. 10–11. These are in Paris, Musée des Arts Décoratifs; and New York, Metropolitan Museum of Art, 17.190.988 (Dimand 1944, fig. 157).
35. Wiet 1929, app. nos. 7, 21, and 33–40 and pl. VI. Among the celebrated examples are those in Cairo, Museum of Islamic Art, 313 (London 1976, no. 139); Berlin, Museum für Islamische Kunst, I 2572 (Berlin 1971, no. 13); and London, Victoria and Albert Museum, 329-1900.
36. For Sultan Hasan's lamps see Wiet 1929, app. nos. 70–118 quarter and pls. XXII–LVII. See also Lamm 1929–30, vol. 1, pp. 453–66, and vol. 2, pls. 193:10, 194:1, 202:1; Harden 1968, no. 159; Atıl 1975, no. 76; Paris 1977, no. 232. For an example of the "egg" see Wiet 1930, no. 96.
37. Wiet 1929, pls. LVIII–LXI.
38. Wiet 1929, app. nos. 128–64, pls. LXIII–LXXXVIII. See also Wiet 1930, no. 99; Dimand 1944, p. 248; Paris 1977, no. 231.
39. Inal's lamp, formerly in the Basilevski Collection, is now in Leningrad, Hermitage (Schmoranz 1899, p. 71). All other pieces are published in Wiet 1929, app. nos. 165–66, 168, and 170 and pls. LXXXIX–XC.
40. New York, Metropolitan Museum of Art, 17.190.985 (Mayer 1933, pp. 83–84; Dimand 1944, fig. 156; Nickel 1972, fig. 5).
41. Mayer 1933, pp. 59–62. One of them is in Konya and the other is in Cairo, Museum of Islamic Art, 312 (Wiet 1930, no. 93; Cairo 1969, no. 178).
42. New York, Metropolitan Museum of Art, 91.1.1534 (Mayer 1933, pp. 50–51, pl. XLI:3; Dimand 1944, p. 241).
43. Mayer 1933, pp. 17–18; Lisbon 1963, no. 5.
44. The vase is in Paris, Louvre, 3365 (Paris 1977, no. 344). The lamps are in London, British Museum, 69 6-24 1 and 69 6-24 2 (Harden 1968, no. 158). See also Mayer 1933, pp. 235–39.
45. London, Victoria and Albert Museum, 580-1875 (Mayer 1933, pp. 189–90).
46. London, British Museum 96 3-21 1; and Paris, Louvre, 3110 bis (Paris 1977, no. 233).
47. New York, Metropolitan Museum of Art, 17.190.991 (Mayer 1933, pp. 186–87; Dimand 1944, p. 241; Nickel 1972, fig. 6). For this glassmaker see also Schroeder 1938.

48. Cairo, Museum of Islamic Art, 3154 (Wiet 1929, pl. VIII; Mayer 1933, p. 241; Cairo 1969, no. 180).
49. Altunbugha's lamp, constructed of four fragments, is in Cairo, Museum of Islamic Art, 4065, 5880–82 (Wiet 1929, pl. IX; Mayer 1933, pp. 63–64). One of Tugaytimur's lamps is in Cairo, Museum of Islamic Art (Wiet 1929, pl. XIII; Wiet 1930, no. 94; Mayer 1933, pp. 232–34).
50. Wiet 1929, app. nos. 56–65 bis, pls. XX–XXI. See also Wiet 1930, no. 95; Dimand 1944, pp. 247–48; Harden 1968, no. 157; Toledo 1969, p. 41; London 1976, no. 138; Vienna 1977, no. 118.
51. Wiet 1929, app. nos. 66–69, pl. XVI; Mayer 1933, pp. 208–10, pl. XXXI:2.
52. Cairo, Museum of Islamic Art, 281 (Wiet 1929, app. no. 8, pl. VII).
53. London, British Museum, 75 7-17 1 (Harden 1968, no. 156).
54. For the study of these lamps see Wiet 1933. One of them is now in Toledo, Toledo Museum of Art, 40.118 (Toledo 1969, p. 34).
55. For the glass finds at Hama see Riis 1953; chapter two in Riis and Poulsen 1957. Fustat finds are published in Pinder-Wilson and Scanlon 1973; this report, however, does not include Mamluk material. For Quseir finds see Whitcomb and Johnson 1979, pp. 144–82.
56. El-Emary 1966, figs. 11–12 and pl. XXXI.
57. For instance, the large bowls in Toledo, Toledo Museum of Art, 44.33 (Sotheby 1944, no. 147), and Paris, Louvre, 7880–65 (Paris 1977, no. 345).
58. For Gallé's copies of Islamic objects see Bird 1972.
59. Most of Brocard's glasses are in Limoges, Dubuché Museum; Paris, Musée des Arts Décoratifs; and Vienna, Österreichisches Museum für angewandte Kunst. Examples of his work are also in American collections, including Corning, New York, Corning Museum of Glass; Toledo, Toledo Museum of Art; Baltimore, Walters Art Gallery; and New York, Metropolitan Museum of Art. See Munich 1972, nos. 193–96, 199–204; Philadelphia 1978, no. IV:27.
60. For examples by Lobmeyer see Munich 1972, nos. 207–14. One of Deck's pieces is illustrated in Munich 1972, no. 197.
61. New York, Metropolitan Museum of Art, 26.77 (Metropolitan 1975). For other pieces discovered at Hama see Riis and Poulsen 1957, pp. 61–69.
62. New York, Metropolitan Museum of Art, 1972.118.42.

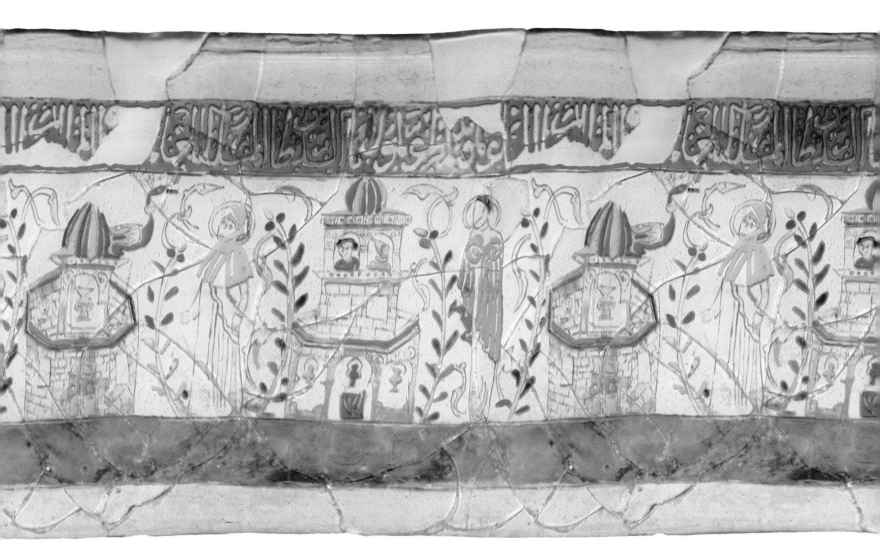

Peripheral view of no. 44

44
Beaker
Glass: gilded, enameled in green, blue, yellow, red, white
Circa 1260

Height: 18.5 cm. (7⅜ in.)
Diameter of rim: 12.1 cm. (4¾ in.)

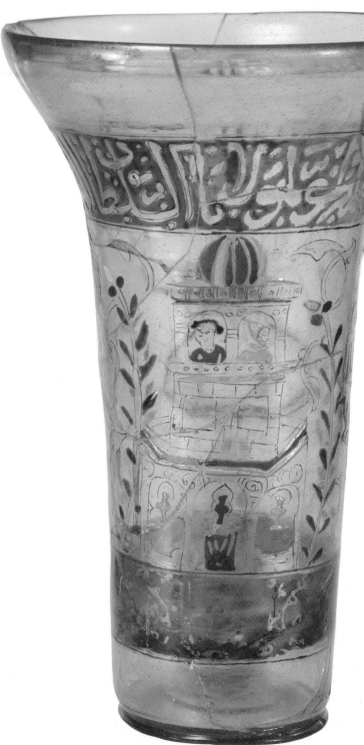

Baltimore, The Walters Art Gallery, 47.17
Purchased 1947
Ex-Dattari Collection

Inscriptions
Band below rim:

<div dir="rtl">عز لمولانا السلطان المالك العالم ...</div>

*Glory to our master, the sultan, the royal,
the learned. . . .*

The shapes, techniques, and decorative repertoire established in the first half of the thirteenth century by Ayyubid glassmakers continued to be employed during the Mamluk period. Early Mamluk glass is often decorated with figural compositions, a feature also observed on contemporary metalwork and ceramics.

The pair of beakers in the Walters Art Gallery (see also no. 45) have unusual compositions in which figures resembling saints alternate with domed structures enclosed by high walls. The scenes appear to depict monasteries inhabited by monks and visitors. Below the flaring rim is a wide blue band containing an inscription outlined in red and filled with gold. A second band, painted in red from the inside, appears above the foot; this band also had inscriptions written in gold, but they have virtually disappeared. Traces of floral scrolls rendered in gold can be detected behind the inscriptions. Although the beakers have been broken and repaired, they are extremely rare examples of Mamluk glass featuring architectural settings.

This beaker, slightly larger than its companion, is decorated with two haloed figures wearing long robes who stand between trees with buds, leaves, and scrolling branches. One of them is attired in a light blue cloak over a gold robe, the other wears a white hooded cape. Both face left in three-quarter view.

The men are placed between two types of brick or stone structures surmounted by ribbed domes. One building has two stories rising above a hexagonal arcade. A pair of figures, the first wearing a yellow hooded outfit and the second bareheaded and attired in red, peek out of the arched windows of the upper floor. Hanging in the arcade below are three lamps, the central one suspended over a chest or box. The other building, enclosed by an octagonal wall, has only one story above the enclosure. A large bird is perched on the edge of the roof. A lamp hangs from the arched opening of the top floor, while a face looks in from one of the windows of the enclosure, which has a central entrance portal flanked by two windows.

Although the precise meaning of the scenes is not clear, they appear to represent personages and structures of a Christian community. The use of Christian themes and Arabic inscriptions on objects made for Muslim rulers was not uncommon in the Ayyubid period. The same combination of Christian and Islamic themes appears on a number of mid-thirteenth-century metal pieces, the most outstanding being a large basin and a unique canteen, both owned by the Freer Gallery of Art in Washington, D.C.[1] This mixed imagery appears to have continued into the early Mamluk period, particularly in Syria.

The painting style of this beaker is commonly associated with Aleppo, which was renowned for its production of glass. Like other large Syrian cities, it had many Christian churches and monasteries and a substantial number of native Christians. The beaker may have been commissioned by a Christian patron who wanted it decorated with scenes reflecting his faith, as well as with standard Arabic inscriptions. Arabic was the native tongue of both the Christian and Muslim residents of Syria, and the phrases used on the beaker were a part of the general culture and understood by members of diverse religious groups.

Published
Drouot 1912, no. 608 and pl. LX.
Lamm 1929–30, vol. 1, pp. 330–31, no. 8; vol. 2, pl. 127:8.

Notes
1. Atıl 1973, nos. 27–28.

47
Perfume sprinkler
Glass : gilded, enameled in green, blue, yellow, red, white
Late 13th century

Height : 19.7 cm. (7¾ in.)
Max. diameter : 16.3 cm. (6⅜ in.)

Toledo, The Toledo Museum of Art, 66.115
Gift of Edward D. Libbey, 1966

This perfume sprinkler, thought to have been found in Syria, is a characteristic example with its delicate form and free style of drawing. Shaped as an ovoid with a slender neck that widens above the body and tapers toward the lip, it is decorated with a gilt and enameled band encircling the shoulders.

The band is divided by two medallions, each containing a roundel placed over a crescent enclosing an animal whose identification is difficult to determine due to the loss of gilt details. A pair of lotus blossoms flanking an oval cartouche adorns the zones between the medallions. The glass matrix is honey colored and bubbly ; the base is slightly recessed and contains the pontil mark.

The crescent, at times identified as a horseshoe, is not an uncommon element in Mamluk art. It is thought to be both a symbol of royalty and a decorative motif (see nos. 114–15).

Published
AQ 1968, pp. 205, 209, fig. 2.
Toledo 1969, p. 39.
Toledo 1969a, p. 92.

48
Fluted bowl
Glass : gilded, enameled in green, blue, yellow, red, white
Late 13th century

Height : 11.1 cm. (4⅜ in.)
Diameter of rim : 17.8 cm. (7 in.)

Toledo, The Toledo Museum of Art, 41.37
Gift of Edward D. Libbey, 1941
Ex-Arthur U. Pope Collection

The spontaneous drawing and delicate enameling of the previous examples is also seen on this small bowl with fluted bottom, rounded sides, and thickened rim. Below the rim is a floral scroll rendered in gold. Two gold bands encircle a wide panel containing a floral arabesque interrupted by twelve medallions, each enclosed by a gold frame.

The floral arabesque is composed of gold branches bearing blossoms and leaves painted in combinations of red and white, yellow and green, and blue and white. The medallions contain the twelve signs of the zodiac, rendered in gold on a deep blue ground : Aries (ram), Taurus (bull), Gemini (two figures), Cancer (figure holding a crescent), Leo (lion with the sun), Virgo (female

holding vegetation), Libra (duck bearing a balance), Scorpio (two scorpions), Sagittarius (centaur-archer), Capricorn (goat), Aquarius (man carrying bucket), and Pisces (a pair of fish). The medallions with Cancer and Leo include their corresponding planets, the moon and the sun. In the medallion for Cancer, the artist has omitted its symbol, the crab, but has included the moon, represented by a figure holding a crescent, to fill the unit. The inclusion of a duck in addition to the balance for Libra constitutes further artistic liberty.

The inside of the bottom of the bowl is enameled and gilded and contains an outer band of inscriptions in gold. Since this area is by far the most abraded and the gilding has disappeared, the inscriptions cannot be read. The center has a row of fifteen fish swimming counterclockwise around a central medallion with a white six-pointed star enclosed by a gold floral scroll.

The shape of the bowl and its decorative layout indicate that its model was metalwork. The depiction in the bottom of bowls and basins of fish swimming in rows is one of the characteristic features of Mamluk metalwork (see nos. 21 and 26–29), as is the representation of astrological symbols (see nos. 13–14 and 16).

Unpublished

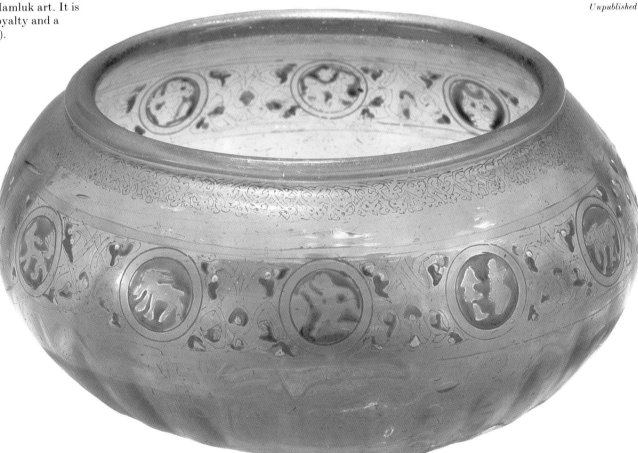

49

Fluted bottle
Glass: gilded, enameled in red, black
Late 13th–early 14th century

Height: 28.0 cm. (11 in.)
Max. diameter: 17.2 cm. (6¾ in.)

Cairo, Museum of Islamic Art, 23968
Found at Qus, 1966

Inscriptions
Two bands on body (repeated):

Glory.

This beautifully proportioned bottle has a heavy foot, pear-shaped fluted body, and slender neck that widens toward the lip. It is adorned with bands of varying widths, with the design sketched in red and painted in black and gold.

A series of red floral scrolls appears on the neck. The prominent band in the center is embellished with black zigzags suggesting a braided pattern. A zone of densely filled gold cloudlike motifs extends from the base of the neck to the upper shoulders.

The body is decorated with a wide band containing six medallions joined by horizontal strips and enclosed by two inscription bands. The inscriptions, written in black on a gold ground, are framed in gold. The same combination of letters is repeated thirty-four times in the upper band and thirty-nine times in the lower, with extra alifs added for decoration.

The medallions are framed by three gold bands; the widest one in the middle has a black scroll. In the center are two alternating themes: a lotus blossom and a hawk attacking a duck, both rendered in gold. The horizontal strips joining the medallions have a gold floral scroll, while two triangular cartouches with similar motifs appear in the interstices. The fluting extends from the foot to just above the upper inscription band.

The sparse decoration of the bottle and limited range of enamels are more than compensated for by the lavish use of gold and delicate fluting. Although medallions with lotus blossoms and hawks attacking birds were commonly used on thirteenth- and fourteenth-century metalwork and glass, fluting seems to have been used only in the early Mamluk period (see nos. 48, 54–55, and 64–65).

A number of Mamluk enameled and gilded glass bottles have identical shapes. Some are fluted, others are plain. Among the fluted examples is a bottle with riders now in Berlin.[1] Figural compositions also appear on an exceptionally large piece with a band of riders in the Metropolitan; an equally large example in Cairo is decorated with dancers.[2]

The honey-colored glass with irregular blemishes is thickly blown. The footring was formed by turning the edges under; in the middle of the base is the pontil mark.

Published
El-Emary 1966, p. 138 and pl. XXXII.
Cairo 1969, no. 177.

Notes
1. Berlin, Museum für Islamiche Kunst, I 2573 (Berlin 1971, no. 515, pl. 10 and fig. 68).
2. New York, Metropolitan Museum of Art, 41.150 (Metropolitan 1975); Cairo, Museum of Islamic Art, 24249 (London 1976, no. 141). Another example, with floral decoration, is in London, British Museum, S 334 (Harden 1968, no. 155).

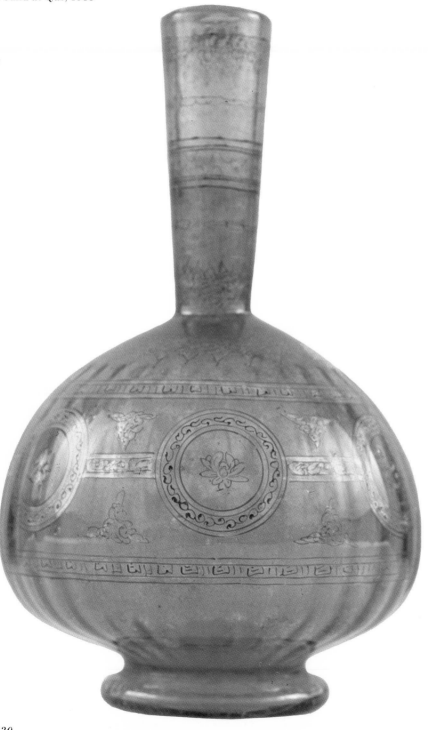

50

Large bottle

Glass: gilded, enameled in green, blue, yellow, red, white

Circa 1300–1320

Made for Dawud, Rasulid sultan of Yemen

Height: 37.3 cm. (14⅝ in.)
Max. diameter: 20.5 cm. (8 1/16 in.)

Detroit, The Detroit Institute of Arts, 30.416
Purchased 1930
Ex-Spitzer and ex-Strauss collections

Inscriptions
Bands on neck and body (repeated):

العالم

The learned.

Four panels on body:

مما عمل برسم السلطان الملك ا * المؤيد هزبر الدنيا والدين د *
داوود ابن يوسف ابن * ابن [sic] عمر عز نصره وسلطانه

*One of the things made for the sultan al-Malik
al-Muayyid Hazbar al-Dunya wa'l-Din Dawud
ibn Yusuf ibn Umar, may his victory and sultanate
be glorious.*

This large bottle, made for Sultan Dawud
(1296–1322), Rasulid ruler of Yemen, is decorated
with a series of horizontal bands encircling the
neck and body. The neck, adorned with a ring,
contains a floral scroll and two rows of fish
swimming to the left, below which is a second
floral scroll. At the base of the neck is an
inscription band, framed above and below by a
frieze of lionlike quadrupeds. The inscription,
written in blue, is placed on a floral scroll
enameled in green, red, yellow, and white.

The upper portion of the body contains four
medallions joined by a horizontal inscription
band; arabesque cartouches are placed above and
below this band, similar to the decorative layout
of the previous bottle (no. 49). Flanking the lower
cartouche is a pair of quadrupeds; two of them
are hares while the remaining resemble lions.
The four medallions are encircled by triple bands,
the middle one depicting a series of lions.
In the center of the medallions is a five-petaled
rosette, the blazon of the Rasulid family.

Below this zone is another inscription band
encircling the widest portion of the body.
Identical to the one at the base of the neck, this
band is broken into four parts by roundels
enclosing lotus blossoms with red and white,
blue and white, and green and yellow petals.
The underside of the body and the high flaring
foot are undecorated. The gilding has virtually
disappeared and most of the design, including the
inscription on the upper portion of the body,
retains only its red outlines.

The dedicatory inscription includes the
honorific Hazbar al-Dunya wa'l-Din, Lion of the
World and Religion, which may account for the
predominance of lions appearing in the neck
bands, framing the blazons, and flanking the lower
cartouches on the body.

The shape of the Detroit bottle can be traced to
the Ayyubid period with an almost identical
layout employed on an example made for Salah
al-Din Yusuf (1237–59), the last Ayyubid ruler of
Syria.[1] Among other fourteenth-century examples
are those in New York, Cleveland, Cairo, and
London;[2] a similar vessel in Paris bears a
dedication to Toquztimur, the imperial *saqi* who
became governor of Aleppo and Damascus in the
1340s (see also nos. 27 and 96).[3] Another bottle in
the Freer, was made for Sultan Ali (1322–63),
Dawud's son and successor.[4]

The rim of the Detroit bottle has been ground
down, possibly because the lip was chipped at one
time. The portion of the neck above the ring was
originally twice as high and similar to those on
contemporary bottles.

The Rasulid sultans of Yemen commissioned
from Mamluk artists many metal and glass
objects, including a brass tray ordered for Sultan
Dawud (no. 22) and a tray made for Yusuf, his
predecessor (no. 14).

Published
Madl, 1898, p. 275.
Schmoranz 1899, p. 16 and figs. 22–23.
Berchem 1904, pp. 50–55.
Migeon 1907, vol. 2, pp. 357–58.
Migeon 1927, vol. 2, pp. 137–38.
Wiet 1929, app. no. 19.
Lamm 1929–30, vol. 1, pp. 401–2, no. 1;
 vol. 2, pl. 179:1.
Aga-Oglu 1930, pp. 26–27 and cover.

Notes
1. Cairo, Museum of Islamic Art, 4261 (Wiet
 1929, pl. I; Cairo 1969, no. 166; London
 1976, no. 135).
2. New York, Metropolitan Museum of Art,
 36.33 (Dimand 1944, fig. 166); Cleveland,
 Cleveland Museum of Art, 44.488 (Hollis
 1945); Cairo, Museum of Islamic Art, 4262
 (Wiet 1929, pl. II); London, Victoria and
 Albert Museum, 328-1900.
3. Paris, Louvre, 3365 (Paris 1971, no. 290;
 Paris 1977, no. 344).
4. Washington, D.C., Freer Gallery of Art,
 34.20 (Atıl 1975, no. 74). For other similar
 bottles see Aga-Oglu 1930, p. 27; and
 Schmoranz 1899, pl. XXIX.

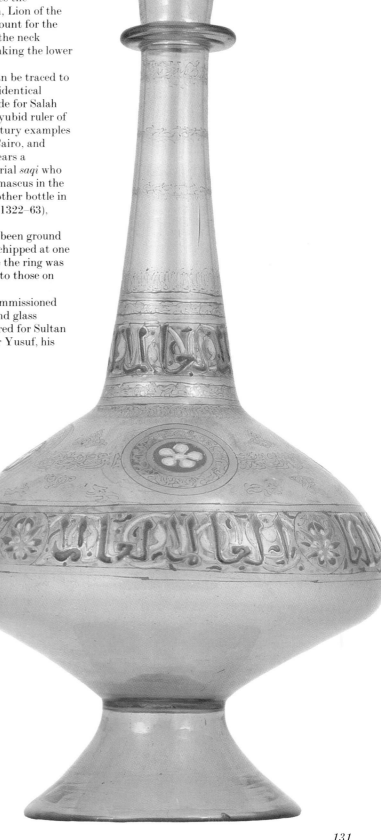

51
Vase
Glass: gilded, enameled in blue, red, white
Mid 14th century

Height: 17.5 cm. (6⅞ in.)
Diameter of rim: 32.0 cm. (12 9/16 in.)

Cleveland, The Cleveland Museum of Art, 44.235
Purchased, The J. H. Wade Fund, 1944

The unusual shape of this vase recalls both a basin
with exaggerated everted rim and a lamp with
flattened neck (see nos. 28 and 52–53). During the
Mamluk period, glassmakers experimented with
many different shapes and produced bowls
(no. 48), candlesticks, and small trays (or platters)
based on metal prototypes.[1] The Cleveland vase
belongs to this group of experimental pieces and
its shape is unique among Mamluk glass.

The decoration consists of a wide band in which
five medallions with geometric designs alternate
with floral arabesques. The same band appears on
the rim and on the body and is framed by bands
composed of alternating large and small trefoils.
The body of the vase is painted on the outside,
while the wide everted rim is enameled from the
inside (or top side). The entire surface of the vessel
is covered with enameled and gilt motifs, creating
a dense overall effect.

A trefoil band painted in blue on a gold ground
encircles the rim. Five medallions on the rim
contain a geometric design radiating from a white
twelve-pointed star enclosing a gold six-petaled
rosette. Polygons formed by radiating and
intersecting bands are painted in red and blue and
enhanced by lotus (?) blossoms. The triangular
units at the edge of the medallions are rendered in
white and adorned with gold dots. The arabesques
between the medallions are executed in gold on a
blue or white field. A continuous thin gold band
encircles the medallions and links them with the
other units.

A second trefoil band defines the neck, a third
appears at the base. Using identical motifs and
colors, the decoration of the body repeats the
design on the rim.

Most of the gilding on this piece is intact, its
original brilliance remarkably well preserved.
The pontil mark can be seen in the recessed base.
The rounded lip was formed by tucking the edge
under the rim; a blemish at the edge suggests that
the lip was not perfectly handled and a chunk of
glass has pulled out. The matrix is honey colored
and bubbly, similar to other examples of secular
Mamluk glass.

The unusual shape and decorative repertoire of
the Cleveland vase presents problems in
attribution. The only contemporary parallel for
the shape is a brass basin, itself a unique object
(no. 28); the same shape appears on several small
glass vessels produced in the eighth and ninth
centuries, and these, too, are considered unusual.[2]
Medallions radiating from twelve-pointed stars are
seen in architectural decoration and manuscript
illumination dating from the second half of the
fourteenth century and on fifteenth-century
metalwork (see nos. 35 and 40). Trefoil bands on
the rim, neck, and base of this vase are also seen
on a fourteenth-century silk fragment (no. 115).
The artist of the Cleveland vase appears to have
revived an earlier glass shape and was possibly
influenced by contemporary metalwork. He has
applied decorative themes employed on
woodwork, illumination, and textiles to create this
piece, which seems to be more an objet d'art than
a functional vessel.

Published
Parke-Bernet 1944, no. 120.
Hollis 1945, p. 180.
Cleveland 1958, no. 716.
Cleveland 1969, p. 210.
London 1976, no. 143.
Cleveland 1978, p. 266.

Notes
1. The tray or platter, in New York, Metropolitan Museum of
 Art, 91.1.1533, also has twelve-pointed stars (Dimand 1944,
 pl. 238; Aanavi 1968, pp. 200–201). The candlestick is
 published in Schmoranz 1899, fig. 34; and Lamm 1929–30,
 pls. 115:9 and 126:17.
2. For the example discovered at Fustat, with references to
 related pieces, see Pinder-Wilson and Scanlon 1973, p. 18,
 no. 2 and fig. 3.

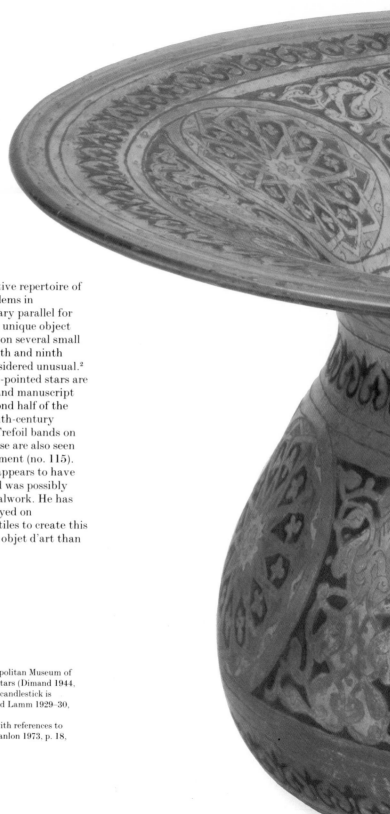

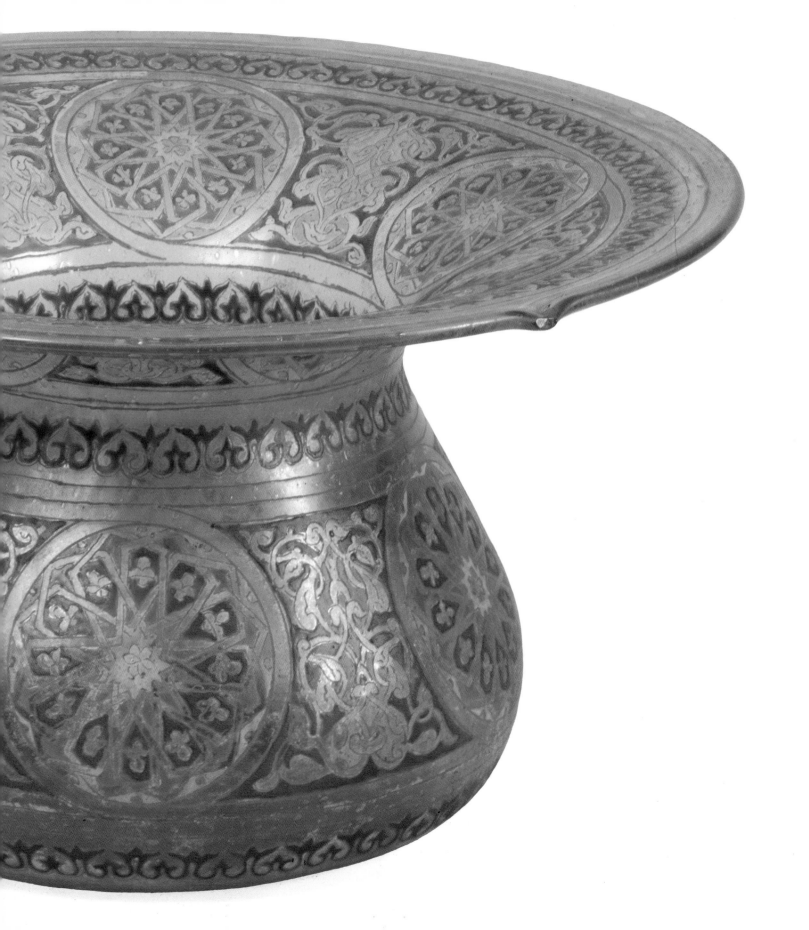

52
Lamp
Glass: gilded, enameled in green, blue, yellow, red,
 white, purple, with applied handles
Circa 1360
Made for Sultan Hasan

Height: 35.5 cm. (13 15/16 in.)
Diameter of rim: 26.2 cm. (10 5/16 in.)

Cairo, Museum of Islamic Art, 288
From Madrasa of Sultan Hasan (built 1356–62),
 1882–99

Inscriptions
Band on neck broken into three panels: Ayat
 al-Nur (Verse of Light; XXIV:35)
Three medallions on neck and body:

عز لمولانا السلطان الملك

Glory to our master, the sultan al-Malik.

Sultan Hasan commissioned hundreds of lamps
for his complex containing a madrasa and
mausoleum built just below the Citadel in the
most prominent square of Cairo. The foundation,
constructed between 1356 and 1362, was
embellished with the most exquisite lamps, many
of which contain Koranic inscriptions and Sultan
Hasan's epigraphic blazon (see no. 31).[1]

This lamp has two unusual features: different
types of floral units adorn the sections between
the handles, and the range of enamels includes a
rare purple in addition to the commonly used
green, blue, yellow, red, and white.

The neck contains the famous Ayat al-Nur,
traditionally found on lamps made for religious
structures. This passage states that God is the
light of the heavens and the earth, His brilliance is
reflected by the mihrab, which is in turn
symbolized by a glass lamp. Many representations
of the mihrab show a lamp hanging in the center,
visually recreating the imagery presented in the
Koran (see no. 111).

The Koranic verse is rendered in blue against a
gold ground filled with a floral scroll that has
white spiraling branches laden with red, green,
and white buds and leaves. The inscription is
interrupted by three medallions with a double
border of floral scrolls painted in gold: the outer
scroll has a gold ground, the inner one is blue.
In the center of the medallion is the epigraphic
blazon of Sultan Hasan: a circular shield divided
into three fields with an inscription in the middle
on a gold ground. The band on the base of the
neck is embellished with a floral scroll interrupted
by three blue roundels enclosing a lotus blossom
on a blue ground.

The body has six applied handles surrounded by
oval cartouches decorated with gold scrolls on a
blue ground identical to those encircling the
epigraphic blazons. A spray of vegetation appears
between the handles, its stem (or trunk) painted
purple with white dots; the blossoms and leaves—
rendered in combinations of red and white, blue
and white, green and yellow—spring from the
stem. Two alternating types of vegetation are
depicted: one has two large lotus blossoms
growing symmetrically at the top, the other has a
single lotus, below which is a peony; a series of
blossoms is placed on either side of the stems.

The tapering lower portion of the body has
three epigraphic blazons enclosed by medallions
repeating the design on the neck. Between the
medallions is a scroll, rendered in blue with
polychrome buds and leaves. It includes
beautifully painted trefoil blossoms resembling
the peculiar flora associated with the reign of
Nasir al-Din Muhammad (see nos. 25–26).

As in all Mamluk glass, the gilded areas have
been abraded, and the decoration of these portions
is recognizable only through the aid of the red
enamel that outlines the design. The matrix is
bubbly and grayish, as in other Mamluk lamps.

Published
Schmoranz 1899, p. 53, no. XVI and pl. XVI.
Herz 1906, p. 321, no. 29.
Herz 1907, p. 298, no. 29.
Wiet 1929, no. 288 and pl. XXIII.
Lamm 1929–30, vol. 1, pp. 458–59, no. 127; vol. 2, pl. 193:8.
Cairo 1969, no. 181.

Notes
1. Lamm lists more than fifty lamps attributed to the madrasa of
 Sultan Hasan (Lamm 1929–30, vol. 1, pp. 453–66; vol. 2,
 pls. 193:10, 194:1, and 202:1). See also Wiet 1929,
 pls. XXIII–LVIII.

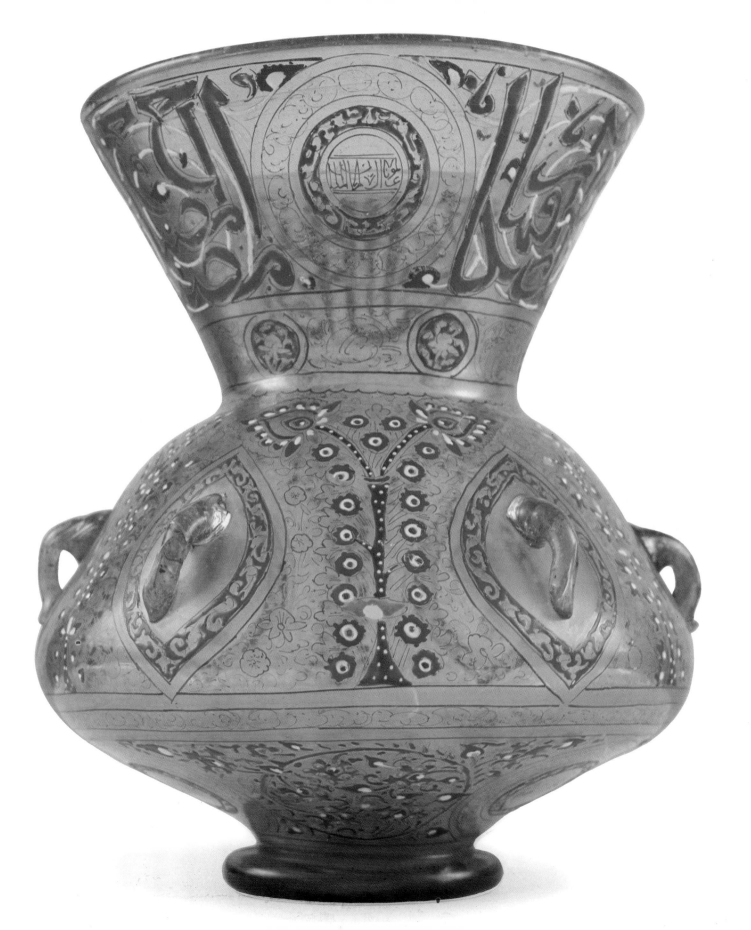

53
Lamp
Glass: gilded, enameled in green, blue, yellow, red,
 white, with applied handles
Circa 1310–20
Made for Hospice of Karim al-Din

Height: 27.5 cm. (10¹³⁄₁₆ in.)
Diameter of rim: 18 cm. (7⅛ in.)

Boston, Museum of Fine Arts, 37.614
Gift of Mr. and Mrs. Edward Jackson Holmes,
 1937
Ex-Ispenian Collection

Inscriptions
Panel on neck: Ayat al-Nur (Verse of Light;
 XXIV:35)
Six panels on body:

مما عمل برسم * الرباط المبارك * انشا العبد *
الفقير الى الله * المقر العالى * الكريمى ادام

*One of the things made for the blessed rabat
[hospice] built by the humble servant of God, the
sublime excellency, al-Karimi, [may his glory be]
eternal.*

The lamp, which has been broken and repaired, is
made of grayish bubbly glass. The neck has two
floral scrolls at the rim and base with blue dots
applied to the cores of the flowers. These bands
are divided into three by roundels bearing stylized
lotus blossoms with blue and white, red and white,
and green and yellow petals. The wide central
panel contains a blue thuluth inscription on a
polychrome scroll. This panel was originally
decorated with gilt, remains of which are visible
in certain areas.

The upper portion of the body has another floral
scroll above a wide inscription panel written in
gold on a blue ground. It is broken into six units
by the handles, which are enclosed by oval
cartouches. Below the inscription panel is an
arabesque frieze with a series of elongated petals
extending to the foot. The upper portion of the
splayed foot repeats the design found on the lower
body and terminates with the same floral scroll
seen on the neck.

The lamp, smaller than the standard examples,
was commissioned by Karim al-Din for the
hospice he built in Cairo. He was born a Christian
and entered the civil service as a secretary. When
he was appointed a chief official by Baybars II in
1309, he embraced Islam and adopted the name
Karim al-Din al-Kabir (Grace of God, the Great)
and the patronymic Ibn Abd al-Karim (son of the
slave or servant al-Karim), a common practice
among Muslim converts. He was transferred into
the service of Nasir al-Din Muhammad when the
sultan regained his throne in 1310. Karim al-Din
served as a judge, imperial steward (*nazir
al-khass*), and vizier until he fell out of favor in
1323 and was dismissed from all his offices.
He died the following year.

A second lamp made for the hospice of Karim
al-Din bears the name of Sultan Nasir al-Din
Muhammad.[1] Since Karim al-Din was not a
former mamluk and did not serve as an amir, he
was not granted a blazon. He belonged to the
class of civil officials called *arbab al-qalam*, men
of the pen.

The shape of the Boston lamp, with angular
body and high splayed foot, differs from the low
bulbous form found on the previous example
(no. 52). Both shapes, as observed in the group
made for the madrasa of Sultan Hasan, were
produced in the middle of the fourteenth century.

Published
Wiet 1929, app. no. 22.
Schroeder 1938, pp. 2–5.

Notes
1. New York, Metropolitan Museum of Art, 17.190.987 (Wiet
 1929, app. no. 21; Schroeder 1938, p. 5; Dimand 1944, p. 241).

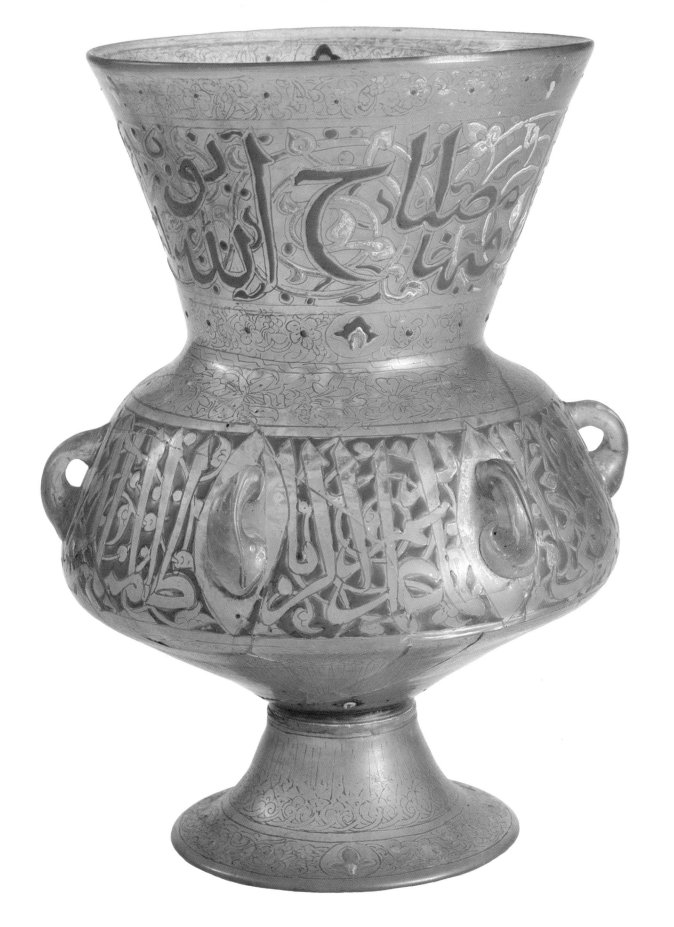

54
Fluted beaker
Purple glass with white trailing
13th century

Height: 15.9 cm. (6¼ in.)
Diameter of rim: 6.5 cm. (2 9/16 in.)

Toledo, The Toledo Museum of Art, 69.365
Gift of Edward D. Libbey, 1969

Although Mamluk glassmakers are celebrated
for their enameled and gilded wares, they also
produced trailed and marvered pieces in which
opaque glass threads were embedded into the
transparent glass and then rolled on a marver or
plate. The threads were frequently combed to
form various patterns. This ancient Near Eastern
technique was revived by the Romans and
continued to be practiced in the Islamic period
until the turn of the fourteenth century.
The precise dating of these trailed and marvered
pieces has not been determined, and many
examples are thought to have been made in Syria
between the eighth and fourteenth centuries.[1]
The shapes of the four pieces from the Toledo
and Corning collections are common to both late
Ayyubid and early Mamluk glass (nos. 54–57).
The beaker, one of the most popular types of
vessels, was executed in different techniques (see
nos. 44–45 and 63–65). In this example the body
is fluted, giving a rippling effect to the irregularly
applied opaque white threads.
Fluting appears on a number of other glass
pieces, including enameled and gilded works (see
nos. 48–49, 55, and 64–65).

Published
JGS 1971, fig. 33 (center).

Notes
1. Lamm 1929–30, pls. 29–32. For examples discovered at Hama
 see Riis and Poulsen 1957, pp. 61–69.

55
Fluted bowl
Purple glass with white trailing
13th century

Height: 6.5 cm. (2 9/16 in.)
Diameter of rim: 9.9 cm. (3⅞ in.)

Toledo, The Toledo Museum of Art, 69.367
Gift of Edward D. Libbey, 1969

This small bowl with high foot was executed in the
same manner as number 54: opaque white trails
were applied in irregular spiral bands and appear
rippled due to the fluting of the lower portion of
the body. Both pieces omit the combing process
that resulted in distinct patterns characteristic of
other examples (nos. 56–57).
The combination of transparent purple glass
and opaque white trails occurs on a great number
of small vessels, including beautifully made
sprinklers shaped as fish and birds.[1] After
comparing the exaggerated sizes of enameled and
gilded glass made for the court (see nos. 50–53),
one may assume that trailed glass was produced
for the bourgeoisie and represents a luxury ware
used in private dwellings.

Published
JGS 1971, fig. 33 (left).

Notes
1. Most appear to be pre-Mamluk (Damascus 1976, fig. 157).

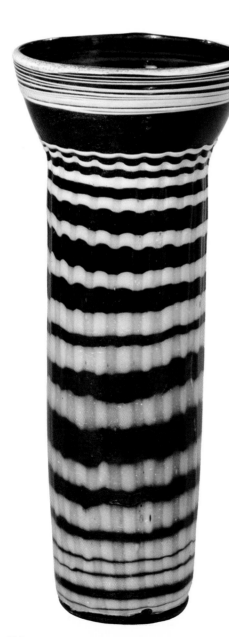

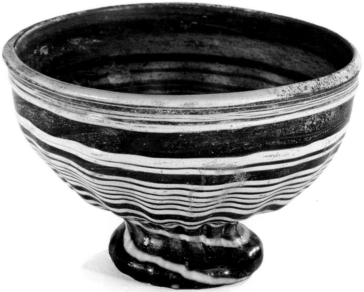

56
Perfume flask
Blue glass with white trailing
13th century

Height: 14.7 cm. (5¾ in.)

Corning, New York, The Corning Museum of
 Glass, 50.1.32
Gift of Steuben Glass, Inc., 1950

In contrast to the previous works (nos. 54–55),
this flask is made of dark blue transparent glass
with opaque white trails combed to form a festoon
pattern. The shape of the piece, with cylindrical
neck, rounded shoulders, and tapering body,
recalls a type of unguentarium used for ointments,
perfumes, and cosmetics. The decorating
technique is as old as the shape and is found in
ancient Near Eastern glass.
 The flask is among the last examples of this
ancient tradition. The shape was eventually
replaced by the more popular perfume sprinkler
with tall slender neck and bulbous body (see nos.
47, 57, and 60), and the trailed decoration was
abandoned in favor of enameling and gilding.

Published
Binghamton 1975, no. G13.

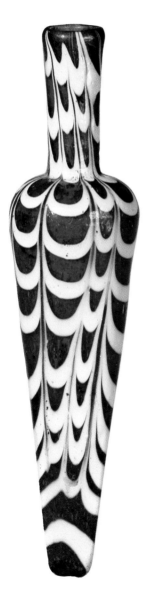

57
Perfume sprinkler
Purple glass with white trailing, applied handles
Late 13th century

Height: 8.6 cm. (3⅜ in.)
Max. diameter: 5.2 cm. (2 1/16 in.)

Corning, New York, The Corning Museum of
 Glass, 71.1.1
Purchased 1971

This precious flask represents both the
continuation of an ancient technique and its
adaption to a new tradition. Trailing opaque
white threads on transparent glass and combing
them to form herringbone or leaf designs is among
the oldest methods of decorating glass practiced in
the Near East. The shape of the piece—with its
slender neck, rounded body, and applied trails
forming two delicate handles—is typical of
Mamluk perfume sprinklers (see nos. 47 and 60).
Its unusual features are the four rounded feet and
central opening; doughnut-shaped vessels,
however, are not unique.[1]
 Mamluk glassmakers were extremely innovative
and created many pieces using this technique.
One of the rare extant examples, in the
Metropolitan, is a fairly large, lidded bowl with
a beautifully combed and feathered design.[2]

Unpublished

Notes
1. Doughnut-shaped vessels, circa 1100, are published in Lamm
 1929–30, pls. 5:4 and 29:14.
2. New York, Metropolitan Museum of Art, 26.77 (Metropolitan
 1975).

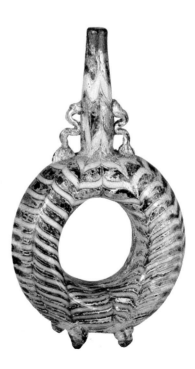

58
Lamp
Colorless glass with applied handles
Second half 13th century

Height: 13.3 cm. (5¼ in.)
Diameter of rim: 9.5 cm. (3¾ in.)

New York, Madina Collection, G3
Ex-Kelekian Collection

The restrained elegance of undecorated Mamluk glass is often overshadowed by the virtuosity displayed in enameled and gilded examples. Mamluk glassmakers excelled in the production of plain vessels and created delicate and harmoniously proportioned objects that rival the aesthetics of the more dazzling enameled and gilded pieces (nos. 58–61).

This small lamp, made of slightly greenish transparent glass, has a funnel-shaped neck with rounded body fused to a high flaring foot. A minuscule hollow rod, used to hold the wick, appears inside the body. The three handles applied to the walls suggest that the lamp could be hung.

This piece belongs to a group of undecorated small lamps used in private homes.[1] They could be carried from room to room, placed on a table, or attached to hooks suspended from the ceiling.

A similar shape, seen in a slightly larger example in the Victoria and Albert Museum in London, has a touch of enameled and gilded decoration. Delicate floral scrolls encircle the rim and foot; tiny riders appear between the handles.[2]

Unpublished

Notes
1. Lamm 1929–30, pls. 7:2, 28:20, and 158:1, all dated second half of the thirteenth century.
2. London, Victoria and Albert Museum, 330–1900 (21 cm. or 8¼ in. high).

59
Goblet
Colorless glass
Second half 13th century

Height: 10.2 cm. (4 in.)
Diameter of rim: 14.3 cm. (5⅝ in.)

New York, Madina Collection, G2

Another undecorated piece is in the shape of a stemmed cup or goblet frequently executed in glass and ceramics (see nos. 62 and 77–78). This goblet has a high flaring foot attached to a receptacle with rounded base, curving sides, and straight rim. This particular form, representing a transition between a footed bowl and stemmed goblet, was most likely used as a drinking vessel.

The stemmed cup itself was the symbol of the *saqi* who used it as a blazon on all his possessions (see nos. 15–16, 28, 109, and 125), at times combined with the heraldic emblem of his master (nos. 27 and 96) or with other charges in a composite blazon (nos. 39 and 124).

Unpublished

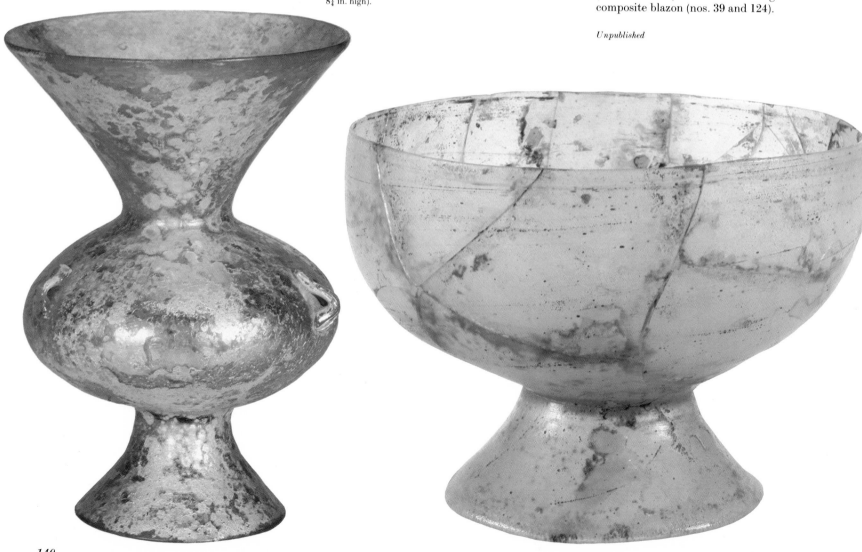

60
Perfume sprinkler
Colorless glass with applied handles
Second half 13th century

Height: 11.8 cm. (4⅝ in.)
Max. diameter: 5.4 cm. (2¼ in.)

New York, Madina Collection, G4

This perfume sprinkler is adorned with a pair of trailed handles and diagonal fluting that encircles the body. Its slender neck and bulbous body also appear in other, more elaborately decorated pieces (nos. 47 and 57). The delicate neck of the flask served the practical function of releasing at one time only a few drops of expensive perfume, which was most likely retained in a heavy oil base. Consequently, the word "sprinkler" appropriately identifies this piece, since the perfume it contained could only be dispensed in sprinkles when the vessel was shaken.

The perfume sprinkler represents a type of luxury item available to the average citizen. Although aromatic cosmetics were expensive, they were in great demand by both local consumers and foreign markets. Revenue from the trade of these luxury goods formed an important part of the Mamluk economy. Spices and herbs from the Orient landed in the ports of southern Arabia, then traveled up the Red Sea to Alexandria and Damietta before being dispatched at a substantial profit to the Mediterranean countries. The citizens of the Mamluk empire benefited from being at the center of this trade route and cherished the aromatic cosmetics available to them.

Unpublished

61
Perfume bottle
Colorless glass: molded
Late 13th–early 14th century

Height: 10.0 cm (3¹⁵⁄₁₆ in.)
Max. diameter: 8.0 cm. (3⅛ in.)

New York, Madina Collection, G5

Perfume was used not only for personal grooming, it also served a ceremonial function and was employed by Muslims, Christians, and Jews during their secular and religious festivities. This flask with a cross represents a group of objects produced for Christian communities and may have been made as a souvenir for pilgrims to the Holy Land.

The piece has a short neck embellished with a rounded lip and molded ring. Its flattened body is decorated with two medallions encircled by bands; a double row of ten scallops with beads in the interstices starts from the v-shaped unit at the neck and frames the sides and the base. An equal-armed cross, with four smaller crosses between its arms, appears in the center of one of the medallions;[1] the other medallion is unadorned.

The clear glass was mold-pressed in low relief. It most likely had a globular stopper that fitted into the lip. Mold-pressing, an ancient technique, which was revived during the Roman period and continued into the Islamic era, was employed on a variety of vessels, weights, and jewelry and even on tiles used to line pavements.[2] Among the flasks made for non-Muslim communities are a series of faceted cruets and bottles, some of which represent Christian crosses and Jewish menorahs. Many are attributed to Syria and are dated either late Roman or early Islamic. The technique of using molds survived into the Mamluk period, as this example demonstrates. The shape of the Madina bottle is characteristic of Mamluk perfume flasks, which were at times decorated with enameled and gilded designs (see no. 46).

Unpublished

Notes
1. Identical crosses, identified as the arms of Jerusalem, appear on the celebrated basin made for Hugh IV of Lusignan, the king of Cyprus (1324–59), now in Paris, Louvre, MAO 101 (D. S. Rice 1956).
2. A number of tiles used in pavements were excavated at Raqqa. They are dated to the ninth century and are now in Damascus, National Museum (Damascus 1976, fig. 79).

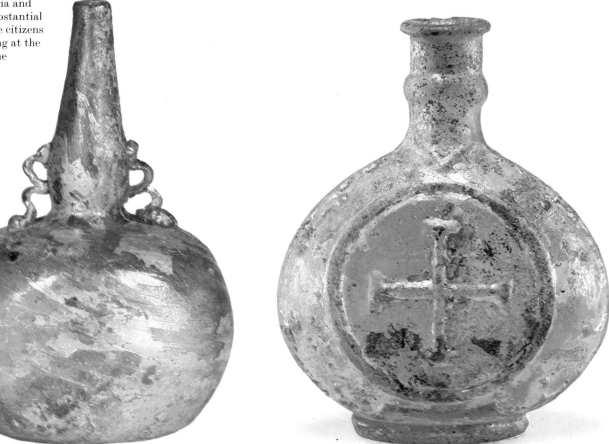

62
Goblet
Blue glass: gilded, enameled
Late 13th century

Height: 7.1 cm. (2$\frac{13}{16}$ in.)
Diameter of rim: 8.5 cm. (3$\frac{5}{16}$ in.)

Corning, New York, The Corning Museum of Glass, 79.1.53
Bequest of Jerome Strauss, 1979

This beautifully proportioned miniature goblet or stemmed cup has a molded lip and footring and a pronounced ring encircling the stem. Made of transparent deep blue glass, it is decorated with an enameled and gilded inscription band placed below the rim. This band has been abraded and only traces of the original decoration are now visible.

The stemmed cup, symbol of the *saqi*, served as a functional vessel and was executed in ceramics as well as in glass (see nos. 59 and 77–78). The Corning goblet is one of the smallest examples in glass.

The ring on the stem is a characteristic feature of the cup as used in the blazon of the *saqi* (see nos. 15–16, 27–28, 96, and 109). This piece may have been a bibelot representing the office of the cup-bearer.

Unpublished

63
Beaker
Blue glass
Late 13th–early 14th century

Height: 9.7 cm. (3$\frac{13}{16}$ in.)
Diameter of rim: 6.1 cm. (2$\frac{7}{16}$ in.)

Corning, New York, The Corning Museum of Glass, 79.1.108
Bequest of Jerome Strauss, 1979

Although the three beakers from the Corning and Toledo museums (nos. 63–65) are almost identical in shape and technique, each has a different glass matrix and tooled and applied decoration. This example, the smallest and the simplest in the series, is made of transparent blue glass. It has a molded lip and pronounced footring. The body appears slightly twisted and widens toward the rim.

Courtly scenes depicted on metalwork, glass, ceramics, and book illustrations often show figures holding such beakers. Drinking was one of the princely pleasures and represented the luxurious and leisurely life of the ruling classes. Scenes of courtly entertainment were traditional in Islamic art and many objects show revelers with cups and beakers accompanied by wine-stewards, dancers, and musicians. Beakers held by enthroned figures came to symbolize imperial power and authority (see nos. 20–21; II, fig. 5).

Unpublished

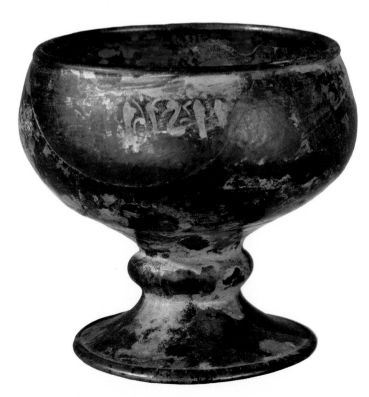

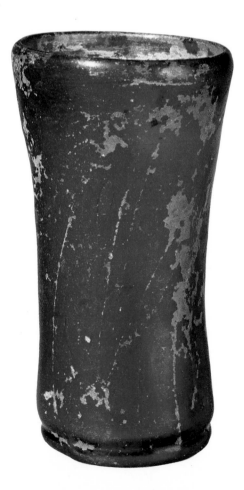

64
Ribbed beaker
Colorless glass with blue ribbing, applied decoration
Late 13th century

Height: 10.5 cm. (4⅛ in.)
Diameter of rim: 6.2 cm. (2 7⁄16 in.)

Corning, New York, The Corning Museum of Glass, 79.1.41
Gift of The Ruth Bryan Strauss Memorial Foundation, 1979

This beaker, with molded lip and footring, has a pair of incised lines encircling
the rim. The body is fluted and decorated with vertical threads of applied
opaque blue glass, which attractively contrast with the slightly greenish
transparent matrix. A series of blue loops bearing blue rings is applied to the
upper portion of the beaker. These decorative as well as functional rings
enable the drinker to attract the attention of the *saqi*: when the drinker
wanted a refill, he shook the beaker, and the loose rings hitting the body
created a pleasing and high-pitched tinkle.

 A number of Islamic drinking vessels, including stemmed cups and beakers,
are decorated with rings attached to the body by loops. Many are dated
between the eighth and twelfth centuries and are attributed to Syria. This
feature appears to have survived at least into the early Mamluk period.

Unpublished

65
Ribbed beaker
Colorless glass with bluish green ribbing
Late 13th–early 14th century

Height: 12.7 cm. (5 in.)
Diameter of rim: 5.5 cm. (2⅛ in.)

Toledo, The Toledo Museum of Art, 23.2127
Gift of Edward D. Libbey, 1923

This example is embellished with two molded rings: one encircles the
thickened lip, the other forms the foot. The body is fluted and enhanced with
applied threads that twist at the top and accentuate the slightly widening
rim. The threads are rendered in opaque bluish green glass and alternate with
the molded ribs and raised edges of the flutes. A pleasing contrast is created
by the opaque ribbing and the greenish tone of the clear glass body.

 The molded rings on the rim and foot and the applied ribbing are well fused
into the matrix. The fluting of the body and the turning of the rim show a
spontaneous handling, indicating that this beaker was made by a master
craftsman who was able to produce a series of these vessels easily and rapidly.

Published
Riefstahl 1961, p. 42.
Toledo 1969, p. 39.

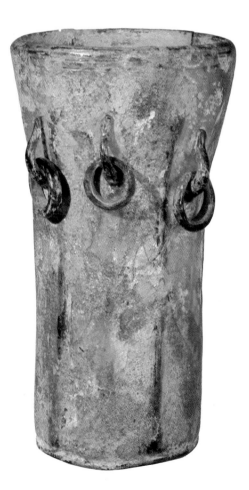

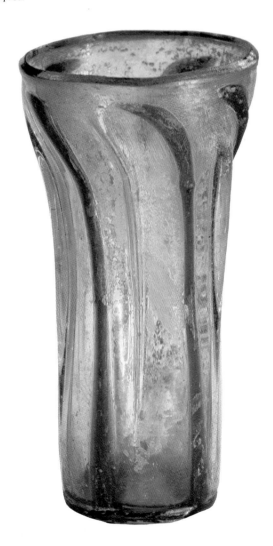

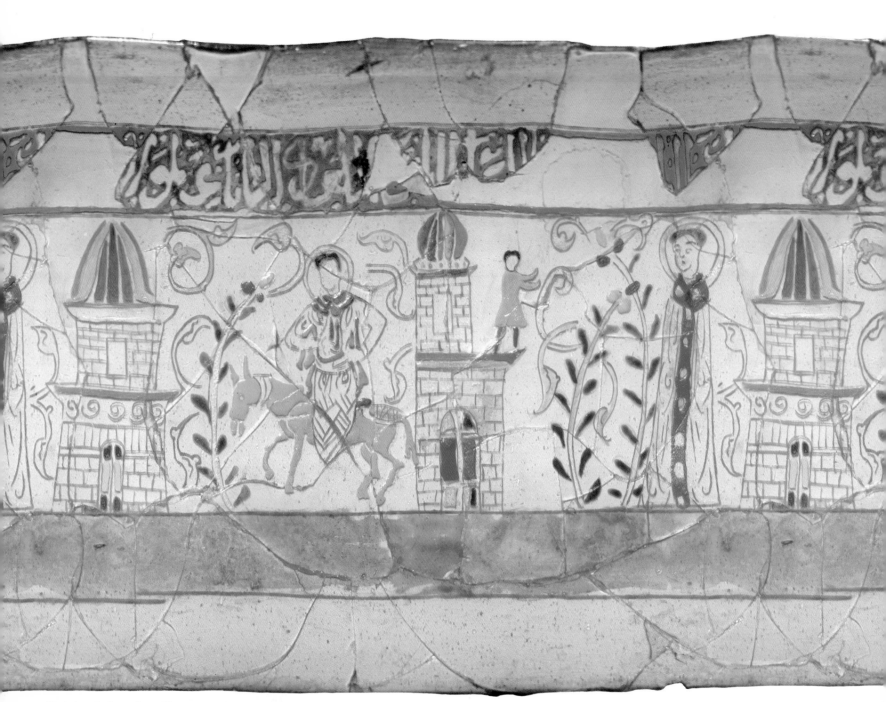

Peripheral view of no. 45

CERAMICS

Bahri Mamluk potters employed a varied repertoire of decorative themes and techniques. Some reveal the continuation of Ayyubid traditions, while others reflect the influence of contemporary Ilkhanid and Golden Horde pottery or imitate Yüan dynasty wares. Their techniques included underglaze-painting, luster-painting, and slip-painting. They also molded and slip-painted their wares, covered them with colored glazes, or left them unglazed. The most characteristic Mamluk ware was a type of sgraffito or incised pottery adorned with bold inscriptions and blazons. The potters also used figural compositions, geometric patterns, and floral motifs to decorate their pieces.

Most of the themes and techniques established in the fourteenth century continued to be practiced in the Burji period. By the turn of the fifteenth century, however, figural compositions were abandoned, luster-painting disappeared, and incised wares with blazons fell out of favor. The impact of blue-and-white Chinese porcelain exported to the Near East was especially important in this period. The themes employed on the majority of underglaze-painted fifteenth-century Mamluk wares derived from Ming dynasty ceramics and were often used in combination with indigenous elements. This adaptation is particularly visible in the production of tiles, which became highly fashionable in the Burji period. Ceramics produced after the collapse of the Mamluk empire reveal the influence of another tradition, that of the imperial court style of the Ottomans with the potters of İznik providing the models.

Bahri Period (1250–1390)

The most common type of pottery executed in the Bahri period is underglaze-painted. It was produced in large quantities both in Egypt and Syria with hardly a distinction between the two regions. The materials excavated at Hama and Damascus in Syria reveal the same shapes, techniques, and decorations as those unearthed at Fustat and Alexandria in Egypt. Potters apparently moved freely throughout the empire and practiced wherever they could set up their workshops.

Both the Egyptian and Syrian underglaze-painted wares had a coarse off white body covered by a white engobe (a thin coating of fine clay). The design was painted in blue, turquoise, green, and black, the most popular combination being blue and black. The earlier examples included a brownish red pigment, which continued the tradition of Ayyubid underglaze-painted wares (see no. 66). The transparent glaze, often thickly applied and greenish in tone, tended to pool and dribble.

The majority of underglaze-painted wares are bowls, jars, albarelli, and jugs. Of these the most common is the bowl, either fairly deep with flaring sides and prominent foot (nos. 66–68) or shallow with curving sides and everted rim (nos. 69–73). Some examples have an exceptionally high foot, identical to the goblet or stemmed cup found in the blazon of the *saqi* or cup-bearer (nos. 77–78). Jars are second in popularity. They were executed in varying sizes and are characterized by an ovoid body, high shoulders, slightly tapering neck, and rounded

lip (nos. 80–83). The albarello, a variation of the jar, is distinguished by its straight or slightly concave sides, sloping shoulders, and high neck. Other shapes include single-handled pots with straight sides and wide everted rims (no. 79), squat jars with curving sides and high straight necks, footed vases with high flaring necks, and an assortment of beakers.

The most common design of the interior of a bowl comprises six, eight, or twelve radiating panels or a series of concentric rings, each filled with alternating floral and geometric motifs. Exterior walls are decorated with petals, double lines, or swirls. Several early Mamluk bowls contain a central medallion enclosed by circular compartments, at times linked by continuous bands that loop around the units (no. 68).

The same combination of floral and geometric components occurs on goblets, some of which are pierced (nos. 77–78). The practice of piercing walls and filling the holes with transparent glaze first appeared on twelfth-century Seljuk wares, apparently in an attempt to simulate the translucency of Sung dynasty porcelain. Its revival in the Mamluk period was purely decorative, the liquid seen through the holes forming a pleasing contrast to the bold blue, green, and black decoration.

The design of Mamluk jars is often compartmentalized, with the shoulder encircled by a band and the body divided into vertical or horizontal units (nos. 80–83). Albarelli or apothecary jars were similarly decorated, employing both horizontal and vertical subdivisions. The neck and shoulder of jars and albarelli generally had inscriptions (no. 81), although there are also examples with bold script encircling the entire body.

Among the most interesting Mamluk ceramics is a series of large and small jars decorated with animals (nos. 82–83). Various birds or waterfowl promenade or fly around the body. Cranes, ducks, geese, and peacocks are commonly represented against a dense ground of loosely sketched floral motifs. One of the unique animals is a winged horse that appears on a large jar (no. 83). Although the representation of horses on Mamluk wares is not unusual and is found on a few fragments of pottery excavated at Fustat, winged creatures are rare.[1]

The decoration of the jar with horses is painted in blue and black as well as in a white slip under a transparent colorless glaze resembling the slip-painted wares of the neighboring Ilkhanids and Khans of the Golden Horde.[2] The Mongol pieces have a similar type of floral decoration in the background with large lotus blossoms and winding vines bearing leaves and buds; the animals are executed in the same spontaneous and lively manner. The stylistic and technical similarities between Mamluk and Mongol slip-painted wares suggest that the artists not only shared a common heritage—that of Ayyubid and Seljuk pottery—but also exchanged decorative themes and motifs. Some Bahri period slip-painted wares are extremely refined and represent the last of the great figural style in the Mamluk ceramic tradition.

Unfortunately, intact pieces with figural compositions have not survived and only a glimpse of the richness of this style is provided by fragments excavated at Fustat, many of which are underglaze-painted in polychrome colors. Among the most interesting shards are those that depict two figures sailing a boat, hunters or mounted warriors, the Descent from the Cross, and riderless horses, one of which has the blazon of the cup-bearer on its saddle.[3] These fragments indicate that potters employed the same themes used by metalworkers and glass-makers to represent various courtly activities, narrative scenes, and Christian subjects.

One of the almost intact pieces is an extremely rare bowl with a central medallion enclosing a bird and a shield with a pair of polo sticks in the cavetto, identifying the office of the polo master.[4] Blazons are found on other underglaze-painted wares, some of which are slip-painted.

A second type of Mamluk pottery is luster-painted and was most likely made for the court. The majority of pieces are jars and albarelli decorated with a brilliant golden luster applied over a rich and deep blue ground. The golden tone of the luster is quite dazzling and far more intense than that seen in Ayyubid and Seljuk examples.

The production of lusterwares is associated with Damascus and is thought to have been first made by the potters of Raqqa, who fled there after the destruction of their city by the Mongols in 1259. The Syrian provenance is confirmed by the inscription on a luster-painted jar that states that it was made in Damascus by Yusuf for Asad al-Iskandarani.[5] Lusterwares might have also been made in Egypt since several fragments were unearthed there.[6] Egyptian production appears to have been limited and was likely the result of the efforts of a single man; wasters with luster-painting dating from the Mamluk period are noticeably absent from the Egyptian finds. Egypt did, however, import Syrian as well as Spanish lusterwares, as indicated by excavated material.

Mamluk luster-painted jars and albarelli follow the same compositions and decorations found on underglaze-painted examples. The horizontal format occurs on the jar made in Damascus by Yusuf, as well as on an example that bears a dedication to an anonymous sultan.[7] It is also employed on yet another jar adorned with inscriptions and birds in foliage (no. 84).

In addition to jars and albarelli painted in golden luster, there exist several bowls with radial designs rendered in blue, turquoise, and brownish red luster.[8] Although their shapes and decorative themes follow the vocabulary of the age, the use of brownish red luster on these wares is quite extraordinary. They could have been made in Syria, reviving a style formerly associated with Raqqa or in Iran where bowls with radial designs using the same color scheme were made under the Ilkhanids.[9]

Mamluk luster-painted jars and albarelli were highly regarded in Europe. Most of the surviving examples were found in Sicily, one of the

major commercial links between the Mamluks and the West.[10] Underglaze-painted jars and albarelli—used to ship luxury items, such as spices and oils—were also in demand by Europeans. Mamluk artists must have taken commissions from the Italian states as indicated by an albarello containing the coat of arms of the city of Florence.[11]

Luster-painted wares ceased to be produced after the turn of the fifteenth century. Their disappearance is blamed on the sack of Damascus in 1401 by the Timurids. The destruction of Damascus, and the consequent demolition of the potters' quarters, coincides with the termination of Mamluk lusterwares, recalling the fate of enameled and gilded glass.

A type of ware made for domestic use and incised with inscriptions and blazons appears to have been an Egyptian specialty in contrast to lusterwares, which were produced in Syria. This ware evolves at the end of the thirteenth century and continues through the fourteenth century. It has a coarse red body covered with a white engobe; the design was incised through the engobe and selected areas were painted in colored slips. The entire piece was then glazed in tones of green, yellow, and brown. The shapes were limited to high-footed large bowls and goblets with flaring straight sides (nos. 93–95). There are also rare pieces such as bowls with rounded bases and jars reflecting metalwork shapes.

The composition of these wares usually follows the layout of contemporary Mamluk metalwork: large inscription panels are broken into three units by circular shields containing blazons (no. 93). Some examples have concentric designs with continuous inscriptions enclosing a central blazon (nos. 94–95) or radial panels subdivided into units bearing inscriptions and blazons.[12]

The inscriptions are badly written and often contain a phrase stating that the piece is "one of the things made for . . . ," followed by the honorific titles employed by amirs who are not further identified. The only exception is a unique bowl with rounded base, its inscription stating that it was made for Shihab al-Din ibn Qarji, identified as an officer in the service of Sultan Nasir al-Din Muhammad.[13] A number of similar pieces found at Fustat, Alexandria, and Luxor contain lengthy inscriptions bearing the name of the maker, Sharaf al-Abawani (no. 95), who is thought to have worked in various locations.[14] The name may, however, identify a workshop specializing in wares for amirs rather than a specific individual.

Another group of incised wares with neither inscriptions nor blazons is adorned with birds, fish, and other animals as well as floral arabesques and geometric designs composed of interlacing bands, stars, and strapwork. The rich collections of such shards in the Museum of Islamic Art in Cairo and the Victoria and Albert Museum in London reveal many themes: some reflect metal prototypes, others share the decorative vocabulary found on ceramics.

One must assume that Mamluk incised wares were made for two types of clientele: the inscribed pieces with blazons were produced for

the officers, and those with other decorations were sold to the public. The former was obviously mass-produced with standardized inscriptions and blazons. An amir who was elevated to a specific office purchased a readymade piece with the appropriate emblem. Presumably, the higher and wealthier amirs preferred to own brass objects inlaid with silver and gold.

Since there are no examples with composite charges of the Burji officers, incised pottery made for amirs seems to have fallen out of fashion in the fifteenth century. On the other hand, those made for public consumption were produced until the end of the Mamluk period. Although the majority of these wares are roughly made, an extraordinary fragment unearthed at Fustat indicates that the potters were capable of creating highly refined works.[15] This piece, decorated with kufic inscriptions and floral scrolls, reveals the hand of an extremely talented artist.

A type of red-bodied ceramic found in Egypt and related to the incised wares is painted in white slip and glazed in brown, green, or yellow. There are also examples made of buff clay with manganese purple used both as a slip and as the overall glaze. The slip is thickly applied and creates a relief; the decoration includes floral compositions, inscriptions, and animals. This ware was produced throughout the Mamluk period, retaining the same humble quality. Most of the intact pieces are bowls, similar in shape to underglaze-painted wares (no. 98).

Another group of slip-painted ceramics is unglazed and decorated with geometric patterns. This type, found in Syria, Palestine, and Jordan, appears to represent a regional tradition still in practice today. Some are large jars, others are smaller jugs and vessels.[16] A rare example is decorated with a blazon and is thought to have been produced in Egypt.[17]

Unglazed molded wares, particularly those shaped as water canteens, popularly called pilgrim flasks, were also a specialty of the Syrian potters. These flasks have a coarse off white body, a flattened round shape with high neck, and a pair of handles attached to the shoulders (nos. 96–97). The same circular mold, often with rounded edges containing decorative bands, was applied to both sides. The decorations include a variety of blazons, geometric motifs, and inscriptions. A few inscriptions give the name of the maker, such as al-Mufid (no. 97), al-Afaf, and Ali al-Himsi.[18] These canteens were an essential part of military gear, similar to the water flasks used today. They were also used by merchants and travelers who had to journey across hot and arid lands.

Other unglazed wares were shaped as lamps and pipes or as spherical ampules, the so-called grenades whose real function is still problematic.

In the fourteenth century Mamluk ceramics began to reveal the influence of Chinese export wares. The wealth of Chinese celadon and blue-and-white wares excavated at Fustat and those found in Syria indicate that among the most lucrative Mamluk trade items were Far Eastern ceramics. It is, therefore, not surprising that the largest group of Bahri period shards and wasters found in Egypt, from Alexandria to Nubia, is imitation celadon. Mamluk examples copy both the shapes and glazes (ranging from bright green to gray green) of the Yüan dynasty originals. The decorations include such traditional Chinese motifs as chrysanthemums or pairs of fish executed in relief. Some examples employ different techniques, combining molding with slip-painting (no. 92).

The potters also produced monochrome glazed jars, which often have fluted bodies. Several were glazed in celadon green while others employed turquoise, reverting to Ayyubid and Seljuk practice. One of the most interesting jars has a fluted body with applied strips forming zigzags and roundels on the shoulders. This example has a domical lid, among the few that have survived.[19] Other monochrome glazed ceramics include goblets, beakers, and vases produced both in Egypt and Syria.

The development and provenance of Bahri period ceramics, which are extremely varied in style and technique, are difficult to determine. There are very few dated and signed examples and even fewer pieces bearing dedications. Dated examples are limited to a few shards excavated at Hama, their inscriptions stating that they were made "in the year 44" or "45," that is in 744 or 745 Hijra (A.D. 1343 or 1344).[20] Potters' signatures and patrons' names are equally rare: Yusuf appears on a luster-painted jar ordered by Asad al-Iskandarani, and the name Sharaf al-Abawani is seen on a series of incised wares, while an unidentified sultan was the patron of another lusterware jar. The majority of incised wares with blazons are dedicated to anonymous amirs, with one exception that identifies its patron as an officer in the service of Sultan Nasir al-Din Muhammad.

In contrast, there are numerous fragments from the Burji period bearing the names of more than thirty potters or workshops. Unfortunately, extremely few signed pieces are intact, and it is not yet possible to determine a chronological or typological sequence.

Burji period (1382–1517)

The most popular technique employed by fifteenth-century potters was underglaze-painting. These wares, made both in Egypt and Syria, have off white and reddish clays. Their shape and decoration either follow fourteenth-century examples or reveal the impact of contemporary Ming dynasty porcelain.

The first group of underglaze-painted wares, that is, those following fourteenth-century traditions, include both deep and shallow bowls and high shouldered jars. They are decorated in blue and black with occasional turquoise and green under a colorless glaze.

A second type of pottery, called "silhouette" ware, is painted in black under a blue, turquoise, or green glaze. Some employ radial designs, others are decorated with overall floral scrolls, large central

blossoms, and geometric patterns. These "silhouette" wares were most likely produced in the fourteenth and fifteenth centuries. Those pieces using blue (ranging from blue gray to deep cobalt) and turquoise glazes are generally associated with Syria and Iran, while the green glazed wares are assigned to Egypt, but black-painted wares with all three glazes appear to have been produced throughout the Mamluk world.

A third group of underglaze-painted wares are painted only in blue. Similar to the fifteenth-century wares of Turkey and Iran, some examples are almost verbatim copies of Ming dynasty porcelain, while others incorporate a more select representation of Chinese motifs. The dominant design was floral: lotus blossoms, peonies, and chrysanthemums with the ubiquitous Chinese floral scroll.

A plate excavated at Hama is probably one of the earliest Syrian copies of Chinese blue-and-white wares. This example, thought to have been made in Damascus before the Timurid sack of the city in 1401, employs the tripartite division and motifs found in Chinese porcelain: a lotus blossom tied with a ribbon appears in the central medallion, a floral scroll in the cavetto, and a wave-and-foam pattern on the rim.[21] The attribution of this piece to Damascus is strengthened by its similarity to a small blue-and-white bowl adorned with a Far Eastern scroll that has a notation in its footring stating: "made in Damascus."[22]

In the beginning of the fifteenth century, Syrian potters began to integrate many Chinese motifs with native elements. For instance, the three blue-and-white bowls from the Madina Collection in New York employ the traditional radial design, but some of the floral scrolls are inspired by Chinese motifs (nos. 74–76). Stylized chrysanthemums decorate a jar of typical Mamluk shape with vertical divisions.[23] A similar adaptation is seen in the Egyptian blue-and-white wares, as exemplified by a vase with a pair of applied handles that copies a Chinese shape. Its decoration with wave-and-foam border, floral scrolls, and concentric wave patterns derives from Far Eastern prototypes, but its style of painting and paneled division are of Mamluk origin.[24] This vase also bears on the footring the signature of the maker, Abu'l-Izz. Another intact blue-and-white vessel with a potter's signature is a jar made by Hajji Agha, who wrote his name on the neck of the piece.[25]

In the Burji period, the majority of potters' names appear on the footrings of vessels, which are now broken. Among some thirty signatures found on fragments are names such as Gaibi, al-Shami (from Shams or Damascus), al-Tawrizi (from Tabriz), al-Misri (from Cairo or Egypt), and al-Hormuzi (from Hormuz).[26] It is not yet possible to identify according to style the hand or studio of any of these artists; they appear to have worked in a similar manner, employing birds, hares, ducks, and other animals, as well as lotus blossoms, peach or pomegranate sprays, and various floral scrolls derived from both indigenous and Chinese traditions. These wares span a broad period of time, extending from the third quarter of the fourteenth century to the

very end of the fifteenth century, further complicating the identification and evolution of individual styles.

Among the few intact pieces bearing signatures is a black-painted lamp decorated with incised floral scrolls made by "Ibn al-Gaibi al-Tawrizi";[27] a large tile from the shrine of Sayyida Nafisa, painted in blue and black, signed "Gaibi ibn al-Tawrizi";[28] and a panel composed of six square tiles with the name "Isa ibn al-Tawrizi."[29]

Without thorough stylistic and technical analysis of the pieces bearing these "signatures," one can only propose theories for the meaning of the words. Most of the fragments are signed by Gaibi or contain the *nisba* al-Tawrizi. Gaibi could have been the name of a workshop that specialized in underglaze-painted wares, similar to the studio of Sharaf al-Abawani, which in the fourteenth century made incised wares for amirs. Al-Tawrizi might have been used to identify a style that at one time was associated with the city of Tabriz, recalling the practice of late Ayyubid and early Mamluk metalworkers who used the *nisba* al-Mawsili. It may also have designated a particular type of ware, such as tiles.

The impact of Chinese themes on underglaze-painted Mamluk wares is also seen in early fifteenth-century Egyptian and Syrian tiles.[30] The celebrated complex of Ghars al-Din al-Khalil al-Tawrizi in Damascus, built before his death in 1430, is almost a museum of hexagonal tiles, most of which employ geometric designs with central rosettes or floral sprays. Some of the motifs found on Egyptian and Syrian tiles—such as willows, water weeds, fruit-bearing branches, lotus and peony scrolls—derive from Chinese wares but are rendered in a local style (see nos. 85–91). A few tiles are decorated with curious ewers, musical instruments, or quivers with textile patterns (nos. 88 and 90–91).

It is difficult to explain the sudden interest in the production of tiles in the Mamluk world. This interest is not limited to Egypt and Syria but also occurs in contemporary Ottoman and Timurid buildings. Unlike Turkey and Iran, the Mamluk world lacked a strong and continuous tradition of tile production, and this new fashion of building decoration must have resulted from close contact with neighboring empires. Tiles were employed on several Mamluk buildings executed between 1330 and 1350, but these were limited to restrained decorations on a few domes, minarets, mihrabs, and windows and are thought to have been the work of artists from Tabriz.[31] Tile revetments became fashionable in the early fifteenth century and continued to be employed during the Ottoman period in Egypt and Syria. Blue was the most common pigment used on tiles. Some pieces also have thin turquoise, green, or black borders. There are also examples painted in blue and black and some with turquoise added. The majority are hexagonal, while a few are composed of several squares or are executed as large single panels. Among the most beautiful Mamluk tiles are those made for Sultan Qaitbay's buildings, which include lunettes and circular examples with his epigraphic blazon.[32]

The only firm conclusion to be derived from the wealth of material dating from the Burji period is that Chinese porcelain, exported in abundance to both Egypt and Syria, provided inspiration for local potters, who first made exact copies and then blended the new motifs with indigenous traditions. This phenomenon, characteristic of Islamic pottery, was observed in the ninth and twelfth centuries with themes provided by T'ang and Sung dynasty wares. In the fifteenth century it was particularly noticeable throughout the Islamic world with the potters of Turkey and Iran following exactly the same process as their colleagues in Egypt and Syria.

The decorative themes on Chinese wares were very appealing to Mamluk potters and their clientele who were familiar with designs incorporating animals and floral motifs. The impact of Chinese blue-and-white wares on Mamluk ceramics was not revolutionary; it did not drastically change the tradition but simply altered the surface decoration and enriched the existing vocabulary.

The study of Mamluk ceramics reveals an extraordinarily energetic production of all types of wares made for the court, the bourgeoisie, and the general public. Although the tradition was not innovative and did not bring forth new techniques, there was a wealth of experimentation with decorative vocabulary and available methods. The potters revived older practices and were inspired by the contemporary arts as well as by export wares. Their works were valued at home and abroad. As observed in all ceramic traditions, there were artists who created new pieces and craftsmen who merely copied them. The most remarkable feature of Mamluk pottery is that talented artists were always available and produced quality products up to the very end of the empire.

Notes

1. For riderless horses see Cairo 1922, pls. 116 and 121.
 Also illustrated in Aly Bahgat and Massoul 1930,
 pl. 7; and Scanlon 1967, fig. 6a.
2. For the so-called Sultanabad wares see Reitlinger
 1944; Lane 1971, chapter 1; Grube 1976, no. 27.
 Golden Horde wares are discussed in Lane 1971,
 pp. 13–14 and pl. 5.
3. Figures sailing a boat are in Cairo, Museum of
 Islamic Art, 5379/25 (Wiet 1930, no. 66b; Cairo 1969,
 no. 129); hunters, same collection, 3902/24 (Cairo
 1922, pl. 122; Aly Bahgat and Massoul 1930,
 pl. LI:2); Descent from the Cross, same collection,
 13174 (Cairo 1922, pl. 123; Cairo 1969, no. 123);
 riderless horses, same collection, 18773 (Cairo 1922,
 pl. 121); and horse with blazon on saddle published
 in Scanlon 1967, fig. 6a.
4. Cairo, Museum of Islamic Art, 5272 (Aly Bahgat and
 Massoul 1930, pl. 6; Cairo 1969, no. 134).
5. Lane 1971, pp. 15–16 and pl. 7.
6. Mostafa 1949.
7. London, Victoria and Albert Museum, 1600–1888
 (Lane 1971, pl. 8). An albarello adorned with vertical
 panels is in London, British Museum, 1934 7-24 1;
 another example decorated with diagonal panels is
 published in Lane 1971, pl. 9.
8. Paris, Louvre, 6081 (Paris 1977, no. 182); and same
 collection, 5970.
9. Atıl 1973, nos. 73–74.
10. A jar in London, Victoria and Albert Museum, and
 an albarello in London, Godman Collection, came
 from Sicily (Lane 1971, pls. 8–9). See also no. 84.
11. Lane 1971, pl. 15.
12. The radial design is quite rare and appears on a bowl
 found at Fustat, now in London, British Museum,
 1908 7-22 1. This example has a napkin blazon.
13. Cairo, Museum of Islamic Art, 3945 (Wiet 1930,
 no. 68; Cairo 1969, no. 143).
14. Marzouk 1957; Abd al-Raziq 1966; Luxor 1979,
 no. 325.
15. A reconstructed drawing is published in Scanlon
 1971, p. 228 (top).
16. Many examples are on display in public museums in
 Aleppo, Amman, Damascus, and Jerusalem.
17. Cairo, Museum of Islamic Art.
18. For pieces inscribed with the name al-Afif see Riis
 and Poulsen 1957, p. 297, nos. 8, 10–11, and 13,
 fig. 1111. For Ali al-Himsi see Riis and Poulsen 1957,
 p. 297, no. 14.
19. London, Victoria and Albert Museum, 392-1887.
20. Riis and Poulsen 1957, pp. 291–92, figs. 1092–94.
21. Damascus, National Museum, A1700 (Lane 1971,
 pl. 13; Damascus 1976, fig. 131).
22. Paris, Louvre, MAO 363 (Paris 1971, no. 87; Paris
 1977, no. 140).
23. London, Victoria and Albert Museum, 413-1918
 (Lane 1971, pl. 14).
24. Cairo, Museum of Islamic Art, 4577 (Cairo 1969,
 no. 136; London 1976, no. 318).
25. London, Victoria and Albert Museum, 557-1905.
26. Most of these are published in Abel 1930, a confusing
 study without typological or chronological sequence.
27. New York, Metropolitan Museum of Art, 91.1.95
 (Dimand 1944, fig. 142; Lukens, 1965, no. 35; Lane
 1971, pl. 17A).
28. Cairo, Museum of Islamic Art, 2077 (Cairo 1969,
 no. 138; London 1976, no. 317).
29. Carswell 1972a, pl. 8.
30. For a study of fifteenth-century Syrian tiles see
 Carswell 1972 and 1972a.
31. Meinecke 1976.
32. The roundel is published in Wiet 1930, no. 69.
 The lunettes are in Aly Bahgat and Massoul 1930,
 pl. O:134–35.

66
Bowl with eight radial panels
Underglaze painted in blue, turquoise, red, black
Late 13th–early 14th century

Height: 12.0 cm. (4¾ in.)
Diameter: 24.5 cm. (9⅝ in.)

Damascus, National Museum, A5356
Found at Aleppo, 1948

A group of underglaze-painted Mamluk bowls (nos. 66–73) displays the same fabric and technique: an off white paste covered with a thin white engobe and decorated with varying combinations of black, blue, green, and turquoise under a transparent colorless glaze. The predominant design is radial, that is, a series of panels radiate from the center. Floral motifs appear in almost every bowl. Several examples contain geometric patterns and a few show simulated inscriptions.

This deep bowl uses an underglaze red in addition to the blue, black, and turquoise pigments usually employed on Mamluk pottery Its shape, design, and color indicate a continuation of the renowned Ayyubid wares of Syria.[1]

The exterior of the bowl has forty-five loosely drawn petals rendered in black. The interior is divided by triple black lines into eight triangular panels that radiate from the star-shaped core. Each panel is outlined in red and turquoise bands and contains a polygon filled with two alternating motifs: a series of four minute dots or crosshatching. A chevron band appears below the rim, which has a plain black border.

Museum records indicate that this bowl came from Aleppo. The same radial design with crosshatching and clusters of dots was used in one of the pieces excavated at Hama, strengthening its Syrian origin.[2]

Published
London 1976, no. 315.

Notes
1. For a comparable piece see Atıl 1975, no. 30. Fragments of this type were found at Baalbek, Fustat, and Hama. See Cairo 1922, pl. 89; Sarre 1925, pl. 22, no. 65; Riis and Poulsen 1957, p. 187.
2. A similar piece with eight-partite divisions using crosshatching in alternate panels was found at Hama (Riis and Poulsen 1957, fig. 771). See also Sarre 1925, pl. 23, no. 64.

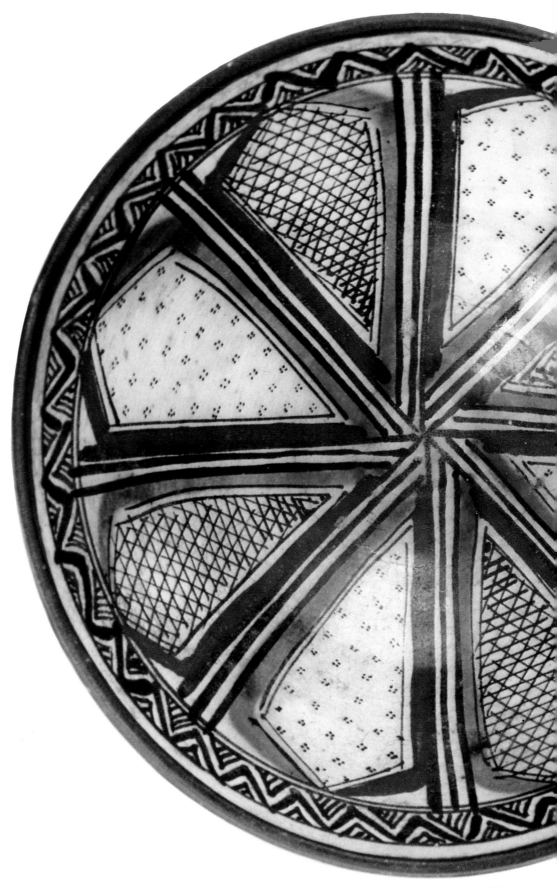

67
Bowl with six radial panels
Underglaze painted in turquoise, black
14th century

Height: 10.0 cm. (3$\frac{15}{16}$ in.)
Diameter: 21.3 cm. (8$\frac{3}{8}$ in.)

Damascus, National Museum, A7414
Purchased 1954

This bowl reveals the same shape and technique observed in the previous
example (no. 66). Its exterior is divided by a series of double black lines into
twenty-one panels with a plain black band on the rim. The interior has six
triangular panels formed by black lines that radiate from the center,
accentuated with six turquoise bands. The panels are filled with two
alternating motifs: a triple s-shaped branch bearing trefoil blossoms and
leaves on a scroll ground and a vertical branch with symmetrically drawn
leaves set on a plain ground enclosed by a trefoil border.

The design utilizes geometric and floral elements based on multiples of
three. The strong radial movement created by the turquoise and black bands
enhanced by the vertical branches is counteracted by the s-shaped scrolls and
lobed borders. The decoration is executed in a spontaneous manner, belying
its highly organized and sophisticated composition.

Bowls with radiating panels are frequently seen in the Ayyubid and Seljuk
periods. This decorative scheme continued to be employed in the fourteenth
century in Syria, Iran, and Turkey.

Unpublished

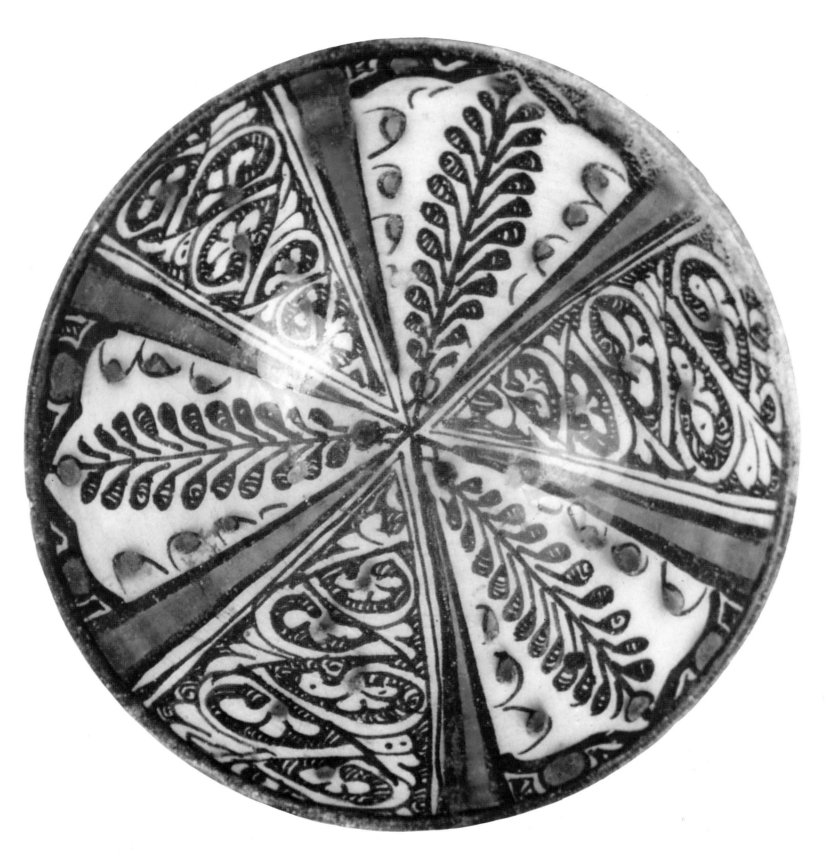

155

68
Bowl with quatrefoil design
Underglaze painted in blue, black
14th century

Height: 8.3 cm. (3¼ in.)
Diameter: 16.2 cm. (6⅜ in.)

New York, Madina Collection, c19

The decoration of this small bowl, based on multiples of four, is executed in a free and flowing manner. The exterior has eight panels defined by double or triple blue lines and filled with s-shaped scrolls. A black band appears on the rim and additional black lines encircle the upper and lower portions of the outer walls.

The interior, framed by a black rim band, contains a central medallion with a twelve-petaled rosette. Four medallions with fan-shaped blossoms appear on the walls with floral sprays in the interstices. A continuous white band encircles the rim and loops around the medallions to define and unite each segment. This feature is one of the most outstanding characteristics of Mamluk art and is frequently observed in manuscript illumination, metalwork, glass, and architectural decoration (see nos. 4, 26, 51, and 101); it is, however, rare in underglaze-painted ceramics. Obviously inspired by the works of contemporary illuminators, metalworkers, glassmakers, and woodworkers, the maker of this bowl experimented with one of their traditional design features.

Unpublished

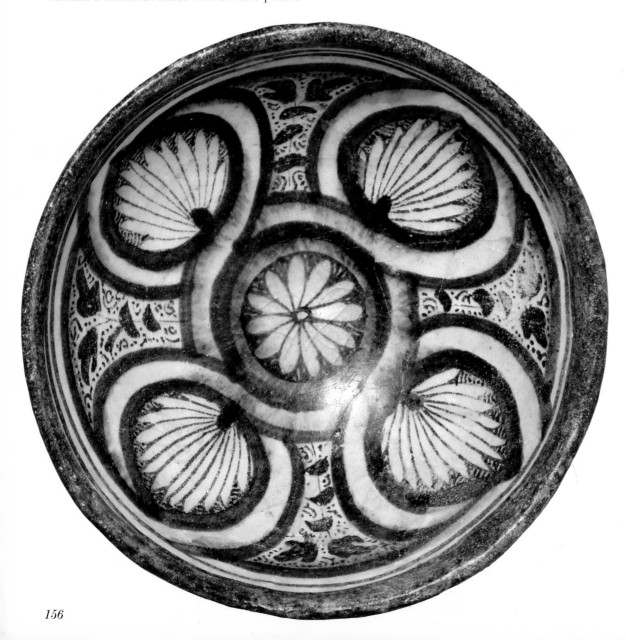

69
Bowl with central hexagon
Underglaze painted in blue, green, turquoise
14th century

Height: 7.6 cm. (3 in.)
Diameter: 33.0 cm. (13 in.)

New York, Madina Collection, c25
Ex-Kelekian Collection

The composition of this shallow bowl with everted rim is based on multiples of three arranged in five concentric rings that radiate from a hexagonal core. The units in each ring are softly curved and overlap one another, giving the impression of a multipetaled blossom. The maker has transformed a geometric design into a floral one, filling each petallike unit with alternating motifs.

The exterior is decorated with a series of blue and green strokes with double bands on the lower portion. A thin green band encircles the rim.

The interior of the rim has a blue chevron band filled with green crosshatching. The hexagon in the center of the bowl has dots and strokes. It is surrounded by crosshatched triangles that create a six-pointed star. The third zone contains six polygons alternately filled with four-petaled florets and clusters of triple dots. The next ring has larger units with fan-shaped blossoms and floral sprays. The last and fifth ring repeats the two designs of the third zone; rounded blossoms appear in the interstices.

Identical blossoms and floral sprays were employed on the previous example (no. 68). The similarity in execution of these motifs suggests that the two bowls were made at the same time, possibly in the same workshop. The peculiar fan-shaped blossoms are also found on other fourteenth-century Syrian wares.[1]

The color scheme of this bowl is unusual, employing a bright green and omitting black, which is the most common pigment in Mamluk underglaze-painted ceramics. The green and blue pigments are thickly applied and appear in relief, recalling slip-painted wares.

Unpublished

Notes
1. They appear on a fragmentary bowl in Amman, Archaeological Museum; a shard in New York, Metropolitan Museum of Art, 08.256.275; and a complete bowl in Beirut (Beirut 1974, no. 27). Similar petal formations are found on bowls excavated at Hama (Riis and Poulsen 1957, fig. 726–27).

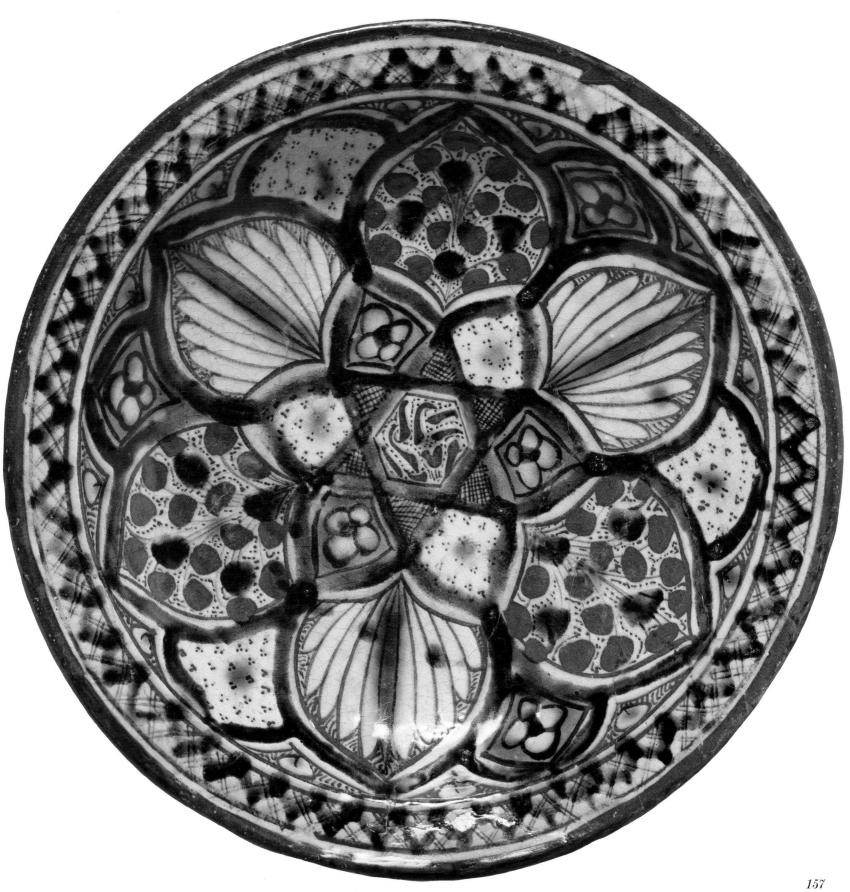

70
Bowl with central star
Underglaze painted in blue, turquoise, black
14th century

Height: 7.5 cm. (2$\frac{15}{16}$ in.)
Diameter: 30.7 cm. (12$\frac{1}{16}$ in.)

Cairo, Museum of Islamic Art, 15986
Purchased, 1949
Ex-Ibrahim Collection

The combination of geometric and floral motifs is
also found on this shallow bowl with everted rim.
A series of concentric swirls decorates the exterior,
while a plain band encircles the rim.

The rim of the interior has a crosshatched
border, painted in blue and divided into five
panels by turquoise units. The same border,
divided into three panels, appears in the center,
enclosing a five-pointed star. Geometric bands fill
the arms of the star, dots and strokes adorn the
core and interstices. The cavetto contains twenty-
six staggered floral sprays radiating from the inner
border; each spray bears two blue florets
alternating with a pair of leaves. Clusters of triple
dots fill the background.

The piece was warped during firing and the
residues of a three-footed sagger can be seen
around the central star. The black pigment, used
in the branches and leaves of the floral spray, was
improperly affixed during the firing and appears
almost greenish in tone.

Unpublished

71
Bowl with directional design
Underglaze painted in blue, turquoise, black
14th century

Height: 6.3 cm. (2$\frac{1}{2}$ in.)
Diameter: 24.1 cm. (9$\frac{1}{2}$ in.)

New York, Madina Collection, c26

The decoration of this unusual bowl is directional,
in contrast to the symmetrical designs observed
on the previous examples. The rim has a blue
crosshatched band divided into seven panels by
turquoise units; the same band, divided into five,
encircles the central medallion. This medallion
reveals two superimposed designs: the first has
four concave sides that create an arrowhead-like
formation, while the second is a trefoil with
extending lateral lines. The irregular segments
created by these designs are filled with dots and
strokes or roundels and dots.

The decoration of the cavetto is equally
complicated: two thick bands with triangular and
rectangular extensions meet at the apex and base
to form an oval enclosure. Each band is outlined
in blue and filled with roundels and leaves; the
remaining zones have minute dots and strokes,
which simulate inscriptions. Both the central
medallion and the cavetto display a dichotomy
between main theme and background.

The strange compositional layouts employed in
the central medallion and cavetto are unique and
do not appear on other examples of underglaze-
painted wares. The crosshatched bands encircling
the rim and medallion are more common and were
seen in the previously discussed bowl (no. 70).
The decoration of the exterior, composed of a
series of eleven swirls separated by pairs of blue
lines, is also found on contemporary bowls (nos. 68
and 72). The artist who made this bowl must have
been a highly individualistic person who deviated
from traditional composition and experimented
with optical designs.

The concept of using a theme that is at once the
main element and the background is not
altogether alien to Mamluk art and can be found
in manuscript illumination (see nos. 2 and 7).

Unpublished

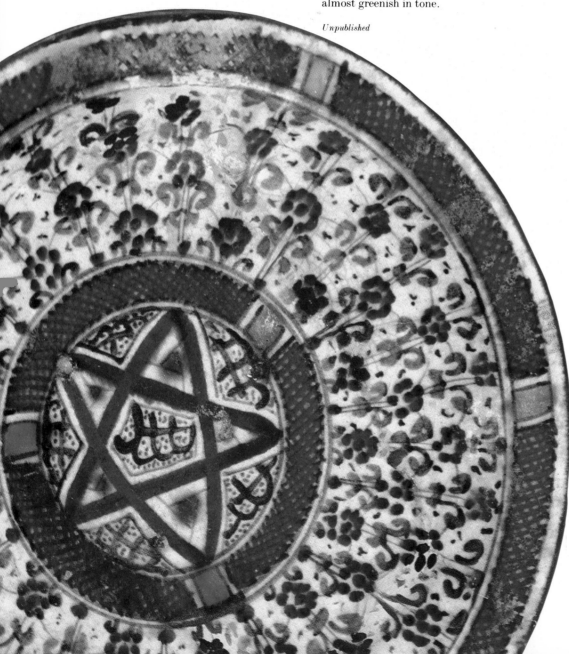

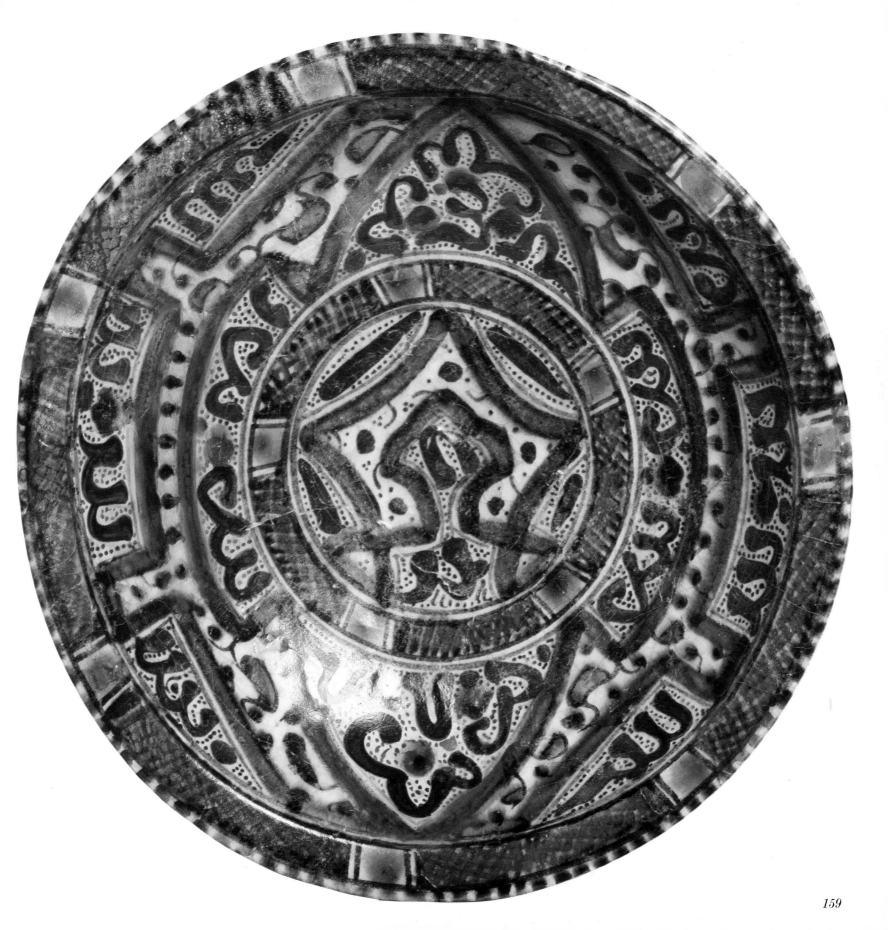

159

72
Bowl with diaper pattern
Underglaze painted in blue, black
14th century

Height: 10.2 cm. (4 in.)
Diameter: 38.1 cm. (15 in.)

New York, Madina Collection, c46

A similar type of experimentation with optical effects is observed in this shallow bowl with everted rim. The exterior is decorated with a series of swirls separated by pairs of blue lines, a device found on a number of contemporary pieces (nos. 68 and 71). In this example, additional lines extend from the swirls to the foot.

A band of blue ovals and diamonds encircles the black rim; scrolls fill the interstices. The cavetto has an identical ground with the main design of overlapping ovals and trefoils rendered in blue, creating a series of units alternately decorated with scrolls and minute dots.

The large central medallion has the appearance of an overall diaper pattern composed of trefoils alternately filled with tightly wound and loosely wound scrolls. The design is meant to be directional, beginning with larger units and terminating with smaller ones or the reverse. This feature was either intentional by the artist, who may have wanted to create an illusionistic effect, or accidental, the maker finding it difficult to draw identical units as the composition progressed. Whatever caused the variations in the size of the units, the overall effect is quite impressive. Only one other contemporary piece employing this theme has been published;[1] unfortunately, that example is fragmentary and it is not possible to determine whether it contains the same optical effect and progression in the size of the elements.

A similar diaper pattern appears on a mid-sixteenth-century plate from İznik, now in the Metropolitan Museum of Art in New York.[2] The model for the pattern used on the İznik plate has been identified as being from the repertoire of fourteenth-century Chinese celadons exported to the Near East.[3] Although the same Chinese design may have influenced the composition of the Madina bowl, parallels for the geometric motif can be found in the Mamluk world. The peculiar "trefoil" units making up the diaper pattern are seen in contemporary art, including doublures of bookbindings and woodwork (see no. 99). It is possible that the potter, influenced by the designs found on Chinese export wares, abstracted one of the motifs from a geometric composition to create an overall pattern.

Unpublished

Notes
1. Grube 1976, no. 246. A shard with an identical design is in New York, Metropolitan Museum of Art, 08.256.101.
2. New York, Metropolitan Museum of Art, 14.40.727 (Denny 1980, pl. 40).
3. Pope 1972.

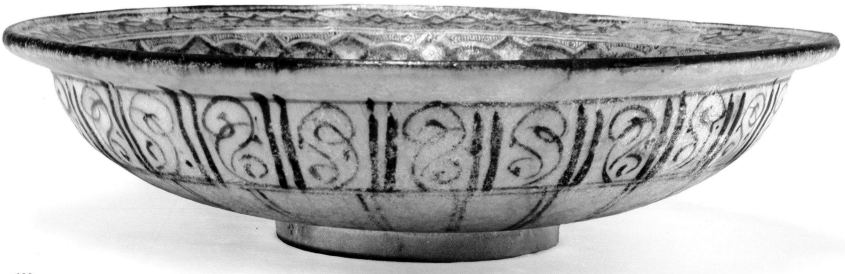

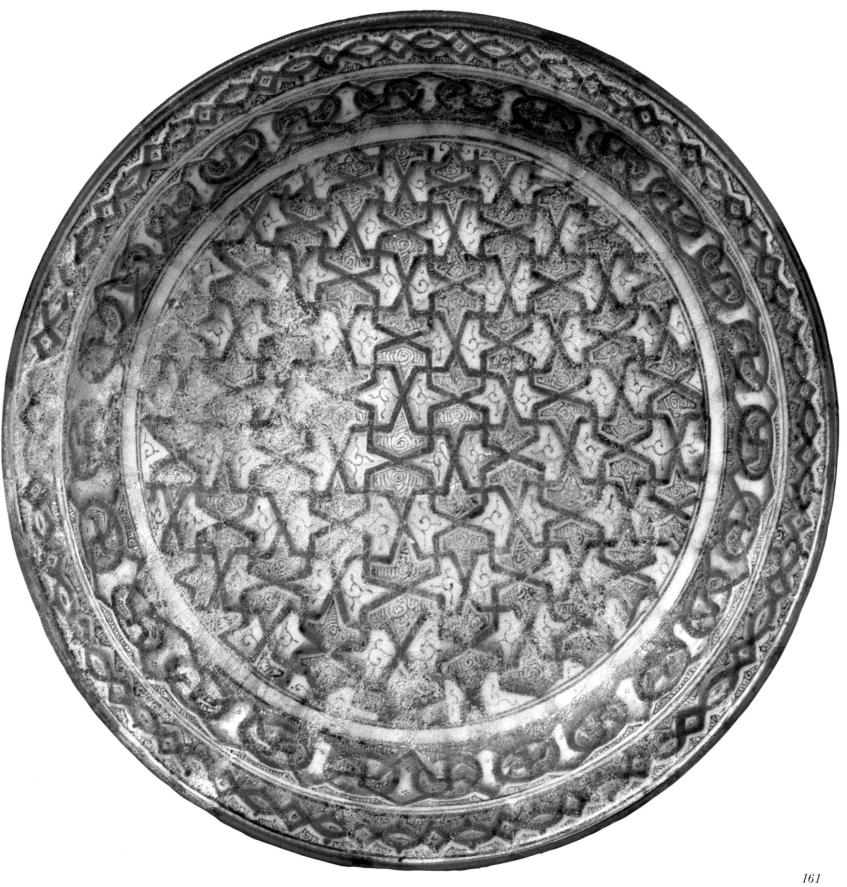

161

73
Bowl with central rosette and star
Underglaze painted in blue, black
14th century

Height: 6.3 cm. (2½ in.)
Diameter: 26.4 cm. (10⅜ in.)

New York, Madina Collection, c23

Since underglaze-painted Mamluk wares were decorated with a variety of themes in different combinations, the typological and chronological development of the ceramic tradition is difficult to establish. This example contains a number of design elements that were used on other pieces, including a central rosette (see nos. 68 and 74–75), a geometric unit (nos. 69–70), and areas filled with minute dots and strokes (nos. 70–71). Its shape, with low foot, curving sides, and everted rim, was also observed on other pieces (nos. 69–72).

This example has a continuous scroll on the exterior. The interior is decorated with three zones designating the rim, cavetto, and center, each encircled by black lines and blue bands. The rim has a series of leaf-shaped strokes on a ground filled with dots and dashes. The center contains an eight-petaled blue rosette within an octagon, which is enclosed by an eight-pointed star placed inside another octagon. The semicircles around the star are enhanced by blue roundels, and the entire unit is enclosed by a blue band. The cavetto repeats the octagonal theme and is framed by a second blue band. The octagon in the cavetto and the arms of the central star are painted in black and decorated with abstracted floral scrolls.

The composition of the bowl, conceived as a series of clearly defined concentric zones, is quite sophisticated, each zone revealing a dichotomy between primary and secondary elements. For instance, the octagons in the center can be seen either as the main motifs or as the field between the rosette, star, and encircling scalloped band.[1]

Mamluk pottery, often dismissed as the humble man's craft, reveals the same high standards observed in manuscript illumination, metalwork, and glass, indicating that artists were capable of producing quality objects, regardless of their material.

Unpublished

Notes
1. An example in Beirut has a hexagon inside a six-pointed star, but its cavetto contains the fan-shaped blossoms seen in nos. 68–69 (Beirut 1974, no. 27).

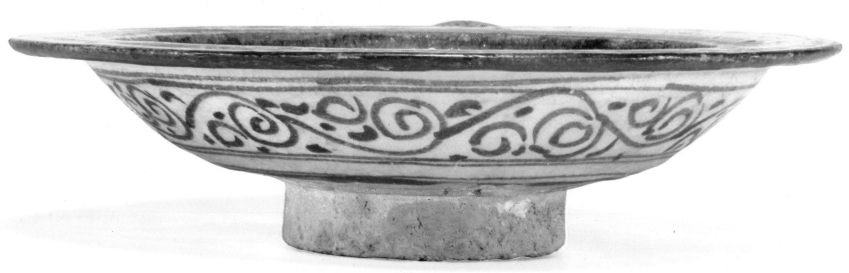

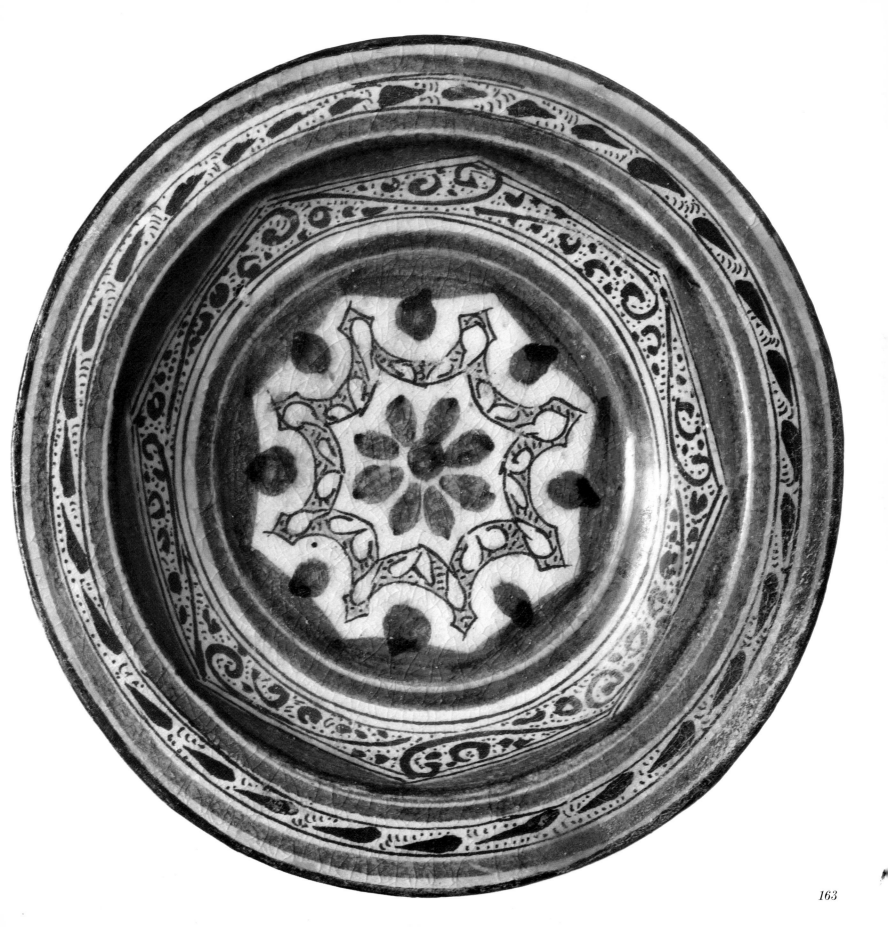

74–75
Pair of bowls with twelve radial panels
Underglaze painted in blue
15th century

Height: 11.5 cm. (4½ in.)
Diameter: 25.4 and 26.0 cm. (10 and 10¼ in.)

New York, Madina Collection, c24 and c45

Although one assumes that Mamluk pottery was produced for mass
consumption, it is not easy to find a series of identical pieces executed in the
same workshop. This pair of blue-and-white bowls proves that Mamluk
pottery was mass-produced. A third example is also in the Madina Collection.
 The bowls have a low foot, flaring sides, and slightly molded lip that turns
under. The exterior has a series of strokes; the interior reveals twelve panels
radiating from a central seven-lobed medallion enclosing a five-petaled
rosette. The panels and the lobed medallion are outlined with double blue
lines. The panels, defined by blue bands, are adorned with alternating designs:
a floral spray of loosely drawn branches, leaves, and buds accentuated by a
single six-petaled blossom and a cluster of overlapping roundels on a scroll
ground. The former can be related to the sprays on an earlier piece (no. 70);
however, the bud with two lobes flanking a spiked petal found in these panels
is closer to the floral element that became popular in the fifteenth century (see
nos. 34–35). It is not easy to identify the type of flora represented in the
second set of panels. The artist may have been attempting to reproduce
pomegranates or bunches of grapes, the latter seen on metalwork and carved
stone plaques dating from the fourteenth century (see nos. 25 and 111).
 The themes employed are indigenous and do not reveal the impact of
Chinese export wares seen in some later blue-and-white wares and tiles (see
nos. 89–91). Designs radiating from blue rosettes were among the decorations
found on early Mamluk underglaze-painted wares (see no. 68).

Unpublished

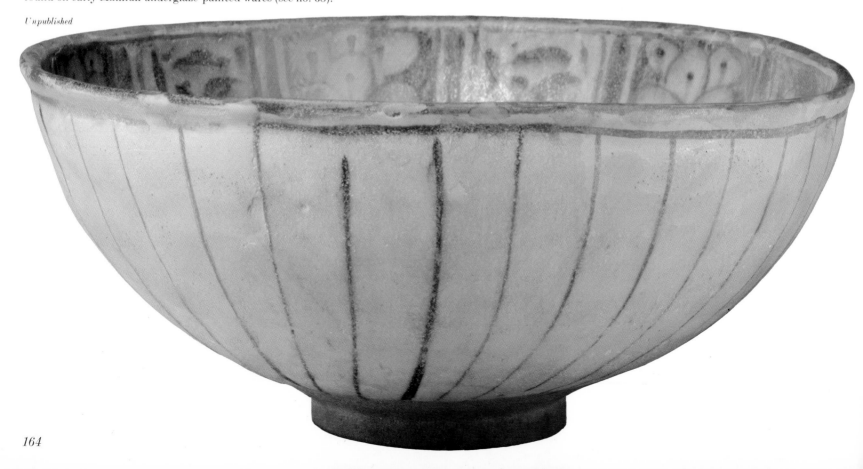

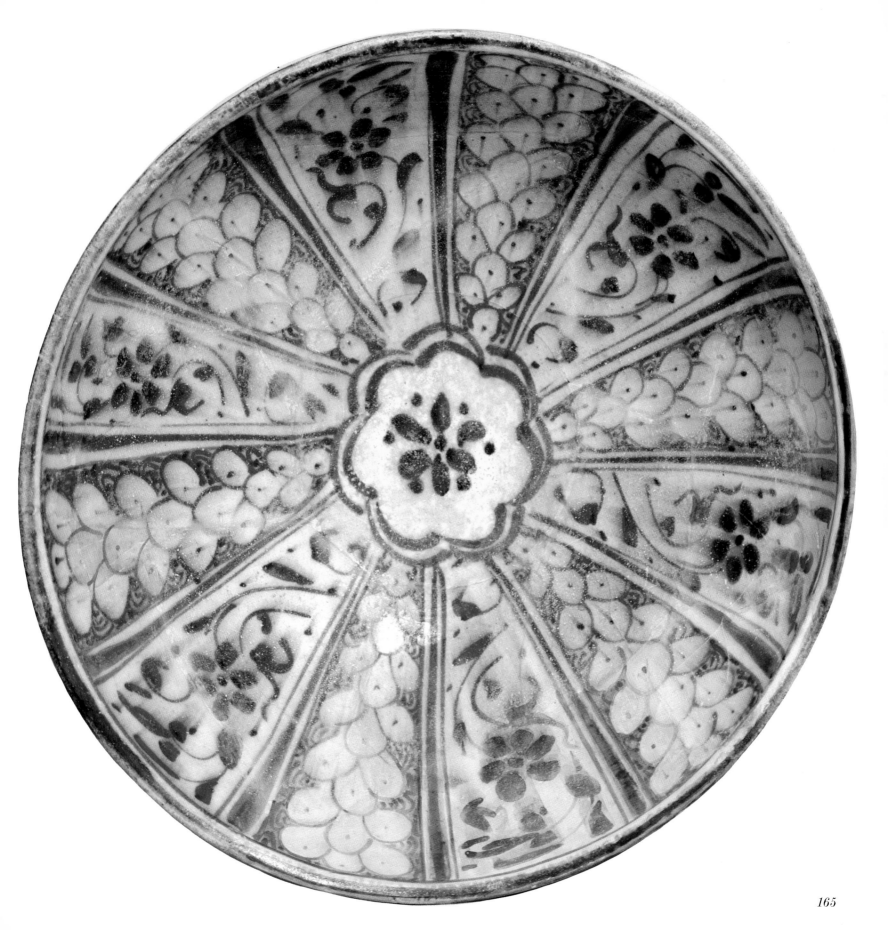

76
Bowl with central cross and diamond
Underglaze painted in blue
15th century

Height: 13.4 cm. (5¼ in.)
Diameter: 34.0 cm. (13¾ in.)

New York, Madina Collection, c47

This bowl is so similar in style and technique to the previously discussed pair
(nos. 74–75) that one can easily assign all three to the same workshop. It is
slightly larger and has a foliated rim. The exterior is divided in two registers:
swirls separated by pairs of lines appear above a series of double strokes.
The foliate rim is encircled by a blue band.

The interior has twelve panels filled with alternating designs radiating from
a central medallion. In contrast to the pair of bowls, the medallion on this
bowl is adorned with a geometric pattern: a cross with braided motifs on its
arms is superimposed on a diamond with trefoils at the corners. Series of thin
lines define the medallion and the radiating panels, which are accented by
additional blue bands.

Six panels contain a loose floral scroll similar to that described earlier (nos.
74–75). The alternating panels employ a horizontal layout with three bars
forming four units, each bearing a thin scroll.

Although the foliate rim and the radial design have parallels in fourteenth-
and fifteenth-century Chinese ceramics, the decorative vocabulary of this
bowl can be traced to an indigenous tradition. The combination of geometric
and floral patterns was part of the traditional repertoire of Mamluk potters.

Unpublished

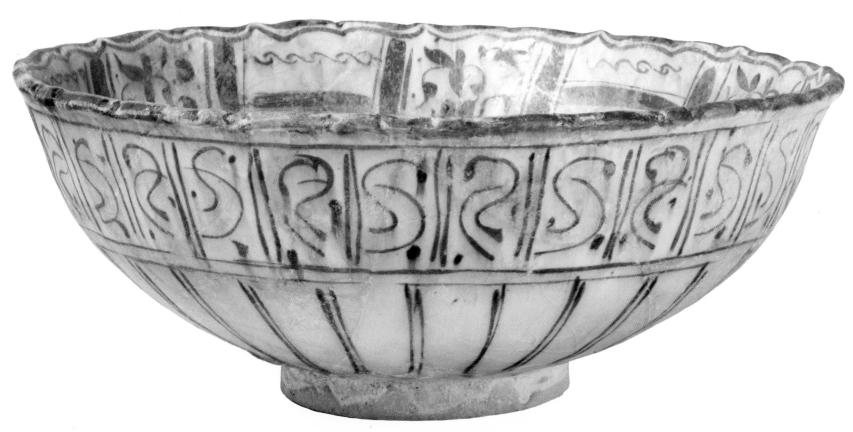

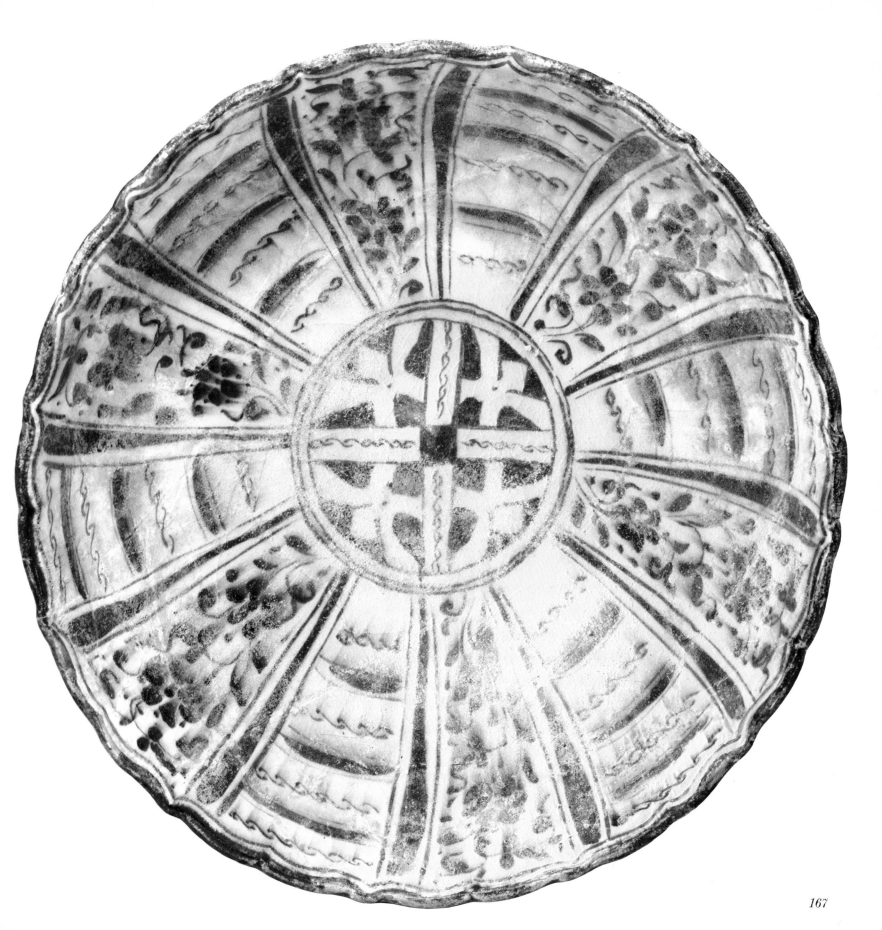

167

77
Goblet
Underglaze painted in blue, black
14th century

Height: 9.8 cm. ($3\frac{3}{4}$ in.)
Diameter: 13.9 cm. ($5\frac{7}{16}$ in.)

London, The British Museum, 1928 7-21 15
Gift of H. Van den Bergh, 1928

Goblets or stemmed cups were produced in ceramics as well as in glass (see nos. 59, 62, and 78). The proportions of these drinking vessels vary: some have tall stems, others—such as this example—are relatively low, resembling a high-footed bowl.

The exterior of this piece has a plain black border on the rim above a braided or meander band. A series of rapidly executed scrolls and strokes with pairs of blue lines decorates the walls. Thin black lines outline the horizontal divisions.

The interior reveals a tripartite design radiating from a hexagon. A band encircles the hexagon and loops around the trefoils in each of the three units on the walls. A roughly beaded border frames the composition. The zones between the three units are filled with crosshatching and accented with foliate cartouches. Additional bands with blue dots appear inside the trefoils and central hexagon.

The trefoils and foliate cartouches on the walls contain stylized blossoms on a dotted ground. Similar floral motifs and dots fill the hexagon, in the center of which is a crouching blue hare. The animal is almost invisible since the blue has bled and the glaze has pooled at the bottom of the piece, camouflaging the design.

The floral motifs on the British Museum goblet form a link between Ayyubid and Mamluk pottery. This piece also represents a type of Egyptian and Syrian ceramic that shows similar animals and cluster of dots common to the so-called Sultanabad wares executed in Iran under the Ilkhanids in the fourteenth century.[1]

Unpublished

Notes
1. A similar bowl with a four-partite design enclosing a hare in London, Keir Collection, has been identified as Iranian (Lane 1971, pl. B; Grube 1976, no. 203). More research must be done on this group before the pieces can be properly attributed to Iran or Syria.

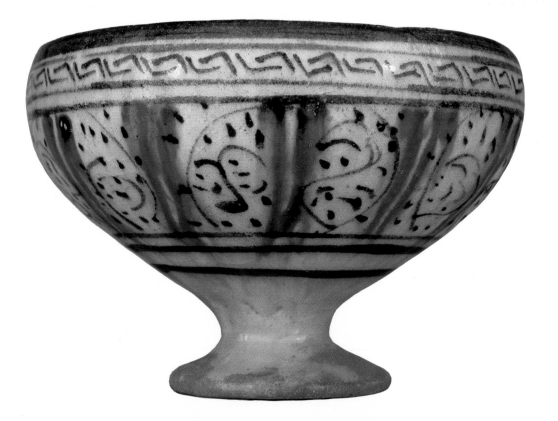

78
Pierced goblet
Underglaze painted in blue, turquoise, black
14th century

Height: 12.1 cm. (4¾ in.)
Diameter: 15.2 cm. (6 in.)

New York, Madina Collection, c18

Similar in shape to the previous example (no. 77), this goblet shows the revival of a popular twelfth-century tradition. Portions of the design were pierced, then covered by a transparent glaze creating "windows" through which one could see the liquid in the vessel. Piercing was first employed on a group of finely potted white Seljuk wares that attempted to simulate the translucency found in Sung dynasty porcelain; the technique was later applied to monochrome and polychrome wares.[1] Its revival in the Mamluk period is remarkable; at least two other similar goblets are known to exist.[2]

This goblet has an elegant shape with a tall flaring stem accentuated by vertical strokes. The exterior of the cup has six triangular units containing trefoils radiating from the foot, with six-petaled blossoms in the interstices. Above this zone are six oval cartouches alternating with six petallike units, all of which are pierced.

The interior walls also display a twelve-partite composition. In the center is a medallion with a six-petaled rosette, framed by a crosshatched band intersected by five turquoise units, similar to those on other contemporary pieces (see nos. 70–71).

Unpublished

Notes
1. Atıl 1973, nos. 14–15, 24, and 48.
2. An identical goblet in New York, Madina Collection, has a central motif radiating from a six-pointed star. For a third example see Grube 1976, no. 249.

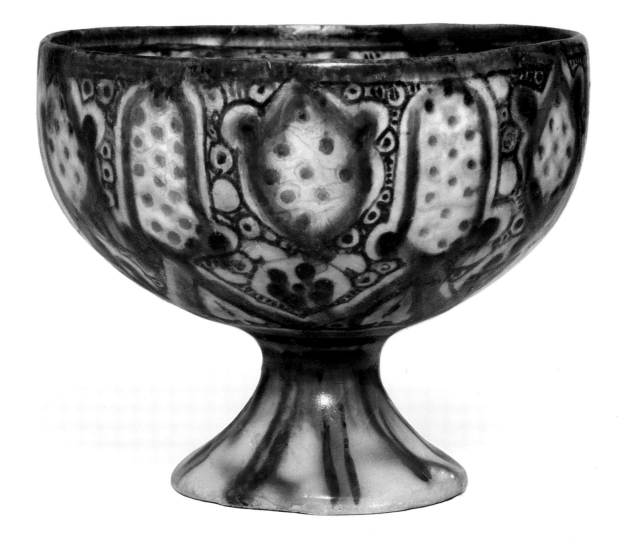

79
Vessel with handle
Underglaze painted in blue, black
14th century

Height: 11.4 cm. (4½ in.)
Diameter of rim: 15.6 cm. (6⅛ in.)

New York, Madina Collection, c14

Underglaze-painted wares using a combination of black and blue are among the most common type of Mamluk pottery. The simple shape of this piece—with cylindrical body, everted rim, and single handle—is accentuated by a series of vertical strokes alternately painted in blue and black. The flattened rim is decorated with a scalloped frieze and thick band.

The shape of the rim indicates that the piece could not have been used as a vessel for pouring or drinking, as the liquid would have spilled when the container was tilted. Its specific purpose is still unknown, although a number of vessels of identical shape have been published.[1] Considering the sanitary facilities of medieval Egypt and Syria, it is possible that this shape served a very humble—and very essential—role, such as that of a chamber pot for a child.

The vessel's harmonious decoration indicates that Mamluk potters produced attractive pieces for daily use, regardless of function.

Unpublished

Notes
1. This was a very popular shape in Ayyubid and Mamluk periods. A number of thirteenth- and fourteenth-century examples were excavated at Hama (Riis and Poulsen 1957, pp. 117–284). A fourteenth-century blue and black pot decorated with lotus blossoms is in Beirut (Beirut 1974, no. 28a). For a fifteenth-century example see Carswell 1979, pl. XXI.

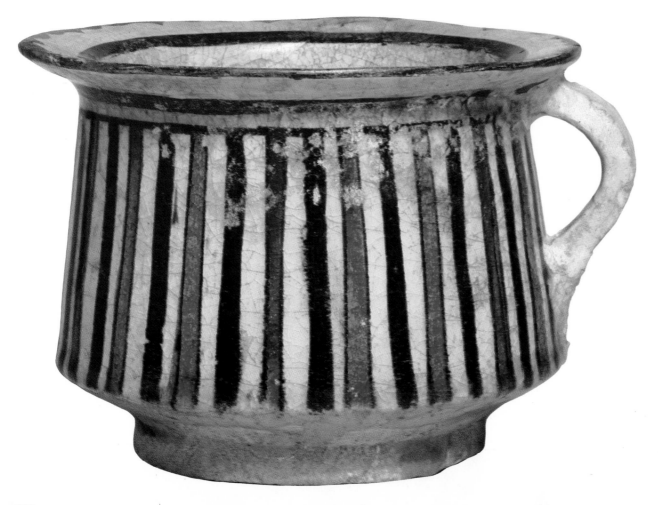

Small jar with vertical panels
Underglaze painted in blue, black
14th century

Height: 16.0 cm. (6¼ in.)
Diameter of rim: 5.7 cm. (2¼ in.)

New York, Madina Collection, c27

The same execution and decoration seen in the
previous vessel (no. 79) appears on this small jar
made for daily use. The rim has a plain black band
and the neck contains a blue chevron pattern on a
scroll ground. The body is decorated with vertical
panels outlined in double black lines and filled
with alternating designs: the chevron pattern on
the neck repeated vertically and the triple strokes
enclosed by random dots. Following the contours
of the jar, these panels increase and decrease in
width as they flow down the outer walls.
 Although this unpretentious piece was meant to
be used in the kitchen for storing spices or oils, the
potter was sensitive to its shape, his design
accentuating the swelling of the shoulders and the
tapering of the body.

Unpublished

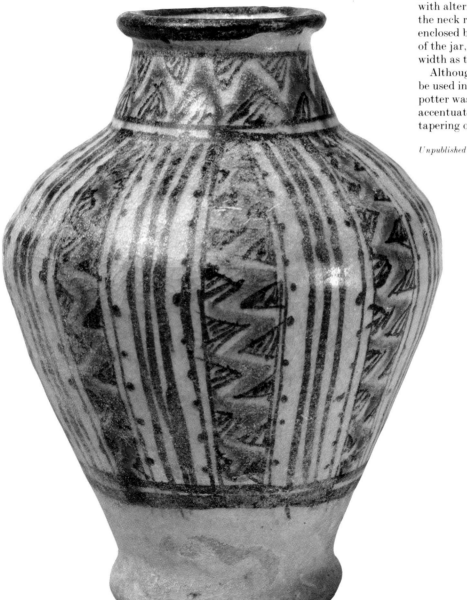

81
Large jar with inscriptions
Underglaze painted in blue, black
14th century

Height: 32.5 cm. (12¹³⁄₁₆ in.)
Diameter of rim: 10.5 cm. (4⅛ in.)

Damascus, National Museum, A4547
Purchased 1947

The decoration of this jar reveals a highly
competent execution with motifs rendered in a
painterly manner. The artist has created a three-
dimensional effect, recalling the low relief of slip-
painted Ilkhanid wares.

A plain black band encircles the everted lip
above a loosely drawn inscription written in black
on a dotted ground placed on the neck. The inscrip-
tion appears to be decorative, consisting of a
series of alifs and lams. It can also be interpreted
as repeating *la-illah*, part of the conventional
pious phrase "there is no God but Allah. . . ."

The body is divided into eight vertical panels
that employ alternating designs. The first has a
pair of superimposed four-petaled blossoms filled
with black dots and placed on a floral ground.
The other is divided into three horizontal units:
the upper and lower contain a pentagon adorned
with a curving branch bearing a palmette
executed in reserve on a scroll ground with black
dots in the interstices; an inscription, identical to
that on the neck, appears in the center. The thick
blue lines separating the panels and outlining the
units have run, providing subtle shading and
enhancing the three-dimensional effect. Two black
bands encircle the body just above the foot.

The off white fabric of the jar was covered with
a white engobe that extends nearly to the foot.
The glaze applied over the black and blue
pigments is slightly greenish and has dribbled
around the base. The incomplete application of
the engobe and the pooling of the glaze are
common to all Syrian wares and are particularly
noticeable on the lower portions of both jars and
bowls.

A jar in the Victoria and Albert Museum in
London has similar proportions and decoration,[1]
while a number of other examples were made in
different techniques (nos. 83–84). These large jars
were kept in pantries and were used to store grains
or oils.

Published
Al-Ush 1963, pp. 104–5 and fig. 1.
Damascus 1976, p. 249, vitrine no. 7 and fig. 140.
London 1976, no. 314.

Notes
1. This piece, which is slightly larger (40.6 cm. or 16 in. high), is
 published in Lane 1971, pl. 10. Other similar jars are in Sèvres,
 Paris, and Naples (Naples 1967, no. 69 and fig. 50).

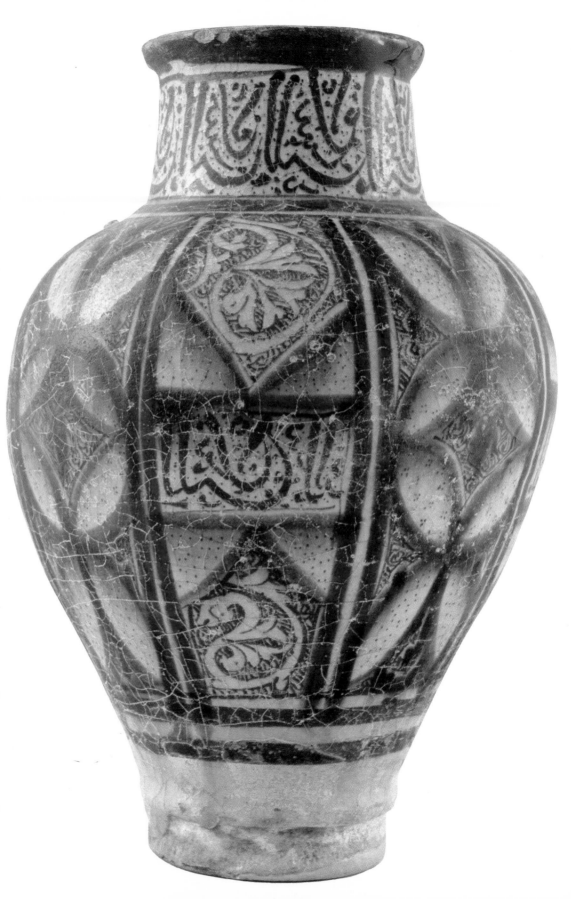

82
Small jar with geese
Underglaze painted in blue, black
14th century

Height: 16.5 cm. (6½ in.)

Damascus, National Museum, A5503
Found at Homs, 1949

Jars were also decorated with animals and birds, as in this charming example.[1] The neck, which has been broken and repaired, depicts two four-legged animals and blossoms. A band of twelve heart-shaped leaves interspersed with roundels appears on the shoulder. The body represents a procession of four geese strolling amidst sprays of leaves on a scroll ground. The geese are painted in reserve, their wing feathers rendered in black; the floral sprays are painted in blue and enclosed by a contour band.

Two black lines encircle the body above the foot, which is partially covered by a white engobe and thick pools of greenish glaze.

The geese are portrayed in a naturalistic and lively manner, indicating that Mamluk potters were as capable of representing animals as they were in employing floral and geometric motifs.

The heart-shaped leaves found on the neck also occur on a number of other fourteenth-century pieces executed in ivory, wood, and stone (see nos. 99–100 and 109).

Unpublished

Notes
1. Geese are also found on a jar in London, Godman Collection (Lane 1971, pl. 11), and on several pieces excavated at Hama (Riis and Poulsen 1957, figs. 746, 748, and 760–61).

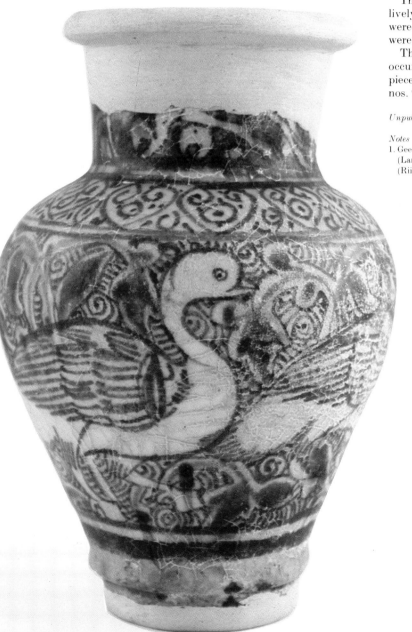

83
Large jar with winged horses
Underglaze painted in white slip with
 blue, black
14th century

Height: 38.1 cm. (15 in.)
Diameter of rim: 12.3 cm. (4⅞ in.)

London, Victoria and Albert Museum,
 482–1864
Purchased 1864

The most impressive group of
underglazed-painted Mamluk wares is a
series of large jars representing oversize
animals executed in a flowing and
spontaneous style that surpasses even
book paintings of the period.[1] These jars
are almost the same size and shape and
were used for storing and transporting
food stuffs. Their exquisite decoration
becomes even more remarkable when one
considers their utilitarian function.

The decoration of this example is
highly unusual. Six shields on the neck
enclose a symbol called *tamgha*, a stamp
or mark used by Turkish tribes.[2] This
symbol, whose origin and meaning are
obscure, may have designated a specific
rank or class, and this jar may have been
made for the household of a Turkish
official who used that emblem.

The body of the jar is adorned with
two winged horses on a floral ground of
trefoils, large split leaves, lotus blossoms,
six-petaled flowers, rounded florets, and
dots. The horses are represented in full
gallop, running to the right; their bodies
are covered with curls, wings are
attached to their shoulders, and their
long tails are knotted. A crane (or
phoenix) and a large lotus blossom
appear between the horses.

The flow of the large split leaves
accentuates the gallop of the horses;
this forward motion, counteracted by the
static position of the crane and lotus,
creates a dramatic balance between
movement and arrest.

Black bands outline the lip, neck, and
body; the white engobe stops short of the
foot and the greenish glaze has pooled at
the base.

Published
Wallis 1887, color fig. 5 and text fig. 12.

Notes
1. For other published examples see Riis and Poulsen
 1957, figs. 764–65 (Louvre jars); Lane 1971, pl. 11.
2. Mayer 1933, pp. 18–19.

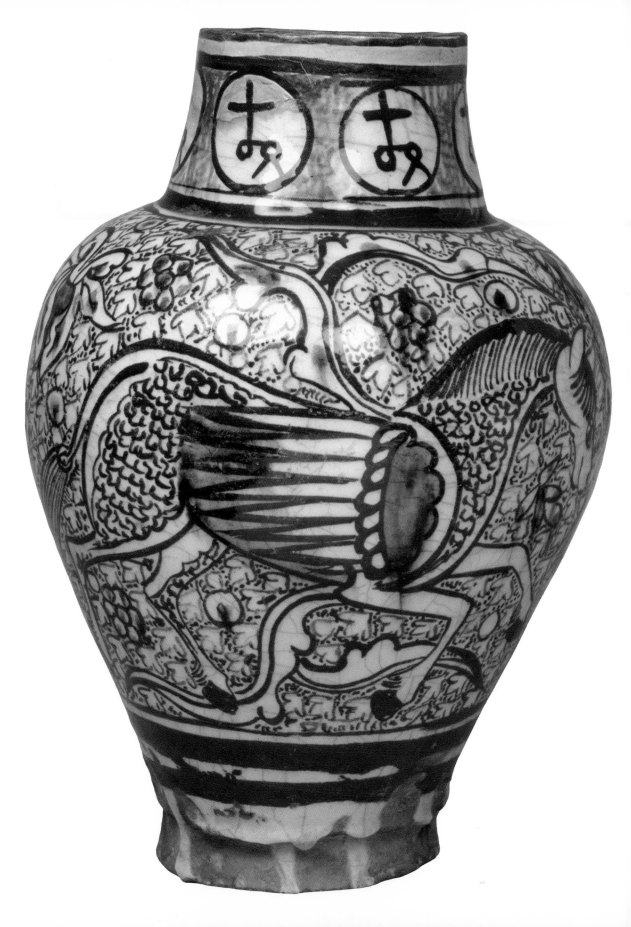

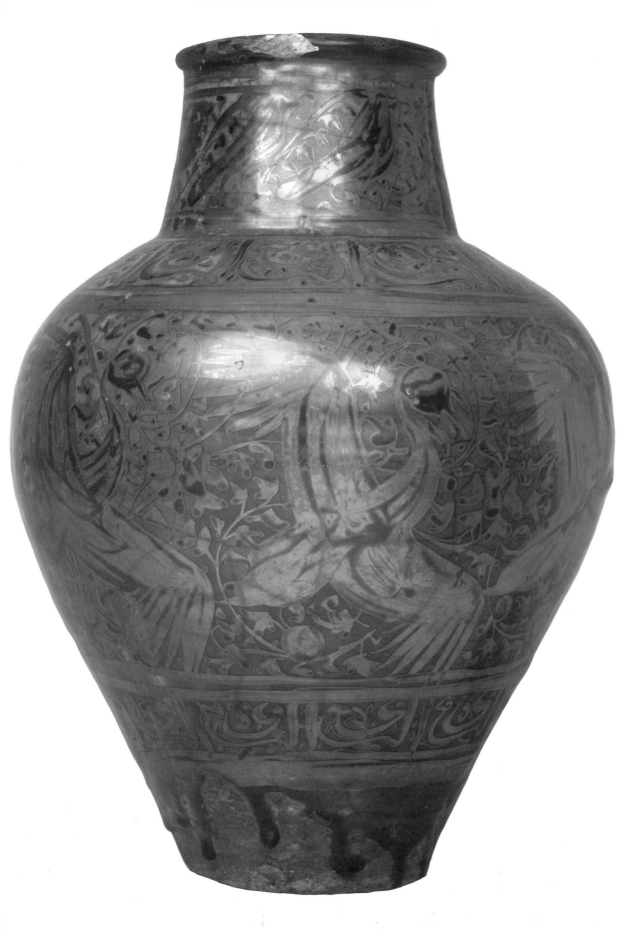

84
Large jar with flying birds
Underglaze painted in blue; overglaze
 painted in golden luster
14th century

Height: 38.1 cm. (15 in.)
Diameter of rim: 13.0 cm. (5⅛ in.)

London, Victoria and Albert Museum,
 1601–1888
Purchased 1888
Found at Trepani, Sicily

The technique of luster-painting, which
was very popular in the Ayyubid and
Seljuk periods, survived into the
fourteenth century and appears on a
number of large jars and albarelli
thought to have been produced in Syria.
Several of these pieces were found in
Sicily, an important commercial link
between the Mamluk world and Europe.
 Luster-painted Mamluk wares are
covered with a deep blue glaze on which
the golden luster was applied and fixed
during a second firing. The clarity of the
golden luster is remarkable and
extremely brilliant in comparison to the
wares of the Ayyubid potters, who used
a dull brownish red luster in combination
with underglaze blue and turquoise
pigments.
 This piece is divided into four
horizontal registers defined by thick
bands, alternately decorated with
inscriptions and birds on a floral ground.
A band with seven birds perched on
branches appears on the neck; the
inscription panel on the shoulder is
repeated on the base; and the body is
decorated with six flying cranes. Similar
to another large jar (no. 81), the
inscriptions repeat a series of alifs and
lams that may have a symbolic meaning.
 The birds are rapidly drawn and face
right, creating a freely flowing counter-
clockwise movement that encircles the
piece. The direction of the birds is
counteracted by the inscriptions that
read from right to left, producing a reverse
clockwise movement. The dichotomy
between movement and arrest described
earlier (no. 83) created a vertical tension;
here, the contrast is in horizontal
registers.

Published
London 1862, no. 7900.
Wallis 1889, pl. 8 and fig. 15.
Migeon 1907, vol. 2, p. 277 and fig. 228.
Migeon 1927, vol. 2, pp. 212–13 and fig. 364.

85
Hexagonal tile with central blossom
Underglaze painted in blue
Circa 1430

Height: 16.7 cm. (6⅝ in.)
Width: 20.3 cm. (8 in.)

New York, Madina Collection, c22b

This tile is decorated with four concentric rings. In the center is a seventeen-petaled blossom enclosed by a lobed medallion, placed on a hexagon with a floral scroll. Beyond this is a ring of six triangles that radiate from the hexagon and produce a six-pointed star. The triangular interstices between the points of the star, filled with strokes, scrolls, and chevrons, create the final hexagon.

The main motif is either the hexagon or the star, depending on how one reads the design. This optical play of primary and secondary themes is also observed on bowls (no. 73).

Since tiles were made for specific buildings that are dated, it is possible at times to compare detached examples with those in situ to determine when and where they were produced. The Madina tile is identical to a group of hexagonal tiles decorating the mosque and mausoleum of Ghars al-Din al-Khalil al-Tawrizi in Damascus.[1] Ghars al-Din's complex, built before his death in 1430, has more than 1,300 hexagonal blue-and-white tiles interspersed with triangular and turquoise glazed tiles.

Even though there is no documentary evidence proving that the Madina tile comes from the complex built by Ghars al-Din, it appears to have been produced at the same time and possibly in the same workshop. Several examples in public and private collections belong to this group.[2]

While the tiles in Ghars al-Din's buildings were set on their straight sides, a number of other hexagonal tiles were designed with the points forming the base (see nos. 86–89). It is not possible to determine how this example was meant to be affixed to the wall since it has a circular design.

Unpublished

Notes
1. Carswell 1972 and 1972a.
2. Carswell 1972, pls. 2 and 4.

86
Hexagonal tile with floral sprays
Underglaze painted in blue
Second quarter 15th century

Height: 19.0 cm. (7½ in.)
Width: 17.0 cm. (6¹¹⁄₁₆ in.)

Damascus, National Museum, A14153
Found at Damascus, 1960

Hexagonal tiles produced in Syria were frequently
decorated with floral motifs and painted in deep
blue, which had a tendency to run. This example,
meant to be set on its point, has a symmetrical
composition: a spray with three leaves—
resembling the banana plant represented on
fourteenth-century blue-and-white Chinese
wares—grows from the point, flanked by large
curving branches bearing willowlike leaves.
Rounded fruit or blossoms fill the corners with
thinner branches and leaves placed between the
main flora.

Although some of the elements recall vegetation
depicted on Chinese ceramics—such as the willow,
banana, and plantain—the rapid drawing,
carefree glazing, and stylized execution indicate
that the artist blended foreign elements with
native traditions.

Museum records do not indicate where in
Damascus this tile was found. The only fifteenth-
century tiles in situ are in the Ghars al-Din
complex, but a number of other buildings, both
religious and secular, must have been adorned
with similar tiles.

Unpublished

87
Hexagonal tile with asymmetrical design
Underglaze painted in blue, turquoise
Second quarter 15th century

Height: 19.0 cm. (7½ in.)
Width: 17.0 cm. (6¹¹⁄₁₆ in.)

Damascus, National Museum, A14154
Found at Damascus, 1960

In contrast to the previous tile (no. 86), this example has an asymmetrical design framed by a turquoise border. It is executed in the same rapid manner and the blue pigment has run during the firing.

A single stem bearing two branches—one laden with blossoms and rounded fruit, the other carrying willowy leaves—springs from a cluster of weeds and grasses at the base. Motifs resembling fruit sprays appear between the floral elements. The softly curving units create a sense of movement, almost as if the branches were caught in a gust of wind. The effect of blowing in the wind is enhanced by the running glaze.

Although identical examples have not yet been discovered, similar hexagonal tiles with swaying branches are in the Museum of Islamic Art in Cairo.[1] The Egyptian examples are more carefully executed and their glazes have not run. Nevertheless, both Egyptian and Syrian tiles display similar themes and techniques and are thus difficult to differentiate.

Unpublished

Notes
1. Carswell 1972a, pl. II, nos. c43 and c45.

88
Hexagonal tile with ewers
Underglaze painted in blue
Second quarter 15th century

Height: 19.0 cm. (7½ in.)
Width: 17.0 cm. (6¹¹⁄₁₆ in.)

Damascus, National Museum, A14155
Found at Damascus, 1960

This tile is decorated with a symmetrical design:
three branches with leaves and rounded blossoms
(or fruit) appear in the center and at the sides,
flanking two ewers. The shape of the ewers is
found in Mamluk metalwork, although the spouts
and handles have been considerably reduced by
the artist (see no. 19).[1] The rounded blossoms in
the branches are filled with crosshatching, a
feature observed in Chinese porcelain exported
to the Near East. This motif, a highly stylized
version of either a lotus blossom or a pome-
granate, frequently appears in Mamluk blue-and-
white tiles (see no. 89).

Tiles with ewers are seen in Ghars al-Din's
complex.[2] Although their symbolism is not clearly
defined, it is obvious that they were associated
with water, specifically the purifying water used
for ablutions and in ritual cleansing. The ewer was
used as the blazon of the *tishtdar*, superintendent
of stores;[3] this symbol, however, does not occur on
any known monument or object associated with
an amir who held that office. The use of ewers on
Syrian tiles should be considered decorative or, at
most, symbolic of ritual ablution.

Unpublished

Notes
1. Among fifteenth-century ewers are those made for the wife of
 Qaitbay in London, Victoria and Albert Museum, 762-1900
 (D. S. Rice 1953a, pl. VI), and the wife of an amir named
 Zayn al-Din Jawhar al-Muini (Melekian-Chirvani 1969,
 figs. 19–25).
2. Carswell 1972 and 1972a.
3. Mayer 1933, pp. 4–5.

89
Hexagonal tile with lotus scroll
Underglaze painted in blue, black
Mid 15th century

Height: 19.2 cm. (7 9/16 in.)
Width: 18.0 cm. (7 1/16 in.)

Cairo, Museum of Islamic Art, 4583
Purchased 1917

This hexagonal tile and the following two examples (nos. 90–91) display an extremely refined technique and meticulously executed design. This one is from Cairo, the other two are from Damascus. Their similar dimensions and compositions indicate that both the Egyptian and Syrian workshops followed the same period style. The artists obviously traveled back and forth, bringing with them their designs and samples, thereby creating a national style.

The tile from Cairo has two thin black lines around the edge, framed by a turquoise band. Growing from the pointed base is a spray with three large rounded fruit or blossoms interspersed with leaves. A floral scroll, evolving from the lower left, encloses the spray. It bears an eight-petaled blossom, two large lotuses, and several trefoil buds amidst swirling branches and pointed leaves. The scroll's model can be traced to fourteenth-century blue-and-white Chinese wares.[1]

The combination of Chinese and local elements appears in a blue-and-white panel made for the *sabil* (fountain) of Qaitbay, now in the Museum of Islamic Art.[2] This panel, adorned with similar lotus blossoms, scrolling branches, and pointed leaves, bears the sultan's epigraphic blazon and dates from the second half of the fifteenth century.

Published
Carswell 1972a, pp. 104–6.

Notes
1. John Carswell has discovered many blue-and-white Chinese porcelains in Syria and is currently working on a publication describing these wares (Carswell 1972b).
2. Riefstahl 1937, fig. 26; Aly Bahgat and Massoul 1930, pl. 0:135.

90

Hexagonal tile with quiver
Underglaze painted in blue, black
Mid 15th century

Height: 19.0 cm. (7½ in.)
Width: 16.7 cm. (6⁹⁄₁₆ in.)

Damascus, National Museum, A7058
Found at Damascus, 1954

This and the following hexagonal tile were never mounted on a wall and, therefore, have clean edges and smooth backs. Both are enclosed by a black band and contain a central motif surrounded by a floral scroll.

In the center of this example is an unusual triangular object with a tassel attached to its base. The object is decorated with a braided border and has a scroll in the central field with a series of points extending from the upper edge. It most likely represents a quiver with arrows. A similar motif, identified as a rug, appears on a contemporary blue-and-white tile in Brussels.[1] In the Brussels example, the "quiver" is enclosed by sprays of crosshatched pomegranates.

Three sprays bearing lotus blossoms, buds, and leaves grow from the two lower sides and the upper left. The blossoms and buds are shaded; crosshatching fills the core of the lotuses. The scroll, similar to the previous example, is derived from Ming dynasty wares, although the central theme is of native origin.

Hexagonal tiles with blazons are not uncommon: an example in Cairo represents a stemmed cup amidst a floral scroll, symbolizing the office of the *saqi*.[2] The depiction of a quiver is unique; it is possible that this tile was made as part of a set with other tiles representing arms and armor requested by a patron, or perhaps it was a sample shown to customers.

Unpublished

Notes
1. Brussels 1976, fig. 74.
2. Carswell 1972a, pl. 12, no. c104.

91
Hexagonal tile with spike fiddle
Underglaze painted in blue, black
Mid 15th century

Height: 19.0 cm. (7½ in.)
Width: 16.7 cm. (6⁹⁄₁₆ in.)

Damascus, National Museum, A7057
Found at Damascus, 1954

Although this example and the one described earlier with quiver are similar in design, the execution of the scroll with lotus blossoms is slightly different. In this tile two scrolling branches evolve from the lower left and upper right and bear a pair of large stylized blossoms with crosshatched centers and shaded outer petals; the buds and leaves are also stylized and uniform in size. Obviously, it was painted by a different hand, probably in the same workshop.

The central motif is a string instrument with square body, long neck with three pegs, and elongated tailpiece terminating in a spike. This particular instrument, of Central Asian origin, is called *rabab* (spike fiddle); it has three strings and is played with a bow. It is still used today in parts of the Near East.

The representation of musical instruments is rare on Mamluk tiles. Only two other examples have been published: one depicts an oud or lute flanked by birds, and the other has an oud surrounded by floral sprays.[1]

Unpublished

Notes
1. The first tile is in London, Victoria and Albert Museum (Carswell 1972, pl. 3, no. 25). The second is in the American University of Beirut (MacKay 1951, pl. XVI, no. 9).

92
Bowl with fish
Molded; slip-painted; glazed in yellowish green
14th century

Height: 5.0 cm. (2 in.)
Diameter: 24.2 cm. ($9\frac{9}{16}$ in.)

London, The British Museum, 1928 7-21 6
Gift of H. Van den Bergh, 1928

The excavations in Egypt and Syria, more
specifically at Fustat and Hama, have unearthed
a vast amount of imitation celadon.[1] The shard
count at Fustat indicates that this type of ware
was produced in quantity, second only to incised
wares (nos. 93–95). Fustat excavations also show
that Chinese celadons were imported and easily
accessible as models for Mamluk potters.

This bowl was molded as well as slip-painted.
The six quatrefoil rosettes on the rim were painted
in slip as were the two fish, composed of roundels,
swimming in the center. The cavetto has molded
flutes. The bowl is glazed in finely crackled
yellowish green on the inside and outside.
The purple streaks seen in the cavetto were
formed by a concentration of copper used to
produce the greenish glaze. This type of cupric
efflorescence is also seen in Chinese celadon.

The bowl's shape with low foot, flaring sides,
and everted rim is Islamic and is seen in several
other fourteenth-century examples (nos. 69–73).
Its decoration and technique imitate the Yüan
period Lung-Ch'üan celadons, in which the motifs
were sprig-molded. The Islamic potter has used a
simpler method to create the same effect.

Yüan celadons were imitated in Iran as well as
in Egypt, and many examples reproduced the
popular theme of a pair of carp swimming in the
center of the bowl. A thematic variation was
frequently employed on Islamic metalwork with
rows of fish swimming in the bottom of brass
bowls and basins (nos. 20–21 and 26–29) and in
early Mamluk enameled and gilded glass (no. 48).

Published
Hobson 1932, p. 65 and fig. 77.

Notes
1. Riis and Poulsen 1957, figs. 353–54; Scanlon 1971, p. 230.

93
Bowl with napkin blazon
Incised through white engobe; slip-painted in
 dark brown; glazed in green, yellow
Mid 14th century

Height: 13.1 cm. ($5\frac{1}{8}$ in.)
Diameter: 21.6 cm. ($8\frac{1}{2}$ in.)

Cairo, Museum of Islamic Art, 5974
Purchased 1922

Inscriptions
Three panels on inside:

مما عمل برسم الامير ... العالى ... عز نصره

*One of the things made for the amir . . . the sublime
. . . may his victory be glorious.*

The most characteristic type of Mamluk pottery
made in Egypt is sgraffito or incised ware. These
wares have a red body covered with a whitish
engobe into which the design was incised. The
decoration recalls themes employed on metalwork
with inscription bands, medallions, and blazons.
The shapes of these ceramic wares are generally
restricted to large bowls and goblets. Incised
wares were extremely popular and were produced
in vast quantity in Egypt.

The inner walls of the bowl on display contain a
wide inscription band broken into three panels by
pear-shaped shields, which are divided into three
fields. The central field bears a *buqja*, napkin, the
blazon of the *jamdar*, master-of-the-robes.
The inscriptions in the three panels are badly
written and difficult to decipher; they seem to
bestow traditional benedictions to an unspecified
amir. Two bands enclose these panels: the upper
one decorated with roughly drawn scrolls, the
lower with a series of vertical strokes and s-shaped
curves. A six-petaled rosette appears in the center.

The interior is glazed in green, with a dark brown
slip applied to the central rosette and shields.
The exterior is unadorned and glazed in yellow.

A central rosette is frequently employed on
underglaze-painted wares (nos. 68, 73–75, and 85),
while the strokes and s-shaped scrolls often appear
on the exterior of fourteenth-century bowls (nos.
68 and 71–72). This incised bowl combines
techniques and compositions of metalwork with
certain motifs common to pottery.

The six-petaled rosette is thought to be an
imperial symbol associated with the house of
Qalawun (see also nos. 27 and 96). The three-
fielded shield with central blazon made its
appearance in the second quarter of the
fourteenth century and continued to be used up to
the end of Bahri Mamluk period. Although the
patron of this bowl is not known, he must have
been a *jamdar* in the court of Nasir al-Din
Muhammad (1293–1341, with interruption) or one
of his descendants.

Unpublished

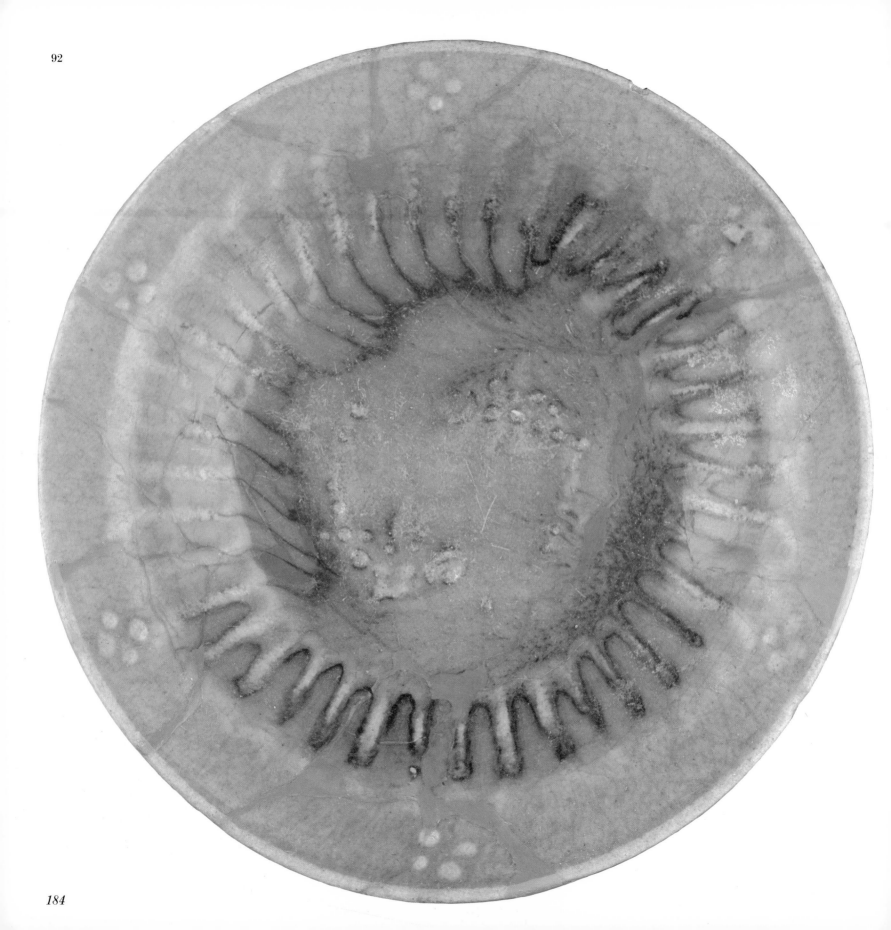

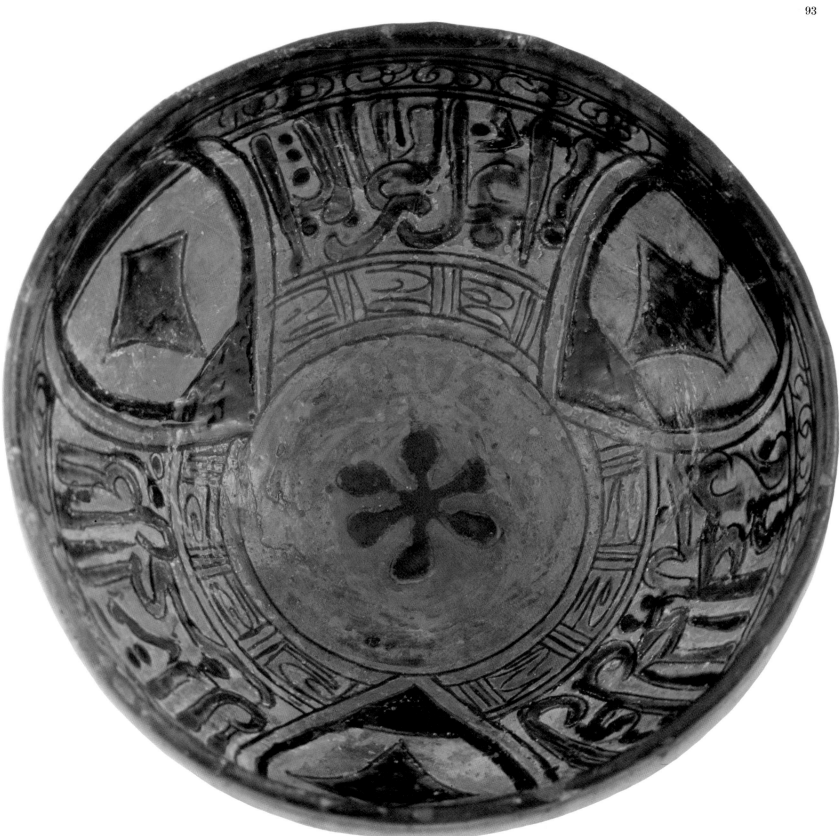

94
Bowl with sword blazon
Incised through white engobe; slip-painted in dark brown; glazed in yellow
Mid 14th century

Height: 24.5 cm. (9⅝ in.)
Diameter: 34.5 cm. (13 9/16 in.)

Cairo, Museum of Islamic Art, 23832
Found at Jabal Adda, Nubia, 1966

This high-footed bowl has a wide inscription panel on the inner walls.
The inscription is badly written and has not been deciphered; it appears to
have been executed by an illiterate craftsman who copied the letters without
knowing their meaning. Below the inscription is a chevron frieze followed by a
zigzag band. The center has a crudely drawn circular shield divided into three
fields; the central field represents a sword, the blazon of the *silahdar* (sword-
bearer). Marks of a three-footed sagger appear around the blazon.

The interior and the unadorned exterior are glazed in yellow; a dark brown
slip has been applied to the blazon, chevron frieze, and small dots between the
letters. The majority of incised Mamluk wares are glazed in brown, in shades
ranging from golden to chocolate. The next most popular glaze was green,
seen in the previous example.

Many of the incised wares contain blazons representing stemmed cups,
napkins, pen boxes, and swords (see no. 93). The inscriptions are often poorly
copied and difficult to read, suggesting that the pottery was mass-produced
without a specific client in mind. A few pieces bear the name Sharaf
al-Abawani, which may designate a particular workshop rather than an
individual artist (see no. 95).

Published
London 1976, no. 320.

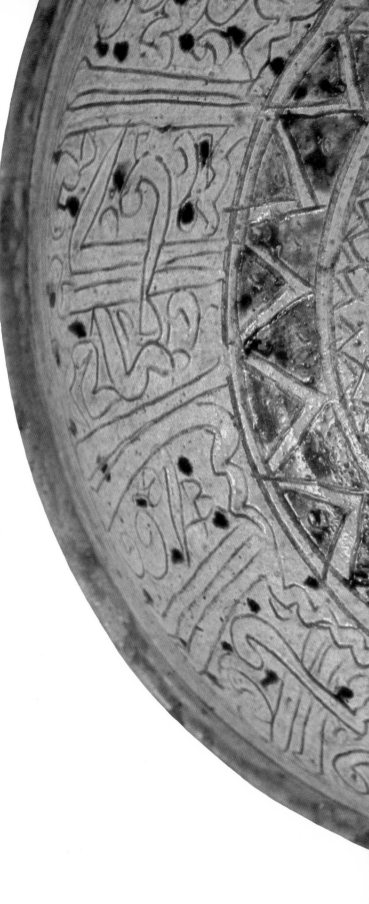

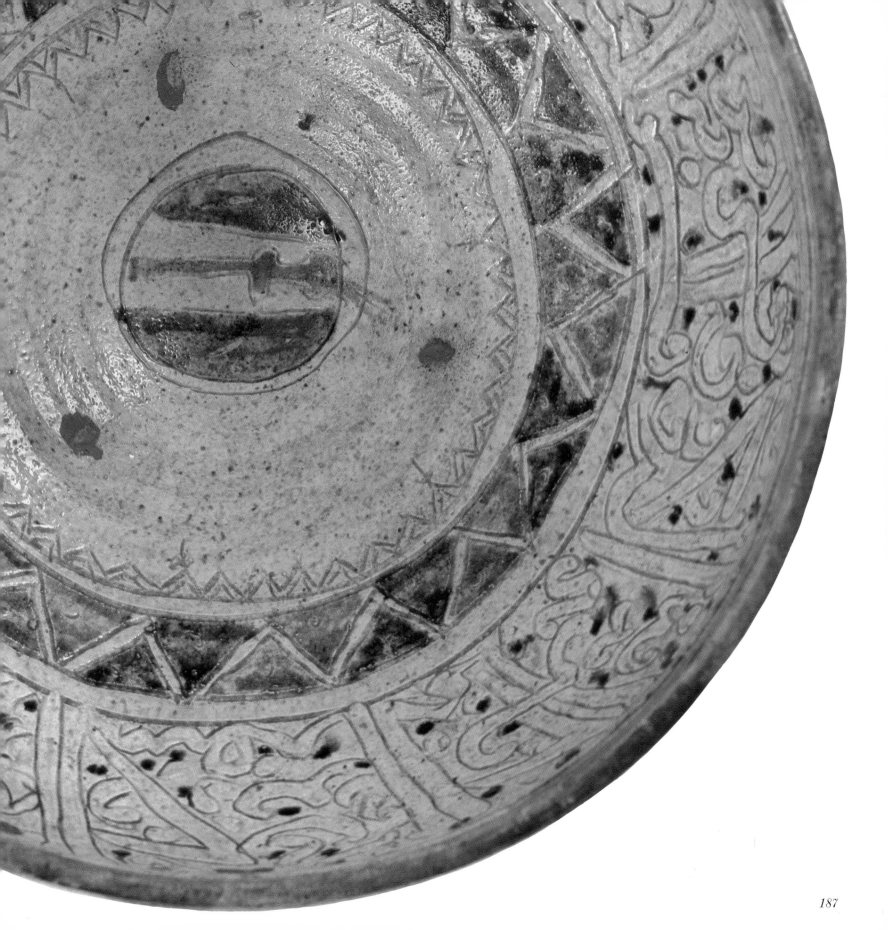

95
Goblet with trumpet blazon
Incised through white engobe; slip-painted in
 brownish red, dark brown; glazed in yellow
Mid 14th century
Made by Sharaf al-Abawani

Height: 17.2 cm. (6¾ in.)
Diameter: 25.4 cm. (10 in.)

Washington, D.C., Embassy of the Arab Republic
 of Egypt, 14922

Inscriptions
Band on exterior:

عمل العبد الفقير المسكين شرف الابوانى غلام الناسى
كلهم العز والفضل والاقبال

*Work of the poor miserable slave Sharaf
al-Abawani, servant of all the people, glory and
superabundance and prosperity.*

Band on interior:

مما عمل برسم ... العالى المولوى الاميرى الكبيرى
المخدومى المجاهدى المرابطى العز

*One of the things made for . . . the excellency, the
master, the great amir, the masterful, the defender
[of the faith], the warrior [of the frontiers], glory
[may his victory be glorious].*

This stemmed cup or goblet belongs to a unique group of Mamluk vessels that bear the name Sharaf al-Abawani. This name appears on a number of fragments found at Alexandria and Fustat, as well as on intact pieces in the Museum of Islamic Art, among which is an identical goblet.[1] A slightly larger example, bearing the same signature, was recently discovered at Luxor.[2]

The chalice-shaped goblet has a high splayed foot with straight sides widening at the rim. A series of incised lines divide the exterior into three horizontal zones. The upper band contains an inscription incised and slip-painted in brownish red; the ground is sparsely decorated with yellow strokes and dots. The middle band is blank, and the last register is decorated with red and brown angular s-shaped motifs.

The interior reveals a similar tripartite layout designated by incised lines: red and brown s-shaped motifs appear on the upper zone, followed by an inscription rendered in red, with brown used in the background motifs; the lowest register has a pair of scalloped lines. The bottom of the goblet contains a circular shield with three bars: the upper and lower fields are painted brown, while a brown trumpet on a red field appears in the center; the shield is enclosed by a wide red band.

The exterior and interior design of the goblet is identical to the examples from Cairo and Luxor. All three pieces have similar inscriptions and crude decorations. The trumpet blazon on this piece is rare and may represent one of the members of the *tablakhana* (imperial military band). It also appears on a fragment of a footring from a similar type of ware.[3] The office of the *tablakhana* does not seem to have an established sign and was at times represented by a drum or possibly a stringed instrument (see no. 91). Drums and trumpets were the two major instruments of the military band and are represented on illustrated manuscripts, including the 1315 copy of al-Jazari's *Automata* (no. I, fig. 1).

The maker of this goblet, Sharaf al-Abawani, must have had a large workshop, which supplied the lesser amirs with ceramic vessels bearing their blazons. These goblets appear to have been mass-produced with predetermined designs and inscriptions; the only variation is seen in the blazons, which may have been added when the pieces were commissioned.

Published
Embassy 1954. pp. 18–19.

Notes
1. Fragments found near Alexandria are now in Alexandria, Faculty of Fine Arts (Marzouk 1957); the Fustat finds are in Cairo, Museum of Islamic Art (Abd al-Raziq 1966).
2. Luxor 1979, no. 325.
3. Meinecke 1972, pl. LIXe.

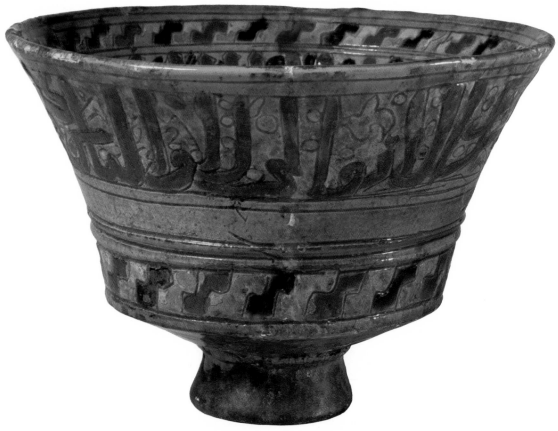

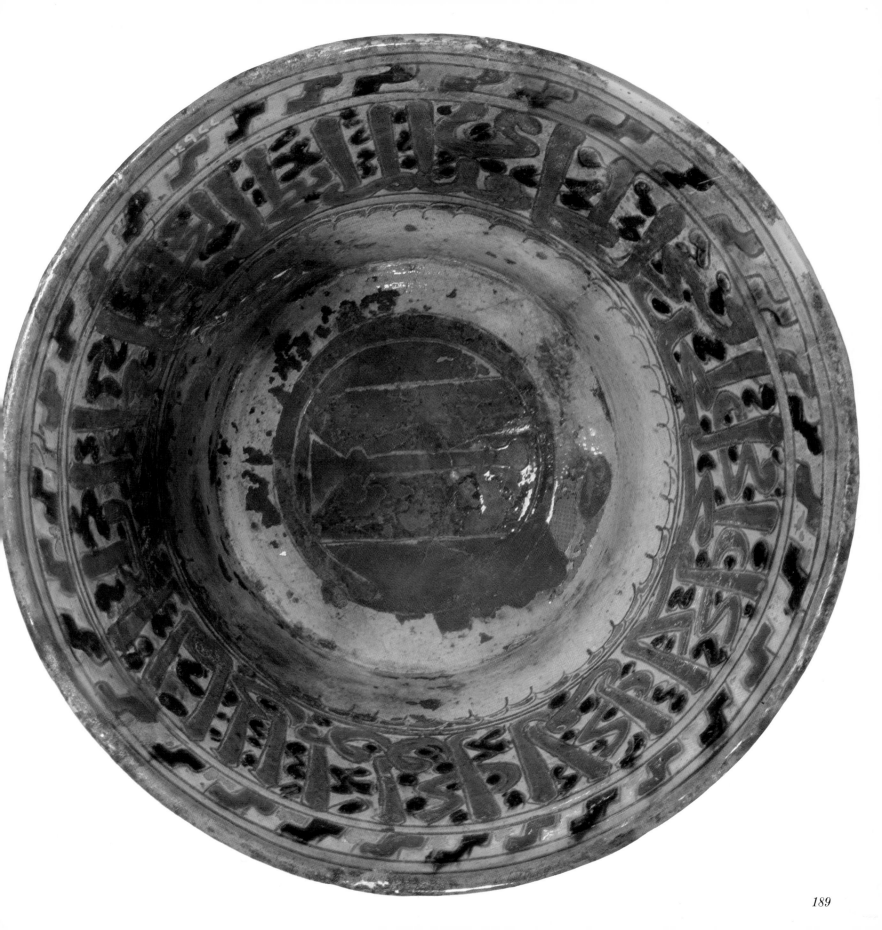

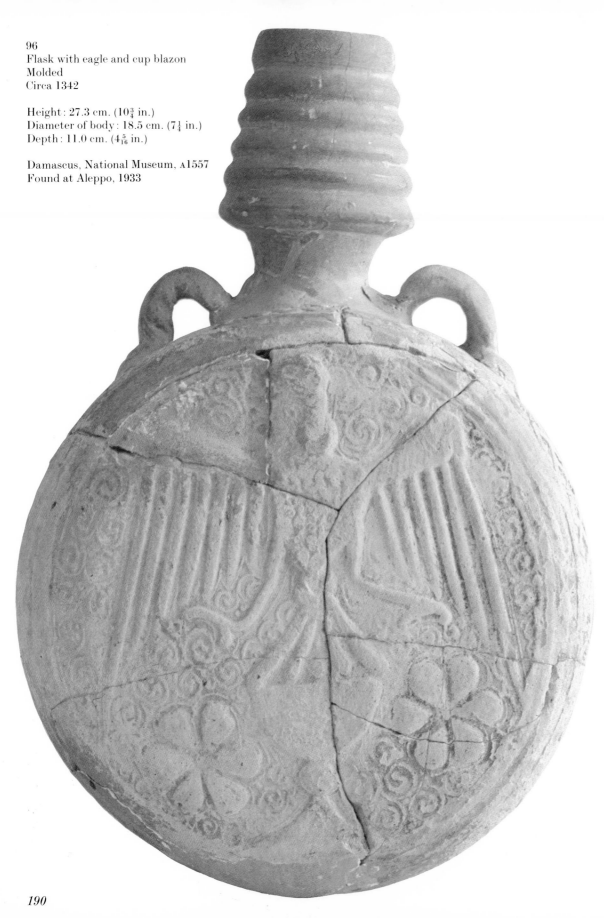

96
Flask with eagle and cup blazon
Molded
Circa 1342

Height: 27.3 cm. (10¾ in.)
Diameter of body: 18.5 cm. (7¼ in.)
Depth: 11.0 cm. (4⁵⁄₁₆ in.)

Damascus, National Museum, A1557
Found at Aleppo, 1933

Although underglaze-painted wares appear to have been produced throughout the Mamluk world, certain types of pottery were more or less restricted either to Egypt or Syria. For example, luster-painted wares were made in Syria (no. 84), while imitation celadon and incised and slip-painted pottery were generally limited to Egypt (nos. 92–95). Unglazed molded wares, shaped as canteens or pilgrim flasks, seem to have been a specialty of the Syrian potters.[1]

These flasks share a common shape: a globular body with flattened sides, straight neck, and two handles attached to the shoulders. The fabric is off white and the decoration is molded. The flasks are unglazed, which allows water to evaporate slowly through the porous body, thus enabling the contents to remain cool for some time.

These functional canteens were an essential part of military gear since amirs and soldiers needed to carry water on strenuous marches through arid zones. Many of them, similar to the example on display, contain the owner's blazon.

The Damascus flask represents an eagle with outstretched wings standing above a stemmed cup. The background is covered with scrollwork and two large six-petaled rosettes appear on either side of the goblet. The curving shoulders of the piece are embellished with braids. Although the same mold was used on both sides, one of the impressions is slightly off center.

The composite blazon with eagle placed over a cup belonged to Amir Toquztimur, who was governor of Hama in 1341. The following year he became governor of Aleppo and was viceroy of Damascus until his death in 1345. He was the *saqi* of Sultan Nasir al-Din Muhammad, whose own blazon was the eagle. Toquztimur's emblem also appears on a basin commissioned by his majordomo, Qushtimur (no. 27). The six-petaled rosette is thought to be a symbol associated with the house of Sultan Qalawun, the father of Nasir al-Din Muhammad (see also no. 93). Its appearance on the Damascus flask may be either symbolic or purely decorative; Amir Toquztimur might have desired to honor the celebrated dynasty of Qalawun as well as his master, Sultan Nasir al-Din Muhammad, whose blazon, the eagle, he has incorporated with the sign of his office, the cup.

Toquztimur's flask has been broken and repaired; the neck and handles are the result of a later restoration.

Published
Damascus 1976, p. 240, vitrine 3 and fig. 135.

Notes
1. Sarre 1925; Sauvaget 1932; Riis and Poulsen 1957, pp. 248–58.

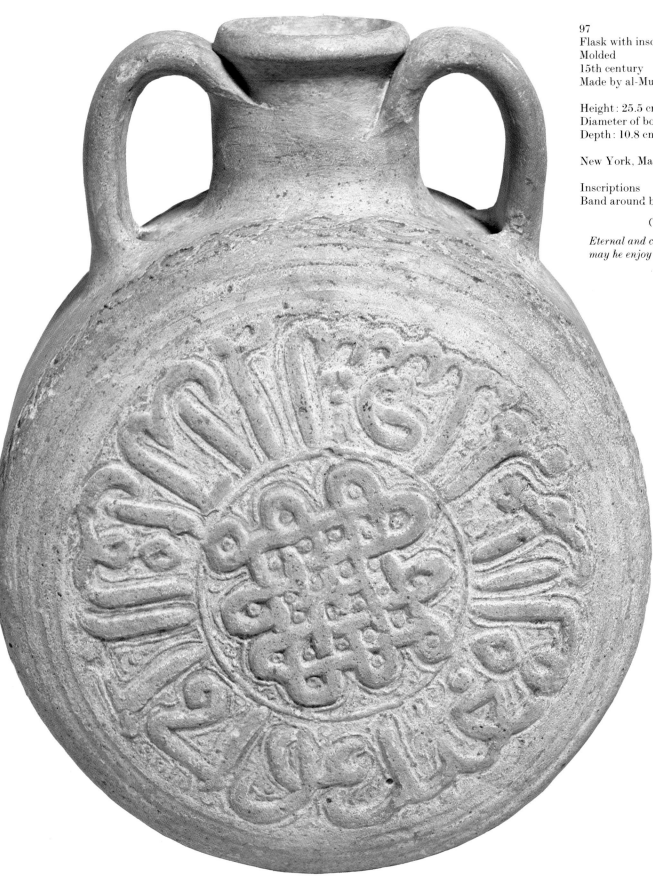

97
Flask with inscriptions
Molded
15th century
Made by al-Mufid

Height: 25.5 cm. (10 in.)
Diameter of body: 20.0 cm. (7⅞ in.)
Depth: 10.8 cm. (4¼ in.)

New York, Madina Collection, c28

Inscriptions
Band around body:

العز الدائم والشامل عمل المفيد عوافى له (؟)

*Eternal and complete glory. Made by al-Mufid,
may he enjoy good health.*

This flask, identical in shape
and technique to the previous
example (no. 96), is decorated
with an inscription band
encircling a central medallion
with an elaborate knot.
The inscription is placed on a
scroll ground and minute dots
appear between the coils of the
central knot. The curving
shoulders are embellished with
a loosely executed scroll.
The same concave mold was
applied to both sides of the
piece.

Although blazons, floral and
geometric decorations, and
animal figures are common to
these flasks, inscriptions with
the name of the maker are rare.
Among the unglazed wares
found at Hama are four
fragmentary flasks signed by
al-Afif; the same name appears
on two intact pieces in London.[1]
Another unglazed canteen was
made by Ali al-Himsi.[2] Similar
flasks with inscriptions were
excavated at Baalbek, some of
which have blazons, floral
motifs, and knotted designs.[3]

Unpublished

Notes
1. For pieces inscribed with al-Afif's
 name see Riis and Poulsen 1957,
 p. 297, nos. 8, 10–11, and 13, fig. 1111.
 The same inscription appears on a
 bottle from Hama in London, British
 Museum; and on another piece from
 Aleppo in London, Victoria and Albert
 Museum (Riis and Poulsen 1957,
 p. 297, no. 10).
2. For Ali al-Himsi's flask see Riis and
 Poulsen 1957, p. 297, no. 14.
3. Sarre 1925, pp. 7–11.

98
Small bowl with floral spray
Slip-painted in white; glazed in brown
15th century

Height: 6.3 cm. (2½ in.)
Diameter: 18.1 cm. (7⅛ in.)

Cairo, Museum of Islamic Art, 23438
Found at Fustat, 1966

Slip-painted Mamluk wares
produced in Egypt have a red
body as do the incised
examples: they are often
painted in white slip and
covered with a yellowish brown
glaze. There are also examples
painted with colored slips and
glazed in green, brown, and
manganese purple.

This bowl is slip-painted in
white and glazed in brown,
which appears yellowish on the
white slip and dark brown over
the red body. Nine roughly
drawn scallops adorn the rim, a
cluster of leaves appears in the
center. The design is rapidly
executed, and one leaf with a
pointed lobe hangs down
toward the cluster. Its free
drawing recalls contemporary
blue-and-white tiles (nos.
86–87).

This bowl represents a rare
type of local pottery, some
examples of which were
painted with a thick slip,
thereby creating a relief
effect not unlike the
imitations of molded celadon.

Unpublished

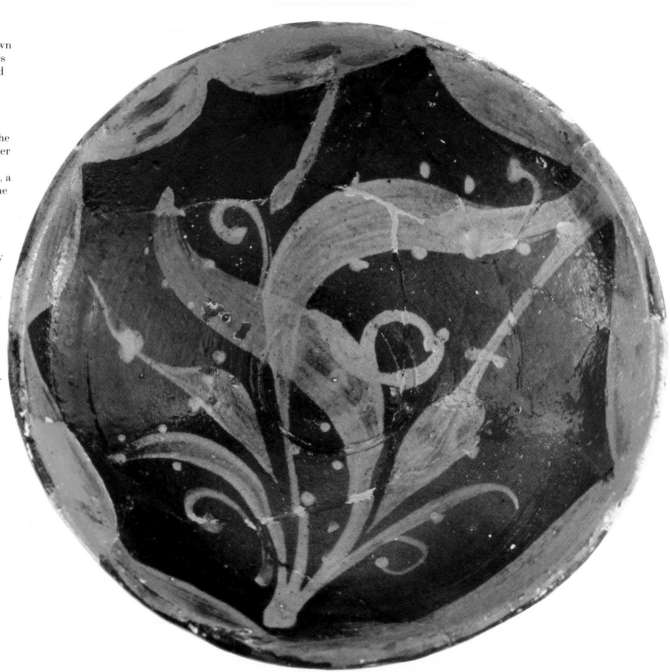

WOODWORK, IVORY, AND STONE

Carved, inlaid, or painted wood and stone are essential elements of Mamluk architectural decoration. To appreciate the harmonious blend of diverse materials and decorative techniques, one must see the decoration in situ within a single structure. With the exception of two objects, an ivory box and a marble jar (nos. 106 and 112), the examples of woodwork, ivory, and stone included in this chapter have been removed from their original environment and provide only a glimpse into the incredible richness found in Mamluk architecture.

Mamluk buildings in Cairo and other major centers have a majestic appearance, whether they are squeezed into irregular lots in a crowded metropolis, spread over and around spacious city squares, or erected in the so-called cemeteries outside the capital. These cemeteries to the north and south of Cairo are in effect miniature cities in which the sultans and amirs built elaborate complexes surrounding their mausoleums. The dedication of such complexes, both in the capital and provinces, served as an excuse to commemorate the donor. The tombs were surrounded by mosques, madrasas, and *khanqas* (Sufi monasteries), which provided facilities for praying, teaching, and housing, assuring a perpetual flow of people who were constantly reminded of the donor's piety and generosity. Other structures, either attached to the complex or conceived as independent units, included fountains (at times combined with schools), hospitals, baths, inns, and markets. The religious and charitable complexes were provided with waqfs (endowments) to support their activities and maintenance through revenues provided by commercial establishments such as *khans* (markets) and *wakalas* (inns). In addition to these religious, charitable, and commercial edifices, the Mamluks built gates and fortresses, bridges and aqueducts, palaces and mansions, administrative headquarters and military barracks.

Their energetic building activities transformed Cairo into a Mamluk city, in which more than 200 Bahri and Burji period structures are still in existence. Aleppo, Damascus, Jerusalem, and other commercial and administrative centers were provided with religious, residential, and military complexes. The preoccupation with erecting new buildings by the ruling class continued under the Ottoman governors, enabling Mamluk traditions to remain alive.

Whether religious or secular, all Mamluk buildings were invariably enriched with stone, wood, stucco, metal, and glass decoration. Stoneworkers carved entrance facades, domes, and minarets; embellished portals and windows; made screens, minbars (pulpits), and mihrabs; and set colored marble into walls, pavements, and fountains. Woodworkers produced doors, window shutters, and intricate screens called *mashrabiyyas*; made cenotaphs, mihrabs, and cupboards; coffered ceilings and domes with *muqarnas* (stalactite) zones of transition, which were subsequently gilded and painted; and designed minbars, *kursis* (lecterns), Koran boxes, and tables inlaid with different woods, ivory, and mother-of-pearl. Stucco workers embellished facades and mihrabs and carved delicate friezes to adorn the interior walls of the chambers. Metalworkers fashioned massive doors, window grilles, and finials on domes and minarets, as well as many furnishings for the buildings. Glassmakers supplied stained-glass panels for windows and made colored and gilt tesserae for mosaics.

Woodwork and Ivory

Carved wood cenotaphs, mihrabs, minbars, screens, doors, and shutters were already employed in Ayyubid structures dating from the first half of the thirteenth century. These furnishings were often decorated with stars and polygons made of different types of wood laid in panels. Among the renowned examples of Ayyubid woodwork are the doors of the mausoleum of Imam al-Shafi in Cairo, which bear the date 1211 and the cenotaph from the same structure.[1]

Mamluk woodworkers continued this tradition, but generally added ivory inlays to the different woods. Individually carved pieces of ivory and rare woods, such as ebony and redwood, were used to construct panels for doors, minbars, and other structures. This elaborate method of production is represented by a panel made of different woods and ivory, each polygonal segment cut and carved separately, then assembled like a mosaic panel with thin strips of ivory employed to outline and define the different elements (no. 99). Compositions were based on geometric patterns that evolve from a central star with six to sixteen points, forming a series of radiating polygons expanding from the core. This type of astral format was fully developed by the early fourteenth century, as observed in manuscript illumination (see nos. 3–4), and became the characteristic design of woodwork and inlaid stone until the end of the Mamluk period.

Wood panels were used in the construction of minbars, which were impressive structures, some as high as 7.5 meters (24 feet).[2] The Mamluk minbar has a portal with a cornice; double doors open to a staircase flanked by balustrades; steps lead to a high platform that is enclosed on three sides and crowned with a second cornice; surmounting the structure is a bulbous dome with a finial. The space below the platform was used as a cupboard, accessible through doors opening from both sides.

Among the earliest Mamluk minbars are those in the mosques of Ahmad ibn Tulun and al-Salih Talai, which date from the late 1290s when Sultan Lajin restored Tulunid and Fatimid buildings. A later example, now in the Museum of Islamic Art in Cairo, was made around 1360 for the mosque of Tatar al-Hijaziyya, daughter of Sultan Nasir al-Din Muhammad. This fine specimen is decorated with *mashrabiyya* panels and ebony and ivory inlays.[3] Several Mamluk minbars remain in situ, including the ones made for the mosque of Sultan Shaykh, called al-Muayyid (1415–20), the *khanqa* of Barsbay (1432), and the mausoleum of Qaitbay (1472–74). The latter is a masterpiece of Mamluk woodwork and possibly one of the last examples to use ivory inlays. The minbar made for the mosque of one of Qaitbay's amirs, Qajmas al-Ishaqi, in 1480/81, employs bone instead of ivory, reflecting

current economic crises, which prohibited the use of expensive materials. A similar development was observed in the production of contemporary metalwork that was devoid of silver and gold inlays.

The minbar was the most impressive item of furniture in Mamluk buildings. Attesting to the importance given to these structures, several bear the names of their makers. The earliest signed example was commissioned in 1267/68 by Baybars I for the Mosque of Medina. This structure, made by Abu Bakr ibn Yusuf, stood for 130 years and was later replaced by Barquq.[4] The name Muhammad ibn Ali al-Mawsili is found on the minbar in the Great Mosque of Aleppo, which contains two inscriptions: one gives the name of Qarasungur al-Jukandar, "al-Maliki al-Mansuri," while the other contains the name of Sultan Nasir al-Din Muhammad.[5] The minbar of Qarasungur, the governor of Aleppo in 1282–90, must have been commissioned during the reign of Sultan Qalawun, whose titles included "al-Mansur," and completed after the accession of his son, that is, after 1293.

Among the early fourteenth-century woodcarvers known by their signed works are Ali ibn Makki and Abdallah Ahmad, who in 1302 made the minbar for the Great Mosque of Hama.[6] This example, commissioned by Kitbugha, was inlaid by Abu Bakr ibn Muhammad and decorated by Ali ibn Uthman, revealing joint efforts of several artists. Other fourteenth-century artists include Muhammad al-Safadi, who made the minbar for Taynal Mosque in Tripoli in 1336; and Ahmad ibn Yusuf, whose minbar executed in 1370 for Sidi Abdallah al-Shafi Mosque (called Masjid Abu'l-Maati) in Damietta is now in the Museum of Islamic Art.[7]

The name of a fifteenth-century woodcarver named Ahmad ibn Isa (circa 1417–92) appears on two minbars: the first was made around 1446 for al-Ghambi Mosque and was later transferred to the madrasa of Barsbay; the second was produced in 1480/81 for al-Mazhariyya Madrasa. Ahmad ibn Isa is thought to have also made the minbar sent to Mecca in 1462 by Sultan Khushqadam as well as the one donated there in 1475 by Sultan Qaitbay.[8] Another late-fifteenth-century woodcarver was Ali ibn Tanin, who executed a minbar for the mosque built in 1485 by Shaykh Abu Ali.[9]

The geometric compositions used in the panels of these minbars are also found on cupboards, doors, window shutters, and *kursis*. Mamluk *kursis* were made to hold the giant Korans of the fourteenth and fifteenth centuries. They consisted of high rectangular platforms with a v-shaped unit on the top. The reciter sat crosslegged on the platform, while the Koran was cradled in the specially designed stand. Among the most beautiful *kursis* are those in Sultan Hasan's complex built between 1356 and 1362 and in Sultan Qaitbay's mausoleum.

A related piece of furniture was the *rahle*, a collapsible bookstand for smaller volumes. An example in the Louvre, inlaid with ivory and different woods, bears a composite blazon consisting of a pen box in the upper field, a cup with a sword in the middle, and a second cup below.[10] The same combination of charges appears on the inlaid wood minbar in

the madrasa built in 1478 by Janem al-Bahlawan, who was formerly in the service of Sultan Jaqmaq.[11]

A different type of furniture, also called *kursi*, is a tall hexagonal table resting on six feet. It is similar in size and shape to the famous metal example made for Sultan Nasir al-Din Muhammad in 1327. One such wood table—inlaid with ivory, bone, redwood, and ebony—was made for a madrasa completed in 1368/69 for Khwand Baraka, the mother of Shaban II.[12] The same type of marquetry or inlay work is found in a hexagonal thirty-volume Koran box designed for the same madrasa.[13] Another beautiful woodwork is a cupboard made for Sultan Barquq around 1390 and inlaid with ebony and ivory.[14]

Screens for windows and entrances, called *mashrabiyyas*, were a specialty of Mamluk woodworkers. These intricate grilles were constructed of individually turned and carved units fitted together to create a lattice (no. 100). They provided privacy and shade and served as decorative accents in religious and secular buildings. In religious structures, the *mashrabiyya* was used to partition sepulchral chambers and prayer areas and to enclose the cenotaphs. Among the earliest and most beautiful screens are those in the madrasa and mausoleum of Qalawun, dated 1284–85, in which the *mashrabiyyas* are used in the entrance to the tomb chamber and around the cenotaph. The best fourteenth-century examples are found in the reception hall of the palace built in 1334–39 by Amir Bashtaq, a son-in-law of Sultan Nasir al-Din Muhammad; between the court and sanctuary of the mosque built in 1339–49 by Amir Altunbugha al-Maridani, the cup-bearer and another son-in-law of the same sultan; and around the cenotaph in the complex of Sultan Hasan. Among the most interesting *mashrabiyyas* found in the complex of Sultan Hasan is a panel representing the interior of a mosque with a minbar and hanging lamp.[15]

The fabrication of *mashrabiyyas* continued into the Burji period as exemplified by those used in the entrance to the tomb chambers in the *khanqa* of Sultan Faraj (1400–1411) and in various *wakalas*, *sabil-kuttabs* (two story-structures with a public fountain on the ground floor and a religious school above), and houses dating from the late fifteenth and early sixteenth centuries. In addition to these religious structures, almost all residential buildings had wood screens installed in cantilevered windows, which not only enabled the residents to look out without being seen but also permitted air to circulate after being cooled by containers filled with water placed on the window sills. These functional and attractive screens continued to be produced for Egyptian and Syrian houses up to the twentieth century.

Some Mamluk structures had gilded and painted wood paneling on the walls and ceilings as well as carved plaques depicting the owner's blazon (no. 101). A unique example from Dumbarton Oaks in Washington, D.C., indicates that Mamluk artists also made carved and painted panels depicting Biblical scenes for the altars of Coptic churches (no. 102). Although only one panel appears to have survived, its refined execution demonstrates the technical expertise of Mamluk woodworkers. Its model, either another scene in carved wood or a painting, no longer exists, and this panel is the only surviving example of figural composition in woodwork.

Mamluk woodworkers also produced a series of bowls that were incised and painted in polychrome colors. The earliest example, found in 1966 at Qus together with several pieces of metalwork and glass (see nos. 28 and 49), is a large bowl, now in the Museum of Islamic Art. A fragment of a similar example was discovered at Fustat, and the Quseir excavations have unearthed a portion of a bowl and a lid.[16] The shape and decorative repertoire of these bowls resemble metalwork; the lid found at Quseir suggests that at least some had covers, recalling those made in purple glass embedded with opaque white threads.[17] Although these wood vessels have not been thoroughly studied, they are thought to have been made in the fourteenth or fifteenth century.

Another group of covered containers was executed in ivory and adorned with inscriptions and latticework. Four of these boxes, in the British Museum and Victoria and Albert Museum in London (no. 106) and formerly in the Rothschild Collection, are almost identical. They have a cylindrical body pierced with latticework and enclosed at the top and bottom by scalloped bands; an inscription panel encircles the lid or the base.[18] The Rothschild box has a flat lid with a central knob and an inscription around the edge, which bears the name of Sultan Salih, indicating that it was made between 1351 and 1354. A mid-fourteenth-century date is also suggested for similar boxes with lids attached by metal mounts; some have braided and beaded bands in addition to inscription and latticework.[19] The sudden appearance and short lifespan of this kind of ivory container are as puzzling as the purpose of the pierced decoration encircling the body. They may have been made as containers for some precious item, possibly an aromatic substance, such as myrrh or perfumed oil, which were fashionable at the court in the middle of the fourteenth century.

In the Mamluk period ivory was frequently used in combination with wood, inlaid either as oblong plaques or as stars and polygons (see nos. 103–5). One oblong piece is carved in two superimposed layers; the central medallion bears a cross, suggesting that it may have belonged to a panel made for a Christian establishment (no. 103). Rectangular plaques were employed in both religious and residential buildings and decorated with dense arabesques or inscriptions containing good wishes, poetic sentiments, or names of patrons (no. 105). Stars and polygons inlaid into woodwork were adorned with floral arabesques and blossoms framed by thin strips of ivory (see no. 104).[20] A few ivory plaques made in the second half of the thirteenth century are decorated with humans and animals, following the figural style of the age,[21] while later examples show a predominance of floral arabesques.

Inlaid and Carved Stone

Mosaics composed of colored- and gilt-glass tesserae and panels inlaid with different stones and mother-of-pearl were among the popular forms of architectural decoration in the Bahri period. The Mamluks revived the tradition of glass mosaic, which was employed on the earliest Islamic structures, such as the Dome of the Rock in Jerusalem, dated 691, and the Great Mosque of Damascus, constructed around 711. The restoration of these buildings by Baybars I may have provided both stimulus and experience for Mamluk artists who used similar materials and techniques to reproduce the decorative themes.

The earliest example of Mamluk glass mosaic appears in the semidome of the mihrab in the mausoleum of Shajar al-Durr in Cairo, completed in 1250.[22] The most notable mosaics are found in the spectacular mausoleum of Baybars I built in 1277 in Damascus. This structure is embellished with the luxurious vegetation and acanthus scrolls found in the original mosaics of the Dome of the Rock in Jerusalem and the Great Mosque of Damascus.[23] The same technique was used in the decoration of the semidome of the mihrabs in the madrasa and mausoleum of Qalawun built in Cairo a few years later.[24]

Qalawun's complex also exhibits the first extensive use of marble paneling. These panels, applied to the mihrab and walls, utilize geometric patterns with stars and polygons, arcades filled with stars and crosses, and kufic inscriptions.[25] The *maristan* or hospital originally a part of the same complex is no longer in existence, but its marble paneling and glass mosaics must have been as dazzling as those in the remaining structures.

Although marble paneling was employed throughout the Mamluk period, the renaissance of glass mosaic was rather brief. Glass-mosaic decoration appears in the semidome of the mihrab of the mosque of Ahmad ibn Tulun, which was restored in 1296 by Sultan Lajin;[26] in the madrasa of Amir Taybars, called the Tabarsiyya, dated 1309/10;[27] in the madrasa of Aqbugha, built between 1333/34 and 1339;[28] and in the mosque of Sitt Miska, finished in 1339/40. This technique is not seen after the middle of the fourteenth century.

Marble paneling, first used in the late Ayyubid period (for example, in the mid-thirteenth-century mausoleums of Najm al-Din Ayyub and Shajar al-Durr),[29] became the main decorative feature of Mamluk architecture after 1300. It was used primarily to emphasize the mihrab and *qibla* wall, which indicates the direction of Mecca toward which the faithful pray.[30] Among the finest marble paneled mihrabs and *qibla* walls are those in the mausoleum of Salar (1303/4), the *khanqa* of Baybars (1306–10), the madrasa of Amir Taybars, the mosque of Amir Almas (1329/30), the mosque of Amir Altunbugha al-Maridani, the complex of Sultan Hasan, and the mosque of Sultan Shaykh. The panels in Sultan Barsbay's *khanqa* are remarkable in that they revive marble and mother-of-pearl decorations made 150 years earlier for the complex of Qalawun (no. 107).

The technique of marble paneling degenerated toward the end of the

Mamluk period, as seen in the mosque of Amir Qajmas al-Ishaqi in which black bitumen and red paste were applied to the white marble mihrab in an attempt to simulate colored inlays. This building also bears the name of the decorator, Abd al-Qadir al-Naqqash, who was obviously proud of his work despite its lack of expensive materials.

Marble inlays were also used in the pavements of Mamluk buildings, some of which had carved fountains in the middle of the courtyards. One of the most elaborate fountains, now in the Museum of Islamic Art, is thought to have come from the palace of Amir Bashtak.

The portals of Mamluk buildings were embellished with dedicatory inscriptions bearing the names of donors as well as their blazons, which were often painted in specific colors. The blazons represented a variety of emblems, including heraldic animals, signs of office, and epigraphy. The lion was used by Baybars I on all his structures, objects, and coins (see no. 108); the cup identified the office of the *saqi* or cup-bearer (no. 109); and the epigraphic blazon, which made its appearance in the second quarter of the fifteenth century, was exclusive to the sultans (no. 110).

Carved and painted stone plaques also served as tombstones and wall revetments. The richest group of decorative slabs was made for the madrasa of Sarghithmish, the *jamdar* or master-of-the-robes of Sultan Hasan. The panels in this building, which was completed in 1356, have unusual designs representing scrolling vines with bunches of grapes, mosque lamps, candlesticks, and, curiously, a human hand. Several detached panels with similar decorations are owned by the Museum of Islamic Art.[31] One depicts a mihrab with a pair of candlesticks and a hanging lamp inscribed with the Ayat al-Nur, Verse of Light (no. 111).

Among the rarer examples of Mamluk stonecarving is a pierced screen embellished with vines and grapes in the mausoleum of Salar and the remarkable stone minbar donated in 1483 by Qaitbay to the *khanqa* of Faraj.

Mamluk stonecarvers also made large marble jars with ovoid bases that originally had special stands. One of the earliest jars was made for the mosque of Tatar al-Hijaziyya.[32] This example, decorated with an overall floral arabesque, is perhaps the most striking of all Mamluk jars. Water jars were commissioned by Qaitbay, whose name appears on three identical pieces (see no. 112).[33]

Of all the Mamluk artistic traditions, only those of the stonecarver and woodworker have withstood the passage of time and change in taste. The Mamluk decorative vocabulary was never totally abandoned; architecture produced during the Ottoman period relied heavily on themes employed in the past. At the end of the nineteenth century there was a renewed interest in Mamluk designs both in the Near East and in the West. In Europe, Mamluk themes, popularly called ''Moorish,'' were applied to interior decoration and accessories. The same fashion appeared in the Ottoman world, as exemplified by one of the suites in the Şale Köşkü at the Yıldız Palace complex in İstanbul. The suite is decorated in typical fourteenth-century Mamluk style, its ceiling adorned with polygons radiating from astral units, its walls lined with cupboards embellished with mother-of-pearl.

Perhaps the greatest homage paid to the artistic tradition of the past appears in the decoration of the Rifai Mosque built in Cairo in the early part of the twentieth century. This structure, erected across the street from the complex of Sultan Hasan, clearly imitates the architectural splendor of the Bahri period.

Notes

1. The doors are still in situ (Creswell 1959, pl. 24c); the cenotaph has been moved to Cairo, Museum of Islamic Art, 409 (Wiet 1930, no. 30).
2. One such example is the minbar made for Sultan Qaitbay, now in London, Victoria and Albert Museum, 1050–1869.
3. Cairo, Museum of Islamic Art, 1080 (Cairo 1969, no. 231).
4. Mayer 1958, p. 25.
5. Mayer 1958, p. 55.
6. Mayer 1958, p. 34.
7. Mayer 1958, pp. 32 and 58.
8. Mayer 1958, pp. 29–30.
9. Mayer 1958, p. 36.
10. Paris, Louvre, 4063 (Paris 1977, no. 225).
11. This amir's blazon is discussed in Meinecke 1972, p. 270, fig. 9:47 and pl. LXVIf.
12. Cairo, Museum of Islamic Art, 449 (Wiet 1930, no. 34; Cairo 1969, no. 235).
13. Cairo, Museum of Islamic Art, 452 (Herz 1907, fig. 32; Cairo 1969, no. 236).
14. Cairo, Museum of Islamic Art, 23767 (Cairo 1969, no. 233).
15. Cairo, Museum of Islamic Art, 526 (London 1976, no. 455).
16. Whitcomb and Johnson 1979, pp. 215–18, figs. 25–26.
17. One of these pieces is in New York, Metropolitan Museum of Art, 26.77 (Metropolitan 1975).
18. London, British Museum, 74 3-2 5 (Migeon 1907, fig. 120) and 91 6-23 8, with lid (Dalton 1909, no. 568); and Rothschild Collection (Migeon 1903, pl. 8). A fifth example was in an auction in Paris (Palais d'Orsay 1979, no. 69).
19. These are in the Cathedral of Saragossa (Madrid 1893, pl. XXXXVII); Peytel Collection (Migeon 1903, pl. 7); Cathedral of Sens (mentioned in Longhurst 1927, p. 60); and London, Victoria and Albert Museum, A68-1923.
20. Paris, Louvre, 7161 and 7460 (Paris 1977, no. 82); Baltimore, Walters Art Gallery (Welch 1979, no. 25).
21. These are extremely rare and include the panels on the doors of a cupboard in Cairo, Coptic Museum, and another door in a private collection.
22. Creswell 1959, pls. 42a–b; Meinecke 1971, pl. IIIa.
23. Meinecke 1971, pp. 63–67, pls. V–VI.
24. Meinecke 1971, pls. IIa–b and IIId.
25. Meinecke 1971.
26. Creswell 1959, pl. 81b.
27. Creswell 1959, pls. 99a and 113b.
28. Meinecke 1973, pl. XIb.
29. Meinecke 1971, pls. IIc and IIIb.
30. For the chronological sequence of Mamluk mihrabs see Creswell 1959, pls. 106–14.
31. Cairo, Museum of Islamic Art, 2785 and 12752 (Cairo 1969, nos. 99 and 201).
32. Cairo, Museum of Islamic Art, 34 (Wiet 1930, no. 12; Cairo 1969, no. 202).
33. Herz 1907, p. 47.

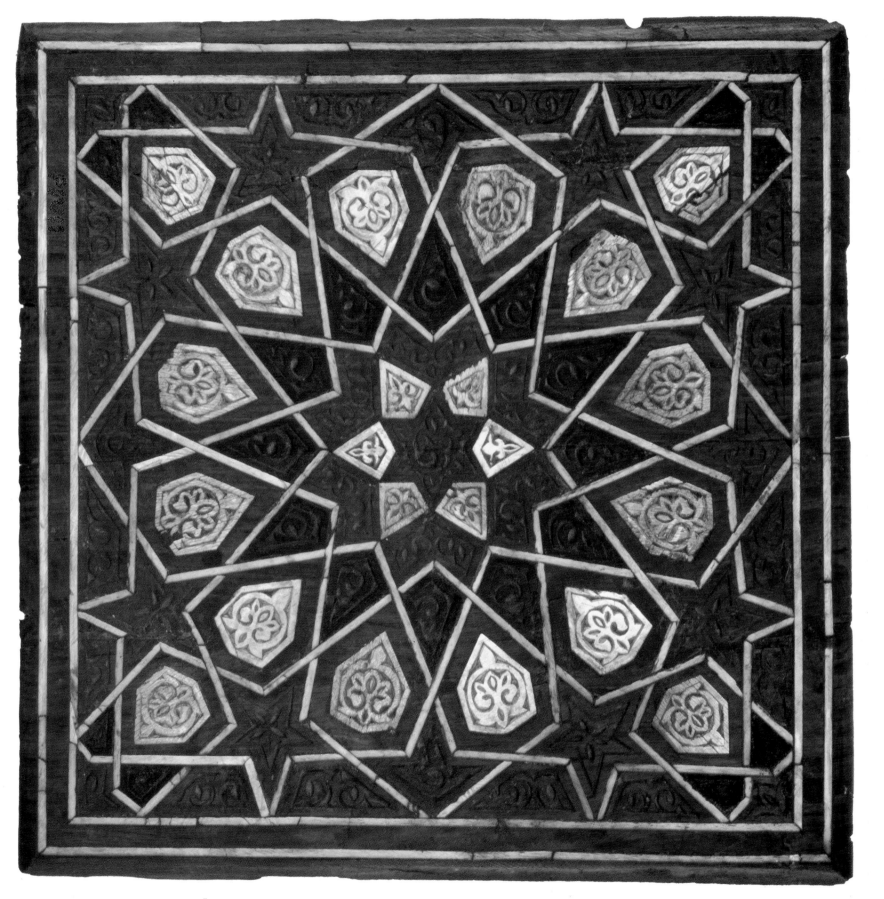

99
Panel with six-pointed star
Wood: carved, inlaid with ivory
14th century

Height and width: 29.6 cm. (11⅝ in.)
Depth: 3.0 cm. (1³⁄₁₆ in.)

Cairo, Museum of Islamic Art, 11719
Gift of Prince Kamal al-Din Husein, 1933

Mamluk artists, who excelled in the production of
woodwork inlaid with ivory, made doors, window
shutters, and cupboards as well as tables and
boxes for both religious and secular buildings.
Their most spectacular pieces were large minbars
commissioned for mosques dedicated by sultans
and amirs.

Geometric compositions were fully exploited in
woodwork, as seen in this example. The design
radiates from a central unit and forms a series of
concentric zones filled with polygons and stars.
Thin strips of ivory encircle the units and link
each segment, producing an intricate maze.
The units are made of ivory and two kinds of
wood, the artists using natural material to create
a colorful effect. The overall impression is similar
to the compositions found on manuscript
illumination (see nos. 3–4).

The panel is composed of six concentric zones
evolving from a central six-pointed star. Six ivory
polygons surround it and form another six-
pointed star; encircling this unit are additional
polygons that create a twelve-pointed star.
The same theme is repeated with dark wood
polygons in the fourth zone; enclosing it is a series
of units inlaid with ivory panels. The final zone is
composed of additional polygons and five-pointed
stars; the corner units have ivory inlays and two
outer segments of dark wood. A pair of ivory
strips forms the border.

Each polygonal unit is carved with floral
designs. The ivory inlays in the second zone have
buds, the larger units in the fifth and sixth zones
contain stylized blossoms enclosed by heart-
shaped leaves.

Since this panel did not come to the Museum of
Islamic Art from a known building, its original
function is unknown. It must have been a part of
a larger piece, such as a minbar or a door.

Unpublished

100
Grille with frame
Wood: carved, turned
Mid 14th century

Height: 77.7 cm. (30⅝ in.)
Width: 75.3 cm. (29⅝ in.)
Depth: 5.5 cm. (2⅛ in.)

Cairo, Museum of Islamic Art, 2726
From Mosque of Aslam al-Silahdar (built 1344/45)

Wood grilles, called *mashrabiyyas*, were both
decorative and functional architectural elements.
They were used as partitions to separate certain
areas, enclose cenotaphs in mausoleums, and
screen entrances and windows. Window grilles
provided privacy in residential buildings, enabling
ladies to look out without being seen; they also
screened out the sun, provided shade, and allowed
air to enter and circulate in the chambers.

The structure of a *mashrabiyya* is complicated
and laborious: each section is turned and carved
separately, then fitted together with butt
fastenings and tongue-and-groove joints to form a
lattice. In one remarkable example in the Museum
of Islamic Art, the latticework forms the pattern
of a lamp hanging over a minbar, recreating the
interior of a mosque.[1]

The grille on display is enclosed by a frame
composed of four sections fitted together with
tongue-and-groove joints. The frame is decorated
with two types of floral design: the side members
have a continuous split-leaf scroll and the top and
bottom show a more complicated design with
lotus blossoms and buds.

The grille is constructed of sixteen intersecting
diagonals, comprising cylindrical units and cubes.
Each cylindrical member has two deeply cut rings,
while the cubes are carved with blossoms enclosed
by heart-shaped leaves, similar to a motif seen on
contemporary ceramics, ivory, and stone (see nos.
82, 99, and 109).

Published
Herz 1906, p. 160, no. 81.
Herz 1907, p. 149, no. 81.
Cairo 1969, no. 230.

Notes
1. Cairo, Museum of Islamic Art, 526 (London 1976, no. 455).

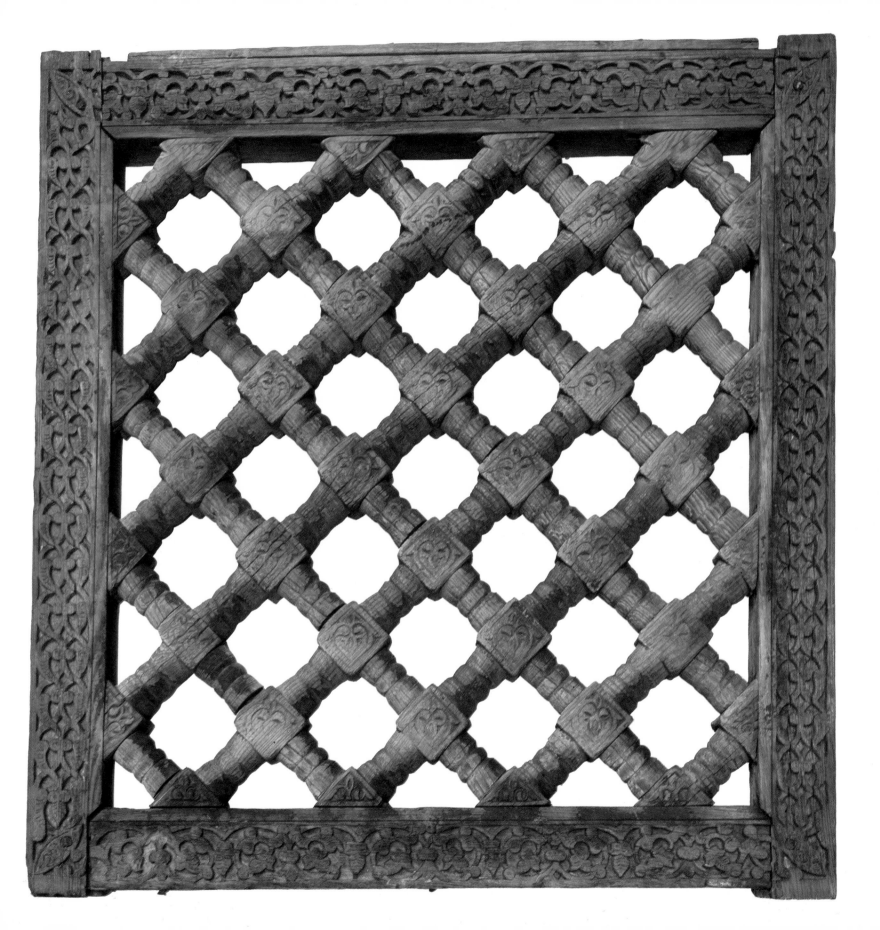

101
Plaque with epigraphic blazon
Wood: carved
Early 16th century

Height: 40.7 cm. (16 in.)
Width: 38.8 cm. (15¼ in.)
Depth: 2.0 cm. (13/16 in.)

Cairo, Museum of Islamic Art, 11754
Gift of Prince Kamal al-Din Husein, 1933

Inscriptions

السلطان الملك الاشرف * قانصوه الغورى * عز نصره

The sultan al-Malik al-Ashraf Qansuh al-Ghuri,
may his victory be glorious.

The central medallion of the plaque contains the
epigraphic blazon of Sultan Qansuh al-Ghuri
(1501–16) written in three fields: the titles of the
sultan appear in the center, his name is given
above, and the popular benediction is placed
below. Surrounding the medallion is a band that
forms loops at the center of each side. The corners
of the plaque are filled with symmetrical floral
scrolls composed of stylized lotus blossoms, buds,
and split leaves. A thin frame encloses the panel.

The band with loops encircling the round blazon
recalls decorative features of manuscript
illumination and metalwork (see nos. 9, 35, and
37–38). Abstracting a single unit from a larger
composition, the woodcarver has followed the
artistic repertoire of the age.

Sultan Qansuh al-Ghuri commissioned a great
number of structures and built a commercial and
residential quarter in Cairo. This plaque may have
come from one of the buildings in that quarter,
called the Ghuriyya. Although there are no traces
of paint on the plaque, it was most likely painted
in the manner of the stone roundel that also bears
his blazon (no. 110).

Unpublished

102
Plaque representing the Sacrifice of Isaac
Wood: carved; with remains of gold leaf on gesso base
14th century

Height: 19.9 cm. (7 13/16 in.)
Width: 13.7 cm. (5⅜ in.)
Depth: 2.3 cm. (⅞ in.)

Washington, D.C., Dumbarton Oaks, 41.7
Purchased 1941
Ex-Kevorkian Collection

Among the clientele of Mamluk woodworkers were
members of the Christian communities of Egypt
and Syria, who commissioned objects and
architectural decoration for their churches.
The decorative themes employed in the churches
can hardly be distinguished from those found in

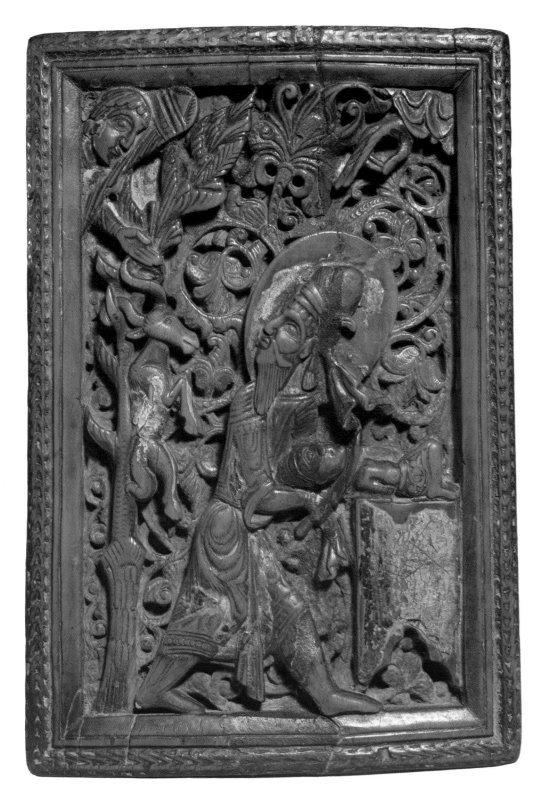

mosques and madrasas as they both rely on the floral and geometric motifs characteristic of the artistic style of the period. Only when an object contains a cross or a Biblical scene can it be identified as having been made for a Christian community (see nos. 44–45, 61, and 103).

The plaque owned by Dumbarton Oaks depicts the Sacrifice of Isaac, a well-known Old Testament theme. The piece is unique in that no other carved wood example with figural composition is known to exist. Said to have come from the Church of Abu Sarga in Cairo,[1] it was most likely a part of an altar screen that contained representations of a series of Biblical stories. Three mortises on the sides and nail holes on the upper and lower edges indicate that it was fitted into a larger panel.

The plaque is deeply carved in two planes: the primary elements of the composition (Abraham, Isaac, and the altar; the angel, tree, and ram; the cloud and hand of God) are executed in high relief and placed on a floral arabesque ground that is carved in low relief. The large palmette in the upper center moves from the background into the foreground, thereby linking the two planes. Portions of the design were originally covered with gesso and gilded; remains of gold leaf can be seen on the altar, Abraham's halo and robe, the ram, and the angel.

The scene depicts the moment when Abraham hears the voice of an angel, just as he is about to sacrifice his son Isaac. Abraham stands in the center of the composition. He holds a knife in his right hand and turns back to look at the winged angel who gestures toward the ram caught in a tree. On the upper right is a cloud formation with the hand of God blessing the event.

The bearded patriarch has an oval halo around his head. He wears an elaborate headdress with a tall crown wrapped in cloth that hangs loosely at the back, a robe tied by a long sash, and high boots. Isaac, attired in only a loin cloth, lies on his back on the altar with the knife held at his throat.

The background is filled with a large floral scroll composed of split leaves, lotus buds, blossoms, and an oversize palmette. The plaque is enclosed by several frames, the outer three of which are adorned with chevron motifs.

Although there are no comparable examples, a number of decorative features found in the plaque have parallels in fourteenth-century Mamluk art. The moiré or watered design used in Abraham's robe and the beaded strips at the hem and upper arm (recalling *tiraz* or inscription bands) are frequently encountered in manuscript illustration, as is the tree with articulated trunk and bud-shaped branches. Abraham appears to be stepping out of the picture plane with one foot placed over the frame, a feature seen in fourteenth-century paintings. The altar with trefoil opening at the base resembles contemporary hexagonal wood or metal tables, and the floral scroll follows the style of the period.

The peculiar headdress of the patriarch is not found in Mamluk art; it is, however, represented in several sixteenth-century Ottoman manuscript illustrations portraying Arabs or Egyptians.[2] This headdress may be an exaggerated version of the traditional garments of the Coptic clergy used by the artist to identify the central figure as one of the founders of the church. In the Mamluk world the garments worn by Christians were similar to those used by Muslims; the shape of their turbans was much the same, with a cloth wound around a central cap.[3]

This scene is a visual translation of a Biblical passage, the "ram [is] caught in a thicket by his horns" (Genesis 22:13). The representation of Abraham in the act of sacrificing Isaac while holding a knife to his throat is peculiar to the Near East and often appears in Islamic manuscripts illustrating the history of the ancient prophets.

Published
Brooklyn 1941, no. 78 and fig. 78.
Dumbarton Oaks 1946, no. 165.
Dayton 1953, no. 71.
Dumbarton Oaks 1955, no. 254.
Dumbarton Oaks 1967, no. 299.

Notes
1. The Church of Abu Sarga (Saint Sergius) is one of the oldest in Cairo.
2. For example, in the *Süleymanname* dated 1558, in İstanbul, Topkapı Palace Museum, H. 1517, fol. 56a. The same headdress is used for Arabs in a circa 1580 painting in Washington, D.C., Freer Gallery of Art, 29.75 (Atıl 1973a, no. 8).
3. Mayer 1952, pp. 65–68.

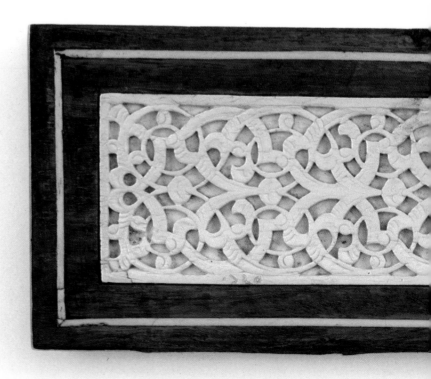

103
Plaque with cross
Ivory: carved, inlaid into wood
14th century

Height: 8.6 cm. (3⅜ in.)
Width: 35.0 cm. (13¾ in.)
Depth: 1.5 cm. (⅝ in.)

Cairo, Museum of Islamic Art, 5620
Gift of Muhammad Mahmud Khalil, 1919

This delicately carved ivory piece has been inlaid into a wood plaque; a thin strip of ivory is placed around the frame. The bottom edge of the plaque has a rail, while the right side contains a tenon, indicating that it was originally inserted into a larger panel.

In the center of the plaque, placed over a floral scroll, is a medallion bearing a cross with trefoil arms. The units on either side also contain floral motifs conceived as superimposed scrolls with overlapping elements. Each unit has a pair of cartouches, roughly shaped as a trefoil, intermingled with scrolling vines bearing rounded buds and split leaves.

This piece might have been attached to a door, cupboard, screen, or altar made for one of the Coptic churches in Egypt. The cross appears on a small glass flask (no. 61) most likely made for pilgrims visiting the Holy Land. Crosses are also found on incised Mamluk pottery and were used either as a decorative element or a blazon, the meaning of which is uncertain.[1]

Published
M. H. Zaki 1956, no. 435 and fig. 435.

Notes
1. Mayer 1933, p. 19 and pl. xiib, nos. 8–11.

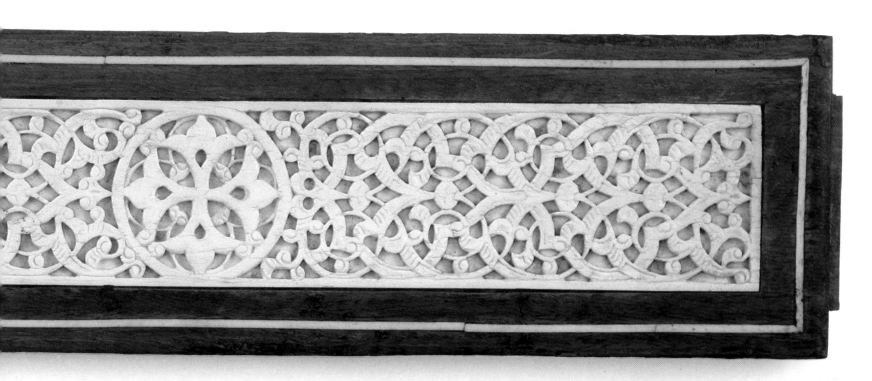

104
Panel with six plaques
Ivory: carved, inlaid into wood
Mid 15th century

Polygons
Average height: 13.4 cm. (5¼ in.)
Average width: 8.3 cm. (3¼ in.)
Depth: 1.5 cm. (⅝ in.)
Star
Height: 12.2 cm. (4¾ in.)
Width: 28.3 cm. (11¹⁄₁₆ in.)
Depth: 1.5 cm. (⅝ in.)

New York, The Metropolitan Museum of Art,
 07.236.26, 07.236.28–31, and 07.236.46
Purchased, The Rogers Fund, 1907

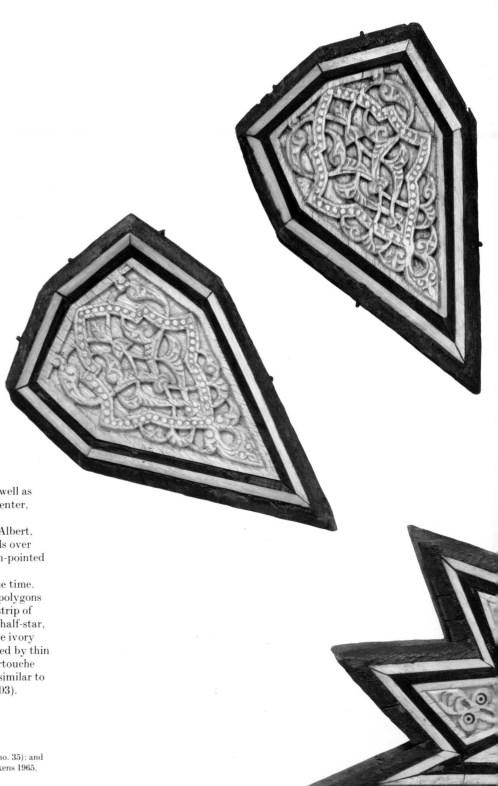

The plaques included in this panel were originally a part of a larger
composition and may have been used to decorate a door or minbar.
The composition of Mamluk doors in the Museum of Islamic Art, as well as
those in situ, is based on medallions with stars and polygons in the center,
half-medallions at the sides, and quarter-medallions in the corners.[1]
The spectacular minbar of Sultan Qaitbay, now in the Victoria and Albert,
has a similar composition.[2] The side panels of this piece, which stands over
7.32 meters (24 feet), are adorned with medallions containing sixteen-pointed
stars. The style of carving and motifs employed are similar to the
Metropolitan panels, which must have been produced about the same time.
 The central motif, half of a sixteen-pointed star with seven small polygons
placed around it, is inlaid into a wood plaque and framed by a thin strip of
ivory. A floral scroll with split leaves and lobed spiked buds fills the half-star,
while the same lobed bud appears in the encircling polygons. The five ivory
plaques in the surrounding zone are also inlaid into wood and enclosed by thin
strips of ivory. The decoration of these units consists of a beaded cartouche
terminating in a bud, superimposed on a floral scroll of split leaves, similar to
the layout on a fourteenth-century piece discussed previously (no. 103).

Published
Metropolitan 1907, p. 208.

Notes
1. See, for example, the door panels in Cairo, Museum of Islamic Art, 5977 (Wiet 1930, no. 35); and
 in New York, Metropolitan Museum of Art, 91.1.2064 (Dimand 1944, fig. 71; and Lukens 1965,
 no. 36).
2. London, Victoria and Albert Museum, 1050–1869.

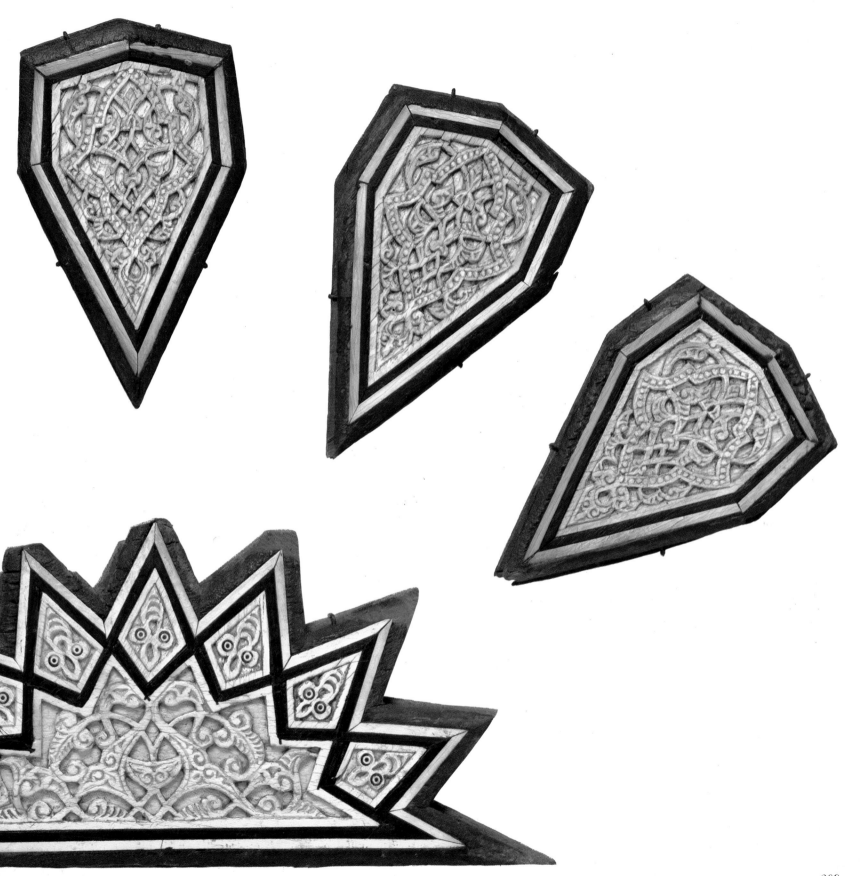

105

Plaque with inscriptions
Ivory: carved, inlaid into wood
Circa 1470

Height: 9.2 cm. (3⅝ in.)
Width: 33.8 cm. (13⁵⁄₁₆ in.)
Depth: 1.5 cm. (⅝ in.)

Cairo, Museum of Islamic Art, 2334
From Madrasa of Qaitbay

Inscriptions

مولانا السلطان الملك الاشرف قايتباى عز نصره

*[Our] master, the sultan al-Malik al-Ashraf
Qaitbay, may his victory be glorious.*

This ivory plaque is inlaid into a dark wood panel
enclosed by a thin strip of ivory and framed by a
lighter wood. The main decoration consists of a
bold inscription that contains the name of the
patron, Sultan Qaitbay. The background is filled
with sprays of lobed and spiked buds and the
characteristic split leaves with pronounced veins
(see also nos. 34–35 and 104).

Sultan Qaitbay, whose patronage of the arts is
represented by several objects, including a
manuscript (no. 9), two pieces of metalwork (nos.
34–35), and a marble jar (no. 112), was also one of
the most enthusiastic builders. He commissioned a
number of *sabils* or fountains, gates, houses,
mosques, *sabil-kuttabs* (schools with fountains),
and *wakalas* (inns).

This plaque came to the museum from one of
the mosque-madrasas built by Qaitbay in Cairo.
It was most likely attached to a larger unit affixed
to a door, window, or minbar.

Published
Wiet 1930, no. 39 (third panel).
Cairo 1969, no. 41.
London 1976, no. 155.

106

Cylindrical box
Ivory: carved, pierced
Mid 14th century

Height: 9.5 cm. (3¾ in.)
Diameter: 14.5 cm. (5¹¹⁄₁₆ in.)

London, Victoria and Albert Museum, 4139–1856
Purchased 1856
Ex-Rhode-Hawkins Collection

Inscriptions
Band on base

ابشر فقد نلت ما تريدن من اعدائك ... وما ظفروا بالذي
ارادوا بل يفعل الله ما يريد
ابشر فقد نلت ... قد حزي بالذي تختاره القدر ويساعدك
على الايام ان تعدل العز والنصر والاقبال والظفر

*Be of good cheer for you will obtain what you will
of your enemies . . . and they will not get what they
desire, rather God will do that which He wills; be
of good cheer for you will obtain . . . and fortune
will go in the way that you choose and will help
you against the vicissitudes of time by glory and
victory and prosperity and good fortune.*

Although ivory was used in abundance to decorate
woodwork, it was rarely used for objects in the
round. There is a remarkable group of cylindrical
boxes that appears to have been made in Cairo in
the fourteenth century. One of them, formerly in
the Rothschild Collection, bears an inscription
giving the name and titles of Sultan Salih, who
reigned between 1351 and 1354.[1] Sultan Salih's
box is almost identical to the one owned by the
Victoria and Albert, and both pieces must have
been produced about the same time.

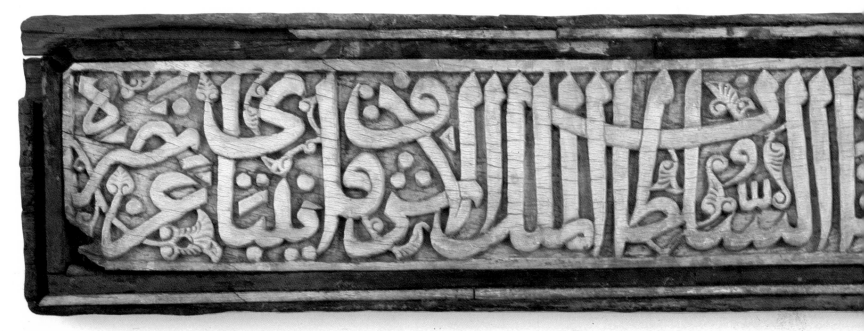

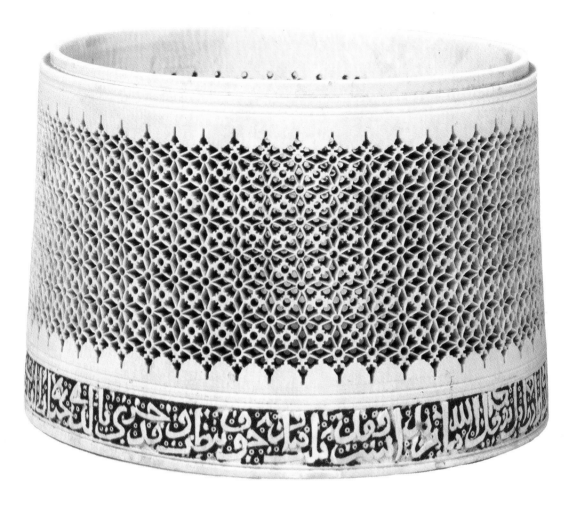

The Victoria and Albert box has an inscription band encircling the base; it is executed in low relief on a ground filled with black bitumen and adorned with tiny roundels. The body of the box is pierced with an overall diaper pattern composed of quatrefoils radiating from roundels linked by diamonds and other roundels with four minute trefoils. A series of lobed scallops encloses the upper and lower edges. The top is recessed and originally contained a flat lid with a central knob, similar to the box made for Sultan Salih. In Sultan Salih's piece, an inscription bearing the name of the patron appears around the lid. It is unfortunate that the lid is missing from the Victoria and Albert box, since it, too, may have contained the name of the owner.

Several other cylindrical boxes belong to this group. One, also in the Victoria and Albert, is a small container with pierced decoration, its lid attached by copper mounts.[2] Two others, in the British Museum, are almost identical to the piece here discussed; one has the inscription band on the top of the body, the other is inscribed on the lid.[3] Another box, in the Cathedral of Saragossa, is also pierced and inscribed and has enameled- and gilt-silver mounts.[4] A fifth, formerly in the Peytel Collection, is carved and not pierced, its lid is attached by metal mounts; in addition to the diaper pattern and inscription panels, it is decorated with bands of roundels and strapwork.[5] Another piece is said to be in the Cathedral of Sens.[6] A seventh example, resembling the Rothschild and Victoria and Albert boxes, was included in a Paris auction.[7] These boxes, dated between the twelfth and fourteenth centuries, have been assigned to Spain as well as Egypt. The only documentary evidence pointing to fourteenth-century Egypt is the piece bearing Sultan Salih's name.

In the fourteenth century there appears to have been a revival throughout the Mediterranean in ivory carving. The Mamluks supplied European markets with ivory from Africa and its popularity among Westerners must have stimulated the production of ivory containers by local artists.

Published
Longhurst 1927, p. 60 and pl. XL.

Notes
1. Migeon 1903, pl. 8.
2. London, Victoria and Albert Museum, A68-1923.
3. London, British Museum, 74 3-2 5 (Migeon 1907, fig. 120) and 91 6-23 8, with lid (Dalton 1909, no. 568).
4. Madrid 1893, pl. XXXXVII.
5. Migeon 1903, pl. 7.
6. Longhurst 1927, p. 60.
7. Palais d'Orsay 1979, no. 69.

107
Inlaid panel
White, yellow, red, black marble with mother-of-
 pearl; set into plaster
Early 15th century

Height: 29.5 cm. (11⅝ in.)
Width: 104.8 cm. (41¼ in.)
Depth: 5.0 cm. (2 in.)

Cairo, Museum of Islamic Art, 3075
Gift of B. Naggar, 1903

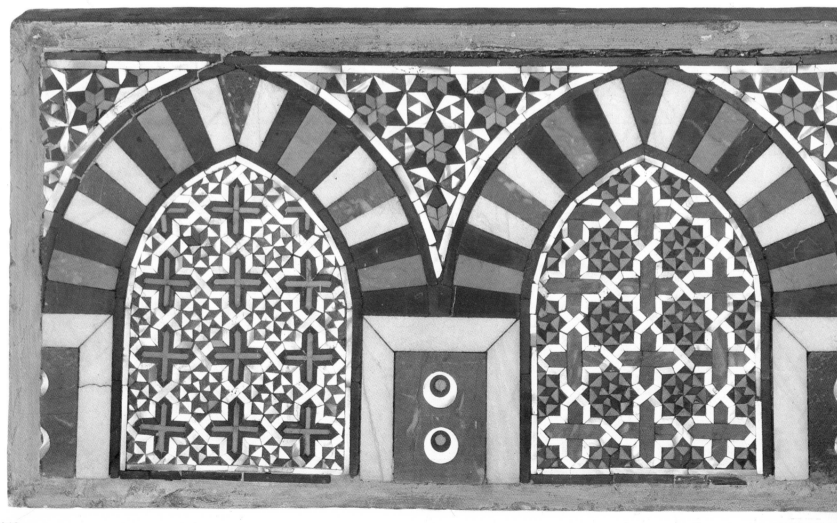

Panels with different colored marble inlays and mother-of-pearl were employed in early Mamluk buildings and appear in full glory in the complex of Sultan Qalawun, built in 1284–85. The tradition continued into the fifteenth century with examples seen in the mausoleum in the *khanqa* of Barsbay, built in 1432 in the northern cemetery of Cairo. The mihrab of this structure has panels adorned with arches, identical to the one from the Museum of Islamic Art.[1]

The panel is composed of four lancet arches with white, black, yellow, and red voussoirs supported by square piers that have broad white bands enclosing a red field with a pair of yellow roundels encircled with white and black bands. The zones between the arches are filled with overall geometric patterns composed of crosses

and eight-pointed stars, recalling luster-painted tile revetments produced in Iran during the late thirteenth and early fourteenth centuries. These units are filled with polychrome marble inlays and outlined with mother-of-pearl, which forms a continuous strip, looping around the stars and crosses. The spandrels are filled with hexagons and six-pointed stars that are further divided into triangles and smaller stars. Mother-of-pearl is also used in the border of the spandrels and in the triangular units.

The sheen of the polished marble and the shimmer of the mother-of-pearl create a sumptuous effect. One can imagine how the different portions of the design were highlighted when sun rays hit the panel or when the building was lit by flickering lamps.

Published
Herz 1906, p. 57, no. 23.
Herz 1907, p. 54, no. 23.
Wiet 1930, no. 15.
Mostafa 1961, p. 34 and fig. 7.

Notes
1. This panel was identified as belonging to the mausoleum of Barsbay by Leonor Fernandez who has made an extensive study of the *khanqa* in her doctoral dissertation, Princeton University, 1980.

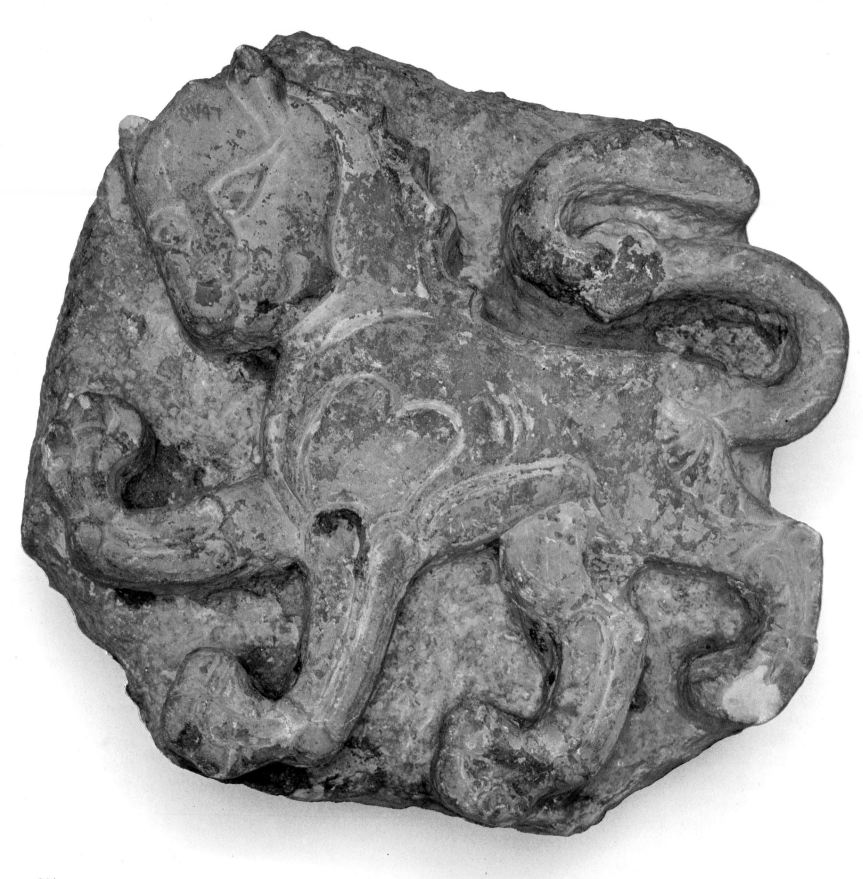

108
Plaque with lion blazon
Stone: carved, with traces of red paint
Late 13th century

Height: 37.5 cm. (14 13/16 in.)
Width: 40.0 cm. (15 3/4 in.)
Depth: 12.7 cm. (5 in.)

Cairo, Museum of Islamic Art, 3796
Purchased 1911

The stone plaque represents a lion facing left with right paw raised; its mane is curled and its knotted tail forms an s-shaped curve above the body. The carving of the plaque is crisp and precise; deeply cut lines accentuate the facial features and the stylized muscles and ribs of the lion. On the animal's rump is a seven-petaled floral motif. A heraldic appearance is created by the tension evoked by the artist's stylized representation of the lion in arrested movement.

Touches of red pigment remaining inside the claws and recesses of the floral design on the rump indicate that the animal was once covered with paint. The slab is of an irregular shape, and the background appears unfinished; it is possible that the lion was to be freestanding and used as an architectural boss.

The lion is identified with Baybars I (1260–77) and was his heraldic blazon (see no. 46). It was used on his coins and numerous castles, fortifications, khans, bridges, and other structures he built in Anatolia, Egypt, Lebanon, Palestine, and Syria.[1] The same blazon was adapted by his son and heir, Baraka Khan (1277–79).

Published
Cairo 1952, p. 33.
Cairo 1969, no. 203 and fig. 35.

Notes
1. Meinecke 1972, pp. 217–19, pl. LII.

109
Plaque with cup blazon
Stone: carved, painted in red, white, green
Early 14th century

Height and width: 46.0 cm. (18 1/8 in.)
Depth: 15.0 cm. (5 7/8 in.)

Cairo, Museum of Islamic Art, 1640
From an old house (Waqf al-Mahrouk) in Cairo

This square plaque contains a circular shield representing a bar above a stemmed cup, both of which are painted in red and framed by a ring. The wide border placed around the shield is composed of twelve trefoils surrounded by heart-shaped leaves with additional trefoils in the interstices. This border, originally painted in white, is enclosed by floral motifs. The plaque appears to have been covered at a later date with green overpainting.

The cup was used as the sign for the office of the *saqi* (cup-bearer) and is found on several objects (see nos. 15–16, 27–28, 96, and 125). The heart-shaped leaves are also encountered on a number of fourteenth-century pieces (see nos. 82 and 99–100).

According to museum records, this plaque came from an old house in Cairo, which may have been the residence of a cup-bearer. Since the house is not dated and the plaque is not inscribed with the name or title of the patron, it has not been possible to identify the owner.

A candlestick made around 1290 (nos. 15–16) for Amir Kitbugha contains an identical blazon with a red bar above a red cup. Although it is tempting to assign the stone plaque to Kitbugha, there is no evidence that he sponsored any religious or secular buildings.

Published
Herz 1906, p. 48, nos. 119–20.
Herz 1907, p. 46, nos. 119–20.
Cairo 1969, no. 204.

110
Roundel with epigraphic blazon
Stone: carved, with traces of brown paint
Early 16th century

Diameter: 49.5 cm. (19 1/2 in.)
Depth: 5.0 cm. (2 in.)

Cairo, Museum of Islamic Art, 6731
From Comité de Conservation des Monuments de l'Art Arabe, 1924

Inscriptions

عز لمولانا السلطان الملك الاشرف * قانصوه الغوري * عز نصره

Glory to our master, the sultan al-Malik al-Ashraf Qansuh al-Ghuri, may his victory be glorious.

The epigraphic blazon of Sultan Qansuh al-Ghuri was a medallion divided into three fields: the center contained the titles of the sultan, the upper panel displayed his name, and the lower panel had a benediction. The blazon was used on all his buildings and objects (see no. 101). Its division and wording are similar to the blazon of Sultan Qaitbay (see nos. 34–35).

The roundel has a wide frame and two horizontal bands defining the three registers. Traces of brown pigment in the background of the lower register suggest that the piece was once painted. It is possible that the letters, which stand in low relief, were painted in a contrasting color or covered with gilt, which has since disappeared.

The Museum of Islamic Art owns several epigraphic blazons of Qansuh al-Ghuri, including a roundel from that portion of the aqueduct built by him in 1506–8.[1] The provenance of this example is not recorded. Qansuh al-Ghuri constructed a great many edifices, and it must have come from one of his structures that was later demolished.

Sultan Qansuh al-Ghuri's epigraphic blazon is still in situ in a number of buildings in Cairo and can be seen in his mausoleum, which was completed in 1503–4.

Published
Wiet 1971, no. 132.

Notes
1. Herz 1907, no. 100.

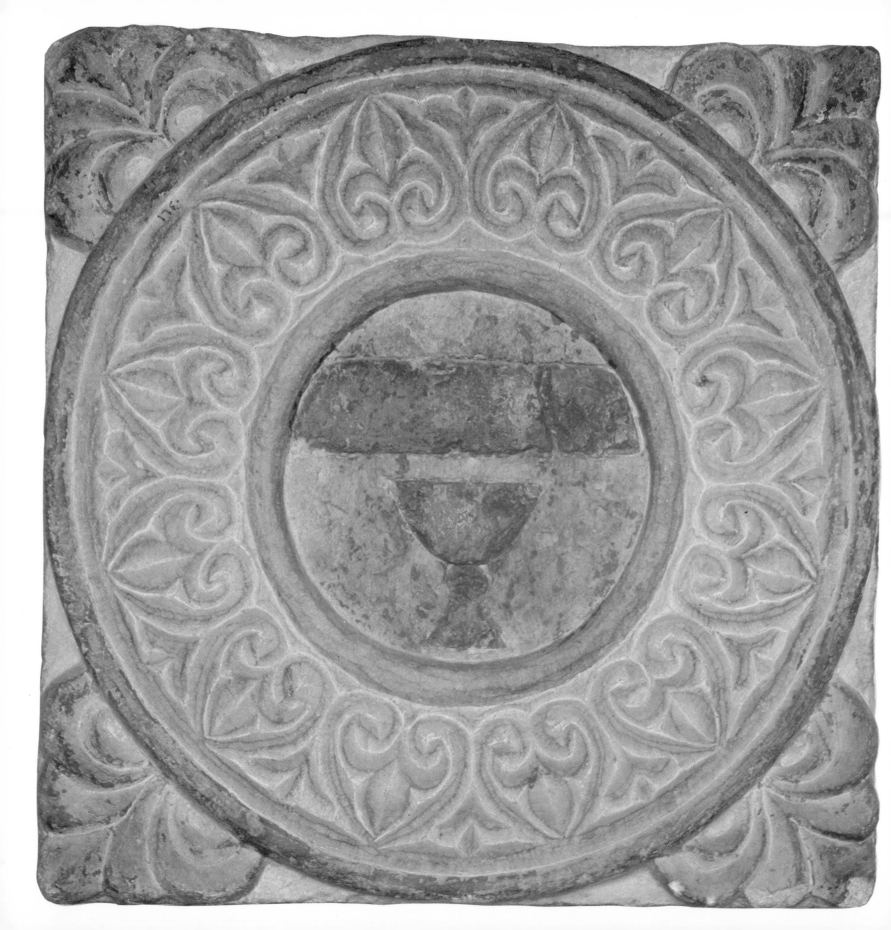

111
Plaque in the shape of a mihrab
Marble: carved, with traces of red, brown paint
Mid 14th century

Height: 60.5 cm. (23 13/16 in.)
Width: 36.0 cm. (14 3/16 in.)
Depth: 2.8 cm. (1 1/8 in.)

Cairo, Museum of Islamic Art, 19
From Badriyya Madrasa, 1882

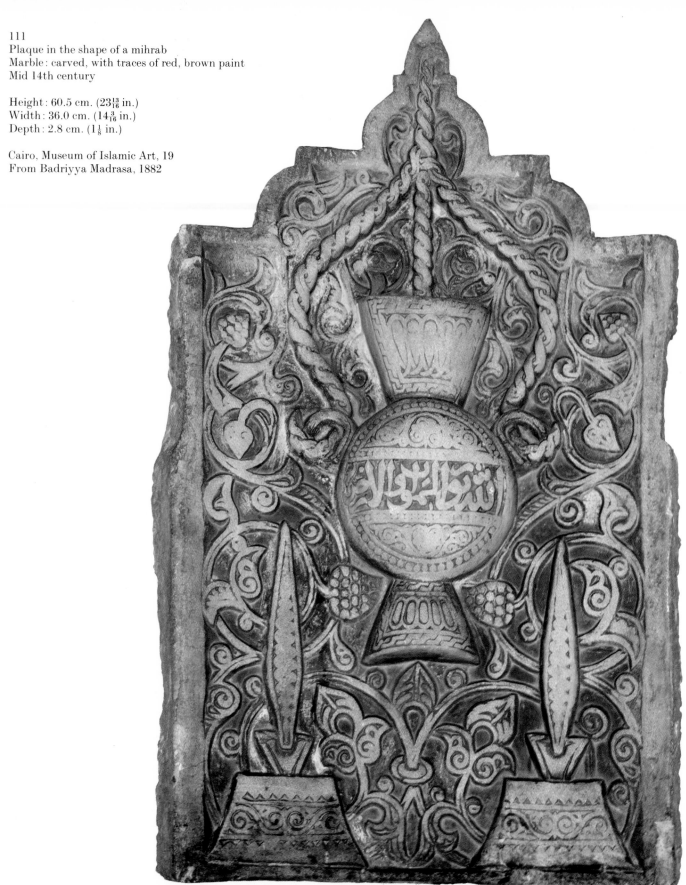

Inscriptions
On lamp:

<div dir="rtl">الله نور السموات والارضى</div>

God is the light of the heavens and the earth [XXIV:35].

Museum records indicate that this slab came from the Badriyya Madrasa[1] and was deposited by the Comité de Conservation des Monuments de l'Art Arabe in 1882 to the eastern court of the mosque of al-Hakim, which housed the first collections of the Museum of Islamic Art in Cairo. When the collection was moved to its present building in 1899, the objects were registered and catalogued.

The rectangular plaque has a foliated crown; in the center is a large lamp, suspended by thick ropes from the apex and flanked by two candlesticks with tapered candles. The neck and foot of the lamp are adorned with lancet leaves and braids, the body bears an inscription panel inserted between floral units enclosed by beaded bands. Although this type of decoration does not occur in existing lamps, the shape and inscription of this representation are characteristic (see nos. 52–53). The candlesticks are embellished with floral scrolls and diamond-shaped motifs. They reproduce the shape found in metalwork, disregarding traditional decoration of inlaid or engraved brasses (see nos. 10, 15–16, 30, and 34).

The background of the plaque is filled with a floral scroll composed of bunches of grapes, heart-shaped buds, and split leaves, with a pair of stylized lotus blossoms below the lamp. Traces of red are found behind the inscription panel on the lamp, and brown paint or stain is detectable in the background. Similar to other examples of carved stone, this plaque must have been completely covered with polychrome paints.

Contemporary slabs decorated with bunches of grapes are found in the madrasa of Sarghithmish, which was completed in 1356.[2] The Museum of Islamic Art also has a tombstone representing a mosque lamp flanked by candlesticks dating from this period.[3]

Published
Herz 1906, p. 44, no. 41.
Herz 1907, p. 42, no. 41.
Wiet 1930, no. 9.
M. H. Zaki 1956, no. 792 and fig. 792.
Mostafa 1958, no. 48.

Notes
1. This madrasa, built in the thirteenth century, no longer exists.
2. Cairo, Museum of Islamic Art, 2785; a second panel is in situ in the madrasa (Cairo 1969, no. 201). Another panel, dating from the thirteenth century, decorated with grapes is in Cairo, Museum of Islamic Art, 12752 (Cairo 1969, no. 195).
3. Cairo, Museum of Islamic Art, 2988 (Cairo 1969, no. 199).

112
Jar
Marble: carved
Circa 1470–90

Height: 61.0 cm. (24 in.)
Diameter of rim: 26.7 cm. (10 9/16 in.)

Cairo, Museum of Islamic Art, 125
From Fountain of Sultan Qaitbay

Inscriptions
Three panels on rim:

<div dir="rtl">اوقف هذا الزير على هذا السبيل المبارك * مولانا السلطان الملك الاشرف *</div>
<div dir="rtl">ابو النصر قايتباى عز نصره بمحمد وآله</div>

This sublime jar was dedicated to the blessed fountain [by our] master, the sultan al-Malik al-Ashraf Abu'l-Nasir Qaitbay, may his victory be glorious through [the Prophet] Muhammad and his descendants.

Among the most beautiful objects produced in the Mamluk period are a series of marble jars used to provide water for the thirsty. The dedication of fountains and water troughs was considered a noble and charitable act. Throughout the history of Islam, structures ranging from simple drinking fountains to larger complexes were donated by pious and wealthy citizens. The Mamluks endowed *sabils*, structures where water was provided to the public, as well as *sabil-kuttabs* in which fountains were built in combination with theological institutes. Sultan Qaitbay (1468–96) is known to have sponsored during his reign at least four *sabils* and two *sabil-kuttabs*. Water jars were commissioned for these fountains as well as for residential and public buildings.

The Museum of Islamic Art owns a number of marble jars that were made for *sabils*, mosques, and madrasas. One of the renowned examples is a large piece (86 cm. or 33 7/8 in. high) adorned with a floral scroll and a frieze of fish; it came from the mosque built in 1360 by Tatar al-Hijaziyya, daughter of Sultan Nasir al-Din Muhammad.[1] This museum also has several jars bearing Sultan Qaitbay's waqf (endowment), including this example.

Qaitbay's jar has a simple but elegant ovoid shape with three straphandles placed on the shoulder. The handles are pierced with a broad braid. An inscription band, carved in low relief, appears between the handles. One of the handles has been broken and water stains appear on the lower half of the body.

These jars had special stands, some of which resembled turtles.[2] Many examples in the Museum of Islamic Art have been placed on Fatimid stands, which were basically water troughs designed to serve a different function.

Published
Herz 1902, no. 51.
Herz 1906, p. 50, nos. 135–37.
Herz 1907, p. 48, nos. 135–37.
Wiet 1929a, no. 497.
Wiet 1971, no. 128 and pl. XXXII.

Notes
1. Cairo, Museum of Islamic Art, 34 (Wiet 1930, no. 12; Cairo 1969, no. 202).
2. Herz 1907, p. 47.

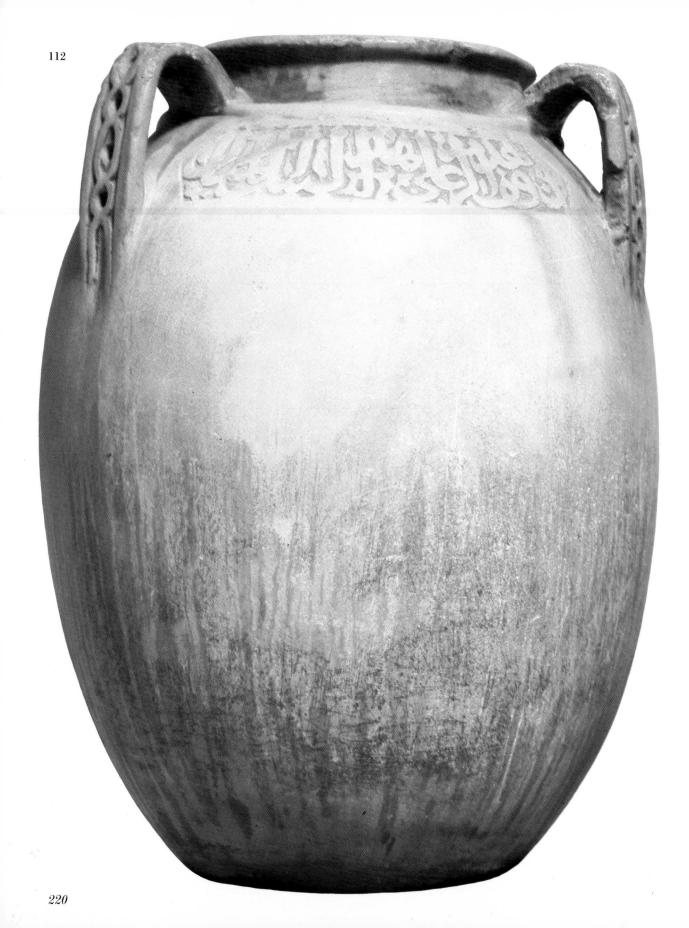

TEXTILES AND RUGS

TEXTILES AND RUGS

The history and development of Mamluk textiles have not yet been properly studied despite the wealth of extant materials woven in silk, printed on linen and cotton, embroidered, and appliquéd. Of all Mamluk textiles, silks are the most exquisite, lavishly executed in brilliant colors and metallic threads. Their decoration is characteristic of Mamluk art, consisting of inscriptions, floral decorations, animal figures, and motifs derived from heraldic emblems.

The most difficult task in the study of Mamluk silks is to identify pieces made in Egypt and Syria and to differentiate these from Chinese textiles produced for the sultans and from Italian and Spanish imitations of Mamluk fabrics. Chinese silks woven for the Mamluk court employed Arabic inscriptions and heraldic motifs similar to those manufactured by local artists. Exported to the West, Mamluk silks were in great demand in the Mediterranean states. They were used as burial shrouds by European royalty, sewn into chasubles and copes for church services, worn by representations of the Virgin, saints, and patriarchs in paintings and altarpieces, and inspired the textile industries of Granada, Lucca, and Venice.

The study of carpets presents a totally different problem. The Mamluk rug makes a sudden appearance at the end of the fifteenth century, immaculately woven in shimmering wools with geometric designs. In contrast to textiles, much has been written about Mamluk rugs, and yet, their origin and evolution are still mysterious and far from being resolved.

Textiles
Woven silks embellished with rich patterns and accentuated with silver and gold thread were highly valued within the Mamluk world; they decorated chambers, were made into robes worn by the court, and were presented as official gifts. The presentation of the *khila* or robe of honor was an Islamic custom in which garments made of expensive fabrics were exchanged as gifts among the sultans or given by the rulers to their amirs as official notification of promotion. Sometimes the sultan would give a complete outfit, including weapons and horsetrappings. Higher officials also practiced this custom and presented similar robes to members of their staff when they advanced in rank. Although historical texts frequently mention ceremonial presentations of the *khila*, there are no extant examples.

In fact, extremely few Mamluk garments have survived. The Victoria and Albert Museum in London owns a number of simple tunics, pants, and vests made for youngsters. An elaborate piece, in Cairo, is a child's shirt adorned with foliate medallions and crescents bearing the words *al-sultan* and *al-kamil* (the perfect).[1] Another small shirt, in Berlin, is decorated with addorsed griffins enclosed by medallions and crescents set within an ogival unit; this example is inscribed *al-sultan* and *al-alim* (the learned).[2] The most important garment is a man's robe or overcoat made of heavy yellow silk and lined with linen, found in 1966 at Jabal Adda in Upper Egypt.[3] The pattern of the silk is made of stars enclosing eight-petaled rosettes and running animals and crosses with lobed medallions and addorsed birds.

In contrast, there exist many caps made of various fabrics, some of which were quilted. Most of these hats are constructed of triangular sections stitched together to form the crown and have a wide band at the rim (no. 17). A few examples have embroidered bands at the rim and frontal panels that extend to the crown.

Silk fabrics were also used on shoes, few of which have survived. One rare piece is a child's sandal, its fabric strap decorated with a crescent bearing the word *al-sultan*.[4]

Mamluk silks sewn into church vestments are more numerous and have remained remarkably well preserved through the ages. The largest collection, in the Church of the Virgin Mary (Marienkirche) in Danzig (now Gdánsk), Poland, includes nine chasubles made of striped silks with inscriptions (*al-sultan* and *al-alim*) and lotus blossoms woven in brilliant colors and metallic thread.[5] A striking fabric decorated with an ogival pattern, now in the Victoria and Albert, was sewn into a chasuble in Spain.[6] An even more elaborate piece (no. 116) was made as a mantle for a sculpture representing the Virgin.

Mamluk silks must have been available in Central Asia and China to serve as models for Yüan dynasty textiles produced for the Mamluk court. Fourteenth-century Yüan dynasty brocades show a blend of Chinese and Islamic motifs.[7] The Chinese elements include the phoenix, *ch'i-lin* (a fantastic creature), dragon, and Dogs of Fu (Buddhist mythical lions), as well as ducks and turtles. As in Mamluk silks, the pattern is usually striped and includes bands inscribed with popular Arabic phrases, such as "glory and victory and perpetuity," "the sultan, the learned," and the characteristic Mamluk benediction, "glory to our master, the sultan." Inscribed bands are often interrupted by medallions. Inscriptions are at times written in a circular formation enclosed by medallions or palmettes. Both arrangements have parallels in many Mamluk objects. The most striking technical feature of Yüan dynasty silks is the use of gilded leather strips, which were employed on the earliest extant Chinese brocades dating from the Sung period.

Yüan dynasty silks with Arabic inscriptions were also made into chasubles in the West. Four chasubles and dalmatics are in the Cathedral of Regensburg (also called Ratisbon), while others are in Brunswick and Kulm (now Chelmno). A dalmatic in Regensburg has vertical stripes decorated with predators and prey, ducks and fish; wide bands adorned either with lotus blossoms, diaper patterns, and crescents or a pair of Dogs of Fu and a rosette, in the center of which is the name of the weaver written in Arabic: "the work of master Abd al-Aziz."[8] A fragment of this fabric, containing a rosette with the same inscription, is in the Victoria and Albert.[9] One may hypothesize that Abd al-Aziz, the weaver, was a Central Asian Muslim called upon to produce silks for export to the Near East. Obviously, Asian merchants

were fully aware of the tastes of the Mamluk court and were enterprising enough to compete with local textile industries in Egypt and Syria.

One of these Chinese textiles is decorated with medallions enclosing addorsed birds (most likely parrots), their wings inscribed with the characteristic Mamluk benediction written in a circular formation: "glory to our master, the sultan, al-Malik, the just, the learned, Nasir al-Din."[10] The inscription indicates that the piece was made for Sultan Nasir al-Din Muhammad (1293–1341, with interruption). A frequently quoted passage from Abu'l-Fida states that camels laden with 700 silks bearing the sultan's name were presented by Abu Said to Nasir al-Din Muhammad in 1323 when peace was concluded between the Ilkhanids and the Mamluks.[11] It is possible that the Chinese fabric described above was part of this shipment.

Nasir al-Din Muhammad's titles, al-Malik al-Nasir, also appear on a number of locally made silks, including a striped fabric (no. 113). This piece is adorned with animals and inscriptions with phrases similar to the example with addorsed parrots made in China. Another striped silk has oval cartouches with the same words as well as medallions enclosing double-headed eagles and addorsed felines.[12] A more extensive inscription appears on a fragmentary cap; it is written in a circular formation and gives the sultan's full name and titles: "al-Malik al-Nasir Nasir al-Dunya wa'l-Din Muhammad ibn al-Sultan al-Malik al-Mansur Qalawun."[13] Yet another silk fragment bears an ogival pattern the units of which are filled either with pomegranates, lotus blossoms, and peonies or addorsed *ch'i-lins*; inscriptions appear in the bands forming the ogival units.[14]

In addition to striped and ogival silks, imperial Mamluk titles appear on fabrics depicting undulating vines and large blossoms. This design was based on Yüan silks, examples of which were excavated at Fustat and have Chinese characters in the flowers.[15] In the Mamluk copies, Arabic inscriptions, placed in the center of the blossoms, contain the phrases, "glory to our master, the sultan al-Malik al-Nasir," and "Nasir al-Dunya wa'l-Din Muhammad [ibn] Qalawun." Fragments of this fabric, found at Jabal Drunka and al-Azam near Asyut in Upper Egypt, are now in Berlin, Leningrad, London, and Cairo.[16]

Woven silks inscribed with the names or titles of sultans help determine the chronological and typological development of Mamluk textiles. The earliest datable piece is decorated with palmettes framed by inscriptions bearing the titles "al-Malik al-Mansur," which suggests that it may have been made for Sultan Qalawun (1279–90).[17] The next example is a gold brocade with the name and titles of Sultan Khalil (1290–93).[18] Another striped silk, decorated with animals running in foliage, lotus sprays, and ducks, has "al-Malik al-Ashraf," which may also refer to the same sultan.[19] The textiles dedicated to Sultan Nasir al-Din Muhammad discussed earlier display a variety of decorative patterns and themes.

The most prominent early Mamluk textile pattern contained vertical or horizontal stripes filled with inscriptions, animals, and floral motifs, often accentuated by stars, rosettes, and crescents (nos. 113–14, 117, and 119). The provenance of these striped silks is not determined, but a clue to one of the production centers is provided by an uncut and unworn sheet of striped silk excavated in 1966 at Jabal Adda.[20] This large fabric (3.45 × 1.52 meters, $11\frac{1}{2}$ × 5 feet) is woven in green, pink, brown, white, and gold and is decorated with stripes and bands depicting predators and prey (lions and hares or gazelles), flying birds, and inscriptions bestowing "glory and victory and long life." One edge of the cloth is stamped "al-Asyuti," which suggests that it was made at Asyut, a town in Upper Egypt famous for its linen and silk manufacture.

Other late thirteenth- and early fourteenth-century silks are decorated with medallions, zigzag patterns, latticework, addorsed birds, griffins, running animals, and floral motifs interspersed with inscriptions. The ogival pattern, which appeared in the early fourteenth century, soon became the most popular textile design. The field was at times densely filled with floral motifs camouflaging the ogival units (no. 116) or more spaciously constructed with the ogee distinctly represented (nos. 115 and 118). Certain floral motifs, such as lotus and peony scrolls, reflect the impact of Chinese designs noted on contemporary manuscript illumination and metalwork. Floral motifs gradually replaced figural compositions, following the development observed in other Mamluk arts.

Among the latest datable pieces of Mamluk textiles are two fragments in the Victoria and Albert decorated with quatrefoils and medallions and inscribed with the benediction "honor to al-Ashraf."[21] The same collection has gold brocade with lotus blossoms, palmettes, and lobed medallions bearing the name "al-Ashraf."[22] These fabrics, assigned to the end of the fifteenth century, may have been made for Sultan Qaitbay (1468–96), whose reign titles included al-Ashraf.

The inscriptions indicate that these luxurious silks were made for the court. Some of them must have been mass-produced without specific patrons in mind and contain the ambiguous dedication *al-sultan al-malik*, which applied to virtually all Mamluk rulers.

Imperial titles were also embroidered on linen. The titles of Nasir al-Din Muhammad, Ismail (1342–45), and Barsbay (1422–38) are found on fragmentary pieces.[23] These may have been used as *tiraz* (inscription) bands on the edges of turbans or on the upper sleeves of garments (see no. II, fig. 5). Embroidered strips also embellished scarves, kerchiefs, and sashes as well as turban wraps. A few of the designs include blazons and imperial symbols (such as a cup or crescent),[24] while the majority have geometric and floral motifs (no. 123). Fragments with embroidery have been found at several sites in Upper Egypt and in recent excavations at Quseir.[25]

Mamluk garments for daily use were made of multicolored pinstriped silks and linens or cottons decorated with embroidered

strips or block-printed designs. Block-printing is thought to have been influenced by Indian cloths exported to the Mamluk world in the fourteenth century. The large number of Indian fabrics found at Fustat attests to their popularity among residents of the capital.[26] Many of these cloths were produced by resist-dying with designs executed in reserve, a technique also used by the Mamluks. The decorative vocabulary of Mamluk printed fabrics relies on local designs, employing inscriptions set against animated scrolls (no. 120) or placed in bands and broken by cartouches (nos. 121–22).

It is almost impossible to comprehend the richness of Mamluk ceremonial garments from the surviving fragments. Textiles played a very important role in the society; they identified different classes and had symbolic uses in court ceremonies.[27] Certain styles and colors were restricted to particular religious or social groups, and the military classes had specific outfits for each regiment and rank. Contemporary terminology used for garments, headdresses, styles, and fabrics is indicative of the complexity in fashion and hierarchy of official dress.

One of the most important ceremonies was the change of clothes at the beginning of the hunting season in autumn. The sultan removed his summer attire and distributed wool garments to his amirs; the court then entered Cairo in a procession. In the spring, clothes were changed again with equal pomp and ceremony. The military aristocracy had different outfits for royal receptions, parades, hunts, polo games, and tournaments in addition to battle dress. Textiles were used to line the streets during official parades and were made into ceremonial and military banners. In the imperial council, each participant was differentiated by the silk hanging placed behind his seat.

Textiles also served to identify sultans, amirs, and their regiments during military campaigns. Banners, cloaks, and blankets, as well as saddlecloths for camels and horses, were appliquéd with blazons (no. 124). Some Mamluk appliqués are extremely delicate, adorned with inscriptions and arabesques recalling the intricate patterns of woven silks.[28] This technique of appliqué is still used in Cairo to produce large ceremonial tents hired for weddings, funerals, and other special events.

The most prestigious Mamluk fabric was the *kiswa*, the black cloth embroidered with Koranic verses in gold and used to cover the Kaaba. Production of the *kiswa* was zealously guarded as an Egyptian privilege. Each year a new *kiswa* was sent to Mecca in a *mahmal* or ceremonial litter accompanied by pilgrims. When the *mahmal* arrived at the Kaaba, the *kiswa* was replaced, and the old one was cut up and distributed among the pilgrims. Baybars I was the first Mamluk sultan to send a *mahmal* to Mecca, and Egypt continued to supply the *kiswa* until the beginning of the twentieth century.

Rugs

The Mamluk rug is perhaps the most striking of all Islamic carpets, woven in jewellike tones of red, green, and blue, with an almost silky

iridescence (nos. 125–28). Mamluk rugs are made of wool, except for a singular example in Vienna, which is woven in silk.[29]

The design of the rugs is unique to the Mamluk world, consisting of a square that is transformed into a rectangle by the addition of two oblong panels. This rectangular component is either single and framed by a wide border or triple, in which case the central square is more prominent and all three units are enclosed by a border. The only exception is the celebrated five-partite rug owned by the Metropolitan Museum of Art in New York.[30]

The decoration of the central square utilizes geometric units radiating from the center. The core is often a multipetaled rosette enclosed by a star, which is in turn placed within a medallion. The encircling zones grow larger as they open out from the core, forming a series of stars, hexagons, octagons, and polygons, each subdivided and decorated in contrasting colors with alternating motifs. The overall effect is similar to the astral compositions of manuscript illumination, woodwork, and inlaid stone. The oblong panels flanking the central square are either tripartite, their components echoing the central design, or contain rows of stylized cypresses, palm trees, papyrus sprays, abstracted florals, and arabesques.[31] The border often consists of medallions alternating with oval cartouches; some later examples have overall floral patterns in the borders.

The origin of Mamluk carpets is quite mystifying. The earliest record of rug weaving under the Mamluks exists in a statement made in 1474 by the Venetian traveler Barbaro in which he describes the carpets of Tabriz and makes a passing remark about these being superior in quality to carpets produced in Cairo.[32] Mamluk rugs were thought to have been made in Damascus, based on Venetian sources, which used the term "damask rugs," most likely referring to their brilliant colors. Friedrich Sarre was the first to identify them with Egypt, and Kurt Erdmann's extensive research has proven that their production was begun in Cairo in the last quarter of the fifteenth century.[33]

Why these rugs made such a sudden appearance in a tropical region where carpets were not required as floor coverings remains an intriguing question. In contrast to other Mamluk arts, which during their formative years relied on earlier techniques established by the Ayyubids, there was no precedent of pile weaving, which the Mamluks could have inherited, nor any evidence of an extensive rug industry before the end of the fifteenth century. The Mamluk rug appears in all its glory from the day it was born, contradicting all other artistic traditions, which evolve from archaic origins and evolve through experimental stages before reaching maturity.

Perhaps an explanation can be provided by an analysis of the political developments of the period. In the fifteenth century the rug weaving centers of the Near East were located in Anatolia and Iran. The complicated alliances and battles between the Mamluk, Ottoman, and Turkman states of Iran and Anatolia caused continual shifts

in political boundaries and movements of peoples. The Akkoyunlu Turkmans finally put an end to the Karakoyunlu Turkmans in 1467, and Tabriz fell to the new rulers. Some artisans chose to remain in their city and continued weaving rugs, as witnessed by Barbaro who was there eight years later; others must have sought employment in the Ottoman and Mamluk capitals. The Mamluks had offered protection to previous émigrés from Iran, including Sultan Ahmad of the Jalairid house and Kara Yusuf of the Karakoyunlu dynasty.

The fall of the Karakoyunlu Turkman state coincides with two remarkable occurrences in the Mamluk world: the appearance of rugs and the beginning of an exceptional painting style. If Karakoyunlu weavers did indeed come to Cairo at the end of the 1460s, they must have found highly supportive patronage at the court of Qaitbay. One can assume that pile weaving flourished under the stimulus provided by the sultan and the expertise of the newcomers. Rugs were made for both religious and residential structures, their proportions determined by the dimensions of large reception halls in palaces and mansions or by smaller prayer chambers in religious establishments. The decorative themes were inspired by the magnificent geometric designs of the art and architecture of the capital and the colors reflected the brilliant tones in stained glass.

This new form of interior decoration was an immediate success, and the rug weavers produced many carpets both for domestic use and for export. As the industry flourished, the reputation of the Mamluk weavers grew, and they came to be among the most sought-after artists. Cairo continued to produce and export rugs up to the seventeenth century, as indicated by an official edict of 1585 in which the Ottoman court called eleven specific Egyptian weavers to İstanbul and by an eyewitness account by the French traveler Thévenot, who visited the former Mamluk capital in 1663 and saw weavers making carpets there.[34]

Inscriptions, one of the most characteristic features of Mamluk art, are noticeably absent in rug decoration. None of the carpets are dated and the patrons and artists remain unknown. There are two examples, however, which bear composite blazons associated with the court of Qaitbay. This blazon consists of a napkin in the upper field, a cup charged with a pen box flanked by two horns in the central zone, and a second cup in the lower field (see no. 124). The blazon is also found in a fragmentary rug in the Textile Museum in Washington, D.C., and in the four corners of a smaller intact rug in the Barbieri Collection.[35] The Textile Museum fragment is thought to have originally been tripartite, measuring 11×4.4 meters (36×14 feet), which makes it one of the largest produced by Mamluk weavers. These are the only two known rugs with blazons. Since both sultans and amirs used this heraldic symbol in the late fifteenth century, the patrons of these rugs cannot be properly identified.

Geometric and astral compositions of Mamluk rugs were eventually abandoned in favor of curvilinear designs and floral motifs, which were popular in the Ottoman court. One of the square Egyptian rugs executed in this style during the second half of the sixteenth century is decorated with Ottoman motifs representing tulips, serrated leaves, and palmettes.[36] A unique seventeenth-century prayer rug represents a stemmed cup "charged" with nine mosque lamps placed between the columns of a mihrab; the inscription at the top is rendered in Hebrew, indicating that it was made for a synagogue.[37] The 1674 inventory of the Yeni Cami in İstanbul lists several Egyptian rugs, including multi-niche prayer rugs, the smallest of which contained 10 mihrabs, while the largest had 132 mihrabs.[38] These were probably among the last examples of the great rug industry that had begun in Egypt during the late Mamluk period.

Notes

1. Cairo, Museum of Islamic Art, 3740 (Cairo 1969, no. 250).
2. Berlin, Museum für Islamische Kunst, I 3191 (Berlin 1971, no. 527, pl. 73).
3. Cairo, Museum of Islamic Art, 23903 (Cairo 1969, no. 251).
4. Spuler 1978, p. 162, no. 91.
5. Falke 1936, figs. 308–9; Schmidt 1958, fig. 146.
6. London, Victoria and Albert Museum, 664-1896 (London 1976, no. 20).
7. Kendrick 1924, pls. XXI–XXII and XXIV; Falke 1936, fig. 294; Schmidt 1958, figs. 91, 102, and 108.
8. Falke 1936, figs. 288–93; Schmidt 1958, fig. 90.
9. London, Victoria and Albert Museum, 8639–1863 (Kendrick 1924, no. 994, pl. XXII).
10. In Danzig (now Gdánsk) and Berlin (Falke 1936, fig. 287; Schmidt 1958, fig. 92; London 1976, no. 15).
11. Lane 1971, p. 4.
12. New York, Metropolitan Museum of Art (Dimand 1944, fig. 170; Schmidt 1958, fig. 129). Another striped silk is published in Lamm 1935, fig. 6.
13. Lamm 1935, fig. 7.
14. Falke 1936, fig. 305; Schmidt 1958, fig. 112.
15. Falke 1936, figs. 285–86; Schmidt 1958, figs. 96 and 130.
16. Berlin fragment is published in Falke 1936, fig. 317; the one in London, Victoria and Albert Museum, is in Kendrick 1924, pl. XII; Cairo, Museum of Islamic Art, 2226 (Herz 1907, fig. 50; Cairo 1969, no. 256). See also Schmidt 1958, fig. 131.
17. Cairo, Museum of Islamic Art, 15608 (Cairo 1969, no. 252).
18. Cairo, Museum of Islamic Art, 15626 (Wiet 1958, pp. 241–43, pl. III; Cairo 1969, no. 253).
19. Cairo, Museum of Islamic Art, 15554 (Cairo 1969, no. 254).
20. Cairo, Museum of Islamic Art, 23899 (Cairo 1969, no. 262).
21. London, Victoria and Albert Museum, 817–1898 (Kendrick 1924, pl. XI) and 1174–1900.
22. London, Victoria and Albert Museum, 753–1904 (Kendrick 1924, pl. XV).
23. Cairo, Museum of Islamic Art, 14529 and 24264 (Izzi 1974, figs. 7–8); same collection, 13736 and 14514 (Izzi 1974, figs. 9–10). Barsbay's name appears on a fragment in the same collection, 800.
24. See Lamm 1937, figs. 2 and 12.
25. Whitcomb and Johnson 1979, pp. 211–15.
26. Pfister 1938.
27. Many of these outfits and their textual references are given in Mayer 1952.
28. Lamm 1937.
29. Vienna, Österreichisches Museum für angewandte Kunst, T 8382 (London 1976, no. 35; Vienna 1977, no. 1).
30. New York, Metropolitan Museum of Art, 1970.105 (Ellis 1967, fig. 13; Dimand and Mailey 1973, fig. 181; Metropolitan 1975, last page).
31. Papyrus sprays, once thought to be unique to rug weavers, appear on a late-fifteenth-century tinned copper tray (Drouot 1980, no. 77).
32. Kühnel and Bellinger 1957, p. 5.
33. Sarre 1921 and 1924; Erdmann 1938, 1940, and 1961.
34. Erdmann 1938, pp. 187–88 and 195–96.
35. Washington, D.C., Textile Museum, 1965.49.1. These rugs are discussed in Ellis 1967.
36. Washington, D.C., Textile Museum, R 16.4.1. (Mackie 1980, fig. 185).
37. Kühnel and Bellinger 1957, pls. XXX–XXXI.
38. Erdmann 1938, p. 197.

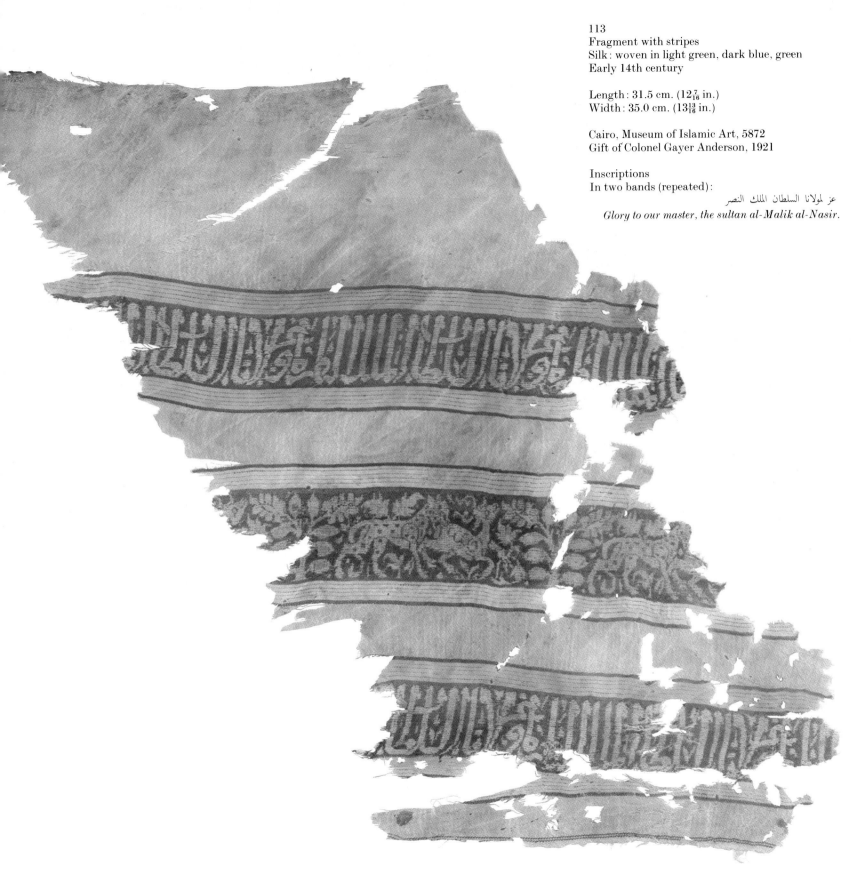

113
Fragment with stripes
Silk: woven in light green, dark blue, green
Early 14th century

Length: 31.5 cm. (12$\frac{7}{16}$ in.)
Width: 35.0 cm. (13$\frac{13}{16}$ in.)

Cairo, Museum of Islamic Art, 5872
Gift of Colonel Gayer Anderson, 1921

Inscriptions
In two bands (repeated):

عز لمولانا السلطان الملك النصر

Glory to our master, the sultan al-Malik al-Nasir.

This fragmentary silk is woven with three horizontal bands: the upper and lower panels bear inscriptions; the central band depicts a leopard pursuing a gazelle flanked by floral sprays with two large lotus blossoms and symmetrically placed oval leaves. Three units of the repeat are visible.

The light green ground of the piece is extremely faded and stained, its original color virtually lost. The bands are in dark blue with the design reserved in light green; touches of bright green are visible in the floral sprays between the combating animals. Each band is enclosed by a series of five lines, the outermost rendered in dark, almost black, blue.

This double cloth, woven with two sets of silk warp and weft, was a part of a larger piece, fragments of which are now in the Victoria and Albert Museum in London and the Benaki Museum in Athens.[1] Another piece owned by the Museum of Islamic Art in Cairo has the pattern reversed and was rendered in dark blue on a light green ground.[2] The inscription on this fragment is properly read only on the reverse, suggesting that the weaver erred when transferring the design or he was illiterate and did not understand the inscription.

Bands with predators and prey appear frequently on early Mamluk textiles (see no. 117) and are encounted in metalwork dating from the late thirteenth century and first half of the fourteenth century (see, for instance, nos. 10, 14–16, 18–19, and 21–22).

The inscription on the Cairo fragment indicates that the cloth was made for royalty, possibly for Sultan Nasir al-Din Muhammad, whose name included the honorific titles al-Malik al-Nasir. This sultan was renowned for his taste for luxurious fabrics. His name and titles appear on several exquisite silks, including an example at the Metropolitan Museum of Art in New York;[3] a piece in Cairo found at Jabal Drunka, near Asyut in Upper Egypt;[4] a fragment from al-Azam, Upper Egypt, now in the Victoria and Albert;[5] and a cap in the Röhss Museum of Arts and Crafts in Sweden.[6]

Published
Wiet 1930, no. 86.
Ross 1931, p. 327, fig. 2.
M. H. Zaki 1948, p. 366 and fig. 296.
M. H. Zaki 1956, no. 607 and fig. 607.
Mostafa 1961, p. 33.
Cairo 1969, no. 257.

Notes
1. London, Victoria and Albert Museum, T122-1921 (Kendrick 1924, no. 959, pl. x; London 1976, no. 16).
2. Cairo, Museum of Islamic Art, 9951 (Cairo 1969, no. 257).
3. New York, Metropolitan Museum of Art (Dimand 1944, fig. 170; Schmidt 1958, fig. 92).
4. Cairo, Museum of Islamic Art, 2226 (Herz 1907, fig. 50). Other fragments of this piece are mentioned as being in East Berlin and Leningrad (Cairo 1969, no. 256).
5. London, Victoria and Albert Museum (Kendrick 1924, no. 957, pl. xii).
6. Lamm 1935, fig. 7.

114
Fragment with star and crescent
Silk: woven in ivory, light blue, dark blue
14th century

Length: 13.0 cm. (5⅛ in.)
Width: 7.5 cm. (2¹⁵⁄₁₆ in.)

Cairo, Museum of Islamic Art, 15532
Purchased 1946

This small fragment represents a complex triple-cloth weaving technique with three sets of warp and weft, of which there are very few Mamluk examples preserved (see also no. 115).[1]

The fragment with a selvage on one side is decorated with two squares. In the center of one is a crescent with a six-petaled rosette between its arms. The crescent and rosette are rendered in ivory on a dark blue ground framed by a thin ivory band. The surrounding zone is filled with an overall geometric pattern executed in ivory on dark blue; it consists of connected eight-pointed stars with light blue cores.

In the center of the other unit is an eight-petaled rosette framed by a diamond enclosed within a square. The next zone has a series of triangles with lancet leaves, creating an eight-pointed star. The outlines of the design are ivory and the ground is dark blue with light blue applied to the lancet leaves and the surrounding field. Dark blue lobed roundels fill the corners and ivory foliate elements appear between the arms of the star. An elaborate version of this eight-pointed star was employed on another woven silk (no. 118).

The crescent, a popular Mamluk decorative motif, is found on many textiles as well as on glass, ceramic, and metal objects (see nos. 47 and 115).[2] It was used as a heraldic symbol on two brass basins: one, dated late thirteenth century, was made for a lady named Fatima, daughter of Amir Sunqur al-Asar; a second bears the name Ali ibn Hilal al-Dawla, who died in 1339.[3] The crescent may also have served as an imperial symbol connected with the house of Sultan Qalawun whose descendants reigned until 1390.

Published
Mostafa 1958, no. 8.
Cairo 1969, no. 261.

Notes
1. A beautiful example in Washington, D.C., Textile Museum, 2.289, now thought to be Mamluk, has the same colors (Mackie 1972, fig. 10).
2. It appears on a shirt in Berlin, Museum für Islamiche Kunst, I 3191 (Berlin 1971, no. 527, fig. 73); a block-printed linen in Cleveland, Cleveland Museum of Art, 29.907; and two fragments in Cairo, Museum of Islamic Art, 12667/1–2 (Cairo 1969, nos. 259–60). It is also found on pottery and metalwork (Mayer 1933, pls. XI–XII, XLII, and XLVII). See also D. S. Rice 1952, pp. 565–69, 577, figs. 2, 7b, pls. 6–7.
3. Rice suggests that the crescent represented the *shadd al-dawawin*, superintendent of chanceries, an office held by Fatima's father as well as by Ali ibn Hilal (D. S. Rice 1952, p. 565).

115
Fragment with ogival pattern
Silk: woven in tan, ivory, dark blue
14th century

Length: 16.0 cm. (6¼ in.)
Width: 30.0 cm. (11¹³⁄₁₆ in.)

Toronto, Royal Ontario Museum, 980.78.44a–b
Gift of Albert and Frederico Friedberg, 1980
Ex-Charles S. Wilkinson Collection

This fragment employs the same triple-cloth technique as the previous example (no. 114). The pattern consists of large ogival units linked to one another by pendants formed by a pair of crescents flanking eight-petaled rosettes between the ogees. The large ogival units contain a central roundel wreathed by lotus blossoms and buds.

The field of the illustrated side is tan (beige and brown), with ivory (actually ivory and light blue) used in the ogival units and in the crescents and rosettes. Dark blue (blue and black) appears in the outlines of the units, in the rosettes between the crescents, in the roundels in the centers of the ogees, and in the floral wreaths. The roundels also have a thin tan border. The other side, not illustrated, has a blue field and brown units with ivory details and outlines, a result of the triple sets of warp and weft.

Similar ogival patterns appear on two other textiles (nos. 116 and 118). One of them (no. 118) has blossoms with spiked petals that are like those in the lotus wreath. The closest parallel for this scroll is on a contemporary glass vessel (no. 51).

The roundels in the centers of the ogees resemble the blazon of the *jashnigir* (imperial taster), which shows a round table. A number of textiles utilize motifs recalling blazons (such as crescents, fleur-de-lis, roundels, and lions), most likely inspired by heraldic emblems but also used as decorative elements.

Unpublished

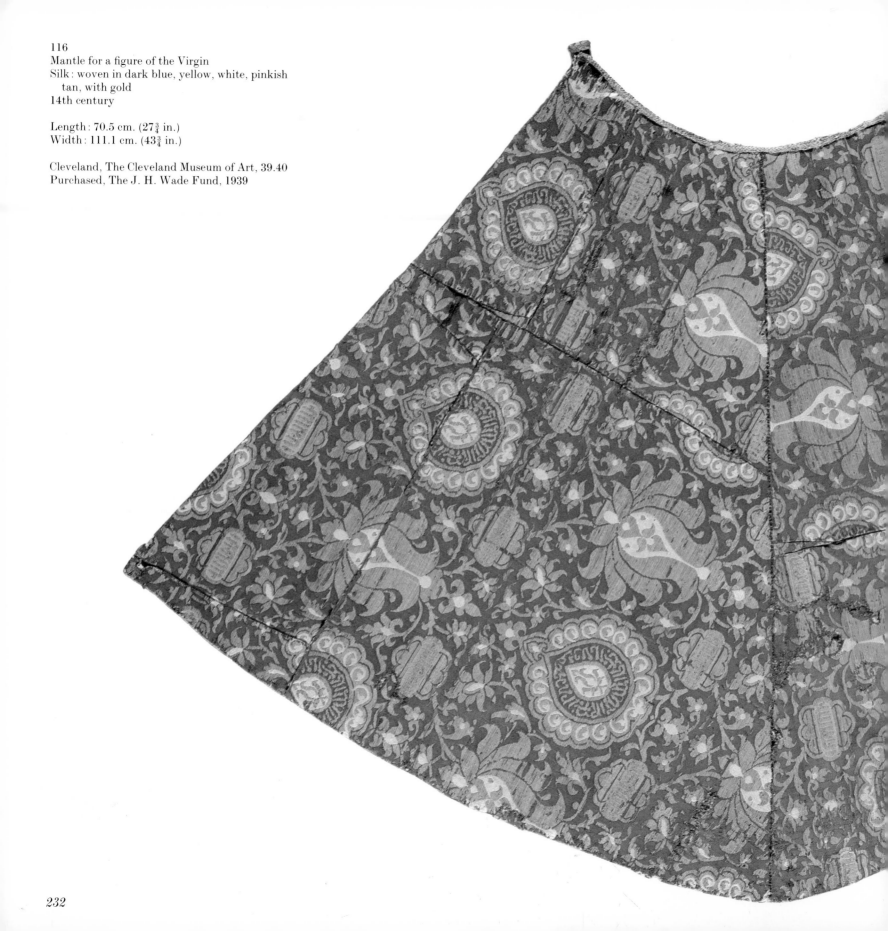

116
Mantle for a figure of the Virgin
Silk: woven in dark blue, yellow, white, pinkish
 tan, with gold
14th century

Length: 70.5 cm. (27¾ in.)
Width: 111.1 cm. (43¾ in.)

Cleveland, The Cleveland Museum of Art, 39.40
Purchased, The J. H. Wade Fund, 1939

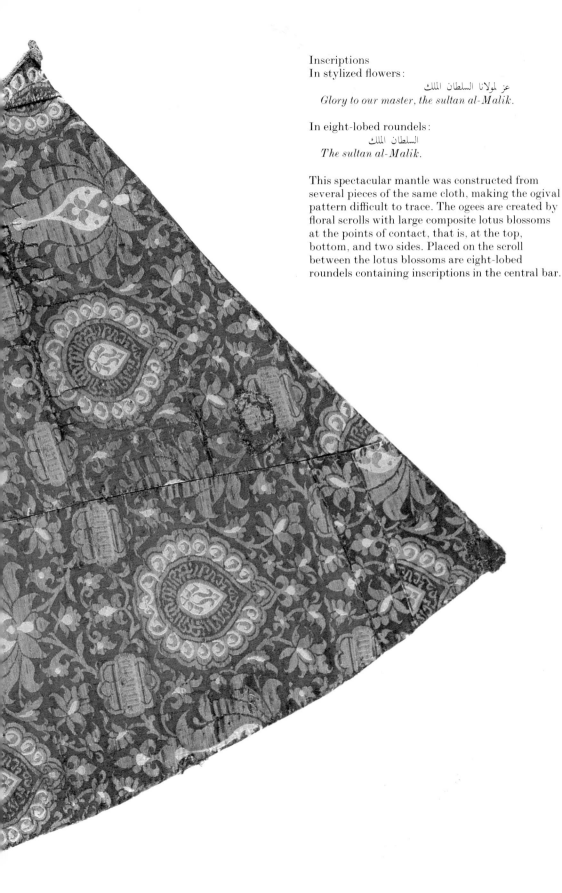

Inscriptions
In stylized flowers:

عز لمولانا السلطان الملك

Glory to our master, the sultan al-Malik.

In eight-lobed roundels:

السلطان الملك

The sultan al-Malik.

This spectacular mantle was constructed from several pieces of the same cloth, making the ogival pattern difficult to trace. The ogees are created by floral scrolls with large composite lotus blossoms at the points of contact, that is, at the top, bottom, and two sides. Placed on the scroll between the lotus blossoms are eight-lobed roundels containing inscriptions in the central bar.

In the middle of each ogee is a highly stylized floral element with three concentric rings: the core has a lotus blossom; the second ring bears a circular inscription, one half of which is the mirror image of the other; and the final lobed ring is adorned with floral motifs. Small leaves, lotus buds, and blossoms grow from the ogival scroll and create a densely filled field.

A tension is created in the movement of the design by reversing the direction of certain elements: the large lotus blossoms in the ogival units face one direction, while the inscriptions in the eight-lobed roundels and the stylized blossom in the center face in an opposite direction.

The ground of the fabric is dark blue and the design is rendered in gold; details are executed in white and pinkish tan; yellow augments the gold.

According to a previous owner, the mantle came from a church near Valencia, Spain. Mamluk silks, cherished at European courts, were often used as ecclesiastical vestments. One of the fabrics with an ogival pattern was made into a priest's chasuble, now owned by the Victoria and Albert.[1] This striking silk, which contains silver and gold, was sewn in Spain, as was the Cleveland mantle. Another interesting ogival silk was made into a child's shirt or robe, now in Berlin.[2] This fragmentary garment contains the bodice with an opening for the neck and a frontal slash fastened by buttons and loops. The ogival units are decorated with a pair of addorsed griffins, enclosed by a band of roundels alternately filled with inscriptions and crescents with six-petaled rosettes. These units, linked by roundels with inscriptions or animals, are placed on a checkerboard-pattern ground. The Berlin shirt is one of the rare extant Mamluk garments.

A fragment with a design similar to that of the Cleveland mantle was used as the orphrey (ornamental band) of a vestment.[3] It bears an identical inscription in the stylized blossoms, with the title al-Ashraf in the eight-lobed roundels. This title was used by several Mamluk sultans, including Qaitbay (1468–96), which suggests that silks with ogival patterns were produced to the end of the fifteenth century.

Published
Underhill 1939, pp. 144–45.
Cleveland 1958, no. 715.
Cleveland 1969, p. 214.
Cleveland 1978, p. 270.

Notes
1. London, Victoria and Albert Museum, 664–1896 (London 1976, no. 20).
2. Berlin, Museum für Islamiche Kunst, I 3191 (Berlin 1971, no. 527, fig. 73).
3. London, Victoria and Albert Museum, 753–1904 (Kendrick 1924, no. 973, pl. xv; London 1976, no. 19).

117

Cap with stripes
Silk: woven in dark blue, white, tan, green, light
 green, dark brown; quilted
14th century

Height: 12.7 cm. (5 in.)
Diameter: 17.2 cm. (6¾ in.)

Cleveland, The Cleveland Museum of Art, 50.510
Purchased, The John L. Severance Fund, 1950

Inscriptions
In bands (repeated):

عز لمولانا السلطان

Glory to our master, the sultan.

Although complete garments from the Mamluk
period are extremely rare, several collections have
a substantial number of caps, most of which are
quilted or adorned with embroidered bands.[1]

The Cleveland cap, one of the best preserved
examples, is said to be from an Egyptian grave.
The fabric from which the cap was made has three
vertical bands: the first is dark blue with white;
the second contains tan, green, light green, and
dark brown stripes; and the last is dark blue with
a frieze of running animals executed in white.

The cap is constructed of seven sections: a
single piece forms the headband with six triangles
stitched together to make the crown. The entire
piece was quilted using a bastlike fiber backing, a
knob was added at the apex.

The pattern of the silk incorporates several
themes found on Mamluk textiles: bands with
running animals and inscriptions, executed in
reserve, similar to a fragment discussed earlier
(no. 113); and thin multicolored stripes, one of the
most popular designs on Mamluk silk, cotton, and
linen fabric.

Caps were worn by men, women, and children,
as observed in manuscript illustrations. It has
been suggested that they represent a type of hat
used indoors called *kalautah*; a kerchief may have
been wound around it when the owner went
outside.[2] As indicated by the large number of
surviving examples, this type of headdress was
very common. One of the rare royal examples
bears an inscription with the name of Sultan Nasir
al-Din Muhammad.[3]

Unpublished

Notes
1. Several caps are in Cairo, Museum of Islamic Art; London,
 Victoria and Albert Museum; and New York, Cooper-Hewitt
 Museum of Design and Decorative Arts.
2. Mayer 1952, pp. 28–29.
3. In Röhss Museum of Arts and Crafts, Sweden, 111/35 (Lamm
 1935, fig. 7).

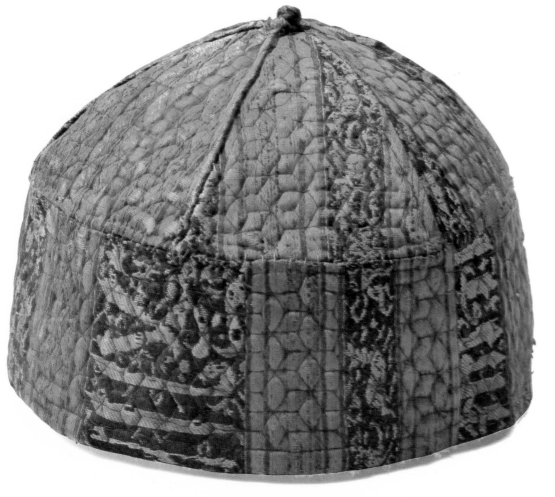

118

Fragment with ogival pattern
Silk: woven in dark blue, light green
14th–15th century

Length: 21.6 cm. (8½ in.)
Width: 22.2 cm. (8¾ in.)

Cleveland, The Cleveland Museum of Art, 18.189
Purchased, The Dudley P. Allen Income Fund,
 1918

This handsome fragment has medallions enclosed
by an ogival pattern. The ogival compartments
are composed of a scrolling vine with peonies and
lotus blossoms. The central medallions have an
eight-petaled rosette in the core within a twelve-
pointed star surrounded by an eight-petaled
blossom embellished with trefoils and lobed spiked
buds. The ground of the fabric is dark blue; the
pattern, originally executed in pale yellowish
green, has faded and now appears as light yellow.

The blossoms in the floral scroll resemble those
seen in fourteenth- and fifteenth-century
manuscript illumination (see nos. 4 and 8) as well
as motifs employed on Chinese silks and blue-and-
white ceramics. According to museum records,
pieces from the same textile are now in Berlin,
Brussels, and Paris.[1]

Ogival patterns were frequently utilized by
Mamluk weavers (see nos. 115–16) and continued
to be popular in the Ottoman period when
traditional Turkish motifs were incorporated into
the design.

Unpublished

Notes
1. The Berlin fragment is published in Falke 1936, fig. 325.

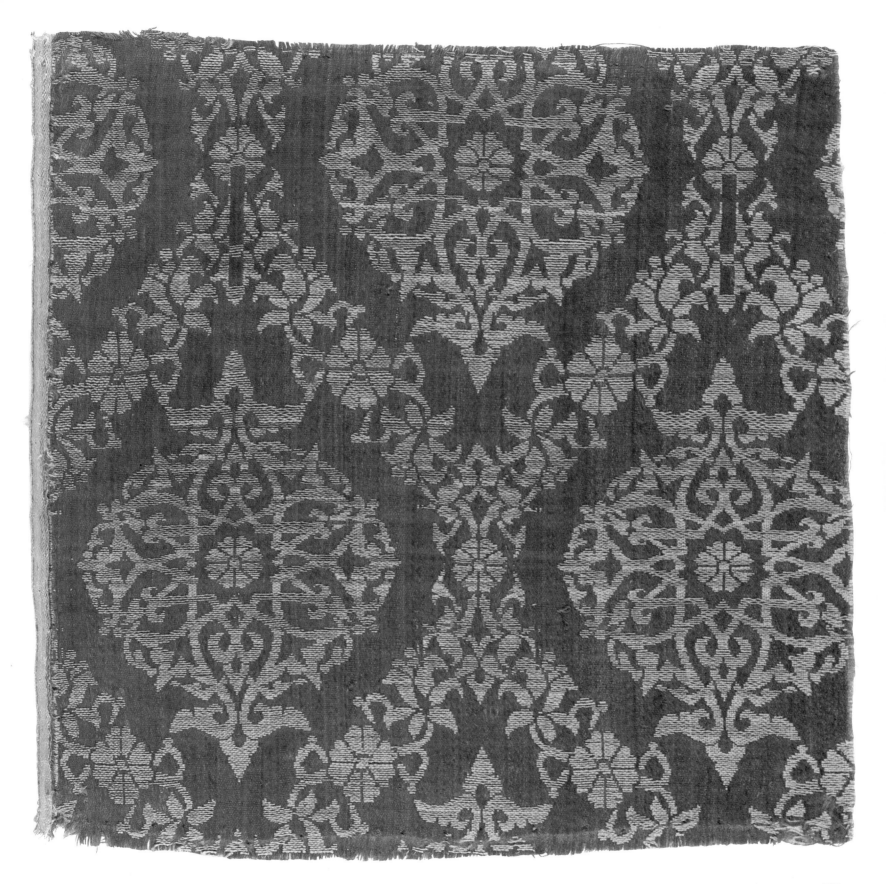

235

119

Fragment with stripes
Silk: woven in dark blue, turquoise, ivory
15th century

Length: 48.9 cm. (19¼ in.)
Width: 29.2 cm. (11½ in.)

New York, Madina Collection, T10
Ex-Kelekian Collection

This vertically striped fragment is in two pieces;
the stitches joining the segments and those
forming the hem on the lower diagonal appear to
be contemporary with the fabric. It must have been
part of a garment requiring piecing and hemming.

The pattern is based on a repeat of dark blue
bands with two designs separated by turquoise
strips. One of the bands is composed of a row of
lotus blossoms, rendered in ivory with turquoise
outlines; the interstices are filled with stylized
leaves using the same color scheme. The second
band has a row of squares with an abbreviated
inscription written in ivory and enclosed by a
turquoise lozenge with ivory trefoils. The lozenges
are joined by pairs of stylized lotus blossoms
flanked by dots.

The brilliance of the turquoise and density of
the dark blue are remarkably well preserved.
A smaller fragment of the same textile is owned
by the Metropolitan Museum of Art.[1]

The inscriptions in the lozenges were most likely
intended to represent the word *al-sultān*.
The abbreviated form of this word is not an
uncommon feature in Mamluk art and appears in
several other textiles, including a fifteenth-
century block-printed linen fragment in the
Cleveland Museum of Art.[2]

Unpublished

Notes
1. New York, Metropolitan Museum of Art, 1979.462.2.
2. Cleveland, Cleveland Museum of Art, 29.907.

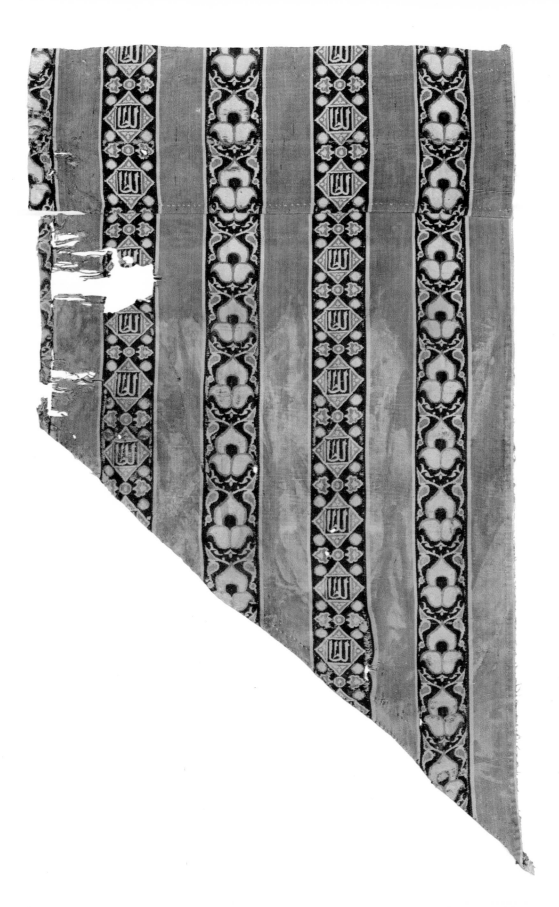

120
Fragment with inscription
Linen: printed in brown on beige
Early 14th century

Length: 19.0 cm. (7½ in.)
Width: 21.3 cm. (9³⁄₁₆ in.)

Cairo, Museum of Islamic Art, 14472
Purchased 1939

Inscriptions

المحبة

Affection.

The next group of textiles (nos. 120–22) are block-printed on off white, ivory, or beige linen or cotton and use for the design only a single color, such as brown, dark blue, or gray.

One of the earliest printed fabrics, this fragment contains an inscription placed on a scroll composed of animal heads. Included amidst the leaves and buds is a bird and the heads of a griffin, lion, hare, and possibly a man. The inscription and scroll are reserved against the brown background.

Arabesques composed of animals were among the decorative repertoire of Mamluk metalworkers and are found on several inlaid brasses (see nos. 10, 13, 22, and 24). One of the most striking compositions appears on the lid of the pen box of Abu'l-Fida (no. 24), which contains a bold inscription on a scroll adorned with similar animals.

Published
Cairo 1969, no. 269 and fig. 47.

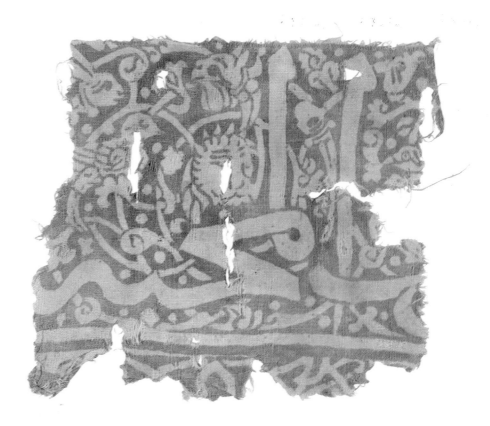

121
Fragment with inscriptions, stars, roundels
Linen : printed in dark blue on off white
Late 15th century

Length : 35.5 cm (14 in.)
Width : 41.0 cm. (16⅛ in.)

Cairo, Museum of Islamic Art, 8204
Purchased 1928

Inscriptions
Band on top (repeated) :

الصبر نعم الناصر ولكل شيء اخر

*Patience is blessed with success and everything is
rewarded.*

This fragment combines an overall repeat pattern
with a distinctive inscription band used as a
border. The inscription is reserved on a dark blue
ground and enhanced by strips of braids and
scrolls placed between the vertical letters.
The wood block used in this section was about 16
centimeters (6¼ inches) wide and was repeated at
least three times.

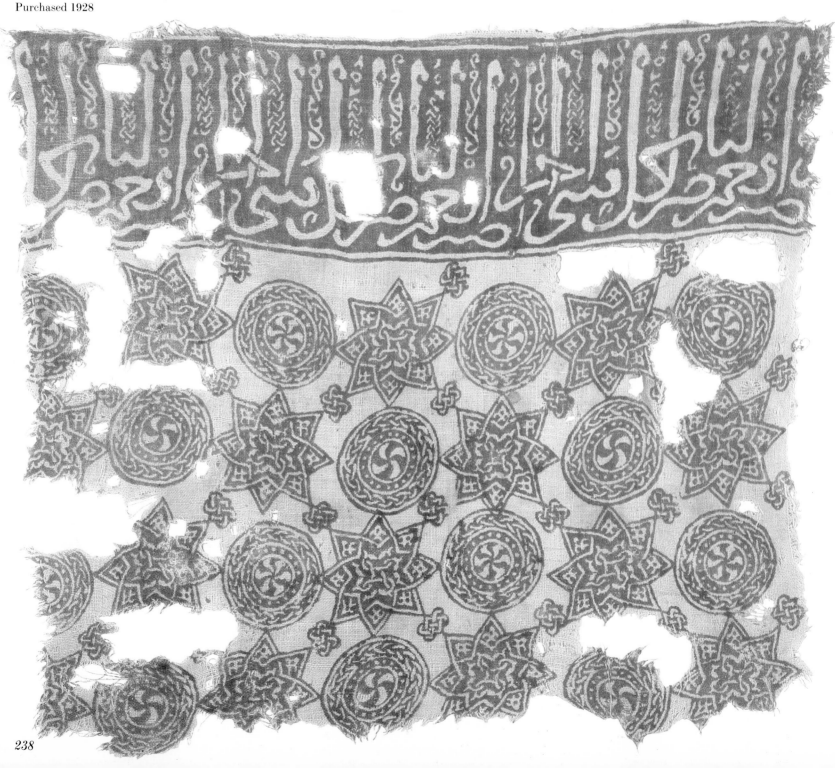

The lower portion is composed of concentric roundels and eight-pointed interlaced stars linked by knots. The roundels contain either four-petaled or six-petaled swirling rosettes framed by beaded bands and braids. The stars are composed of pairs of overlapping quatrefoils with additional interlace in the center. Four blocks were repeated to create the pattern: stars, concentric roundels with four or six petals, and knots.

Printed fabrics using different wood blocks were mass-produced. There also exist block-stamped textiles depicting human figures and animals.[1]

Similar to the early Mamluk fragment with inscriptions (no. 120), this printed cloth reveals the impact of contemporary metalwork. The same style of script and decorative motifs can be seen on several contemporary metal pieces (see nos. 36–39). Inscriptions placed against a scroll and decorative units composed of knots and stars formed by overlapping quatrefoils became fashionable during the third quarter of the fifteenth century and continued to be employed in Mamluk art for several generations.

Published
Pfister 1938, p. 75 (M.A. 8204) and pl. XXVIIIb.
Cairo 1969, no. 270 and fig. 48.

Notes
1. The Textile Museum, Washington, D.C., has a printed cloth with a series of lions; the figure of a man appears on a fragment in Cairo, Museum of Islamic Art, 7924 (Mostafa 1961, fig. 67).

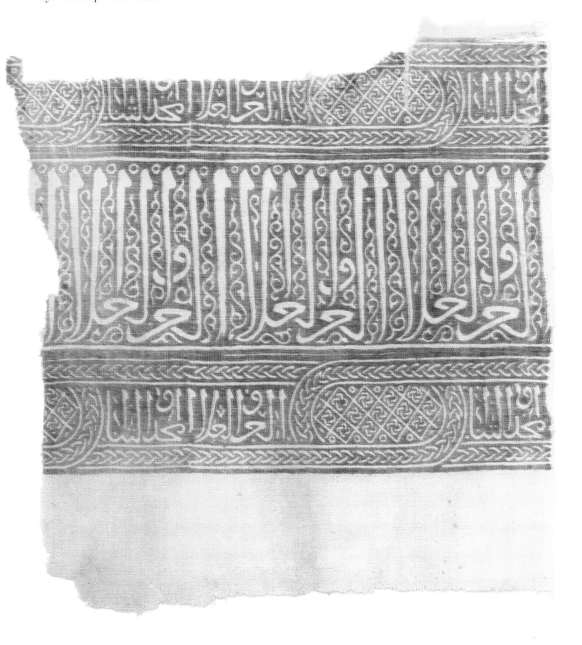

122
Fragment with inscriptions
Cotton: printed in gray on off white
Late 15th century

Length: 24.0 cm. (9 7/16 in.)
Width: 23.8 cm. (9 3/8 in.)

Washington, D.C., The Textile Museum, 73.725
Purchased in Cairo, 1954

Inscriptions
Upper and lower panels (repeated):

<div dir="rtl">العز والعال المجد والثنا</div>

Glory and sublimity, exhaltation and praise.

Central panel (repeated):

<div dir="rtl">العز والعال</div>

Glory and sublimity.

This fabric is decorated with a wide inscription band, resembling the fragment discussed earlier (no. 121). Since complete garments have not survived, it is difficult to imagine the location of this band on the finished robe.

The design was rendered in reserve using a large wood block about 15 centimeters (5 7/8 inches) wide. This fragment contains 1 1/2 repeats, the joints of the block are visible in the braided bands.

The composition is divided into three horizontal registers. The upper and lower bands are identical and about half the height of the central unit. They are decorated with inscriptions interrupted by oval cartouches enclosing latticework filled with knots and roundels. A continuous braid defines the panels and loops around the cartouches.

The central band has a hierarchic inscription with a row of roundels on the top and scrolls with split leaves between the vertical letters.

This fragment is a perfect example of the impact of metalwork on printed textiles. Its model must have been similar to a contemporary bowl and basin (nos. 37–38).

Published
Welch 1979, no. 26.

123
Fragment with octagons
Beige silk: embroidered with yellow, green,
 brown, black
15th century

Length: 8.5 cm. (3⅜ in.)
Width: 28.0 cm. (11 in.)

Cairo, Museum of Islamic Art, 12619/11
Purchased 1934

A group of Mamluk silk, linen, and cotton fabrics
is embellished with embroidered bands,
continuing the Ayyubid practice.[1] Surviving
examples of Mamluk embroidery are compara-
tively simple and often very delicate. Some were
used to decorate the bodices of shirts and robes
and the hems of skirts and sleeves; others adorned
the edges of fine cotton or linen cloth wrapped
around the head. Among the embroidered Mamluk
pieces are examples bearing the names of sultans,
including Nasir al-Din Muhammad and Barsbay,
which may have been used as inscription bands
(*tiraz*) on turban wraps or on garments.[2]

This small fragment has an embroidered band
composed of a series of square units separated by
vertical strips. In the center of each square is a
yellow roundel surrounded by eight petals
alternately rendered in green and brown.
The blossom is set within a green octagon, with
yellow triangles in the corners forming a square.
The vertical strips are stitched in yellow and
enhanced with brown dots. Black thread is used to
form the borders around the units.

Unpublished

Notes
1. Cairo, Museum of Islamic Art, 3085 (Wiet 1930, no. 87; Cairo
 1969, no. 255).
2. Cairo, Museum of Islamic Art, 14529 (Izzi 1974, fig. 7); same
 collection, 8000. See also Izzi 1974, fig. 8.

124
Fragment with composite blazon
Beige wool: woven; appliquéd in blue, green,
 yellow, red, white
Late 15th century

Length: 22.8 cm. (9 in.)
Width: 30.5 cm. (12 in.)

New York, The Metropolitan Museum of Art,
 1972.120.3
Purchased, The Rogers Fund, 1972

Woven fabrics appliquéd with heraldic symbols
are among the most characteristic Mamluk
textiles. Many are coarsely executed and represent
the full range of blazons, including lions, stemmed
cups, napkins, and swords. One of the more
unusual pieces depicts a figure riding a mule,
thought to be the emblem of the courier.[1] Blazons
identified the ranks of amirs and were used on
banners, baggage, tents, and blankets as well as
on the saddlecloths of horses and camels.

This example has a composite blazon placed in a
circular shield, enclosed by a lobed medallion
executed in blue. Some of the appliqués have
disintegrated, and the original fabrics are visible
only in minute areas. The shield is divided into
three fields designated by red, yellow, and dark
blue. The upper field bears a white *buqja* or cloth
in which clothes are wrapped, commonly called a
"napkin," which was the symbol of the *jamdar*
(master-of-the-robes). The lower field has a white
stemmed cup identifying the *saqi* (cup-bearer).
The central field shows a blue stemmed cup
charged with a white pen box, the combined
symbols for the *saqi* and *dawadar* (secretary);

flanking the cup is a pair of dark green elements
with white tips. These elements were thought to
be "trousers of nobility," because they suggest the
legs of loose pants. Recently, they have been
identified as drinking horns or powder horns, both
of which have obscure meanings.[2]

Burji Mamluks used blazons with composite
charges. In contrast to the Bahri blazons, which
represented a distinct office held by an individual,
these composite blazons were shared by a corps of
amirs who served one master.[3]

The particular combination of six heraldic signs
seen on the appliqué was used by Sultan Qaitbay
(1468–96) and his amirs. It was also employed by
Sultan Janbalat (1500–1501) and Sultan Qansuh
al-Ghuri (1501–16), both of whom were formerly
in the service of Qaitbay.

Sultan Qaitbay's composite blazon is found on a
number of late-fifteenth-century carpets and
metalwork. A rug fragment in the Textile Museum
shows an identical blazon with the same
combination of colors.[4] This blazon appears on a
tinned-copper tray (no. 39) as well as on other
contemporary objects.[5]

Unpublished

Notes
1. Cairo, Museum of Islamic Art, 13208. The same subject
 appears in a brass statuette and ceramic fragment in Cairo,
 18618 and 14691 (Mostafa 1958, nos. 61–63, fig. 21).
2. Mayer 1933, pp. 19–22; and Mayer 1938.
3. For a study of these composite blazons see Meinecke 1972,
 pp. 273–78; and Meinecke 1974, pp. 231–40.
4. Washington, D.C., Textile Museum, 1965.49.1 (Ellis 1967,
 figs. 1 and 10 and cover). Another rug with the same blazon
 has a different color scheme (Ellis 1967, fig. 11).
5. Mayer 1933, pl. LXII; Mayer 1937, pl. 1b; Cairo 1969, no. 90;
 and Allan 1969 and 1971.

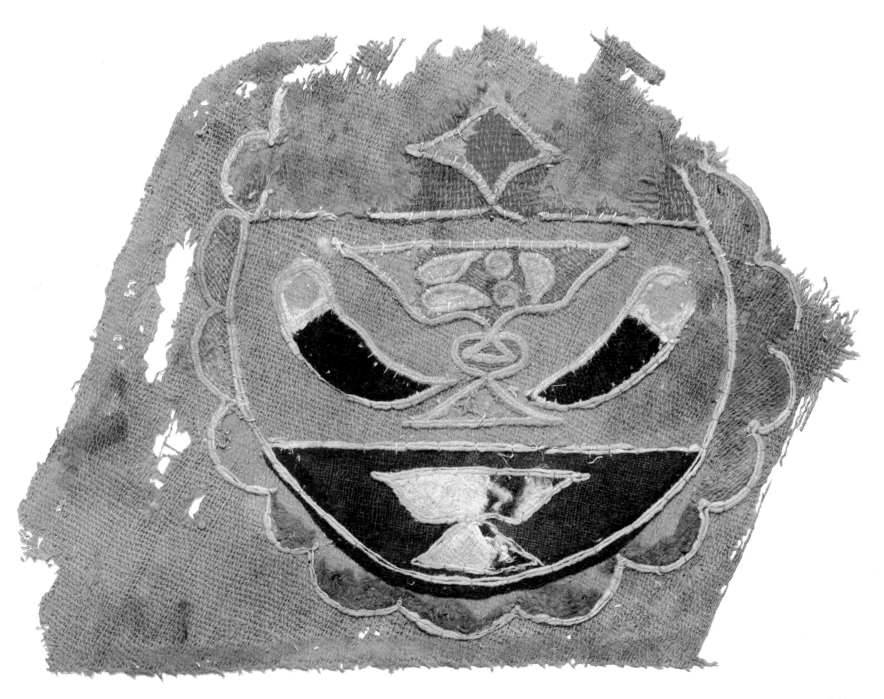

125
Rug with cup motif
Wool: woven with red, green, blue pile
Late 15th century

Length: 1.86 m. (6 ft. 1¼ in.)
Width: 1.37 m. (4 ft. 6 in.)

Washington, D.C., The Textile Museum, R 16.1.2
Acquired between 1920 and 1926

The layout of this rug is characteristic of the smaller, almost square Mamluk carpet. A wide border encloses the field, which is divided into three horizontal units consisting of a central square flanked above and below by two rectangular panels. The height of the rectangular panels is approximately one-third that of the square and is equal to the width of the border.

The corners of the central square are cut by triangles, creating an octagon with a green ground. The octagon contains a blue polylobed medallion, which encloses an eight-pointed star with a multipetaled rosette in the core. The area between the star and lobed medallion has floral motifs springing outward from the arms of the star. The angles of the octagon bear eight isolated and irregular polygons with a red ground; each of these units is adorned with a multipetaled rosette enclosed by a square with papyrus motifs springing from its sides and corners. The field of the octagon is filled with similar papyrus sprays, some of which appear to grow from the eight stemmed cups placed between the polygons. The triangles in the corner bear a checkerboard pattern with a stylized lotus blossom (or fleur-de-lis) in each segment.

The rectangular panels above and below the central unit reveal a tripartite division separated by papyrus sprays. Each panel has three squares, their corners cut out to form octagons. The central octagon in both panels is on a red ground and contains an eight-lobed medallion enclosing an eight-pointed star; each of the lateral units has a green ground and a sixteen-pointed star surrounding a square. Multipetaled rosettes appear in the core of the units, which are filled with additional floral elements.

The border is blue and embellished with red oval cartouches that alternate with green lobed medallions. The cartouches in the center of the long sides have shrunk and form medallions. The decoration of these two medallions follows that of the polygons in the central field; the same design appears in the oval cartouches, which have, instead of a square, a row of three diamonds (or lozenges) in the middle. The green eight-lobed medallion encloses a square with a central rosette. The narrow guard borders are decorated with scrolls bearing leaves.

The compositional layout of the rug is reminiscent of the illuminated frontispieces, which reveal similar proportions and internal divisions. Radiating designs of geometric components filled with floral motifs are a characteristic feature of Mamluk art, as observed in manuscripts, metalwork, glass, ceramics, woodwork, and textiles (see nos. 4, 35, 51, 99, and 114).

The stemmed cups represented in the central square appear to have been inspired by the blazon of the *saqi* (see nos. 15–16, 27–28, 96, and 109). Here, the cups are used as a decorative feature and cannot be identified as blazons. The same decorative motif is found on a rug in Berlin.[1]

Published
Kühnel and Bellinger 1957, pp. 9–10 (R 7.2), pls. I and III.
Ellis 1974, fig. 10.
Textile Museum 1976, fig. 5.

Notes
1. Erdmann 1940, fig. 3.

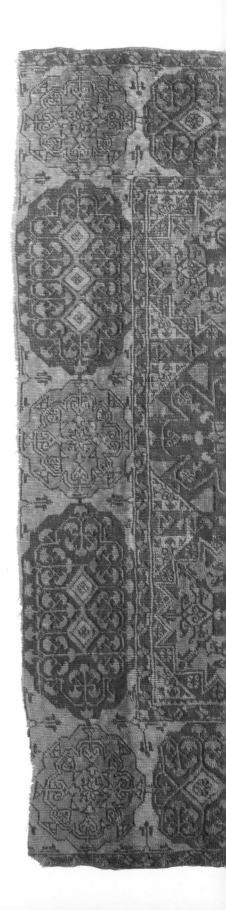

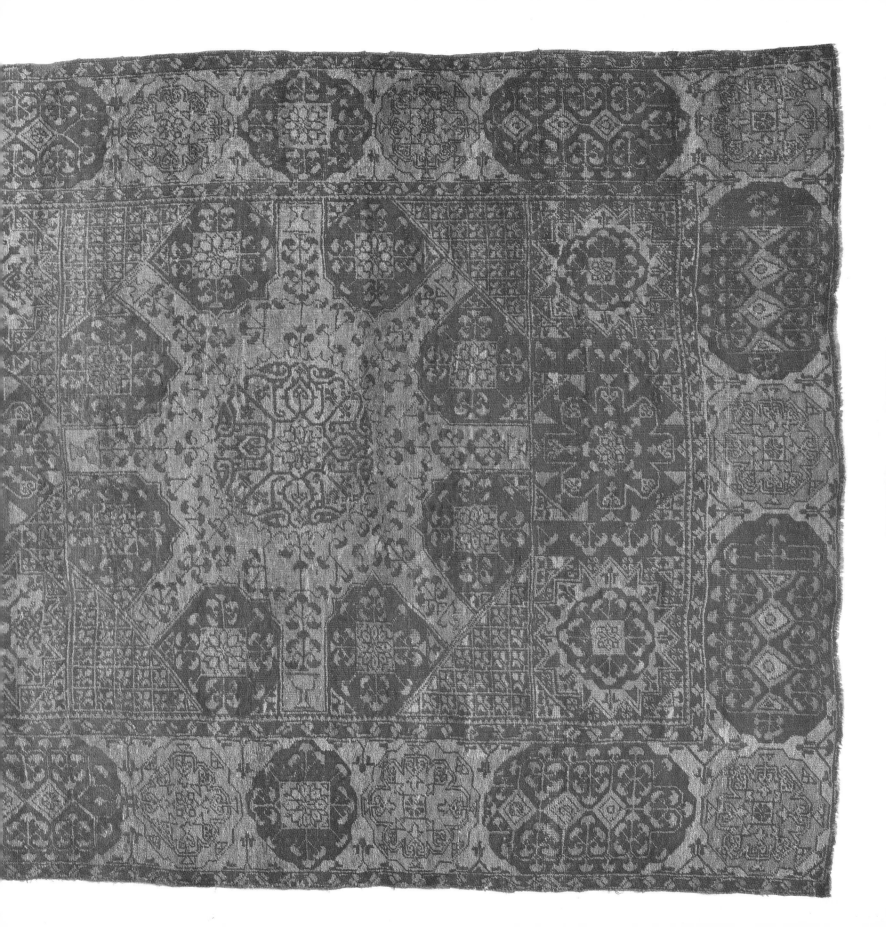

126
Rug with palm trees and cypresses
Wool: woven with red, green, blue pile
Circa 1500

Length: 1.88 m. (6 ft. 2 in.)
Width: 1.34 m. (4 ft. 4 in.)

Washington, D.C., The Textile Museum, R 16.1.3
Purchased 1951
Ex-Kelekian Collection

The layout and color scheme of the previous example (no. 125) appear in this rug, which is almost the same size. The central square displays the ultimate expression of a geometric pattern based on multiples of eight. It contains a central octagon filled with red lancet leaves on a green ground. In the core is a multipetaled red blossom enclosed by a red medallion surrounded by an eight-pointed star. Triangles placed around the octagon transform it into an eight-pointed star enclosed by a frame with red papyrus sprays on a blue ground. Encircling this zone is a series of polygons with rosettes, which form an immense sixteen-pointed star. The corners of the central square have red quatrefoils on a green ground.

The transverse bands above and below the central square have a red ground with four green palm trees alternating with five green cypresses flanked by blue papyrus sprays, all of which are oriented toward the center.

The blue border is densely packed with alternating oval cartouches and eight-lobed medallions, rendered in red on green or green on red. These units are filled with papyrus motifs, which evolve from four blue lozenges in the middle of the ovals; they also radiate from squares in the medallions filled with multipetaled blossoms. The ovals in the center of the long sides are contracted and contain only three lozenges. Double guard borders, decorated with leaf scrolls, repeat the color scheme, using red on green or red on blue.

This rug contains a number of decorative elements employed on other contemporary arts. The naturalistic cypresses growing on the transverse bands are similar to those on metal objects and tiles and to those in the stained-glass windows in the mausoleum of Sultan Qaitbay, completed in 1472–74.[1] The papyrus sprays, once thought to be limited to Mamluk carpets, also occur on a tinned-copper tray.[2] The combination of cypresses, palm trees, and papyrus sprays appears to be unique to rug weavers.[3]

Published
Kühnel and Bellinger 1957, p. 15 (R 7.13). pls. I and VII.

Notes
1. For instance the ewer made for Qaitbay's wife in London, Victoria and Albert Museum (D. S. Rice 1953a, pl. VI).
2. Drouot 1980, no. 77.
3. For other rugs decorated with trees see Kühnel and Bellinger 1957, pls. II, VI, and VIII; Berlin 1971, no. 529, pl. 11.

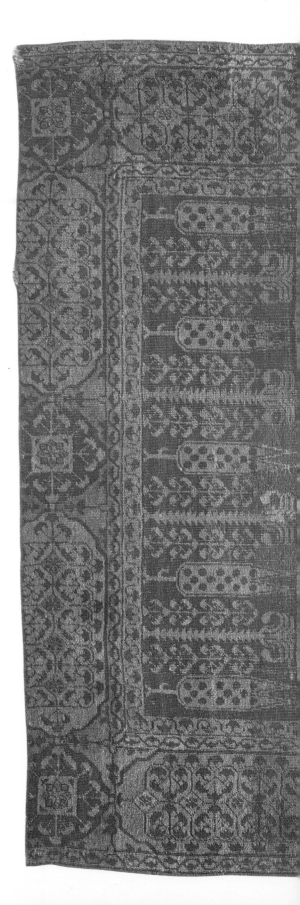

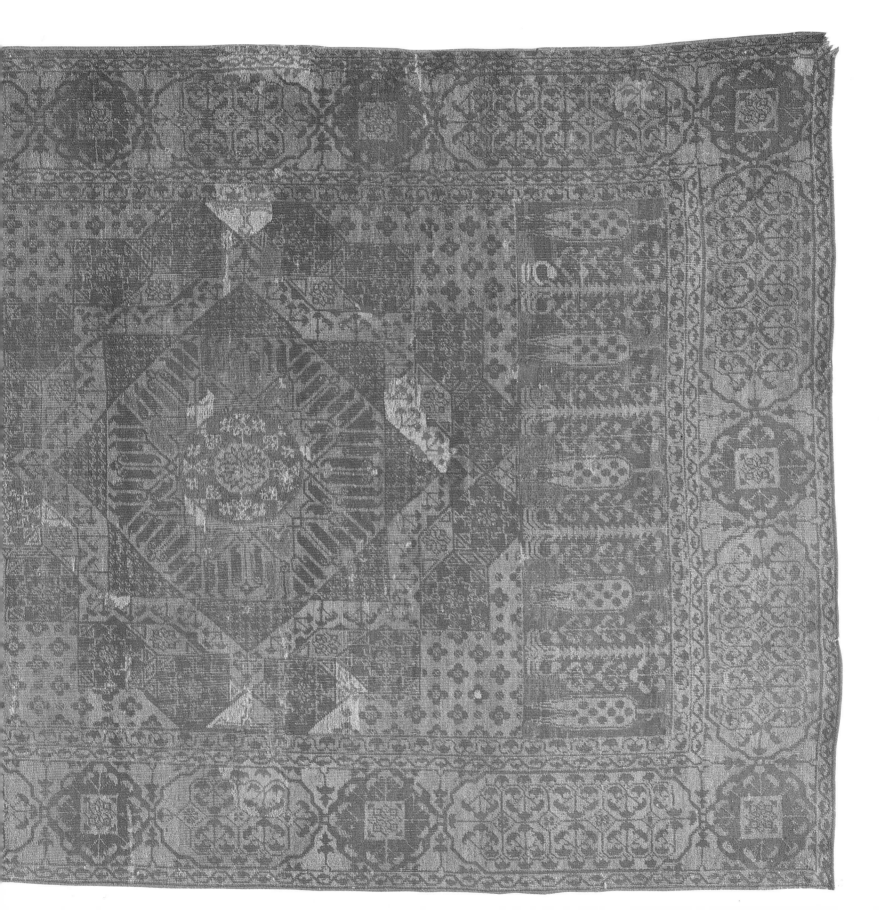

127
Rug with central star
Wool: woven with red, green, blue, brown,
 yellow pile
Early 16th century

Length: 2.0 m. (6ft. 6 in.)
Width: 1.48 m (4 ft. 10¼ in.)

Washington, D.C., The Textile Museum, R 16.2.3
Purchased 1951
Ex-Kelekian Collection

The brilliant reds, greens, and blues found on the earlier Mamluk rugs (nos. 125–26) were later enhanced by the addition of other colors, such as brown and yellow, as seen on this example.

The layout of this rug is similar to those described earlier and contains a geometric pattern based on multiples of eight. The octagon, which is more prominent in the other rugs, has blended with the encircling triangles to become a sixteen-pointed star. The central square and transverse bands share red ground, the upper and lower portions distinguishable only by the variation in motifs and surface colors.

The main theme of the central square is a sixteen-pointed star with red lancet leaves on a blue ground. The yellow medallion in the middle is filled with red and green flowers, which form a double quatrefoil around an eight-pointed star; this star encloses an identical element, in the core of which is a multipetaled rosette surrounded by a diamond in a square. The sixteen-pointed star is encircled by a green band that has eight arms with lobed medallions inserted between them. Sixteen polygons interspersed around the lobed medallions create another sixteen-pointed star, its points cut off by the frame. Square units in the corners, enclosing octagons surrounded by a lattice filled with lotus blossoms, complete the composition.

The rectangular bands above and below the central square have three horizontal rows of floral units oriented toward the center. The inner row contains chalicelike plants interspersed with floral units; the middle alternates stylized miniature cypresses with larger papyrus sprays surmounted by lotuses; and the outer row has two types of arabesque cartouches.

The blue border is filled with green ovals and red medallions containing the same green or red papyrus sprays and blue lozenges seen in the previous example (no. 126). Additional sprays of red papyrus fill the interstices. The units are framed by a continuous yellow ribbon that loops around the tiny roundels placed on four sides of each medallion. The double guard borders have two types of floral scrolls, rendered in red on blue and green on red.

The overall effect of a centrifugal design radiating from the core, its outermost elements cut off by the frame, is strikingly similar to the compositions of manuscript illuminations (see nos. 3–4). The thin ribbon connecting the cartouches and medallions is also seen in contemporary illumination and late-fifteenth-century objects (see nos. 9, 35, 37–39, 101, and 122).

The peculiar chalicelike plants and the arabesque cartouches used in the transverse bands are found on several Mamluk rugs and appear to be a part of the repertoire of Mamluk weavers.

Published
Kühnel and Bellinger 1957, p. 31 (R 7.12), pls. II and XVII.
Ellis 1974, fig. 9.

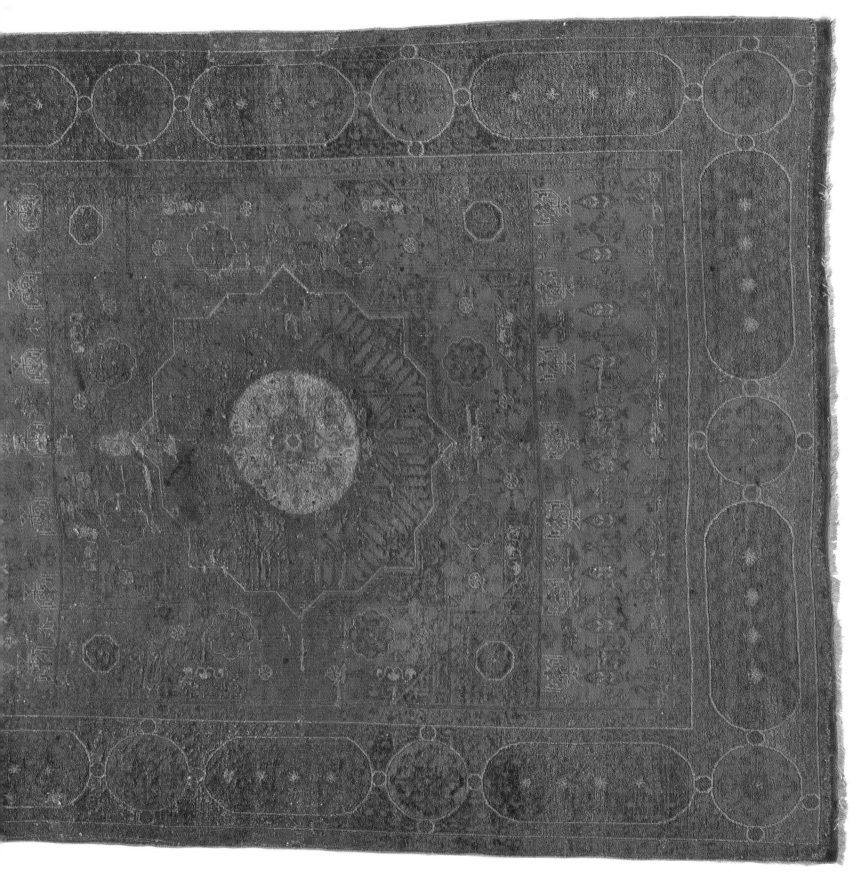

128

Rug with large octagon
Wool: woven with red, green, blue, ivory, yellow
 pile
First quarter 16th century

Length: 1.97 m. (6 ft. 5 in.)
Width: 1.53 m. (5 ft.)

Washington, D.C., The Textile Museum, R 16.2.8
Purchased 1932

This example represents a stylistic development in the almost square Mamluk rug with tripartite field and wide border. The rectangular bands above and below the central unit are narrower (one-sixth the height of the central unit) and create a slightly elongated center in contrast to the square format seen earlier; the border has a continuous pattern, which disregards the compartmentalized design.

These features—together with the addition of ivory and yellow to the traditional red, green, and blue—suggest that the rug is later in date than the others. However, the employment of a concentric octagon as the main theme and the abundant use of floral motifs based on papyrus plants are traditional and follow the stylistic and decorative features of Mamluk rugs.

The nearly square central unit is almost completely covered by a large octagon with blue papyrus sprays on a red ground. In the center of each side is an eight-lobed medallion attached by a stem to an inner octagon. This octagon, filled with green lancet leaves on a red ground, encloses another identical element, decorated with red papyrus motifs on a green ground. Inside is a fourth octagon with an ivory medallion, its radiating flames rendered in yellow. In the center of the medallion is an eight-pointed star enclosing a minute octagon with a six-petaled rosette. The corner triangles have red papyrus sprays placed around octagonal units with yellow rosettes. Two scrolls of stylized lotus blossoms join the triangles at the top and bottom.

The transverse bands have additional papyrus motifs intermingled with heart-shaped motifs, split leaves, and blossoms, rendered in red on a green ground. A chevron band encircles the transverse bands; thin strips, filled with papyrus leaves, run vertically between the bands along the outer edges.

The border, executed in blue with touches of yellow on a red ground, displays an enlarged version of the motifs used in the transverse bands. Floral scrolls adorn the double guard borders: one has a blue papyrus on a red ground, the other shows blue and red leaves on a yellow ground.

The dynamism of the radiating units, evolving from an ivory core enclosed by a golden halo, creates a kaleidoscopic effect with brilliantly colored rings unequaled in any rug tradition. The elements evolve from an almost microscopic core and increase in size as they move outward. A similar centrifugal force is observed in illuminations of the Koran and can be interpreted as having cosmic implications and symbolizing celestial light. The color scheme of this carpet recalls the red, blue, green, and yellow stained-glass windows that burst into jewellike tones when lit by sunlight. Light is also an important factor in Mamluk rugs, for their appearance and design change as the rays of the sun and flicker of oil lamps play upon their surfaces.

Published
American Art 1930, no. 730.
Kühnel and Bellinger 1957, p. 37 (R 7.7), pls. I and XXI.
Ellis 1974, fig. 11.

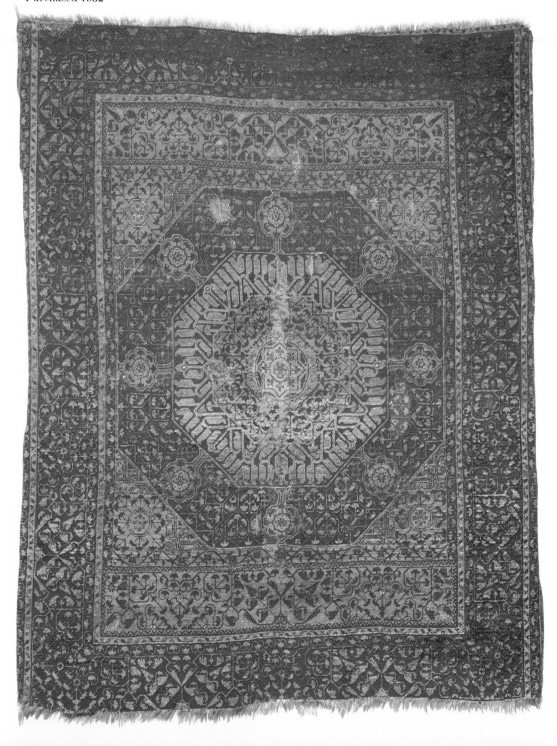

ILLUSTRATED MANUSCRIPTS

The first half of the thirteenth century was the classical age of illustrated Arabic manuscripts, with the studios of Baghdad, Mosul, and Damascus executing scores of literary and scientific texts embellished with paintings. The artists of Iraq and Syria appear to have continued producing illustrated books after the Mongol invasion of the 1250s even though many urban centers were destroyed and populations were uprooted. Although several manuscripts dated to the second half of the thirteenth century contain original compositions, most of the paintings copy those produced in the classical period. Included among the original works are the first illustrated version of al-Qazwini's voluminous treatise on cosmology, the *Ajaib al-Makhluqat* (*Wonders of Creation*), executed during the lifetime of the author in 1280 in Wasit,[1] and the encyclopedic *Rasail Ikhwan al-Safa* (*Epistles of the Sincere Brethren*), completed in 1287 in Baghdad.[2]

Attributed to Syria is a unique text called *Muzhaf al-Suwar* (*Book of Images*), illustrated in 1270 with crudely drawn personifications of the chemical elements.[3] Also attributed to Syria is the *Dawat al-Atibba* (*Banquet of the Physicians*), an eleventh-century work by Ibn Butlan, which was adorned with eleven carefully executed illustrations in 1272.[4] The paintings in this manuscript are the earliest dated examples of the Mamluk style that flourished in the fourteenth century.

Although about sixty illustrated Arabic texts are known to have been made during the Mamluk period, the provenance of only a few works can be determined and many have been assigned to Egypt, Syria, or Iraq without adequate documentation. The majority of these manuscripts are repetitive, that is, they are copies of texts such as al-Jazari's *Kitab fi Marifat al-Hiyal al-Handasiyya* (*Book of Knowledge of Ingenious Mechanical Devices*, popularly called the *Automata*), al-Hariri's *Maqamat* (*Assemblies*), and Ibn al-Muqaffa's Arabic translation of the animal fables *Kalila wa Dimna*. Their paintings represent subjects established in the classical period with few iconographic innovations. In the second half of the fourteenth century texts on *furusiyya*, that is, horsemanship, began to be illustrated and these soon became one of the popular books copied in ensuing years. The *furusiyya* genre is concerned with the art of warfare; it is unique to the Mamluks and characteristic of their militaristic society.

The most original Mamluk manuscripts are the epic histories written in Turkish that appeared at the end of the fifteenth century. They were illustrated by a group of foreign artists who most likely immigrated from the Turkman courts at Shiraz and Baghdad.

Imperial patronage, so lavishly bestowed upon architecture, religious texts, metalwork, glass, and other luxury arts, is lacking in Mamluk painting. The most beautiful illustrated manuscripts, such as the Vienna *Maqamat*, were undoubtedly executed for the court, but none bear dedications to those sultans who were otherwise celebrated for commissioning spectacular Korans.

The dedications of illustrated manuscripts indicate that they were made for a handful of second generation mamluks, most of whom are not known historically. These patrons, born Muslims, were raised in an Islamic society and absorbed its culture. In contrast, their fathers who constituted the ruling elite, the *arbab al-suyuf*, men of the sword, were of Turkish or Circassian origin and had been purchased outside the Islamic world. Arabic was a foreign language to the military oligarchy, whose members did not show a keen interest in literary activities.

It would be unjust to accuse the Mamluks of being nonintellectual since they did sponsor works on geography, history, theology, and various sciences. Some sultans, including Barsbay, Jaqmaq, Qaitbay, and Qansuh al-Ghuri, were bibliophiles and commissioned a number of illuminated books for their personal libraries. In contrast to the neighboring courts of the Ilkhanids, Jalairids, Muzaffarids, Akkoyunlus, Karakoyunlus, Timurids, and Ottomans in Iran, Iraq, and Turkey, patronage of court painters was not one of the outstanding contributions of the Mamluks. The only exception was Sultan Qansuh al-Ghuri, who not only commissioned literary texts but illustrated manuscripts as well.

Bahri Period (1250–1390)

The majority of Bahri period illustrated manuscripts were executed during the sultanates of Nasir al-Din Muhammad (1293–1341, with interruption), Hasan (1347–61, with interruption), and Shaban II (1363–76), who were among the most enthusiastic patrons of art in Mamluk history. Although these three sultans were not directly responsible for any particular illustrated manuscript, their reigns witnessed an extraordinary burst of artistic energy, the effect of which was felt on the production of book painting.

Among the earliest illustrated Mamluk manuscripts are five copies of the *Maqamat*, a literary text devoted to the escapades of Abu Zayd and his friend al-Harith. Fifty of these stories, called *maqama* (seances or sessions), were compiled in the twelfth century by al-Hariri and became the most popular Arabic text to be illustrated in the first half of the thirteenth century. Two of the Mamluk copies were produced around 1300 and are now in the British Library.[5] One bears the name of the painter Ghazi ibn Abd al-Rahman al-Dimashqi (that is, from Damascus). A third work, dated 1323, also in the British Library, is unfinished and many scenes are merely sketched.[6]

The paintings in these early Mamluk manuscripts reveal a refined style, which is fully developed in a version of the *Maqamat* copied in 1334 by Abu'l-Fadail ibn Abu Ishaq now in Vienna (no. II). The frontispiece of this manuscript represents an enthroned ruler with inscribed *tiraz* bands on his turban and robe. The high quality of execution, the abundant use of gold leaf, and the brilliantly textured garments suggest that this work may indeed have been made for the sultan.

A fifth illustrated copy of the *Maqamat*, dated 1337, was the last to be produced in the Mamluk period.[7] This manuscript, which is at Oxford, bears a dedication to Nasir al-Din Muhammad, son of a "high

official" named Husam al-Din Tarantay; unfortunately, neither the patron nor his father have been identified in historical sources. The paintings in the first three manuscripts, attributed to Syria, follow the compositional schemes and figure types established in the classical period; those in the remaining two versions, assigned to Egypt, are highly decorative, and serve as embellishments to the text rather than as visual commentaries.

The next group of manuscripts consists of copies of the *Automata* written by al-Jazari for Nasir al-Din (1201–22), the Artukid sultan of Diyarbakır. The work is devoted to the construction of fifty mechanical devices, including clocks, drinking vessels, pitchers, and basins, as well as fountains and other hydraulic devices. The first illustrated version of this text was rendered from the author's autograph in 1206, and all later copies remained faithful to the representations found in this manuscript.[8] Although the illustrations of the *Automata* were meant to depict scientific instruments, they are basically paintings of automated toys, which became very popular in the fourteenth and fifteenth centuries.

More than a dozen illustrated copies of the *Automata* were produced during the Mamluk period, the earliest of which was completed in 1315 by Farrukh ibn Abd al-Latif (no. I). This manuscript, formerly in the Kevorkian Collection, is now dispersed among several public and private collections. Two other versions were made in the Bahri period. One of these appears to have been illustrated in the second half of the thirteenth century.[9] The other is dated 1354 and was copied by Muhammad ibn Ahmad al-Izmiri (from İzmir) for another Nasir al-Din Muhammad, son of the "late excellency Tulaq al-Hasani al-Maliki al-Salihi."[10] The patron's father was a well-known figure who served as a military judge under Sultan Hasan and Sultan Salih. The provenance of these three copies of the *Automata* cannot be determined with certainty; it is thought that the 1354 manuscript was produced in Egypt.

Around the time that the *Automata* was being made for Tulaq's son, there occurred a revival of a third group of illustrated manuscripts, copies of the *Kalila wa Dimna*. This work, a compilation of fables thought to have been written down about the year 300 by an Indian Brahman named Bidpai, was first translated into Pahlavi and then rendered into Arabic by Ibn al-Muqaffa around 750. Ibn al-Muqaffa's version was the source for subsequent translations into dozens of Eastern and Western languages. The book narrates ethical tales enacted by animals, including two jackals named Kalila and Dimna, which teach just behavior to kings. A copy at Oxford was transcribed in 1354 by Muhammad ibn Ahmad (no. III); an undated second version now in Paris was produced about the same time; a single folio of a third contemporary manuscript has also survived.[11] The paintings in these works contain naïvely charming representations of animals in simplified compositions, which recall the first illustrated version of the *Kalila wa Dimna* produced between 1200 and 1220, possibly in Syria.[12]

Books on animals were unusually popular during the Bahri Mamluk period. For instance, painters created sensitive representations of animals in the *Sulwan al-Muta* (*Prescription for Pleasure*), originally written in 1159 by Ibn Zafar al-Sigilli (the Sicilian), inspired by the fables in the *Kalila wa Dimna*. One illustrated copy of this text is known to have been made in the second quarter of the fourteenth century.[13] Another singular manuscript produced a few decades later was the *Kitab al-Hayawan* (*Book of Animals*), a ninth-century treatise on zoology and animal behavior written by al-Jahiz. Its anonymous fourteenth-century painter was particularly taken by the reproductive habits of his subjects.[14]

A related work, the *Kitab Manafi al-Hayawan* (*Book on the Usefulness of Animals*), was composed and transcribed in 1354 by Ibn al-Durayhim al-Mawsili, who died six years after completing the text.[15] The paintings in this book are exceptional: the delicate execution of domestic and wild animals, birds, fish, reptiles, and insects reveals both an observation of nature and inspiration from Central Asian and Far Eastern styles, which is particularly noticeable in the calligraphic use of line and the painterly handling of pigments. Flowers, birds, and animals are also discussed in the *Kashf al-Asrar* (*Disclosure of Secrets*) of Ibn Ghanim al-Maqdisi, a copy of which was illustrated in the middle of the fourteenth century.[16]

The provenance of these manuscripts devoted to animals cannot be precisely determined and the works themselves offer no clues. The patrons' names are not provided and the cities in which the calligraphers and painters worked are not mentioned.

An even more problematic group of manuscripts consists of copies of the Arabic translation of *De Materia Medica* of Dioscorides, devoted to the pharmaceutical uses of plants, and the *Ajaib al-Makhluqat* of al-Qazwini, first illustrated in 1280. There are three copies of *De Materia Medica*, one of which is thought to have been made in the late thirteenth century, another is dated 1301, and a third was completed in 1334.[17] The paintings in these manuscripts are generally attributed to Iraq, but they could very well have been made in the Mamluk world. A similar work is the *Masalik al-Absar fi Mamalik al-Ansar* (*Ways of Seeing the Chief Cities*), the twelfth volume of an encyclopedia composed by al-Umari who died in 1349.[18] It contains illustrations of animals and plants, recalling the subjects treated by both Dioscorides and al-Qazwini. This work, attributed to Egypt or Syria, must have been produced shortly after it was written.

The paintings in three copies of al-Qazwini's cosmology are attributed to either Egypt or Iraq and are assigned to the third quarter of the fourteenth century or to the fifteenth century. The earliest manuscript of the series is thought to be the one divided between the Freer Gallery of Art in Washington, D.C., and the Spencer Collection of the New York Public Library; the second is in Leningrad; and the third in Dublin.[19] The paintings in these manuscripts form a coherent group; their style is unlike that of contemporary illustrations

produced in Egypt, Syria, and Iraq and is also completely different from the representations found in the 1280 copy of the same work. It is not yet possible without further documentation to more specifically assign this group.

The production of secular manuscripts in the middle of the fourteenth century was highly energetic and included the illustration of texts previously enhanced with paintings as well as those that did not have pictorial prototypes. Although several books, such as the *Sulwan al-Muta* and *Kitab Manafi al-Hayawan*, were adorned with paintings for the first—and often only—time, the repertoire of pictorial themes was often taken from other illustrated texts.

Among the more unusual mid-fourteenth-century paintings are those illustrating an anonymous treatise on musical instruments entitled *Kashf al-Gunum*.[20] This work, which contains representations of single musicians, quartets, and a seven-piece chamber orchestra, is undated but bears a dedication to Sayf al-Din Abu Bakr, the son of the "late excellency" Minglibugha, an unknown descendant of an unidentifiable former mamluk.

The most original illustrated work of the second half of the fourteenth century was the *Nihayat al-Su'l wa'l-Umniyya fi Taallum Amal al-Furusiyya*, the cumbersome title of a manual that roughly translates as "all that one needs to know about the exercises of horsemanship." The author, al-Aqsarai (died 1348), wrote the treatise in Damascus where he was trained by the famous masters of *furusiyya*. The earliest illustrated version of al-Aqsarai's text was copied in 1366 by Umar ibn Abdallah (no. IV). The dedication, which was partially covered about a century later by the ex libris of Sultan Jaqmaq, contains the titles "al-Maliki al-Ashrafi," indicating that the original patron was an amir in the service of Shaban II. The paintings in this manuscript represent riders demonstrating the use of various weapons.

A second version of the same text was copied by Ahmad ibn Umar in 1371; a third example was executed in 1373 by Ahmad al-Misri in Damascus.[21] A manuscript in the British Library, dated 1383, was copied by Ali ibn Hamid who left blank spaces for illustrations.[22] The date of this work indicates that it was produced during the reign of Barquq, the first of the Burji Mamluks.

Burji Period (1382–1517)
The illustrated manuscripts executed during the last two decades of the fourteenth and first half of the fifteenth century are copies of such well-established books as the *Kalila wa Dimna*, *Automata*, and manuals on *furusiyya*. At least four versions of Ibn al-Muqaffa's *Kalila wa Dimna* were produced in the late fourteenth century, the earliest of which, now in Cambridge, is dated 1388. The paintings in this work and in two manuscripts in Munich are based on mid-fourteenth-century renditions and repeat the same scenes.[23] Of these manuscripts, the 1388 *Kalila wa Dimna* has the most extensive picture cycle with

120 paintings; it is written on parchment, which is unusual for Mamluk manuscripts.

The *Automata* was copied and illustrated until the end of the Burji period. A volume made in 1458 has schematic illustrations; another, completed in 1485, contains only diagrams and sketches; a third, with sketchy illustrations, bears the date 1486.[24] Three undated copies of the *Automata* in Cairo, Dublin, and Paris, also may have been produced in the fifteenth century and contain mostly drawings and diagrams.[25] Yet another undated work in İstanbul is perhaps the earliest of these Burji period manuscripts; it is of high quality and adorned with 152 carefully rendered illustrations.[26]

Works on *furusiyya*, which first appeared in the third quarter of the fourteenth century, and other texts devoted to the subject of horses were also illustrated in this period. A copy of the *Kitab al-Zardaqa* (*Book on Farriery*) in İstanbul was dedicated to Yalbay Mirkhanibay al-Hamzawi, who is thought to have been in the service of Sultan Barsbay.[27] An undated and poorly illustrated version of al-Aqsarai's treatise on horsemanship, now in London, as well as a copy in İstanbul, were most likely made in the fifteenth century.[28] A related treatise, the *Kitab fi Ilm al-Furusiyya* of al-Rahman, is dated 1396 and contains diagrams of military tactics; another work on horsemanship, by al-Tabari was completed in 1466.[29] The paintings in the second manuscript follow a completely different representational cycle than that in al-Aqsarai's manual; it has sixty-one extremely naïve and crude paintings, which repeat the compositions found in an undated copy dispersed between the Keir Collection in London (thirty-one paintings) and the Museum of Islamic Art in Cairo (three paintings).[30]

The paintings in the dispersed manuscript, executed by a single hand, illustrate various weapons and depict the use of different types of military equipment in war exercises. Their style points to an area outside the Mamluk world and shows affinities with the paintings of the Karakoyunlu Turkman school. The artist must have emigrated to the Mamluk court in the middle of the fifteenth century and illustrated this *furusiyya* text around the 1460s. Another illustrated *furusiyya* written by Ibn Akhi Khuzam was copied in 1470.[31] The paintings of this manuscript were executed by local artists and follow the fourteenth-century Mamluk themes established by the 1366 copy of al-Aqsarai's treatise and do not show the impact of the Karakoyunlu style.

The painter of the Keir Collection *furusiyya* apparently did not come alone to the Mamluk court. Members of the same Karakoyunlu Turkman school also illustrated the unique *Iskandarnama* (*Book of Iskandar* or Alexander the Great) of Ahmedi.[32]

Written in Turkish, this work was dedicated to an official named Khushqadam ibn Abdallah, who was the treasurer of Sayfi Ali Bay, the secretary (*dawadar*) of Sultan Timurbugha. Although undated, it must have been produced during Timurbugha's two-month sultanate, between December 1467 and January 1468; the work is now in the

İstanbul University Library. The author, Ahmedi (1334?–1413), was a native of Anatolia who was educated in Cairo. Ahmedi returned to his homeland before 1390, at which time he composed the *Iskandarnama*, which recalls the Alexander cycles in the Persian poems of Firdausi and Nizami. The copy made for Khushqadam ibn Abdallah is among the first illustrated versions of this work, which was extremely popular in the Turkish Islamic courts.[33]

The İstanbul *Iskandarnama* contains twelve paintings, including a diagram of the constellations of the zodiac. The manuscript opens with a frontispiece respresenting an enthroned ruler entertained by his court, following the format of fifteenth-century Karakoyunlu Turkman manuscripts. The remaining paintings depict the wisdom, loves, hunts, and battles of the hero, concluding with his death and funeral procession. The figures and their settings, as well as the compositions, are taken from almost contemporary manuscript illustrations produced in Baghdad and Shiraz under the patronage of Pir Budak, the Karakoyunlu prince.

Pir Budak was given the rule of Fars in southern Iran by his father, Jahan Shah (1439–67), the Karakoyunlu sultan. The prince was an enthusiastic patron of illustrated books and established a court studio in Shiraz, which was enriched by artists from Herat after the conquest and brief occupation of that city by the Karakoyunlus in 1458. Pir Budak's independent attitudes threatened his father who defeated him in 1462 and forced the prince to move his court to Baghdad. He was killed by Jahan Shah in 1466 and his painting studio was dispersed. The dates of Pir Budak's political problems and ultimate death coincide with the appearance of the Turkman style in Cairo, indicating that some of the artists of his court sought employment in the Mamluk capital.

The *Iskandarnama* is extremely important for several reasons. Primarily, it proves that a group of Turkman artists came to Cairo at the end of the 1460s and were immediately employed, establishing a new school of painting; secondarily, it indicates the beginning of the genre of Turkish historiography, which reached its epitome under the Ottomans several generations later; finally, it is the earliest illustrated copy of Ahmedi's celebrated work and contains paintings specifically created for this text. Furthermore, it points to an interesting development in which illustrated works written in Turkish were beginning to be sponsored by the Mamluk court.

The first ruler to show any interest in this type of historical text was Sultan Barquq, who had commissioned Darir of Erzurum to compose in Turkish a voluminous biography of the Prophet Muhammad. Darir's *Siyar-i Nabi*, completed in 1388, was illustrated at the end of the sixteenth century at the Ottoman court, with Barquq's patronage commemorated in the frontispiece, which represents the author presenting the book to the Mamluk sultan.[34]

Turkman artists, and possibly their local apprentices, were employed by Sultan Qansuh al-Ghuri in the creation of another unique manuscript, the first Turkish translation of the *Shahnama* of Firdausi, the epic history of Iran (no. v). One of the artists of the *Shahnama* also painted the frontispiece of an undated anthology of Turkish poems commissioned by the same sultan. The scene shows two officials flanking an enthroned personage, who possibly portrays the patron of the work.[35]

Qansuh al-Ghuri was the first and the last Mamluk sultan to show an active interest in painting. This new development in the patronage of literature and painting at the Mamluk court came to an untimely end with the Ottoman conquest of Egypt and Syria. The personal libraries of the last sultans, including those of Qaitbay and Qansuh al-Ghuri, were shipped to İstanbul. The painters of the last Mamluk court must have been taken to the Ottoman capital, where they joined the imperial painting studio.

Sultan Selim's booty must have included the unusual Mamluk playing cards now in the Topkapı Palace Museum in İstanbul.[36] These forty-eight cards are from two incomplete decks arranged in four suites of coins, cups, polo sticks, and swords with their face-value or number cards represented by multiplication of the motifs. These cards must have been used in gambling, games, and in fortunetelling, the rules and procedures of which are still unknown.

The production of illustrated manuscripts virtually ceased in Egypt and Syria after the Ottoman conquest. There were sporadic revivals of the popular Arabic texts, but the illustrations show little artistic merit.[37]

In spite of the lack of strong and continued imperial patronage, Mamluk artists produced the most refined examples of postclassical painting in the Arab world. They excelled in the representation of animals, particularly notable in manuscripts dating from the middle of the fourteenth century, and created new themes in their illustrations of the *furusiyya* manuals. Conceived as book decorations, meant to be enjoyed for their beautiful colors, rich textures, and charming figures, Mamluk painting did not require the reading of the text to be appreciated. In this context, the painters were true decorators, embellishing the manuscripts in the same manner as illuminators.

Notes

1. Munich, Bayerisches Staatsbibliothek, Cod. Arab. 484 (Ettinghausen 1962, pp. 138–39).
2. İstanbul, Süleymaniye Library, Esad Efendi, 3638 (Ettinghausen 1962, pp. 98–102).
3. İstanbul, Archaeological Museum Library, 1574 (Ettinghausen 1962, pp. 59–60).
4. Milan, Biblioteca Ambrosiana, A. 125 Inf. (Haldane 1978, pp. 76–77).
5. London, British Library, Add. 22114 (Ettinghausen 1962, p. 146; James 1976, fig. 21; Haldane 1978, pp. 67–71); same collection, Or. 9718, painted by Ghazi ibn Abd al-Rahman (Haldane 1978, pp. 62–63).
6. London, British Library, Add. 7293 (Haldane 1978, pp. 64–65).
7. Oxford, Bodleian Library, Marsh 458 (Ettinghausen 1962, p. 152; James 1976, fig. 21; Haldane 1978, pp. 83–84).
8. İstanbul, Topkapı Palace Museum, A. 3472 (Stchoukine 1934; Holter 1937a, no. 10; Buchthal 1940, no. 10).
9. İstanbul, Topkapı Palace Museum, A. 3461.
10. The bulk of the copy dated 1354 is in İstanbul, Süleymaniye Library, Aya Sofya, 3606, and has fourteen paintings; about twenty-two other paintings have been removed and are now in various private and public collections (Atıl 1975, no. 52; Haldane 1978, p. 55).
11. Paris, Bibliothèque Nationale, Arabe 3467 (Ettinghausen 1962, p. 155; Haldane 1978, pp. 95–99). The single folio is in Cambridge, University Library (Walzer 1957).
12. Paris, Bibliothèque Nationale, Arabe 3465 (Holter 1937a, no. 26; Buchthal 1940, no. 26; Ettinghausen 1962, pp. 62–63).
13. The bulk of the manuscript is now in a private collection in Kuwait (Haldane 1978, pp. 59–60; see also George V 1975, no. 131). Two folios are owned by Washington, D.C., Freer Gallery of Art, 54.1 and 54.2 (Atıl 1975, nos. 53–54); a third folio is in Geneva, Sadruddin Aga Khan Collection (Welch 1978, vol. 3, A.M. 4).
14. Milan, Biblioteca Ambrosiana, S.P. 67 (Löfgren and Lamm 1946; Ettinghausen 1962, p. 157; Haldane 1978, pp. 78–80).
15. Madrid, Escorial Library, Arabe 898 (Lorey 1935; Ettinghausen 1962, p. 3; James 1976, fig. 23; Haldane 1978, pp. 50–51).
16. İstanbul, Süleymaniye Library, Lala Ismail, 565 (Ettinghausen 1962, pp. 159–60; Haldane 1978, pp. 52–53).
17. The late-thirteenth-century copy is dispersed among Paris, Bibliothèque Nationale, and several other collections (Grube 1959, p. 179, no. X, fig. 18). The work dated 1301 is in Leiden, University Library, Cod. 289 Warn (Buchthal 1940, p. 163, no. 3); while the other, completed in 1334, is in London, British Library, Or. 3366 (Grube 1959, p. 180, no. XII).
18. Alexandria, Municipal Library, 3355 (Farès 1952; Haldane 1978, p. 41). Farès mentions two other manuscripts on herbaria, one of which is in a private collection in Mosul, and the other in Princeton, University Library, 1064.
19. Washington, D.C., Freer Gallery of Art, 54.33–114 and 57.13; New York, Public Library, Spencer Collection, MS 45 (Atıl 1975, nos. 55–70). This manuscript is also attributed to early-fifteenth-century Diyarbakır (Badiee 1980). Leningrad, Academy of Sciences; and Dublin, Chester Beatty Library, MS 128 (Atıl 1975, p. 150, notes 31–32). Belonging to this series is a fifteenth-century folio in Oxford, Ashmolean Museum (London 1976, no. 546). Another copy in London, British Library, Or. 4701, attributed to Egypt, late fifteenth century (London 1976, no. 577), appears to be closer in style to sixteenth-century Safavid works.
20. İstanbul, Topkapı Palace Museum, A. 3465 (Karatay 1962–69, no. 7424).
21. The work dated 1371 is in London, British Library, Add. 18866 (Smith 1979). The second *furusiyya* manuscript, dated 1373, is in İstanbul, Topkapı Palace Museum, A. 2651 (James 1974a, figs. 3 and 8; Haldane 1978, p. 58).
22. London, British Library, Add. 23487 (James 1974a, p. 74). There may have been a copy of the same work dated 1398 in Cairo, National Library, which is now lost (James 1974a, p. 74). For a study of the extant manuscripts see Tantum 1979.
23. Cambridge, Corpus Christi College, MS 578 (Haldane 1978, pp. 44–46). Munich, Bayerisches Staatsbibliothek, Cod. Arab. 616 and 617 (Haldane 1978, pp. 81–82). The fourth copy is in a private collection.
24. The copy dated 1458 is in İstanbul, Topkapı Palace Museum, A. 3350. This manuscript appears to have been photographed and deposited in Cairo, National Library, Riyada 486 (Haldane 1978, p. 42). The copy dated 1485 is in Paris, Bibliothèque Nationale, Arabe 2477 (Haldane 1978, p. 89). The copy dated 1486 is in Oxford, Bodleian Library, Greaves 27 (Haldane 1978, p. 88).
25. Cairo, National Library, Riyada 668 (Haldane 1978, p. 43). Dublin, Chester Beatty Library, MS 4187; this work bears a date, 1329, added at a later period (Haldane 1978, p. 47). Paris, Bibliothèque Nationale, Arabe 5101, with blank spaces left for illustrations (Hill 1974, p. 5, no. 10).
26. İstanbul, Topkapı Palace Museum, H. 414.
27. İstanbul, University Library, A. 4689 (Edhem and Stchoukine 1933, no. XLIII; James 1976, fig. 34). Another book on horses, the *Baytarnama*, is recorded as being in Cairo, National Library, 49 (Holter 1937a, no. 74).
28. London, British Library, Or. 3631 (Mostafa 1970–71, pls. 3–19; Haldane 1978, p. 61). İstanbul, Süleymaniye Library, Aya Sofya, 4197 (James 1974a, p. 73, note 3; Haldane 1978, p. 48, note; Tantum 1979, p. 201, note 2).
29. Al-Rahman's work is in İstanbul, Topkapı Palace Museum, A. 3467; al-Tabari's manuscript, same collection, R. 1933 (Karatay 1962–69, no. 7416; Mostafa 1970–71, pls. 24, 26, 28, 30, 32, 34, 36, 38, and 41–44).
30. London, Keir Collection (Mostafa 1970–71, pls. 23, 25, 27, 29, 31, 33, 35, and 37; Grube 1976a, II.7–37, pls. 4 and 12; Haldane 1978, pp. 72–73); Cairo, Museum of Islamic Art, 18019 and 18035–36 (Mostafa 1958, p. 39).
31. Paris, Bibliothèque Nationale, Arabe 2824 (Haldane 1978, pp. 90–92).
32. İstanbul, University Library, T. 6044 (Edhem and Stchoukine 1933, no. XLIV; İnal 1976, figs. 21–22).
33. The earliest illustrated version of this work was produced in Amasya in 1416, a few years after the death of Ahmedi (Atıl 1980, pp. 155 and 234, notes 10–11).
34. This work, conceived in six volumes, was completed in 1594/95. The volumes are in İstanbul, Topkapı Palace Museum, H. 1221–23; Dublin, Chester Beatty Library, MS 419; and New York, Public Library, Spencer Collection, MS 3 (Atıl 1980, pp. 206–7, figs. 100–101).
35. Berlin, Staatsbibliothek, Ms. or. oct. 3744 (Stchoukine 1971, no. 111; Berlin 1980, no. 017).
36. İstanbul, Topkapı Palace Museum, YY. 1066 (Mayer 1971; Ettinghausen 1974). Other unusual Mamluk illustrations are sketches: one of them represents prisoners, Cairo, Museum of Islamic Art, 15688 (Cairo 1969, no. 278, fig. 50); another depicts a battle scene, New York, Metropolitan Museum of Art, 1975.360; and a third has a mounted falconer, London, Keir Collection (Ettinghausen 1974, fig. 33).
37. The following manuscripts are difficult to identify but were probably made in Egypt or Syria: *Automata*, dated 1561, Leiden, University Library, Or. 656 (Hill 1974, p. 4, no. 2); *Automata*, sixteenth century, Leiden, University Library, Or. 117 (Hill 1974, p. 4, no. 3); *Automata*, dated 1638, Oxford, Bodleian Library, Frazer 186 (Haldane 1978, p. 87); *Maqamat*, seventeenth century, Manchester, John Rylands University Library, Arabe 680 (James 1976, fig. 29); *Kitab al-Baytara*, dated 1578, Paris, Bibliothèque Nationale, Arabe 2826 (Haldane 1978, pp. 93–94); *Ajaib al-Makhluqat*, mid sixteenth century, İstanbul, Topkapı Palace Museum, H. 408 (Karatay 1962–69, no. 7172); *Ajaib al-Makhluqat*, eighteenth century, Munich, Bayerisches Staatsbibliothek, Cod. Arabe 462 (Ettinghausen 1962, p. 181); *Kalila wa Dimna*, dated 1672, Manchester, John Rylands University Library, Arabe 487 (James 1976, fig. 35); and *Kalila wa Dimna*, eighteenth century, İstanbul, Archaeological Museum Library, 344 (Ettinghausen 1962, p. 81). One of the more interesting works made in Cairo is the 1567 copy of the *Hümayunnama*, a Turkish version of the *Kalila wa Dimna*, translated by Ali Çelebi, in İstanbul, Topkapı Palace Museum, H. 359 (İnal 1976). The provenance of another work, the *Qanun al-Dunya wa Ajaibha* (*Order of the World and Its Marvels*) of Ahmad ibn Ali, dated 1563, is generally given as Egypt due to the representation of a number of Cairene monuments. However, since the work also depicts other cities of the Islamic world, such as Mecca, Jerusalem, Baghdad, Damascus, and İstanbul, it could have been produced in any provincial Ottoman center. This work is in İstanbul, Topkapı Palace Museum, R. 1638 (Ettinghausen 1962, p. 180; James 1976, fig. 30; Haldane 1978, pp. 56–57).

Since the paintings from the *Automata*, *Maqamat*, *Kalila wa Dimna*, *Nihayat al-Su'l wa'l-Umniyya*, and *Shahnama* are represented by color reproductions in the exhibition, they are illustrated in black-and-white in the catalogue.

Kitab fi Marifat al-Hiyal al-Handasiyya of
al-Jazari
Copied by Farrukh ibn Abd al-Latif al-Katibi
al-Yaquti al-Mawlawi, December 28, 1315

Height: 31.4 cm (12⅜ in.)
Width: 21.9 cm (8⅝ in.)
Written in naskhi script: 21 lines, 173 known
 folios, 122 known paintings, 9 diagrams

Dispersed among several collections

*Fig. 1. The Clock of the Drummers
 (Washington, D.C., Freer Gallery of Art, 42.10b).*

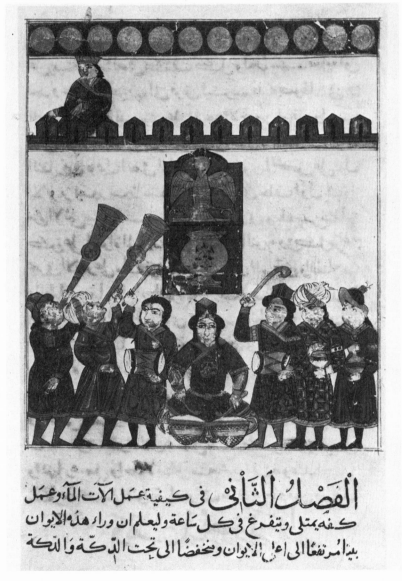

The *Kitab fi Marifat al-Hiyal al-Handasiyya (Book
of Knowledge of Ingenious Mechanical Devices)*,
commonly called the *Automata*, was composed by
Badi al-Zaman ibn al-Razzaz al-Jazari and
dedicated to Nasir al-Din (1201–22), the Artukid
sultan of Diyarbakır in southeastern Anatolia.
The work is an engineering treatise devoted to the
construction of fifty mechanical devices grouped
under six categories. Each device is described in a
separate chapter divided into sections that give
instructions on how to build its diverse components.

 The first category contains ten clocks (fig. 1);
the second describes ten drinking vessels (fig. 2);
the third is comprised of ten automated ewers and
basins used for bloodletting or handwashing
(figs. 3–4); the fourth has ten chapters on the
construction of fountains and other hydraulic
systems; the fifth includes five similar machines;
and the last gives instructions for making five
miscellaneous devices, such as an automated
palace gate, protractor, alarm clock, and locks and
bolts. In the introduction to the work, al-Jazari
mentions that he has provided 173 illustrations,
including a diagram for each section.

 The earliest copy of the *Automata* was produced
in 1206 from the autograph of al-Jazari who must
have completed his work before this date. This
manuscript, now in the Topkapı Palace Museum,
was transcribed by Muhammad ibn Yusuf ibn
Uthman al-Haskafi (from Hasankeyf near
Diyarbakır) and contains 179 folios with 60
illustrations, which became the models for all later
copies.[1] It must have been available to an
anonymous thirteenth-century artist who used
similar paintings and diagrams in his undated
work, which has 211 folios with 143 illustrations.[2]
One of these manuscripts was used by Farrukh ibn
Abd al-Latif, who copied and most likely
illustrated the same text dated the last day of
Ramadan 715 corresponding to December 28,
1315. This version—originally in İstanbul, then in
New York in the Kevorkian Collection, and
recently sold in London—contains 150 folios with
98 paintings, 9 diagrams, and the colophon.[3]
Twenty-three folios with paintings removed from
the manuscript in the 1930s are presently in
diverse public and private collections.[4] Since the
colophon of the work appears on folio 207, the
manuscript originally had that many folios with
at least 130 paintings and diagrams.

 The provenance of the 1315 *Automata* has not
yet been determined and the manuscript has been
attributed by different scholars to Diyarbakır,
Damascus, and Cairo. It is thought to be the
second oldest copy of al-Jazari's treatise, based on
a notation in the manuscript stating that this is a
copy of a copy of the autograph, that is, a copy of
the 1206 version; but the same statement is also
found on several later renditions of the *Automata*.

 The illustrations in the 1315 *Automata* are
among the most refined examples of Mamluk
painting. The diagrams included in the sections

are clearly drawn and the paintings of the completed automata, which appear at the beginning of each chapter, are not only structurally correct but also conceived as independent compositions rendered in brilliant colors and embellished with rich decorative motifs. The artist uses shading in his figures, attempting to render volume while remaining true to his subject.

The second chapter of category one, describing the clock of the drummers, shows a group of musicians below the parapet of a castle (fig. 1). At every hour the discs above the parapet change color, the figure on the parapet moves over one crenelation, the eagle in the center leans forward to drop a ball into a vase, which rings a chime, and the musicians below play their instruments. The instruments include trumpets, drums, cymbals, and a double drum, recalling those used by the *tablakhana*, the Mamluk military band.

The ninth chapter of category two contains a whimsical device with two elderly *shaykhs*, holy men, holding beakers and wine bottles while sitting in a domed pavilion (fig. 2). At given intervals one *shaykh* pours wine into the beaker of his companion, who drinks it and nods his head in contentment. Then the other *shaykh* offers his friend a drink, who takes it and nods. This automated toy has four feet and was meant to be placed on a table.

Described in the sixth chapter of category three is a more serious and functional device: a basin used to measure the amount of blood taken from a patient (fig. 3). The automaton has a platform with four columns placed above a large basin. As the blood collects in the basin, two scribes on the platform record the amount in dirhams (a measure corresponding to three grams) on a tablet or on the dics incised on the platform. The patient is bled until 120 dirhams accumulate in the basin and both scribes record that number.

Another basin used for handwashing is the subject of the tenth chapter in the same category (fig. 4). Similar to the device with drinking *shaykhs*, it is a domed pavilion resting on four feet; inside is a female figure holding a ewer and towel. When the bird on the dome whistles, water begins to pour from the spout of the ewer and collects in a basin attached to the pavilion; it is drunk by a duck and released into the tank under the servant. When the water in the tank rises to a certain level, it activates the arm of the figure, which extends the towel.

Many of the devices in the *Automata* are princely toys, meant to amuse the court while serving a functional use. Although there is no evidence that any of these machines were ever made, the entertainment provided by the illustrations made the *Automata* one of the most popular books in the Mamluk period.

Published
Aga-Oglu 1931.
Dimand 1955, p. 90.
Ettinghausen 1962, p. 93.
Grube 1962, nos. 7–8.
Sotheby 1967, nos. 17–18.
Sotheby 1969, nos. 19–20.
Sotheby 1970, no. 13.
Grube 1972, nos. 21–23.
Hill 1974, pls. II–V, VIII–XII, XIV–XVIII, XX, XXII–XXIII, and XXVI–XXVIII.
Atıl 1975, nos. 44–51.
B. W. Robinson 1976, no. 4.
Grube 1976a, no. II.6 and pl. 3.
Haldane 1978, pp. 74–75.
Sotheby 1978, no. 133.

Notes
1. İstanbul, Topkapı Palace Museum, A. 3472 (Stchoukine 1934; Holter 1937a, no. 10; Buchtal 1940, no. 10). Some of the folios in this manuscript were repaired at a later date. Only twenty-eight of the sixty illustrations represent human figures.
2. İstanbul, Topkapı Palace Museum, A. 3461.
3. Sotheby 1978, no. 133.
4. The known folios are in the following collections: Washington, D.C., Freer Gallery of Art, 30.71–77 and 42.10 (eight folios); New York, Metropolitan Museum of Art, 55.121.11–15 and 57.51.23 (six folios); Boston, Museum of Fine Arts, 31.124–26 (three folios); New York, Kraus Collection, nos. 21–23 (three folios); Cleveland, Cleveland Museum of Art, 45.383; Jerusalem, L.A. Mayer Memorial for Islamic Art; London, Keir Collection, no. II.6.

Fig. 2. Mechanical Device with Two Drinking Men (Washington, D.C., Freer Gallery of Art, 30.77a)

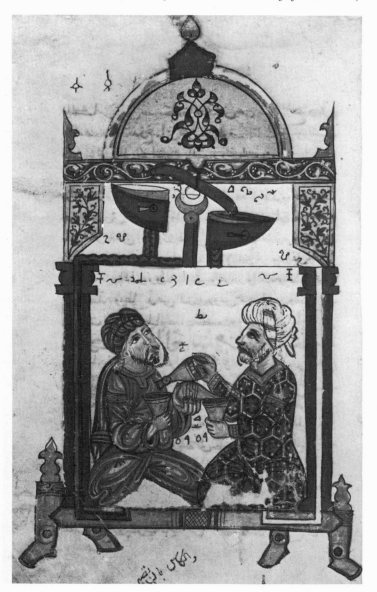

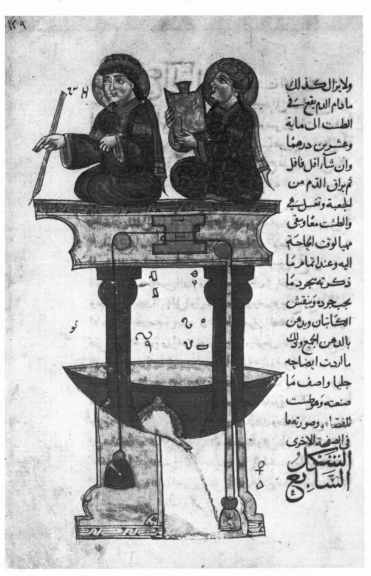

Fig. 3. The Basin of the Two Scribes
 (Washington, D.C., Freer Gallery of Art, 30.76a)

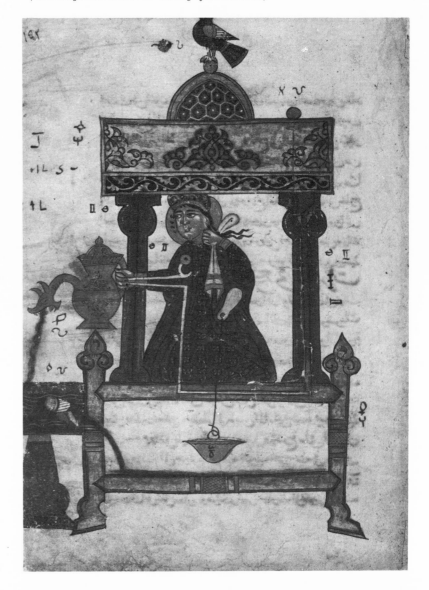

Fig. 4. The Basin of the Servant
 (Washington, D.C., Freer Gallery of Art, 30.75a)

II

Maqamat of al-Hariri
Copied by Abu'l-Fadail ibn Abu Ishaq, March 29, 1334

Height: 37.0 cm. (14$\frac{9}{16}$ in.)
Width: 25.5 cm. (10 in.)
Written in naskhi script: 13 lines, 195 folios, 70 paintings

Vienna, Nationalbibliothek, A.F. 9

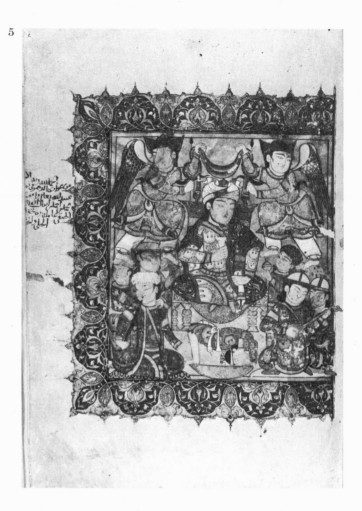

5

Fig. 5. Frontispiece with Enthroned Ruler (fol. 1a)
Fig. 6. Tavern Scene (fol. 42b)
Fig. 7. Abu Zayd Delivers a Sermon in a Mosque (fol. 95b)
Fig. 8. Abu Zayd Gives a Lecture in a School (fol. 170b)

The *Maqamat*, which consists of short satirical stories edged with social
criticism, is among the earliest examples of the Arabic belles-lettres tradition.
The stories relate the escapades of Abu Zayd, a roguish hero whose linguistic
abilities enable him to swindle people and evade punishment, and his dim-
witted friend, al-Harith, who narrates these picaresque episodes. About four
hundred of these stories, some of which date to the eighth century, were
compiled by al-Hamdhani around the year 1000. Fifty of the *maqama* were
written down by al-Hariri (1054–1122), whose work became the most widely
copied and illustrated version in the thirteenth and fourteenth centuries.

The first illustrated copies of al-Hariri's *Maqamat* were produced in the
early decades of the thirteenth century: one undated version is assigned to the
second quater of the thirteenth century and a second, attributed to Syria, was
completed in 1222.[1] Two other illustrated manuscripts, attributed to
Baghdad, were made in the 1230s and contain the most elaborate paintings.[2]
An equally refined version was produced between 1242 and 1258 for
al-Mustasim, the last Abbasid caliph of Baghdad.[3] Another copy, with
considerably weaker illustrations, is dated 1256.[4]

The figure types and settings established by these six manuscripts produced
in Syria and Iraq between the 1220s and 1250s were used as models by
fourteenth-century Mamluk painters. The most striking Mamluk copy was
transcribed by Abu'l-Fadail ibn Abu Ishaq in Rajab 22, 734 (March 29, 1334).
Although the manuscript does not bear a dedication, its meticulously detailed
illustrations painted on gold leaf suggest that it was produced for the court.
The scenes are highly decorative with doll-like figures attired in beautiful
garments placed within interior or exterior settings, indicated by such simple
devices as arches, curtains, or sprays of flowers. The compositions are
simplified, with groups of conversing figures filling the picture frame.
The paintings are purely decorative, devoid of action, drama, and pictorial
narrative. In this sense they recall the figural compositions of early Mamluk
metalwork and enameled and gilded glass (see nos. 20–21).

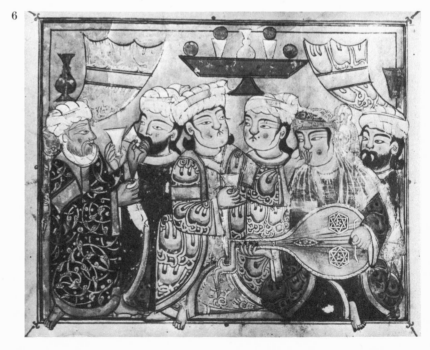

6

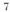

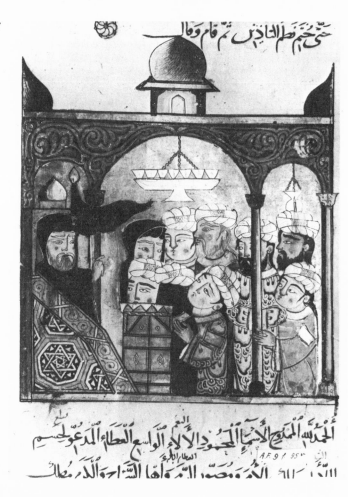

<div dir="rtl">

حتى ختم نظم القصائد ثم قام وقال

الحمد لله المنعم الأسبأ الأسبأ المحمود دلاث الأواسع العطاء المدعو لحسم

A.F.9 f 95 v

اللهم واحد ومصون ... امها وأها الشـ ... احه الذ ... م مطلك
</div>

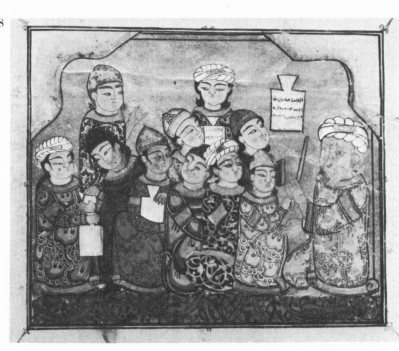

The work opens with a frontispiece representing an enthroned ruler entertained by his courtiers (fig. 5). The ruler sits crosslegged on a high throne, holding a beaker and handkerchief; he wears a turban, moiré-patterned robe accented with gold bands, and short-sleeved coat decorated with arabesques. Inscriptions appear on his turban and sleeves. A pair of crowned angels holds a scarf over his head. Flanking the prince are six courtiers with round faces and almond-shaped eyes who wear turbans and brimmed hats with feathers; the foremost figures play a lute and flute. In the foreground an acrobat performs with a large circular basin. The garments of the figures and the throne are embellished with various moiré designs and floral arabesques. Even the ears of the figures are decorated with florets, a feature observed throughout this manuscript. The composition is two dimensional with no attempt made to provide a sense of depth or volume.

A similar decorative quality is observed in the illustration of the twelfth *maqama*, which represents six figures in a tavern (fig. 6). The setting is indicated by curtains, beakers, bottles, and a large bowl with fruit floating above the revelers. The youthful figure in the center fondles the female lutist while others look on or hold beakers.

The twenty-eighth *maqama* describes an episode in the Great Mosque of Samarkand in which Abu Zayd delivers a sermon (fig. 7). The illustration for this story is one of the most elaborate in the manuscript and represents the interior of a domed building with columns separating the aisles. A mosque lamp and large lantern with seven receptacles for candles hang from the ceiling. Abu Zayd sits in the minbar (pulpit) on the left, attired in black with a black banner next to him, symbolic of the Abbasid caliphate. The congregation of nine figures portrays various races and ages, including a negro, beardless youths, black-bearded middle-aged men, and white-bearded elders. In front of the minbar is a metal box that most likely contains the Koran (see no. 25).

In the illustration of the forty-sixth *maqama* (fig. 8), Abu Zayd, depicted throughout the manuscript as an elderly man with a white beard, is shown lecturing to a group of ten students in Homs. The setting is indicated by an archway, floral rug, and writing tablet suspended over the group. The hero sits on the right, waving a stick while the students listen intently, some holding their tablets, one taking notes.

The Vienna manuscript is among the last illustrated copies of the *Maqamat* produced in the Mamluk world. Unlike the *Automata* and the *Kalila wa Dimna*, whose illustrations could be understood without reading the text, the paintings of the *Maqamat* becomes meaningless if the linguistic nuances of the stories cannot be appreciated. The text requires a highly educated and literary audience that can comprehend and thus be amused by its language and verbal gymnastics. Therefore, it is not surprising that the *Maqamat* had a limited reception among the Mamluks whose native tongue was Turkish. Since the paintings could not convey the essential character of the stories or stand on their own as pictorial commentaries, illustrated versions of the *Maqamat* ceased to be produced in the Mamluk court after the 1330s.

Published
Holter 1937, pp. 15–35.
Haldane 1978, pp. 100–103 (with bibliography).

Notes
1. The undated copy is in Paris, Bibliothèque Nationale, Arabe 3929 (Holter 1937a, no. 18; Buchthal 1940, no. 18; Ettinghausen 1962, p. 82). The manuscript dated 1222 is in the same collection, Arabe 6094 (Holter 1937a, no. 25; Buchthal 1940, no. 25; Ettinghausen 1962, p. 79; James 1976, fig. 4).
2. A copy dated circa 1225–35 is in Leningrad, Academy of Sciences, s 23 (Holter 1937a, no. 32; Buchthal 1940, no. 32; Ettinghausen 1962, pp. 106–8 and 111–13; James 1976, figs. 9–11 and 13). The other, completed in 1237, is in Paris, Bibliothèque Nationale, Arabe 5847 (Holter 1937a, no. 31; Buchthal 1940, no. 31; Ettinghausen 1962, pp. 114, 116–19, and 121-22; James 1976, figs. 7–8 and 12).
3. İstanbul, Süleymaniye Library, Esad Efendi 2916 (Grabar 1963).
4. London, British Library, Or, 1200 (Holter 1937a, no. 34; Buchthal 1940, no. 34).

III

Kalila wa Dimna of Ibn al-Muqaffa

Copied by Muhammad ibn Ahmad ibn Safi ibn
 Qasim ibn Abd al-Rahman al-Sufi, May 19,
 1354

Height : 36.5 cm. (14⅜ in.)
Width : 25.0 cm. (9⅞ in.)
Written in naskhi script : 15 lines, 152 folios,
 77 paintings

Oxford, Bodleian Library, Pococke 400

Fig. 9. *Burzoe Traveling to India (fol. 12b)*
Fig. 10. *Slaying of the Camel (fol. 60a)*
Fig. 11. *The Tortoise and the Geese (fol. 61b)*
Fig. 12. *The King of the Elephants and the Hare*
 (fol. 99a)

Few books in the ancient world were as widely
read and circulated as the collection of fables
called the *Kalila wa Dimna,* named after the two
jackals who are the protagonists of the stories.
The work, taken from tales in two Indian epics,
the *Panchatantra* and the *Mahabharata,* is thought
to have been written by a Brahman named Bidpai
around the year 300. It was translated from
Sanskrit into Pahlavi (Middle Persian) and Syriac
in the sixth century. The Pahlavi version, which is
now lost, was rendered into Arabic by Abdallah
ibn al-Muqaffa around 750 and became the source
for subsequent translations into many Eastern
and Western languages.

The earliest illustrated version of Ibn
al-Muqaffa's work was made in the first quarter
of the thirteenth century.[1] One of the later
manuscripts produced in the Mamluk period was
transcribed by Muhammad ibn Ahmad ibn Safi
ibn Qasim ibn Abd al-Rahman al-Sufi, known as

Ibn al-Ghazuli, on Monday, the twenty-fifth day
of Rabii II, 755 (May 19, 1354). The opening folios
of this copy are missing. The text begins with a
description of the mission of Burzoe who was sent
to India by the Sasanian king Khosrau Nushirvan
to obtain the *Kalila wa Dimna.* This is followed by
the introduction of Ibn al-Muqaffa, who trans-
lated the Pahlavi version into Arabic, Burzoe's
biography, and thirteen chapters devoted to
fables, which teach moral behavior and good
conduct to rulers.

The paintings in this copy are carefully made.
They follow the text closely and illustrate all
major episodes. One of the scenes (fig. 9)
represents Burzoe traveling to India, accompanied
by two men. The Sasanian official is attired in
Arab dress and wears a white turban with a gold
robe. The figures ride in a landscape suggested by
two large flowering trees and a ground line of
green grass.

9

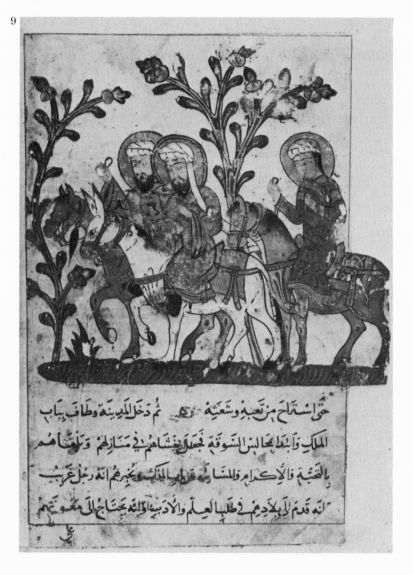

10

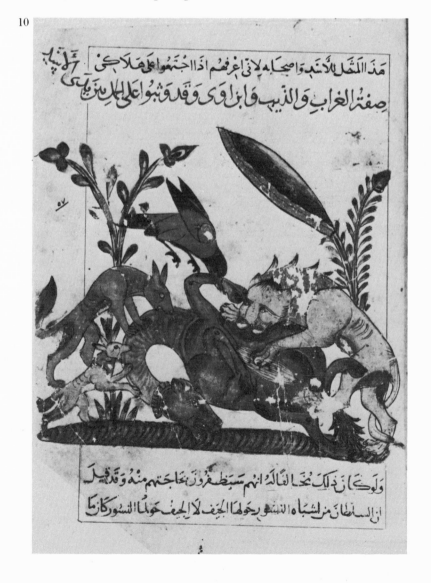

Chapter three, entitled "The Lion and the Ox," is the longest in the book and is devoted to stories on friendship, mistrust, and treachery. One of the fables describes a fight between a lion and an elephant. The lion, badly wounded by the elephant, can not hunt for prey and provide his friends with food. His friends—the crow, the wolf, and the jackal—resort to treachery and trick the camel into offering itself as food, upon which they devour the poor animal (fig. 10). These paintings, set against a simple background, represent the animals in naturalistic poses while creating dramatic movement.

Another episode in the same chapter narrates the story of the foolish tortoise who would not listen to good advice. When his pond dried out, the geese offered to take him to another watering hole. They told him to bite on a stick, the ends of which they would hold in their mouths while flying (fig. 11). When the villagers saw this peculiar sight, they started talking. Unable to resist answering them, the tortoise opened his mouth and fell to his death.

The sixth chapter, called "The Owls and the Crows," teaches rulers to never trust an enemy. This advice is illustrated by the story of the hares whose meadow was being trampled by a herd of elephants. One of the cunning hares decides to trick the elephants and stands on a high ground overlooking a pond. He beckons the king of the elephants and states that he was sent by the powerful moon who wants the elephants to leave the meadow. The elephant sees the reflection of the moon in the pond, which starts moving when he wades in (fig. 12). He becomes convinced of the power of the moon, gathers his herd, and departs from the meadow.

Simplified settings with stylized landscape elements and charming portrayals of animals who have distinct personalities enhance the fantastic quality of the fables. Compositions depict essential features of the tales without elaboration or unnecessary details. They are almost graphic illustrations of the stories, expressed with clarity and sensitivity.

The representation of animals in fables and in zoological texts was particularly popular in the middle of the fourteenth century. The paintings produced during this period show a delight in portraying members of the animal kingdom whose wisdom and courage, behavior and usefulness found a great attraction in the Mamluk world.

Published
Atıl 1981 (with bibliography).

Notes
1. Paris, Bibliothèque Nationale, Arabe 3465 (Holter 1937a, no. 26; Buchthal 1940, no. 26; Ettinghausen 1962, pp. 62–63).

11

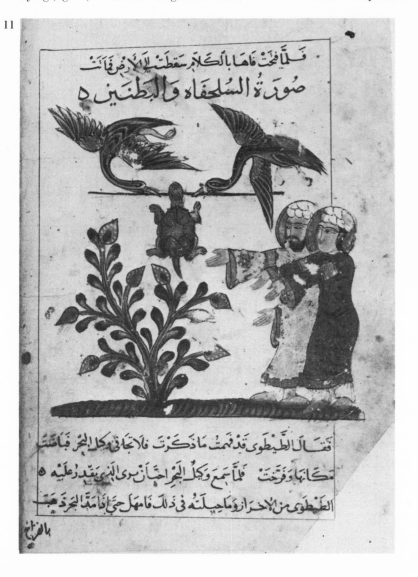

12

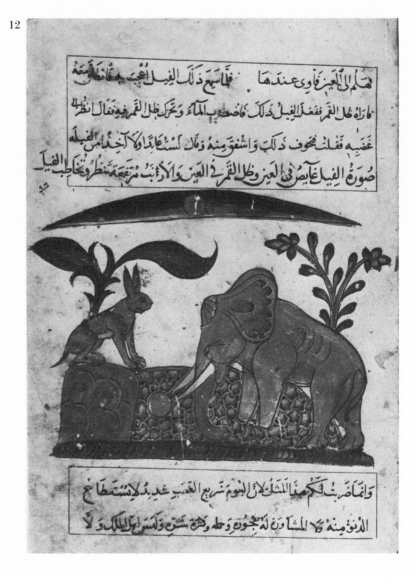

IV

Nihayat al-Su'l wa'l-Umniyya fi Taallum Amal al-Furusiyya of al-Aqsarai
Copied by Umar ibn Abdallah ibn Umar al-Shafii, January 1366
Painted by Ali

Height : 29.0 cm. (11⅜ in.)
Width : 20.0 cm. (7⅞ in.)
Written in naskhi script : 19 lines, 319 folios, 19 paintings

Dublin, The Chester Beatty Library, Add. Cat. MS 1

Fig. 13. *Four Knights with Lances Riding around a Pool (fol. 118b)*
Fig. 14. *Knight Spearing a Bear (fol. 134b)*
Fig. 15. *Galloping Knight with Sword (fol. 146b)*
Fig. 16. *Knight with Flaming Sword and Shield (fol. 156b)*

The treatise on horsemanship entitled *Nihayat al-Su'l wa'l-Umniyya* was written by Muhammad ibn Isa ibn Ismail al-Hanafi al-Aqsarai who died in Damascus in 1348. The author had studied military exercises with Nasir al-Din al-Rammah, a pupil of the master Najm al-Din al-Ahdab, and with Izz al-Din Abd al-Aziz al-Rammah, a Bahri Mamluk in the Citadel of Damascus. The work, completed in the second quarter of the fourteenth century, was dedicated to Ala al-Din Asanbay al-Abu Bakri, viceroy of Syria.

Al-Aqsarai's treatise is comprised of twelve *talim*, lessons, designed for the teaching and practice of horsemanship and warfare in the hippodrome as well as on the battlefield. The chapters include exercises in the use of the bow and arrow, lance, sword, mace, and other weapons; formation of armies, military tactics, and ruses employing fire and smoke; advice on division of booty, Islamic law regarding protection of the enemy, and conclusion of treaties; and various branches of knowledge required by soldiers, such as the practice of

augury and treatment of wounds.

In the fourteenth and fifteenth centuries, this treatise became the most popular book on *furusiyya*, and many copies were illustrated. The oldest illustrated version was transcribed in Jumada I, 767 (January 1366) by Umar ibn Abdallah ibn Umar al-Shafii. This manuscript has a frontispiece with the title of the book and the dedication, which was painted over in the fifteenth century by the ex libris of Sultan Jaqmaq (1438–53). Although the name of the original patron is obscured, several words can be detected, including "for the treasury of our master, the high amir . . . al-Aiay al-Maliki al-Ashrafi," indicating that this person was in the service of Shaban II.

It has been suggested that the manuscript was made for either Timurtash al-Alay or Ala al-Din Taybugha al-Alay, treasurer or majordomo of the powerful Yelbugha who was the commander of the army and the most influential amir during the sultanate of Shaban II.[1] Patronage of the work may have been stimulated by the sack of

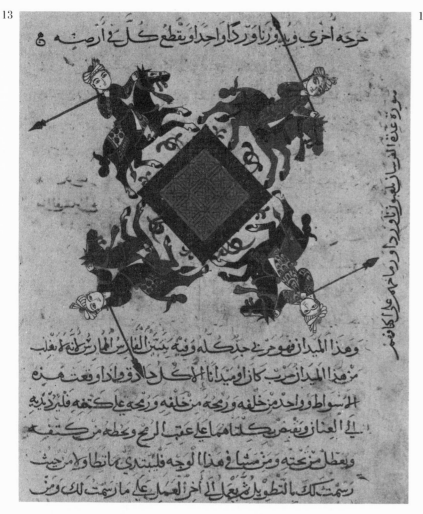

13

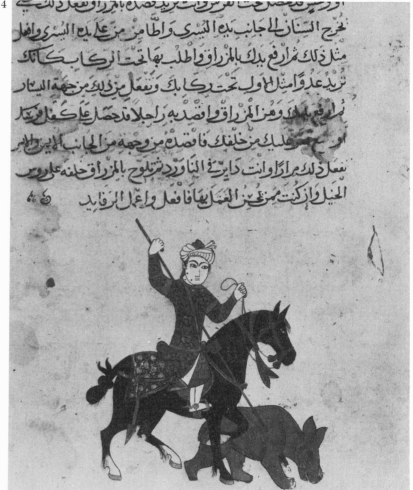

14

Alexandria by the Crusaders in 1365, which prompted Yelbugha, to prepare a massive retaliatory attack and build up the army and navy. The spirit of jihad, holy war, permeating in 1366 must have spurred the interest in *furusiyya* manuals and hence the first illustrations of al-Aqsarai's work.

One of the chapters in lesson two—which is devoted to the use of the lance—describes advancing, retreating, and encircling. The illustration represents four horsemen bearing lances over their shoulders riding around the hippodrome pool in a clockwise direction (fig. 13). The youthful knights wear turbans, boots, and moiré-patterned coats over robes. A border of grass and plants encloses the square pool with its stylized waves rendered in an interlace.

The same lesson includes instructions on the use of the lance against wild animals, which is represented by a figure on a black horse spearing a bear (fig. 14). The warrior, attired in a similar fashion as the previous figures, wears over a moiré robe a coat decorated with large lotuses. A mace is tucked into his saddle, which has a floral saddlecloth.

A galloping rider brandishing a sword illustrates the section in lesson three describing the use of the sword (fig. 15). The text states that the rider's sleeves are pushed back and that he rises out of his saddle as he strikes with his sword.

This lesson also instructs the horsemen on how to use fire as well as the sword and shield. A warrior wearing a helmet carries a sword and shield while riding a black horse with a red and gold saddlecloth (fig. 16). His helmet, sword, and shield have been ignited. The figure appears older than the other riders and has a black mustache and beard.

The paintings in this manuscript appear only in the beginning of the text and illustrate lessons related to the use of the lance and sword. One of these scenes (fol. 149a) bears the name of the painter, Ali, written on the mace attached to the saddle.[2] Ali was most likely responsible for all the paintings used as prototypes for later copies of al-Aqsarai's manuals.[3]

Other Mamluk *furusiyya* texts produced in the second half of the fifteenth century draw upon a different representational style and are profusely illustrated with different exercises, types of weapons, military maneuvers, and ceremonies.[4]

Published
James 1974a.
Haldane 1978, pp. 48–49 (with bibliography)

Notes
1. James 1974a, pp. 84–86.
2. James 1974a, p. 80 and fig. 12.
3. See, for example, London, British Library, Add. 18866, dated 1371 (Smith 1979); and Istanbul, Topkapı Palace Museum, A. 2651, dated 1373 (James 1974a, figs. 3 and 8; Haldane 1978, p. 58).
4. These expanded versions include the manuscript dispersed between London, Keir Collection, and Cairo, Museum of Islamic Art (Mostafa 1958, p. 39; Mostafa 1970–71, pls. 23, 25, 27, 29, 31, 33, 35, and 37; Grube 1976a, II.7–37, pls. 4 and 12; Haldane 1978, pp. 72–73); and the copy dated 1466 in Istanbul, Topkapı Palace Museum, R. 1933 (Karatay 1962–69, no. 7416; Mostafa 1970–71, pls. 24, 26, 28, 30, 32, 34, 36, 38, and 41–44).

15

16

V

Shahnama of Firdausi

Translated into Turkish by Sharif and copied by
Husein ibn Hasan ibn Muhammad al-Huseini
al-Hanafi in Cairo, March 2, 1511

Height: 41.0 cm. (16⅟₁₆ in.)
Width: 25.0 cm. (9⅞ in.)
Written in naskhi script: 25 lines, 1170 folios in
2 volumes, 62 paintings

İstanbul, Topkapı Palace Museum, H. 1519

Fig. 17. Enthronement of Jamshid (fol. 22b)
Fig. 18. Zal Climbing the Wall to Reach Rudaba
(fol. 115a)
Fig. 19. Rustam Killing the Elephant (fol. 146a)
Fig. 20. Enthronement of Kaiqubad (fol. 188a)

The *Shahnama*, a history of Iran composed by
Firdausi of Tus around the year 1000 and
dedicated to Sultan Mahmud of Ghazna, is the
most celebrated epic in Persian literature and was
illustrated throughout Islamic history. This
voluminous work was translated into Turkish at
the court of the last Mamluk sultan, Qansuh
al-Ghuri, by Sharif. The manuscript was
transcribed by Husein ibn Hasan ibn Muhammad
al-Huseini al-Hanafi and illustrated by artists who
followed the late-fifteenth-century style associated
with the Turkman courts at Baghdad and Shiraz
and at the same time incorporated local elements.

Sharif's Turkish version, which is rendered in
verse, begins with a praise of Sultan Qansuh
al-Ghuri and describes his interest in scientific and
literary books. The author writes that the sultan,
who knew Persian well, had many copies of the
Shahnama in his library and wanted the text
translated so that others could read and
understand it. The sultan insisted that Sharif

undertake the translation and create a work that
would eternalize the translator's name.

Volume one, which contains 616 folios,
concludes with a notation stating that this part
was finished in the Qubbat al-Huseini on the first
night of Shaban 913 (December 6, 1507). The text
of the *Shahnama* terminates on folio 1152 of the
second volume; it is followed by a discussion of
important sultans, beginning with Mahmud of
Ghazna (fols. 1152–60). Then the author describes
the court of Qansuh al-Ghuri, the palaces,
madrasas, and fountains built by the sultan and
concludes by saying that the work was begun
during the first year of Qansuh al-Ghuri's
sultanate and finished in ten years, on Monday,
the second day of Zu'l-Hijja 916 (March 2, 1511)
in al-Muayyad Mosque built by Sultan Shaykh.

One of the first paintings in the manuscript
represents Jamshid seated on a gold throne,
attended by his *silahdar* (sword-bearer); a *saqi*
(cup-bearer) pours wine in the foreground and two

courtiers with a lutist appear on the left (fig. 17). Although the composition and figure types follow Turkman traditions, the artist has inserted several local elements, such as the oblong panel inscribed with typical Mamluk benedictions and a round shield with an epigraphic blazon on the wall in the background and a blue-and-white goblet in the foreground. The tree behind the wall is rendered in a painterly manner, one of the characteristics of the painters of the *Shahnama*.

A local structure with inlaid marble panels, trefoil crenelations, and a two-story pavilion with a ribbed dome forms the background for the scene representing Zal climbing the wall to reach his beloved Rudaba (fig. 18). This painting, one of the most beautifully executed examples in the manuscript, transgresses the frame with the pavilion placed outside the left margin.

The female figures, their attires and gestures, as well as Zal's portrayal, rely on Turkman models, but the setting was inspired by contemporary Mamluk architecture. The trees on the lower left are executed in the same painterly manner as those in the first scene; here a tree bears oval fruit, which may depict mangoes native to Egypt.

In the scene representing young Rustam killing a mad elephant with a single blow (fig. 19), Rustam, who wears a white nightshirt, swings his ox-headed mace and strikes the head of an enormous elephant, which keels under the blow. The famous feat is observed by a group of male and female figures from a chamber surmounted by a ribbed dome jutting out of the picture frame on the left. The artist has depicted a fifteenth-century Mamluk bedroom with original furnishings: a platform bed on four legs with headboard is supplied with two pillows and a quilt encased in a white sheet. The bulky knotted curtain hanging over the bed reveals an understanding of mass and volume unique to this painter. The painter has taken certain liberties and rendered the elephant gray,

although the text specifies a white animal.

A similar interest in portraying local settings and furnishings occurs in the scene depicting the enthronement of Kaiqubad who sits on a gold sphinx throne under a domed baldachin raised by three steps from the floor (fig. 20). The arch embellished with arabesques and the carved wood doors in the background are taken from fifteenth-century Mamluk buildings.

In their depiction of local settings and traditional furnishings, the artists of the *Shahnama* reveal the enthusiasm of newcomers. The incorporation of these native elements enables us to reconstruct the life of the Mamluk court in the beginning of the sixteenth century.

Published
Atasoy 1968.
Atasoy 1969.
Mostafa 1970–71, pls. 20–22.

19

20

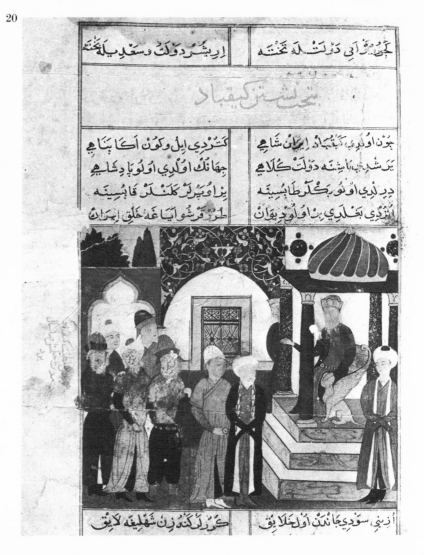

KEY TO SHORTENED
REFERENCES

Aanavi 1968 Aanavi, Don. "Western Islamic Art." *The Metropolitan Museum of Art Bulletin* 27, no. 3 (November 1968):197–203.

Abd el-Rauf 1962 Abd el-Rauf Ali Yusuf. "Tuhaf fanniyya minasr al-mamalik" [Some masterpieces from the Mamluk period]. *Al-madjala* 62 (March 1962):96–105.

Abd al-Raziq 1966 Abd al-Raziq, Ahmad. "Documents sur la Poterie d'Époque Mamelouke: Sharaf al-Abawani." *Annales Islamologiques* 6 (1966):21–32.

Abel 1930 Abel, Armand. *Gaibi et les Grand Faïenciers Égyptiens d'Époque Mamlouke*. Cairo:Imprimerie de l'Institut Français d'Archéologie Orientale, 1930.

Aga-Oglu 1930 Aga-Oglu, Mehmet. "An Important Glass Bottle of the Fourteenth Century." *Bulletin of the Detroit Institute of Arts* 12, no. 3 (December 1930):25–27.

Aga-Oglu 1931 Aga-Oglu, Mehmet. "On a Manuscript by al-Jazari." *Parnassus* 3, no. 7 (November 1931):27–28.

Aga-Oglu 1945 Aga-Oglu, Mehmet. "About a Type of Islamic Incense Burner." *Art Bulletin* 27 (1945):28–45.

Allan 1969 Allan, James W. "Later Mamluk Metalwork: A Series of Dishes." *Oriental Art*, n.s. 15, no. 1 (Spring 1969):38–43.

Allan 1970 Allan, James W. "Mamluk Sultanic Heraldry and the Numismatic Evidence: A Reinterpretation." *Journal of the Royal Asiatic Society* 2 (1970):99–112.

Allan 1971 Allan, James W. "Later Mamluk Metalwork II: A Series of Lunch-boxes." *Oriental Art*, n.s. 17, no. 2 (1971):156–64.

Aly Bahgat and Massoul 1930 Aly Bahgat and Massoul, Felix. *La ceramique musulmane de l'Égypte*. Cairo:Imprimerie de l'Institut Français d'Archéologie Orientale, 1930.

American Art 1930 [American Art Association.] *V. and L. Benguiat Collection: Rare Old Rugs, Tapestries and Textiles*. Sale catalogue. New York:American Art Association, Anderson Galleries, Inc., 1930.

Angoulême 1974–75 *Aspects de l'art en pays arabe*. Catalogue of an exhibition presented by Musée Municipal d'Angoulême, Musées de la Ville de Nice, and Musée Archéologique de Marseille. Paris:Inspection Générale des Musées Classés et Contrôlés, 1974–75.

AQ 1968 "Accessions of American and Canadian Museums; October–December, 1967." *Art Quarterly* 31, no. 2 (Summer 1968):205–31.

Arberry 1955–56 Arberry, Arthur J. *The Chester Beatty Library: A Handlist of the Arabic Manuscripts*. 8 vols. Dublin:Emery Walker Ltd., 1955–56 (vols. 1–2); Dublin:Hodges, Figgis & Co., Ltd., 1958–66.

Arberry 1967 Arberry, Arthur J. *The Koran Illuminated: A Handlist of the Korans in the Chester Beatty Library*. Dublin:Hodges, Figgis & Co., Ltd., 1967.

Aslanapa 1977 Aslanapa, Oktay. *Yüzyıllar Boyunca Türk Sanatı (14. yüzyıl)* [Turkish art through the centuries (14th century)]. Ankara:Devlet Kitapları, 1977.

Atasoy 1968
Atasoy, Nurhan. "1510 Tarihli Mamluk Şehnamesinin Minyatürleri." *Sanat Tarihi Yıllığı 1966–1968* (İstanbul, 1968):49–69.

Atasoy 1969
Atasoy, Nurhan. "Un manuscrit mamluk illustré du Šahnama." *Revue des études islamiques* 37 (1969):151–58.

Atıl 1973
Atıl, Esin. *Ceramics from the World of Islam.* Washington, D.C.:Freer Gallery of Art, Smithsonian Institution, 1973.

Atıl 1973a
Atıl, Esin. *Turkish Art of the Ottoman Period.* Washington, D.C.:Freer Gallery of Art, Smithsonian Institution, 1973.

Atıl 1975
Atıl, Esin. *Art of the Arab World.* Washington, D.C.:Freer Gallery of Art, Smithsonian Institution, 1975

Atıl 1980
Atıl, Esin. "The Art of the Book." In *Turkish Art,* edited by Esin Atıl, pp. 137–238. Washington, D.C.: Smithsonian Institution Press; New York:Harry N. Abrams, Inc., 1980.

Atıl 1981
Atıl, Esin. *Kalila wa Dimna: Fables from a Fourteenth-Century Arabic Manuscript.* Washington, D.C.: Smithsonian Institution Press, 1981.

Ayalon 1961
Ayalon, David. "Notes on the *Furusiyya* Exercises and Games in the Mamluk Sultanate." In *Scripta Hierosoloymitana.* Studies in Islamic History and Civilization, edited by Uriel Heyd, vol. 9:31–62. Jerusalem: Magnes Press, Hebrew University, 1961.

Ayalon 1977
Ayalon, David. *Studies on the Mamluks of Egypt (1250–1517).* London:Variorum Reprints, 1977.

Ayalon 1978
Ayalon, David. *Gunpowder and Firearms in the Mamluk Kingdom.* Reprint ed. London:Frank Cass and Company Limited, 1978.

Badiee 1980
Badiee, Julie Anne Oeming. *An Islamic Cosmography: The Illustrations of the Sarre Qazwini.* Ph.D. dissertation, University of Michigan. Ann Arbor, Mich.:University Microfilms International, 1980.

Baer 1973–74
Baer, Eva. "The Nisan Tasi: A Study in Persian–Mongol Metal Ware." *Kunst des Orients* 9, no. 1/2 (1973–74):1–46.

Baltimore 1957
The History of Bookbinding, 524–1950 A.D. Catalogue of an exhibition at Baltimore Museum of Art. Baltimore:Trustees of the Walters Art Gallery, 1957.

Barrett 1949
Barrett, Douglas. *Islamic Metalwork in the British Museum.* London:Trustees of the British Museum, 1949.

Beirut 1974
Musée Nicolas Sursock. *Art Islamique dans les collections privés libanaises.* Catalogue of an exhibition at Musée Nicolas Sursock. Beirut:Musée Nicolas Ibrahim Sursock, 1974.

Berchem 1904
Berchem, Max Van. "Notes d'archéologie arabe." *Journal Asiatique* 3, 10th ser. (January–February 1904):5–96.

Berlin 1965
Erwerbungen Islamischer Kunst 1954–1964. Berlin:Staatliche Museen, Preussischer Kulturbesitz, 1965.

Berlin 1971
Museum für Islamische Kunst, Berlin: Katalog 1971. Berlin:Staatliche Museen, Preussischer Kulturbesitz, 1971.

Berlin 1980
Islamische Buchkunst aus 1000 Jahren. Catalogue of an exhibition at Staatsbibliothek Preussischer Kulturbesitz, Berlin, and Wissenschaftszentrum, Bonn. Berlin:Staatsbibliothek Preussischer Kulturbesitz, 1980.

Binghamton 1975
Islam and the Medieval West. Catalogue of an exhibition at University Art Gallery. Edited by Stanley Ferber. Binghamton, N.Y.:State University of New York, 1975.

Bird 1972
Bird, Virgil H. "Reflection of Mamluk Dynasty Art on the Early Glass of Emile Gallé." *Glass* 1 (November–December 1972):29–32.

Bosch 1952
Bosch, Gulnar Kheirallah. "Islamic Bookbindings: Twelfth to Seventeenth Centuries." Ph.D. dissertation, University of Chicago, 1952.

Briggs 1940
Briggs, Amy. "Timurid Carpets." *Ars Islamica* 7, (1940):20–54.

Brooklyn 1941
Pagan and Christian Egypt: Egyptian Art from the First to the Tenth Century A.D. Catalogue of an exhibition at Brooklyn Museum. Brooklyn, Brooklyn Museum, Brooklyn Institute of Art and Science, 1941.

Brussels 1976
Mekhitarian, Arpag. *Les Arts de l'Islam.* Catalogue of an exhibition at Musées Royaux d'Art et d'Histoire. Brussels:Musées Royaux d'Art et d'Histoire, 1976.

Buchthal 1940
Buchthal, Hugo; Kurz, Otto; and Ettinghausen, Richard. "Supplementary Notes to K. Holter's Check List of Islamic Illuminated Manuscripts Before A.D. 1350." *Ars Islamica* 7 (1940):147–64.

Cairo 1922
La Céramique Égyptienne de l'Époque Musulman: Planches, publiée sous les auspices du Comité de Conservation des Monuments de l'Art Arabe. Basel:Frobenius S.A., 1922.

Cairo 1952
Dalil mathaf al-fann al-islami (dar al-athar al-arabiyya sabiqan) [Guide to the Museum of Islamic Art (formerly Museum of Arab Art)]. Preface by Zaki Muhammad Hasan. Cairo:Matbaat dar al-kutub, 1952.

Cairo 1969
Islamic Art in Egypt: 969–1517. Catalogue of an exhibition at Semiramis Hotel on the occasion of the Millenary of Cairo. Cairo:Ministry of Culture U.A.R., 1969.

Cairo 1969a
Islamic Art in Egypt: 969–1517—An Exhibition—Loan Objects. Handlist of an exhibition at Semiramis Hotel on the occasion of the Millenary of Cairo. Cairo:Ministry of Culture U.A.R., 1969.

Carswell 1966
Carswell, John. "An Early Ming Porcelain Stand from Damascus." *Oriental Art,* n.s. 12 (1966):176–82.

Carswell 1972 Carswell, John. "Some Fifteenth-Century Hexagonal Tiles from the Near East." *Victoria and Albert Museum Yearbook* 3 (1972):59–75.

Carswell 1972a Carswell, John. "Six Tiles." In *Islamic Art in the Metropolitan Museum of Art*, edited by Richard Ettinghausen, pp. 99–109. New York: Metropolitan Museum of Art, 1972.

Carswell 1972b Carswell, John. "China and the Near East: The Recent Discovery of Chinese Porcelain in Syria." In *The Westward Influence of the Chinese Arts from the 14th to the 18th Century*. Colloquies on Art and Archaeology in Asia, no. 3, edited by William Watson, pp. 20–25. London: University of London, Percival David Foundation of Chinese Art, 1972.

Carswell 1979 Carswell, John. "Sin in Syria." *Iran* 17 (1979):15–24.

Chambéry 1970 *Arts de l'Islam*. Catalogue of an exhibition at Musée d'Art et d'Histoire de Chambéry. Chambéry: Inspection Générale des Musées Classés et Contrôlés, 1970.

Christie 1931 Christie, A. H. "Islamic Minor Arts and Their Influence upon European Work." In *The Legacy of Islam*, edited by Thomas Arnold and Alfred Guillaume, pp. 108–51. Oxford: Clarendon Press, 1931.

Çığ 1978 Çığ, Kemal. "Two Metal Koran Cases Recently Discovered in the Topkapı Palace Museum." In *Fifth International Congress of Turkish Art*, edited by G. Fehér, pp. 261–66. Budapest: Akadémiai Kiadó, 1978.

Cleveland 1958, 1969, 1978 *Handbook of the Cleveland Museum of Art*. Cleveland: Cleveland Museum of Art, 1958, 1969, 1978.

Comité 1922 Comité de Conservation des Monuments de l'Art Arabe. *Comptes Rendues des Exercices 1915–1919*, vol. 32. Cairo and Milan, 1922.

Creswell 1959 Creswell, K. A. C. *The Muslim Architecture of Egypt*, vol. 2. Oxford: Clarendon Press, 1959.

Dalton 1909 Dalton, O. M. *Catalogue of the Ivory Carvings of the Christian Era*. London: British Museum, 1909.

Dam 1928 Dam, Cornelia H. "An Egyptian Kursi." *The* [Philadelphia] *Museum Journal* 19 (1928):284–89.

Damascus 1976 *Catalogue du Musée Nationale de Damas*. Catalogue by Abu'l-Faraj al-Ush, Adnan Joundi, and Bachir Zouhdi. Damascus: Direction Générale des Antiquitiés et des Musées, 1976.

Dayton 1953 *Flight: Fantasy, Faith, Fact*. Catalogue of an exhibition at Dayton Art Institute. Dayton: Dayton Art Institute, 1953.

Denny 1980 Denny, Walter B. "Ceramics." In *Turkish Art*, edited by Esin Atıl, pp. 229–99. Washington, D.C.: Smithsonian Institution Press; New York: Harry N. Abrams, Inc., 1980.

Devonshire 1927 Devonshire, Mrs. R. L. "Some Dated Objects in Mr. Ralph Harari's Collection." *Apollo* 6, no. 33 (September 1927):121–26.

Dimand 1928 Dimand, Maurice. "Dated Specimens of Mohammedan Art in the Metropolitan Museum of Art." *Metropolitan Museum Studies* 1 (1928):99–113.

Dimand 1931 Dimand, Maurice. "Unpublished Metalwork of the Rasulid Sultans of Yemen." *Metropolitan Museum Studies* 3 (1931):229–37.

Dimand 1941 "A Review of Sasanian and Islamic Metalwork in *A Survey of Persian Art*." *Ars Islamica* 8 (1941):192–214.

Dimand 1944 Dimand, Maurice. *A Handbook of Muhammadan Art*. 2d rev. ed. New York: Metropolitan Museum of Art, 1944.

Dimand 1955 Dimand, Maurice. "An Exhibition of Islamic and Indian Paintings." *The Metropolitan Museum of Art Bulletin* 14, no. 4 (December 1955):85–102.

Dimand and Mailey 1973 Dimand, M. S., and Mailey, Jean. *Oriental Rugs in the Metropolitan Museum of Art*. New York: Metropolitan Museum of Art, 1973.

Drouot 1912 *Collections de feu M. Jean P. Lambros d'Athènes et de M. Giovanni Dattari du Caire: Antiquités égyptienne, greques et romaines*. Sale catalogue by J. Hirsch and A. Sambon, June 1912. Paris: Hôtel Drouot, 1912.

Drouot 1980 *Art d'Orient, Collection du Dr. J. C. Lacoux et à Divers*. Sale catalogue by Claude Boisgirard and Axel de Heeckeren, May 21, 1980. Paris: Hôtel Drouot, 1980.

Dumbarton Oaks 1946 *Handbook of the Collection*. Washington, D.C.: Dumbarton Oaks Research Library and Collection of Harvard University, 1946.

Dumbarton Oaks 1955 *Handbook of the Dumbarton Oaks Collection, Harvard University*. Washington, D.C.: Dumbarton Oaks, 1955.

Dumbarton Oaks 1967 *Handbook of the Byzantine Collection, Dumbarton Oaks*. Washington, D.C.: Dumbarton Oaks, 1967.

Edhem and Stchoukine 1933 Edhem, Fehmi, and Stchoukine, Ivan. *Les Manuscrits Orientaux Illustrés de la Bibliothèque de l'Université de Stamboul*. Paris: E. de Boccard, 1933.

Ellis 1967 Ellis, Charles Grant. "Mysteries of the Misplaced Mamluks." *Textile Museum Journal* 2, no. 2 (December 1967):3–20.

Ellis 1974 Ellis, Charles Grant. "Is the Mamluk Carpet a Mandala? A Speculation." *Textile Museum Journal* 4, no. 1 (December 1974):30–50.

El-Emary 1966 El-Emary, Amal A. "Studies in Some Islamic Objects Newly Discovered at Qus." *Annales Islamologiques* 6 (1966):121–38.

Embassy 1954 [Embassy of Egypt.] *Egyptian Antiquities in the Collection of the Embassy of Egypt*. Catalogue by M. H. el-Zayyat. Washington, D.C.: Embassy of Egypt, 1954.

Erdmann 1938 Erdmann, Kurt. "Kairener Teppiche, Teil I: Europäische und islamische Quellen des 15–18 Jahrhunderts." *Ars Islamica* 5 (1938):179–206.

Erdmann 1940 Erdmann, Kurt. "Kairener Teppiche, Teil II: Mamluken- und Osmanenteppiche." *Ars Islamica* 7 (1940):55–81.

Erdmann 1961

Erdmann, Kurt. "Neuere Untersuchungen zur Frage der Kairener Teppiche." *Ars Orientalis* 4 (1961):65–105.

Ettinghausen 1954

Ettinghausen, Richard. "Review of *Le Bapistère de St. Louis* by D. S. Rice." *Ars Orientalis* 1 (1954):245–49.

Ettinghausen 1959

Ettinghausen, Richard. "Near Eastern Book Covers and Their Influence on European Bindings: A Report on the Exhibition 'History of Bookbindings' at the Baltimore Museum of Art, 1957–58." *Ars Orientalis* 3 (1959):113–31.

Ettinghausen 1962

Ettinghausen, Richard. *Arab Painting*. Geneva: Éditions d'Art Albert Skira, 1962.

Ettinghausen 1974

Ettinghausen, Richard. "Further Notes on Mamluk Playing Cards." In *Gatherings in Honor of Dorothy E. Miner*, edited by U. E. McCracken, L. M. C. Randall, and R. H. Randall, Jr., pp. 51–78. Baltimore: Walters Art Gallery, 1974.

Falke 1936

Falke, Otto von. *Decorative Silks*. 3d ed. New York: William Helburn, Inc. 1936.

Farès 1952

Farès, Bishr. "Un Herbier arabe illustré du XIV^e siècle." In *Archaeologia Orientalia in Memoriam Ernst Herzfeld*, edited by G. C. Miles, pp. 84–88. Locust Valley, N.Y.: Augustin, 1952.

George V 1975

Art Musulman. Sale catalogue by René Boisgirard and Claude Boisgirard, March 24, 1975. Paris: Hôtel George V, 1975.

Grabar 1963

Grabar, Oleg. "A Newly Discovered Illustrated Manuscript of the Maqamat of Hariri." *Ars Orientalis* 5 (1963):97–109.

Gray 1940

Gray, Basil. "The Influence of Near Eastern Metalwork on Chinese Ceramics." *Transactions of the Oriental Ceramic Society* 18 (1940–41):47–60.

Grube 1959

Grube, Ernst J. "Materialien zum Dioskurides Arabicus." In *Aus der Welt der Islamischen Kunst, Festschrift für Ernst Kühnel*, edited by Richard Ettinghausen, pp. 163–94. Berlin: Verlag Gebr. Mann, 1959.

Grube 1962

Grube, Ernst J. *Muslim Miniature Paintings from the XIII to the XIX Century from Collections in the United States and Canada*. Venice: Neri Pozza, 1962.

Grube 1972

Grube, Ernst J. *Islamic Paintings from the 11th to the 18th Centuries in the Collection of Hans P. Kraus*. New York: H. P. Kraus, 1972.

Grube 1976

Grube, Ernst J. *Islamic Pottery of the Eighth to the Fifteenth Century in the Keir Collection*. London: Faber & Faber Limited, 1976.

Grube 1976a

Grube, Ernst J. "Pre-Mongol and Mamluk Painting." In *Islamic Painting and the Arts of the Book*, by B. W. Robinson, Ernst J. Grube, G. M. Meredith-Owens, and R. W. Skelton, pp. 67–119. London: Faber & Faber Limited, 1976.

Güvemli and Kerametli 1974

Güvemli, Zahir, and Kerametli, Can. *Türk ve Islâm Eserleri Müzesi* [Turkish and Islamic Arts Museum]. İstanbul: Akbank, 1974.

Haldane 1978

Haldane, Duncan. *Mamluk Painting*. Warminster, England: Aris & Phillips Ltd., 1978.

Harden 1968

Harden, D. B.; Painter, K. S.; Pinder-Wilson, R. H.; and Tait, Hugh. *Masterpieces of Glass*. London: Trustees of the British Museum, 1968.

Hartner 1938

Hartner, Willy. "The Pseudoplanetary Nodes of the Moon's Orbit in Hindu and Islamic Iconographies." *Ars Islamica* 5 (1938):113–54.

Hartner 1973–74

Hartner, Willy. "The Vaso Vescovali in the British Museum: A Study in Islamic Astrological Iconography." *Kunst des Orients* 9, no. 1/2 (1973–74):99–130.

Hasan Abd al-Wahhab 1955

Hasan Abd al-Wahhab. "Tawqiat al-sunna ala athar misr al-islamiyya" [Artists' signatures on the monuments of Muslim Egypt]. *Bulletin de l'Institut d'Égypte* 36 (1955):533–58.

Herz 1902

Herz, M. "Le Musée National du Caire (premier article)." *Gazette des Beaux-Arts* 28, 3d per. (July 1902):45–59.

Herz 1906

Herz, Max. *Catalogue Raisonné des Monuments exposés dans le Musée National de l'Art Arabe*. 2d ed. Cairo: Imprimerie de l'Institut Français d'Archéologie Orientale, 1906.

Herz 1907

Herz, Max. *A Descriptive Catalogue of the Objects Exhibited in the National Museum of Arab Art*. 2d ed. Translated by G. Foster Smith. Cairo: National Printing Department, 1907.

Hill 1974

Hill, Donald R., trans. and ed. *The Book of Knowledge of Ingenious Mechanical Devices*. Dordrecht and Boston: D. Reidel Publishing Company, 1974.

Hobson 1932

Hobson, R. L. *A Guide to the Islamic Pottery of the Near East*. London: Trustees of the British Museum, 1932.

Hollis 1945

Hollis, H. "Two Examples of Arabic Enameled Glass." *The Bulletin of the Cleveland Museum of Art* 32 (December 1945):179–81.

Holter 1937

Holter, Kurt. "Die Galen-Handschrift und die Makamen des Hariri der Wiener Nationalbibliothek." *Jahrbuch der Kunsthistorischen Sammlungen in Wien*, n.s. 9, special no. 104 (1937):1–48.

Holter 1937a

Holter, Kurt, "Die islamischen Miniaturhandschriften vor 1350." *Zentralblatt für Bibliothekwesen* 54 (1937):1–37.

İnal 1976

İnal, Güner. "Kahirede Yapılmış bir Hümâyünnâme'nin Minyatürleri." *Belleten* 40, no. 159 (July 1976):439–65.

Izzi 1974 — Izzi, Wafiyya. "Objects Bearing the Name of al-Nasir Muhammad and His Successor." In *Colloque International sur l'Histoire du Caire*, pp. 235–41. Cairo: Ministry of Culture of the Arab Republic of Egypt, General Egyptian Book Organization, 1974.

James 1974 — James, David. *Islamic Art: An Introduction*. London, New York, Sydney, and Toronto: Hamlyn Publishing Group Limited, 1974.

James 1974a — James, David. "Mamluke Painting at the Time of the 'Lusignan Crusade,' 1365–70: A Study of the Chester Beatty *Nihayat al-su'l wa'l-umniya* . . . manuscript of 1366." *Humaniora Islamica* 2 (1974): 73–87.

James 1976 — James, David. "Arab Painting." *Marg* 29, no. 3 (June 1976): 1–50.

JGS 1971 — "Recent Important Acquisitions." *Journal of Glass Studies* 13 (1971): 134–47.

Kalus 1975 — Kalus, Ludvik. "Un bouclier mamelouk dans les collections du Musée de l'Homme à Paris." *Armi Antiche* (Turin, 1975): 23–28.

Karatay 1962–69 — Karatay, F. E. *Topkapı Sarayı Müzesi Kütüphanesi: Arapça Yazmalar Kataloğu* [The Topkapı Palace Museum Library: Catalogue of Arabic manuscripts]. 4 vols. İstanbul: Topkapı Sarayı Müzesi, 1962–69.

Kendrick 1924 — Kendrick, A. F. *Catalogue of Muhammadan Textiles of the Medieval Period*. London: Victoria and Albert Museum, 1924.

Kratchkovskaya 1935 — Kratchkovskaya, Vera A. "Novuie materialui dlya musul'manskoi epigrafiki i paleografiki" [New material for Islamic epigraphy and paleography]. *Zapiski Instituta Vostokovedeniya, Akademii Nauk*, SSR 3 (1935): 191–209.

Kühnel 1939 — Kühnel, Ernst. "Zwei Mosulbronzen und ihr Meister." *Jahrbuch der Preussischen Kunstsammlungen* 60 (1939): 1–20.

Kühnel 1963 — Kühnel, Ernst. *Islamische Kleinkunst*. 2d ed. Brunswick, Germany: Klinkhardt & Biermann, 1963.

Kühnel 1970 — Kühnel, Ernst. *The Minor Arts of Islam*. Translated by K. Watson. Ithaca, N.Y.: Cornell University Press, 1970.

Kühnel and Bellinger 1957 — Kühnel, Ernst, and Bellinger, Louisa. *The Textile Museum, Catalogue Raisonné: Cairene Rugs and Others Technically Related, 15th Century–17th Century*. Washington, D.C.: National Publishing Company, 1957.

Lamm 1929–30 — Lamm, Carl Johan. *Mittelalterliche Gläser und Steinschnittarbeiten aus dem Nahen Osten*. 2 vols. Berlin: Verlag Dietrich Reimer/Ernst Vohsen, 1929–30.

Lamm 1935 — Lamm, Carl Johan. "Arabiska Inskrifter pa nagra Teltifragment fran Egypten." In *Röhsska Konstslöjdmuseets Arstryck*, pp. 47–55. Göteburg, Sweden, 1935.

Lamm 1937 — Lamm, Carl Johan. "Some Mamluk Embroideries." *Ars Islamica* 4 (1937): 65–76.

Lamm 1952–54 — Lamm, Carl Johan. "A Falconer's Kettledrum of Mamluke Origin in Livrustkammaren." *Livrustkammaren: Journal of the Royal* [Swedish] *Armoury* 6 (1952–54): 80–96.

Lane 1971 — Lane, Arthur. *Later Islamic Pottery*. 2d ed. rev. London: Faber & Faber Limited, 1971.

Lane-Poole 1886 — Lane-Poole, Stanley. *The Art of the Saracens in Egypt*. Small and large format. London: Chapman and Hall, Ltd., 1886.

Lapidus 1967 — Lapidus, Ira Marvin. *Muslim Cities in the Later Middle Ages*. Cambridge: Harvard University Press, 1967.

Lings 1976 — Lings, Martin. *The Quranic Art of Calligraphy and Illumination*. London: World of Islam Festival Trust, 1976.

Lings and Safadi 1976 — Lings, Martin, and Safadi, Yasin Hamid. *The Qur'an*. London: World of Islam Publishing Company Ltd., 1976.

Lisbon 1963 — *L'Art de l'Orient Islamique: Collection de la Fondation Calouste Gulbenkian*. Lisbon: Museu Nacional de Arte Antiga, 1963.

Löfgren and Lamm 1946 — Löfgren, Oscar, and Lamm, Carl Johan. *Ambrosian Fragments of an Illuminated Manuscript Containing the Zoology of al-Ğahiz*. Uppsala, Sweden: Lundequistska Bokhandeln, 1946.

London 1862 — *Catalogue of the Special Exhibition of Works of Art of the Medieval, Renaissance and More Recent Periods on Loan at the South Kensington Museum. June 1862*. Rev. ed. Edited by J. C. Robinson. London: G. E. Eyre and W. Spottiswoode, 1863.

London 1976 — *The Arts of Islam*. Catalogue of an exhibition at Hayward Gallery. London: Arts Council of Great Britain, 1976.

Longhurst 1927 — Longhurst, Margaret H. *Catalogue of Carvings in Ivory, Part I*. London: Victoria and Albert Museum, 1927.

Lorey 1935 — Lorey, Eustache de. "Le Bestiaire de l'Escurial." *Gazette des Beaux-Arts* 14, 6th per. (1935): 228–38.

Lukens 1965 — Lukens, Marie G. *Islamic Art*. New York: Metropolitan Museum of Art, 1965.

Luxor 1979 — *The Luxor Museum of Ancient Egyptian Art: Catalogue*. Cairo: American Research Center in Egypt, 1979.

MacKay 1951 — MacKay, Dorothy. *A Guide to the Archaeological Collections in the University Museum, Beirut: American University of Beirut, Museum of Archaeology*, 1951.

Mackie 1972 — Mackie, Louise W. *From Persia's Ancient Looms*. Washington, D.C.: Textile Museum, 1972.

Mackie 1980 — Mackie, Louise W. "Rugs and Textiles." In *Turkish Art*, edited by Esin Atıl, pp. 299–373. Washington, D.C.: Smithsonian Institution Press; New York: Harry N. Abrams, Inc., 1980.

Madl 1898 — Madl, Karel B. "Altorientalische Gläser." *Kunst und Kunsthandwerk* 1 (1898):273–80.

Madrid 1893 — *Las Joyas de la Exposición Histórico-Europea de Madrid, 1892*. Madrid:Sucesor de Laurent, 1893.

Marcq-en-Barœul 1979 — *Arts en pays d'Islam*. Catalogue of an exhibition sponsored by Fondation Anne et Albert Prouvost. Marcq-en-Barœul:Fondation Anne et Albert Prouvost, 1979.

Marzouk 1957 — Marzouk, M. A. "Three Signed Specimens of Mamluk Pottery from Alexandria." *Ars Orientalis* 2 (1957):497–501.

Mayer 1933 — Mayer, L. A. *Saracenic Heraldry: A Survey*. Oxford:Clarendon Press, 1933.

Mayer 1937 — Mayer, L. A. "New Material for Mamluk Heraldry." *Journal of the Palestine Oriental Society* 17 (1937):52–62. Also appeared as a separate reprint published in Jerusalem by Syrian Orphanage Press, 1937.

Mayer 1938 — Mayer, L. A. "Une énigme du blason musulman." *Bulletin de l'Institut d'Égypt* 21 (1938–39):141–43.

Mayer 1943 — Mayer, L. A. "Saracenic Arms and Armour." *Ars Islamica* 10 (1943):1–12.

Mayer 1952 — Mayer, L. A. *Mamluk Costume: A Survey*. Geneva:Albert Kundig, 1952.

Mayer 1958 — Mayer, L. A. *Islamic Woodcarvers and Their Works*. Geneva:Albert Kundig, 1958.

Mayer 1959 — Mayer, L. A. *Islamic Metalworkers and Their Works*. Geneva:Albert Kundig, 1959.

Mayer 1971 — Mayer, L. A. *Mamluk Playing Cards*. Edited by R. Ettinghausen and O. Kurz. Leiden:E. J. Brill, 1971. Originally published in *Bulletin de l'Institut Français d'Archéologie Orientale* (1939):113–18.

Meinecke 1971 — Meinecke, Michael. "Das Mausoleum des Qala'un in Kairo, Untersuchungen zur Genese der mamlukischen Architekturdekoration." *Mitteilungen des Deutschen Archäologischen Instituts Abteilung Kairo* 27, no. 1 (1971):47–80.

Meinecke 1972 — Meinecke, Michael. "Zur mamlukischen Heraldik." *Mitteilungen des Deutschen Archäologischen Instituts Abteilung Kairo* 28, no. 2 (1972):214–87.

Meinecke 1973 — Meinecke, Michael. "Die Moschee des Amirs Aqsungur an-Nasiri in Kairo." *Mitteilungen des Deutschen Archäologischen Instituts Abteilung Kairo* 29, no. 1 (1973):9–38.

Meinecke 1974 — Meinecke, Michael. "Die Bedeutung der Mamlukischen Heraldik für die Kunstgeschichte." *Zeitschrift der Deutschen Morgenländischen Gesellschaft*, supp. 2 (1974):213–40.

Meinecke 1976 — Meinecke, Michael. "Die Mamlukischen Fayencemosaikdekorationen: Eine Werkstätte aus Tabriz in Kairo (1330–1350)." *Kunst des Orients* 11 no. 1/2 (1976–77):85–144.

Melekian-Chirvani 1969 — Melekian-Chirvani, Assadullah Souren. "Cuivres inédits de l'époque de Qa'itbay." *Kunst des Orients* 6, no. 2 (1969):99–133.

Melekian-Chirvani 1970 — Melekian-Chirvani, Assadullah Souren. "L'Art du métal dans les pays arabes II: Deux chandeliers mossouliens au Musée des Beaux-Arts." *Bulletin des Musées et Monuments Lyonnais* 4, no. 3 (1970):45–62.

Metropolitan 1907 — "Complete List of Accessions, October 20 to November 20, 1907." *Bulletin of the Metropolitan Museum of Art* 2, no. 12 (December 1907).

Metropolitan 1975 — "Islamic Art." *The Metropolitan Museum of Art Bulletin* 33, no. 1 (Spring 1975).

Migeon 1900 — Migeon, Gaston. "Les cuivres arabes." *Gazette des Beaux-Arts* 23, 3d per. (1900):119–31.

Migeon 1903 — Migeon, Gaston. *Exposition des Arts Musulmans au Musée des Arts Décoratifs*. Paris:Librarie Centrale des Beaux-Arts, 1903.

Migeon 1907 — Migeon, Gaston. *Manuel d'art musulman*. 2 vols. Paris:Alphonse Picard et Fils, 1907.

Migeon 1922 — Migeon, Gaston. *Musée du Louvre: L'Orient Musulman*. 2 vols. Paris:Éditions Albert Morancé, 1922.

Migeon 1927 — Migeon, Gaston. *Manuel d'art musulman*. 2 vols. 2d ed. Paris:Éditions Auguste Picard, 1927.

Mostafa 1949 — Mostafa, Mohamed. "Two Fragments of Egyptian Luster Painted Ceramics from the Mamluk Period." *Bulletin de l'Institut d'Égypte* 31 (1949):377–82.

Mostafa 1958 — Mostafa, Mohamed. *Unity in Islamic Art: Guide to the 2nd Temporary Exhibition*. Catalogue of an exhibition at Museum of Islamic Art. Cairo:Ministry of Culture and National Guidance, Publication of the Museum of Islamic Art, Cairo, 1958.

Mostafa 1961 — Mostafa, Mohamed. *The Museum of Islamic Art: A Short Guide*. Cairo:Publications of the Museum of Islamic Art, General Organization for Government Printing Offices, 1961

Mostafa 1970–71 — Mostafa, Mohamed. "Miniature Paintings in Some Mamluk Manuscripts." *Bulletin de l'Institut Égyptien* 52 (1970–71):5–15.

Munich 1972 — *World Cultures and Modern Art: The Encounter of 19th and 20th Century European Art and Music with Asia, Africa, Oceania, Afro- and Indo-America*. Catalogue of an exhibition on the occasion of the Games of the XXth Olympiad, Munich, 1972. Munich:Bruckmann, 1972.

Naples 1967 — *Arte Islamica a Napoli*. Catalogue by Umberto Scerrato. Naples:Istituto Universitario Orientale di Napoli, 1967.

Nickel 1972 — Nickel, Helmut. "A Mamluk Axe." In *Islamic Art in the Metropolitan Museum of Art*, edited by Richard Ettinghausen, pp. 213–25. New York:Metropolitan Museum of Art, 1972.

Palais d'Orsay 1979 — *Art d'Orient, Art d'Extrême-Orient*. Sale catalogue by Claude Boisgirard and Axel de Heeckeren, April 26, 1979. Paris: Palais d'Orsay, 1979.

Papadopoulo 1979 — Papadopoulo, Alexandre. *Islam and Muslim Art*. Translated by R. E. Wolf. New York: Harry N. Abrams, Inc., 1979.

Paris 1938 — *Les Arts de l'Iran, l'ancienne Perse et Bagdad*. Catalogue of an exhibition at Bibliothèque Nationale. Paris: Bibliothèque Nationale, 1938.

Paris 1967 — *Vingt ans d'acquisitions au Musée du Louvre 1947–1967*. Catalogue of an exhibition at Orangerie des Tuileries. Paris: Réunion des Musées Nationaux, 1967.

Paris 1970 — *La France de St. Louis*. Catalogue of an exhibition at Salle des Gens d'Armes du Palais de Justice. Paris: Ministère des Affaires Culturelles, 1970.

Paris 1971 — *Arts de l'Islam des origines à 1700 dans les collections publiques françaises*. Catalogue of an exhibition at Orangerie des Tuileries. Paris: Ministère des Affaires Culturelles, Réunion des Musées Nationaux, 1971.

Paris 1977 — *L'Islam dans les collections nationales*. Catalogue of an exhibition at Grand Palais. Paris: Éditions des Musées Nationaux, 1977.

Parke-Bernet 1944 — *Furniture and Objects of Art. Property of the Late J. P. Morgan. Part 2*. Sale catalogue no. 547, March 22–25, 1944. New York: Parke-Bernet Galleries, Inc., 1944.

P[aul] 1910 — P[aul], F. V. "Oriental Glass." [Boston] *Museum of Fine Arts Bulletin* 8, no. 48 (December 1910):50–51.

Pedersen 1928 — Pedersen, Johs. *Islams Kultur*. Copenhagen: Gyldendalske Boghandel, 1928.

Pfister 1938 — Pfister, R. *Les Toiles Imprimées de Fostat et l'Hindoustan*. Paris: Les Éditions d'Art et d'Histoire, 1938.

Philadelphia 1978 — *The Second Empire, 1852–1870: Art in France under Napoleon III*. Catalogue of an exhibition at Philadelphia Museum of Art, Detroit Institute of Arts, and Grand Palais, Paris. Philadelphia: Philadelphia Museum of Art; Detroit: Wayne State University Press, 1978.

Pinder-Wilson and Scanlon 1973 — Pinder-Wilson, R. H., and Scanlon, George T. "Glass Finds from Fustat: 1964–71." *Journal of Glass Studies* 15 (1973):12–30.

Pope 1959 — Pope, John A. "An Early Ming Porcelain in Muslim Style." In *Aus der Welt der Islamischen Kunst. Festschrift für Ernst Kühnel*, edited by Richard Ettinghausen, pp. 357–75. Berlin: Verlag Gebr. Mann, 1959.

Pope 1972 — Pope, John A. "Chinese Influences on Iznik Pottery: A Re-examination of an Old Problem." In *Islamic Art in the Metropolitan Museum of Art*, edited by Richard Ettinghausen, pp. 125–39. New York: Metropolitan Museum of Art, 1972.

Pope and Ackerman 1964–67 — Pope, A. U., and Ackerman, P., eds. *A Survey of Persian Art*. 14 vols. Reprint ed. London and New York: Oxford University Press, 1964–67.

Reitlinger 1944 — Reitlinger, Gerald. "Sultanabad." *Transactions of the Oriental Ceramic Society* 20 (1944–45):25–34.

Répertoire — Combe, Étienne; Sauvaget, Jean; and Wiet, Gaston; eds. *Répertoire Chronologique d'Épigraphie Arabe*. 15 vols. Cairo: Imprimerie de l'Institut Français d'Archéologie Orientale, 1931–56.

D. S. Rice 1950 — Rice, D. S. "The Blazons of the 'Baptistère de St. Louis.'" *Bulletin of the School of Oriental and African Studies* 23, no. 2 (1950):367–80.

D. S. Rice 1952 — Rice, D. S. "Studies in Islamic Metal Work I." *Bulletin of the School of Oriental and African Studies* 14, no. 3 (1952):564–78.

D. S. Rice 1953 — Rice, D. S. *Le Baptistère de St. Louis*. Paris: Les Éditions du Chêne, 1953.

D. S. Rice 1953a — Rice, D. S. "Studies in Islamic Metal Work IV." *Bulletin of the School of Oriental and African Studies* 15, no. 3 (1953):489–503.

D. S. Rice 1955 — Rice, D. S. "Studies in Islamic Metalwork V." *Bulletin of the School of Oriental and African Studies* 17, pt. 2 (1955):207–31.

D. S. Rice 1956 — Rice, D. S. "Arabic Inscriptions on a Brass Basin Made for Hugh IV of Lusignan." In *Studi Orientalistici in onore di Giorgio Levi della Vida*, vol. 2, pp. 1–13. Rome: Istituto per l'Oriente, 1956.

D. S. Rice 1957 — Rice, D. S. "Inlaid Brasses from the Workshop of Ahmad al-Dhaki al-Mawsili." *Ars Orientalis* 2 (1957):283–326.

D. T. Rice 1965 — Rice, David Talbot. *Islamic Art*. New York and London: Frederick A. Praeger, Publishers, 1965.

Riefstahl 1931 — Riefstahl, Rudolf M. *Turkish Architecture in Southwestern Anatolia*. Cambridge: Harvard University Press, 1931.

Riefstahl 1937 — Riefstahl, Rudolf M. "Early Turkish Tile Revetments from Edirne." *Ars Islamica* 4 (1937):249–81.

Riefstahl 1961 — Riefstahl, Rudolf M. "Ancient and Near Eastern Glass." *Museum News* [The Toledo Museum of Art] 4, no. 2 (Spring 1961):27–46.

Riis 1953 — Riis, Paul Jørgen. "Saracenic Blazons on Glass from Hama," In *Studia Orientalia Ioanni Pedersen*, pp. 295–302. Copenhagen: Munksgaard, 1953.

Riis and Poulsen 1957 — Riis, Poul Jørgen, and Poulsen, Vagn. *Hama, Fouilles et Recherches de la Fondation Carlsberg, 1931–1938. IV/2: Les verreries et poteries medievales*. Copenhagen: I Kommission Hos Nationalmuseet, 1957.

B. W. Robinson 1976 — Robinson, B. W. "Rothschild and Binney Collections: Persian and Mughal Arts of the Book." In *Persian and Mughal Art*, pp. 11–96. Catalogue of an exhibition at Colnaghi's, London. London: P. & D. Colnaghi & Co., Ltd., 1976.

B. W. Robinson 1976a — Robinson, B. W. "Unillustrated Manuscripts." In *Islamic Painting and the Arts of the Book* by B. W. Robinson, Ernst J. Grube, G. M. Meredith-Owens, and R. W. Skelton, pp. 285–99. London:Faber & Faber Limited, 1976.

H. R. Robinson 1967 — Robinson, H. Russell. *Oriental Armour*. New York:Walker & Company, 1967.

Rogers 1974 — Rogers, J. Michael. "Evidence for Mamluk–Mongol Relations, 1260–1360." In *Colloque International sur l'Histoire du Caire*, pp. 385–403. Cairo:Ministry of Culture of the Arab Republic of Egypt, General Egyptian Book Organization, 1974.

Rogers 1978–79 — Rogers, J. Michael. "Review of *L'Islam dans les collections nationales*." *Kunst des Orients* 13, no. 2 (1978–79):198–206.

Ross 1931 — Ross, E. Denison, ed. *The Art of Egypt Through the Ages*. London:Studio, Ltd., 1931.

Sarre 1921 — Sarre, Friedrich. "Die ägyptische Herkunft der sogen. Damaskus-Teppiche." *Zeitschrift für bildende Kunst* 32 (1921):75–82.

Sarre 1924 — Sarre, Friedrich. "Die ägyptischen Teppiche." *Jahrbuch der Asiatischen Kunst* 1 (1924):19–23, 25.

Sarre 1925 — Sarre, Friedrich. *Keramik und andere Kleinfunde der islamischen Zeit von Baalbek*. Berlin and Leipzig:Walter de Gruyter & Co., 1925.

Sarre and Martin 1912 — Sarre, F., and Martin, F. R. *Die Ausstellung von Meisterwerken muhammedanischer Kunst in München 1910*. 4 vols. Berlin:F. Bruckmann, 1912.

Sauvaget 1932 — Sauvaget, Jean. *Poteries Syro-Mésopotamiennes du XIV^e siècle*. Documents des Études Orientales de l'Institut Français de Damas, vol. 1. Damascus:Institut Français de Damas, 1932.

Scanlon 1967 — Scanlon, George T. "Fustat Expedition: Preliminary Report 1965, Part II." *Journal of the American Research Center in Egypt* 6 (1967):65–86.

Scanlon 1971 — Scanlon, George T. "The Fustat Mounds: A Shard Count." *Archaeology* 24 (1971):220–33.

Schmidt 1958 — Schmidt, Heinrich J. *Alte Seidenstoffe*. Brunswick, Germany:Klinkhardt & Biermann, 1958.

Schmoranz 1899 — Schmoranz, Gustav. *Old Oriental Gilt and Enamelled Glass Vessels*. Vienna and London:Imperial Handels-Museum of Vienna, 1899.

Schroeder 1938 — Schroeder, Eric. "The Lamp of Karim al-Din: An Arab Enamelled Glass of the Early Fourteenth Century." *Bulletin of the* [Boston] *Museum of Fine Arts* 36 (1938):2–5.

Smith 1979 — Smith, Rex G. *Medieval Muslim Horsemanship: A Fourteenth-Century Arabic Cavalry Manual*. London:British Library, 1979.

Sotheby 1944 — *Catalogue of the Collection of Chinese Ceramics, Paintings and Jades, Persian Pottery and Islamic Glass Antiquities and Works of Art, Textiles, Rugs, Carpets and Fine English Furniture: The Property of the Late Mrs. George Eumorfopoulos*. Sale catalogue, April 20–21, 1944. London:Sotheby & Co., 1944.

Sotheby 1967 — *Catalogue of Highly Important Oriental Manuscripts and Miniatures: The Property of the Kevorkian Foundation*. Sale catalogue, December 6, 1967. London:Sotheby & Co., 1967.

Sotheby 1969 — *Catalogue of Highly Important Oriental Manuscripts and Miniatures: The Property of the Kevorkian Foundation*. Sale catalogue, December 1, 1969. London:Sotheby & Co., 1969.

Sotheby 1970 — *Catalogue of Highly Important Oriental Manuscripts and Miniatures: The Property of the Kevorkian Foundation*. Sale catalogue, December 7, 1970. London:Sotheby & Co., 1970.

Sotheby 1978 — *Catalogue of Important Oriental Manuscripts and Miniatures: The Property of the Hagop Kevorkian Fund*. Sale catalogue, April 3, 1978. London:Sotheby Parke-Bernet & Co., 1978.

Sotheby 1980 — *Catalogue of Important Oriental Manuscripts and Miniatures*. Sale catalogue, April 21, 1980. London:Sotheby Parke-Bernet & Co., 1980.

Sourdel-Thomine 1971 — Sourdel-Thomine, Janine. "Clefs et serrures de la Ka'ba: Notes d'épigraphie arabe." *Revue des Études Islamiques: Articles et Mémoires* 39, no. 1 (1971):29–86.

Sourdel-Thomine and Spuler 1973 — Sourdel-Thomine, J., and Spuler, B. *Die Kunst des Islam*. Berlin:Propyläen Verlag, 1973.

Spuler 1978 — Spuler, Friedrich. *Islamic Carpets and Textiles in the Keir Collection*. London:Faber & Faber Limited, 1978.

Stchoukine 1934 — Stchoukine, Ivan. "Un manuscrit du traité d'al-Jazari sur les automates du VII siècle de l'hegire." *Gazette des Beaux-Arts* 11, 6th per. (1934):134–40.

Stchoukine 1971 — Stchoukine, Ivan; Fleming, Barbara; Luft, Paul; and Sohrweide, Hanna. *Illuminierte Islamische Handschriften*. Verzeichnis der Orientalischen Handschriften in Deutschland, vol. 16. Wiesbaden:Frans Steiner Verlag GMBH, 1971.

Tantum 1979 — Tantum, Geoffrey. "Muslim Warfare: A Study of a Medieval Muslim Treatise on the Art of War." In *Islamic Arms and Armour*, edited by Robert Elgood, pp. 187–201. London:Scolar Press, 1979.

Taymur 1942 — Taymur, Ahmad. *Al-taswir ind al-arab* [Painting among the Arabs]. Edited by Zaki M. Hasan. Cairo:Lajnat al-talif wa'l-nasir, 1942.

Textile Museum 1976 — *Masterpieces in the Textile Museum*. Washington, D.C.:Textile Museum, 1976.

Toledo 1969 — *Art in Glass: A Guide to the Glass Collection*. Toledo:Toledo Museum of Art, 1969.

Toledo 1969a — "Treasures for Toledo," *Museum News* [The Toledo Museum of Art] 12, no. 4 (Winter 1969):87–122.

Underhill 1939 — Underhill, Gertrude. "Textiles from the H. A. Elsburg Collection." *The Bulletin of the Cleveland Museum of Art* 26, no. 9 (November 1939):143–46.

Al-Ush 1963 — Al-Ush, Muhammad Abu'l-Faraj. "Namathej min al-khazaf al-arabiyya al-islamiyya fi'l-mathaf al-watani bi dimishq" [Samples of Arab-Islamic pottery in the National Museum of Damascus]. *Al-marifah* (Damascus, May 1963): 103–11.

Vavra 1954 — Vavra, Jaroslav R. *5000 Years of Glass Making: The History of Glass*. Translated by I. R. Gottheiner. Prague:Artia, 1954.

Vienna 1977 — *Kunst des Islam*. Catalogue of an exhibition at Schloss Halbturn. Vienna:Österreichisches Museum für angewandte Kunst, 1977.

Wallis 1887 — Wallis, Henry. *Notes on Some Examples of Early Persian Pottery. No. 2*. London:Henry Wallis, 1887.

Wallis 1889 — Wallis, Henry. *Notes on Some Examples of Early Persian Lustre Vases. No. 3*. London:W. Griggs, 1889.

Walzer 1957 — Walzer, Sofie. "An Illustrated Leaf from a Lost Mamluk Kalilah wa-Dimnah Manuscript." *Ars Orientalis* 2 (1957):503–5.

Welch 1978 — Welch, Anthony. *Collection of Islamic Art: Prince Sadruddin Aga Khan*. Vol. 3. Geneva: Chateau de Bellerive, 1978.

Welch 1979 — Welch, Anthony. *Calligraphy in the Arts of the Muslim World*. Austin:University of Texas Press, 1979.

Whitcomb and Johnson 1979 — Whitcomb, Donald, and Johnson, Janet H. *Quseir al-Qadim 1978: Preliminary Report*. Cairo:American Research Center in Egypt, Inc., 1979.

Wiet 1929 — Wiet, Gaston. *Catalogue Général du Musée Arabe du Caire: Lampes et bouteilles en verre émaillé*. Cairo: Imprimerie de l'Institut Français d'Archéologie Orientale, 1929.

Wiet 1929a — Wiet, Gaston. *Matériaux pour un Corpus Inscriptionum Arabicarum, Première Partie: Égypte*. Vol. 2. fasc. 1. Mémoires publiés par les membres de l'Institut Français d'Archéologie Orientale du Caire, vol. 52. Cairo:Imprimerie de l'Institut Français d'Archéologie Orientale, 1929.

Wiet 1930 — Wiet, Gaston. *Album du Musée Arabe du Caire*. Cairo:Imprimerie de l'Institut Français d'Archéologie Orientale, 1930.

Wiet 1932 — Wiet, Gaston. *Catalogue Général du Musée Arabe du Caire: Objets en cuivre*. Cairo:Imprimerie de l'Institut Français d'Archéologie Orientale, 1932.

Wiet 1932a — Wiet, Gaston. "L'Exposition d'Art persan à Londres." *Syria* 13 (1932):65–93 and 196–212.

Wiet 1933 — Wiet, Gaston. "Les Lampes d'Arghun." *Syria* 14 (1933):203–6.

Wiet 1958 — Wiet, Gaston. "Inscriptions mobilières de l'Égypte musulmane." *Journal Asiatique* 246, no. 3 (1958): pp. 237–85.

Wiet 1971 — Wiet, Gaston. *Catalogue Général du Musée de l'Art Islamique du Caire: Inscriptions Historiques sur Pierre*. Cairo:Imprimerie de l'Institut Français d'Archéologie Orientale, 1971.

A. Zaki 1966 — Zaki, Abd ar-Rahman. "Important Swords in the Museum of Islamic Art in Cairo." *Vaabenhistoriske Aarbøger* 13 (Copenhagen, 1966):143–52 (Danish) and 153–57 (English).

M. H. Zaki 1948 — Zaki, Muhammad Hasan. *Funun al-islam* [Arts of Islam]. Cairo:Maktabat al-nahda al-misriyya, 1948.

M. H. Zaki 1956 — Zaki, Muhammad Hasan. *Atlas al-funun al-zukhrufiya wa'l-tasawir al-islamiya* [Atlas of Moslem decorative and pictorial arts]. Cairo:Cairo University Press, 1956.

Ziada 1969 — Ziada, Mustafa M. "The Mamluk Sultans to 1293." In *A History of the Crusades II: The Later Crusades, 1191–1311*, edited by Robert L. Wolff and Harry W. Hazard, pp. 735–58. Kenneth M. Setton, gen. ed. 2d ed. Madison, Milwaukee, and London:University of Wisconsin Press, 1969.

Ziada 1975 — Ziada, Mustafa M. "The Mamluk Sultans, 1291–1517." In *A History of the Crusades III: The Fourteenth and Fifteenth Centuries*, edited by Harry W. Hazard, pp. 486–512. Kenneth M. Setton, gen. ed. Madison and London:University of Wisconsin Press, 1975.

BIBLIOGRAPHY

HISTORY
General (Selected)

Abu-Lughod, Janet L. *Cairo: 1001 Years of the City Victorious.* Princeton: Princeton University Press, 1971.

Ashtor, E. *A Social and Economic History of the Near East in the Middle Ages.* Berkeley, Los Angeles, and London:University of California Press, 1976.

—— "Some Unpublished Sources for the Bahri Period." In *Scripta Hierosolymitana.* Studies in Islamic History and Civilization, edited by Uriel Heyd, vol. 9, pp. 11–30. Jerusalem:Magnes Press, Hebrew University, 1961.

Ayalon, David. *L'Esclavage du Mamelouk.* Oriental Notes and Studies, The Israel Oriental Society, no. 1. Jerusalem:Israel Oriental Society, 1951.

—— "The Eunuch in the Mamluk Sultanate." In *Studies in Memory of Gaston Wiet*, edited by Myriam Rosen-Ayalon, pp. 267–95. Jerusalem:Institute of Asian and African Studies, The Hebrew University of Jerusalem, 1977.

—— *Gunpowder and Firearms in the Mamluk Kingdom.* Reprint ed. London:Frank Cass and Company Limited, 1978.

—— "Notes on the *Furusiyya* Exercises and Games in the Mamluk Sultanate." In *Scripta Hierosolymitana.* Studies in Islamic History and Civilisation, edited by Uriel Heyd, vol. 9, pp. 31–62. Jerusalem:Magnes Press, Hebrew University, 1961.

—— *Studies on the Mamluks of Egypt (1250–1517).* London:Variorum Reprints, 1977.

Bacharach, Jere L. "Circassian Mamluk Historians and Their Quantitative Data." *Journal of the American Research Center in Egypt* 12 (1975):75–87.

Balog, Paul. *The Coinage of the Mamluk Sultans of Egypt and Syria.* New York:American Numismatic Society, 1964.

Brinner, William M., ed. and trans. *A Chronicle of Damascus, 1389–1397.* Berkeley:University of California Press, 1963.

Colloque International sur l'Histoire du Caire. Cairo: Ministry of Culture of the Arab Republic of Egypt, General Egyptian Book Organization, 1974.

Cook, M. A., ed. *Studies in the Economic History of the Middle East: From the Rise of Islam to the Present Day.* London, New York, Toronto:Oxford University Press, 1970.

Darrag, Ahmad. *L'Égypte sous le règne de Barsbay, 825–841/1422–1438.* Damascus:Institut Français, 1961.

Dols, Michael W. *The Black Death in the Middle East.* Princeton:Princeton University Press, 1977.

Dunlap, D. M. *Arab Civilization to A.D. 1500.* New York and Washington, D.C.:Praeger Publishers, 1971.

Encyclopedia of Islam. 1st ed. Leiden:E. J. Brill; London:Luzac & Co., 1913–38. See entries "Mamluks," "al-Nasir," and "Sha'ban."

Encyclopedia of Islam. 2d ed. Leiden:E. J. Brill; London:Luzac & Co., 1960–. See entries "al-Bahriyya," "Barkuk," "Barsbay," "Baybars I," "Baybars II," "Burdjiyya," "Faradj," "Hilal," "al-Kahira," "Ka'it Bay," "Khalil," "Khushkadam," and "Inal."

Fischel, Walter J. *Ibn Khaldun in Egypt, His Public Functions and Historical Research (1382–1406): A Study in Islamic Historiography.* Berkeley and Los Angeles:University of California Press, 1967.

Gaudefroy-Demombynes, M. *La Syrie à l'Époque des Mamelouks d'après les auteurs arabes.* Paris:Paul Geuthner, 1923.

Gibb, H. A. R., trans. *The Travels of Ibn Battuta, A.D. 1325–1354.* Vol. 1. The Hakluyt Society, 2d series, no. 110. Cambridge:Cambridge University Press, 1958.

Hitti, Philip K. *History of the Arabs from the Earliest Times to the Present.* 10th ed. London:Macmillan; New York:St. Martin's Press, 1970.

—— *History of Syria.* 2d ed. London:Macmillan; New York:St. Martin's Press, 1957.

——, ed. and trans. *Al-Suyuti's Who's Who in the 15th Century.* New York:Syrian American Press, 1927.

Hodgson, Marshall G. S. *The Venture of Islam.* Vol. 2. Chicago and London:University of Chicago Press, 1974.

Holt, P. M., ed. *The Eastern Mediterranean Lands in the Period of the Crusades.* Warminster, England:Aris & Phillips, 1977.

Humphreys, R. Stephen. "The Emergence of the Mamluk Army." *Studia Islamica* 45 (1977):67–99 and 46 (1977):147–182.

—— *From Saladin to the Mongols: The Ayyubids of Damascus, 1193-1260.* Albany:State University of New York Press, 1977.

Ibn Iyas. *An Account of the Ottoman Conquest of Egypt in the Year A.H. 922 (A.D. 1516).* Translated by W. H. Salmon. London:Royal Asiatic Society, 1921.

Kortantamer, Samira. *Ägypten und Syrien zwischen 1317 und 1341 in den Chronik des Mufaddal b. Abi'l-Fada'il.* Islamkundeliche Untersuchungen, 23. Freiburg im Breisgau, West Germany:K. Schwarz, 1973.

Lane, Edward William. *An Account of the Manners and Customs of the Modern Egyptians.* London: Murray, 1860. Reprint, New York:Dover Publications, Inc., 1973

Lane-Poole, Stanley. *Cairo: Sketches of its History, Monuments and Social Life.* London:Virtue, 1892; 2d ed., 1895; 3d ed., 1898.

—— *A History of Egypt in the Middle Ages.* London: Methuen & Co., 1901. 4th ed., new impression, London:Frank Cass & Co., Ltd., 1968.

Lapidus, Ira Marvin. *Muslim Cities in the Later Middle Ages.* Cambridge:Harvard University Press, 1967.

Latham, J. D., and Peterson. W. F., eds. and trans. *Saracen Archery: An English Version and Exposition on a Mamluk Work on Archery.* London, 1970.

Little, Donald Presgrave. *An Introduction to Mamluk Historiography: An Analysis of Arabic Annalistic and Biographical Sources for the Reign of al-Mamlik an-Nasir Muhammad ibn Qala'un.* Wiesbaden: F. Steiner Verlag GMBA; Montreal:McGill-Queen's University Press, 1970.

Lyons, U., and M. C., eds. and trans. *Ayyubids, Mamluks and Crusaders.* Cambridge:Heffer, 1971.

Margoliouth, D. *Cairo, Jerusalem and Damascus: Three Chief Cities of the Sultans.* London:Chatto & Windus, 1907.

Mayer, L. A. *Mamluk Costume: A Survey.* Geneva:Albert Kundig, 1952.

Migeon, Gaston. *Le Caire, le Nil et Memphis.* Paris: Librairie Renouard, 1906.

Muir, William. *The Mameluke or Slave Dynasty of Egypt, 1260–1517 A.D.* London:Smith, Elder & Co., 1896. Reprint ed., New York:AMS Press, Inc., 1973.

Niemeyer, W. *Ägypten zur Zeit der Mamluken: eine kulter landeskundliche Skizze.* Berlin:D. Reimer, 1936.

Parry, V. J., and Yapp, M. E., eds. *War, Technology and Society in the Middle East*. London, New York, and Toronto:Oxford University Press, 1975.

Petry, Carl. "Geographic Origins of Academicians in Cairo during the Fifteenth Century." *Journal of Economic and Social History of the Orient* 23 (1980): 142–52

—— "Geographic Origins of the Civil Judiciary in the Fifteenth Century." *Journal of the Economic and Social History of the Orient* 21 (1978):52–53

—— "Geographic Origins of Religious Functionaries in Cairo during the Fifteenth Century." *Journal of the Social and Economic History of the Orient* 23 (1980): 240–64.

Poliak, A. N. *Feudalism in Egypt, Syria, Palestine, and the Lebanon, 1250–1900*. London:Royal Asiatic Society, 1939. Rev. reprint ed., Philadelphia: Porcupine Press, 1977.

Popper, William. *Egypt and Syria under the Circassian Sultans, 1382–1468 A.D.: Systematic Notes to Ibn Taghri Birdi's Chronicles of Egypt*. University of California Publications in Semitic Philology, vols. 15–16. Berkeley and Los Angeles:University of California Press, 1955 and 1957.

Quatremère, Étienne Marc. *Histoire des Sultans Mamlouks de l'Égypte*, 4 vols. in 2. Paris:Oriental Translation Fund of Great Britain and Ireland, 1845.

Rabie, Hassanein. *The Financial System of Egypt, A.H. 564–741/ A.D. 1169–1341*. London Oriental Series, vol. 25. London, New York, and Toronto:Oxford University Press. 1972.

—— "Political Relations Between the Safavids of Persia and the Mamluks of Egypt in the Early Sixteenth Century." *Journal of the American Research Center in Egypt* 15 (1978):75–82.

Raymond, André, and Wiet, Gaston. *Les Marchés du Caire: Traduction annotée du texte de Maqrizi*. Cairo:Institut Français d'Archéologie Orientale du Caire, 1979.

Richards, D. S., ed. *Islam and the Trade of Asia: A Colloquium*. Oxford, Bruno Cassirer Ltd.; Philadelphia:University of Pennsylvania Press, 1970.

Sauvaget, Jean. *Introduction to the History of the Muslim East: A Bibliographical Guide*. Berkeley and Los Angeles:University of California Press, 1965.

—— ed. and trans. *"Les trésors d'or" de Sibt ibn al-'Ajami*. Beirut:Institut Français de Damas, 1950.

Scanlon, George T., ed. and trans. *A Muslim Manual of War*. Cairo:American University in Cairo, 1961.

Schäfer, Barbara. *Beiträge zur mamlukischen Historiographie nach dem Tode al-Malik an-Nasirs*. Islamkundeliche Untersuchungen, 15. Freiburg im Breisgau, West Germany:K. Schwarz, 1971.

Spuler, Berthold. *The Muslim World: A Historical Survey. Pt. 2: The Mongol Period*. Translated by F. R. C. Bagley. Leiden:E. J. Brill, 1960.

Wiet, Gaston. *Cairo: City of Art and Commerce*. Translated by Seymour Feiler. Norman:University of Oklahoma Press, 1964.

—— *L'Égypte arabe de la conquête arabe à la conquête ottomane, 642–1517*. Histoire de la nation égyptienne, edited by G. Hanotaux, vol. 4. Paris:Société de l'Histoire Nationale, 1937.

—— "L'Égypte musulmane." In *Précis de l'histoire d'Égypte*, vol. 2. Cairo:Institut Français d'Archéologie Orientale, 1932.

—— *Histoire des Mamlouks Circassiens*. Cairo:Institut Français d'Archéologie Orientale, 1945.

Zetterstéen, K. V. *Beiträge zur Geschichte der Mamlukensultane in den Jahren 690–741 der Hiǧra, nach arabischen Handschriften*. Leiden:E. J. Brill, 1919.

Ziada, Mustafa M. "The Mamluk Sultans, 1291–1517." In *A History of the Crusades III: The Fourteenth and Fifteenth Centuries*, edited by Harry W. Hazard, pp. 486–512. Kenneth M. Setton, gen. ed. Madison and London:University of Wisconsin Press, 1975.

—— "The Mamluk Sultans to 1293." In *A History of the Crusades II: The Later Crusades, 1191–1311*, edited by Robert L. Wolff and Harry W. Hazard, pp. 735–58. Kenneth M. Setton, gen. ed. 2d ed. Madison, Milwaukee, and London:University of Wisconsin Press, 1969.

Ziadeh, Nicola A. *Damascus under the Mamluks*. Norman:University of Oklahoma Press, 1964.

—— *Urban Life in Syria under the Early Mamluks*. Beirut:American Press, 1953.

Heraldry

Allan, James W. "Mamluk Sultanic Heraldry and the Numismatic Evidence: A Reinterpretation." *Journal of the Royal Asiatic Society* (1970):99–112.

Artin, Yacoub. *Contribution à l'étude du blason en Orient*. London:Quartich, 1902.

—— "Trois différentes armoires de Kait Bay." *Bulletin de l'Institut Égyptien*, 2d ser., no. 9 (1889):67–77.

Balog, Paul. "New Considerations on Mamluk Heraldry." *American Numismatic Society Museum Notes* 22 (1977):183–211.

Godard, André. "Notes complémentaires sur les tombeaux de Maragha (Adharbaidjan)." *Athar-é Iran* 1–2 (1936):125–69 and 350.

Kurz, Otto. "Mamluk Heraldry and *Interpretatio Christiana*." In *Studies in Memory of Gaston Wiet*, edited by Myriam Rosen-Ayalon, pp. 297–307. Jerusalem:Institute of Asian and African Studies, The Hebrew University of Jerusalem, 1977.

Mayer, L. A. "Le Blason de l'Amir Salar." *Journal of the Palestine Oriental Society* 5 (1925):58–60.

—— "Une énigme du blason musulman." *Bulletin de l'Institut d'Égypt* 21 (1938–39):141–43.

—— "Huit objets inédits à blasons mamluks en Grèce et en Turquie." In *Mélanges Maspero III: Orient Islamique*, pp. 97–104. Cairo:Imprimerie de l'Institut Français d'Archéologie Orientale, 1940.

—— "A New Heraldic Emblem of the Mamluks." *Ars Islamica* 4 (1937):349–51.

—— "New Material for Mamluk Heraldry." *Journal of the Palestine Oriental Society* 17 (1937):52–62. Also appeared as separate reprint, published in Jerusalem by Syrian Orphanage Press, 1937.

—— *Saracenic Heraldry: A Survey*. Oxford:Clarendon Press, 1933.

—— "Das Schriftwappen der Mamlukensultane." *Jahrbuch der Asiatischen Kunst* [Beiträge zur Kunst des Islam Festschrift für Friedrich Sarre] 2, no. 2 (1925):183–87.

Meinecke, Michael. "Die Bedeutung der Mamlukischen Heraldik für die Kunstgeschichte." *Zeitschrift der Deutschen Morgenländischen Gesellschaft*, supp. 2 (1974):213–40.

—— "Zur mamlukische Heraldik." *Mitteilungen des Deutschen Archäologischen Instituts Abteilung Kairo* 28, no. 2 (1972):214–87.

P[ier], G. C. "Saracenic Heraldry in Ceramic Decoration." *Bulletin of the Metropolitan Museum of Art* 3 (1908):8–11.

Rogers, E. T. "Le Blason chez les Princes musulmans de l'Égypte et de la Syrie." *Bulletin de l'Institut Égyptien*, 2d ser., no. 2 (1882):83–131.

—— "Das Wappenwesen der muhamedanischen Fürsten in Egypten und Syrien." *Vierteljahrsschrift für Heraldik, Sphragistik und Genealogie* (Berlin, 1882):407–30.

Sauvaget, Jean. "Cinq blasons mamelouks inédits." *Journal Asiatique* 227 (1935):300–305.

Inscriptions and Documents (Selected)

Abd al-Latif Ibrahim. "Silsilat al-dirasat al-wathaiqiyya 1: al-wathaiq fi khidmat al-athar— al-asr al-mamaluki" [Series of studies in documents 1: Documents in service of archaeology—The Mamluk period]. In *Al-mutamar al-thani li'l-athar fi'l-bilad al-arabiyya. Baghdad, 18–28 November 1958*, pp. 205–87. Cairo:Arab League, 1958.

—— "Silsilat al-dirasat al-wathaiqiyya 2: wathiqa al-sultan qaitbay—al-madrasa bi'l-quds wa al-jami bi-gaza" [Series of studies in documents 2: Contracts of Sultan Qaitbay—The madrasa in Jerusalem and the mosque in Ghaza]. In *The Third Congress for Archaeology in Arab Countries, Fez, 8th–18th November, 1959*, pp. 389–444. Cairo:Mafabi jaridat al-sabah, 1961.

—— "Silsilat al-wathaiq al-tarikhiyya al-quamiyya. Majmuat al-wathaiq al-mamlukiyya 1: wathiqat al-amir akhur kabir qaraquja al-hasani" [Series of documents pertaining to national history. A group of Mamluk documents 1: The deed of Qaraquja al-Hasani]. *Bulletin of the Faculty of Arts, Cairo University* 28, pt. 2 (1959):183–251.

—— "Al-tawthiqat al-shariyya wa'l-ashhadat fi zahr wathiqat al-ghuri" [Legal documentation and attesting on the verso of (waqf) document of al-Ghuri]. *Bulletin of the Faculty of Arts, Cairo University* 19, pt. 1 (1960):293–420.

Berchem, Max Van. *Matériaux pour un Corpus Inscriptionum Arabicarum. Première partie: Égypte I: Le Caire*. Mémoires publiés par les Membres de l'Institut Français d'Archéologie Orientale du Caire, vol. 19. Paris:Leroux, 1894–1903.

—— "Notes d'archéologie arabe." *Journal Asiatique* 3, 10th ser. (January–February 1904):5–96.

Combe, Étienne; Sauvaget, Jean; and Wiet, Gaston; eds. *Répertoire Chronologique d'Épigraphie Arabe*. 15 vols. Cairo:Imprimerie de l'Institut Français d'Archéologie Orientale, 1931–56.

Sauvaget, Jean. "Noms et surnoms de mamelouks." *Journal Asiatique* 238 (1950):31–58.

Wiet, Gaston. "Inscriptions mobilières de l'Égypte musulmane." *Journal Asiatique* 246, no. 3 (1958): 237–85.

—— *Matériaux pour un Corpus Inscriptionum Arabicarum. Première partie: Égypte. 2, fasc. 1*. Mémoires publiés par les Membres de l'Institut Français d'Archéologie Orientale du Caire, vol. 52. Cairo:Imprimerie de l'Institut Français d'Archéologie Orientale, 1929.

ART

Abd el-Rauf Ali Yusuf. "Tuhaf fanniyya minasr al-mamalik." [Some masterpieces from the Mamluk period]. *Al-madjala* 62 (March 1962):96–105.

L'Art de l'Orient Islamique: Collection de la Fondation Calouste Gulbenkian Foundation. Lisbon:Museu Nacional de Arte Antiga, 1963.

Arts de l'Islam des origines à 1700 dans les collections publiques françaises. Catalogue of an exhibition at Orangerie des Tuileries. Paris : Ministère des Affaires Culturelles, Réunion des Musées Nationaux, 1971.

The Arts of Islam. Catalogue of an exhibition at Hayward Gallery. London:Arts Council of Great Britain, 1976.

Aslanapa, Oktay. *Yüzyıllar Boyunca Türk Sanatı (14. yüzyıl).* [Turkish art through the centuries (14th century)]. Ankara:Devlet Kitapları, 1977.

Atıl, Esin. *Art of the Arab World.* Washington, D.C.: Freer Gallery of Art, Smithsonian Institution, 1975.

Catalogue du Musée Nationale de Damas. Catalogue by Abu'l-Faraj al-Ush, Adnan Joundi, and Bachir Zouhdi. Damascus:Direction Générale des Antiquitiés et des Musées, 1976.

Dalil mathaf al-fann al-islam (dar al-athar al-arabiyya sabiqan) [Guide to the Museum of Islamic Art (formerly Museum of Arab Art)]. Preface by Zaki Muhammad Hasan. Cairo:Matbaat dar al-kutub, 1952.

Dimand, Maurice. *A Handbook of Muhammadan Art.* 2d rev. ed. New York:Metropolitan Museum of Art, 1944.

El-Emary, Amal A. "Studies in Some Islamic Objects Newly Discovered at Qus." *Annales Islamologiques* 6 (1966):121–38.

Grabar, Oleg. "Islamic Peoples, Arts of, IV: Visual Arts." *Encyclopaedia Britannica,* 15th ed. pp. 1001–2: Mamluk Art.

Grube, Ernst J. *The World of Islam.* New York and Toronto:McGraw-Hill Book Company, 1966.

Hasan Abd al-Wahhab. "Tawqiat al-sunna ala athar misr al-islamiyya" [Artists' signatures on the monuments of Muslim Egypt]. *Bulletin de l'Institut d'Égypt* 36 (1955):533–58.

Herz, Max. *Catalogue Raisonné des Monuments exposés dans le Musée National de l'Art Arabe.* 2d ed. Cairo:Imprimerie de l'Institut Français d'Archéologie Orientale, 1906.

—— *A Descriptive Catalogue of the Objects Exhibited in the National Museum of Arab Art.* 2d ed. Translated by G. Foster Smith. Cairo:National Printing Department, 1907.

Islam and the Medieval West. Catalogue of an exhibition at University Art Gallery. Edited by Stanley Ferber. Binghamton, N.Y.:State University of New York, 1975.

Islamic Art in Egypt: 969–1517. Catalogue of an exhibition at Semiramis Hotel on the occasion of the Millenary of Cairo. Cairo:Ministry of Culture U.A.R., 1969.

Islamic Art in Egypt: 969–1517—An Exhibition—Loan Objects. Handlist of an exhibition at Semiramis Hotel on the occasion of the Millenary of Cairo. Cairo: Ministry of Culture U.A.R., 1969.

L'Islam dans les collections nationales. Catalogue of an exhibition at Grand Palais. Paris:Éditions des Musées Nationaux, 1977.

Izzi, Wafiyya. "Objects Bearing the Name of al-Nasir Muhammad and His Successor." In *Colloque International sur l'Histoire du Caire,* pp. 235–41. Cairo:Ministry of Culture of the Arab Republic of Egypt, General Egyptian Book Organization, 1974.

James, David. *Islamic Art: An Introduction.* London, New York, Sydney, and Toronto:Hamlyn Publishing Group, Ltd., 1974.

Kühnel, Ernst. *The Minor Arts of Islam.* Translated by K. Watson. Ithaca, N.Y.:Cornell University Press, 1970.

Kunst des Islam. Catalogue of an exhibition at Schloss Halbturn. Vienna:Österreichisches Museum für angewandte Kunst, 1977.

Lane-Poole, Stanley. *The Art of the Saracens in Egypt.* London:Chapman and Hall, Ltd., 1886.

Migeon, Gaston. *Manuel d'art musulman.* 2 vols. Paris:Alphonse Picard et Fils, 1907.

—— *Manuel d'art musulman.* 2 vols. 2d ed. Paris: Éditions Auguste Picard, 1927.

—— *Musée du Louvre: L'Orient Musulman.* 2 vols. Paris:Éditions Albert Morancé, 1922.

Mostafa, Mohamed. "Human Figures in the Art of the Mamluk Period." *Egypt Travel Magazine* 20 (March 1956):16–19.

—— *Le Musée de l'Art Arabe.* Cairo:Société Orientale de Publicité, 1949.

—— *The Museum of Islamic Art: A Short Guide.* Cairo:Publications of the Museum of Islamic Art, General Organization for Government Printing Offices, 1961.

—— *Unity in Islamic Art: Guide to the 2nd Temporary Exhibition.* Catalogue of an exhibition at Museum of Islamic Art. Cairo:Ministry of Culture and National Guidance, Publication of the Museum of Islamic Art, Cairo, 1958.

Musée Arabe. *Éxposition d'Art Musulman.* Catalogue of an exhibition at Musée national arabe. Cairo:R. Schindler, Imprimeur, 1947.

Museum für Islamische Kunst, Berlin: Katalog 1971. Berlin:Staatliche Museen, Preussischer Kulturbesitz, 1971.

Musée Nicolas Sursock. *Art Islamique dans les collections privés libanaises.* Catalogue of an exhibition at Musée Nicolas Sursock. Beirut:Musée Nicolas Ibrahim Sursock, 1974.

Otto-Dorn, Katarina. *L'Art de l'Islam.* Paris:Éditions Albin Michel, 1967.

Papadopoulo, Alexandre. *Islam and Muslim Art.* Translated by R. E. Wolf. New York:Harry N. Abrams, Inc., 1979.

Rice, David Talbot. *Islamic Art.* New York and London:Frederick A. Praeger, Publishers, 1965; rev. ed., 1975.

Rogers, J. Michael. "Evidence for Mamluk–Mongol Relations, 1260–1360." In *Colloque International sur l'Histoire du Caire,* pp. 385–403. Cairo:Ministry of Culture of the Arab Republic of Egypt, General Egyptian Book Organization, 1974.

—— *The Spread of Islam.* Oxford:Elsevier-Phaidon, 1976.

Ross, E. Denison, ed. *The Art of Egypt through the Ages.* London:Studio Ltd., 1931.

Sarre, F., and Martin, F. R. *Die Ausstellung von Meisterwerken muhammedanischer Kunst in München 1910.* 4 vols. Berlin:F. Bruckmann, 1912.

Shafi'i, Farid. "Mameluke Art." *Enciclopedia Universale dell'Arte,* vol. 9, cols. 419–28. 1964.

Sourdel-Thomine, J., and Spuler, B. *Die Kunst des Islam.* Berlin:Propyläen Verlag, 1973.

Welch, Anthony. *Calligraphy in the Arts of the Muslim World.* Austin:University of Texas Press, 1979.

Wiet, Gaston. *Album du Musée Arabe du Caire.* Cairo:Imprimerie de l'Institut Français d'Archéologie Orientale, 1930.

Zaki, Muhammad Hasan. *Funun al-islam* [Arts of Islam]. Cairo:Maktabat al-nahda al-misriyya, 1948.

—— *Atlas al-funun al-zukhrufiya wa'l-tasawir al-islamiya* [Atlas of Moslem decorative and pictorial arts]. Cairo:Cairo University Press, 1956.

ARCHAEOLOGY

Aly Bahgat. "Les fouilles de Fustat." *Syria* 4 (1923): 59–65.

Kubiak, Wladyslaw B., and Scanlon, George T. "Fustat Expedition: Preliminary Report, 1966." *Journal of the American Research Center in Egypt* 10 (1973):11–26.

Riis, Poul Jørden, and Poulsen, Vagn. *Hama, Fouilles et Recherches de la Fondation Carlsberg, 1931–1938. IV/2: Les verreries et poteries medievales.* Copenhagen:I Kommission Hos Nationalmuseet, 1957.

Scanlon, George T. "Ancillary Dating Materials from Fustat." *Ars Orientalis* 7 (1968):1–17.

—— "Fustat Expedition: Preliminary Report, 1965." *Journal of the American Research Center in Egypt* 5 (1966):83–112.

—— "Fustat Expedition: Preliminary Report, 1965, Part II." *Journal of the American Research Center in Egypt* 6 (1967):65–86.

—— "Fustat Expedition: Preliminary Report, 1968, Part I." *Journal of the American Research Center in Egypt* 6 (1974):81–91.

—— "Fustat Expedition: Preliminary Report, 1968, Part II." *Journal of the American Research Center in Egypt* 13 (1976):69–90.

—— "Preliminary Report: Excavations at Fustat, 1964." *Journal of the American Research Center in Egypt* 4 (1965):7–30.

Whitcomb, Donald, and Johnson, Janet H. *Quseir al-Qadim 1978: Preliminary Report.* Cairo:American Research Center in Egypt, Inc., 1979.

ARCHITECTURE

Abd ar-Raziq, Ahmed. "Trois fondations féminines dans l'Égypte mamlouke." *Revue des études islamiques* 41 (1973):95–126.

Ahmad Fikri. *Masajid al-qahira wa madarisuha* [Mosques and madrasas of Cairo]. Cairo:Dar al-maarif, 1961.

Behrens-Abouseif, Doris. "A Circassian Mamluk Suburb North of Cairo." *Art and Archaeology Research Papers* 14 (December 1978):17–23.

Brandenburg, Dietrich. *Islamische Baukunst in Ägypten.* Berlin:Bruno Hessling, 1966.

—— "Moristan Kalaun: Eine alter arabische Medizinschule." *Colloquium* 15, no. 4/5 (Berlin, 1961):20–21.

Briggs, Martin S. *Muhammadan Architecture in Egypt and Palestine.* Oxford:Clarendon Press, 1924.

Brinner, W. M. "Dar al-Sa'ada and Dar al-Adl in Mamluk Damascus." In *Studies in Memory of Gaston Wiet,* edited by Myriam Rosen-Ayalon, pp. 235–47. Jerusalem: Institute of Asian and African Studies, The Hebrew University of Jerusalem, 1977.

Burgoyne, Michael. "Tariq Bab al-Hadid : A Mamluk street in the old city of Jerusalem." *Levant* 5 (1973) :12–35.

Comité de Conservation des Monuments de l'Art Arabe. *Comptes Rendues des Exercices 1915–1919*, vol. 32. Cairo and Milan, 1922.

Creswell, K. A. C. *The Muslim Architecture of Egypt*, vol. 2. Oxford :Clarendon Press, 1959.

—— "The works of Sultan Bibars al-Bunduqdari in Egypt." *Bulletin de l'Institut Français d'Archéologie Orientale* 26 (1926) :129–93.

Garcin, Jean Claude. "Le Caire et la Province : Constructions au Caire et à Qus sous les Mameluks Bahrides." *Annales Islamologiques* 8 (1969) :47–62.

Glidden, Harold W. "The Mamluk Origin of the Fortified Khan at al-Aqabah, Jordan." In *Archaeologica Orientalia in Memoriam Ernst Herzfeld*, edited by George C. Miles, pp. 116–18. Locust Valley, N.Y. :Augustin, 1952.

Hasan Abd al-Wahhab. "Asr al-mamalik al-bahriya : dawlat al-zahir baybars al-bunduqdari" [Period of the Bahri Mamluks : Reign of al-Zahir Baybars al-Bunduqdari]. *Al-imara* 2, nos. 9–10 (1940) :468–80.

—— "Asr al-mamalik al-bahriya : al-mansur qalawun" [Period of the Bahri Mamluks : Al-Mansur Qalawun]. *Al-imara* 3, no. 2 (1941) :85–92.

—— "Asr al-mamalik al-bahriya : al-nasir muhammad ibn qalawun" [Period of the Bahri Mamluks : Al-Nasir Muhammad ibn Qalawun]. *Al-imara* 3, nos. 7–8 (1941) :291–300.

—— "Asr al-mamalik al-bahriya : madrasat al-sultan hasan" [Period of the Bahri Mamluks : Madrasa of Sultan Hasan]. *Al-imara* 4, nos. 3–4 (1942) :115–22.

—— "Asr al-mamalik al-bahriya : takmilat al-sultan hasan" [Period of the Bahri Mamluks : Sequel to Sultan Hasan]. *Al-imara* 4, no. 5 (1942) :184–93.

—— "Asr al-mamalik al-bahriya : takmilat asr al-nasir muhammad ibn qalawun" [Period of the Bahri Mamluks : Sequel to the period of al-Nasir Muhammad ibn Qalawun]. *Al-imara* 4, nos. 1–2 (1942) :59–69.

—— "Asr al-mamalik al-sharakisa : dawlat al-zahir barquq wa ibnihi faraj" [Period of the Circassian Mamluks : Reign of al-Zahir Barquq and his son Faraj]. *Al-imara* 5, no. 1 (1945) :32–37 ; 6, nos. 3/4 (1946) :56–63.

—— "Asr al-mamalik al-sharakisa : al-malik al-muayyad shaykh" [Period of the Circassian Mamluks : Al-Malik al-Muayyad Shaykh]. *Al-imara* 9, nos. 1/2 (1949) :47–53.

—— "Khanqah faraj ibn barquq wa ma haulaha" [The Khanqah of Faraj ibn Barquq and its surroundings]. In *The Third Congress for Archaeology in Arab Countries, Fez, 8th–18th November 1959*. Cairo :Matabi jaridat al-sabah, 1961.

—— *Jami al-sultan hasan wa ma haulaha* [The mosque of Sultan Hasan and its neighborhood]. Cairo :Wizarat al-thaqafa, 1962.

—— *Tarikh al-masajid al-athariyah* [History of the old mosques]. 2 vols. Cairo :Dar al-kutub al-misriya, 1946.

Hautecour, Louis, and Wiet, Gaston. *Les Mosquées du Caire*. 2 vols. Paris :Leroux, 1932.

Herz, Max. *Die Baugruppe des Sultans Qala'un in Kairo*. Abhandlungen des Hamburgischen Kolonialinstituts, vol. 42, Hamburg :Friederichsen, 1919.

—— *La Mosquée du Sultan Hassan au Caire*. Cairo : Comité de Conservation des Monuments de l'Art Arabe, 1899.

Hoag, John O. *Islamic Architecture*. New York :Harry N. Abrams, Inc., 1977.

Humphreys, R. Stephen. "The Expressive Intent of the Mamluk Architecture of Cairo : A Preliminary Essay." *Studia Islamica* 35 (1972) :69–119.

Ibrahim, Laila Ali. "Four Cairene Mihrabs and Their Dating." *Kunst des Orients* 7, no. 1 (1970–71) :30–39.

—— "The great Hanqah of the Emir Qawsun in Cairo." *Mitteilungen des Deutschen Archäologischen Instituts Abteilung Kairo* 30, no. 1 (1974) :37–64.

—— *Mamluk Monuments of Cairo*. Cairo :Istituto Italiano di Cultura per la R. A. E., 1976.

—— "Middle-Class Living Units in Mamluk Cairo : Architecture and Terminology." *Art and Archaeology Research Papers* 14 (December 1978) :24–30.

—— "The Transitional Zones of Domes in Cairene Architecture." *Kunst des Orients* 10, no. 1/2 (1975) :5–23.

Jomard, E. F. "Description abrégée de la ville et de la citadelle de Caire, suivie de l'explication du plan de cette ville et de ses environs . . ." In *Déscription de l'Égypte, État Moderne*, vol. 2, pp. 579–778. Paris :Imprimerie Imperiale, 1822.

Kessler, Christel. "The Carved Masonry Domes of Medieval Cairo." *Art and Archaeology Research Papers* (June 1976).

—— "Funerary Architecture within the City." In *Colloque International sur l'Histoire du Caire*, pp. 257–67. Cairo :Ministry of Culture of the Arab Republic of Egypt, General Egyptian Book Organization, 1974.

Lezine, A. "Les salles nobles des palais mamelouks." *Annales Islamologiques* 10 (1972) :63–148.

Marzouk, M. A. "Arwa al-madafin al-islamiya fi misr : qubbat al-sultan qalawun" [The most beautiful mausoleum in Egypt : The mausoleum of Sultan Qalawun]. *Al-hilal* 50, no. 2 (Cairo, July–August 1944) :519–23.

Mayer, L. A. "Arabic Inscriptions of Gaza." *Journal of the Palestine Oriental Society* 3 (1923) :69–78 ; 5 (1925) :66–68 ; 10 (1930) :59–63 ; 11 (1931) :144–51.

—— *The Buildings of Qaytbay, as Described in His Endownment Deed. Fascicule I—Text and Index*. London :Probsthian, 1938.

—— "Two inscriptions of Baybars." *Quarterly of the Department of Antiquities of Palestine* 2 (1933) :27–33.

Meinecke, Michael. "Byzantinsche Elemente in der mamlukischen Architektur." *Kunstchronick* 23, no. 10 (1970) :295–99.

—— *Die Madrasa des Amirs Mitqal in Kairo*. Cairo :Deutsches Archäologisches Institut, 1976.

—— "Mamlukische Marmordekorationen in der osmanischen Türkei." *Mitteilungen des Deutschen Archäologischen Instituts Abteilung Kairo* 27, no. 2 (1971) :207–20.

—— "Das Mausoleum des Qala'un in Kairo : Untersuchungen zur Genese der mamlukischen Architekturdekoration." *Mitteilungen des Deutschen Archäologischen Instituts Abteilung Kairo* 27, no. 1 (1971) :47–80.

—— "Die Moschee des Amirs Aqsungar an-Nasiri in Kairo." *Mitteilungen des Deutschen Archäologischen Instituts Abteilung Kairo* 29, no. 1 (1973) :9–38.

Meinecke, Michael, ed. *Islamic Cairo : Architectural Conservation and Urban Development of the Historic Centre*. Proceedings of a Seminar Organized by the Goethe Institute, Cairo, October 1–5, 1978. London :Art and Archaeology Research Papers, 1980.

——, et al. *Die Restaurierung der Madrasa des Amirs Sabiq ad-Din Mitqal al-Anuki und die Sanierung des Darb Qirmiz in Kairo*. Mainz :Deutsches Archäologisches Institut Abteilung Kairo, Archäologische Veröffentlichungen XXIX, 1980.

Meinecke-Berg, Viktoria. "Quellen zu Topographie und Baugeschichte in Kairo unter Sultan an-Nasir Muhammad b. Qala'un." *Zeitschrift der Deutschen Morgenländischen Gesellschaft*, supp. 3, no. 1 (1977) :538–50.

—— "Eine Stadtansicht des mamlukischen Kairo aus dem 16. Jahrhundert." *Mitteilungen des Deutschen Archäologischen Instituts Abteilung Kairo* 32 (1976) :113–32.

Ministry of Waqfs. *The Mosques of Egypt, from 21 H. (641) to 1365 H. (1916)*. Giza (Orman) :Survey of Egypt, 1949.

Mitchell, George, ed. *Architecture of the Islamic World : Its History and Social Meaning*. London :Thames and Hudson, 1978.

Mostafa, Saleh Lamei. *Kloster und Mausoleum des Farag ibn Barquq in Kairo*. Gluckstadt, West Germany : Augustin, 1968.

Parker, Richard B., and Sabin, Robin, *A Practical Guide to Islamic Monuments in Cairo*. Cairo :American University in Cairo Press, 1974.

Prisse D'Avennes, A. C. T. E. *L'Art arabe d'après des monuments du Kaire*, 3 vols. Paris :A. Morel et Cie., 1869–77.

Raymond, André. "Les constructions de l'émir Abd al-Rahman Kuthuda au Caire." *Annales Islamologiques* 2 (1972) :235–51.

Russell, Dorothea. *Medieval Cairo and the Monasteries of the Wadi Natrun*. London :Weidenfeld and Nicolson, 1962.

Sauvaget, Jean. "Caravansérails Syriens du Moyen-Âge II : Caravansérails Mamelouks." *Ars Islamica* 7 (1940) :1–19.

—— "Un momument commémoratif d'époque mamelouke" In *Mélanges Maspéro*, vol. 3, pp. 15–18. Cairo :Imprimerie de l'Institut Français d'Archéologie Orientale, 1940.

—— *Les monuments historiques de Damas*. Beirut : Imprimerie Catholique, 1932.

—— "Un relais du Barid Mamelouk." In *Mélanges Gaudefroy-Demombynes*, pp. 41–48. Cairo :Imprimerie de l'Institut Français d'Archéologie Orientale, 1935–45.

Survey of Egypt. *Index to Mohammedan Monuments Appearing on the Special 1 :5000 Scale Map of Cairo*. [Giza] :Survey of Egypt, 1951.

Walls, Archibald G., and King, David A. "The Sundial on the West Walls of the Madrasa of Sultan Qaytbay in Jerusalem." *Art and Archaeology Research Papers* 15 (June 1979) :16–27.

MANUSCRIPTS
Bookbindings

Abd al-Latif, Ibrahim. "Jilda mushaf bi-dar al-kutub al-misriya" [Koran bindings in the Egyptian National Library]. *Bulletin of the Faculty of Arts, Cairo University* 20, pt. 1 (1962) :81–107.

Bosch, Gulnar Kheirallah. "Islamic Bookbindings : Twelfth to Seventeenth Centuries." Ph.D. dissertation, University of Chicago, 1952.

Ettinghausen, Richard. "Near Eastern Book Covers and Their Influence of European Bindings: A Report on the Exhibition 'History of Bookbinding' at the Baltimore Museum of Art, 1957–58." *Ars Orientalis* 3 (1959):113–31.

The History of Bookbinding, 524–1950 A.D. Catalogue of an exhibition at Baltimore Museum of Art. Baltimore:Trustees of the Walters Art Gallery, 1957.

Levey, Martin. "Mediaeval Arabic Bookmaking and its Relation to Early Chemistry and Pharmacology." *Transactions of the American Philosophical Society*, n.s. 52, pt. 4 (1962).

Illuminations

Arberry, Arthur J. *The Chester Beatty Library: A Handlist of the Arabic Manuscripts.* 8 vols. Dublin:Emery Walker Ltd., 1955–56 (vols. 1–2); Dublin: Hodges, Figgis & Co. Ltd., 1958–66.

—— *The Koran Illuminated: A Handlist of the Korans in the Chester Beatty Library.* Dublin:Hodges, Figgis, & Co., Ltd., 1967.

Karatay, F. E. *Topkapı Sarayı Müzesi Kütüphanesi: Arapça Yazmalar Kataloğu* [The Topkapı Palace Museum Library: Catalogue of Arabic manuscripts]. 4 vols. Istanbul:Topkapı Sarayı Müzesi, 1962–69.

Lings, Martin. *The Quranic Art of Calligraphy and Illumination.* London:World of Islam Festival Trust, 1976.

Lings, Martin, and Safadi, Yasin Hamid. *The Qur'an.* London:World of Islam Publishing Company, Ltd., 1976.

Robinson, B. W. "Unillustrated Manuscripts." In *Islamic Painting and the Arts of the Book* by B. W. Robinson, Ernst J. Grube, G. M. Meredith-Owens, and R. W. Skelton, pp. 285–99. London:Faber & Faber Ltd., 1976.

Stchoukine, Ivan; Fleming, Barbara; Luft, Paul; and Sohrweide, Hanna. *Illuminierte Islamische Handschriften.* Verzeichnis der Orientalischen Handschriften in Deutschland, vol. 16. Wiesbaden:Frans Steiner Verlag GMBH, 1971.

Illustrations

Aga-Oglu, Mehmet. "On a Manuscript by al-Jazari." *Parnassus* 3, no. 7 (November 1931):27–28.

Anet, C. "Dr. F. R. Martin and Oriental Painting, 'Le Traite des Automates.'" *Burlington Magazine* 23 (1913):49–50.

Atasoy, Nurhan. "Un manuscrit mamluk illustré du Šahnama." *Revue des études islamiques* 37 (1969):151–58.

—— "1510 Tarihli Mamluk Şehnamesinin Minyatürleri." *Sanat Tarihi Yıllığı 1966–1968* (Istanbul, 1968):49–69.

Atıl, Esin. *Kalila wa Dimna: Fables from a Fourteenth-Century Arabic Manuscript.* Washington, D.C.:Smithsonian Institution Press, 1981.

Buchthal, Hugo. "Three Illustrated Hariri Manuscripts in the British Museum." *Burlington Magazine* 77 (1940):144–52.

Buchthal, Hugo; Kurz, Otto; and Ettinghausen, Richard. "Supplementary Notes to K. Holter's Check List of Islamic Illuminated Manuscripts Before A.D. 1350." *Ars Islamica* 7 (1940):147–64.

Coomaraswamy, A. K. "The Treatise of al-Jazari on Automata." *Museum of Fine Arts, Boston, Communications to the Trustees*, vol. 6. Boston:Museum of Fine Arts, 1924.

Creswell, K. A. C. "Dr. F. R. Martin's MS. 'Treatise on Automata.'" *The Yearbook of Oriental Art and Culture, 1924–1925* (1925):33–40.

Edhem, Fehmi, and Stchoukine, Ivan. *Les Manuscrits Orientaux Illustrés de la Bibliothèque de l'Université de Stamboul.* Paris:E. de Boccard, 1933.

Ettinghausen, Richard. *Arab Painting.* Geneva:Éditions d'Art Albert Skira, 1962.

—— "Further Notes on Mamluk Playing Cards." In *Gatherings in Honor of Dorothy E. Miner*, edited by U. E. McCracken, L. M. C. Randall, and R. H. Randall, Jr., pp. 51–78. Baltimore:Walters Art Gallery, 1974.

Farès, Bishr. "Un Herbier arabe illustré du XIVe siècle." In *Archaeologia Orientalia in Memoriam Ernst Herzfeld*, edited by G. C. Miles, pp. 84–88. Locust Valley, N.Y.:Augustin, 1952.

Glidden, Harold W. "A Note on the Automata of al-Djazari." *Ars Islamica* 3 (1936):115–16.

Grube, Ernst J. "Materialien zum Dioskurides Arabicus." In *Aus der Welt der Islamischen Kunst, Festschrift für Ernst Kühnel*, edited by Richard Ettinghausen, pp. 163–94. Berlin:Verlag Gebr. Mann, 1959.

—— *Muslim Miniature Paintings from the XIII to XIX Century from Collections in the United States and Canada.* Venice:Neri Pozza, 1962.

—— *Islamic Paintings from the 11th to the 18th Century in the Collection of Hans P. Kraus.* New York:H. P. Kraus, 1972.

—— "Pre-Mongol and Mamluk Painting." In *Islamic Painting and the Arts of the Book* by B. W. Robinson, Ernst J. Grube, G. M. Meredith-Owens, and R. W. Skelton, pp. 67–119. London:Faber & Faber Limited, 1976.

Haldane, Duncan. *Mamluk Painting.* Warminster, England:Aris & Phillips Ltd., 1978.

—— "Scenes of Daily Life from Mamluk Miniatures." In *The Eastern Mediterranean Lands in the Period of the Crusades*, edited by P. M. Holt, pp. 78–89. Warminster, England:Aris & Phillips Ltd., 1977.

Hill, Donald R., trans. and ed. *The Book of Knowledge of Ingenious Mechanical Devices.* Dordrecht and Boston: D. Reidel Publishing Company, 1974.

Holter, Kurt. "Die frühmamlukische Miniaturenmalerei." *Die Graphischen Künste* 2 (1937):1–14.

—— "Die Galen-Handschrift und die Makamen des Hariri der Wiener Nationalbibliothek." *Jahrbuch der Kunsthistorischen Sammlungen in Wien*, n.s. 9, special no. 104 (1937):1–48.

—— "Die islamischen Miniaturhandschriften vor 1350." *Zentralblatt für Bibliothekwesen* 54 (1937):1–37.

James, David. "Arab Painting." *Marg* 29, no. 3 (June 1976):1–50.

—— "Mamluke Painting at the Time of the 'Lusignan Crusade,' 1365–70: A Study of the Chester Beatty *Nihayat al-su'l wa'l-umniya . . .* manuscript of 1366." *Humaniora Islamica* 2 (1974):73–87.

Löfgren, Oscar, and Lamm, Carl Johan. *Ambrosian Fragments of an Illuminated Manuscript Containing the Zoology of al-Ğahiz.* Uppsala, Sweden: Lundequistska Bokhandeln, 1946.

Lorey, Eustache de. "Le Bestiaire de l'Escurial." *Gazette des Beaux-Arts* 14, 6th per. (1935):228–38.

Mayer, L. A. "A Hitherto Unknown Damascene Artist." *Ars Islamica* 9 (1942):168.

—— *Mamluk Playing Cards.* Edited by R. Ettinghausen and O. Kurz. Leiden:E. J. Brill, 1971. Originally published in *Bulletin de l'Institut Français d'Archéologie Oriental* 48 (Cairo, 1939):113–18.

—— "Zur titelblatt der Automata Miniaturen." *Orientalistische Literaturzeitung* 35 (1932):cols. 165–66.

Mostafa, Mohamed. "An Illustrated Manuscript on Chivalry from the Late Circassian Mamluk Period." *Bulletin de l'Institut Égyptien* 51 (1969–70):1–14.

—— "Un manuscrit illustré sur la Chevalerie vers la fin du règne des Mamluks Circassiens (Résumé)." In *Colloque International sur l'Histoire du Caire*, pp. 333–34. Cairo:Ministry of Culture of the Arab Republic of Egypt, General Egyptian Book Organization, 1974.

—— "Miniature Paintings in Some Mamluk Manuscripts." *Bulletin de l'Institut Égyptien* 52 (1970–71):5–15.

Mousa, Ahmad. *Zur Geschichte der islamischen Buchmalerie in Ägypten.* Cairo:Government Press, 1931.

Al-Munajjed, Salahuddin. *Le manuscrit arabe jusqu'au Xe siècle de l'Hijra, Vol. 1: Les Specimens.* Cairo:League des États Arabes, Institut des Manuscrits, Arabes, 1960.

Rice, D. S. "A Miniature in an Autograph of Shahab al-Din ibn Fadlellah al-Umari." *Bulletin of the School of Oriental and African Studies* 13 (1951):856–67.

Riefstahl, Rudolf M. "The Date and Provenance of the Automata Miniatures." *The Art Bulletin* 11, no. 2 (June 1929):206–15.

Smith, Rex G. *Medieval Muslim Horsemanship: A Fourteenth-Century Arabic Cavalry Manual.* London: British Library, 1979.

Stchoukine, Ivan. "Un manuscrit du traité d'al-Jazari, sur les automates du VII siècle de l'hegire." *Gazette des Beaux-Arts* 11, 6th per. (1934):134–40.

Tantum, Geoffrey. "Muslim Warfare: A Study of Medieval Muslim Treatise on the Art of War." In *Islamic Arms and Armour*, edited by Robert Elgood, 187–201. London:Scolar Press, 1979.

Taymur, Ahmad. *Al-taswir ind al-arab* [Painting among the Arabs]. Edited by Zaki M. Hasan. Cairo:Lajnat al-talif wa'l-nasir, 1942.

Walzer, Sofie. "An Illustrated Leaf from a Lost Mamluk Kalilah wa-Dimnah Manuscript." *Ars Orientalis* 2 (1957):503–5.

—— "The Mamluk Illuminated Manuscripts of Kalila wa-Dimna." In *Aus der Welt der Islamischen Kunst, Festschrift für Ernst Kühnel*, edited by Richard Ettinghausen, pp. 195–206. Berlin:Verlag Gebr. Mann, 1959.

Wittek, P. "Datum und Herkunft der Automaten-Miniaturen." *Der Islam* 19 (1930–31):213–51.

METALWORK

Aga-Oglu, Mehmet "About a Type of Islamic Incense Burner." *Art Bulletin* 27 (1945):28–45.

—— "Ein Prachtspiegel im Topkapu Sarayi Museum." *Pantheon* 6 (1930):454–57.

Aly Bahgat. "Histoire de la Houdjra de Médine ou salle funeraire du Prophète, à propos d'un chandelier offert par Qayt Bay." *Bulletin de l'Institut Égyptien*, 5th ser., no. 8 (1914):73–94.

Allan, James W. "Later Mamluk Metalwork: A Series of Dishes." *Oriental Art*, n.s. 15, no. 1 (Spring 1969): 38–43.

—— "Later Mamluk Metalwork II: A Series of Lunch-Boxes." *Oriental Art*, n.s. 17, no. 2 (1971):156–64.

Artin, Yacoub. "Les armes de l'Égypte aux XVe et XVIe siècles." *Bulletin de l'Institut Égyptien*, 4th ser., no. 7 (1907):87–90.

—— "Un sabre de l'Emir Ezbek el-Yussufi el-Zaheri (900 H.—1494 A.D.)." *Bulletin de l'Institut Égyptien*, 3d ser., no. 9 (1899):219–59.

—— "Un brûle parfum armorié." *Bulletin de l'Institut Égyptien*, 4th ser., n.s. 6 (1905):15.

—— "Un bol competier en cuivre blasonné du XVe siècle." *Bulletin de l'Institut Égyptien*, 5th ser., no. 3 (1910):90–96.

Baer, Eva. "Fish-pond Ornaments on Persian and Mamluk Metal Vessels." *Bulletin of the School of Oriental and African Studies* 31 (1968):14–27.

Bahnassi, Afif. "Fabrication des Épées de Damas." *Syria* 53 (1976):281–94.

Barrett, Douglas. *Islamic Metalwork in the British Museum*. London:Trustees of the British Museum, 1949.

Çığ, Kemal. "Two Metal Koran Cases Recently Discovered in the Topkapı Palace Museum." In *Fifth International Congress of Turkish Art*, edited by G. Fehér, 261–66. Budapest:Akadémiai Kiadó, 1978.

Combe, Étienne. "Cinq cuivres musulmans datés des XIIe, XIVe, et XVe siècles de la Collection Benaki." *Bulletin de l'Institut Français d'Archéologie Orientale* 30 (1931):49–58.

Coomaraswamy, A. K. "Two Examples of Muhammadan Metal Work." *Bulletin of the* [Boston] *Museum of Fine Arts* 29 (1931):70–72.

Dam, Cornelia H. "An Egyptian Kursi." *The* [Philadelphia] *Museum Journal* 19 (1928):284–89.

Devonshire, Mrs. R. L. "Sultan Salah ed-Din's Writing-Box in the National Museum of Arab Art, Cairo." *Burlington Magazine* 35 (1919):241–45.

Dimand, Maurice. "Unpublished Metalwork of the Rasulid Sultans of Yemen." *Metropolitan Museum Studies* 3, pt. 2 (1931):229–37.

Ettinghausen, Richard. "Review of *Le Baptistère de St. Louis* by D. S. Rice." *Ars Orientalis* 1 (1954):245–49.

Fehérvári, Géza. *Islamic Metalwork of the Eighth to the Fifteenth Century in the Keir Collection*. London: Faber & Faber Limited, 1976.

G[alvan] C[abrerizo], M. L. "Bandeja oriental, de cobre." In *Acquisiciones del Museo Arqueológico Nacional (1940–45)*, pp. 165–66. Madrid, 1974.

Glück, Heinrich. "Ein Moscheeleuchter des Mamelukensultans Nasir ad-Din Muhammad aus zwei Jahrhunderten." *Wiener Beiträge zur Kunst- und Kulter-Geschichte Asiens* 4 (1930):26–27.

Grabar, Oleg. "Two Pieces of Islamic Metalwork at the University of Michigan." *Ars Orientalis* 4 (1961): 360–68.

Gray, Basil. "The Influence of Near Eastern Metalwork on Chinese Ceramics." *Transactions of the Oriental Ceramic Society* 18 (1940–41):47–60.

Hartner, Willy. "The Pseudoplanetary Nodes of the Moon's Orbit in Hindu and Islamic Iconographies." *Ars Islamica* 5 (1938):113–54.

—— "The Vaso Vescovali in the British Museum: A Study in Islamic Astrological Iconography." *Kunst des Orients* 9, no. 1/2 (1973–74):99–130.

Kalus, Ludvik. "Un bouclier mamelouk dans les collections du Musée de l'Homme à Paris." *Armi Antiche* (Turin, 1975):23–28.

Karabacek, J. "Ein damascenischer Leuchter des XIV. Jahrhunderts." *Repertorium für Kunstwissenschaft* 2 (1876):265–82.

Kühnel, Ernst. "Zwei Mosulbronzen und ihr Meister." *Jahrbuch der Preussischen Kunstsammlungen* 60 (1939): 1–20.

Lamm, Carl Johan. "A Falconer's Kettledrum of Mameluke Origin in Livrustkammaren." *Livrustkammaren: Journal of the Royal* [Swedish] *Armoury* 6 (1952–54):80–96.

Maspero, Jean. "Deux vases de bronze arabes du XVe siècle." *Bulletin de l'Institut Français d'Archéologie Orientale* 7 (1910): 173–75.

Massignon, M. L. "Six plates de bronze de style mamelouke." *Bulletin de l'Institut Français d'Archéologie Orientale* 10 (1912):79–88.

Mayer, L. A. "A Dish of Mamay as-Saqi." *Berytus* 2 (1935):62–63.

—— "A dish of Shadbak the Atabak." *Quarterly of the Department of Antiquities in Palestine* 8 (1939):40–41.

—— *Islamic Metalworkers and Their Works*. Geneva: Albert Kundig, 1959.

—— À propos du blason sous les Mamluks circassiens." *Syria* 18 (1937):389–93.

—— "Saracenic Arms and Armour." *Ars Islamica* 10 (1943):1–12.

—— "Three Heraldic Bronzes from Palermo." *Ars Islamica* 3 (1936):180–86.

—— "Zwei syro-ägyptische Leuchter im Bernischen Historischen Museum." *Jahrbuch des Bernischen Historischen Museum, Ethnographische Abteilung* 16 (1936):24–27.

Melikian-Chirvani, Assadullah Souren. "L'Art du métal dans les pays arabes II: Deux chandeliers mossouliens au Musée des Beaux-Arts." *Bulletin des Musées et Monuments Lyonnais* 4, no. 3 (1970):45–62.

—— "Cuivres inédits de l'époque de Qa'itbay." *Kunst des Orients* 6, no. 2 (1969):99–133.

Nickel, Helmut. "A Mamluk Axe." In *Islamic Art in the Metropolitan Museum of Art*, edited by Richard Ettinghausen, pp. 213–25. New York:Metropolitan Museum of Art, 1972.

Reich, S., and Wiet, Gaston. "Un astrolabe syrien du XIV siècle." *Bulletin de l'Institut Français d'Archéologie Orientale* 38 (1939):195–202.

Rice, D. S. "Arabic Inscriptions on a Brass Basin Made for Hugh IV of Lusignan." In *Studi Orientalistici in onore di Giorgio Levi della Vida*, vol. 2, pp. 1–13. Rome:Istituto per l'Oriente, 1956.

—— *Le Baptistère de St. Louis*. Paris:Les Éditions du Chêne, 1953.

—— "The Blazons of the 'Baptistère de St. Louis.'" *Bulletin of the School of Oriental and African Studies* 23, no. 2 (1950):367–80.

—— "Inlaid Brasses from the Workshop of Ahmad al-Dhaki al-Mawsili." *Ars Orientalis* 2 (1957):283–326.

—— "Two Unusual Mamluk Metal Works." *Bulletin of the School of Oriental and African Studies* 20 (1957): 487–500.

—— "Studies in Islamic Metal Work I." *Bulletin of the School of Oriental and African Studies* 14, no. 3 (1952):564–78.

—— "Studies in Islamic Metal Work IV." *Bulletin of the School of Oriental and African Studies* 15, no. 3 (1953):489–503.

—— "Studies in Islamic Metal Work V." *Bulletin of the School of Oriental and African Studies* 17, pt. 2 (1955):207–31.

Robinson, H. Russell. *Oriental Armour*. New York: Walker & Co., 1967.

Rogers, J. Michael. "Review of *Islamic Metalwork of the Eighth to the Fifteenth Century in the Keir Collection* by G. Féhérvari." *Bibliotheca Orientalis* 34, no. 3/4 (May–June 1977):236–44.

Ruthven, Peter. "Two Metal Works of the Mamluk Period." *Ars Islamica* 1 (1934):230–34.

Sauvaget, Jean. "La citadelle de Damas." *Syria* 2 (1931):59–90 and 216–41.

Scerrato, Umberto. *Metalli islamici*. Milan:Fratelli Fabbri Editori, 1966.

Sourdel-Thomine, Janine. "Clefs et serrures de la Ka'ba: Notes d'épigraphie arabe." *Revue des Études Islamiques: Articles et Mémoires* 39, no. 1 (1971): 29–86.

Stephan, St. H. "A Forged 'Mamluke' Copper-plate." *Journal of the Palestine Oriental Society* 19 (1939): 45–47.

Stöcklein, Hans. "Die Waffenschätze im Topkapu Sarayi Müzesi zu Istanbul: Ein vorläufiger Bericht." *Ars Islamica* 1 (1934):200–218.

Wiet, Gaston. *Catalogue Général du Musée Arabe du Caire: Objets en cuivre*. Cairo:Imprimerie de l'Institut Français d'Archéologie Orientale, 1932.

Zaki, Abd ar-Rahman. "Important Swords in the Museum of Islamic Art in Cairo." *Vaabenhistoriske Aarbøger* 13 (Copenhagen, 1966):143–52 (Danish) and 153–57 (English.)

Zaki, Muhammad Hasan. "Kursi min an-nahas bi-ism as-sultan al-mamluki muhammad ibn qalawun [A brass table with the name of the Mamluk Sultan Muhammad ibn Qalawun]. *Al-thaqafa* 1, no. 5 (1939):24–25.

GLASS

Abdul-Hak, Selim. "Contribution à l'étude de la verrerie musulmane du VIIIe au XVe siècles." *Les Annales Archéologiques de Syrie* 8–9 (1958–59):3–20.

Aga-Oglu, Mehmet. "An Important Glass Bottle of the Fourteenth Century." *Bulletin of the Detroit Institute of Arts* 12, no. 3 (December 1930):26–27.

Artin, Yacoub. "Une lampe armoriée de l'Emir Sheikhou." *Bulletin de l'Institut Égyptien*, 4th ser., no. 6 (1905):7–13.

Bird, Virgil H. "Reflection of Mamluk Dynasty Art on the Early Glass of Emile Gallé." *Glass* 1 (November–December 1972):29–32.

Dimand, Maurice. "An Enameled Glass Bottle of the Mamluk Period." *Bulletin of the Metropolitan Museum of Art*, n.s. 3 (1944–45):73–77.

—— "A Syrian Enameled Glass Bottle of the XIV Century." *Bulletin of the Metropolitan Museum of Art* 31 (1936):105–6.

Harden, D. B.; Painter, K. S.; Pinder-Wilson, R. H.; and Tait, Hugh. *Masterpieces of Glass*. London: Trustees of the British Museum, 1968.

Hein, Wilhelm. "Eine datierbare Moscheelampe aus der Mamlukenzeit." *Wiener Zeitschrift für die Kunde des Morgenlandes* 53 (1957):88–91.

—— "Mittelalterliche Moscheelampen aus der Mamlukenzeit." *Alte und moderne Kunst* 2, no. 4/5 (1957):14–16.

Herz, Max. "Deux lampes en verre émaillé de l'Émir Toghaitimor (pour l'histoire du signe Ra-Neb-Taoui dans l'art musulman)." *Bulletin de l'Institut Égyptien*, 5th ser., no. 1 (1908):181–87.

Hollis, H. "Two Examples of Arabic Enameled Glass." *The Bulletin of the Cleveland Museum of Art* 32 (December 1945):179–81.

Jacquemart, André. "Lampe de mosquée en verre émaillé, travail persan du XIIIᵉ siècle. Plat vénitien, travail arabe." In *Les collections celebres d'oeuvres d'art*, edited by Edouard Lièvre. Paris:Goupil and Cie, 1869.

Lamm, Carl Johan. *Mittelalterliche Gläser und Steinschnittarbeiten aus dem Nahen Osten*. 2 vols. Berlin:Verlag Dietrich Reimer/Ernst Vohsen, 1929–30.

—— "Un verre émaillé et doré à inscription rasulide." *Le Monde Orientale* 25 (1931):81–84.

Martinovitch, N. "A Glass Globe of Arghun." *Eastern Art* 2 (1930):245.

Mayer, L. A. "Islamic Glassmakers and Their Works." *Israel Exploration Journal* 4 (1954):262–65.

—— "Une lampe armoriée d'Alep." *Revue Archéologique Syrienne* 2 (1932):85–86.

—— "Review of *Une lampe sépulcrale . . .* by P. Ravaisse." *The Journal of the Palestine Oriental Society* 13 (1933):115–17.

Pinder-Wilson, R. H., and Scanlon, George T. "Glass Finds from Fustat: 1964–71." *Journal of Glass Studies* 15 (1973):12–30.

Ravaisse, Paul. *Une lampe sépulcrale en verre émaillé au nom d'Arghun en Nasiri . . . de la collection J. Chappée*. Paris:Paul Geuthner, 1931.

Riis, Paul Jørgen. "Saracenic Blazons on Glass from Hama." In *Studia Orientalia Ioanni Pedersen*, pp. 295–302. Copenhagen:Munksgaard, 1953.

Schmoranz, Gustav. *Old Oriental Gilt and Enamelled Glass Vessels*. Vienna and London:Imperial Handels-Museum of Vienna, 1899.

Schroeder, Eric. "The Lamp of Karim al-Din: An Arab Enamelled Glass of the Early Fourteenth Century." *Bulletin of the* [Boston] *Museum of Fine Arts* 36 (1938):2–5.

Toledo Museum of Art. *Art in Glass: A Guide to the Glass Collection*. Toledo:Toledo Museum of Art, 1969.

Wiet, Gaston. "Les Lampes d'Arghun." *Syria* 14 (1933):203–6.

—— "Les lampes en verre de la collection Gulbenkian." *Annales de l'Institut de Études Orientales*, Université d'Alger (1937):19–26.

—— "Lampes en verre émaillé." *Bulletin de l'Institut d'Égypte* 14 (1931–32):117–26.

—— *Catalogue Général du Musée Arabe du Caire: Lampes et bouteilles en verre émaillé*. Cairo:Imprimerie de l'Institut Français d'Archéologie Orientale, 1929.

Zaki, Muhammad Hasan. "Lampes arabes." *La Femme nouvelle* (December 1951).

—— "Al-mishkawat al-zujajiya fi'l-asr al-mamalik." [Glass mosque-lamps from the Mamluk period]. *Al-thaqafa* 2, no. 65 (1940):31–35.

CERAMICS

Abd al-Raziq, Ahmad. "Documents sur la Poterie d'Époque Mamelouke: Sharaf al-Abawani." *Annales Islamologiques* 6 (1966):21–32.

Abel, Armand. *Gaibi et Les Grand Faïenciers Égyptiens d'Époque Mamlouke*. Cairo:Imprimerie de l'Institut Français d'Archéologie Orientale, 1930.

Aly Bahgat. "Les fouilles de Foustat: Découverte d'un four de potier arabe datant du XIVᵉ siècle." *Bulletin de l'Institut d'Égypte*, 5th ser., no. 8 (1914):233–45.

Aly Bahgat and Massoul, Felix. *La ceramique musulmane de l'Égypte*. Cairo:Imprimerie de l'Institut Français d'Archéologie Orientale, 1930.

Carswell, John. "Six Tiles." In *Islamic Art in the Metropolitan Museum of Art*," edited by Richard Ettinghausen, pp. 99–109. New York:Metropolitan Museum of Art, 1972.

—— "Some Fifteenth-century Hexagonal Tiles from the Near East." *Victoria and Albert Museum Yearbook* 3 (1972):59–75.

Fehérvári, Géza. *Islamic Pottery: A Comprehensive Study Based on the Barlow Collection*. London:Faber & Faber Limited, 1973.

Grube, Ernst J. *Islamic Pottery of the Eighth to the Fifteenth Century in the Keir Collection*. London:Faber & Faber Limited, 1976.

Hobson, R. L. "A Fourteenth-Century Egyptian Albarello." *British Museum Quarterly* 9 (1934):51–52.

—— *A Guide to the Islamic Pottery of the Near East*. London:Trustees of the British Museum, 1932.

Jungfleisch, Marcel. "À propos d'une publication du Musée Arabe du Caire: Gaibi et les grands faïenciers égyptiens d'époque mamelouke." *Bulletin de l'Institut d'Égypte* 14 (1931–32):257–74.

Kubiak, Wladyslaw B. "Medieval Ceramic Oil Lamps from Fustat." *Ars Orientalis* 8 (1970):1–18.

Lacam, Jean. "La céramique Mameluke au Musée des Arts Décoratifs." *Faenza* 37 (1951):98–104.

Lane, Arthur. *Later Islamic Pottery*. 2d ed. rev. London:Faber & Faber Limited, 1971.

Marzouk, M. A. "Egyptian Sgraffito Ware Excavated at Kon-ed-Dikka in Alexandria." *Bulletin of the Faculty of Arts, Alexandria University* 13 (1959):2–23.

—— "Three Signed Specimens of Mamluk Pottery from Alexandria." *Ars Orientalis* 2 (1957):497–501.

Maunier, Ph. "La fleur-de-lis dans l'art arabe." *Bulletin de la Société Nationale des Antiquaires de France* (1925):215–16.

Meinecke, Michael. "Mamluk Faience Mosaik." *Sixth International Congress of Iranian Art and Archaeology, Oxford, 10th–16th September 1972, Summaries of Papers*, p. 59.

—— "Die Mamlukischen Fayencemosaikdekorationen: Eine Werkstätte aus Tabriz in Kairo (1330–1350)." *Kunst des Orients* 11, no. 1/2 (1976–77):85–144.

Mostafa, Mohamed. "Saraf al-abawani, sani'l-fukhar al-mutli fi'l-qarn al-thamim al-hijri" [Sharaf al-Abawani, a glazed pottery craftsman of the eighth century of the Hijra]. In *Mutamar al-athar fi'l-bilad al-arabiya al-munaqid fi dimishq, saif, 1947*, pp. 159–64. Giza:Marbaat jamiat fuad, 1948.

—— "Two Fragments of Egyptian Luster Painted Ceramics from the Mamluk Period." *Bulletin de l'Institut d'Égypte* 31 (1949):377–82.

Musée de l'Art Arabe du Caire. *Le Céramique Égyptienne de l'Époque Musulman: Planches, publiée sous les auspices du Comité de Conservation des Monuments de l'Art Arabe*. Basel:Frobenius S.A., 1922.

P[ier], G. C.. "Saracenic Heraldry in Ceramic Decoration." *Metropolitan Museum of Art Bulletin* 3 (1908):8–11.

Reyhanlı, Tülây. "Türk ve İslâm Eserleri Müzesinde Bulunan Memlûk Keramikleri" [Mamluk ceramics found in the Turkish and Islamic Arts Museum]. *Sanat Tarihi Yıllığı* 4 (İstanbul, 1970–71):215–35.

Sarre, Friedrich. *Keramik und andere Kleinfunde der islamischen Zeit von Baalbek*. Berlin and Leipzig:Walter de Gruyter & Co., 1925.

Sauvaget, Jean. *Poteries Syro-Mésopotamiennes du XIVᵉ siècle*. Documents des Études Orientales de l'Institut Français de Damas, vol. 1. Damascus:Institut Français de Damas, 1932.

Scanlon, George T. "The Fustat Mounds: A Shard Count." *Archaeology* 24 (1971):220–33.

Toueir, Kassem. "Céramique mameloukes à Damas." *Bulletin des études orientales* 26 (1973):209–17.

Al-Ush, Muhammed Abu'l-Faraj. "Namathej min al-khazaf al-arabiya al-islamiyya fi'l-mathaf al-watani bi dimishq" [Samples of Arab-Islamic pottery in the National Museum of Damascus]. *Al-marifah* (Damascus, May 1963):103–11.

Vaux, R. de, and Steve, A. M. *Fouilles à Qaryet el-Enab Abu Ghosh, Palestine*. Paris:Gabalda, 1950.

WOODWORK, IVORY, AND STONE

David-Weill, Jean. *Bois à épigraphes (époques mamlouke et ottomane)*, vol. 2. Bulaq, Egypt:Imprimerie Nationale, 1936.

Hamdi, Ahmad Mamduh. "Zakhrafat al-akhshab fi asr al-mamalik" [Decoration on woodwork in the Mamluk period]. *Minbar al-islam* 19, no. 11 (April 1962):102–5.

Kühnel, Ernst. "Die mamlukische Kassettenstil." *Kunst des Orients* 1 (1950):55–68.

Mayer, L. A. *Islamic Woodcarvers and Their Works*. Geneva:Albert Kundig, 1958.

Wiet, Gaston. *Catalogue Général du Musée de l'Art Islamique du Caire: Inscriptions Historiques sur Pierre*. Cairo:Imprimerie de l'Institut Français d'Archéologie Orientale, 1971.

TEXTILES

Falke, Otto von. *Decorative Silks*. 3d ed. New York:William Helburn, Inc., 1936.

Golombek, Lisa, and Gervers, Veronika. "Tiraz Fabrics in The Royal Ontario Museum." In *Studies in Textile History*, edited by Veronika Gervers, pp. 82–125. Toronto:Royal Ontario Museum, 1977.

Kendrick, A. F. *Catalogue of Muhammadan Textiles of the Medieval Period*. London:Victoria and Albert Museum, 1924.

Kühnel, Ernst. *Islamische Stoffe aus ägyptischen Gräbern in der Islamischen Kunstabteilung und in der Stoffsammlung des Schlossmuseums*. Berlin:Wasmuth for Staatliche Museen zu Berlin, 1927.

—— "La Tradition Copte dans les Tissus Musulmans." *Bulletin de la Société d'Archéologie Copte* 4 (1938):79–89.

Lamm, Carl Johan. "Arabiska Inskrifter pa nagra Teltfragment fran Egypten." In *Röhsska Konstslöjdmuseets Arstryck*, pp. 47–55. Göteborg, Sweden, 1935.

—— *Cotton in Medieval Textiles of the Near East*. Paris:Paul Geuthner, 1937.

—— "Some Mamluk Embroideries." *Ars Islamica* 4 (1937):65–76.

Marzouk, M. A. *History of Textile Industry in Alexandria 331 B.C.–1517 A.D.* Alexandria:Alexandria University Press, 1955.

—— "The Tiraz Institutions in Mediaeval Egypt." In *Studies in Islamic Art and Architecture in Honour of Professor K. A. C. Creswell*, pp. 157–62. Cairo:American University Press, 1965.

Mostafa, Mohamed. "Mamluk Brocades." *Egypt Travel Magazine* 15 (October 1955):21–25.

Pfister, R. *Les Toiles Imprimées de Fostat et l'Hindoustan*. Paris:Les Éditions d'Art et d'Histoire, 1938.

Schmidt, Heinrich J. *Alte Seidenstoffe*. Brunswick, Germany:Klinkhardt & Bierman, 1958.
—— "Damaster der Mamlukenzeit." *Ars Islamica* 1 (1934):99–109.

RUGS

Beattie, May. "Review of *Oriental Rugs in the Metropolitan Museum of Art* by M. S. Dimand and Jean Mailey." *Oriental Art* 20, no. 4 (Winter 1974): 449–52.

Cavallo, Adolph S. "A Carpet from Cairo." *Journal of the American Research Center in Egypt* 1 (1962):69–75.

Dimand, M. S., and Mailey, Jean. *Oriental Rugs in the Metropolitan Museum of Art*. New York:Metropolitan Museum of Art, 1973.

Ellis, Charles Grant. "Is the Mamluk Carpet a Mandala ? A Speculation." *Textile Museum Journal* 4, no. 1 (December 1974):30–50.

—— "Mysteries of the Misplaced Mamluks." *Textile Museum Journal* 2, no. 2 (December 1967):3–20.

Erdmann, Kurt. "Kairener Teppiche, Teil I: Europäische und islamische Quellen des 15–18 Jahrhunderts." *Ars Islamica* 5 (1938):179–206.

—— "Kairener Teppiche, Teil II: Mamluken- und Osmanenteppiche." *Ars Islamica* 7 (1940):55–81.

—— "Kairo als Teppichzentrum." *Forschungen und Fortschritte* 14 (1938):207–10.

—— "Neuere Untersuchungen zur Frage der Kairener Teppiche." *Ars Orientalis* 4 (1961):65–105.

—— *Der Orientalische Knüpfteppich*. 1955. 2d ed., Tübingen:Wasmuth, 1960.

—— "Some Observations on the So-Called Damascus Rugs." *Art in America* 19 (1931):3–22.

—— "Wietere Beiträge zur Frage der Kairener Teppiche." *Berichte aus den ehem. Preussischen Kunstsammlungen*, n.s. 9 (1959):12–22.

Kühnel, Ernst, and Bellinger, Louisa. *The Textile Museum, Catalogue Raisonné: Cairene Rugs and Others Technically Related, 15th Century–17th Century*. Washington, D.C.:National Publishing Company, 1957.

Riefstahl, Rudolf M. "Das Palmenmotiv auf einem Ägyptischen Teppich der Ballardsammlung." *Jahrbuch der Asiatischen Kunst* 2 (1925):159–62.

Sarre, Friedrich. "Die ägyptische Herkunft der sogen: Damaskus-Teppiche." *Zeitschrift für bildende Kunst* 32 (1921):75–82.

—— "Die ägyptischen Teppiche." *Jahrbuch der Asiatischen Kunst* 1 (1924):19–23, 25.

Scheunemann, Brigitte. "Das Papyrusmotiv aus Ägyptischen Teppichen Mamlukischer Zeit." *Kunst des Orients* 2 (1955):52–58.

Spuler, Friedrich. *Islamic Carpets and Textiles in the Keir Collection*. London:Faber & Faber Ltd., 1978.

Troll, Siegfried. "Damaskus-Teppiche." *Ars Islamica* 4 (1937):201–31.

Unger, Edmund de. "The Origin of the Mamluk Carpet Design." *Hali* 2, no. 4 (1980):321–22.

Zaki, Abd ar-Rahman. "Sajajid qahiriya wa ukhra muttasila biha min al-nahiya al-fanniya." [Technical and artistic aspects of Cairene rugs and others related]. *Al-majalla* 2 (1958):119–21.

Zick-Nissen, Johanna. "Ein Mamlukisches Wirteppichfragment." *Berichte aus den Staatlichen Museen der Stiftung Preussischer Kulturbesitz*, n.s. 14 (1964):43–44.

APPENDIX

NAMES OF ARTISTS

Calligraphers
Abu'l-Fadail ibn Abu Ishaq: no. II, figs. 5–8
Ahmad ibn Muhammad: no. 3
Ali ibn Muhammad: no. 6
Farrukh ibn Abd al-Latif: no. I, figs. 1–4
Husein ibn Hasan: no. V, figs. 17–20
Muhammad ibn Ahmad: no. III, figs. 9–12
Qanem al-Sharifi: no. 9
Umar ibn Abdallah: no. IV, figs. 13–16

Illuminators
Ibrahim al-Amidi: no. 6

Metalworkers
Ahmad ibn Husein al-Mawsili: no. 22
Mahmud ibn Sunqur: no. 13
Muhammad ibn Ali al-Hamawi: no. 36
Muhammad ibn al-Zayn: nos. 20–21
Muhammad ibn Hasan al-Mawsili: no. 10

Painters
Ali: no. IV, figs. 13–16

Potters
Al-Mufid: no. 97
Sharaf al-Abawani: no. 95

NAMES OF PATRONS

Sultans
Mamluk
 Barsbay: nos. 7–8, 41
 Hasan: nos. 31, 52
 Nasir al-Din Muhammad: no. 26
 Qaitbay: nos. 9, 34–35, 105, 112
 Qansuh al-Ghuri: nos. 101, 110
 Shaban II: nos. 5–6, 33
 Tumanbay I: no. 42

Rasulid
 Dawud: nos. 22, 50
 Yusuf: no. 14

Amirs
 Arghun Shah: no. 4
 Badr al-Din Baysari: no. 11
 Kitbugha: nos. 15–16
 Qushtimur: no. 27
 Tabtaq: no. 28
 Tarabay: no. 43

Others
 Karim al-Din: no. 53
 al-Wathiq bi'l-Mulk al-Wali: no. 36

DATED PIECES

1269 Candlestick: no. 10
1281 Pen box: no. 13
1304/5 Pen box: no. 23
1315 *Automata*: no. I, figs. 1–4
1334 Koran: no. 3
1334 *Maqamat*: no. II, figs. 5–8
1354 *Kalila wa Dimna*: no. III, figs. 9–12
1363/64 Key: no. 33
1366 *Nihayat al-Su'l*: no. IV, figs. 13–16
1369 Koran: no. 5
1372 Koran: no. 6
1425 Koran: noṣ. 7–8
1482/83 Candlestick: no. 34
1511 *Shahnama*: no. V, figs. 17–20

HERALDIC SYMBOLS

Royal Emblems
Mamluks
 Crescent: nos. 47, 114–15
 Eagle: nos. 11–12, 27, 96
 Epigraphic blazon: nos. 9, 26, 29–31, 34–35, 52, 101, 110
 Lion: nos. 46, 108
 Rosette, six-petaled: nos. 12, 17, 27–28, 93, 96
Ayyubids of Hama
 Bends in lower half of shield: nos. 24, 46
Rasulids of Yemen
 Rosette, five-petaled: nos. 14, 22, 50

Signs of Office
 Composite: nos. 39, 124
 Cup: nos. 15–16, 27–28, 96, 109, 125
 Napkin: no. 93
 Sword: no. 94
 Table: no. 115
 Trumpet: no. 95

Other
 Ewer: no. 88
 Quiver: no. 90
 Spike fiddle: no. 91
 Tamgha: no. 83

COLLECTIONS

MAMLUK SULTANS

Bahri Period (1250–1390)

1250	Shajar al-Durr
1250–57	Aybak (al-Muizz Izz al-Din)
1257–59	Ali (al-Mansur Nur al-Din)
1259–60	Qutuz (al-Muzaffar Sayf al-Din)
1260–77	Baybars I, al-Bunduqdari (al-Zahir Rukn al-Din)
1277–79	Baraka Khan (al-Said Nasir al-Din)
1279	Salamish (al-Adil Badr al-Din)
1279–90	Qalawun, al-Alfi (al-Mansur Sayf al-Din)
1290–93	Khalil (al-Ashraf Salah al-Din)
1293–94	Nasir al-Din Muhammad (al-Nasir), first reign
1294–96	Kitbugha (al-Adil Zayn al-Din)
1296–99	Lajin (al-Mansur Husam al-Din)
1299–1309	Nasir al-Din Muhammad (al-Nasir), second reign
1309–10	Baybars II, al-Jashnigir (al-Muzaffar Rukn al-Din)
1310–41	Nasir al-Din Muhammad (al-Nasir), third reign
1341	Abu Bakr (al-Mansur Sayf al-Din)
1341–42	Kujuk (al-Ashraf Ala al-Din)
1342	Ahmad (al-Nasir Shihab al-Din)
1342–45	Ismail (al-Salih Imad al-Din)
1345–46	Shaban I (al-Kamil Sayf al-Din)
1346–47	Hajji I (al-Muzaffar Sayf al-Din)
1347–51	Hasan (al-Nasir Nasir al-Din), first reign
1351–54	Salih (al-Salih Salah al-Din)
1354–61	Hasan (al-Nasir Nasir al-Din), second reign
1361–63	Muhammad (al-Mansur Salah al-Din)
1363–76	Shaban II (al-Ashraf Nasir al-Din)
1376–82	Ali (al-Mansur Ala al-Din)
1382	Hajji II (al-Salih Salah al-Din), first reign
1382–89	Barquq (al-Zahir Sayf al-Din), Burji Mamluk
1389–90	Hajji II (al-Muzaffar al-Salih Salah al-Din), second reign

Burji Period (1382–1517)

1382–89	Barquq (al-Zahir Sayf al-Din), first reign
1389–90	Hajji II (al-Muzaffar al-Salih Salah al-Din), Bahri Mamluk
1390–99	Barquq (al-Zahir Sayf al-Din), second reign
1399–1405	Faraj (al-Nasir Nasir al-Din), first reign
1405–6	Abd al-Aziz (al-Mansur Izz al-Din)
1406–12	Faraj (al-Nasir Nasir al-Din), second reign
1412	al-Mustain (al-Adil), Abbasid Caliph
1412–21	Shaykh (al-Muayyad Sayf al-Din)
1421	Ahmad (al-Muzaffar)
1421	Tatar (al-Zahir Sayf al-Din)
1421–22	Muhammad (al-Salih Nasir al-Din)
1422–38	Barsbay (al-Ashraf Sayf al-Din)
1438	Yusuf (al-Aziz Jamal al-Din)
1438–53	Jaqmaq (al-Zahir Sayf al-Din)
1453	Uthman (al-Mansur Fakhr al-Din)
1453–61	Inal (al-Ashraf Sayf al-Din)
1461	Ahmad (al-Muayyad Shihab al-Din)
1461–67	Khushqadam (al-Zahir Sayf al-Din)
1467	Bilbay (al-Zahir Sayf al-Din)
1467–68	Timurbugha (al-Zahir)
1468–96	Qaitbay (al-Ashraf Sayf al-Din)
1496–98	Muhammad (al-Nasir)
1498–1500	Qansuh (al-Zahir)
1500–1501	Janbalat (al-Ashraf)
1501	Tumanbay I (al-Adil Sayf al-Din)
1501–16	Qansuh al-Ghuri (al-Ashraf)
1516–17	Tumanbay II (al-Ashraf)

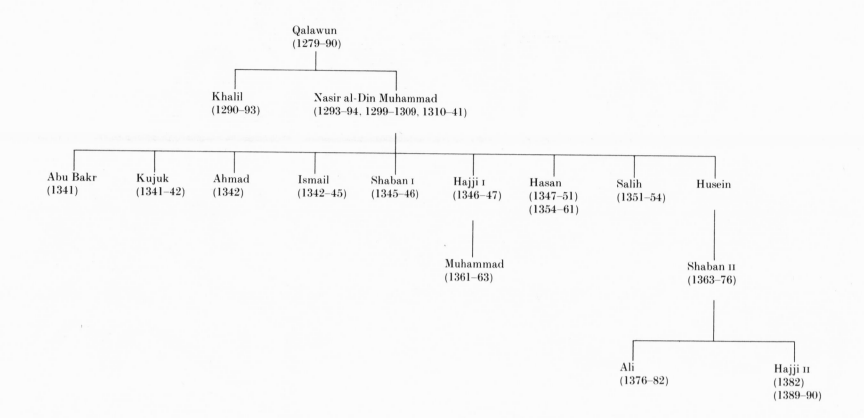

About the Author

Esin Atıl, a native of Turkey, received a Ph.D. degree from the University of Michigan, Ann Arbor. Since 1970, Dr. Atıl has been curator of Near Eastern art at the Smithsonian Institution's Freer Gallery of Art in Washington, D.C. She has prepared several noteworthy exhibitions and catalogues, including *2500 Years of Persian Art* (1971), *Ceramics from the World of Islam* (1973), *Turkish Art of the Ottoman Period* (1973), *Art of the Arab World* (1975), and *The Brush of the Masters: Drawings from Iran and India* (1978). Her most recent publications include the comprehensive *Turkish Art* (1980) and the charming yet instructive *Kalila wa Dimna: Fables from a Fourteenth-Century Arabic Manuscript*. Dr. Atıl is a member of the editorial board of *Ars Orientalis* and *Muqarnas*.